Funding Guide

Arts

Susan Forrester
David Lloyd

DIRECTORY OF SOCIAL CHANGE

THE ARTS FUNDING GUIDE

Sixth edition

Susan Forrester and David Lloyd

Copyright © The Directory of Social Change 2002

First published 1989

Second edition 1991

Third edition 1994

Fourth edition 1996

Fifth edition 1999

Sixth edition 2002

Published by

The Directory of Social Change

24 Stephenson Way

London NW1 2DP

Tel: 020 7209 5151

Fax: 020 7391 4804

E-mail: books@dsc.org.uk

from whom further copies and a full publications list are available.

The Directory of Social Change is a Registered Charity no. 800517

ISBN 1 903991 10 2

British Library Cataloguing in Publication Data

A catalogue record for this book is available from the British Library

Cover design by Lenn Darroux

Designed and typeset by Linda Parker

Printed and bound by Page Bros., Norwich

Other Directory of Social Change departments in London:

Courses and Conferences tel: 020 7209 4949

Charityfair/Charity Centre tel: 020 7209 1015

Publicity tel: 020 7391 4900

Research tel: 020 7391 4880

Directory of Social Change Northern Office:

Federation House, Hope Street, Liverpool L1 9BW

Courses and Conferences tel: 0151 708 0117

Research tel: 0151 708 0136

CONTENTS

See also Funding from Europe

Museums, Galleries, Libraries, Archives

Other National Arts Bodies
Arts, architecture, craft, design heritage, languages

Education and Youth

See also International

Metropolitan Area Grant Schemes

Local Authority Funding

PART THREE – SUPPORT FROM COMPANIES

PART FOUR – CHARITABLE TRUSTS

Appendices

Indexes

INTRODUCTION

'The open space for artistic expression is expanding. It is increasingly difficult in a more democratic, self-organising, less deferential and more educated society to prescribe any one particular role for art to play … The Arts Council's fundamental role … is to promote exploration through art. Art as enquiry.'

Peter Hewitt, chief executive, Arts Council of England

The space for artistic expression may be expanding, but what about the systems of funding support?

Important changes have been taking place during the production of this new guide. Whilst change is inevitable (and all guides can be seen as 'history' by the time they are published) this current process is fundamental. The transformations being wrought are far-reaching. Major national governmental agencies are reshaping themselves and how they conduct their support at a regional level is a key issue.

STRUCTURAL CHANGES

National

The chair of Arts Council of England (ACE) dropped a depth charge in 2001 with his announcement that a new integrated body would take over the regional arts boards. The boards' dependence on ACE grant-in-aid made the results a foregone conclusion, particularly when it was apparent that the secretary of state for Culture, Media and Sport supported these proposals. At the time of writing (July 2002) the council board members, legally in charge of this new structure, had been appointed, and include the chairs of the regional bodies. For the grant-seeker the main outcomes will not kick in until 2003. Meanwhile the regional arts bodies continue with their own individual development funding programmes during 2002/03. This writer guesses that the smaller funding streams (outside the main revenue funding to organisations) will be 'simplified' and rationalised across England whilst allowing for regional variations – much as with the Regional Arts Lottery Programme. But who knows? ACE has clearly stated that under the new structure it expects the regional offices to be responsible for funding decisions.

Regionalisation

The new regional structure of ACE follows the boundaries of the Regional Development Agencies and the government offices for the regions. This has led to the loss of one arts board. The South and South East Arts Boards have been merged into one new regional body (and some other exchange of smaller areas to allow other regional arts councils follow the nine regional boundaries). Superficially it seems that ACE is centralising its power. It says not. It remains to be seen if the reverse will be true.

Whatever the case, regionalisation is a force affecting funding throughout all key governmental arts funding agencies. The young national Film Council appears to be moving in the opposite direction to ACE by regionalising and 'devolving' its powers. It has been instrumental in the foundation of *independent* regional bodies covering all aspects of the industry support – production, production development, locations, exhibition, archives, education, training, etc. This process has varied in complexity from region to region. At the time of writing, the London and Yorkshire agencies had not been established.

In another branch of the arts – museums, libraries and archives – new regional structures are also being formed. New single agencies working across these areas (museums includes galleries) are being established at regional level to promote and develop their work. This change is being led by Resource: the Council for Museums, Libraries and Archives, itself a relatively new organisation which draws together bodies which had previously been separately represented and funded.

All these changes should help to feed the work of the infant Regional Cultural Consortiums which have been set up to champion the spectrum of cultural and creative industries in each region, including tourism and sport. One of their main tasks has been to formulate a regional cultural strategy. They are also expected to advise and inform central government, Lottery distributors, local government and regional bodies such as Regional Development Agencies.

Regional priorities and differences are reflected in the funding made available via the Regional Arts Lottery Programme and other Lottery distributors. The creation of a new regional tier of government – the English Regional Assemblies (ERAs) – was on the agenda, and a White Paper under consultation, at the time of writing this introduction. It is unlikely that any assembly will be in place before the end of the next five years (2007). Nor will they be compulsory. Regions expressing a strong desire for one will have the opportunity to vote for one in a referendum. The North East and the North West are expected to be among the first to move to create an ERA.

The other national arts funding bodies in Scotland, Wales and Northern Ireland have been taking a long, hard look at their practice. The most radical review took place within the Arts Council for Wales and resulted in a complete overhaul of its processes. It has a new staffing structure, responsibilities are dispersed to each of its three 'regional' offices and simplified funding arrangements allow executive staff to take the lesser funding decisions. It has also introduced an open application system for a wide range of individuals to offer their services to join a National Panel of Experts which will assist with decisions on larger disbursements.

All these new structures and processes, which demand the positive agreement and co-operation of many different bodies, take time to develop and mature.

The key point is that no self-respecting arts organisation (of whatever size) which is looking for funding can afford to disregard changes in government structures and responsibilities whether at the most local or the regional level. Indeed, recent consultations could eventually lead to the introduction of wider powers for parish and town councils that could affect cultural aspects of their areas.

FUNDING 'TRENDS' – THE ARTS AS A FORCE FOR SOCIAL CHANGE

The ability of the arts to generate other social benefits is given considerable public emphasis. The issues – access, education, cultural diversity, social regeneration, and social inclusion – continue to be highlighted and the major arts funding bodies emphasise these inter-linked issues in their development programmes. 'Art form' classifications for support seem to be 'disappearing' or at least be far less dominant. A different kind of 'joined up thinking' is taking place.

The Arts Lottery funding has done much, not just through its major capital projects, but also through its Regional Arts Lottery Programmes, to encourage a wide variety of initiatives to widen audiences throughout the country. And not just audiences, its funding programmes aim to encourage and strengthen a wider range of participatory opportunities. Access in all its meanings.

There is pressure arising, via the Department of Culture, Media and Sport, for a fairer, more equal geographical distribution of funding by each of the Lottery distributors. This has followed the joint *fairshare* initiative arranged between the New Opportunities Fund and the Community Fund, which started in 2002. The suggestion is that other Lottery distributors are recalcitrant in this respect and that each should be required to demonstrate that all parts of the UK are getting a 'fair' allocation from their funds.

The department has also funded a major £40 million pilot project – Creative Partnerships started in spring 2002 in 16 deprived areas across England including Birmingham, Merseyside, east London and the Tees Valley. The partnerships links 25 schools from each area with a variety of arts and cultural organisations, giving the young people a chance to make real connections with artists and culture. Our culture secretary expects this venture will produce 'lower truancy rates and youth offending'.

This excellent venture has a rather ironic side in view of the desperately low position of arts education in schools. As the National Campaign for the Arts says in its June 2002 issue of *Arts Care,* 'Perhaps of greatest issue for the arts community is the lack of a requirement for young people to experience the arts as part of formal education from the age of 14 onwards.'

CHANGING FACES IN COMPANIES AND TRUSTS

Arts & Business (A&B), along with its government-funded Partnership Scheme, is fostering interesting developments in the business world, many of which involve the employees of companies in more a direct engagement with the arts and artists. In addition A&B's campaign work with the newly formed Prince of Wales' Arts and Kids Foundation aims 'to attract additional investment by businesses and to raise the profile of the exemplary work being carried out with young people by arts organisations throughout the UK'. It will be interesting to see how companies respond to this challenge.

As an instance of a 'trend' it is worth noting that the Baring Foundation, one of the few major grant-making trusts with a clear arts policy, recently gave its programme of core funding specifically to arts organisations working with young people because they are underfunded and 'passed over'. The foundation is also conscious that, whilst funding to the arts may be raised from grant-making trusts for arts activities that counter social exclusion/disadvantage, it can now be hard to raise money for the arts, pure and simple, for 'arts for art's sake'. Apart from grant-making trusts with a particular interest in music, very few specifically support contemporary work. On the plus side, more 'new' money is available through newly established trusts, such as the Foyle Foundation, and greatly enlarged major trusts, such as the Fairbairn and Hamlyn Foundations.

CHANGING PERCEPTIONS – ÉLITISM AND SOCIAL INCLUSION

Whatever your position on the arts, the accusation that they are élitist and for the privileged seem, at last, to be losing ground – even in that bastion of privilege, the Royal Opera House. The House is starting to live down its appalling public image. It has been able to show in 2002 that its opera audiences are young, and less well off than most people would expect – nearly a quarter earn less than £15,000 a year (nearly a half less than £30,000). It sells cheaper seats, school nights, TV relays into piazzas, and Sunday night concerts from Bjork to Ravi Shankar.

Cultural 'snobbism' thrives at both ends of the social spectrum – from opera to football. Increasing acceptance of our cultural diversity in all its richness is also helping to break down false divisions founded in perceptions of class, race, background and privilege. Talvin Singh is a prime example of talent transcending categorisation with work that moves between traditional and populist forms fusing western with eastern, ancient with modern.

This is why the quotation at the head of this introduction is so interesting, and provocative for those thinking about the harsh realities of money. What kind of 'exploration' or 'enquiry'? The exploration of beneficial social and behavioural changes which can be effected through the arts? The explorations by driven, questioning (sometimes bloody-minded) artists pushing the boundaries of artistic experience? Or the colourful panoply of skills, interests and activities between these poles?

The recent period has been marked by bureaucratic change. It can only be hoped that the administrations of the varied funding bodies don't get completely bogged down in bureaucratic stress and keep creative, alive and openminded in their work for the arts and artists.

TAKING A NEW LOOK AT YOUR ORGANISATION

TAKE A NEW LOOK AT YOURSELF
and others may do so also

'What on earth has branding got to do with me?' you may ask. 'We are not part of Commodity Culture' could be your response, with a touch of disdain.

It's always valuable to take a different look at yourselves and what you do. It can help freshen up your fundraising and partnerships with whatever source, governmental agencies and grant-making trusts, as well as companies. The suggested workshop will be illuminating and useful, as well as a lively form of bonding exercise for staff.

The more you know yourself the better you will be able to present yourself.

Francis Booth of the brandbuilder consultancy recommends his workshop on the branding issue for small and medium-sized organisations.

BRANDING IN THE ARTS

'Build a better mousetrap and the world will beat a path to your door.' An old saying, but we know it isn't true any more. The business world has been using branding for many years to build recognition and loyalty but some arts organisations are still sceptical about its use for them. Although *The Mousetrap* has been running in the West End for nearly 50 years, hundreds of theatres, dance companies, galleries, museums and orchestras struggle to find sponsors and audiences.

> Branding builds loyalty; loyalty builds audiences
>
> Branding connects you to sponsors' brand needs
>
> Branding gives focus to the people who work in the organisation

The fact is, you already have a brand, whether you know it or not, whether you exploit it or not – even whether you like it or not. For example, some London theatres like the Royal Court and the Almeida moved out of their original buildings while they were being refurbished. A few years ago you might have said that the buildings were their main asset, but in both cases their brand was so strong that they could put on productions in other places and audiences still came because they knew what to expect.

A brand is not just a logo. In fact the logo is the last thing you should think about. First, it is important to analyse and understand your own brand and make sure everyone in the organisation shares this understanding and communicates it to your sponsors and your audience. What would help you and your sponsors understand what your brand is saying? A *brand plan*. You can employ consultants to create such a plan for you, or you can create one yourself. Here's how.

Set aside a whole day to run a brand-building workshop; invite both the creative and administrative people, as well as external board members, friends, external agencies and, if possible, sponsors. You are going to analyse the five key elements of your brand:

- product
- positioning
- personality
- promise and
- presentation.

Product: what you do

What is the difference between a brand and a product? Here's one example. Vauxhall make a small open-topped sports car. It's low, fast and looks stylish. Lotus make a similar car with similar performance for almost exactly the same price. But whereas Lotus sell thousands of their car, Vauxhall sell almost none – you may never have seen one. Why? Because the Lotus brand is associated with exciting, fast cars and Vauxhall's is associated with dull company cars. As a reviewer said: 'while Lotus evokes the oily smell of the race track, Vauxhall has the oily smell of the sales rep'. It doesn't matter how good the product is if the brand isn't giving the right message.

> Your product is what you *do*; your brand is what you are

In your workshop, try to agree on a single sentence that explains your product – what you do – to someone who has never heard of you and knows nothing about the arts. This is harder than it sounds and should cause some lively debate.

> Loyalty is to brands not to products. Products can change; brands must be consistent

Positioning: where you stand

In the arts the competition for audiences comes not just from similar arts organisations (in what marketers would call the same category) but from other arts as well as from other uses of people's time and money: cinema; Classic FM; TV; eating out; football, etc.

Where do you stand in relation to all these people competing for your audience? And how does the audience know where to place you in relation to the other choices they have?

> Positioning differentiates you from other, similar organisations

Positioning is a way of answering these questions for your sponsors and audience. A positioning chart has two axes and you use it to position yourself and similar organisations. The first task is to pick two pairs of oppositions that are relevant to defining what you do as opposed to what the other organisations do. For example, you could have a chart which had two axes labelled:

standard repertoire / new repertoire
traditional style / avant-garde style

So, if you perform standard works in experimental styles, you would be at the top left. And if one of your competing organisations performs new works in

experimental styles they would be at the top right. And so on until the chart has all the relevant organisations in their respective places.

Some other suggestions are:

world-class	/	amateur
fun	/	serious
conservative	/	innovative
traditional	/	experimental
affordable	/	luxury
central	/	local
predictable	/	unpredictable
socially committed	/	arts for art's sake

There are plenty of others; use the workshop to brainstorm the ones that are right for you.

Personality: who you are

The personality of a brand makes people relate to it. Sponsors need to be able to feel that the brand is like a person they like and want to spend time with. If you can understand how you want the brand to feel to its audience, in these personal terms, you can use this knowledge in all your communications of the brand and build relationships.

> Brands have personalities. Brand loyalty is a form of relationship

As a team, imagine your brand is a person: where does he/she: buy food; buy clothes; go on holiday; what car does he/she drive; what kind of watch would he/she wear; kinds of colours/patterns would he/she dress in?

> If your brand were a person, what kind of person would it be?

Next, circle the attribute from each pair you think represents the brand best. Add any others you think are interesting:

male	\	female
urban	\	suburban
single	\	family
enthusiastic	\	reserved
serious	\	lighthearted
young	\	mature
adventurous	\	conservative
unconventional	\	conventional
sophisticated	\	ingenuous
fashionable	\	timeless
traditional	\	hip

Finally, imagine your brand is looking for a date; write an ad of no more than 20 words to go in the personal column! Apart from being fun to do, this is a great way to sum up the strengths of the brand in a very succinct way.

> People today define themselves by the brands they use

The other aspect of a brand's personality relates to how using it reinforces people's image of themselves; this applies as much to arts brands as to cosmetics, clothes and cars. And, increasingly, brands are not simply aspirational any more; there is no obvious 'best' or most coveted brand in terms simply of quality or cost. Brands today have more subtle meanings. People build their own self-image and choose their brands to reinforce it. And sponsors are also looking to work with organisations that reinforce their brand personality.

Promise: why sponsors and audiences return

The strongest and oldest global brands are the most consistent. A McDonalds burger, a Coke, a pair of Levis are always going to be the same every time, anywhere in the

> Marketing is from Mars, branding is from Venus

world. People become loyal to them because they know what they are going to get. The brand has made them a promise.

The product can change but if the brand is strong enough people will trust it and try the new product. As long as it keeps the promise.

Here are some examples of promises. They all take the form: 'whenever I visit _____ I know I will get':

- an uplifting evening; world-class playing; interesting programmes;
- relaxing and soothing night out; beautiful music with tunes I know and can hum;
- easygoing, entertaining plays and musicals; not too challenging after a hard day;
- no legroom; sweltering heat; long queues at the bar; outrageous prices.

> Write your brand's promise from the point of view of the audience, not yourself

As the last one shows, not all brands have good promises. Be realistic when you formulate yours.

A strong and well-expressed promise enables a sponsor to see how what you promise your customers matches what your sponsors promise theirs.

Presentation: how the brand looks and feels

Some of the important aspects in communicating your branding to the outside world are:

- logo/typeface
- colour scheme
- tone of voice
- tagline
- name.

> 360° branding means that everything you do and say must reflect the attributes of the brand

All these elements should follow from the work you have just done. They all need to be tightly controlled to make sure they reflect the brand attributes you have already identified.

There is no space here to go into details on all of these and no time in the workshop; they need detailed work

and may need outside specialist help from designers, marketers and PR. However, while you are still in workshop mode you can look briefly at them as a team.

Logo/typeface

The maximum number of fonts a brand needs is two: say, a sans serif one for headings and (optionally) a serif one for body copy. These should reflect your brand personality. All your brand's design, print and web work should be done only in this combination of fonts.

> Does your current choice of fonts reflect your new brand personality?

If you choose a distinctive enough typeface for headings you can also use it as a logo. This is more powerful than having a separate graphic as a logo.

This is not the time to choose the exact font, but you can decide what kind of font(s) you should have. As a group, decide if you are happy that your current logo and typeface match the personality you identified.

Colour scheme

Like fonts, a brand's colour scheme should be very restricted and reflect the brand's personality.
You already discussed what colour your brand is. Do you have a colour scheme that matches this? If not, what kind of colour scheme should replace it?

> A swatch of 3–5 colours should cover all your design work

Tone of voice

If a close friend wrote you a letter but didn't sign it, you might recognise who it was from. All the articles in the *Economist* magazine read as if they were written by the same person.

> The same tone of voice should be used in all the ways you talk to your audience, your sponsors and the press

This is the idea of tone of voice. Would people recognise you without your name and logo? You have already described a type of person that represents the brand. How would this person talk?

Go back to the personality attributes and pick out two or three attributes that will define your tone of voice, or pick from this list:

- intimate
- authoritative
- formal
- chatty
- confident
- knowing
- witty
- young
- hip
- serious
- ironic.

Tagline

Let's look at some good examples. Unfortunately, very few of these come from the arts.

- the ultimate driving machine
- go create
- think different
- because I'm worth it
- relax.

Classic FM does it all in one word. The product is the relaxing bits from classical music. The positioning is classical/popular on one axis and difficult/easy on the other. The brand personality is friendly, relaxing. The user personality is a busy person who needs to find time to relax. And the promise is soothing, relaxing music.

> A good tagline sums up all the brand's attributes in a memorable phrase that lasts for years

See if you can create a tagline in the workshop. As a starter, go back to the ad you wrote for the personals and the promise you made to your audience to see if this sparks off any thoughts.

Name

In the end, a brand is just a name. Arts brands tend to have literal, descriptive names (except for small touring theatre companies for some reason) and never change them. But the name is the most powerful expression of the brand.

Does your name express the brand attributes you have just identified? If it doesn't, and you want to create a new brand, change it!

If you have a huge, loyal following under your present name, don't touch it. But maybe you can make only a small change so the new name has continuity: shorten; simplify; focus on the key brand attributes. Do you have to have 'theatre' or 'orchestra' in the name for instance?

This is too big an issue to decide now, but what is the feeling in the room: change the name or leave it?

This should be a good, if contentious way to end a day's branding workshop!

Francis Booth has very kindly given the above article freely to this guide.

He is an independent consultant and adviser in the arts. Over the past decade his clients have included major UK arts organisations. Previously he was brand manager and worldwide marketing communications manager for a large multinational based in Asia Pacific and latterly in New York.

He can be contacted at: brandbuilder, 55 Independent Place, London E8 2HE, Office 020 7275 9950; Mobile: 07720 837931 Fax: 020 7503 210; E-mail: francis@brandbuilder.co.uk

Part one
UK OFFICIAL SOURCES

NATIONAL ARTS COUNCILS

The Arts Council of England
The Arts Council of England
 Regional Offices
 Regional Arts Lottery Programme
The Scottish Arts Council
The Arts Council of Wales
The Arts Council of Northern Ireland

THE ARTS COUNCIL OF ENGLAND

14 Great Peter Street, London SW1P 3NQ
Tel: 020 7 333 0100; Information Helpline: 020 7973 6517;
Minicom: 020 7973 6564; Fax: 020 7973 6590

E-mail: enquiries@artscouncil.org.uk
Website: www.artscouncil.org.uk
Contact: Wendy Andrews, Head of Communication
Chair: Gerry Robinson
Secretary-general: Peter Hewitt

Grant-in-aid from DCMS: £336.8 million (2003/04); £297.3 million (2002/03); £252.2 million (2001/02)

Fundamental change to the arts funding system in England was taking place at time of editing this guide.

The Arts Council of England (ACE) is the national funding body for the arts in England. It is responsible for fostering the arts across the nation through the distribution of annual grant-in-aid from central government through the Department of Culture, Media and Sport and revenue generated by the National Lottery.

It operates at 'arm's length' from government as regards artistic decision-making, although it is expected to account for its decisions to government, the arts community and the general public. It was established under a Royal Charter, which sets out its constitution, describes its membership and gives it three objects:
- to develop and improve the knowledge, understanding and practice of the arts;
- to make the arts more accessible to the public;
- to advise and co-operate with departments of government, local authorities, the Arts Councils of Scotland, Wales and Northern Ireland and other bodies on matters concerned, whether directly or indirectly, with the foregoing objects.

Everything the Arts Council does is intended to further one or more of these objects. Its mission statement gives more active expression to the ideas in the Charter: 'to develop, sustain and promote the arts in England'.

The new single arts funding and development agency

From 1 April 2002, the Arts Council of England and the English Regional Arts Boards joined together to form a single development organisation for the arts in England. (The formerly independent regional bodies had been funded annually by ACE grant-in-aid and Lottery funds.)

The objective is to 'build a national force for the arts which will deliver more funding and increased profile to artists and arts organisations, benefiting audiences everywhere.'

Regional representation

Regional councils are to consist of 15 members (20 in the case of Southern and South East region) six of whom are from local authorities, and the remaining nine members appointed after a 'transparent public search'.

The nine chairs of the regional councils will also serve on the national council.

The nine regional directors will serve on the executive board of the national council.

Schedule/broad plans

The new structure was released to the staff in mid July. The process of assimilating people into posts will begin in autumn. New programmes will be announced, the new identity launched and the new structure will become operational in early 2003.

Three organisational principles are shaping the development of the new, national structure.

- Core Business – who are priority customers, the level of service to be provided and where core priorities lie.
- Growth – increasing funding, defining new areas of work, increasing support for risk-taking and under-resourced work.
- Profile and Leadership – improving public investment in the arts by becoming a champion for the arts in England.

ACE plans to devolve more funding responsiblity to the regions and to develop a more integrated funding system countrywide. Readers must check the funding position for their organisation with the relevant area of ACE and/or with the appropriate regional office.

Lottery funding

Share of proceeds from National Lottery Distribution Fund: £183 million (2000/01); £188 million (1999/2000)

Lottery grant commitments: £131 million (2000/01); £182.3 million (1999/2000)

Arts Capital Programme

(for grants between over £100,000 and £5 million)

This programme supports arts capital projects, including buying equipment and commissioning public art. There are two planned spending rounds between 2000 and 2005.

The first round of the Arts Capital Programme took place early in 2001 and resulted in 61 projects being admitted to the programme. (For information on all the projects chosen, please see the press releases for 12 June 2001.) The second round of the Arts Capital Programme is planned for 2003. Information about the priorities and about how to apply will be available during 2002.

Applications for the second spending round are expected to be invited from the end of 2002 or early 2003.

Note: *Organisations requiring less than £100,000 for capital projects should apply to the Regional Arts Lottery Programme (see separate entry).*

National Touring Programme

The programme supports the distribution of work from across a broad range of arts disciplines and scales to audiences in England. Awards are over £5,000 and applicants are advised to seek advice from Arts Council officers concerning an appropriate level for their application. Grants are awarded towards time-limited touring projects, and may also contribute towards associated research or commissioning, and preparation.

For more information and advice contact the relevant department. The application and monitoring forms, as well as some case studies of supported projects, are available to download.

Collaborative Arts 020 7973 6573
Dance 020 7973 6794
Drama (including Carnival, Circus and Street Arts) 020 7973 6432
Literature 020 7973 6441
Music 020 7333 0100 ext 6599
Visual Arts 020 7973 6428
Touring 020 7973 6500
E-mail: enquiries@artscouncil.org.uk

Recovery Programme

The Recovery Programme is designed to assist organisations faced with imminent insolvency to develop recovery plans, in conjunction with the key stakeholders, which will enable them to secure their operational stability in the medium term.

For further information, please contact the Stabilisation Unit on 020 7973 6466.

Stabilisation Programme

The Arts Council's Stabilisation Programme aims to enable organisations to develop and refocus their work, giving them an opportunity to put themselves on a more secure footing. These awards are to help organisations develop their own stabilisation strategies and to provide the funding necessary to enable change. The programme is aimed at larger scale organisations which are central to arts provision in England and have a financial turnover of £250,000 or more and audiences in excess of 25,000 per year.

For further information, please contact the Stabilisation Unit on 020 7973 6466.

Regional Arts Lottery Programme (see separate entry)

Awards for All (see separate entry)

Awards for All is jointly run by lottery distributors in England, with applications being considered by nine regional committees. The scheme is administered by the Community Fund and offers a one-stop-shop service, distributing grants of between £500 and £5,000 to community and voluntary groups for arts, charities, sports or heritage activities.

THE ARTS COUNCIL OF ENGLAND REGIONAL OFFICES

Grant-in-aid from ACE budgeted to Regional Arts Boards (RABs): £150,061,324 (2003/04); £130,280,589 (2002/03); £113,910,933 (2001/02)

(RABs have also developed funding support for their initatives from a range of local, regional, national and international sources.)

The Arts Council of England (ACE) and the regional arts boards merged on 1 April 2002. For some time the arts boards and the Arts Council will continue to operate much as before, under existing names and brands, although they are one single legal entity. Rebranding is not anticipated before autumn, 2002.

Regional boundaries

The main practical change initially has been the merging of Southern Arts and South East Arts into one regional area – Southern and South East. Other smaller changes have been made to the composition of the regional boards. Their areas are shown with each of their addresses at time of writing (May 2002). The subsequent nine regional councils cover the same area as the Regional Development Agencies and other regional bodies.

Existing points of contact in both the boards and ACE remain the same for a period. Any contracts clients have with arts boards transferred from 1 April to the Arts Council of England, to which all future payments are made.

Funding responsibilities

The major part of the regional arts boards funding is to revenue clients funded on a regular basis. ACE has devolved a substantial amount of its revenue funding to the regional arts boards in recent years. This process is expected to be developed further within the new integrated structure.

Development funding schemes

During 2002/03 the regional boards are continuing to operate their own specific development funds. They can be accessed at the regional arts online service: www.arts.org.uk

After this period the nature of the funding schemes to be provided regionally is not known. It is likely that a more comprehensive, integrated set of policies may start

to operate across England rather like the Regional Arts Lottery Programme where there are broad guidelines within which regional priorities occur. This is only supposition.

REGIONAL ARTS LOTTERY PROGRAMME

Regional Arts Lottery commitments: £23.2 million (2000/01); £19.2 million (1999/2000)

Due to changes within the arts funding system, the Regional Arts Lottery Programme (RALP) will continue from April 2002 in much the same form as the previous years, with very few changes. New application packs and regional priorities were introduced then. The longer term redesign of RALP is planned to take place over 2002.

The Regional Arts Lottery Programme is managed by the English regional arts boards. Support is available for arts projects, small scale capital and organisational development in five areas of work:

- access;
- education;
- production and distribution;
- investment in artists;
- development and sustainability of arts organisations.

Applications are assessed according to five criteria – quality of artistic and educational activity; public benefit; ability to manage the project; contribution to regional and national priorities; and financial viability.

Each RAB has set its own regional priorities within the above parameters.

RALP is a rolling programme with no set deadlines and the following key features:

- up to £100,000 for capital funding projects;
- other grants may range between £2,000–£30,000 with potential for funding over three years. Proposals for organisational development also qualify;
- partnership funding requirements;
- work may be within one or more regions;
- only one project per applicant can be supported at any one time by each region;
- applicants have to be formally constituted as an organisation with a bank account.

Main criteria:

- the quality of the artistic and education activity planned (including the involvement of artists);
- the financial viability of the project;
- the relevance of the project to particular regional priorities;
- the public benefit offered by the project (including marketing plans to reach that public, its potential impact and value for money);
- the ability to manage the project.

Awards for All offers grants for projects under £5,000 (see separate entry).

Applications: Further information and applications forms are available from each regional office and from their website.

All applicants are strongly advised to contact their relevant regional office before submitting a formal application.

East England Arts

Eden House, 48–49 Bateman Street, Cambridge CB2 1LR
Tel: 01223 454400; Minicom: 01223 306893; Fax: 0870 242 1271
E-mail: info@eearts.co.uk
Website: www.arts.org.uk
Chief Executive: Andrea Stark

Area covered: Bedfordshire, Cambridgeshire, Essex, Hertfordshire, Norfolk, Suffolk, and unitary authorities of Luton, Peterborough, Southend on Sea, Thurrock.

Grant-in-aid from ACE: £9,338,195 (2003/04); £8,303,580 (2002/03); £7,116,585 (2001/02)

East Midlands Arts

Mountfields House, Epinal Way, Loughborough LE11 0QE
(moving to Nottingham end of December 2002)
Tel: 01509 218292; Fax: 01509 262214
E-mail: info@em-arts.co.uk
Website: www.arts.org.uk
Chief Executive: Laura Dyer

Area covered: Derbyshire (including High Peak of Derbyshire transferred as part of new reorganisation); Leicestershire, Lincolnshire, Northamptonshire, Nottinghamshire; unitary authorities of Derby, Leicester, Nottingham, Rutland.

Grant-in aid from ACE: £10,362,283 (2003/04); £8,838,003 (2002/03); £7,771,701 (2001/02)

London Arts

Elme House, 2 Pear Tree Court, London EC1R 0DS
Tel: 020 7608 6100; Textphone: 020 7608 4101; Fax: 020 7608 4100
E-mail: info@lonab.co.uk
Website: www.arts.org.uk
Executive Director: Sarah Weir

Area covered: The 32 London boroughs and the Corporation of the City of London.

Grant-in-aid from ACE: £39,859,964 (2003/04); £35,179,211 (2002/03); £29,886,048 (2001/02)

Northern Arts

Central Square, Forth Street, Newcastle upon Tyne NE1 3PJ
Tel: 0191 255 8500 (and minicom); Fax: 0191 230 1020
E-mail: info@northernarts.org.uk
Website: www.arts.org.uk
Chief Executive: Andrew Dixon

Area covered: Durham, Northumberland; unitary authorities of Darlington, Hartlepool, Middlesborough, Redcar and Cleveland, Stockton-on-Tees; metropolitan districts of Newcastle upon Tyne, Gateshead, North Tyneside, Sunderland, South Tyneside.

Grant-in-aid from ACE: £12,912,747(2003/04); £10,170,654 (2002/03); £11,410,893 (2001/02)

North West Arts

Manchester House, 22 Bridge Street, Manchester M3 3AB
Tel: 0161 834 6644; Minicom: 0161 834 9131; Fax: 0161 834 6969
E-mail: info@nwarts.co.uk
Website: www.arts.org.uk
Chief Executive: Michael Eakin

Area covered: Cheshire, Cumbria (transferred from Northern Arts as part of new regional organisation); Lancashire, Merseyside, Greater Manchester; unitary authorities of Blackburn with Darwen, Blackpool, Halton, Warrington.
The board has offices in both Manchester and Liverpool.

Liverpool Office: Graphic House, 107 Duke Street, Liverpool L1 4JR
Tel: 0151 709 0671; Fax: 0151 708 9034; E-mail: nmorrin@nwarts.co.uk

Grant-in-aid from ACE: £20,220,986 (2003/04); £17,350,742 (2002/03); £15,491,266 (2001/02)

Development schemes
From April 2002 only:
- Project Funding for Individuals.
- Project Funding for Arts Organisations.

South West Arts

Bradninch Place, Gandy Street, Exeter EX4 3LS
Tel: 01392 218188; Fax: 01392 413554
E-mail: claire.gulliver@swa.co.uk
Website: www.arts.org.uk
Chief Executive: Nick Capaldi

Area covered: Cornwall, Devon, Dorset (excluding Christchurch), Gloucestershire, Somerset; unitary authorities of Bath and North East Somerset, Bristol, North Somerset, Plymouth, South Gloucestershire, Torbay. On 1 April 2003 Wiltshire, Swindon, Bournemouth, Poole and Christchurch will transfer to South West Arts.

Grant-in-aid from ACE: £10,400,524 (2003/04); £8,932,570 (2002/03); £7,766,575 (2001/02)

Southern and South East

Note: *During 2003 the regional council relocates to Brighton.*

Tunbridge Wells Office:
Union House, Eridge Road, Tunbridge Wells TN4 8HF
Tel: 01892 507200; Fax: 0870 242 1259; E-mail: infotw@seaa.co.uk
Website: www.arts.org.uk/sea

Winchester Office:
13 St Clement Street, Winchester SO23 9DQ
Tel: 01962 855099; Fax: 0870 242 1257; E-mail: infowin@ssea.co.uk
Website: www.arts.org.uk/sa
Executive Director: Felicity Harvest

The amalgamation of the two former regional arts boards, reflecting the government's regional development agencies and planning boundaries, makes this the most populated region within the new national arts body and the second largest geographically.

Area covered: Kent, Surrey, East Sussex, West Sussex, Buckinghamshire, Hampshire, Isle of Wight, Oxfordshire, unitary authorities of Bournemouth, Bracknell Forest, Brighton and Hove, the Medway towns, Milton Keynes, Portsmouth, Reading, Slough, Southampton, Swindon, West Berkshire, Wiltshire, Windsor and Maidenhead, Wokingham.

In the interim the organisation is known as Southern and South East Arts and the two staffs are working together from their existing offices in Winchester and Tunbridge Wells.

Grant-in-aid from ACE:
Southern Arts £11,917,878 (2003/04); £10,223,848 (2002/03); £9,182,875

South East Arts £6,746,888 (2003/04); £5,563,574 (2002/03); £4,847,711 (2001/02)

West Midlands

82 Granville Street, Birmingham B1 2LH
Tel: 0121 631 3121; Information services 24 hour ansaphone: 0121 624 3200;
Minicom: 0121 643 2815; Fax: 0121 643 7239
E-mail: info@west-midlands-arts.co.uk
Website: www.arts.org.uk
Chief Executive: Sally Luton

Area covered: Shropshire, Staffordshire, Warwickshire, Worcestershire; metropolitan districts of Birmingham, Coventry, Dudley, Sandwell, Solihull, Walsall and Wolverhampton; unitary authorities of Hereford, Stoke-on-Trent, Telford and Wrekin.

Grant-in-aid from ACE: £14,615,990 (2003/04); £12,563,387(2002/03); £11,361,686 (2001/02)

Yorkshire Arts

21 Bond Street, Dewsbury, West Yorkshire WF13 1AX
Tel: 01924 455555; Minicom: 01924 438585; Fax: 01924 466522
E-mail: info@yarts.co.uk
Website: www.arts.org.uk
Chief Executive: Andy Carver

Area covered: North Yorkshire; unitary authorities of East Riding, Kingston upon Hull, North East Lincolnshire, North Lincolnshire, York; metropolitan districts of Barnsley, Bradford, Calderdale, Doncaster, Kirklees, Leeds, Rotherham, Sheffield, Wakefield.

Grant-in-aid from ACE: £13,685,869 (2003/04); £11,914,782 (2002/03); £10,315,832 (2001/02)

THE SCOTTISH ARTS COUNCIL

12 Manor Place, Edinburgh EH3 7DD
Tel: 0131 226 6051; Help Desk: 0845 603 6000 + 0131 240 2443/2444 open Mon–Fri 9am–5pm; Fax: 0131 225 9833

E-mail: help.desk@scottisharts.org.uk
Website: www.scottisharts.org.uk

Total income: £56 million (2002/03); £54.9 million (2001/02); £50.6 million (2000/01);
comprising
Scottish Executive grant-in-aid: £35.9 million (2002/03)
Lottery funding: about £20 million (2002/03)

The Scottish Arts Council (SAC) is the national organisation with specific responsibility for the funding and development of the arts in Scotland. Its main sources of funds are annual grant-in-aid from the Scottish Executive and its share of the 'good causes fund' for the arts from the National Lottery.

In summer 2002 the council published a draft plan showing its priorities over the next five years (following on from its 1998–2002 plan). It will be available on the web, but was not public at time of editing.

Budgeted funding 2002/03
(figures rounded up and Lottery funding excluded)

Arts Development
- Music £13,188,000
- Drama £7,445,000
- Dance £3,605,000
- Visual arts £2,571,000
- Literature £1,462,000
- Crafts £432,000
- Traditional Arts £500,000
- International £300,000
- Multi-arts organisation £1,654,000
- Policy and Research £220,000

Strategic Development
- Cross Artform £1,344,000
- Education and Lifelong Learning £223,000
- Arts in the Community £200,000
- Area Development £155,000
- Audience and Sales Development £120,000 (Lottery funding also)
- Cultural Diversity £100,000 (Lottery funding also)
- Arts and Disability £100,000

Note: *The majority of the council's grants expenditure is spent on revenue (three year and annual) funding of arts organisations. The largest grants are made to the four national companies. Projects and schemes, and awards to individual artists, account for about one fifth of funding (excluding Lottery funding).*

Project funding
Applicants should always check to obtain up-to-date information about current schemes. From time to time specific new funding schemes are introduced e.g. 2002 is designated the **Year of Cultural Diversity**, a UK wide initiative.

Crafts
- Awards for Individual Development
- Exhibitions
- Crafts Development
- Start-up Grant

Dance
- Projects and Touring by Scottish Dance Companies
- Dance Promoters
- Scottish Traditions of Dance
- Choreographic Development

Drama
- Playwrights' Commissions
- Projects by Scottish Theatre Companies
- Touring by Non-Scottish Theatre Companies
- Seed Funding

Literature
- Book Awards
- Grants to Magazines
- Grants to Publishers
- Support for Translation
- Writers' Bursaries
- New Writers; Bursaries
- Literature Events

- Writing Fellowships
- Storytelling Projects
- Storytelling Bursaries
- Writers in Scotland

Music

- Music Commissions
- Music Promotions and Events
- Education and Outreach
- Creative Artists' Bursaries
- Music Bursaries
- Recording

Visual Arts

- Assistance Grants to Individual Artists
- Research and Development Grants
- Visual Artists' Awards
- Amsterdam Studio Residency
- New Projects Fund
- Visual Arts Education Awards
- Hiring Touring Exhibitions

Others

- Arts in the Community
- Conference Fund
- Cross-artform Colloborations
- International Projects in Scotland

Lottery funding

Total funding: £20 million (2002/03); £20 million (2001/02); £19.8 million (2000/01)

Applicants should note that, given the anticipated reduction in funds available through the National Lottery, and the call for there to be a more equitable spread of funding throughout Scotland, in the future higher priority is likely to be given within every Lottery scheme to appropriate applications from areas which have benefited to a lesser extent in the past.

Capital

Funding available: £9.5 million (2002/03); £10 million (2001/02); £9 million (2000/01)
This scheme helps to develop a suitable network of arts buildings and facilities throughout Scotland.

Advancement

Funding available: £1 million (2002/03); £1,350,000 (2001/02); £1,795,000 (2000/01)
This scheme helps arts organisations to achieve positive change to improve long-term prospects.

Access and Participation

Funding available: £1.3 million (2002/03); £1.4 million (2001/02); £1.5 million (2000/01)
This scheme aims to increase the range and number of people enjoying the arts.

Children and Young People

Funding available: £1 million (2002/03); £1 million (2001/02); £1 million (2000/01)

Social Inclusion and LA Partnerships

Funding available: £850,000 (2002/03); £400,000 (2001/02); £300,000 (2000/01)
This scheme encourages non-arts agencies with responsibility for policy development in areas such as housing, environment or regeneration, to develop arts projects in their fields. It will also encourage arts activities as an essential part of work in Social Inclusion Areas.

Audience and Sales Development

Funding available: £600,000 (2002/03); £500,000 (2001/02); £500,000 (2000/01)

This scheme helps arts organisations and artists to increase audiences.

Skills and Professional Development

Funding available: £400,000 (2002/03); £500,000 (2001/02); £500,000 (2000/01)

This scheme helps professional artists and support staff to develop creative and technical skills.

Creative Scotland Awards

Funding available: £400,000 (2002/03); £400,000 (2001/02); £400,000 (2000/01)

This scheme provides major bursaries of £25,000 to artists to develop their creative work.

Creative Industries Companies' Development

Funding available: £150,000 (2002/03); £150,000 (2001/02)

Additional Lottery funding for 2002/03 was also budgeted for:
New Work – £1 milllion
Cultural Diversity – £280,000
Cross Border Touring – £120,000

Awards for All (see separate entry) a multi Lottery Distributor scheme (SAC contributed £1 million in 2002/03 and in the preceding two years). Grants of between £500 and £5,000 are made to a wide range of activities by smaller organisations with yearly turnovers of less than £15,000. The Lottery programmes are only open to organisations.

Applications for all schemes

For detailed guidelines to each fund and the latest information, contact the Help Desk (see address above), Tel: 0131 240 2443/2444. The lines are open Monday-Friday, 9am–5pm and messages can be left outside these hours. Fax: 0131 225 9833; E-mail: help.desk@scottisharts.org.uk

The relevant departments will be happy to give further advice before you submit your application. Many scheme guidelines and application forms are downloadable, otherwise contact the Help Desk.

Note: *There are differing arrangements for closing dates for applications according to the size of grant applied for.*

Council Members and Committee Chairs: James Boyle Chair (Chair, Business Committee); Dale Idiens (Vice-Chair and Chair, Crafts Committee); Sam Ainsley (Chair, Visual Arts Committee); Joanna Baker; Councillor Elizabeth Cameron; Richard Chester; Bill English (Chair, Combined Arts Committee); James Faulds; Maud Marshall (Chair, National Lottery Capital Committee); Dr Ann Matheson (Chair, Literature Committee); Louise Mitchell (Chair, Music Committee); John Scott Moncrieff (Chair, Drama Committee); Bill Speirs (Chair, Lottery Arts Projects Committee)

Staff: Director: Graham Berry

THE ARTS COUNCIL OF WALES

9 Museum Place, Cardiff CF1 3NX
Tel: 029 20 376500; Minicom: 029 2039 0027; Fax: 029 2022 1447

E-mail: information@ccc-acw.org.uk or firstname.surname@ccc-acw.org.uk
Website: www.ccc-acw.org.uk
Contact: Angela Blackburn, Communications Officer

Donations to all causes: £34,383,000 (2002/03) including Lottery funding and total overheads

Local Offices:
North Wales Office
36 Prince's Drive, Colwyn Bay LL29 8LA
Tel: 01492 533440; Minicom: 01492 532288; Fax: 01492 533677

West and Mid Wales Office
6 Gardd Llydaw, Jackson Lane, Carmarthen SA31 1QL
Tel: 01267 234248; Fax: 01267 233084

South Wales Office
New offices setting up. At spring 2002 still based at Cardiff office.

Total funding: £34,383,000 (2002/03)

National Assembly for Wales grant-in-aid: £20,783,000 (2002/03) – a 23% increase in funding from the preceding year.

National Lottery Distributors' Fund: £13,600,000 – The Arts Council for Wales is responsible for distributing 5% of the total lottery arts money.

The Arts Council of Wales (ACW) is the national organisation with specific responsibility for the funding and development of the arts in Wales. Its main sources of funds are an annual grant from the Welsh Assembly and its share of the 'good causes fund' for the arts from the National Lottery. It also receives funds from other sources including local authorities.

During 2001 its entire operations underwent a major review. The senior management team now includes three local directors for North, West and Mid Wales, and South Wales each of which is based in separate offices (see addresses above). Local directors are responsible for the work of ACW in their regions each leading a team comprising arts development officers and scheme administrators.

- North Wales team leads on drama.
- Mid and West Wales team leads on visual arts and crafts.
- South Wales team leads on music and dance.

Advisory systems

As part of the restructuring process, ACW's current panels and committees have been replaced with a National List of Advisers. Existing members of panels/committees have been invited to join this list and ACW has advertised for members

of the public interested in becoming an adviser. The National List of Advisers will be consulted on policy development and the assessment of grant applications.

The new structure has changed the point of contact for many revenue funded organisations and people applying for project funding.

The Arts Council of Wales received a welcome 23% increase in Assembly funding for the financial year 2002/03. At the end of January 2002 the director announced the council's three priorities:
- to redress the economic shortfall after years of standstill funding, most revenue clients to receive a 15% increase in their annual revenue funding;
- to redress historical anomalies.
- to implement the strategic priorities identified in the comprehensive consultation process, including increased funding for:
 - community arts projects;
 - youth arts;
 - creative industries;
 - dance.

Annual revenue grants

This accounts for the most of its spending (over 80%). From its annual grant-in-aid (non-Lottery expenditure) the council provides regular annual revenue grants to organisations which produce and present work, including national companies, galleries, festivals, venues, agencies, umbrella bodies, and producing and other organisations. During 2001 two-year funding agreements with revenue-funded clients was being introduced. In April 2002 a total of 122 organisations were allocated £15.4 million for 2002/03 (a further four large-scale venues were expected to become revenue clients shortly).

It also operates a number of schemes which provide grants and other forms of financial support on a one-off basis.

New schemes: 2002 to 2007

ACW has drawn up, with the arts sector, a five-year Arts Development Strategy for Wales identifying key themes and priorities for each scheme for the five-year period. The new schemes aim to be more inclusive than in the past, easier to understand and easier to access.

During 2002/03, they are being closely reviewed and comments are encouraged.

Most of the schemes are funded through proceeds from the National Lottery.

Note: *Applicants should approach the ACW office nearest to their own address for advice and guidance about the schemes, and also send their applications there. Make sure the most up to date guidelines are obtained.*

ACW is bound to provide evidence of **additionality** of investment which it defines as:
- a completely new activity that has never taken place before;
- an activity that has taken place before, funded through public or any other subsidy, but which has now lost its subsidy through no fault of its own.

Any organisation applying for funding must prove that they will provide an activity or a service for the people of Wales. They may be based outside Wales. Eligible organisations include: community groups, clubs or societies; artists' groups and co-operative ventures; non-profit distributing groups or trusts; registered charities; companies limited by guarantee; local authorities and educational institutions; private commercial organisations such as partnerships and companies limited by shares who require funding for a project that will not directly benefit their private interests.

ACW's revenue-funded clients are eligible to apply for funding through these schemes but their proposals must clearly be in addition to their revenue-funded programme.

Decisions on grants

- **Fast Track grants (up to £5,000)** – (excluding Creative Wales Awards and the Publications scheme). Continuous assessment and no closing dates. Decisions within one or two months by at least three ACW officers, including a senior officer or higher.
- **Applications from £5,001 to £25,000** – by at least three ACW officers, including a local director or higher. If thought necessary, review and assessment by at least two national advisers and at least one senior officer or higher.
- **Applications over £25,000** – by a group of at least three ACW officers, including a local director or higher. Also review and assessment by at least two national advisers and at least one senior officer or higher. Final decision by ACW's local committee or ACW's council.
- **National projects** – A national officer group decides national projects (i.e. projects covering more than one local ACW area). It includes officers from all ACW offices. If applications are over £25,000 then the council makes the final decision.

Partnership/shared funding

The Welsh Assembly Government has asked the ACW for certain applications 'to require an element of partnership funding and/or contributions in kind, from other sources, commensurate with the reasonable ability of different kinds of application, or applicant in particular areas to obtain such support'. ACW intends to be flexible in its interpretation of this requirement.

ACW usually considers up to 90% of a project cost for both individuals or organisations. **In exceptional circumstances, partnership funding for individuals may be waived but officers have to be consulted**.

- Local authorities are normally expected to contribute at least 25% partnership funding, but should consult with their local ACW office
- ACW usually considers up to 50% of the costs if the main aim of the project is to promote health, social welfare or other associated non-arts issues and if your constitution indicates that your organisation's main purpose is not arts activity.

Partnership funding can include the applicant's own funds, earned income, grants from other organisations, in-kind contributions, e.g. free use of space to work in, or volunteer time.

Professional development: training
Aims:
- The provision of artistic, creative, technical, business, marketing and managerial training in the arts in Wales.
- Support for individuals or organisations wishing to undertake or purchase training, whether within Wales, the UK or abroad.

ACW wishes to support arts training in Wales. Other organisations such as Education and Learning Wales (ELWa) and the Higher Education Funding Council of Wales (HEFCW) have a responsibility to support education, training and learning and ACW will not provide funding that other organisations should support. ACW is negotiating with ELWa to provide clear guidance on the range of activities each organisation will support. Until these arrangements are confirmed individuals and organisations are asked to contact their local ELWa office, local ACW office or Arts Training Wales for advice before applying.

Priorities/themes:
- training provision in the Welsh language;
- training the trainers programmes;
- training opportunities for artists and arts workers from a minority ethnic background;
- training opportunities for those working with young people and children.

Funding:
Individuals: Minimum – £250; maximum – £2,000.
Organisations undertaking training: Minimum – £250; maximum – £5,000.
Organisations providing training: Minimum – £1,000; maximum – £40,000.

Arts Training Wales (an independent organisation funded by ACW) can help identify training opportunities within an area or assist in developing a new training provision: Arts Training Wales, PO Box 5, CF62 3QA, Tel: 01446 754112; Fax: 01446 754113; E-mail: admin@a-t-w.com

All ELWa Regional offices can be contacted on Tel: 08456 088066; Website: www.elwa.org.uk

Professional development: 'Creative Wales' Awards
Aims:
- To enable practising artists working in any creative discipline or across disciplines to enhance and refresh their skills and creativity.
- To support the creation of new, experimental work (without the need to demonstrate audience development outcomes).

The awards are for any practising or newly qualified artist working in Wales, whether in paid employment or not. The scheme includes all traditional and emerging artforms, interdisciplinary activities and all sectors such as contemporary, community, voluntary, youth and education. The awards are classified as bursaries.

Applications are encouraged from artists working with young people, artists working in the Welsh language and artists from an ethnic minority background.

Funding:

Minimum – £500; maximum – £25,000. The majority are likely to be less than £10,000.

Production and Audience Development

Aim:

- To increase the range of work produced in Wales, which also increases the number of people attending arts events.

All traditional, new and emerging artforms and interdisciplinary activities are included. The scheme is primarily aimed at the professional sectors. (New work created within community, voluntary, youth and education sectors should apply to ACW's *Taking Part and Arts in the Community* scheme or *Children, Young People and the Arts* scheme.) The scheme supports:

- The creation/re-creation of artistic product in Wales, including performance, installation, music publishing and recording (not literary publishing – see *Publication* Scheme), exhibitions, visual arts and craft production, public art (see also ACW Capital Lottery scheme) and new media (not film production – see *Film Production* scheme);
- Commissioning work for publication, exhibition or performance in Wales (applications by organisations);
- New creative initiatives for established, new and emerging artists and arts organisations in Wales.

'All proposals need to demonstrate a link to widening the range of arts audiences and attenders in Wales through the product being produced.'

Applications to tour work in Wales not involving any production costs should be made to ACW's *Presentation and Audience Development* scheme.

Priorities/themes:

- touring product in all artforms;
- music commissions (this scheme is co-funded by the Performing Rights Society Foundation);
- production for young people;
- production in the Welsh language;
- work which develops cultural diversity;
- work for 'geographical areas of low opportunity in the arts as an audience'.

Funding:

There are two levels of award.

Between £1,000 and £25,000, including capital equipment costs up to £2,000, for local and regional production and touring in particular (the likely majority of awards).

From £25,000 to a maximum of £100,000, including capital equipment costs for national, all-Wales production and touring.

For advice on touring performing arts work in Wales please also contact: Creu Cymru, The Touring Agency for Wales, 8H Science Park, Aberystwyth SY23 3AH, Tel: 01970 639444; E-mail: post@creucymru.co.uk

Presentation and Audience Development

(also refer to *Night Out* scheme see below)

Aim:

- To support the presentation of a wide range of arts events that also increase the number and scope of people attending arts events in Wales.

The scheme includes all traditional and emerging artforms and interdisciplinary activities, including film exhibition, in all sectors whether professional or voluntary. Specifically:

- single events and festivals through to year round programmes;
- cross-border touring into Wales for UK-based artists and arts organisations;
- touring and presentation of international work from outside Wales and the UK;
- guarantees against loss, where appropriate;
- touring of work originated or produced in Wales where production costs are not required (see *Production and Audience Development* scheme if production or commissioning costs are required).

All proposals will need to demonstrate a link to widening the range of arts audiences and attenders in Wales through the event being proposed.

Priorities/themes:

- programming in socially disadvantaged areas and geographical areas of low opportunity in the arts;
- cross-border touring support for middle and large scale events;
- events which particularly encourage young people as audiences;
- programming of culturally diverse product and/or encouraging ethnic minority audiences;
- programming of Welsh language product and encouraging Welsh speaking audiences.

Funding:

This project is 'additional' – at least 10% of the total costs from another source (please refer to guidance on 'additionality', see page 31).

Minimum – £250; maximum award – £50,000 (although normally for national events programme). Very few awards likely at this higher level. The majority of awards will be up to £10,000.

For advice on touring performing arts work in Wales, including cross-border touring please contact:
Creu Cymru, The Touring Agency for Wales, 8H Science Park, Aberystwyth SY23 3AH, Tel: 01970 639444; E-mail: post@creucymru.co.uk

Festivals advice is also available from:
Festivals of Wales, PO Box 20, Conwy LL22 8ZQ, Tel: 01492 573760

Capacity Building and Development Fund

Aim:

- To help artists and arts organisations develop their potential and build sustainability in the arts.

This involves a wide range of support and is flexible enough to respond to the specific needs of each artist, arts organisation and sector. Professional and voluntary activity are included. *You are strongly encouraged to discuss any planned application to this scheme with your local ACW office before applying.* Support includes:

- start-up and development grants for individual artists;
- supporting umbrella body development and county arts forums;
- research, development and initialisation grants;
- professionalisation of arts workers and sustainability of arts provision;
- community development, organisational development, business planning, marketing initiatives and artistic and management reviews;
- conferences and sector representative body development.

Applications for training should be made separately to ACW's *Professional Development – Training* scheme. Applications for capital feasibility studies and development funding should be made to ACW's *Capital Lottery* programme.

A wide range of costs are included: salaries; fees; administration and overheads (to a maximum of 20% of total project costs); commissioning research and reviews; travel and 'Go & See' grants; membership and sectoral support services in the arts; business start up (when in partnership with other economic development and training support sources); transport schemes and new marketing initiatives.

No retrospective costs. Time-limited support, not long-term revenue funding.

Priorities/themes:

- strengthening the arts infrastructure including opportunities for individual artists to develop their economic potential;
- projects in socially disadvantaged areas, particularly within Welsh Assembly Government's Communities First Areas and geographical areas of low Lottery take-up;
- projects which support sustainable community development;
- activities which support arts provision for young people;
- activities which support arts provision for ethnic minority communities;
- activities which support arts provision for Welsh speaking communities;
- umbrella and sector representative bodies;
- activities which promote and support craft within Wales (this scheme is co-funded by the WDA for craft promotion initiatives).

Funding:
This project is 'additional' – at least 10% of the total costs from another source (please refer to guidance on 'additionality', see page 31).
Individuals: Minimum – £250; maximum – £5,000.
Organisations: Minimum – £250; maximum – £50,000.

For voluntary sector initiatives also contact:
Voluntary Arts Wales, PO Box 200, Welshpool, Powys SY20 7WN
Tel: 01938 556455

Taking part in Arts in the Community

The scheme is primarily aimed at the voluntary cultural sector in Wales (voluntary and amateur arts groups, umbrella organisations for voluntary and amateur arts groups, community arts organisations, organisations using art as part of their wider policy, and organisations representing groups of volunteers).

Aims:
- To support opportunities to take part in the arts.
- To support participatory arts projects in regeneration or community settings, particularly where the project is part of a wider community development programme (including activities to improve social inclusion, health and economic development).

A wide range of costs including salaries, fees, administration and overheads (to a maximum of 20% of total project costs), production costs including materials, marketing, translation costs, venue hire and site costs, travel, childcare and transport costs and capital equipment costs up to £2,000.

No retrospective costs, prizes, fund-raising activities, or capital equipment costs of £2,000 or more.

Priorities/themes:
- projects in socially disadvantaged areas, particularly within Welsh Assembly Government's Communities First Areas and geographical areas of low Lottery take-up;
- projects which support sustainable community development;
- increasing and widening participation in the arts;
- activities which support arts provision for young people and links with local authority youth strategies;
- participatory music projects as part of the Welsh Assembly Government's Music Development Fund;
- activities which support arts provision for ethnic minority communities;
- activities which support arts provision for Welsh speaking communities.

Funding:
Minimum – £250; maximum – £100,000, although top awards are likely to involve widespread provision, a range of activities and be few in number.

For voluntary sector initiatives please also contact: Voluntary Arts Wales, PO Box 200, Welshpool, Powys SY20 7WN, Tel: 01938 556455

Cultural Diversity June 2002 – March 2004
Aims:
- To celebrate the Year of Cultural Diversity across Wales and the UK beginning June 2002.
- To enable the implementation of ACW's Cultural Diversity Strategy and Action Plan (2000) throughout the arts in Wales.
- To increase the attendance and participation of ethnic minority people in Wales in the arts.

- To promote employment and increase training opportunities for ethnic minority people in the arts in Wales.
- To promote the principles and benefits of cultural diversity and race equality within a multicultural and multi-lingual Wales.

A wide range of activities and initiatives can be supported including:
- provision of training opportunities for ethnic minority people in fields of the arts where people from ethnic minority backgrounds are clearly under-represented;
- guarantees-against-loss for the presentation of culturally diverse work;
- a 'high risk' fund to encourage professional, culturally diverse artistic exploration;
- encouraging the emergence of ethnic minority artists and arts companies;
- special events to celebrate the Year of Cultural Diversity.

Priorities/themes:
- new and emerging ethnic minority artists and arts organisations;
- articipation and education projects;
- work experience training for ethnic minority young people in under-represented fields of the arts;
- programming of culturally diverse product throughout Wales;
- multicultural community festivals.

Funding:
A wide range of costs may be assisted including: salaries; fees; training allowances; administration and overheads (to a maximum of 20% of total project costs); production costs including materials; marketing; translation costs; workshop costs; venue hire and site costs; travel and transport costs and capital equipment costs up to £2,000. No retrospective costs, fund-raising activities, or capital equipment costs of £2,000 or more.
Individuals: Minimum – £250; maximum – £5,000.
Organisations: Minimum – £250; maximum – £25,000.

For advice on touring performing arts from abroad contact:
Creu Cymru, The Touring Agency for Wales, 8H Science Park, Aberystwyth, SY23 3AH, Tel: 01970 639444; E-mail: post@creucymru.co.uk

For advice on all aspects of this scheme contact:
CADMAD, Boston Buildings, 70 James Street, Cardiff, CF10 5EZ
Tel: 029 2045 2808

For advice and consultation with ethnic minority communities and organisations contact:
Commission for Racial Equality Wales, Tel: 029 2072 9200; Fax: 029 2072 9220;
All Wales Ethnic Minority Association, Tel: 029 2066 4213;
North Wales Race Equality Network, Tel 01492 535850;
Swansea Bay Race Equality Council, Tel: 01792 457035;
Valleys Race Equality Council, Tel: 01443 401555;
South East Wales Race Equality Council, Tel: 01633 250006;
Race Equality First, Tel: 029 2022 4097.

Children, Young People and the Arts

The scheme is aimed at professional and voluntary cultural sectors and also includes organisations in the statutory sector such as local education authorities, schools, colleges and youth services.

Aims:

- To support arts opportunities as both participants and audiences for children and young people (up to the age of 25 years old).
- To support a wide range of activities in all artforms whether traditional, new, emerging or interdisciplinary, including new work, peer led activities, artists-in-residence, youth arts groups, artists-in-schools programmes and workshop activities.

All activities must be additional to statutory provision and the core curriculum.

Criteria:

- The project should demonstrate that it fits within relevant local authority strategies and plans for youth arts and arts education activities or that local authority education/arts/youth service advisers have been consulted and support your application.
- Youth projects over £5,000 should show evidence of links with the 'Youth Work Curriculum Statement for Wales' (Wales Youth Agency and Welsh Assembly Government 2001).

Priorities/themes:

- projects in socially disadvantaged areas, particularly within the Welsh Assembly Government's Communities First Areas and geographical areas of low Lottery take-up;
- participatory music projects as part of the Welsh Assembly Government's Music Development Fund;
- activities which promote culturally diversity in the arts;
- provision for Welsh speaking children and young people.

Funding:

A wide range of costs may be assisted including: salaries, fees, administration and overheads (to a maximum of 20% of total project costs), production costs including materials, marketing, translation costs, workshop costs, venue hire and site costs, travel, childcare and transport costs, and capital equipment costs up to £2,000. The scheme cannot pay for any retrospective costs, fund-raising activities, or capital equipment costs of £2,000 or more.

Minimum −£250; maximum − £50,000, although awards of this scale are likely to involve widespread provision, involve a range of activities and be few in number.

For advice on Youth Work Curriculum Statement for Wales contact:
Wales Youth Agency, Leslie Court, Lon-y-Llyn, Caerphilly CF83 1BQ
Tel: 029 20855700

Publications

This scheme brings together existing schemes and programmes which support publishing in Wales, with the exception of *Periodical Franchises*: these are to be reviewed

and advertised during 2002/03. A general review of provision for literature is being held during 2002/03.

Aim:

- To facilitate the production of a wide range of artistic and cultural publications and to enhance the professional practice of Welsh literary publishers.

One-off grants for:

- production of books of Welsh interest or by writers living in Wales; for both children and adults; and writing on all artforms;
- production grants for individual books;
- publishing programmes;
- small presses and magazines;
- commission grants;
- electronic and other publishing.

Priorities/themes:

- creative literature (poetry, fiction, creative non-fiction);
- publications on artforms other than literature which are aimed at raising the level of critical debate and developing the careers of individual artists;
- writing for young people;
- publishing of work which reflects Wales as a multicultural and multilingual country.

From April 2002, translation grants (towards commissioning translations of Welsh literature in Welsh or English) will be administered by Welsh Literature Abroad, University of Wales, Aberystwyth SY23 2AX. Tel 01970 622544/ 33; Fax 01970 621524; E-mail: snr@aber.ac.uk

Funding:

Contributions towards anticipated deficits, usually range between £50 and £5,000. Maximum − £25,000. Commission grants normally meet 50–80% of the total commission fee(s).

Contact for advice and receipt of application:

Literature Team at ACW's Cardiff Office.

The scheme complements the Welsh Books Council's support for a wide range of books in Welsh only. In some cases, ACW and the Welsh Books Council will need to confer regarding which body is more appropriate to deal with an application.

Other schemes

Local Authority Arts Development

Local authorities should consult with their local ACW office for advice on this scheme.

Stabilisation Programme

Further guidance and information about this scheme will be available from your local ACW office during 2002/03.

Revenue Funding Scheme

Decisions on this scheme will be made by ACW's Council and will apply to next financial year only, i.e. 2003/04 onwards. Check for current information.

Agency Administered Schemes

Cywaith Cymru.Artworks Wales

This scheme runs a national Artist in Residence programme. Also:

- **Vital Knowledge – Artists' Mentoring Scheme** Grants up to £250.
- **Artists at Work** Developed with A&B Arts and Business Wales, for businesses interested in exploring creative collaboration and hosting an artist in residence and for artists keen to develop their practice through working in industry. Grants for artists up to £5,000.
- **Good Ideas – Artist Led Projects** Grants up to £5,000 for artists with projects that involve community collaboration and demonstrate innovative thinking and artistic practice.

For further information contact: Sue Llewelyn, AiR Administrator, Cywaith Cymru. Artworks Wales, 11-12 Mount Stuart Square, Cardiff CF10 5EE
Tel: 029 2058 9453; E-mail: info@cywaithcymru.org

Academi / Yr Academi Gymreig / The Welsh Academy

This national society which promotes the writers and the literatures of Wales runs for ACW:

- Writers on Tour;
- Writer's Residencies;
- Programme Support Scheme.

Contact: Academi, Mount Stuart House, Mount Stuart Sq, Cardiff CF10 5FQ,
Tel: 029 2047 2266; E-mail: post@academi.org
Website: www.academi.org

Other schemes and services

International Arts

Inter-Recce

These grants encourage professional practitioners to explore contacts with producers, presenters and promoters in countries outside the UK with a view to future collaborations.

Application deadlines are on the last Friday of every month. Applicants will be notified of decisions within 4 weeks of the deadline.
Contact: Wales Arts International, Cardiff office

Project Development and Presentation

Assistance grants to encourage productions, performances and exhibitions taking place in countries outside the UK, often developed from research funded through Inter-recce. Partner funding necessary.

Application deadlines: 17 May, 19 July, 13 September, 15 November 2002 and 14 February 2003.

Applicants will be notified of decisions within 8 weeks of the deadline.

Contact: Wales Arts International, Cardiff office

Literature

Development Services for Writers

- **Writers' Critical Service** Providing assessments of writers' work to help them develop their skills. A small fee is payable.
 Applications: may be submitted at any time.
 Contact: Literature Team, Cardiff office
- **Mentoring** Providing advice and assistance to promising authors to help develop their work to a publishable standard.
 Application deadlines: 1 May 2002
 Contact: Literature Team, Cardiff office

Lottery

Capital Grants

These grants are for the construction or refurbishment of buildings, public art and purchasing equipment such as musical instruments and staging. Grants are also available for feasibility and development studies. All applications over £50,000 need to be pre-registered with the Capital Team.

Applications may be submitted at any time.

Contact: Capital Team, Cardiff office

Film

Professional training and education opportunities are offered through the ACW's new schemes, while equipment purchase and refurbishment matters will remain with ACW Capital funding.

Responsibility for distributing Lottery film funding has been delegated to Sgrîn – Media Agency for Wales (see separate entry).

Questions of distribution and exhibition were raised in ACW's Consultation on Film Policy in early 2002.

Touring and Presentation

Community Touring – Night out

This scheme supports community organisations throughout Wales with access to suitable premises who wish to promote occasional professional performing arts events for their locality. Schools and colleges may participate if offering a service to the wider community, generally outside normal teaching time.

Applications may be submitted at any time.

Contact: Community Touring Team, Cardiff office

Visual Arts and Crafts

Interest free loans

Loans of up to £1,000, interest-free and repayable over three years, are available to professional visual artists and craftspeople, who have been in practice for at least two years. They are intended for any purpose to assist with the costs of running a professional studio or workshop. Applicants must be permanently resident in Wales. **Applications may be submitted at any time.**
Contact: Visual Arts and Craft Team, Carmarthen office

Collectorplan

These are interest-free loans of up to £2,000 to members of the public wishing to buy contemporary art and craft from galleries in Wales participating in the Collectorplan scheme. The loans are available to any UK resident over the age of 18, subject to usual status enquiries. Loans up to £1,000 are repayable over a maximum of 10 months, and loans up to £2,000 are repayable over a maximum of 15 months. **Applications may be submitted at any time, through participating galleries.**
Contact: Collectorplan Administrator, Cardiff office

Council Members: Sybil Crouch (Chairman), Dai Davies, Roger Davies, Meg Elis, Edmond Fivet, Stephen Garrett, Ellen ap Gwynn, Harry James, Daniel Jones, Geraint Lewis, Alan Lloyd, Janet Roberts, Penny Ryan, Clare Thomas and Dewi Walters

Staff: Chief Executive: Peter Tyndall

THE ARTS COUNCIL OF NORTHERN IRELAND

MacNeice House, 77 Malone Road, Belfast BT9 6AQ
Tel: 028 9038 5200; Lottery Department: 028 9066 7000; Fax: 028 9066 1715; Lottery Department: 028 9066 4766

E-mail: public affairs@artscouncil-ni.org
Website: www.artscouncil-ni.org
Contact: Damian Smyth, Public Affairs Officer
Chief Executive: Roisin McDonough

Government grant-in-aid: £7.4 million (2002/03); £7.837 million (2001/02)

The Arts Council of Northern Ireland is a registered charity and company limited by guarantee which receives an annual grant-in-aid from the Northern Ireland Executive through the Department of Culture, Arts and Leisure. In addition, the Arts Council has statutory functions under the National Lottery Act 1993 as amended by the National Lottery Act 1998.

Its mission – 'Inspiring the Imagination, Building the Future'.

The council does not devolve responsibility down to committees, as was previously the case, but consults panels of external advisers before making decisions regarding grants, awards, scholarships and bursaries.

Strategy 2001 – Seven objectives for the next five years

- Increase opportunities for artists.
- Strengthen the arts infrastructure.
- Engage with community arts.
- Engage with voluntary arts.
- Increase access for disabled people.
- Enhance young people's access.
- Increase audiences for the arts.

Arts organisations operating all year round and implementing an artistic and financial policy agreed in partnership with the council receive renewable annual grants (revenue awards). These grants for 2001/02 to 113 organisations absorbed the major part (£5.7 million) of the council's funding. They are negotiated each year – the deadline for applications falls in autumn (October or November) each year.

In April 2001 the council introduced a single new programme of support for the individual artist covering all art forms and initiatives. It replaced the support for projects awarded previously. Other support to organisations is via Lottery funding.

Support for the Individual Artist Programme

General Arts Award Scheme
For specific projects, specialised research, personal artistic development and certain materials/equipment.
Awards of up to £3,000.

Major Individual Awards Scheme
To create the circumstance in which established artists can develop individually with a view to attempting extended or ambitious work.
Four awards of £10,000 each.

'Outside Arts' Scheme
For artists and groups of artists who wish to exhibit, present or perform their work (whether new or already existing) in venues not normally regarded as 'art specific' or in areas where public access to the arts is limited. Specific areas are chosen each year: Strabane District Council and Coleraine District Council for 2002/03.
Awards up to £1,500.

Artists in Education
Residency awards for a school/consortium of schools or a consortium of youth clubs and/or other agencies within each of the Education & Library Board areas, for artist/s introducing innovative high quality learning programmes – six months in length and a total of 400 hours.
Five awards of £10,000 each.

Young Artist

Awards for young, exceptionally talented people who have finished academic qualifications and wish to spend time learning with a relevant professional practitioner. Three awards up to £3,000 each.

Professional Training

For individuals to acquire business, financial and marketing skills as well as an induction into the expectation of possible partners/employers in non-arts sectors. Awards up to £2,000.

Travel Awards Scheme

To people working in the arts in Northern Ireland to travel outside Ireland in advancement of their skills and expertise, or the furtherance of their career. Awards vary according to destination with the highest allocation of £800.

International Residency Awards Scheme

Specific residency locations as set up by the council of arranged by artists in other recognised artists residences. Awards of up to £5,000 for self-arranged residencies.

Arts and Disability Awards Ireland

A partnership between the Arts Council/An Chamhairled Ealaion and the Arts Council of Northern Ireland and the Arts and Disability Forum. Awards up to £5,000 out of a total of £18,000 available.

Arts Criticism Awards

To encourage quality criticism across all art forms. Ten awards of £500 each.

Several awards are administered by the council on behalf of other organisations including British School in Rome, etc. Enquire for further details or access on website.

Lottery Department

Tel: 028 9066 7000; Fax: 028 9066 4766; E-mail: lottery@artscouncil-ni.org

Grant available: £7,450,000 including £750,000 for administration (1999/2000–2001/2002)
No up-to-date information provided.

If a group is applying for **less than £5,000** contact **Awards For All**, a joint Lottery scheme for local groups, not individuals (see separate entry).

Access to the Arts

This programme is designed to support arts in the community. It will support new projects and initiatives created for and by communities which increase the level of participation in the arts and which encourage the development of arts skills. It will also enhance and develop existing programmes and projects previously funded from other sources for which funding has ceased.

Priority will be given to projects which: address the needs of communities in areas of social and economic deprivation; support the involvement of children and young people; involve art forms or geographic areas which have not substantially benefited from Lottery funding; are located in rural communities.

Grants from £5,000 to £40,000 per year for up to 3 years are offered. The minimum partnership funding needed from non-Lottery, non-Arts Council sources is 10%.

The New Work

This programme is designed to take new work to people throughout Northern Ireland. Projects might include the commissioning and production of original fiction, poetry, plays, dance, visual art including public art, craft and emerging technologies, music, opera, and new field work in the traditional arts. We will give high priority to proposals which create innovative original work by Northern Ireland artists.

Grants from £5,000 are offered. Awards for a single piece of new work will normally not exceed £50,000. The minimum partnership funding needed from non-Lottery or non-Arts Council sources is: 10% for projects between £5,000 and £29,999; 25% for projects between £30,000 and £99,999; 50% for projects over £100,000.

Audience Development

This programme is designed to bring new people to the arts and to take the arts to people throughout Northern Ireland. The programme includes three elements: Touring, Education/Outreach and Marketing. Applications can be made which cover one, two or all three elements.

Funding covers touring of works or performances in all art forms. Priority will be given to tours which include venues outside Belfast and/or Derry.

Within education/outreach priority will be given to proposals directed at young people or which raise awareness of cultural diversity within Northern Ireland.

Grants are offered from £5,000 to £100,000 per year for a period of up to three years. Grants for years two and three are only guaranteed for as long as the Lottery continues to operate and on condition that you meet your monitoring obligations.

The minimum partnership funding needed from non-Lottery or non-Arts Council sources is: 10% for projects between £5,000 and £29,999; 25% for projects over £30,000.

Film – Turning creative ideas into reel vision

Funding available for:

- development of feature films;
- production of feature films;
- development of television drama series;
- support for low budget film makers.

All genres and subject matter are welcomed including shorts, experimental, documentary and animation. Grants from: £2,000–£20,000 for development; £2,000–£200,000 for production. Matching funding required:

- 25% minimum for development applications;
- 50% minimum for production applications greater than £30,000;
- 25% minimum for production applications less than £30,000.

Building a framework for the arts

With limited funds available, areas which have already received substantial capital grants are unlikely to benefit from further new build grants. However, it is recognised that some urban areas may require further capital investment to provide a full range of arts events. Applications duplicating facilities within the same catchment area are discouraged. Applications for new projects have to demonstrate that they will not have a negative impact on existing facilities.

Equipment

The programme is designed to enable organisations to purchase equipment which will assist them to fulfil their potential in delivering the best artistic service possible to the people of Northern Ireland. Grants from £5,000 are offered. The minimum partnership funding you need to find from non-Lottery or non-Arts Council sources is 25%.

The following are examples of what can be applied for: lighting, stage, sound, video, office equipment, musical instruments, rostra, transport. However Community Bands cannot apply for musical instruments.

Criteria for decision making: Projects are assessed against published priorities and on the quality of the project.
Criterion 1: Public benefit
Criterion 2: Quality of arts activities planned
Criterion 3: Financial viability and quality of management
Criterion 4: Partnership funding

Council Members: Prof Brian Walker, chair; Ms Eilis O Baoill, vice-chair; Ms Maureen Armstrong; David Boyd; Cllr Martin Bradley; Dr Maurna Crozier; Ronald Dunn; David Hyndman; Judith Jordan; James Kerr; Dr Tess Maginess; Prof Brian McClelland; Ms Gerri Moriarty; Aidan Shortt; Mrs Margaret Yeomans

Staff: Chief Executive: Roisín McDonough
Lottery Director: Tanya Greenfield

OTHER NATIONAL LOTTERY SOURCES

Comprehensive Lottery funding information
Awards for All
Community Fund
The Heritage Lottery Fund
Millennium Awards Scheme
National Endowment for Science, Technology and the Arts (NESTA)
The National Foundation for Youth Music
New Opportunities Fund
unLTD, the Foundation for Social Entrepreneurs

COMPREHENSIVE LOTTERY FUNDING INFORMATION

Tel: Helpline: 0845 2750000; Textphone: 0845 275 0022
Website: www.lotterygoodcauses.org.uk

Information covering ALL the Lottery good causes can be accessed.

It can be difficult finding you way around the maze of funding opportunities run by the Lottery distributors. The telephone line is a godsend particularly with the New Opportunities Fund which announces new policies, consults, drafts strategies, reconsults, etc., etc., so that it is often difficult to be sure when a new programme becomes operational (or if another has become defunct).

AWARDS FOR ALL

Tel: 0845 600 2040 – application packs; 0845 755 6656 – Minicom
Website: www.awardsforall.org.uk

Funding: £40 million for England

Awards for All is a grant programme for small groups involved in arts, sports, heritage, education, environment, health and voluntary and community activities who want grants of between £50 and £5,000. Criteria include increasing skills and creativity and improving quality of life.

Each country and each region in England has a particular focus to meet local needs, for example helping black and minority ethnic groups or older people.

Grants are open to small non-profit organisations and some statutory bodies such as parish town councils, schools and health bodies, but **not** to fund statutory responsibilities. Priority is given to groups with a lower income. Groups must spend the money within twelve months of receiving the grant. There is no requirement for match funding.

In England, Scotland and Northern Ireland the scheme is funded by all five National Lottery distributors. In **Wales** the funding partnership is between three distributors – the Community Fund, Heritage Lottery Fund and the New Opportunities Fund (as at April 2002).

In England and Scotland, the programme awards grants to groups with an income of £20,000 or less each year. Check the figure for Wales or Northern Ireland.

COMMUNITY FUND

Corporate/UK Office: St Vincent House, 16 Suffolk Street, London SW1Y 4NL
Tel: 020 7747 5300; Enquiries Line: 020 7747 5299; Fax: 020 7747 5214
E-mail: enquiries@community-fund.org.uk
Website: www.community-fund.org.uk

Total grant budget: £287 million (2001/02), expected to decline to £213 million from 2004 onwards

Community Fund is the operating name of the National Lottery Charities Board, the independent organisation set up by Parliament in 1994 to distribute money raised by the National Lottery to support charities, voluntary and community groups. Its main aim is to help meet the needs of those at greatest disadvantage in society and to improve the quality of life in the community.

Strategic Plan 2002– 2007

A significant proportion of the funds is to be directed at projects targeting specified beneficiary groups and identified geographical areas. However the fund will continue as a 'generalist grant giver' and will continue to fund projects outside these groups.

Greater emphasis is to be placed on long-term change and outcomes. Funded groups will have to demonstrate that they are making a measurable short-term difference and contributing to making a long-term difference to the lives of the people they seek to help. Targeted groups:

- children and young people;
- black and minority ethnic groups (including travellers);
- refugees and asylum seekers;
- older people and their carers;
- people in areas disadvantaged by social or economic change, whether urban or rural;
- disabled people (mental and physical) and their carers.

There is no maximum size of grant however the average grant has been around £80,000. Grants are given for one, two or three years and may cover 100% of a project's costs.

Country and regional funding priorities

There are different funding priorities for Wales, Scotland, Northern Ireland, each England region and for projects working throughout England. These are listed in

different country and regional leaflets available with the application pack or from the website. If a project does not meet one of these priorities it may still be awarded a grant.

The board does not support the arts as such however many projects in which arts serve as a form of social therapy, tackling the wider demands of the personal and social development of the most needy and disadvantaged people, may be considered for support.

Examples of successful applicants to the Community Fund which are relevant to this guide include:

Templar Arts and Leisure Centre, Argyll & Bute, to demolish existing building and build a new centre (£407,000);

Cascade Theatre in Education Group, Carrick, for disadvantaged groups and individuals to participate in drama-based workshops (£136,660 over 3 years);

Educational Theatre Services, Birmingham, theatre work with young people to raise awareness of and prevention of teenage pregnancy (£75,217);

Cartwheel Community Arts, Rochdale, developing literacy and language skills through arts and creative play (£64,568 over three years).

For grants of between £500 and £5,000 see also separate entry for **Awards for All**.

Applications: Obtain an application pack, including the leaflet for the country or region where most of the people who will benefit from your project live. You can get an application pack by phoning 0845 791 9191 (Minicom: 0845 755 6656) or by accessing the website: www.community-fund.org.uk

For further information contact:
Wales Office
2nd Floor, Ladywell House, Newtown, Powys SY16 1JB
Tel: 01686 611705; Minicom: 01686 610205; Fax: 01686 621534;
E-mail: enquiries.wales@community-fund.org.uk

Northern Ireland Office
2nd Floor, Hildon House, 30-34 Hill Street, Belfast BT1 2LB
Tel: 028 9055 1455; Minicom: 028 9055 1431; Fax: 028 9055 1444;
E-mail: enquiries.ni@community-fund.org.uk

East of Scotland Office
Norloch House, 36 King's Stables Road, Edinburgh EH1 2EJ
Tel: 0131 221 7100; Enquiries line: 0870 240 2391; Fax: 0131 221 7120;
Minicom: 0131 221 7122; E-mail: enquiries.scotland@community-fund.org.uk

West of Scotland Office
2nd Floor, Highlander House, 58 Waterloo Street, Glasgow G2 7DB
Tel: 0141 223 8600; Enquiries line: 0870 240 2391; Fax: 0141 223 8620;
Minicom: 0131 221 7122; E-mail: enquiries.scotland@community-fund.org.uk

England Head Office
1st Floor, Reynard House, 37 Welford Road, Leicester LE2 7GA
Tel: 0116 258 7000; Fax: 0116 255 7398 or 7399; Minicom: 0116 255 5162;
E-mail: enquiries.england@community-fund.org.uk

England Regional Offices
London
Camelford House, 89 Albert Embankment, London SE1 7UF
General Enquiries: 020 7587 6600; Fax: 020 7587 6610; Minicom: 020 7587 6620;
E-mail: enquiries.lon@community-fund.org.uk

South East
3rd Floor, Dominion House, Woodbridge Road, Guildford, Surrey GU1 4BN
General Enquiries: 01483 462900; Fax: 01483 569893; Minicom: 01483 568764;
E-mail: enquiries.se@community-fund.org.uk

South West
Beaufort House, 51 New North Road, Exeter EX4 4EQ
General Enquiries: 01392 849700; Fax: 01392 491134; Minicom: 01392 490633;
E-mail: enquiries.sw@community-fund.org.uk

Eastern
Elizabeth House, 2nd Floor, 1 High Street, Chesterton, Cambridge CB4 1YW
General Enquiries: 01223 449000; Fax: 01223 312628; Minicom: 01223 352041;
E-mail: enquiries.ea@community-fund.org.uk

East Midlands
City Gate East, 2nd Floor, Tollhouse Hill, Nottingham NG1 5NL
General Enquiries: 0115 934 9300; Fax: 0115 948 4435; Answer Machine: 0115
934 9331; Minicom: 0115 948 4436; E-mail: enquiries.em@community-fund.org.uk

West Midlands
Edmund House, 4th Floor, 12–22 Newhall Street, Birmingham B3 3NL
General Enquiries: 0121 200 3500; Fax: 0121 212 3081; Minicom: 0121 212 3523;
E-mail: enquiries.wm@community-fund.org.uk

Yorkshire and the Humber
3rd Floor; Carlton Tower, 34 St Pauls Street, Leeds LS1 2AT
General Enquiries: 0113 224 5300; Fax: 0113 244 0363; Minicom: 0113 245 4104;
Information Line: 0113 224 5301; E-mail: enquiries.yh@community-fund.org.uk

North West (including Merseyside)
Ground Floor, Dallam Court, Dallam Lane, Warrington WA2 7LU
General Enquiries: 01925 626800; Fax: 01925 234041; Minicom: 01925 231241; E-
mail: enquiries.nw@community-fund.org.uk

North East
6th Floor, Baron House, 4 Neville Street, Newcastle upon Tyne NE1 5NL
General Enquiries: 0191 255 1100; Fax: 0191 233 1997; Minicom: 0191 233 2099;
E-mail: enquiries.ne@community-fund.org.uk

THE HERITAGE LOTTERY FUND

7 Holbein Place, London SW1W 8NR
Tel: 020 7591 6000; Fax: 020 7591 6001
E-mail: enquire@hlf.org.uk
Website: www.hlf.org.uk
Contact: Joanna Finn, Information and Publications Manager

Grant total: £330 million (2001/02); £330 million (2000/01)

The Heritage Lottery Fund (HLF) aims to improve the quality of life by safeguarding and enhancing the heritage of buildings, objects and the environment, whether man-made or natural, which have been important in the formation of the character and identity of the United Kingdom. It also aims to assist people to appreciate and enjoy their heritage, allowing them to hand it on in good heart to future generations.

Any organisation or individual may apply for funding for an eligible project. For the time being, it is not expected that grants will be made for individual sites or buildings in private or commercial ownership. Grants may be made for certain projects which include privately owned property as part of a wider area, or certain 'umbrella' schemes put forward by a public or other not-for-profit organisation.

Approximate annual spend

Historic buildings and sites	£132m
Countryside and land	£81m
Museums and galleries	£62m
Industrial, transport and maritime	£25m
Documentary heritage	£15m
Revenue grant programme	£11m

Partnership funding for HLF projects: as a maximum HLF can fund up to 75% on projects where the total project cost is more than £100,000 and up to 90% on projects which are less than £100,000.

Main grants programme

This covers natural habitats and countryside; urban green spaces, including parks; archaeological projects; historic buildings and sites, including townscapes and places of worship; museum collections; historic library collections and archives, including photographic, sound and film archives; industrial, transport and maritime heritage.

This programme funds projects where the main costs are for capital spending on work, or buying items, aimed at preserving and improving access to things which are of importance to the heritage. Costs which can be considered: buying land, buildings, objects, archives and collections; conservation work of all kinds; providing facilities to improve public enjoyment or knowledge of heritage assets, particularly for disabled people; giving historic buildings a new use; providing better housing for archives or collections; cataloguing archives and collections; using information technology to extend public access to archives and collections; improvements to access; project development costs in certain circumstances.

Grants for under £5,000 are not normally given.

Seven criteria are used to assess applications to the Main Grants Programme:
- importance of the project to the heritage;
- conservation benefits of the project;
- access benefits of the project;
- extra public benefits the project will create;
- the quality of design of the project;
- financial needs and planning of the project;
- the strengths of the applicant organisation.

Examples of capital projects
Ballymena Area Museum, Northern Ireland, rehousing museum collection (£4,441,000);
Blackpool Grand Theatre, restoration (£239,000);
Birmingham Museums and Art Gallery, for acquisition of ormolu objects (£210,000);
Hastings Fishermen's Museum, extension and storage space (£198,500);
Potteries Museum and Art Gallery, Stoke-on-Trent, acquisition of prints (£53,800);
Kingston Museum, environmental, security and display improvements for temporary display area (£31,300);
Museum of Islay Life Scotland, for improved access and display area (£25,500).

Revenue grants programme
This programme supports projects aimed at widening understanding and enjoyment of the heritage, and widening access to heritage information, where the main costs are spending not related to capital.

The costs that may be considered are: fixed-term extra staff costs or the costs of advice; targeted market research and marketing; project-related training; research, compilation and publication (where you cannot pay the cost of publication through commercial means); equipment and materials; information and communication technology hardware and software; enabling costs, such as transport; evaluation.

Grants are not normally given for projects over £100,000. Projects should last for up to three years.

Revenue grant applications must meet one or more of the following priorities:
- developing new audiences for the heritage;
- delivering educational benefits, particularly for children and young people;
- increasing study, understanding and enjoyment of the heritage, history and natural history of the UK;
- encouraging people to take an active part in heritage activities.

In addition applicants must:
- provide research and analysis on which the project is based;
- show commitment to equal opportunities;
- prove previous relevant track record;
- show evaluation strategies;
- show the long-term benefits of the project;
- show the financial needs and planning of the project.

Revenue grants in 2000/01 relevant to this guide included:
Wakefield MBC Museums and Arts, developing new audiences – free transport to Wakefield Museum, Sandal castle and Pontefract Museum for under-fives and over fifty-five age groups from deprived neighbourhoods (£15,900);
Museum of South Somerset, Hendford, Yeovil, education benefits – to establish a range of resources to support AS/A2 A level teaching (£15,900);
Blackburn Museum and Art Gallery, kimono exhibition and conservation project (£16,235);
Museum of London, to increase access to oral history at the museum (£149,500).

Your Heritage – grants for heritage projects £5,000 to £50,000

This programme supports a wide range of projects involving the national, regional and local heritage of the United Kingdom. To qualify for a grant your project must either:

- care for and protect our heritage; or
- increase understanding and enjoyment of our heritage.

The project must also:

- give people a better opportunity to experience heritage by improving access: and
- help to improve people's quality of life by benefiting the community and wider public.

When assessing your application HLF looks at:

- whether there is a need or demand (or both) for your project;
- whether your project is well thought out (including a realistic view of its longer-term role) and will involve work of high quality;
- how you plan to manage your project during and after completion;
- how you will measure your project's success in meeting its aims; and
- whether your project costs are sound and will provide good value for money overall.

Other grant programmes include: Townscape Heritage Initiative; Urban Parks Programme; Local Heritage Initiative (England only, in partnership with the Countryside Agency, see separate entry); Joint Places of Worship Scheme (England with English Heritage).

Small grants: See separate entry, **Awards for All**, for grants between £500 and £5,000.

Trustees: Ms Liz Forgan, chair; Professor Chris Baines; Robert Boas; The Earl of Dalkeith; Nicholas Dodd; Sir Angus Grossart; Patricia Lankester; Susan Palmer; Professor Tom Pritchard; Mary Ann Sieghart; Giles Waterfield; Primrose Wilson; James Wright

Country and Regional Committees and Offices

Committee for the East Midlands
Gill Gardiner, Chair; Sue Clayton; Gareth Fitzpatrick; Tony Hams; Derek Latham;
Angela Watson
For information ring: 020 7591 6042
Regional manager: Anne Jenkins

Committee for the East of England
Amanda Arrowsmith, Chair; David Bell; John Blatchly; David Potter; Richard Powell;
Marion Williams
For information ring: 020 7591 6044
Regional manager: Robyn Greenblatt

Committee for London
Mary Austin, Chair; Val Bott; Marc Jordan; Sue Millar; Catherine Ross; Terry Stacy
For information ring: 020 7591 6044
Regional manager: Sue Bowers

Committee for the North East
Richard Bailey, Chair; Phillip Hughes; Grace McCombie; Adrian Osler; Chris Spray
For information ring: 020 7591 6045
Regional manager: Eilish McGuinness

Committee for the North West
Andrew White, Chair; Bruce Bennison; Mark Blundell; Kate Dickson; Gary Morris;
Anne Selby
For information ring: 020 7591 6045
Regional manager: Tony Jones

Committee for South East England
Sarah Ward, Chair; Graham Collings; Deborah Dance; Martyn Heighton; John Leigh-
Pemberton; Jane Weeks
For information ring: 020 7591 6043
Regional manager: Tessa Hilder

Committee for the South West
Caroline Dudley, Chair; Roger Martin; Caroline Sandwich; Adrian Tinniswood; David
Viner; Graham Wills
For information ring: 020 7591 6043
Regional manager: Beverley Peters

Committee for the West Midlands
Jeff Carpenter, Chair; Peter Courtis; Katie Foster; Michael Freeman; Simon Penn;
Elizabeth Perkins
For information ring: 020 7591 6042
Regional manager: Sheena Vick

Committee for Yorkshire and the Humber
Ian Carstairs, Chair; Patrick Ferguson; David Fletcher; Sophie Forgan; Terry Hodgkinson; V V Ramaswamy
For information ring: 020 7591 6045
Regional manager: Ray Taylor

Committee for Scotland
28 Thistle Street, Edinburgh EH2 1EN
Tel: 0131 225 9450; Fax: 0131 225 9454
Sir Angus Grossart, Chair and trustee; The Earl of Dalkeith (trustee); Marc Ellington; John Gerrard; Margaret Maclean; Graham McNicol; Graham U'ren; Jennifer Wilson
Regional manager, Scotland: Colin McLean

Committee for Wales
Companies House, Crown Way, Cardiff CF14 3UZ
Tel: 029 2034 3413; Fax: 029 2034 3427
Professor Tom Pritchard, Chair and trustee; Chris Delaney; Julia Evans; David Freeman; Elinor Gwynn; Richard Keen
Regional manager, Wales: Jennifer Stewart

Committee for Northern Ireland
Glendinning House, 6 Murray Street, Belfast BT1 6DN
Tel: 029 9031 0120; Fax: 028 9031 0121
Primrose Wilson, Chair and trustee; Denise Ferran; Alan Gailey; Margaret Gallagher; Ian B McQuiston; Annesley J Malley
Regional manager, Northern Ireland: Kevin Baird

Expert Panel, Museums, Libraries and Archives: Dr Patrick Greene, Chair; Dr Helen Forde; Nell Hoare; Karen Knight; Sally MacDonald; Andrew Scott; Dr J Michael Smethurst; Dr Charles Saumarez Smith; David Vaisey

Expert Panel, Historic Buildings and Land: Les Sparks, Chair; Alan Baxter; Peter Burman; David Lambert; Rodney Melville; Dr Alison Millward; Michael Morrison; Dr Anna Ritchie; Matthew Saunders; Jane Sharman; David Streeter; Dr Hilary Taylor

Director: Anthea Case
Director of Operations: Stephen Johnson

MILLENNIUM AWARDS SCHEME

Website: www.millennium.gov.uk
Total funding: about £20 million each year

Charities, voluntary organisations and local authorities across the UK are running schemes in partnership with the Millennium Commission. These 'Award Partners' run the application and assessment process, although the Millennium Commission retains the final decision-making responsibility when it comes to making each award. The awards run over a period of years.

A Millennium Awards programme provides grants directly to *individuals*. It enables them to 'achieve their personal aspirations and release their potential, enriching their lives and their communities in the new millennium'.

From end 2002 a £100 million endowment will be transferred to a separate body to administer a new awards scheme for individuals (see entry for UnLTD).

A number of illustrative projects related to the interests of this guide follow. For a full current list contact the Millennium Commission direct or access their website.

The Awards Schemes run until 2004.

Barrow CRC Cultural Achievement Millennium Awards
Tel: 01229 430 801; Fax: 01229 877 850
Website: www.barrowcc.org.uk
Total grant: £215,000 (2000–2003)
Barrow Community Regeneration Company is offering 60 people living in the borough of Barrow in Furness the opportunity to develop their own community projects which will expand the cultural capacity of people in Barrow. Awards will be around £2,800 and winners will receive training to develop their skills and abilities.

Commedia Millennium Awards
Tel: 0114 279 5219; Fax: 0114 279 8976; E-mail: cma@commedia.org.uk
Website: www.commedia.org.uk
Total grant: £970,000 (2000–2003)
A three year awards scheme to enable 225 individuals to make a short film, radio or Internet production about an issue or concern relevant to people living in their community (grants around £3,900). Its seven rounds were completed by the end of March 2002. However it is possible that further funding may become available.

Jewish Music Institute Millennium Awards
Tel: 020 8909 2445; Fax: 020 8909 1030
Total grant: £248,035 (for three years)
Up to 50 awards of between £2,000–£5,000 will enable individuals throughout the UK to use Jewish music (any form) as a tool for promoting understanding, mutual respect and tolerance between communities. The scheme is open to all regardless of their background or experience in music, Jewish or non-Jewish. The scheme launched in Spring 2001.

Skillset Millennium Awards

Tel: 020 7534 5302; Fax: 020 7534 5333

Total grant: £1.1 million (2002–2004)

Individuals in the black and minority ethnic communities across the UK are offered awards of around £8,000 to enable them to attend specialist training courses in media applications. All award winners will receive £500 to use their newly acquired skills to undertake a community media project.

You and Your Community, a new scheme, was announced in May 2002. It is being administered for the Millennium Commission in each of the four nations of the UK by:

- The Scarman Trust;
- The Scottish Community Foundation;
- Wales Council for Voluntary Action.
- the Northern Ireland Voluntary Trust.

To apply call: 0800 06801 2000.

Check directly for further details.

Applications: A list of Awards Partners and their schemes is available by telephoning 020 7880 2072.

Free phone number for individuals interested in applying for an award: 0800 06801 2000.

NATIONAL ENDOWMENT FOR SCIENCE, TECHNOLOGY AND THE ARTS (NESTA)

Fishmongers' Chambers, 110 Upper Thames Street, London EC4 R 3TJ

Tel: 020 7645 9500; Enquiries: 020 7645 9538; Fax: 020 7645 9501

E-mail: nesta@nesta.org.uk

Website: www.nesta.org.uk

Trustees: Lord Puttnam, Chair; Daniel Alexander; Dr Christopher Evans; Sue Hunter; Professor Janice Kirkpatrick; Francois Matarasso; Genista McIntosh; Dame Bridget Ogilvie; Professor Sir Martin Rees; Carol Vorderman; Derek Wanless; David Wardell.

Donations to all causes: about £10 million annually

NESTA is an independent public body set up in 1998 with a one-off endowment of £200 million of Lottery money to support and promote talent, innovation and creativity in the fields of science, technology and the arts. To achieve this it runs three programmes:

Invention and Innovation

This programme provides crucial support for ideas, often at an early stage. Awards ranging from £5,000–£50,000 are given to individuals or micro-businesses to develop

an idea or products. The programme is open to anyone in the UK and applications are made via the website. NESTA takes a financial stake in supported projects, investing any returns in its programmes.

Fellowships

This programme enables talented people to develop their ideas and fulfil their creative potential. The programme is not open access. NESTA appoints 'talent scouts' – nominators who are in contact with emerging new talent in a range of disciplines. The pool of nominators is continually refreshed – each nominator suggests two people and is then replaced. Awards will usually be within the range of £25,000–£70,000.

Education

This programme encourages people of all ages to engage in science, technology and the arts, exploring innovative approaches for others to share. The programme is not open access. NESTA's education team develops and pilots educational projects with schools, universities and organisations that promote public understanding and participation in science, technology and the arts.

Examples of awards had been made by spring 2001 included:

under Invention and Innovation
Rodger Jackman and Elizabeth Leader for Wildthings – a Theatre for Environmental Learning, to develop the theatre – teamed up with London Zoo and National Geographic (£38,500);
Michael Medora and Nigel Robiette, for MoviPoster, the world's first moving 3D poster (£56,000);
Duncan Betts, guitarist and songwriter, for Music Wheels, an innovative aproach to learning the fundamentals of music theory (£82,000 over two years);

under Fellowships
Bronwen Edwards, musician and science educator, to develop interactive science and music learning (£58,000 over three years);
Gwyneth Lewis, for a poetic journey, (£75,000 over five years);
John McCloskey, film animator (£72,000 over three years);
Sophie Fiennes, extending the boundaries of film (£36,000 over three years).

For further examples of awards under the three programmes visit www.nesta.org.uk

Applications: There is no closing date. Applications may be may via the web and news and developments are posted on the website.

THE NATIONAL FOUNDATION FOR YOUTH MUSIC (YOUTH MUSIC)

One America Street, London SE1 ONE
Tel: 020 7902 1060; Fax: 020 7902 1061
E-mail: info@youthmusic.org.uk
Website: www.youthmusic.org.uk

Contact: Christina Coker, Chief Executive
Trustees: Gavin Henderson, Chairman; Sir Simon Rattle; Lesley Garrett; Sir Elton John; Mick Hucknall; George Benjamin; Professor Edward Gregson; Geraldine Connor; Richard Stilgoe; Anthony Blackstock; Rob Dickins; The Duchess of Kent.
Beneficial area: UK

The foundation was set up by the Department for Culture, Media and Sport and launched in 1999 as a delegate distributor of £10 million a year of Arts Council of England Lottery funds for six years to 2005. It also raises additional funds from the private sector and before its official launch in June 1999 had pledges from a number of bodies including the British Phonographic Industry and the Calouste Gulbenkian Foundation.

It aims to improve access to quality music-making experiences in a wide range of musical genres, for young people, particularly those socially excluded. It will not only distribute funds but also offer advocacy, strategic advice and guidance.
The foundation aims to:
- increase access to young people making music;
- support a wide range of styles and musical and cultural traditions;
- improve provision to geographical regions and areas of special need;
- promote the highest quality of music provision.

The foundation is about all sorts of music and all sorts of children and young people.

Over the three years to March 2005 the emphasis is on three specific areas:
- professional development and training of music leaders;
- the building of partnership between organisations working with young people;
- support of music-making as part of early learning.

From April 2002 these aims are tackled by initiatives in five different strands:
- open programmes available by application;
- key partnerships with established organisations;
- strategic new partnerships in specially selected areas that have a measurable impact;
- action research and development;
- annual special initiatives such as 2002's Song for Youth – 'Drop in the Ocean' – a specially commissioned song and education pack to enable over half a million young people to sing new repertoire and give a new teaching resources for thousands of music teachers.

Youth Action Zones have been set up to reach communities which have few opportunities and little access to music-making. The zones target areas of social and economic need by providing workshops, rehearsals, performances and one-to-one teaching and mentoring partnerships between music organisations and schools. Seventeen areas were 'actioned' by March 2002 – Birmingham, Bristol and Gloucester, Cornwall, Greater Manchester, Humber, Lancashire, Liverpool, Lincolnshire, London, North of England, North Yorkshire, Norfolk, Shropshire and Herefordshire, South East, South Yorkshire, Staffordshire, Thanet.

Contact: YMAZ Co-ordinator – Katrina Duncan

Funding programmes operational in spring 2002:
- Singling challenge;
- Instrument Swop;
- Plug into Music;
- Sound Inventors;
- Instrument Purchase.

Funding programmes will change, develop and be discontinued over the life of this guide. It is important for organisations to acquire direct from Youth Music the most current information about funding schemes and partnership initiatives in their area.

Applications: Contact Youth Music direct or access full information with guidelines and application forms on their website.

NEW OPPORTUNITIES FUND

1 Plough Place, London EC4A 1DE
Tel: 020 7211 1800; enquiries line: 0845 000 0121; Fax: 020 7211 1750
E-mail: general.enquiries@nof.org.uk
Website: www.nof.org.uk

Trustees: Board members: Baroness Pitkeathley, Chair; Jill Barrow; David Campbell; Jane Hutt; Dugald Mackie; Professor Allan Patmore; Dr Sian Griffiths; Roisin McDonough; Professor Eric Bolton; Nita Clarke; Melinda Letts.

The New Opportunities Fund is a non departmental public body which receives its directions for grantmaking from the Department of Culture, Media and Sport. It is now by far the largest distributor of the National Lottery funding to good causes.

It supports **health**, **education and environment** projects across the UK and works across the sectors, public, private and voluntary. The funding for its programmes is divided between England, Scotland, Northern Ireland and Wales on the basis of population, weighted to reflect levels of deprivation.

By working in partnership with other organisations, including other lottery distributors and the voluntary sector, the fund intends to support sustainable projects that will:

- improve the quality of life for people throughout the UK;
- address the needs of those who are most disadvantaged in society;
- encourage community participation;
- complement relevant local and national strategies and programmes.

Its programmes share four key values: partnership, consultation, strategic use of funding and the promotion of social inclusion.

FairShare

This new programme, to which both the Community Fund and NOF contribute, was to be launched in late spring/early summer 2002. The total funding of £169 million is to be directed to 62 disadvantaged communities across the UK which have low take up of Lottery funding.

Education

Out of School Hours Childcare and Neighbourhood Nurseries were the two areas open to application in April 2002.

Environment

Green Spaces and Sustainable Communities

This programme aims to help urban and rural communities throughout the UK understand, improve or care for their natural environment. Most of the money has been allocated to green spaces projects that will make better use of existing green spaces and make them more accessible to the public. Projects could include creating or improving space for children's play, recreation and playing fields, improvements to parks, or access to the countryside. The remainder of the fund is given over to 'community involvement in sustainable development'. This covers such activities as waste minimisation, transport, consumption, promotion of biodiversity and energy efficiency.

The programme is administered across the UK via 12 'Award Partners', who run umbrella schemes or delegated grant programmes to deliver funding at a local level.

Transforming Communities

This programme launched in summer 2002. At the time of writing it was expected to support local initiatives to improve the environment by including waste recycling, alternative energy and other wider environmental concerns.

Health

At the time of writing the only two programmes open to application were: Children's Palliative Cancer Care; Heart and Stroke and Cancer Care (a preventative scheme).

UnLTD, THE FOUNDATION FOR SOCIAL ENTREPRENEURS

Mezzanine Floor, Elizabeth House, York Road, London SE1 7NQ
Tel: 020 7401 5305; Fax: 020 7401 5486
Website: www.unltd.org.uk

Contact: John Rafferty, Interim Chief Executive
Trustees: Jeremy Oppenheim,chair; Michael Norton; Andrew Mawson; James Cornford; Laurence Demarco; Liz Firth; Kate Kirkland; Tim Cantle-Jones; Christopher Smallwood; Tanya Pein; Yasmin Gillani; Martyn Williams.

UnLTD was formed in 2000 through a partnership between seven leading UK non-profit organisations that work with individuals who make a difference to their communities: Ashoka UK Trust; Changemakers; Comic Relief; Community Action Network; Scarman Trust, School for Social Entrepreneurs; Social Entrepreneurs Network Scotland (SENSCOT).

'At our core, is an ethos of inclusion: trusting people, creating hope and overcoming isolation'.

It was selected as the preferred candidate to adminster the legacy of £100 million from the Millennium Commission. It will be using the interest to fund enterprising individuals working to improve our society.

At the point of editing the actual arrangements were not in place.

Contact UnLTD directly to find out full details about their policies and programmes.

MEDIA/MOVING IMAGE

National:
The Film Council
First Light
Scottish Screen
Sgrîn – Media Agency for Wales
The Northern Ireland Film and Television Commission (NIFTC)

Regional media agencies:
EM Media
London Regional Media Agency
The London Film and Video Development Agency
North West Vision
Northern Film and Media Office
Screen East
Screen South
Screen West Midlands
South West Screen
Yorkshire Media Industries Partnership
Yorkshire Media Production Agency
Yorkshire Media Training Consortium

Examples of other resources:
cre8 Studios
The First Film Foundation
The Gaelic Broadcasting Committee
The Gaelic Television Training Trust
Glasgow Film Office
Glasgow Media Access Centre
Lighthouse
Mersey Film & Video
Northern Visions Media Centre
VET Bursary programme
Yorkshire Community Media Fund

National

THE FILM COUNCIL

10 Little Portland Street, London W1W 7JG
Tel: 020 7861 7861; Helpline: 020 7861 7924; Fax: 020 7861 7862
E-mail: info@filmcouncil.org.uk
Website: www.filmcouncil.org.uk

Chief Executive: John Woodward

Donations to all causes: £150 million over three years (2001/02–2003/04)

The Film Council was set up to work with the public and private sectors to make film an essential part of the UK's creative economy and to build the environment for a sustainable and vibrant film culture. It launched in April 2000 with a *UK-wide* remit to develop 'a coherent strategy for film culture, the development of the film industry and the encouragement of inward investment, and determine the allocation of resources between them'. It channels all Department for Media, Culture and Sport funding for film apart from the grant to the National Film and Television School.

The council is also a Lottery distributor in its own right, guaranteeing, for the first time, a dedicated share of Lottery resources for film production amounting to at least £27 million, a significant increase on previous years.

Over the next three years total investment of public and lottery money is expected to reach £150 million, at least £145 million of which will be channelled through the Film Council.

Be sure to check for the up-to-date situation regarding support from the Film Council. As a young body its programmes are evolving, developing and changing. In the first instance check out its website.

Production Funding

General

One of the Film Council's main aims is to try and form long-term relationships with both producers and writing talent. Its production and development funds work closely together to try to ensure cross-fertilisation of both ideas and projects at an early stage. Before applying, filmmakers need to know which of the council's three funds is the most appropriate for their project. The council will not provide support from more than one fund at any one time. Its funding, on the whole, adopts the industry practice of providing funding in the form of *investment* rather than grants.

The Film Council is 'committed to reflecting the richness and vitality of Britain's multicultural society and helping to create a culturally diverse film industry'. In

view of underrepresentation to date, it prioritises work with Black and Asian filmmakers and actively encourages applications involving Black or Asian talent.

Franchises: In addition to the three tranches of funding described below the Film Council provides major funding to three film franchises – DNA Ltd, The Film Consortium Ltd and Pathé Pictures Ltd. The Film Council will not fund projects already supported by a franchise.

1 The Development Fund

Funding: £5 million annually
Head of the Development Fund: Jenny Borgars

The fund aims to broaden the quality, range and ambition of British film projects and the talent being developed. More specifically, it aims to raise the quality of screenplays produced in or from the UK through strategically targeted development initiatives engaging with the industry at first on a project by project basis. The fund will, over time, build creatively focused relationships, with a breadth of talent, from 'first timers' to experienced practitioners. By investing in projects at all stages of their development, the fund also seeks to enable British film companies to grow sustainable businesses.

Funding of less than £10,000 may be made to individuals but funding in excess of £10,000 is only available to companies.

Applications are accepted at all stages of development from treatment onwards.

Projects should be developed as feature length theatrical films for commercial exploitation in the UK and the rest of the world and be intended for production in the English language unless there are mitigating factors to the contrary.

The Development Fund also maintains a number of 'slate' funding deals with companies who have successfully responded to open tenders for business and creative proposals. Details of these investments (13 as at March 2002) can be obtained from the press office.

The Film Council reserves the right to fund projects in a number of ways, but it is normally provided as investment. Funding is available for all stages of development up to pre-production. The fund can agree to meet the following costs: writer's fees; writer's research fees; reasonable overhead costs of the producer (limited to 15% of the total Film Council investment); payments to acquire and option rights to adapt works for the screen; producer fees; producer's reasonable legal costs; script readings/ editors; executive producer/mentor; other specific requirements, e.g. special effects/ story boarding; a 'package' to present to potential partners; budget; schedule; casting; and other legitimate development costs at the discretion of the fund.

2 The New Cinema Fund

Funding: £5 million annually
Head of the New Cinema Fund: Paul Trijbits (who makes decisions on funding with the two deputies with specific responsibilities for the nations and regions, and for cultural diversity)

Short film funding plan

£750,000 a year

This fund encourages unique ideas, innovative approaches and new voices. It is committed to supporting work from the regions and from Black, Asian and other ethnic minorities. Feature film production is central to its role. In addition, the fund intends to capitalise on the benefits offered by new technology in making and showing films.It works closely with established and 'emerging' new media content providers and distributors, and actively explores new forms for delivery of films to the public.

Projects should be submitted in script form and be feature length theatrical films for commercial exploitation in the UK and the rest of the world, intended for production in the English language (unless mitigating factors to the contrary). The projects should be quality films in any genre – thriller, horror, sci-fi, drama, documentary, social realist, etc.

If both the producer and director are 'first timers', i.e. without previous feature film production experience, the council reserves the right to ensure that the film is realised under the guidance of an experienced executive producer, with the relevant costs to be included in the production budget.

The council normally contributes between 15% and 50% of a film's budget. In the case of digitally produced lower-budget films, it may be able to contribute a higher proportion of the budget. Funding will usually be provided as an investment.

Projects which do not have the potential to secure a UK theatrical release or a high profile television/electronic broadcast are unlikely to obtain assistance.

Pilots: The fund also supports the making of 'pilots' to illustrate a project's potential and to assist in raising finance. Direct production costs (excluding 'above-the-line' costs) up to £7,500 are available, usually as an investment repayable to the Film Council (with a 50% premium) upon commencement of principal photography of a feature film based on, or connected to, the pilot film.

The New Cinema Fund actively liaises with public film funds equivalent to the Film Council outside the UK.

Shorts Schemes to develop emergent talent

Digital Shorts are funded regionally. *Have to under 10 mins!*

The New Cinema Fund is partnering with organisations in each region and nation of the UK. Each partner organisation is supporting at least eight digital films a year with a budget of up to £10,000 each. Individual filmmakers should apply directly to the partner organisations for funding.

Scotland

Glasgow Media Access Centre Ltd

Contact: Cordelia Stephens
Tel: 0141 553 2620; E-mail: admin@g-mac.co.uk
Website: www.g-mac.co.uk

Northern Ireland
Northern Ireland Film Commission
Contact: Andrew Reid
Tel: 028 9023 2444; E-mail: info@nifc.co.uk
Website: www.nifc.co.uk

East of England
Screen East
Contact: Kate Gerova
Tel: 01603 756879; E-mail: info@screeneast.co.uk

East Midlands
EMMI/Intermedia Film & Video Ltd
Contact: Peter Carlton
Tel: 0115 955 6909; E-mail: info@intermedianotts.co.uk

South of England
Lighthouse
Contact: Caroline Freeman
Tel: 01273 384222; E-mail: cfreeman@lighthouse.org.uk

West Midlands
Screen West Midlands
Contact: Paul Green
Tel: 0121 643 9309; E-mail: info@central-screen.easynet.co.uk

North West of England
Moving Image Development Agency
Contact: Helen Bingham and Lyn Papadopoulos
Tel: 0151 708 9858; E-mail: mida@ftcnorthwest.co.uk

North of England
Northern Production Fund
Contact: Tom Harvey
Tel: 0191 269 9201; E-mail: info@northernarts.org.uk

South West of England
South West Screen
Contact: Sarah-Jane Meredith
Tel: 0117 927 3226; E-mail: sarah-jane@swscreen.co.uk
Website: www.swscreen.co.uk

Yorkshire and Humberside
Yorkshire Media Production Agency
Contact: Chris Finn
Tel: 0114 249 2204; E-mail: admin.ympa@workstation.org.uk

The New Cinema Fund and FilmFour Lab

Each is investing £250,000 a year divided between four major schemes encouraging directors, producers and other creative talent to push their creative boundaries. In the first year of the scheme the four targeted areas are as follows.

- **Cinema Extreme** Encourages and develops the careers of filmmakers with an original vision and cinematic flair. Applications from writer-directors or director and team (writer and/or producer) are welcome. Applicants should be at a stage where they are able to use the scheme as a launch pad into the making of their first feature film.

 The Bureau, an independent film production company, is managing the initial submission and selection process for the fund. The final selection will be made by FilmFour Lab and the New Cinema Fund in association with The Bureau. Four films were commissioned in 2002, with five films in 2003. The first deadline for submissions was 5 April 2002.

- **ComedyShorts** Encourages proven comedy talent to make the transition into theatrical filmmaking. Production company, Shine, has been selected to manage the scheme. They short list, select and produce the shorts in consultation with the New Cinema Fund and FilmFour Lab. Established comedy writers, as well as directors, commercials directors and stand up comedians are invited by Shine to become involved. A master class on developing film comedy is held prior to the script deadline. Short listed projects go through a development training programme. Applicants without the relevant experience will not be considered. Biographies, credits, and showreels will be required, in addition to agent contact details where appropriate. Four to five films are to be commissioned in 2002.

- **Internet / Viral Shorts** Produces short films inspired and/or influenced by the possibilities opened up by the Internet and viral distribution. Around eight ultra-short films for a total package budget of £50,000.

 The scheme will be launched in Spring 2002.

- **Completion Fund** The Film Council and FilmFour Lab have contributed to a *one-off fund* for partly completed shorts. The closing date for entries was end March 2002. Readers should check if this support is available in subsequent years.

The Short Channel

In early 2002 a competition was held by the New Cinema Fund in partnership with the French state film body Centrale National de la Cinématographie (CNC) to promote co-operation between French and British film production companies. The scheme delivered six short films based on three screenplays: three pairs of directors (British and French) will work on three scripts, finally producing one French and one British version, i.e. six films in total. The first public viewing of the films will take place at the Dinard Film Festival in October 2002.

First Light

Total funding: £1 million for the first year (2001/02)

The administration is delegated to an external body (see entry on page 71 for **HI8US First Light Ltd** which administers this scheme giving 8–18 year olds the chance to make a digital short film). The above funding includes management costs, not expected to be more than 10% of the total budget.

3 The Premiere Fund

Funding: £10 million annually
Head of the Premiere Fund: Robert Jones

The Premiere Fund invests in popular, commercially viable, feature film productions attractive to worldwide audiences. It can give investment support, from project development through to marketing and distribution. Its investments also aim to stimulate greater breadth of experience and expertise across the UK film industry, and to assist the development of sustainable British film businesses capable of long-term growth. Projects should be feature length theatrical films for commercial exploitation in the UK and the rest of the world and be intended for production in the English language.

The Premiere Fund will generally expect the production company to have secured, or be in the advanced stages of securing a director and the principal cast of the film.

Projects will be assessed on their creative merit and audience potential. The fund will work with the Business Affairs and Finance departments of the Film Council to assess a project fully. There should be a realistic likelihood of recoupment of investment and profit potential based on revenue projections which take into account the entire 'package' of elements and the proposed deal terms for each individual project. In addition to the basic elements of its application, the production company will also need to present a convincing vision for its project, in terms of creative direction, financing, distribution and marketing.

In order to expand business and creative relationships with Europe a minimum of 20% of each fund is earmarked for European-backed films (approximately £4.2 million a year).

Regional Investment Fund

Funding: £6 million a year (2001/02–2003/04)
The fund is helping to build a new film, television and media structure in each region which will determine its own industrial and cultural priorities, including cinema exhibition and film education. Its partner organisations cover the whole of the UK and are able to provide production funding, producer support, facilities, access to training and company development (see separate country and regional entries).

Film Festivals

Support for film festivals in England comes from the Film Council via the regional film funding bodies (see separate entries). In Scotland, Wales and Northern Ireland, festivals are supported by the national film bodies.

Film Training Fund

Total funding: £1 million annually

Applications: The detailed guidelines for each fund can be downloaded from the website or obtained direct from the Film Council. They explain the assessment criteria for determining the eligibility of projects for funding and help with completing the

application form. These guidelines should be read in conjunction with the Contract Parameters for the relevant fund and the General Contract Parameters before making an application. Once the application form is completed (along with the Equal Opportunities monitoring form), it should be sent to the head of the relevant fund at the address above.

Please call the Film Council's Helpline on 020 7861 7924 if further guidance is required.

FIRST LIGHT

Hi8us First Light Limited, Room 419, The Custard Factory, Gibb Street, Birmingham B9 4AA
Tel: 0121 693 2091; **Fax:** 0121 693 2096
E-mail: info@firstlightmovies.com
Website: www.firstlightmovies.com
Contact: Catherine O'Shea, Director, First Light

Total funding: £1 million (2001/02 and 2002/03) This includes management costs, not expected to be more than 15% of the total budget.

First Light was set up as a one year pilot project operating throughout the UK between April 2001 and summer 2002. Its remit has been extended to May 2003 and provisionally to May 2004, subject to a review of the pilot year.

In 2001 First Light supported over 150 short films made by young people between the ages of 7 and 18. Across the UK over two thousand young people have been writing, acting, directing, lighting, editing and exhibiting their own films.

First Light is a Lottery funded Film Council initiative, managed by Hi8us First Light Ltd. It enables children between the ages of 7 and 18 to make films of up to ten minutes long, using a range of digital technology. The intention is to fund a wide range of delivery organisations, for example media centres, schools, and youth agencies, to make and support these productions. Grants will be awarded to organisations with a track record of working with groups of young people in video and film. Funds are for new work, not for projects that have already started. The scheme will also support collaborations between groups linked within a particular region or by areas of interest, to enable organisations without a track record in film and video production to work in collaboration with more experienced organisations.

First Light aims to reach the widest range of young people, especially those at risk from social exclusion. It also aims to fund the widest possible range of projects from a variety of organisations across the UK. Projects may be fiction, creative documentaries or animation.

The emphasis is on the involvement of the young people in the filmmaking process. Applicants must show how the young people are to be fully engaged with the filmmaking process, from content, development, to production, distribution and exhibition.

Each application for funding will be assessed against detailed criteria. Full criteria for each scheme can be obtained in the printed guidelines or from the website.

Funding has been split into two strands.

First Light Studio Awards

These are large awards for organisations with a track record of filmmaking with young people and proven outreach ability or strong partners with all relevant skills. Open to private companies, local authorities, schools, voluntary organisations, educational or charitable trusts for between three and six films of 5 to 10 minutes long. The maximum grant is £6,000 per film with a maximum of £36,000 for the whole proposal.

Timescale within which production to be completed: 8 months.

Large awards announced in December 2001 included:
Slough Borough Council, Berks 'What are we like?' 10 films including a mixture of dramas, comedy, sitcom, dance on film and documentaries, 112 young people of all ages participating; Sharnbrook Upper School, Beds 'Ouse Valley Films' for two films – one Bollywood, one drama /documentary, 190 young people aged 12–18 participating;
Four Corners Film Workshop, East London 'Screen Rhythms' for five films – four documentaries and one drama with 43 young people participating;
Junk TV Ltd, Brighton 'Five Short Films' including drama/documentaries about youth culture, 50+ young people involved;
Hall Place Studios Ltd, Leeds 'First Shot Project' for six films – all dramas, some with comedy elements with 43 young people participating from all ages between 7 and 18;
City of Edinburgh Council – Education Department, 'Digital City' for nine films including a mixture of dramas, animations, and documentary with over 100 young people involved;
Edinburgh Film Workshop Trust 'Nature into Art' five films including animations using natural materials, 106 young people aged 8–15 participating.

First Light Pilot Awards

Smaller awards for organisations to support one, or possibly two, productions by groups of young people. Open to any constituted youth-focused organisation for one or two films of between one to five minutes long. The maximum grant is £5,000 per project for one or two films. Partnership funding must be a minimum of 30% of the total project cost, with at least 15% in cash.

Timescale within which production to be completed: 4 months.

Small awards announced in December 2001:
Raw Material Music and Media Ltd, London;
Black Pyramid Film and Video Project, Bristol, Dreams and Directions;
Haltwhistle Film Project, Northumberland;
Achievement Bute, Bute Scotland;
Kings Heath Junior School, Birmingham;
Llanfyhanger Rhos y Corn Brechfa Community Association, Brechfa, Wales;
Children's Video Trust, London;

Flintshire Schools Arts Agency, Mold, Wales;
Jack Drum Arts Ltd, Co. Durham;
Cirencester College, Cirencester, Glos;
Dance 4, Nottingham, JEEP Ltd, Leeds;
SEA Productions & Animation, Barnsley;
Foundation for Art & Creative Technology, Liverpool;
Cinema Obscura, Wiveliscombe, Somerset;
Kings Corner Project, London;
Alnwick District Playhouse Trust, Northumberland.

Financial points common to both schemes

These are not a capital schemes. Equipment expenditure as a general rule, should be no more than 10% of the total cost of the project.

In-kind contributions can include: discounted production facilities (at a discount below any existing discounts for community or education groups); staff costs; materials, premises, transport, donated labour (e.g. supervision of children), etc. Anticipated earned income is not eligible as partnership funding.

Productions First Light will fund:
- short films made by young people;
- cinematic projects including drama, animation and documentary films with a strong creative slant;
- films of any genre – from comedy to horror via musicals and action movies;
- in general, films shot on digital cameras.

Diversity and social inclusion is a Film Council priority and young people from ethnic minority groups, with disabilities and from different social backgrounds are key to the Film Council's commitment to supporting the First Light scheme.

Applications: Contact Hi8us direct for printed guidance leaflets and application forms. They are also available from the website (see above).

SCOTTISH SCREEN

249 West George Street, Glasgow G2 4QE
Tel: 0141 302 1700; **Fax:** 0141 302 1711
E-mail: info@scottishscreen.com
Website: www.scottishscreen.com

Contact: Isabella Edgar, Information Manager
Chief Executive: Steve McIntyre

Scottish Screen is responsible to the Scottish Executive for developing all aspects of screen industry and culture in Scotland through script and company development, short film production, distribution of the National Lottery film production finance, training, education, exhibition funding, locations support and the Scottish Film and Television Archive.

Production Development

During 2002 Scottish Screen had various film schemes in partnership with a range of other bodies.

- **Cineworks** is a new entrant production scheme partly supported by Scottish Screen to offer opportunities for filmmakers to make their first professional films. An extensive development and training programme is included. All types of work including animation and documentary are eligible. Included in the scheme is a partnership with the Film Council to produce very low-budget digital shorts. For further information visit: www.cineworks.co.uk

- **Tartan Shorts** is a joint initiative with BBC Scotland to create an opportunity for Scotland's filmmaking talent to make cinematic short films. The scheme has been running for several years and each year, three projects are awarded up to a maximum of £60,000 to produce a 35mm film. Each film should be approximately 10 minutes long.

- **New Found Land** is a collaboration with the Scottish Media Group and the National Lottery to enable new filmmakers to work on longer-form drama. Six half hour projects are commissioned and shot using new digital technology, with budgets of approximately £50,000.

- **New Found Films** is a new production scheme offering emerging Scottish talent a first step into feature film production. For 2003 we are looking for scripts and proposals to make two 90-minute productions with production budgets of £200,000 each. New Found Films will be managed by Scottish Screen with funding from Scottish TV and Grampian TV and the National Lottery Fund.

- **Short Film Factory** is a drama based scheme to make four 8.5-minute films per year. An extensive training and development programme is included. For further details go to: www.eightandahalf.com

- **Four Minute Wonders** is a music production scheme whereby each month around £5,000 can be won to develop and produce a video based on a new piece of music. The new track will be uploaded to the 4minutewonders.com web site at the beginning of each month.

- **ALT-W** is an initiative set up to support Scotland's new media development and promote creative entrepreneurial talent and innovative digital productions, which can be accessed via the web. Production grants of up to £2,000 are on offer and discretionary grants for research and development of up to £500 may be awarded if the project requires it. Projects can be at any stage of development. For further details visit: www.ALT-W.com

- **Tartan Smalls** offers an opportunity for new talent to work in the children's area, or existing talent (without previous children's experience) to enter this exciting creative genre. Three or four projects will be shortlisted with a budget of £35,000.

- **This Scotland 2002** is a documentary production scheme for new and existing talent and will commission single documentaries within one overall strand. The scheme will be co-produced by Scottish TV, Grampian TV and Scottish Screen. Thirteen half-hour television documentaries for broadcast will be commissioned.

Other funding

Outside of the various schemes, Scottish Screen will occasionally invest in one-off short film projects.

Development

Development funding can be sought under the Seed Fund or through Script Development Funding/Project Development Funding (see Lottery below).

The **Seed Fund** is intended to encourage feature film projects at the early stages of development, typically where a project is insufficiently developed to be eligible for an award under the Lottery-funded Script Development scheme.

It is open to both companies and individuals. The maximum award is £5,000 and takes the form of a loan repayable if the project goes into production. Applications are considered on a monthly basis.

Scottish Screen National Lottery production funding

From 7 April 2000, Scottish Screen assumed responsibility for allocating National Lottery funds for all aspects of film production in Scotland. This represents about £3m per year for film production. Other National Lottery funding programmes operated by the Scottish Arts Council remain open to film and video projects and organisations. Contact SAC for further details. The various funding programmes operated by Scottish Screen are as follows:

Feature film production finance

Funding is available up to £500,000 per project for feature films (including feature length documentaries) aimed at theatrical distribution.

Short film production funding

Applications for under £25,000 are accepted on a continuous basis. Short films requesting in excess of £25,000 will be considered by the full Lottery Panel on specified dates.

Script development funding

Funding between £2,500 and £25,000 is available to projects which would benefit from further development of the script prior to packaging and financing. The project will be already at first draft or at the very least full treatment stage (including sample scenes where appropriate). The Scheme is aimed at projects which can make a robust case that this level of investment will materially advance the treatment or script towards the stage where it can attract the interest of financiers and/or key players.

Project development funding

Funding up to £75,000 is available for second-stage development of feature films. This is aimed at projects already at a relatively advanced stage. It will support elements such as script polish, preparation of schedule and budget, casting, etc. Applications for under £25,000 are accepted on a continuous basis.

Distribution and exploitation support

Funding of up to £25,000 is available for completed feature films to support print and advertising costs associated with the commercial exploitation of the film in the

UK marketplace. Funding may also be applied to overseas sales and marketing of completed features.

Company development programme
Finance of up to £75,000 is available as working capital funding into companies to support a slate of film, television and multi-media projects and to develop the commercial success of that company.

Short film award schemes
On an annual, basis, Scottish Screen will consider applications, of up to £60,000 from outside bodies to operate short film production schemes. Previous examples included Cineworks operated by the Glasgow Media Access Centre.

Twenty First Films – low budget film scheme
This scheme offers support for low budget features (including feature documentaries) with budgets up to around £600,000.

Contact: Production Development Department: 0141 302 1742

Cinema exhibition
Annual revenue grants are made to 9 cultural cinemas, the Edinburgh International Film Festival, BFFS Scotland and the French Film Festival.

Exhibition development fund
The fund supports projects which increase cinema provision, the range of films screened, greater awareness of moving image culture and increase audiences for innovative programmes. Grants normally do not exceed 50% of project costs.

Training and education
Scottish Screen Training endeavours to provide a wide range of high quality training and education resources designed to meet the forecast and identified needs of our industry and educational communities.

- **Education** – supporting National projects designed to promote and develop an understanding of Media Studies amongst young people, Support teachers of Media Education through training and information, working to ensure the development of Media Studies at policy level. Runs annual festival 'Scottish Students on Screen'
- **Short Courses** – for both individuals and companies, designed to aid professional and business development.
- **New Entrants Training Scheme** – broadcast film and video industry approved 18 month full-time scheme training in the technical, craft, design and production grades to assistant level.
- **Skillset Industry Qualifications** – Scottish Screen is the Open Assessment Centre for NVQ/SVQ in Scotland.
- **Training Bursaries** – can help with attendance at business development and training events at home and overseas, attendance at international festivals where a filmmaker has a film screening, attendance at festivals and other events as programme research for specific exhibition initiatives.

SGRÎN – MEDIA AGENCY FOR WALES

The Bank, 10 Mount Stuart Square, Cardiff Bay, Cardiff CF1 6EE
Tel: 029 2033 3300; Fax: 029 2033 3320
E-mail: sgrin@sgrin.co.uk
Website: www.sgrin.co.uk

Contact: Luned Meredith, Marketing Manager
Address 2: Gronant, Caernarfon, Gwynedd LL55 1NS
Tel: 01286 671 295; Fax: 01286 671 296
E-mail: sgrîn@sgrin.demon.co.uk
Chief Executive: J Berwyn Rowlands

Sgrîn is the primary organisation for film, television and new media in Wales. It is a limited company and is funded by a range of agencies – including the Arts Council of Wales, the Film Council, S4C, and the Welsh Development Agency. Its aims are:

- to champion film, television and media in Wales to develop to its full potential;
- to raise the profile and awareness of Welsh film, television and new media in Wales and beyond;
- to support cultural development and encourage participation in all aspects of film, television and new media in Wales;
- to encourage the art of filmmaking in Wales;
- to acquire, preserve and make available Wales' film and television heritage.

Its departments include: Production; Exhibition and Education; Marketing; New Media Group Wales; Media Antenna; National Screen and Sound Archive of Wales.

Production

The department aims to stimulate and support film and television activity throughout Wales, with a particular emphasis on identifying and nurturing new talent. In partnership with other funders, it runs a variety of short film schemes. These offer a range of opportunities for new, intermediate and more experienced filmmakers to make challenging and innovative films for the international market.

Complimentary support and advice is offered to individuals, including one-to-one meetings relating to specific projects. Invited industry experts and filmmakers are brought together for business surgeries, establishing a network of finance and distribution contacts.

Film Fund for Wales

In spring 2002 Sgrîn was working with the National Assembly and Finance Wales to create a Film Fund for Wales with European Objective 1 monies. If successful this will result in more funds being available for filmmakers in Wales. A diversity of finance sources in Wales may also allow each fund to identify areas of specific interest – e.g. 'cultural' or 'commercial' or 'new filmmakers'.

Lottery Funding: about £900,000 a year (may reduce in future years)
The responsibility for distributing Lottery film funding was delegated to Sgrîn in

April 2002 although ultimate responsibility remains with ACW. *Consultations have been held about Lottery Film Policy and a final draft was presented in May 2002.*

Script development

The focus up to 2002 has been on company-based script development work. The Individual Screenwriter Awards scheme launched in 2001 is the first time awards have been made to individuals. The funding allocated for this scheme is taken from within the nominal allocation for script development work.

Film production

Lottery film funds are available for short and feature film production.

- For short films a maximum of 10 minutes duration is proposed to improve the cinema and festival distribution potential. The current maximum contribution of 50% of an approved budget, or £30,000, whichever is the lower, will be the agreed norm, in line with standard industry expectations.

- Awards to feature films are made against the standard criteria of quality and financial viability, and on the cultural basis of the project.

A key philosophy of Lottery funding is the concept of additionality. Lottery funding should be used for projects which would not otherwise be able to take place. In terms of film production, this means that purely commercial feature projects should not see Lottery film funding as an automatic source of funding.

Other funding

ACW has funded many groups through Capital funding (for building/cinema projects, equipment purchases) and Arts For All revenue funding (for film festivals and film societies). This is expected to continue.

Distribution

Wales currently has no resident distributor. Films made or financed in Wales must seek distribution deals elsewhere. 'Benefit to the public'/public access is a key Lottery requirement.

THE NORTHERN IRELAND FILM AND TELEVISION COMMISSION (NIFTC)

21 Ormeau Avenue, Belfast BT2 8HD
Tel: 028 9023 2444; Fax: 028 9023 9918
E-mail: info@niftc.co.uk
Website: www.niftc.co.uk

Chief Executive: Richard Taylor

Donations to all causes: £1+ million (2002/03)

The Northern Ireland Film Commission is an integrated agency for the development of the film industry and film culture in Northern Ireland.

Lottery film funding

The Arts Council of Northern Ireland (ACNI) delegated responsibility for film finance to NIFTC for a three year pilot period from 2002/03. This amounted to more than £1 million in the first year (13% of total ACNI Lottery funding).

For further information contact the NIFTC or try consulting its website.

Promotion and production

The commission promotes awareness of Northern Ireland locations, crews and facilities to producers nationally and internationally, and promotes films produced in Northern Ireland. It also supports the development and production of films in Northern Ireland and encourages private sector investment in the industry.

The *Bill Miskelly Award* of £1,000 is given annually to a postgraduate student undertaking a film and television study course.

Training

The commission is the recognised industry training body for Northern Ireland. People interested in specialist short courses, training grants for freelance technicians and support for trainees on productions should approach the commission for further information.

Cinema and education

The commission funds a number of film festivals and organisations including the Foyle Film Festival, Derry, and the Cinemagic International Film Festival for Young People, Belfast.

Regional media agencies

In accordance with the Film Council's objectives, regional media development agencies are being established to develop a sustainable and accessible film and media industry in the regions of the UK. These are intended to be integrated regional agencies with the capacity to determine their own industrial and cultural priorities for film and related media.

The Film Council has committed additional resources between 2001/02 and 2003/04 to its Regional Investment Fund to catalyse this integrated regional planning, to strengthen the existing regional infrastructure and to expand film activities.

This integrated function means that each regional agency needs also to absorb the roles of the regional film commission and the relevant training agency into its structure. This major development process is naturally highly variable from region to region. In some regions, such as London and Yorkshire, negotiations towards the new structure are proving more tricky and drawn out than in others.

The areas of activity to be covered by the regional media agencies include:

- production;
- development;
- archives;
- education;
- exhibition;
- location exploitation;
- training;
- and most importantly inward investment.

In addition the agencies are administering all Film Council Lottery funds for the region and all film funding of the former regional arts boards, except 'artists' film, video and new media' which continues to be funded via the Arts Council of England and the regional arts bodies.

The following entries were compiled at end spring 2002. They show the uneven development at that point in time. However the entries provide the reader with the directions to acquire the most up-to-date information.

EM MEDIA

35–37 St Mary's Gate, Nottingham NG1 1PU
Tel: 0115 950 9599; **Fax:** 0115 958 3250
E-mail: info@em-media.org.uk
Website: www.em-media.org.uk

Chair: Ian Squires, Managing Director of Carlton Broadcasting, Central Region
Chief Executive: Ken Hay
Head of Operations: Debbie Williams
Head of Production: Peter Carlton peter.carlton@em-media.org.uk

EM Media, the new regional agency for the development of a sustainable and accessible film and media industry in the East Midlands, is supported by the Film Council at a national level and East Midlands Development Agency at a regional level. It is working with key partner organisations around the region, to increase the quality and quantity of opportunities for individuals to see, make and understand film and media, through production support agencies, specialist regional cinemas and the developing media archive, MACE.

Funding

Regional Investment Fund for England (RIFE)
EM Media distributes Lottery funds on behalf of the Film Council to infrastructure, clients and projects which meet one or more of its objectives. Funding priorities are broad and inclusive:

- developing viable film and media businesses;
- developing and promoting regional talent;
- developing access and opportunity for the end user.

Applicants are expected to meet at least one priority. The application process is two stages. Partnership funding is required. Full details and guidance are on the web and advice is available from staff.

East Midlands Media Investment
(Mark Two – the first fund was administered by Intermedia Film and Video Ltd, Nottingham and ended December 2001. This second phase started during 2002.)
 A development and co-finance fund part-funded by the European Regional Development Fund.

Production and business development
EM Media can offer a range of specialist business advice to film and media businesses in the East Midlands (from business planninng to sourcing financial investment).

Further support

By spring 2002 EM Media had established its remit to absorb the work of longstanding regional agencies:

- **locations and facilities** formerly the role of the East Midlands Screen Commission;
- **education and training** formerly the role of the Midlands Media Training Consortium has been brought together by EM Media to carry out a wider film and media education role.

LONDON REGIONAL MEDIA AGENCY

At the time of writing this agency (final name not known) was in the process of being established through consultation and negotiation between the main parties – London Film Commission, London Skillset and the London Film and Video Development Agency (LFVDA).

As no further useful information could be provided and the timescale for actual establishment was unclear, an entry about the LFVDA follows.

THE LONDON FILM AND VIDEO DEVELOPMENT AGENCY (LFVDA)

114 Whitfield Street, London WIP 5RW
Tel: 020 7383 7755 ; Fax: 020 7383 7745
E-mail: gill.henderson@lfvda.demon.co.uk
Website: www.lfvda.demon.co.uk

Contact: Gill Henderson, Chief Executive

Grant total: approx £750,000 (2002)

The London Film and Video Development Agency (LFVDA) provides funding, information, advice and professional support to makers of independent film, video and television in London. It also advises and assists other agencies and organisations working in similar areas.

Support for productions

- London Production Fund (LPF) – The LPF is supported by funding from Carlton Television and FilmFourLab as well as LFVDA.
- East London Fund – Partfunded by the European Regional Development Fund and available for work in East End and the Lea Valley.
- London Artists Film and Video Awards.
- Digital Tales, commissioned by FilmFourLab.
- Young People's Fund.
- Other initiatives – a range of special small schemes in particular London boroughs.

The LFVDA also has funds to support exhibition and festivals.

NORTH WEST VISION

109 Mount Pleasant, Liverpool L3 5TF
Tel: 0151 708 8099; Fax: 0151 708 9859
E-mail: firstnamefirstletterofsurname@northwestvision.co.uk
Website: www.northwestvision.co.uk

Chair: David Fraser, former Director of International Production at Granada Television
Chief Executive: Alice Morrison
Contact re funding schemes: Jane Gregory

North West Vision has taken on the work carried out by:
- Moving Image Development Agency (MIDA);
- The Film and Television Commission @ North West England;
- The film work of the North West Arts Board except funding and responsibility for artists' work in film, video and new media.

It has also taken over the annual revenue funding of many organisations in the region such as First Take Video, Mersey Film & Video and others.

NORTHERN FILM AND MEDIA OFFICE (NFM)

Central Square, Forth Street, Newcastle upon Tyne NE1 3PJ
Tel: 0191 269 9200; Fax: 0191 269 9213
E-mail: firstname.surname@nfmo.co.uk
Website: under design early May 2002

Chair: Michael Chaplin, writer for television and theatre, former Chair of the Northern Production Fund
Chief Executive: Tom Harvey, previously Managing Director of XPT, a digital media company, BBC Independent Commissioning Group manager, former Director of Edinburgh International Television Festival

Northern Film and Media (NFM) exists to build a vibrant, sustainable film and media industry in the north east region of England. It was set up in late 2001 as a limited company to cover the existing responsibilities of:
- Northern Production Fund;
- Northern Screen Commission;
- Northern Media Training;
with additional responsibilities for exhibition, education and archives. It is also administering all Film Council Lottery funds for the region and all film clients from Northern Arts.

As at spring 2002 NFM has successfully raised investment from One NorthEast's Regional Innovation Fund to develop the film and media sector in the North East region.

SCREEN EAST

Anglia House, Norwich NR1 3JG
Tel: Helpdesk: 0845 6015670; Fax: 01603 767 191
E-mail: firstname@screeneast.co.uk
Website: www.screeneast.co.uk

Chair: Graham Creelman, Managing Director of Anglia Television, Chair of Living East (regional cultural consortium for east of England)
Chief Executive: Laurie Hayward

Funding: Film Council Lottery £900,000 (2002/03); European funding for training; Regional Development Agency funding assured but awaited at time of editing.

Screen East is the film and moving image agency for the East of England and distributes the Regional Investment Fund for England (RIFE) on behalf of the Film Council in Bedfordshire, Cambridgeshire, Essex, Hertfordshire, Norfolk and Suffolk. RIFE funding is supported by the National Lottery to help develop a sustainable economy for film and the moving image in the region.

Regional Investment Fund (information as at May 2002)

Priorities:

- 1 **Developing and promoting regional talent and innovation** supporting:
 a) development finance for scripts and feature films, documentaries and digital media for broadcast, cinematic and other forms of film and moving image;
 b) short film and TV production, completion and distribution across a range of genres and contexts.
- 2 **Growing viable film and moving image businesses** supporting:
 a) company development and marketing plans, training needs analysis and organisational development projects to build creative capacity, competitiveness and sustainability;
 b) local clusters and regional sector development partnerships for freelance individuals and companies;
 c) discretionary small-scale capital awards up to £5,000.
- 3 **Developing audiences and cultural partnerships** supporting:
 a) access and choice for audiences to a wide range of film and the moving image particularly in under-served localities;
 b) educational projects and initiatives designed to develop the quality and availability of media education on a regional and sub-regional basis;
 c) archive services and access for audiences to a wide range of film and moving image heritage.

Note: *Funded projects will be monitored to an agreed standard.*

Screen East may solicit applications, on the basis of its published priorities, or suggest that an application be revised to meet a particular priority at stage two.

Projects will be supported at a level between 20% and 70% of the total cost, to a maximum of £20,000. It is likely that most awards will involve investment of between

20%–50% from Screen East. The minimum eligible award is £500. Please note that the maximum award available for certain strands has been capped below £20,000.

Decisions are made by a committee of Screen East officers in consultation with the chair of the Screen East Lottery Panel. This committee meets bimonthly.

Please check for the most up-to-date programme of support by calling the Help Desk noted above. At the time of editing the website was not up and running.

Applications: All organisations based or working in the East of England region, registered as limited companies; charities; lead bodies for consortia with defined partnership agreements; schools, societies, colleges, libraries and universities; legally constituted sole traders.

Freelance individuals resident in the region can apply under priorities 1 & 2 for awards up to £5,000.

A two-stage application operates. Applications can be made at any time throughout the year.

SCREEN SOUTH

Folkestone Enterprise Centre, Shearway Business Park, Shearway Road, Folkestone, Kent CT19 4RH
Tel: 01303 298 222
E-mail: info@screensouth.org
Website: www.screensouth.org

Chair: Graham Benson, Chair, Blue Heaven Productions
Chief Executive: Gina Fegan

This large South East region includes Buckinghamshire, Oxfordshire, Hampshire, Surrey, Berkshire, East and West Sussex, Kent and The Isle of Wight.

Screen South's funding schemes for 2002/03 feature two sections:
- Strands – aimed at the development and training of filmmakers;
- Open Funds – available to those with projects that deliver our regional priorities such as film festivals, education activities, heritage projects, film societies and so on.

Funding workshops are being run three times a year.

The Funding Committee meets every month to consider applications. Those seeking funding can take the chance to present projects face to face with the decision-makers, and to hear the quality of others competing for the same funds.

No single awards are expected to exceed £10,000.

SCREEN WEST MIDLANDS

3rd Floor, Broad Street House, 212 Broad Street, Birmingham B15 1AY
Tel: 0121 643 9309; Fax: 0121 643 9064
E-mail: firstname@screenwm.co.uk
Website: www.screenwm.co.uk

Chair: Rod Natkiel, also Chair of West Midlands Arts at end of 2001
Chief Executive: Ben Woollard

Production:
Contact: Paul Green, Production Executive
Tel: see above; E-mail: paul.green@central-screen.easynet.co.uk

Archive Education Exhibition
Contact: Steve Chapman, Client Liaison Officer

- **Archive** The first priority is the establishment of the archive facility. Screen West Midlands is supporting, and working with the Media Archive for Central England (MACE) and its Midlands partners.
- **Education** The feasibility of establishing screen education centres is being explored in partnership with media organisations, local authorities, schools and colleges, the Learning and Skills Councils, regional cinemas, libraries, City Learning Centres, Grids for Learning and other venues.
 It will also be supporting the creation of media clubs for out-of-school provision.
- **Exhibition** Support to festivals mainly.

Training
Training and career development for new entrants, established talent and those wishing to re-train working with the Midlands Media Training Consortium (MMTC). Programmes include 'Media Solutions' funded by the European Social Fund, Skillset's 'Freelance Training Fund' and the 'Skills Investment Fund Trainee Scheme', in partnership with Skillset, the lead industry training body.

Location exploitation
In addition, SWA aims to attract national and international productions to the region by promoting locations and providing prompt and accurate information on facilities, crews and local support services.

SOUTH WEST SCREEN

59 Prince Street, Bristol BS1 4HQ
Tel: 0117 377 6066; Fax: 0117 377 6067
E-mail: firstname.surname@swscreen.co.uk
Website: www.swscreen.co.uk

Chair: Jeremy Payne, Managing Director of HYV
Chief Executive: Caroline Norbury, former CEO of First Take films
Projects Manager: Sarah-Jane Meredith, former Chief Executive of South
West Media Development Agency

South West Screen (SWA), incorporated in November 2001, is a merger of three
independent media development organisations:
- South West Media Development Agency;
- Skillnet South West;
- South West Film Commission.

SWA will provide strategic leadership for film and the moving image in the South
West region and aims to invest in a wide range of initiatives.

At the time of editing the website was not completed. Current funding for all its
initiatives are to be displayed.

Exclusions: Organisations and applicants based outside the South West region.
Students.
Applications: Contact the agency for current information and details of how to
apply. SWMDA has a database/mailing list that is free to join. Once on the list you
will be sent regular, relevant information. SWMDA also produces a bi-annual
newsletter.

YORKSHIRE MEDIA INDUSTRIES PARTNERSHIP

Yorkshire Screen Commission, The Workstation, 15 Paternoster Row,
Sheffield S1 2BX
Tel/Fax: 0114 279 6511

The partnership has comprised the Yorkshire Media Production Agency (YMPA),
Yorkshire Media Training Consortium, Yorkshire Screen Commission, Yorkshire Arts,
the Culture Company and the Community Media Association.

It was allocated funding over 2001/02 from the Film Council's Regional Investment
Fund for England to implement a plan to develop a regional media agency.

During 2002 a further consultation is being held in Yorkshire about the development
of the new regional agency.

*In the meantime all queries regarding media development and production in the Yorkshire
region should be made to YMPA.*

Training support may be available through the Yorkshire Media Training
Consortium.

YORKSHIRE MEDIA PRODUCTION AGENCY (YMPA)

The Workstation, Paternoster Row, Sheffield S1 2BX
Tel: 0114 249 2204; Fax: 0114-249 2293
E-mail: admin.ympa@workstation.org.uk
Website: www.ympa.org.uk

Head of Development: Ann Tobin, Tel: 0114 249 5504

Yorkshire Media Production Agency (YMPA) is a production and development company for all forms of media. It is part funded by the European Regional Development Fund for projects in South Yorkshire. However the agency can offer support to a wide range of projects throughout Yorkshire.

Exclusions: Full-time students.
Applications: Obtain full details and an application form. At a monthly steering committee meeting applications are processed and assigned to a project officer who will contact the applicant to discuss further progress.

YORKSHIRE MEDIA TRAINING CONSORTIUM

40 Hanover Square, Leeds L23 1BQ
Tel: 0113 294 4410; Fax: 0113 294 4989
E-mail: info@ymtc.co.uk
Website: www.ymtc.co.uk

Part of the partnership looking at the establishment of a regional film agency.

Examples of other resources

The following organisations give an indication of the various additional types of support available throughout the UK.

Be sure to ask your media agency for full information.

There are resource bases throughout the country which provide facilities, equipment and training at low cost for the beginner. They may also provide low cost/free options and funding opportunities.

At the time of editing (May 2002) certain centres were administering the Film Council's **Digital Shorts** scheme on its behalf.

Scotland
Glasgow Media Access Centre Ltd
Tel: 0141 553 2620; E-mail: admin@g-mac.co.uk
Website:www.g-mac.co.uk
Contact: Cordelia Stephens

East Midlands
Intermedia Film & Video Ltd
Tel: 0115 955 6909; E-mail: info@intermedianotts.co.uk

South of England
Lighthouse
Tel: 01273 384222; E-mail: cfreeman@lighthouse.org.uk
Contact: Caroline Freeman

Yorkshire and Humberside
Yorkshire Media Production Agency
Tel: 0249 2204; E-mail: admin.ympa@workstation.org.uk
Contact: Chris Finn

Approach your regional film agency for information about resource agencies in your area.

Information for beginners
The First Film Foundation (see separate entry) produces a useful guide, *First Facts*, for emerging writers, directors and producers. It answers the questions most commonly asked by new filmmakers, from making their first short films to preparing their first feature films. Information on funding initiatives, professional training and developing a career in the UK film industry. Price £10 plus £1 for p+p. Cheques payable to 'First Film Foundation', along with name and address.

The examples below are only illustrative and in no way intended as a guide to these services.

cre8 STUDIOS

Town Hall, Regent Circus, Swindon SN11QF
Tel: 01793 463224; Minicom: 01793 436659; Fax: 01793 463223
E-mail: info@cre8studios.org.uk
Website: www.swindon.gov.uk

Cre8, formerly Media Arts, is funded by South West Screen.

First Stop
Encourages the making of film, video, photography and sound projects in Swindon. Multimedia projects are welcome. The scheme is open to all who live or work within the Swindon, who want to involve the local community, or whose project can benefit Swindon.

Express
Operates in the same way and enables people with small projects to apply for equipment credits and credits for films or tapes.

Also available:

- screenwriting residency days (free one to one advice sessions);
- media library – free access and loans;
- advice and support – free consultations. Check the website or e-mail for up-to-date information.

Exclusions: Student projects.

Applications: A panel considers *First Stop* applications every six months (deadlines end September and March) and successful applicants are informed within a week of the meeting. *Express* applications can be submitted at any time, with a decision being made within 10 working days.

THE FIRST FILM FOUNDATION

9 Bourlet Close, London W1P 7PJ
Tel: 020 7580 2111; **Fax:** 020 7580 2116
E-mail: jonathan@firstfilm.demon.co.uk
Website: www.firstfilm.co.uk
Contact: Jonathan Rawlinson, Director
Beneficial area: UK and Ireland

This charity was set up in 1987 to help new British writers, producers and directors make their first feature film. **It does not provide funds itself** but gives impartial, practical advice and information to new filmmakers on how to develop a career in the film industry. In addition it provides a number of educational and promotional programmes to give filmmakers the contacts, knowledge and experience they need.

The First Film Foundation currently operates the following schemes.

New Directions
This is the foundation's main showcase scheme for presenting new British filmmaking talent to the UK and US film industry. Six new directors and producers are selected on the basis of previous work in short films and their development slate. The filmmakers and their selected work are presented to top entertainment industry executives at exclusive screenings in London, New York and Los Angeles. The filmmakers are then hosted for a week in each prospective city to develop contacts and establish working collaborations with the US and UK film industry. Meetings are set up with relevant studios, agents, distributors and production companies providing a unique opportunity to develop contacts and form working collaborations. The deadline for applications in 2001 was in March.

Comedy Shorts
A competitive scheme to make a short film with a comedy theme.

First Feedback
A series of intensive script development workshops focusing on writers from the nations and regions.

Script Feedback

Provides a professional script report on any full-length feature, short film, or TV drama script submitted. This service requires a £45 (incl. VAT) administration fee for a feature script, or £25 (incl. VAT) for a short script (max. length 30 mins).

First Film Fund

A completion fund, launched in 2001, for up to eight short films per year seeking post-production finance.

Sci-fi Shorts

A short science-fiction film competition.

Applications: More information is available than can be given in this entry. Full details of programmes and schemes, including entry criteria, deadlines and fees, are available from the above address (please enclose a large SAE), by calling 020 7580 2111 or from the foundation's website.

THE GAELIC BROADCASTING COMMITTEE

4 Harbour View, Cromwell Street Quay, Stornoway, Isle of Lewis HS1 2DF
Tel: 01851 705550; **Fax:** 01851 706432
E-mail: admin@ccg.org.uk
Website: www.ccg.org.uk
Contact: John Alick Macpherson, Deputy Director

Donations to all causes: £6,970,000 (1999/2000)

The Gaelic Broadcasting Committee (formerly the Gaelic Television Committee) had its mandate extended under the 1996 Broadcasting Act to include responsibilities for sound programmes, as well as television, and to undertake a consultative role in relation to Gaelic programmes on digital television.

The fund finances a wide variety of programmes and series for the Gaelic speaking community and also funds the Gaelic Television Training Trust (see separate entry). In 1999/2000 its support covered:

- Television Production – £6,632,000;
- Development Grants – £219,000;
- Radio Production Grants – £119,000.

This funding was spread between Independents 41%; BBC 30%; ITV 29%. Funded programmes are broadcast on ITV, BBC and Channel 4.

Applications: Contact the Project Audit Officer, Donnie MacDonald, when seeking to apply for support.

THE GAELIC TELEVISION TRAINING TRUST

Sabhal Mor Ostaig, Teangue Sleat, Isle of Skye 1B44 8RQ
Tel: 01471 844 373; Fax: 01471 844383
Contact: Catriona Johnston

Donations to all causes: £240,000 budgeted (2001/02); £240,000 (2000/01)

The trust is funded jointly by the Gaelic Broadcasting Committee and the European Social Fund, with support from the Scottish Broadcasting companies and Enterprise companies.

Funding is provided for full-time training through this trust. The committee also funds placements and short courses to enhance skills already developed within the industry.

Applications: Applicants must be fluent in Scottish Gaelic. Contact the trust for further details.

GLASGOW FILM OFFICE

City Chambers, Glasgow G2 1DU
Tel: 0141 287 0424; Fax: 0141 287 0311
E-mail: film.office@ced.glasgow.gov.uk
Website: www.glasgowfilm.org.uk
Contact: Hamish Walker, Administrator

Total operating budget: £630,000 each year for the three years to 2004/05

Total grants funding: £350,000 each year for the three years to 2004/05

Glasgow Film Office (GFO) has been assisting film development in Glasgow since 1997 (over 40 productions). Phase Two of its work started in spring 2002. Grants are strictly focused on assisting local production companies capable of growth, facilities and services companies, and freelance technical personnel.

With production companies the intention is to move high-impact productions and, for TV, high-value content into production. High-impact productions are those having a budget in excess of £200,000 or directly contributing in excess of £100,000 into the local economy – these could be feature films, feature documentaries, commercials, etc. High-value TV content has a commissioned value of at least £50,000. No production funding is available for feature length drama.

All grants offered by GFO reqire the beneficiaries to raise at least 50% of the cost from their own resources or by introducing private sector funds (GFO cannot 'double-fund' alongside other public agencies). Grants are drawn from a limited financial resource and not all applications can be successful.

Production company funding

Product commercialisation

Funding assists growth companies working to a business plan, to identify national and international buyers and commissioners, to optimise the exploitation of development projects, formats, franchises and completed programmes with unexploited value. Much support will be in kind as advice and guidance. Further help also via access to specialist advisers in, for example, intellectual property. Direct grants under this measure will depend on proposed activity and presentation of detailed budget.

New writer integration

Applications should be made by production companies intending to work with new writing talent. The aim is to nudge established companies to look beyond tried and tested writers and for GFO to share the gamble in developing fresh ideas.

Awards are between £5,000, £3,000 and £1,000, depending on the unit value of the commissioned product (minimum of £50,000 per hour).

New director/producer integration

To give talented young teams with strong ideas a financial hook with which to approach established growth companies to warehouse short film projects and work in other innovative formats. The majority of proposals are expected to shoot and edit digitally and be under 25 minutes duration.

Applications should be made via the production company sponsoring the team.

Awards up to £7,500 are based on an average production budget of £30,000 (average award expected to be £5,000).

Funding programmes open to facilities/service companies and freelance personnel

Growing the service base

Designed to assist local facilities and services companies penetrate the market generated by international film production, network TV commissions and new platforms for digital output.

Much of the support is earmarked for specialist consultancy services with the remainder offered to assist the pursuance of new market opportunities. The maximum level of support to one company will be £10,000 for staged development of the company's business plan.

Technical skills development

This small fund supports a diverse range of activities, e.g. approved courses/seminars, designed to improve the knowledge and skills base of experienced freelance personnel working in the industry.

Awards are normally 50% of cost of course (excluding travel and accommodation) up to £1,000.

Infrastructure support grants

These grants are offered to mobile high-impact productions considering locating in Glasgow as a cash incentive to buy in approved local facilities and services rather than import them.

Awards are 50% of actual approved facilities and services costs up to £50,000.

GLASGOW MEDIA ACCESS CENTRE

3rd Floor, 33 Albion Street, Glasgow G1 1LH
Tel: 0141 553 2620
E-mail: admin@g-mac.co.uk
Website: www.g-mac.co.uk and www.cineworks.co.uk

Training

The centre provides training for film and video makers across a wide range of subjects. It caters for complete beginners as well as for those with more experience and expertise. Courses run at regular intervals.

Little Pictures

A scheme for 5-minute digital movies to be made by people who have gone on a GMAC training course.

GMAC Ltd also hire a wide range of equipment to members – digital cameras, sound and lighting kits, AVD edit suites. There is a monthly screening of members' work and a bimonthly newsletter.

Cineworks

Total funding: £180,000 (2001/02)

This short fim production scheme commissions five high quality films from emergent talent in drama, documentary and animation each year. It is run by Glasgow Media Access Centre in partnership with the Film and Video Access Centre in Edinburgh, Scottish Screen nd BBC Scotland.

Applications are received from writers, producers and/or directors from across Scotland in March and are assessed by a panel of filmmakers and funders on the following criteria:

- quality of script/idea;
- production team talent/track record;
- feasibility of budget;
- distribution potential.

From the initial applications, 12 projects are short-listed and go through a two month training and development programme during which mentors and script editors from Scottish production companies are assigned to each team to help them hone and improve their project ready for re-submission. At the end of this period five projects are commissioned by the selection panel.

Three levels of award are available: £5,000 completion /£10,000 production / £15,000 production. A proportion of each award will take the form of in kind support.

Contact: Cordelia Stephens at cineworksfilms@aol.com or visit the website www.cineworks.co.uk

LIGHTHOUSE

Media@, 9–12 Middle Street, Brighton BN1 1AL
Tel: 01273 384222; Fax: 01273 384233
E-mail: info@lighthouse.org.uk
Website: www.lighthouse.org.uk

'Lighthouse is committed to developing new talent in digital media and film. We do this through a range of training and production activities which include artist commissions, new directors schemes for Broadcast TV, digital workshops with young people and intensive courses in new media production.

'Lighthouse act as producers in all of our project work, specialising in building partnerships, planning, fundraising, marketing, distribution, curation and management. Our work bridges the arts, education and industry sectors and brings together professional and cultural organisations and individuals from across the region. Lighthouse seeks to provide opportunities to individuals to develop their skills and achieve their aims.'

MERSEY FILM & VIDEO

13 Hope Street, Liverpool L1 9BQ
Tel: 0151 708 5259; Fax: 0151 707 8595
E-mail: mfv@hopestreet.u-net.com
Website: changing

Formal and informal advice sessions are run.

Production and post-production facilities including DVD.

Bursaries for community groups, charity groups and others who are promoting a cause, etc. with in kind facilities.

NORTHERN VISIONS MEDIA CENTRE

4 Lower Donegall Street Place, Belfast BT1 2FN
Tel: 028 9024 5495; Fax: 028 9032 6608
E-mail: northern.visions@dnet.co.uk
Website: www.northernvisions.org

Contact: David Hyndman

The centre is funded by a number of sources including the Northern Ireland Film and Television Commission, the Arts Council of Northern Ireland and the Belfast City Council.
See website for new initiatives and up-to-date details.

Exclusions: Full-time students; people outside the Greater Belfast area.

VET BURSARY PROGRAMME

Lux Building, 2–4 Hoxton Square, London NI 6US
Tel: see below
E-mail: post@vet.co.uk
Website: www.vet.co.uk

VET (Video Engineering and Training) is committed to supporting independent, charitable and community based video production. To encourage new and interesting work VET offers a range of discounted services to low and unfunded projects.

Its bursary programme offers six free bursaries each year providing the benefit of industry standard editing equipment for two eight-hour days which can be used for on-line or sound dubbing.

Projects which fail to win a bursary, or which cannot fit the free bursary timetable, may be able to get a 'discounted bursary'. Contact the bookings team and register as a bursary user.

Contact:
Bursaries – Tel: 020 7505 4700; Fax: 020 7505 4800; E-mail: bursaries@vet.co.uk
Training – Tel: 020 7505 4747; Fax: 020 7505 4800; E-mail: training@vet.co.uk
Editing/Multimedia – Tel: 020 7505 4700; Fax: 020 7505 4800; E-mail: facilities@vet.co.uk

Applications: Contact VET for further details. In 2002 there were three application periods for VET bursaries with deadlines at the beginning of February, May and September.

YORKSHIRE COMMUNITY MEDIA FUND

Community Media Association, 15 Paternoster Row, Sheffield S1 BX2
Tel: 0114 279 5219
E-mail: judith@commedia.org.uk
Website: www.commedia.org.uk/yorkshire

The fund, an initiative to support community media in the Yorkshire and the Humber region, has been supported by Yorkshire Forward, the regional development agency.

At spring 2002 it was not known if further funding will become available later in the year. Check the website to find out.

MUSEUMS, GALLERIES, LIBRARIES, ARCHIVES

Resource: The Council for Museums, Libraries and Archives
Museums and Galleries Education Programme
Museums, Libraries and Archives Councils/Single Regional Agencies
The National Fund for Acquisitions (Scotland)
The Scottish Museums Council
The Council of Museums in Wales
Northern Ireland Museums Council
British Library's Co-operation and Partnership Programme

RESOURCE: THE COUNCIL FOR MUSEUMS, LIBRARIES AND ARCHIVES

16 Queen Anne's Gate, London SW1H 9AA
Tel: 020 7273 1444; **Fax:** 020 7233 3686
E-mail: chris.alexander@resource.gov.uk
Website: www.resource.gov.uk
Contact: Grants Officer

Resource is the council for museums, archives and libraries, formed in April 2000 through the amalgamation of the Museums and Galleries Commission with the Library and Information Commission.

Resource has grant functions, but this is only one part of what it does. It is a strategic body responsible for libraries and archives as well as museums. It advises, advocates and plans on behalf of the whole sector.

Regional activity lies at the heart of much of Resource's work. The focus is on developing and supporting a regional infrastructure for the museums, archives and libraries sector, based on two important projects:

- a network of regional 'hubs', to promote excellence and act as leaders of regional practice;
- single regional agencies to be developed as strategic bodies for the museums, libraries and archives domains.

Resource envisages that museums become more innovative and outward-looking, seeking partnerships with other museums and other bodies in order to achieve lasting social and economic benefits and also engaging with community services, health workers, librarians, archivists, art workers and so on. (There are over 1,800 registered museums and galleries in the UK, 1,434 of which are in England.)

The following grant schemes are relevant to users of this guide at the time of writing (spring 2002). Be sure to check current programmes on Resource's website and to be in touch with the developing Single Regional Agencies (see separate entry).

Resource/V&A Purchase Grant Fund

Grant total: £1 million (2001/02 and in the previous year)
This fund, administered by the Victoria & Albert Museum on behalf of Resource, helps with the purchase of objects relating to the arts, literature and history priced at £500 or over by non-national museums, art galleries, libraries and record offices. Objects, collections or archives of any date costing between £500 and £300,000 are eligible for support. The maximum grant is 50% of the purchase price up to an annual limit, currently £80,000.
Applications: Contact Resource/ V&A Purchase Grants Fund, V&A Museum, London SW7 2RL, Tel: 020 7942 2536; E-mail: puchasegrantfund@vam.ac.uk

Preservation of Industrial and Scientific Material (PRISM)

Grant total: £250,000 (2001/02 and in the previous year)
This fund, administered by the Science Museum on behalf of Resource, aims to further the preservation of material relating to the history and development of science, technology, industry, medicine and natural history. The fund awards grants towards the cost of acquisition and conservation of such material. All museums registered with Resource can apply. At the fund's discretion, applications can also be accepted from other charitable or public bodies engaged in the preservation of eligible material. Maximum grant is 50% of project costs for acquisition, and 70% for conservation. All grants are limited to a minimum of £500 and a maximum of £20,000 on any one item or project. Aggregated grants to any one institution are limited to a total of £20,000 in any one financial year.
Applications: Contact the Manager, PRISM Grant Fund, The Science Museum, South Kensington, London SW7 2DD; Tel: 020 7938 8005; Fax: 020 7938 9736; Website: www.sciencemuseum.org.uk/collections/prism/index.asp

AIM EdWeb

A small grant to encourage Independent Museums to develop educational content for the National Grid for Learning and will test the effectiveness of the EdWeb Guide to Producing Online Education Materials and the Resource-funded Museums Online project.
Website: www.museums.org.uk/aim/EdWeb/edweb.html

Conservation Awards 2002

The Pilgrim Trust Conservation Awards for 2002 scheme has now been launched. Resource is one of the partners overseeing the scheme but the 2002 Awards are administered by the United Kingdom Institute for Conservation.

Designation Challenge Fund

The Designation Challenge Fund available to Museums with Designated Collections is currently under review.

Applications: Contact the MCG for current details. Application deadlines vary for different programmes.

MUSEUMS AND GALLERIES EDUCATION PROGRAMME

Funding: £1 million (2002/04)

Since 1999 the Department for Education and Skills (DfES) has funded this programme which has supported 65 individual innovative museum and gallery education projects improving links between museums, galleries and schools.

Additional funding of £1 million for a second phase between 2002 and 2004 is being administered through Resource.

The intention is to fund projects which use the collections of museums and galleries to contribute to raising standards of achievement in schools and also to enrich their curriculum. The great variety of creative initiatives supported so far have included:

'Does Art Make a Difference?' – resident artists used the Dulwich Picture Gallery's Old Master paintings to conduct literacy and basic arts skills sessions in three local schools (an inner city comprehensive, a special needs school for children with severe disabilities, a secure centre for young offenders with extreme social problems); in Hackney, the Science Museum, Hackney Museum and The City Literary Institute teamed up with local schools to develop activities, workshops and resources to support children's learning of science at Key Stage 2.

In April 2002 applications were invited from each of the nine English regional agencies responsible for museums and galleries for the period 2002/04.

A separate fund for contemporary visual art is being developed.

Information: Criteria for funding is available on the Resource website or from Julie Street, Resource's Formal Learning Adviser, Tel 020 7273 1402; E-mail: julie.street@resource.gov.uk

MUSEUMS, LIBRARIES AND ARCHIVES COUNCILS/ SINGLE REGIONAL AGENCIES

Funding: £7.9 million (2002/03) twice the allocation to the regions compared with the previous year

('Museums' includes galleries which have a permanent collection – contemporary commercial galleries are not included in this remit)

New regional agencies are being established in each of the nine English regions. The single agencies will expand on the work of the existing Area Museum Councils, Regional Archive Councils, Regional Library Systems and Library Development Agencies and will be responsible for all three domains. They will promote, lead, support and represent museums, archives and libraries, and enable them to provide

the best services possible to the public. They will be constituted as charitable and corporate entities, through which Resource will, in future, channel its regional work and funding.

Their responsibilities cover eight core activities in the regions: strategic leadership; advocacy; stewardship; learning and access; funding and support; research; continuous improvement; and knowledge management.

Region	*Total allocation 2002/03* £
North East	745,000
South West	883,000
West Midlands	821,000
Yorkshire	963,000
North West	1,044,000
East Midlands	593,000
South East	1,122,000
East of England	707,000
London	1,042,000
Total	7,920,000

Timescale for establishment: The new agencies will be established in all nine English regions by April 2004. In fact, all bar one (the London region were expected in April 2002 to be established by April 2003).

Links to the Resource website regional pages are:
www.resource.gov.uk/action/regional/00regional.asp and
www.resource.gov.uk/action/regional/regagenciesqas.asp
Check these to find out up-to-date information.

Listing of regional agencies
(as at early May 2002)

The newly established single regional agencies are listed first, followed by the regional representatives for archives, libraries and museums.

East Midlands
East Midlands Museums, Libraries and Archives Council (EMMLAC)
Courtyard Buildings, Wollaton Park, Nottingham NG8 2AE
Contact: Tim Hobbs, chief executive

North East
North East Museums, Libraries and Archives Council (NEMLAC)
House of Recovery, Bath Lane, Newcastle Upon Tyne NE4 5SQ
Tel: 0191 222 1661; Fax: 0191 261 4725
Contact: Sue Underwood, chief executive; E-mail: sue.underwood@nemlac.co.uk

South East
South East Museums, Libraries and Archives Council (SEMLAC)
Unit 8, City Business Centre, Hyde Street, Winchester, Hampshire S123 7RA
Tel: 01962 844 909
Contact: Helen Jackson, chief executive; E-mail: helenj@semuseums.org.uk

East of England
Eastern Regional Archive Council
Gildengate House, Anglia Square, Upper Green Lane, Norwich, NR3 1AX
Tel: 01603 761 349; Fax: 01603 761 885
Contact: John Alban, chair; E-mail: Jr.alban.nro@norfolk.gov.uk

MUSE
5 Honey Hall, Bury St Edmunds. Suffolk IP33 1HF
Tel: 01284 723 100; Fax: 01284 701 394
Contact: Tim Heathcote; E-mail: timh.semseast@eidosnet.co.uk

ELISA
County Library, Northgate Street, Ipswich IP1 3DE
Tel: 01234 228 752; Fax: 01234 228 993
Contact: Barry George; E-mail: georgeb@deal.bedfordshire.gov.uk

London
London Museums Agency
Cloister Court, 22–26 Farringdon Lane, London EC1R 3AJ
Tel: 020 7459 1700; Fax: 020 7490 5225
Contact: Fiona Talbott, director; E-mail: fiona.talbott@londonmuseums.org

LLDA
35 St Martin's Street, London WC2H 7HP
Tel: 020 7641 5266
Contact: David Murray, director; E-mail: david.murray@llda.org.uk

London Archive Regional Council
c/o London Museums Agency, Cloister Court, 22–26 Farringdon Lane,
London EC1R 3AJ
Tel: 020 7549 1704; Fax: 020 7490 5225
Contact: Emma Halsall, London archive development officer;
E-mail: emma.halsall@londonmuseums.org

North West
North West Regional Archive Council
Cumbria Record Office, The Castle, Cumbria CA3 8UR
Tel: 01228 607 285; Fax: 01228 607 299
Contact: Jim Grisenthwaite, chair; E-mail: Jim.grisenthwaite@cumbriacc.gov.uk

NWMS
Griffin Lodge, Cavendish Place, Blackburn BB2 2PH
Tel: 01254 670 211; Fax: 01254 681 995
Contact: Ian Taylor, director; E-mail: ian@nwms.demon.co.uk

NWL
County Library HQ, County Hall, PO Box 61, Preston PR1 8RJ
Tel: 01772 264 010; Fax: 01772 264 880
Contact: David Lightfoot, county library manager;
E-mail: David.lightfoot@lcl.lancscc.gov.uk

South West
SWMC
Creech Castle, Bathpool, Taunton, Somerset TA1 2DX
Tel: 01823 259 696; Fax: 01823 270 933
Contact: Sam Hunt, director; E-mail: samhunt@swmuseums.co.uk

SWRLS
County Librarian, Somerset County Library HQ, Mount Street, Bridgwater,
Somerset TA6 3ES
Tel: 01278 451 201; Fax: 01278 452 787
Contact: Rob Froud, director; E-mail: rnfround@somerset.gov.uk

South West Regional Archive Council
Cornwall Record Office, County Hall, Truro, Cornwall TR1 3AY
Tel: 01872 323 125; Fax: 01872 270 340
Contact: Paul Brough, chair; E-mail: pbrough@cornwall.gov.uk

West Midlands
WMRMC
Hanbury Road, Stoke Prior, Bromsgrove, Worcs B60 4AD
Tel: 01527 872 258
Contact: Kathy Gee, chief executive; E-mail: gee@wm-museums.co.uk

West Midlands Regional Archive Council
Herbert Art Gallery and Museum, Jordan Well, Coventry, CV1 5QP
Tel: 024 7683 2375; Fax: 024 7683 2410
Contact: Roger Vaughan, chair; E-mail: roger.vaughan@coventry.gov.uk

TLP-WM
3rd Floor, Central Library, Birmingham B3 3HQ
Tel: 0121 303 2613; Fax: 0121 464 1609
Contact: Linda Saunders; E-mail: linda.saunders@dial.pipex.com

Yorkshire
Yorkshire Museums Council
Farnley Hall, Hall Lane, Leeds LS12 5HA
Tel: 0113 263 8909; Fax: 0113 279 1479
Contact: Barbara Woroncow, director; E-mail: barbara@yhmc.org.uk

Yorkshire Regional Archive Council
West Yorkshire Archive Service, Registry of Deeds, Newstead Road,
Wakefield, WF1 2DE
Tel: 01924 305 982; Fax: 01924 305 983
Contact: Keith Sweetmore; E-mail: keith@wyasbrad.demon.co.uk

YLI

c/o Central Library, Northgate, Halifax HX1 1UN

Tel: 01422 392 600; Fax: 01422 392 615

Contact: Martin Stone, hon. secretary; E-mail: mstone@calderdale.gov.uk

THE NATIONAL FUND FOR ACQUISITIONS (SCOTLAND)

National Museums of Scotland, Chambers Street, Edinburgh EH1 1JF

Tel: 0131 247 4106; Fax: 0131 247 4308

E-mail: hrw@nms.ac.uk

Website: www.nms.ac.uk

Contact: Hazel Williamson, Fund Administrator

Grant total: £200,000 (2001/02 and in three previous years)

The fund is administered by the National Museums of Scotland (NMS) on behalf of the Scottish Executive. It is divided into two parts.

The Art Fund

Grant total: £180,000 in 158 grants 1999/2000

This fund assists in the acquisition of objects relating to the arts, literature and history. Only exceptionally can this fund be used to assist with the dismantling and removal of objects. Grants for the conservation of objects will not normally be made, although potential conservation needs should be covered in all applications.

The Science Fund

Grant total: £5,000 in six grants 1999/2000

This fund assists with the acquisition of objects and manuscripts relating to the history of science, natural sciences, technology, industry and medicine. Grants may be made towards dismantling, emergency restoration, transport and re-assembly, where these are closely connected to the acquisition process.

Not-for-profit museums, art galleries, libraries, record offices and other similar institutions in Scotland can apply. The collection must be permanent, housed in suitable conditions, normally open to the public, and staffed or supervised by qualified personnel.

For museums and galleries, grants may be made to assist in the purchase of any appropriate object, or group of objects. For libraries and record offices, grants may be made to assist in the purchase of works of art, printed items in rare or limited editions or of local or specialist interest (other than reproductions or current publications), manuscripts, manuscript maps or plans, documents and archival photographs.

From time to time the NMS director may vary the balance between the Art Fund and the Science Fund, in order to encourage acquisition from one or other sector. The total amount of grant payable in any particular case will be at the discretion of the NMS director subject to the following conditions:

- the maximum level of grant will normally be 50% of total eligible costs;

- in assessing the level of assistance, account will be taken of any other sources of funding of a national character (for example, the National Heritage Memorial Fund or the National Art-Collections Fund);
- for applications where the total purchase price is less than £5,000, at least 25% of the total costs must be forthcoming from local sources, whether from the applicant's own resources, or from contributions made by private individuals, locally-administered charitable trusts, etc. For applications where the total purchase price is £5,000 or over, at least 10% of the total costs must be forthcoming from local sources.

The director may specify a maximum figure for assistance towards the purchase of any single object; he may also set a limit on the amount of assistance receivable by any one institution within a financial year.

Exclusions: Normally the museums and galleries of private societies or commercial companies are excluded from this scheme, as are the nationally funded museums and galleries. Grants are not made for the purchase or restoration of museum, gallery or library equipment, for framing, or for display materials. Friends organisations are not eligible to apply. Grants will not be made towards the acquisition of objects (or coherent groups of objects) whose value is less than £100, with the exception of treasure trove material.

Applications: A booklet of guidance to applicants should be obtained first. This section only covers some key points.

An application form must be completed and signed by the chairman of the governing body of the applying institution, or the curator or other head. A photograph of the object should be enclosed wherever possible. In the case of books and manuscripts this may be a photocopy of as much of the material as is required to show its nature and quality.

Bids at auction sales can cause problems and at least five working days are normally required prior to the sale for proper assessment.

No application can be considered where the object is the subject of a binding agreement to purchase or has already been acquired and paid for.

Decisions on grant applications are made after consultation, as appropriate, with staff of the three Scottish National Institutions (NMS, the National Galleries of Scotland and the National Library of Scotland). The decision reached by the director of the NMS is final.

THE SCOTTISH MUSEUMS COUNCIL

County House, 20–22 Torphichen Street, Edinburgh ED3 8JB
Tel: 0131 229 7465; Fax: 0131 229 2728
E-mail: inform@scottishmuseums.org.uk
Website: www.scottishmuseums.org.uk

Grant total: £210,000 (2000/01); £230,000 (1999/2000)

The Scottish Museums Council is an independent body with charitable status funded principally by the Scottish Executive Education Department. The council's main aim is to improve the quality of local museum provision in Scotland. Membership is open to local authorities, independent museums and galleries, historic houses – in fact to any museum, gallery or similar body in Scotland.

The council represents the interests of local museums in Scotland, and all members can benefit from the council's advisory, training and information services. Members eligible for grant-aid have access to a wide range of financial assistance schemes (revenue funding is not provided). To qualify for financial assistance, a museum's constitution or trust deed must be approved by the Scottish Museums Council. There are further detailed provisions about what is expected from trustees and staff.

Grants are available for the following:
- Management, Marketing and Fundraising;
- Stewardship – including Collection Care and Conservation and Collections Management;
- Training;
- Interpretation, Display and Publications;
- Education;
- Posts.

In addition the council runs:
- the Small Museums Fund for limited but immediate response to the needs of small independent museums;
- the Conservation Fund for immediate response to remedial conservation costs or projects which cannot be incorporated in grant-aid applications;
- the Access Challenge Fund to improve all types of access;
- the Environment Fund which covers aspects of natural sciences.

Exclusions: Revenue funding; purchase of objects for collections; work funded through insurance claims.

Applications: Grant applications should be discussed with council staff at an early stage. Further details on criteria for grant-making under each of the headings listed above is available from the Finance Manager.

Note: *Minimum application value – £200 from any member with an annual budget under £25,000.*

THE COUNCIL OF MUSEUMS IN WALES

Unit 15, Gwenfro, Wrexham Technology Park, Wrexham LL13 7YP
Tel: 01978 314402; Fax: 01978 314410
E-mail: nwales@cmw.org.uk
Website: www.cmw.org.uk
Contact: John Marjoram, Assistant Director, North and Mid Wales

Grant total: £280,000 (2002/03); £346,000 (2001/02); £182,000 (2000/01)

The Council of Museums in Wales is a membership body of local authorities and non-nationally funded museums within the Principality registered with the Museums and Galleries Commission. The spectrum ranges from small society museums through to large municipal institutions and includes regimental, university and country house museums besides industrial complexes. The council is established as a charitable, limited company. It is mainly funded by the National Assembly of Wales. It is based in Cardiff with a second office in North Wales.

The council fosters the preservation of the Welsh heritage through support of local museums as both a provider and enabler. In the former role it offers professional, management, curatorial, conservation, training advice and training packages. It also represents its members at local and national level. As an enabler the council administers grant-aid for project and challenge-funding to eligible museums (Resource registered).

Priority areas which feature in CMW's forward plan:
- Subsidised Post Scheme;
- Care of Collections;
- Training;
- Education and Access;
- Display and Interpretation.

The council awards some 90–100 grants each year. Its annual report showed these listed in the following categories: Curatorial Staff; Professional Development; Collections Management; Public Services – feasibility studies and capital.

In April 2002 a consultation about the co-ordination and administrative amalgamation of support for museums, galleries, libraries and archives, similar to the reorganisation in England, was announced.

Exclusions: Purchase of exhibits and property.

Applications: The bulk of grant applications are processed together in February/March for availability early in the incoming financial year, though depending on resources awards continue to be made throughout the period. Projects should be discussed with council officers well in advance of submission.

Specific challenge funds will be available in 2002/03 and 2003/04 for ICT Education and Innovation. Thee will be special timetables and application forms.

NORTHERN IRELAND MUSEUMS COUNCIL

66 Donegall Pass, Belfast BT7 1BU
Tel: 028 90550215; Fax: 028 90550216
E-mail: info@nimc.co.uk
Website: www.nimc.co.uk
Contact: Chris Bailey, Director

Donations to all causes: £62,000 (2000/01); £59,000 (1999/2000)

The Northern Ireland Museums Council is a non-departmental public body which channels central government support to local, non-centrally funded museums. It receives its core grant from the Department of Culture, Arts and Leisure. It provides advice and information; training; grant-aid; support for the care of collections; advocacy for museums. Grant-aid is usually provided up to 65% of the total project costs.

Grants may be made under the following headings:

Collections Care
Grant total: £29,000 (2000/01); £23,000 (1999/2000)
For preventative and remedial conservation, documentation, security and storage.

Use of Collections
Grant total: £21,000 (2000/01); £22,000 (1999/2000)
To improve public access and understanding of collections including educational use relating to the NI curriculum and lifelong learning, improvement in standards of interpretation, design and display.

Training and Travel grants
Grant total: £50 (2000/01); £1,500 (1999/2000)

Feasibility grants
Grant total: £3,500 (2000/01); £11,000 (1999/2000)
Support studies into the development of museums.

Specimen Purchase Fund
Grant total: £7,000 (2000/01); £1,700 (1999/2000)
Helps museums buy specimens for their collections related to the arts, literature, archaeology, history and science.

Exclusions: Only members of NIMC are normally eligible for grants. However feasibility support may be awarded to unregistered museums and bodies considering the establishment of museums.

Applications: Forms and guidance notes are available on its website. Separate guidelines available from the NIMC for the Specimen Purchase Fund.

BRITISH LIBRARY'S CO-OPERATION AND PARTNERSHIP PROGRAMME

The British Library, Fourth Floor, 96 Euston Road, London NW1 2DB
Tel: 020 7412 7333; Fax: 020 7412 7155
E-mail: henry.girling@bl.uk
Website: www.bl.uk
Contact: Henry Girling

Funding: £500,000 (2001/02)

The allocation for 2002/03 was not known as at 1 April 2002 but is expected to be in the region of £400,000.

The programme supports collaboration between different types of libraries to promote lifelong learning. Funding has also been provided by Resource (see separate entry) to allow the programme to include more projects involving museums and archives.

Examples of grants relevant to this guide have included:
Cecilia: mapping the UK music resource – Lead institution: International Association of Music Libraries, Archives and Documentation Centres (United Kingdom Branch) – (£51,050; jointly funded with the Research Support Libraries Programme and Resource: The Council for Museums, Archives and Libraries);
Performing Arts Resource Discovery – Lead institution: Theatre Museum.

OTHER NATIONAL ARTS BODIES

Arts, architecture, craft, design, heritage, languages

Arts and Humanities Research Board
Commission for Architecture and the Built Environment
The Crafts Council
The Design Council
The National Heritage Memorial Fund
Local Heritage Initiative
Welsh Language Board – Bwrdd Yr Iaith Gymraeg
Ulster-Scots Agency – Tha Boord o Ulsetr Scotch
Irish Language Agency – Foras na Gaeilge
The Northern Ireland Community Relations Council

ARTS AND HUMANITIES RESEARCH BOARD (AHRB)

Whitefriars, Lewins Mead, Bristol BS1 2AE
Tel: 0117 987 6500; Fax: 0117 987 6600
Website: www.ahrb.ac.uk
Chairman: Professor Sir Brian Follett
Chief Executive: Professor David Eastwood

Postgraduate Awards Division: Team Leaders have overall responsibility for a particular scheme; Awards Assistants focus on specific institutions.

Advanced Research Division: Head of the Research Division, Team Leaders and Research Awards Assistants. Team Leaders have overall responsibility for a particular scheme; Awards Assistants focus on specific subject areas and deal with specific panels and initial queries.

Details of staff are available on the website.

Core Funding Scheme for Higher Education Museums, Galleries and Collections (HEMGCs)

Total Funding: £8,000,000 (Applications accepted in 2001 only)

In 2001 the Board launched a new funding scheme designed to assist with the basic running costs of certain Higher Education Museums, Galleries and Collections

(HEMGCs). The scheme supersedes the previous regime of special non-formula funding administered by the Higher Education Funding Council for England (HEFCE).

The central purpose of the scheme is to offer a source of stable, medium-term **core funding** that can assist with the costs of stewardship of existing collections. 'Stewardship' is taken to cover a wide range of activities, including preservation and care of the collection, physical security, conservation, documentation and cataloguing, presentation and display, and access and outreach both to the higher education community and to the wider public.

The new scheme is aimed at museums and galleries which can demonstrate that their collections are of the highest quality and regional, national or international importance; and where some significant part of the collection is always on display. The scheme applies not only to HEMGCs within the AHRB's usual subject domain, but also to those outside the arts and humanities – such as natural history collections. Since the scheme is still funded solely by HEFCE, it is confined to HEMGCs in England.

Funding to successful applicants will be awarded for a period of five years, starting from the 2001–02 academic year.

The Board has also set up a separate scheme to provide modest amounts of funding for specific projects.

Special project funding
Total funding: £250,000 (2002-03)
From the 2002–03 academic year the AHRB intends to offer an annual competition for special project funding open to university-based museums in England. Small-scale grants will be available to museums or galleries that are seeking to develop their stewardship of, and access to, collections that are potentially of strategic importance.

The AHRB also offers other funding schemes that may assist HEMGCs, but these are confined to academic staff whose expertise is within the arts and humanities. These schemes include:

- research exchanges;
- resource enhancement.

See below for further information.

Postgraduate Awards in the Arts and Humanities
Total funding: £23 million budgeted (2002/02); £22 million (2001/02)

The closing date for applications to these schemes was **1 May in 2001**.
The AHRB adopts a liberal approach to the interpretation of its subject domain, which spans a wide range of subjects across the arts and humanities. It seeks to support work which aims to improve, enhance or develop creativity, insight, knowledge and understanding in the creative activities, history, languages, literatures and systems of thought and belief of human beings past and present.

Studentships in the Humanities
Awards are distributed in two separate competitions: Competition A, which provides one-year and two-year studentships for full-time study on Master's courses; and

Competition B, which provides studentships of up to three years for full-time study, or of up to five years for part-time study, for a doctoral degree.

Professional and Vocational Awards (PVA)

PVA support students undertaking a full-time, postgraduate Diploma or Master's course in certain practice-based professional and vocational areas of study. The subject areas covered by the PVA scheme are: art and design; practice-based drama and media studies; interpreting and translation; librarianship, archives and information management; museum studies and heritage management.

Awards for Doctoral Study in the Creative and Performing Arts

This scheme supports students pursuing a programme of practice-based doctoral research in subject areas such as: art and design; musical performance; and drama, dance and performing arts.

Funding for research students is now also available through the Board's scheme of research grants, as academic members of staff may include in their application the cost of supporting postdoctoral students who are undertaking work which contributes to the research project.

More detailed information on all of the schemes can be found in the *Guide to Applicants for Postgraduate Awards in the Arts and Humanities*. It is important that each potential applicant is clear about the detailed requirements re residency and qualifications. These can be accessed on the website.

Note: *The rates of grant are reviewed annually.*

Advanced Research Awards in the Arts and Humanities

Total funding: £23 million budgeted (2002/03); £20 million (2001/02)

Full details of these schemes can be obtained from the website or direct from the office. The following schemes are available.

Research Grants Scheme

Provides up to £100,000 a year, for up to five years, to substantial research projects which may involve some teamwork.

Small Grants in the Creative and Performing Arts

Offer up to £5,000 to meet the direct costs of research projects, including such items as travel, maintenance and consumables.

Research Leave Scheme

Provides funding for research leave of three or four months in order to complete a piece of research. The period funded by the AHRB must be matched by a (preceding) period funded by the institution. The Board meets the full salary costs of the award-holder during the research leave period that it funds.

Fellowships in the Creative and Performing Arts

Provide support for the appointment of full-time research fellows in the creative and performing arts in the form of a flat rate grant of £17,500 pa for three years.

Research Exchanges

Promote and support collaboration between researchers in academic departments and colleagues who work in, for example, libraries, archives museums, galleries, studios and theatres. An exchange normally takes the form of a period of secondment for three or four months to undertake a specific programme of research activity. The Board provides £3,500 per month in support of the exchange.

Research Centres Scheme

Provides support for AHRB centres which serve as a focus for research activity in a field of study that is of strategic importance within a wider subject or disciplinary area. The maximum length of an award is five years, with a maximum grant of £875,000 over that period.

Resource Enhancement Scheme

Grants of up to £100,000 a year are available for up to three years to meet the costs of projects to improve the utilisation and accessibility of research resources and materials of all kinds, or to develop the intellectual infrastructure of a specific area of study.

Innovation Awards

Grants of up to £50,000 for one year to support notably innovative research projects which seek to challenge existing models, perceptions, research methods or modes of thought.

Lists of successful applications are posted on the website.

COMMISSION FOR ARCHITECTURE AND THE BUILT ENVIRONMENT

16th Floor, Tower Building, 11 York Road, London SE1 7NX
Tel: 020 7960 2400 /2405
E-mail: enquiries@cabe.org.uk
Website: www.cabe.org.uk
Contact: Bridget Sawyers/Helen Edmundsen, Head of Regions
Chairman: Sir Stuart Lipton

Grant available: £500,000 a year for a regional funding programme

The commission came into operation in September 1999 as the national agency to encourage better standards of architecture and built environment, taking on the Royal Fine Art Commission's design review role, advising government departments and other public bodies on architecture and urban design, encouraging a wider interest in and understanding of architecture in the regions and among the general public.

Regional Funding Programme

In August 2001 a Regional Funding Programme was set up with an initial £500,000 a year over two years. In due course there will be a separate small grants programme for project funding between £5,000 and £30,000.

CABE is working in partnership with other bodies and does not intend establishing its own network of regional offices.

The Funding Programme, which covered England only, was competitive with only one funding round within the initial programme timescale of 1 April 2002 to 31 March 2004. Applications had to be presented by the end of October 2001.

The themes for the first two years:
- providing public education and participation in architecture and the built environment;
- improving the quality of architecture and procurement at the interface of design and construction;
- enabling public and non-profit distributing clients to design and build better buildings through the provision of technical assistance;
- assisting in the creation of new regional organisations to undertake some or all of the above objectives.

Applications have to meet one or more of these funding themes.

Particular interest in programmes that included:
- outreach education work in schools, preparation of teaching packs and tools to increase understanding of the built environment;
- action to ensure the development of better public buildings by promoting and disseminating best practice;
- promotion of the importance of design and its value to society;
- working to ensure greater consideration of design within the land use planning process;
- creation of an architecture centre or resource, static or mobile, virtual or real;
- actively facilitating public involvement and consultation in the design of major schemes.

Grants ranged from £20,000–£80,000 per year and could be for two year's funding. An organisation can only submit one application.

The funding provided by CABE needed to be matched with a minimum of 20%. If in kind support was part of this match funding then a minimum of 30% was required.

Exclusions:
- Local authorities, including institutions or services they manage directly.
- Health authorities, including institutions or services they manage directly.
- Other public bodies.
- Registered social landlords.
- Individuals.
- Companies, partnerships or other bodies that exist to trade for profit.

- Organisations not established in England.
- Feasibility studies. (These will be funded separately on their individual merits under the small grants programme.)
- Purchase of land or buildings or capital costs of building works or access work.
- Grants for vehicles unlikely unless part of a mobile resource facility.
- Design development / detailed design for building, construction, refurbishment or conversion.
- Endowments and fundraising.
- Public art installations or art/architecture collaborations (these will continue to be funded by CABE through other means).
- Loans or down payments for loans and mortgages.
- Retrospective funding.

Applications: Full details of CABE's funding programmes can be downloaded from the internet and are available at the above addresses. Applications should be sent to CABE addressed to the Regional Funding Programme.

THE CRAFTS COUNCIL

44a Pentonville Road, London N1 9BY
Tel: 020 7278 7700; Fax: 020 7837 6891
E-mail: info@craftscouncil.org.uk
Website: www.craftscouncil.org.uk
Contact: Michelle Bowen, Business Development Officer
Director: Dr Louise Taylor

Total grant-in-aid from Arts Council of England: £2,423,000 (2000/01)

The Crafts Council is an independent charity incorporated under Royal Charter, with the aims 'to advance and encourage the creation of works of fine craftsmanship and to foster, promote and increase the interest of the public in the work of craftspeople and in the accessibility of those works to the public'. It receives core funding from the Arts Council of England. It also generates income from its own activities and financial support for export projects through the Department of Trade and Industry.

The Crafts Council is the lead organisation supporting the crafts. It is the recognised centre for information on British craftspeople and it organises major exhibitions that present and interpret contemporary work. Its education activities around the exhibition programme encourage understanding of craft practice and its publications stimulate critical thinking and writing about the crafts. The council supports new businesses by direct grants to makers, training programmes and opportunities to sell and promote work in this country and abroad. The history of contemporary art is assured by the purchase of work for the permanent collection.

The council's funding scheme is open to craftspeople in England.

Setting-up Scheme

Grants are offered to help with the costs of setting up a first workshop. Applications can be made either before the workshop is established, or at any time during the first two years of operation. Applicants must plan to spend the majority of their time in the workshop (a maximum of 16 hours employment outside the workshop each week is allowed). Makers working from home are eligible provided that the space is considered suitable.

This scheme consists of two parts, maintenance and equipment. Makers can apply for both or one of these types of grant, but it is not possible to apply separately at different times. The level of grant may also depend on the other grants given towards the costs setting up and running the business.

- Equipment grants are for 50% of the total cost of essential equipment up to a maximum of £5,000 (e.g. 50% of £10,000). Second-hand equipment is eligible. For certain expensive items not constantly in use, 50% of the hiring costs during the first year will be considered.
- Maintenance grants are for £2,500 for one year. The grant is paid in quarterly instalments with the first instalment released when the workshop is in production.

A total of 25 grants was given in 2000/01.

A two-day business and marketing course is also provided for all grant recipients.

The council is an assessor for the Lottery.

Individual craftspeople should also contact their regional arts board/office about the schemes for support to individuals.

Applications: Obtain full details of current funding support and be sure to check the closing dates. Applications are considered by a committee of crafts people four times a year. The closing dates are 1 March, 1 June, 1 September and 1 December.

Application forms need to be submitted with a curriculum vitae and six slides of recent work. The application process has two stages with the initial selection based on the slides.

The council also publishes a useful handbook – *Running a Workshop* (£7.50 + £2.00 p&p).

THE DESIGN COUNCIL

34 Bow Street, London WC2E 7DL
Tel: 020 7420 5200; Fax: 020 7420 5300
E-mail: info@designcouncil.org.uk
Website: www.designcouncil.org.uk
Contact: Kirstine Murphy

Design Council Innovation Fund
Total funding: £250,000 (2001/02)

The Design Council Innovation Fund has helped scores of projects since 1994, when it was known as Special Design Project Funding. They range from summer schools and seminars to research projects and training packages.

The council wants to encourage a diverse range of applications. However, applications are assessed on five issues.

- *Design Council purpose* Is the project consistent with the purpose of the Design Council – 'to inspire the best use of design, in the world context, to improve prosperity and well being'?
- *Audience* Does the project involve people in business or education? How will it reach its intended audience?
- *Outcomes* Are the planned outcomes realistic and will they have a significant impact on the intended audience?
- *Management and conduct* Does the proposed project team have the knowledge and experience to deliver the project? Is the project well planned with appropriate milestones and budgets?
- *Funding* Is the level of funding requested appropriate for the planned outcome? Is this a project which would not happen without support from the Design Council Innovation Fund?

The minimum amount awarded to any single project is £10,000 and the maximum £40,000. These payments can be staged over the year. While the entire cost of a project may be covered, applications which show that other organisations are also contributing to the cost (in cash or in kind) will be looked upon favourably. More than one application can be made but the projects must be distinctly different and the maximum any organisation can receive in total is £75,000. Funding is available for one year only. A further application can be made in the following year for continued funding but, each year, the council gives priority to new projects before considering continuing ones.

Successful applicants are allocated a point of contact at the Design Council for the project who will provide guidance and support if needed. They are expected to provide a short interim report and a final report in electronic as well as hard form. The final payment is only made on receipt of a satisfactory final report.

The successful applicant owns the intellectual property. The council requires the rights to make full use of the project outputs in whatever way it sees fit, provided it is non-commercial and with the purpose of promoting the effective use of design.

Appropriate acknowledgements are made of material developed with support of the fund.

Examples of successful applicants include:

the University of Southampton is developing a guide for design and technology based businesses to help them to raise venture capital;

the Teaching Company Scheme developed a three day training programme for people who manage product and service development in small and medium sized enterprises;

Sheffield Hallam University won funding to develop educational tools aimed at MBA and other management training courses. The material is helping design users to communicate their needs to designers;

Nuffield Design and Technology Project and the Design Museum worked together to produce a handling collection of Millennium Products for teachers to use in design and technology classes;

New Designers in Business gained funding for a series of seminars, supported by a mentoring programme, aimed at helping young designers to improve their business management skills;

Central St Martins College of Art and Design won funding to create a CD-Rom containing information for manufacturers and designers about designing for people with disabilities;

the London Open House scheme created a 'passport to design' to guide children around buildings during 'Open House' weekend – drawing their attention to design issues and explaining how designers and architects work.

Applications: The application process is in two stages. The first stage (project outline) allows for quick and easy feedback about whether the proposal could attract funding. The second stage (full application) provides the detailed information on which the application is decided.

THE NATIONAL HERITAGE MEMORIAL FUND (NHMF)

7 Holbein Place, London SW1W 8NR
Tel: 020 7591 6000; Fax: 020 7591 6001
E-mail: enquire@hlf.org.uk
Website: www.nhmf.org.uk
Contact: Owen Roffe, Information Officer

Grant total: £5 million (2001/02); £3.5 million (2000/01); £2.5 million (1999/00)

The National Heritage Memorial Fund (NHMF), funded annually by the Department of Culture, Media and Sport, was initially funded by the sale of land compulsorily purchased for military reasons in wartime. Its role is to protect land, buildings, objects and collections which are of outstanding interest and are important to the national heritage. The NHMF is also the national distributor of the Heritage Lottery Fund.

The NHMF still carries out its original functions which is as the fund of last resort. It is able in an emergency to move with great rapidity.

Grants are available for the purchase of land, buildings, works of fine and decorative art, museum collections, archives, manuscripts and items of transport and industrial history. Except for historic buildings and structures (for which there are already sources of funding) the fund can sometimes help with conserving and restoring a heritage asset which is at risk.

Applications should *only be made as a last resort*, after all other possible sources of funding have been tried. The fund will only pay for the total cost of a project in exceptional cases.

Grants in 2000/01 included:
The Foundling Museum Trust, to enable this unique collection of 18th century art to be displayed intact near its original site (£3 million towards an endowment fund); Victoria & Albert Museum for the restoration of the Hereford Screen (£375,000); National Museums and Galleries of Wales for the Jackson Silver Collection 426 items of 14th to 18th century silver (£300,000).

Exclusions: Yearly revenue funding; day-to-day running costs or maintenance; costs of payroll staff; development studies; research projects; costs already spent; general furniture, fittings and equipment costs.

Applications: Full guidelines and an application form are available from the fund.

LOCAL HERITAGE INITIATIVE (LHI)

Countryside Agency, John Dower House, Crescent Place,
Cheltenham GL50 3RA
Tel: 01242 521381; Fax: 01242 584270
E-mail: lhi@countryside.gov.uk
Website: www.lhi.org.uk
Contact: Central team

Funding: £3.5 million a year up to 2004/05
Funding comes from the Heritage Lottery Fund and the Countryside Agency with sponsorship from the Nationwide Building Society.

The Local Heritage Initiative (LHI) is a national grant scheme devised by the Countryside Agency and administered by them on behalf of the Heritage Lottery Fund. It is intended to help local groups to investigate, explain and care for their local landmarks, landscape, traditions and culture. It was launched in February 2000 and is planned to run for 10 years.

The scope of LHI is very wide and includes many categories of local heritage:
- **Archaeological heritage** Enquiries into, and interpretation of, locally important visible features, for example, hill forts, burial mounds, moats, field systems, ridge and furrow, standing stones and ancient village sites.

- **Built heritage** Locally distinctive built heritage elements and small features, like field barns, pumps, wells, gates and walls, bridges, railings, milestones, architectural details, cobbles, memorials, village greens or traditional signs.
- **Customs and traditions** Historic and cultural associations with the land and activities of local people, for example stories, poems, songs, dialect, recipes, traditions and famous people – also heritage features relating to how people lived, worked, played, such as place names, field names, parish boundaries, open spaces, viewpoints, and local rights of way.
- **Industrial heritage** Physical features related to locally important industries, such as chimneys, lime kilns, packhorse trails, wagonways, canals, quarries, mineral pits, spoil heaps, mills, mines, smithies and coopers.
- **Natural heritage** Locally characteristic landscape features and wildlife habitats, such as hedgerows, copses, pollards, orchards, small heathland areas, hay meadows, water meadows, reedbeds, ponds, streams and springs.

Examples of grants relevant to this guide:
Northumberland National Park Environmental Association, for the Hareshaw Linn Community Play, funding to research the area's history, and employ the writer, director and musicians (£10,500);
Maryport Festivals Group for Maryport Songs of the Sea Festival of sea shanties, clogg dancing, stories and guided walks around the port (£7,000).

Eligibility: The LHI is designed for rural or suburban areas of England. This includes most areas except the centres of large towns and cities.

New or existing community or voluntary groups can apply for funding. They do not have to be a registered charity but they must have a formal constitution and an open bank or building society account. Groups that are not locally based must be able to show that their project began at the community level and that it has support from local people. Grant-aid is available for costs associated with:

- an investigation of local heritage, leading to an explanation and presentation of information discovered;
- material and labour for a programme of community-led action, e.g. conservation or restoration of heritage assets;
- work to help public access, enjoyment and appreciation of heritage assets;
- specialist advisers to help with the project;
- charges such as archive costs;
- activities to involve the wider community, especially young people;
- production of information;
- essential equipment to make projects efficient and effective (max 50% of costs);
- training for volunteers;
- provision for long-term care of the project and assets;
- legal advice and volunteer insurance costs specifically associated with LHI projects.

The LHI anticipates that most projects will last between one and two years.

Funding levels

Standard grants are between £3,000 and £15,000, paid in arrears, to cover 60% of project costs. The remaining 40% may be made up from cash, in kind donations,

volunteer labour, or a mixture of these. Groups are encouraged to apply for more complex projects, e.g. those involving investigation, explanation and action, in 2 or 3 phases. In exceptional circumstances it may be possible to offer a higher rate of grant-aid, or advance payments. However, the maximum amount any one group or project may apply for is £25,000.

The Nationwide is offering additional payments of up to £5,000 for projects that may have difficulty raising matching funding or want to go further than is possible with standard levels of funding. The additional payments are intended for projects that would otherwise not go ahead. Awards will be made four times per year and are available through the LHI application process.

Exclusions: Individuals and profit-making organisations are not eligible to apply. The following are also ineligible:
- work carried out prior to receiving and accepting any offer of grant;
- provision of expert advice or management skills by the applicant or group members (although this can count as in kind contributions);
- items that only benefit an individual;
- core funding for group activities such as staff salaries;
- routine maintenance or one-off repair projects.

Applications: Applicants must complete a detailed form explaining their project and its background. Applications are assessed by a regional Countryside Agency project officer; final decisions are made by the Heritage Lottery Fund. The LHI has promised to give a decision on all applications within three months.

Full details are on the website. Information packs and application form are available from Tel: 0870 9000401

Be sure to check the website for up-to-date details.

WELSH LANGUAGE BOARD – BWRDD YR IAITH GYMRAEG

Market Chambers, 5–7 St Mary Street, Cardiff CF1 2AT
Tel: 029 2087 8000; Fax: 029 2087 8001
E-mail: grantiau@bwrdd-yr-iaith.org.uk
Website: www.bwrdd-yr-iaith.org.uk
Contact: Dr Huw Onllwyn Jones, Head of Grants Department

The board was established under the Welsh Language Act 1993 and is funded by the National Assembly for Wales. It aims to promote and facilitate the use of Welsh. It makes the following grants open to voluntary organisations.

Main Grants Programme
Grant total: £2,870,000 (2001/02); £2,562,000 (2000/01); £2,361,000 (1999/2000); £2,272,000 (1998/99)

The board is able to support a wide range of activities relating to the use of Welsh including the the following (no priority in the order):
- developing the use of Welsh by the voluntary sector;
- developing the use of Welsh by the private sector;
- producing resources to make Welsh easier to use;
- encouraging and facilitating the use of Welsh by children and young adults;
- encouraging and facilitating the use of Welsh by learners above the age of 16;
- undertaking research which is relevant to the board's work;
- strengthening the use of Welsh in communities;
- safeguarding and developing the activities of organisations established to promote the use of Welsh;
- providing people with information about the opportunities that exist for them to make use of the language;
- encouraging people and organisations to use the language as a normal part of their day-to-day activities.
- applications which increase the use of Welsh in the field of Information Technology are welcomed.

Two types of grant are relevant to this guide: Project Grants and Core Grants.

The Board contributes no more than 70% of an activity's cost.

A total of 32 grants were made in 2001/02 ranging between £400 and £668,000 including:
Welsh Books Council (£632,704);
National Eisteddfod of Wales (£276,000);
Mentrau Iaith Myrddin (£79,643);
CYD (Welsh for Adults) (£86,000).

Small Grants Scheme
Grant total: £15,000 (2001/02 and in 2 preceding years)
Contact: Dr Huw Onllwyn Jones

Grants of up to 50% of the total cost, (to a maximum £300), are made towards the cost of translating, designing and publishing bilingual materials. Priority is given to voluntary or private organisations just beginning to use Welsh and those with extensive public contact. A total of 107 grants were made in 2000/01. They included:
Rheilffordd Ucheldir Cymru, Welsh Highland Railway (£164);
Pantri'r Fferm (£292);
Will Aid (£300);
Friends of Nant Fawr (£120).

Exclusions: The following are **not** funded under the Main Grants Programme: The production of bilingual material (funded by the *Small Grants Scheme*); staff costs for providing bilingual services; provision of educational materials; attending Welsh for Adults courses.

Applications: Full guidelines and application forms are available for both programmes. The Small Grants Scheme applications are assessed as soon as possible after being received by the board. The Main Grants Programme applications are invited from the beginning of August with a closing date of end October in 2001.

ULSTER-SCOTS AGENCY – THA BOORD O ULSTER SCOTCH

Franklin House, 5th Floor, 10–12 Brunswick Street, Belfast BT2 7GE
Tel: 02890 231113; Fax: 02890 231898
E-mail: info@ulsterscotsagency.org
Website: www.ulsterscotsagency.com
Contact: George Holmes, Cultural Development Manager

Grant-in-aid: £1.29m(2001/2002); £667,000(2000/2001)

The aim of the Ulster-Scots Agency is to promote the study, conservation, development and use of Ulster-Scots as a living language; to encourage and develop the full range of its attendant culture; and to promote an understanding of the history of the Ulster-Scots. The Ulster-Scots Agency is funded by grants from the Department of Culture, Arts and Leisure in Northern Ireland and the Department of Arts, Heritage, Gaeltacht and the Islands in the Republic of Ireland.

Its aims are:
- **Linguistic development** To support Ulster-Scots as a living language and to promote its use and development.
- **Culture** To be a key contributor to the development of Ulster-Scots Culture.
- **Education** To establish partnerships with the education and community sectors to promote the study of the Ulster-Scots language, culture and history.
- **Understanding of Ulster-Scots** To develop the public's understanding of the Ulster-Scots language and culture.

Programme expenditure – 2001/02

Theme Programme	£K
Linguistic Dictionary and Development Surveys	475
Culture Cultural Support Grants	125
Education School of Ulster-Scots Studies	100
Educational programmes and materials, etc.	100
Promoting Acceptance Marketing and Promotional Programme	95
Total Programme Expenditure	895

IRISH LANGUAGE AGENCY – FORAS NA GAEILGE

7 Marion Square, Dublin 2
Tel: 0845 309 8142; Fax: 0845 639 8401
E-mail: eolas@bnag.ie
Website: www.bnag.ie

Foras Na Gaeilge is responsible for the promotion of the Irish language on an all-island basis. It advises administrations, North and South, as well as public bodies and other groups in the private and voluntary sectors on all matters relating to the Irish language. It also undertakes supportive projects and makes grants to bodies and groups throughout the island of Ireland.

Its main activities include:
- promotion of the Irish language (through advertising, competitions, events and sponsorships);
- funding Irish language organisations and activities;
- sponsorship of bilingual events;
- publication of guides and resource material;
- workshops and training seminars;
- launches and exhibitions;
- production, distribution and promotion of Irish-language and Irish-interest books;
- development of new terminology in Irish and the compilation and publication of Irish-language dictionaries;
- supporting Irish-language education.

THE NORTHERN IRELAND COMMUNITY RELATIONS COUNCIL

6 Murray Street, Belfast BT1 6DN
Tel: 028 90 227500; Fax: 028 90 22 7551
E-mail: info@community-relations.org.uk
Website: www.community-relations.org.uk
Contact: Ray Mullan, Director of Communications

Donations to all causes: £2 million (2000/01); £2,014,000 (1999/2000); £1,795,000 (1998/99)

The Northern Ireland Community Relations Council was established in January 1990 as a charitable company. It assists other organisations to address communal divisions in Northern Ireland. It supports a wide range of groups involved in bringing about increased understanding and contact between Protestants and Catholic communities. Most of its funding comes from the Central Community Relations Unit of the Northern Ireland Department of Finance and Personnel, the remainder from the European Union.

The following grant schemes have relevance to this guide.

Core-funding Grant Scheme

Grant total: £1.3 million(2000/01); £1.2 million (1999/2000 and in previous year)

Core funding over three years is given to organisations of strategic importance in community relations or cultural traditions. Grants range from £5,000 to £180,000 a year with the majority in the £30,000 to £70,000 range.

A total of 34 grants were awarded in 2000/01 including:
Comhchoiste Na Gaelige Aontroim Thuaidh – Irish language network;
Belfast Community Theatre;
Ulster-Scots Heritage Council.

Deadline for applications: 31 December for funding in the next year.
Contact: Michelle Cherry, Project Officer

Community programme

The Council's Community programme encourages dialogue and relationship building within and between local communities. The programme strives to influence the development of community relations policy and practice across a wide range of groups and organisations. It has two grant-aiding schemes. Eligible project costs include: venue hire, trainer/facilitators costs, travel and administration. It is recommended to allow at least eight weeks for the processing of grant applications.

Community Grant Scheme

Grant total: £290,000 (2000/01); £235,000 (1999/2000 and in 1998/99)
This grant scheme seeks to increase opportunities for people from differing traditions to develop relationships of trust and understanding and the confidence to address issues of difference between them. It is open to locally-based groups involved in community development, women's groups, churches' groups, tenant associations and other organisations involved in community relations and reconciliation projects. The scheme is aimed primarily at projects involving adults.

It awards small grants up to the maximum of £10,000, however allocations are usually in the region of £500 to £1,000. The most successful projects having attained funding in the past are those with clear community relations strategies. Applications have included projects that explore and examine issues of identity, difference, conflict, sectarianism, relationships within a divided society, etc. Funds have supported community relations training, series of discussions/debates on community relations issues, facilitation of political dialogue, etc.

Examples of relevant beneficiaries include:
Ballynafeigh Community Development Association.
Contact for further information: Michaela Mackin, Programme Director

The Community Relations Development Grant Scheme

Grant total: £30,000 (2000/01 and in the 2 previous years)
The Scheme is designed to help all organisations from the more established to the new and emerging groups, engaged in community relations work, to undertake a

process of review, reflection and self evaluation that will enable them to undertake community relations work more effectively.

Support is available for evaluation and objective setting for community relations work, drawing up of development plans, management training and staff development.

Examples of relevant beneficiaries include:
Ballymurphy Women's Centre.

Contact for further information: Michaela Mackin, Programme Director

Cultural Diversity Programme

Cultural Diversity Grant Scheme
Grant total: £125,000 (2000/01 and in the 2 previous years)
This programme awards small grants, usually under £2,000 but they can be as much as £7,000, to community organisations involved in cultural diversity work. Successful projects have included historical talks, public debates, exhibitions, festivals and performances, particularly where common myths and stereotypes are investigated and questioned. Applications need not always be cross-community projects, and can be enjoyable as well as demanding, but they do need to genuinely consider cultural diversity issues to be eligible for funding.

Due to considerable demand for this scheme, there is usually a waiting list, so it is always best to apply at least eight weeks in advance if support is required for a particular date. The council does not fund projects retrospectively.

Previous grants have included:
Conradh na Gaeilge, towards the Celtic Festival of Samhain;
Multi-Cultural Resource Centre, for their Food and Arts Festival;
Sole Purpose Productions, for a touring play about marching;
Tartaraghan Boys Brigade, for an exhibition on the horrors of World War I.

Most awards are for below £3,500.

Deadlines for applications: The committee meets five times a year. Applications for grants under £1,500 can be considered at any time.
Contact: Tony Langlois, Project Officer

Publications and Media Grant Scheme
Grant total: £100,000 (2000/01); £80,000 Media and £60,000 Publications (1999/ 2000 and in previous years)
Awards are primarily assessed according to their relevance to Cultural Diversity issues and their likely contribution towards improving community relations in Northern Ireland. This scheme is mostly intended to assist projects which stimulate public debate but which would not be financially viable.

Authors or groups seeking assistance to produce a book need to apply through established local publishers who have experience of the market and access to good distribution networks. Eligible themes for books include history (where it concerns matters of general local interest), politics, the exploration of identity and regional traditions. Fiction is not eligible for support under this grant scheme.

Applications for financial assistance with media projects such as CD-ROMs, websites, film or other broadcast material, are considered by the Council. To ensure that Community Relations Council funds are spent effectively, applicants for film or radio projects will need to ensure that the results of their work will be broadcast locally.

Contact: Tony Langlois, Project Officer

Research Grants Scheme
Grant total: £50,000 (2000/01); £40,000 (1999/2000)
The programme is currently inviting applications from individuals for its annual research awards, which aim to support original research and other creative approaches to community relations. Suggested themes for this years research projects are: Citizenship, Sharing/segregation, Religion, The Media, Multiculturalism.

Contact: Tony Langlois, Project Officer

EDUCATION AND YOUTH

Children's Fund
Millennium Volunteers
Youth Service Unit, DfES
National Voluntary Youth Organisations in Wales
Creative Partnerships

CHILDREN'S FUND

Website: www.dfee.gov.uk/childrensfund

Total Funding: £100 million (2001/02); £150 million (2002/03); £200 million (2003/04)

A Cabinet Committee on Children and Young People's Services chaired by the Chancellor, co-ordinates policies on government services for tackling poverty and disadvantage among children and young people. It is supported by the Children and Young People's Unit, located in the Department for Education and Employment which operates across departmental boundaries, and includes qualified people from across the civil service, the wider public sector and the voluntary and private sectors.

The Children's Fund will make available £380 million to develop services to identify children who are showing early signs of difficulty and provide them and their families with the support they need to overcome barriers and disadvantage. Local partnerships have been invited to draw up proposals showing how they can use money from the fund to expand preventive services in their area. In the first instance, chief executives of local authorities will be invited to draw together key local providers and identify which partnerships can best plan for and manage services to be funded. The voluntary and community sectors, children and their families are expected to be key partners in local partnerships.

By April 2004, the fund will support some activity in all areas of England; the first year of funding is focused on those areas in England with the highest levels of need and disadvantage amongst children and young people. The first 40 local authority areas to take part in the programme were announced in early 2001.

The Local Network
Total Funding: £70 million over 3 years
£10 million (2001/02); £20 million (2002/03); £40 million(2003/04)

Some funding is distributed directly to local voluntary and community groups through a network of local funds. It caters for children of all ages and focuses on helping local and community groups to provide local solutions to the problem of child poverty with strong emphasis on children and young people's own aspirations and views.

The Network will consist of around 50 local funds covering the whole of England and rolled out gradually with the first 17 areas announced in late spring 2001.

Grants will be made under four themes:

- **economic disadvantage** – imaginative schemes to enable families to improve their living standards;
- **isolation and access** – prevention and crisis work with hard to reach groups;
- **aspirations and experiences** – bridging the gap between the childhood experiences of children in poverty and their contemporaries; and
- **children's voices** – giving children a chance to articulate their own needs.

The age range for support is 0–19 plus grants for work with families that will directly benefit that age group. One-off grants are up to £7,000, or up to £4,000 for each of two years, committed in advance.

Community Foundation Network with its member community foundations has been appointed to administer the Local Network of Children's Funds. They are working in partnership with other voluntary organisations such as Rural Community Councils and Councils for Voluntary Service to provide a fund administrator in each local network area.

The Local Network Fund for Children & Young People
A National Call Centre has been set up as initial contact point for this network: Tel: 0845 113 0161

Media enquiries and specific questions not answered by the call centre can be directed to the people listed below.

Birmingham
The Birmingham Foundation
Contact: Harvey Mansfield, Tel: 0121 326 6886 / 8575;
E-mail: team@bhamfoundation.co.uk

Black Country
The Birmingham Foundation
Contact: Harvey Mansfield, Tel: 0121 326 6886 / 8575;
E-mail: team@bhamfoundation.co.uk

Cornwall
Cornwall Independent Trust Fund
Contact: Allan Chesney, Tel: 01288 341298; E-mail: allan@chesney.fsbusiness.co.uk

East Sussex
Sussex Rural Community Council
Contact: Teresa Gittins, Tel: 01273 473422; E-mail: teresa.gittins@srcc.org.uk

Greater Manchester
Community Foundation for Greater Manchester
Contact: Cath Drummond, Tel: 0161 214 0940;
E-mail: enquiries@community foundation.co.uk

Humberside
Humber & Wolds Rural Community Council
Contact: Mary Cornwell, Tel: 01430 430904 / 432037;
E-mail: m.cornwall@ruralnet.org.uk

Kent
Kent Community Foundation
Contact: Ann Chaplin, Tel: 01732 520190 / 001;
E-mail: achaplin@caf.charitynet.org

Lancashire
Community Futures
Contact: Richard Davey, Tel: 01772 718710; E-mail: ccl@communityfutures.org.uk

Leicestershire
Leicester Charity Link
Contact: Jim Munton, Tel: 0116 2222209; E-mail: jim-munton@charity-link.org

London
London Community Foundation
Contact: Paul Rodgers, Tel: 020 7422 8615 / 8616; E-mail: info@londoncf.org

Merseyside / Halton
Sefton Community Foundation
Contact: Dave Roberts, Tel: 01704 512900 / 531192; E-mail: dave@seftoncf.org.uk

Norfolk
Norfolk Rural Community Council
Contact: John Dixon, Tel: 01953 851408

Nottinghamshire
Nottinghamshire Community Foundation
Contact: Phil Lyons, Tel: 01623 422010 / 648579;
E-mail: plyons@mansfield2010.co.uk

South Yorkshire
South Yorkshire Community Foundation
Contact: Erica Dunmow, Tel: 0114 273 1765 / 278 0730; E-mail: info@sycf.org

Tees Valley
Cleveland Community Foundation
Contact: Kevin Ryan, Tel: 01642 314 200/01642 313 700;
E-mail: ccftrust@yahoo.com

Tyne & Wear
Community Foundation Serving Tyne & Wear and Northumberland
Contact: George Hepburn, Tel: 0191 222 0945 / 230 0689;
E-mail: general@communityfoundation.org.uk

West Yorkshire
Calderdale Community Foundation
Contact: Steve Duncan, Tel: 01422 349700 / 350017;
E-mail: enquiries@ccfound.co.uk

Children's Fund Local Network – 2001/02

The first 17 areas and their funds

Area	Description	Grant allocation (£)
London	All Boroughs	1,821,600
Greater Manchester	Met County: Manchester, Salford, Oldham, Rochdale, Bolton, Tameside, Trafford, Wigan, Bury, Stockport	800,800
West Yorkshire	Met County: Bradford, Kirklees, Calderdale, Wakefield, Leeds	624,800
Merseyside/Halton	Metropolitan boroughs: Knowsley, Sefton, Liverpool, St Helens, Wirral, Halton	545,600
Birmingham/Solihull	Met county: Birmingham & Solihull	466,400
Lancashire	County + Unitaries: Lancashire, Blackpool & Blackburn with Darwin	404,800
South Yorkshire	Met County: Doncaster, Barnsley, Rotherham, Sheffield	396,000
Tyne and Wear	Met County: Newcastle upon Tyne, Gateshead, South Tyneside, North Tyneside, Sunderland	360,800
The Black Country	Met county: Sandwell, Wolverhampton, Walsall & Dudley	352,000
Kent	Unitary (Medway) + County (Kent)	334,400
Nottinghamshire	Nottinghamshire & Nottingham	299,200
Humberside	Kingston upon Hull, NE Lincolnshire, N Lincolnshire, East Riding	272,800
Tees Valley	Middlesbrough, Hartlepool, Redcar & Cleveland, Stockton-on-Tees, Darlington	255,200
Leicestershire	County +Unitary (Leicester)	220,000
Norfolk	County	176,000
East Sussex	East Sussex and Brighton & Hove	176,000
Cornwall	County	149,600

Local Network Areas Funding – 2002/03

North East

Total funding: £1,523,100

Tees Valley (Middlesbrough, Hartlepool, Redcar & Cleveland, Stockton-on-Tees, Darlington) £437,500;

Tyne & Wear (Newcastle upon Tyne, Gateshead, South Tyneside, North Tyneside, Sunderland) £644,500;

Durham (County) – *new area* £275,700;

Northumberland (County) – *new area* £165,400.

North West

Total funding: £3,684,500

Merseyside/Halton (Knowsley, Sefton, Liverpool, St Helens, Wirral, Halton) £977,000;

Greater Manchester (Manchester, Salford, Oldham, Rochdale, Bolton, Tameside, Trafford, Wigan, Bury, Stockport) £1,452,700;

Lancashire (Lancashire, Blackpool & Blackburn) £726,500;

Cheshire (Cheshire, Warrington) – *new area* £310, 400;

Cumbria (Cumbria) – *new area* £217,900.

Yorkshire & Humberside

Total funding: £2,566,700

South Yorkshire (Doncaster, Barnsley, Rotherham, Sheffield) £699,200;

West Yorkshire (Bradford, Kirklees, Calderdale, Wakefield, Leeds) £1,137,400;

Humberside (Kingston upon Hull, NE Lincolnshire, N Lincolnshire, East Riding) £478,500;

North Yorkshire (County, and York) – *new area* £251,600.

East Midlands

Total funding: £1,845,100

Nottinghamshire (Nottingham and Nottinghamshire) £525,800;

Leicestershire (Leicester and Leicestershire) £389,200;

Derbyshire (County, and Derby) – *new area* £407,100;

Lincolnshire (County) – *new area* £265,200;

Northamptonshire (County) – *new area* £257,800.

West Midlands

Total funding: £2,426,300

Birmingham/Solihull £825,300;

The Black Country (Sandwell, Wolverhampton, Walsall & Dudley) £631,000;

Shropshire (County, Telford & Wrekin) – *new area* £207,400;

Staffordshire (County, Stoke on Trent) – *new area* £427,000;

Warwickshire (County, Coventry) – *new area* £335,600.

East

Total funding: £804,900

Norfolk £305,100;

Bedfordshire (County, Luton) – *new area* £254,600;

Suffolk (County) – *new area* £245,200.

South West
Total funding: £1,327,600
Cornwall (Cornwall with Isles of Scilly) £252,600;
Devon (County, Torbay and Plymouth) – *new area* £452,200;
Former Avon (Bristol, Bath & NE Somerset, N Somerset and S Gloucs) – *new area* £371,300;
Dorset (County, Bournemouth and Poole) – *new area* £251,500.

South East
Total funding: £1,472,200
Kent (Medway, Kent) £592,000;
East Sussex (East Sussex and Brighton & Hove) £297,700;
Hampshire (County, Southampton, Portsmouth and Isle of Wight) – *new area* £582,500.

London
Total funding: £3,349,600
All London Boroughs £3,349,600.

Community Foundation Network can be contacted on 020 7713 9326 or E-mail: smcdougall@communityfoundations.org.uk

Further information is available from the website: www.dfee.gov.uk/childrensfund or from the Children and Young People's Unit on 0207 273 5692.

MILLENNIUM VOLUNTEERS

This programme is targeted at young people and functions UK-wide but is organised differently in each of the four countries.

All young people aged 16 to 24 (inclusive) can become Millennium Volunteers. There are no benefit sanctions, whether young people are unemployed or in full or part-time education or training. Participants are supported and encouraged to make a sustained commitment to volunteering. Their achievements are recorded and recognised by a national certificate. This programme is entirely separate from the New Deal although participants can take part in both schemes. Its key principles are: community benefit; inclusiveness; ownership by young people; partnership; quality; recognition; sustained personal commitment through a Volunteer Plan; variety; voluntary participation.

England

Department for Education and Skills
Millennium Volunteers Unit, Room N2 Moorfoot, Sheffield S1 4PQ
Tel: 0114 259 4146; Helpline: 0800 917 8185; Fax: 0114 259 4510;
E-mail: millennium.volunteers@dfee.gov.uk
Website: www.millenniumvolunteers.gov.uk
Contact: Phil Naylor

Total funding: £15 million a year (2001/02–2003/04)

The central funding of this programme is already fully committed to some 200 projects by organisations contracted under this scheme. Successful bidders have met the following priorities:
- to fill in the gaps in existing MV provision across England;
- to focus on government priorities, particularly in education, health, safer communities and rebuilding local communities (particularly the most deprived local authority districts and those involved in New Deal for Communities);
- and to open up opportunities to more community-based and local voluntary organisations.

Whilst 'new' organisations are no longer be able to apply to the Department for Education and Skills it may be possible for local organisations to contact a contracted organisation to receive support for the volunteer component of their work. Access the website to find a local link.

Scotland

Volunteer Development Scotland
72 Murray Place, Stirling FK8 2BX
Tel: 01786 479593; E-mail: mv@vds.org.uk
Website: www.mvscotland.org.uk
Contact: Craig Sanderland, Scottish Co-ordinator

A consortium of four organisations – Volunteer Development Scotland, Community Learning Scotland, YouthLink Scotland and Community Service Volunteers – advises the Scottish Executive and administers the programme on its behalf. There are three categories of funding:
- Placement Providers – for organisations creating opportunities for Millennium Volunteers;
- Matchmakers – for agencies helping promote the programme, match volunteers and offer them advice, help under represented groups to become involved, etc.;
- Young People Led Projects.

Wales

Wales Council for Voluntary Action
Baltic House, Mount Stewart Square, Cardiff CF10 5FH
Tel: 02920 431700; E-mail: jcoles@wcva.org.uk
Website: www.wcva.org.uk
Contact: Jo Coles

In Wales this programme is managed by a co-ordinatory group of the Council for Wales Voluntary Youth Service, Wales Council for Voluntary Action and the Wales Youth Agency. A Millennium Volunteers information service is also provided.

Organisations may apply for grants of between £50–£5,000 to cover volunteer expenses. There are no closing dates and no limit on the number of applications a registered organisation can make.

The programme has been favourably reviewed by the Welsh Assembly.

Northern Ireland

c/o Northern Ireland Voluntary Development Agency
Annsgate House, 70–74 Ann Street, Belfast BT1 4EH
Tel: 02890 813817; Fax: 02890 237570; E-mail: helen@volunteering-ni.org
Website: www.volunteering-ni.org
Contact: Helen McDonald

Voluntary and statutory organisations have become delivery partners:
▪ supporting groups of young people wishing to set up and manage their own projects;
▪ recruiting and matching volunteers to new or existing opportunities.

The programme has been funded for a further two years to 2004. The main funding commitments have been made for this period, however valuable link ups can be made within the scheme.

YOUTH SERVICE UNIT, DFES

Department for Education and Skills, E4A Moorfoot, Sheffield S1 4PQ
Tel: 0114 259 3043; Fax: 0114 259 3180
E-mail: robert.scott@dfes.gis.gov.uk
Website: www.connexions.gov.uk
Contact: Robert Scott

Grants to National Voluntary Youth Organisations (NVYOs)
Funding: £18 million (three years 2002/05)

These grants to NVYOs finance part of the cost of projects aimed at promoting the personal and social education of young people in England. They support planned

programmes of informal and experiential education providing opportunities for young people which help them cope with the transition from childhood to adult life.

Priorities for funding

The two main objectives of the 2002/05 scheme are:

- to combat social exclusion and inequality through targeting priority groups such as the disadvantaged (especially in inner cities, on run-down housing estates or in rural areas); the disaffected or at risk of drifting into crime; minority ethnic communities; young people with disabilities;
- to raise the standard and quality of youth work by, for instance, training programmes for youth workers and volunteers, increasing young peoples' participation in management and decision-making.

The projects focuses on 13–19 year olds. Joint working and partnership among NVYOs are encouraged. The 2002/05 scheme includes several joint projects.

Grants are normally between £10,000 and £100,000 a year and do not exceed 50% of the total cost of the project. The DfES grant is for up to 50% of the cost of a project. The grant can include core funding. This recognises the cost to the organisation of running a grant-funded project.

The arts-based organisations supported under this programme include:
National Association of Youth Theatres;
National Youth Theatre of Great Britain;
National Youth Music Theatre;
Philharmonia Orchestra;
The British Gospel Arts Consortium.

Many of the organisations who get grant funding under this scheme provide youth work based on arts activities.

Exclusions: Youth exchanges, holiday playschemes, vocational preparation or volunteering for its own sake.

Applications: Advice and full guidance notes, etc, can be obtained directly from the Youth Service Unit.

All organisations applying for grant have to be registered with the department as a NVYO. The 1999/2002 scheme has some 90 registrants.

Applications for grant under the 1999/2002 scheme were called for by 12 October 1998. Successful applicants are offered grants for the financial year 1999/2000, together, if appropriate, with indicative levels of grant for the following two years. Grants in these years depends on the outcome of monitoring and evaluation.

NATIONAL VOLUNTARY YOUTH ORGANISATIONS IN WALES

Wales Youth Agency, Leslie Court, Lon Y Llyn, Caerphilly CF83 1BQ
Tel: 02920 855700
E-mail: wya@msn.com
Website: www.wya.org.uk
Contact: Wayne Warner

Grants to National Voluntary Youth Organisations in Wales

Grant total: £500,000 budgeted (2001/02); £361,000 (2000/01 and in previous two years)

This scheme is administered by the Wales Youth Agency on behalf of the Welsh Assembly.

Grants are made to assist national voluntary youth organisations working in Wales to increase the extent and quality of programmes of informal and social education for young people, in the age range 11 to 25 years, with particular emphasis on 13 to 19 year olds. Financial assistance is given towards central costs and projects undertaken by a single organisation or a combination of organisations and agencies with a distinct Welsh dimension. Any **national** voluntary youth organisation which shows that it provides good youth work (as defined by the Youth Work Curriculum Statement for Wales) is eligible to apply.

A total of 15 grants were made in 2000/01 ranging between £7,000 and £45,000. Grants do not normally exceed 50% of an organisation's total income and are available for up to three years.

Applications: Detailed guidance and application forms are available from July onwards. The deadline for applications is 1 October.

CREATIVE PARTNERSHIPS

Funding from DCMS: £40 million (2002/04)

Creative Partnerships is a national initaitive which aims to create new ways of involving young people of school age in the cultural life of their communities. The project is taking place in 16 locations throughout the country.

For more information access the following website: www.artscouncil.org.uk

METROPOLITAN AREA GRANT SCHEMES

The Association of London Government
Greater Manchester Grants Scheme
West Yorkshire Grants

In the late 1980s the metropolitan counties were abolished. There were provisions which allowed all the constituent metropolitan boroughs of a former metropolitan county to set themselves up as an association with the capacity to levy a contribution from all of them for the purposes of providing common services, including the arts. The arts funding arrangements of the three borough associations which developed from this capability are given below. They have provided significant support for arts organisations which cover more than one of the constituent boroughs.

THE ASSOCIATION OF LONDON GOVERNMENT

Social Policy and Grants Division, Arts Regeneration and Culture Team,
59 1/2 Southwark Street, London SE1 OAL
Tel: 020 7934 9999; Fax: 020 7934 9991
Website: www.alg.gov.uk
Contact: Paula Ghosh, Principal Arts Officer

A review of the Arts and Culture sector started in July 2001 and many changes are likely to take place. At the time of writing it was not possible to provide more information. Independent museums are no longer funded.

The London Borough Grants Committee (now known as the Grants Committee) merged with the Association of London Government (ALG) from the end of March 2001.

The committee which arose after the demise of the Greater London Council is the largest funder of the voluntary sector in London with over 650 organisations receiving grants in any one year. Each of the 33 London boroughs contributes to the budget of the scheme on the basis of its population. Its work covers a wide range of voluntary initiatives – housing, social services, community work, legal and other advice centres, employment, arts, recreation and the environment. Some £28 million is expected to be disbursed in 2002/03.

Grants are made to non-profit-making organisations which provide a service of benefit to *London as a whole or an area covering more than one borough*. The committee's highest priority is tackling poverty and combating disadvantage, discrimination and deprivation.

Grants, ranging in size from £2,000 to £700,000, are made to over 500 organisations a year. There are no restrictions on the kinds of grant that may be made. However large-scale capital grants are rarely given and grants are usually for one-off revenue purposes or for ongoing revenue costs. Most are approved for a year at the end of which they are reviewed for renewal.

Arts grant total: £1,676,000 (2001/02)

The Arts Funding Policy aims to:
- increase popular participation, involvement and access;
- develop support for grass roots, special communities of interest and minority arts;
- foster greater dynamism in the arts;
- improve the geographical spread of arts provision.

The committee is interested in funding strategic initiatives, rather than small highly localised activities, whatever their worth.

The breakdown of grants in groupings is as follows (figures have been rounded up).

	£
Building-based groups	825,000
Festivals	198,000
Museums	62,000
Outer London Arts Development Fund	200,000
Touring Arts	265,000
Training and Arts Coordinating	126,000

The Outer London Arts Development Scheme will continue until 2002/03. This scheme, administered in association with individual outer London boroughs, provides one-off, non-recurrent grants for projects which improve the accessibility and availability of the arts in outer London and contribute to their development. In 2001/02 a total of 30 grants were made ranging between £3,000 and £10,000. Application forms are available both from borough arts officers and the ALG. Applications have to be submitted around mid/late February. Guidelines and application forms are available from October/November.

GREATER MANCHESTER GRANTS SCHEME

AGMA Grants Unit, Chief Executive's Department, PO Box 532, Town Hall, Manchester M60 2LA
Tel: 0161 234 3364; Fax: 0161 236 5405
E-mail: agma.grants@notes.manchester.gov.uk
Contact: Grants Officer

Grant total: about £3.3 million (2002/03)

This scheme was established following the abolition of the Greater Manchester Council in 1986. The Association of Greater Manchester Authorities (AGMA)

comprises the 10 local councils (Bolton, Bury, Manchester, Oldham, Rochdale, Salford, Stockport, Tameside, Trafford, Wigan). Funding is sharply focused on strategic county-wide services. Currently there are two major funding priorities, either or both of which an organisation must meet:

- to contribute to the recognition of Greater Manchester locally, nationally and internationally as a creative and vibrant county helping to create the conditions necessary to attract potential investment;
- to contribute to an improved quality of life for all its residents through its first priority above and by supporting agencies which assist those who are vulnerable or disadvantaged.

In addition emphasis is placed on organisations which:
- attract significant revenue from other sources;
- provide a county-wide service or form part of a county-wide service or which contribute to an issue of county-wide concern;
- provide coverage over at least the majority of the 10 districts.

Note: *The criteria for the scheme were under review in spring 2002.*

In 2001/02 most of the funding was distributed in **revenue grant-aid**. The major part of this funding was disbursed to 20 arts organisations. The largest grants, ranging between £120,200 and £547,800 were made to:

North West Arts Board;

Hallé Concerts Society;

National Museum of Labour History;

Royal Exchange Theatre Company;

Contact Theatre Company.

A further 10 arts organisations received **one-off** grants ranging between £1,000 and £5,000 including: GW Theatre Company; Black Labrador Community Arts; Business in the Arts: North West.

No new revenue funds are available.

Exclusions: Individuals.

Applications: Full guidelines and an application form should be obtained for the one-off funding. There are four funding cycles a year: January for consideration in May; April for consideration in August; July for consideration in November; October for consideration in February.

WEST YORKSHIRE GRANTS

PO Box 5, Nepshaw Lane South, Morley, Leeds
Tel: Direct line: 0113 289 8215; Fax: 0113 253 0311
E-mail: jmitchell@wyjs.org.uk
Website: www.wyg.wyjs.org.uk
Contact: Janet Mitchell, Grants Officer

Grant total: £1.13 million (2002/03 and 2001/02); £1.16 million (2000/01)

Note: *Policies and criteria may be revised for 2003/04.*

These grants are administered by a joint committee of the metropolitan district councils of Bradford, Calderdale, Kirklees, Leeds and Wakefield. Priority is given to:

- organisations that make a strategic impact on the social or cultural infrastructure of West Yorkshire, taking into consideration the number of districts served, the funding received from other sources including local authorities, and the level of user support;
- organisations providing support services to the voluntary sector in West Yorkshire.

Organisations must operate in or benefit people from a minimum of three districts. Grants are only offered on an annual basis.

The majority of the 36 grants given in 2002/03 were at a standstill level. In 2001/02 a total of 32 grants was made ranging between £2,000 and £289,542 with much of the funding allocated to art organisations. The largest grant was made to Opera North. Arts grants included:

Opera North (£289,542);
Northern Ballet Theatre (£165,550);
West Yorkshire Playhouse (£97,659);
Public Arts (£20,500);
Huddersfield Contemporary Music Festival (£14,722);
Bradford Film (£9,422);
Artlink West Yorkshire (£7,852);
Ilkley Literature Festival (£5,125);
Mikron Theatre (£4,000).

Applications: Full eligibility critieria are available from the grants officer. The closing date is normally the end of October for funding in the following year.

LOCAL AUTHORITY FUNDING

This introduction gives some basic advice to newcomers about the structures and responsibilities of local authorities and about how to develop fruitful relationships with them.

Most arts groups – whether large, medium, or small; conventional or experimental; new or long-established; professional or amateur; performance, visual, literary – find that their relationships with the local authority/authorities in which they work are essential to them. These relationships are likely to be in a variety of working partnerships in which the financial assistance that the local authority may also be able to offer is not the primary or sole link. As is shown in the tables below, the total spend by local authorities on grants to artists and arts organisations is not inconsiderable but far smaller than the amount they spend on the services they provide and run themselves.

LOCAL CULTURAL STRATEGIES

Arts organisations need to understand the organisation of the local authority for their own area and not assume that one authority is the same as another in its structures – this is often far from the case. By nature local authorities are individualistic. Arts organisations need to be informed about the development of their particular local arts strategies and to tap into it.

They need also to be aware of the place of the arts within the wider cultural context of their area. The Department for Culture, Media and Sport published in mid-1999 *Local Cultural Strategies,* Draft Guidance for Local Authorities, which had been prepared in partnership with the Local Government Association, the Chief Leisure Officers' Association and a wider steering group of professional associations and non-government agencies. **Local Cultural Strategies** will aim to co-ordinate cultural activities and integrate them into overall development plans and strategies. Fourteen local authorities piloted this work between 1999–2001, but many other authorities have also been embarking on this work. Consultation is a key feature, indeed a requirement, in the development of these strategies – so arts agencies of all kinds will be consulted along with many other local organisations and groups. Arts organisations should be ensure they take part in this important aspect of local influence. (These are paralleled by **Regional Cultural Consortiums** which have also been developing their own regional strategies – see separate entry).

In May 2002, the Local Government Association published a paper *A Place at the Table? culture and leisure in modern local government* about how 'culture is playing its part in the wider corporate agenda'. It is very useful reading for art organisations giving a picture of the current position and its opportunities. It is accessible via the website www.lga.gov.uk (search under the title).

LOCAL GOVERNMENT ORGANISATION

Local government in the UK is structured in two contrasting ways. In Scotland, Wales, Northern Ireland and parts of England, a single tier 'all purpose council' is responsible for all local authority functions (These include Unitary, Metropolitan or London Borough authorities.) The remainder of England has a two-tier system, in which two separate councils divide responsibilities between district and county councils.

In England, unlike Scotland and Wales, the introduction of unitary authorities has been piecemeal. Some counties and districts have been abolished and replaced entirely by unitary authorities (Berkshire) whilst other counties remain (Surrey). In many counties new unitary authorities co-exist alongside the counties of which they had formerly been a part. So the local authority system in England has become extremely varied. At the time of writing (spring 2002) there were 34 county councils, 238 district councils, 47 English shire unitary authorities, 33 London boroughs and 36 metropolitan authorities.

The two-tier structure

Since the two-tier structure of county and district councils will remain in many areas it is important to distinguish their different responsibilities. The following table shows which level of council to approach, the overlapping interests and also those areas that are not specifically arts-related but which can be useful sources of support, for instance:

- education departments (buildings, artists in schools programmes, discretionary grants to young people for advanced study in the arts, etc.);
- libraries and museums services (organisation of events as part of educational and outreach work);
- economic development and tourism departments (strategies to attract visitors and inward investment particularly the special action zones, and European funding);
- planning departments (urban and rural development);
- social services (arts activities for client groups).

Many authorities, both county and district have European Officers. (Enquire of the Chief Executive's Department.)

Main functions of County and District Councils

County Councils	District Councils
Education	Council tax/uniform business rate collection
Personal social Services	Housing
Planning	Planning
• strategic planning	• local plans
• mineral and waste	• applications (listed buildings)
• highway development control	
• historic buildings	

Transport
- public transport
- highways/parking
- traffic management
- footpaths/bridleways
- transport planning

Emergency planning

Environmental services
- waste disposal

Recreation and art
- parks and open spaces
- support for the arts
- museums
- encouraging tourism

Economic development

Libraries

Consumer protection

Transport
- unclassified roads
- offstreet car parking
- footpaths/bridleways
- street lighting

Emergency planning

Environmental services
- waste collection
- building regulations
- general environmental services
- street cleaning
- environmental health

Recreation and art
- parks and open spaces
- leisure centres/swimming pools
- museums/art galleries
- encouraging tourism

Economic development

Revenue Collection

Further Information

The Local Government Association puts out some very useful factsheets about the structures and responsibilities of local authorities which are also available on the web. Contact: Local Government Association, 26 Chapter Street, London SW1P 4ND Info line Tel: 020 7664 3131; Fax: 020 7664 3030; Website: www.lga.gov.uk

LOCAL GOVERNMENT ARTS EXPENDITURE IN ENGLAND

County councils, in many areas of the country, have a long history of working in close co-operation with district councils to develop the arts. In general, districts tend to provide facilities and support for community arts and the amateur arts sector, while county councils concentrate on support for strategic arts organisations, links with library and education services, and the development of innovative arts projects.

The following tables display their expenditure between the various types of authority which now exist. By far the highest area of expenditure is on venues.

Total net revenue expenditure, 2000/01

by main budgetary heading and authority type (£ millions)

	Counties	Unitary	Districts	Met. districts	London authorities (a)	Section 48 Schemes	Total (b)
Net spending on venues	0.7	17.2	40.1	16.8	26.1	–	100.9
Arts development/ staff costs	1.5	2.5	8.4	2.5	2.8	–	17.6
Net spending on promotions	0.2	1.2	2.7	1.3	1.3	–	6.6
RAB subscriptions	0.6	0.5	0.6	0.6	–	0.3	2.6
Grants to artists/arts organisations	2.4	4.1	4.5	10.6	6.3	5.1	33.0
Total net revenue spend (b)	**5.4**	**25.5**	**56.3**	**31.8**	**36.5**	**5.4**	**160.8**

Note: n=279

(a) Includes City of London

(b) Totals may not sum due to incomplete data and/or rounding

Section 48 refers to funding by joint metropolitan authorities (see entries)

Source: *Local Authority Expenditure on the Arts in England, 2000/01*
Arts Council of England, April 2002

Total Net Revenue Expenditure – 1997/98

by main budgetary heading and authority type (£ millions)

	Counties	Unitary	Districts	Met	London	Section 48	Total*
Net spending on venues	2.3	14.0	48.5	16.4	27.3	0.0	108.6
Arts officers/development	1.7	1.2	7.3	1.9	1.3	0.0	13.5
Net spending on promotions	0.5	0.1	2.1	0.7	0.7	0.0	4.1
RAB subscriptions	1.1	0.3	0.7	0.5	0.0	0.3	2.9
Grants to artists/arts organisations	3.8	2.5	4.5	9.7	4.8	5.0	30.4
Total net revenue spend*	**9.5**	**18.3**	**63.6**	**29.1**	**34.1**	**5.3**	**159.7**

Note: *totals may not sum due to rounding

Section 48 refers to funding by joint metropolitan authorities (see entries)

Source: *Local Authority Expenditure on the Arts in England, 1997/98*
Arts Council of England, March 1998

As these tables show, expenditure by local authorities on the arts has not increased in real terms in the three years since 1997/98. In fact the rise in the overall expenditure between these years is a mere £1.1 million. Not 'level pegging'!

Spending on venues accounts for the highest proportion, well over two thirds, of local authorities' total arts expenditure. But there has been a noticeable drop, from 68% in 1997/98 to 63% in 2000/01 in its proportional contribution over this period. This fall is due largely to the reduction in spending on venues by district authorities, the largest contributor (down to £40.1 million in 2000/01 from £48.5 million in 1997/98).

During this period 1997/98–2000/01, staff, promotional costs and grants to artists/ arts organisations have risen, However the proportionate rise in grants to artists/arts organisations is lower than for staff and promotion costs.

LOCAL CONTACTS

Readers seeking grants and other forms of advice and support should be in touch with the range of local authority officers with information and support services of value to their organisation. The varied range of potential contacts has been indicated above. In addition your authority may well have a Lottery Officer. You may find it rewarding to develop working relationships with officers dealing with regeneration, employment/training and with links to European Structural Funds, and with social services officers, as well as with arts officers. It cannot be taken for granted that the arts officer will be fully conversant with the opportunities in other sectors of council business.

Whilst it is vital to contact the arts officer, if there is one, or to find the officers responsible for the arts who service the relevant committees, it is also vital find out the names of the councillors serving on committees, particularly the chairperson.

There are very few committees dealing solely with the arts. Responsibility for the arts may be shared with leisure, sport, tourism, community development, environment and amenities, and so on. The most common form of decision-making body for making grants to arts organisations and individual artists is the Leisure Services Committee (or similar bodies such as Leisure and Amenities, Leisure and Tourism, Community and Leisure, Recreation and Tourism, and occasionally Tourism and Economic Development). Often more than one committee may be involved and the full leisure committee may work in tandem with a financial committee – Policy and Resources, or General Purposes.

Whilst there are a few authorities with specialist arts committees or committees with arts in their title, the general pattern is for a sub-committee, answerable to a policy and resources or leisure committee, to have delegated responsibility for arts grants and/or grants generally.

That being said, 'modernisation' taking place in local government is leading to the development of new structures of decision-making. A cabinet style of decision-making is subsuming these committees in some authorities.

Developing relationships with local authorities

The level of support given to the arts will vary considerably from one council to another, with some being generous, and others less so. Where a group is based (or, if itinerant, where it performs or mounts its exhibitions) can make an enormous difference to its chances of getting support and to the number of levels of council officialdom it has to contact and the degree of advice and support it obtains.

Find out about their arts interests

Before approaching councillors and council officers, it is wise to find out how much your local council gives to the arts and the particular projects it supports. This information is readily available in the minutes of local meetings. It is also interesting to find out what comparable councils give. If yours is one of the councils which is spending little on the arts, it may be useful long-term ammunition to be able to underline this point to your council by making suitable comparisons, though this will probably not help you much in the short term where changes in council budgets are unlikely.

Vital research

Acquaint yourself with the working procedures of your local councils. Find out:

- what principal responsibilities each tier or type in your area has, particularly with regard to the arts;
- what each relevant council's stated policies are, so that if, for example, a council lays strong emphasis on providing educational facilities and services you may be able to take advantage of this when applying for a grant for any part of your operation which fits into the education category;
- how and when decisions on grant-making are taken;
- what organisations they have funded in the past and the amounts they have given in individual grants – this more than anything else will give you a picture of their general approach and preferences for arts support;
- which councillors and council officers will be involved in the decisions to fund you and which are likely to be sympathetic to your organisation. Some councils have specially appointed arts officers and if there is one in your area he/she should obviously be your first contact.

A good source of information on your council's attitude to the arts should be, once again, your **Regional Arts Board**. Its staff will be experienced in dealing with all the different local authorities in their region and will know many of the problems you are likely to come up against as well as, hopefully, some factors which might operate in your favour. There are many funding partnerships between local authorities and RABs, and certainly much mutual consultation between these bodies.

Making your case

Once you have discovered the councillors and council officers whose support you need, you should spend time interesting and involving them in your organisation. Invite them to events, which will also be a good opportunity for them to meet your colleagues. If there are people with local influence on your board or who support you in some way, persuade them to talk to some of the key councillors and officials

about the value of your organisation. (It is advisable to check these local VIPs' political persuasions first, and 'match' them with councillors with similar political views.) It is a good idea to prepare the ground in this way before a formal application is made for grant, so that you have a fair idea of what will be acceptable and what will not. Make sure that all those responsible for contacting and lobbying councillors are properly briefed: first, on the local importance of the organisation (backed up by audience figures, analysis, etc.) and, second, on what is needed from the council. If councillors receive conflicting or muddled statements from a variety of sources this could damage your case considerably.

Particular considerations

Apart from information particular to your council, there are criteria which all councils are likely to use when considering your proposal which you should take into account at an early stage.

- How well does the work and objectives of your organisation fit in with your council's stated policies and priorities?
- Are there any organisations in the area doing similar work? If there are, do these organisations receive local authority funding? Are there sound reasons why the authority should fund your organisation as well as, or instead of, those it is already funding?
- How successful are you? Is your work of a high calibre? And what outside evidence can you obtain to support this? How many people attend your events? And how many of them come from the local authority area? Are there other ways in which you can demonstrate local community support, such as membership or local fund-raising?
- How well organised are you in terms of financial and administrative control? Are you reliable? Is your work endorsed by way of grants from the Arts Council, your RAB or one or other of the leading trusts with an interest in the arts?
- How strongly do the local people feel about you as a valuable amenity? Would local opposition be strong if you were forced to disband from lack of funds?

Media coverage

While you are talking privately to council officers and councillors you should also be directing your efforts at your local media to reinforce your message. Items on local radio and in the local paper about the importance and quality of your work, reviews and interviews in which you outline future plans of benefit to the community should also have an effect on councillors' opinions.

Council Tax relief

In addition to giving you a grant, or as an alternative, the local authority can also give you relief on your Council Tax. If your organisation is a registered charity you can get 80% relief on any premises you occupy. Your local authority can also at its own discretion give you relief on all or part of the remaining 20%. Council Tax relief is given only if you apply for it and only for the current and following rate years (1 April to 31 March). It cannot be granted retrospectively. You can apply for Council Tax relief, however, even if your charitable status has not yet been officially approved by the Charity Commission (the Inland Revenue in Scotland and Northern Ireland).

Once you have been granted Council Tax relief, you should continue to obtain it automatically, but check your annual bill to make sure this is happening. Because of pressure on financial resources, many councils are now less willing to give discretionary relief. But it is certainly worth applying for it, and continuing to apply for it each year, if you are unsuccessful at the first attempt.

Local councils may be able to offer you gifts in kind as well as cash grants: second-hand office equipment and furniture; premises for your use either free or at a low rent; help with transport maintenance; staff secondments (though these are rarely made in the arts field); access to the council bulk purchasing scheme which may offer lower prices than elsewhere. But you will only be able to find out if such support is available if your contacts with councillors and council officials are good.

Regular contact

Whatever support you are looking for, you should be talking regularly to councillors and council officials, especially those who are of particular importance to you. Keep them informed of your activities throughout the year, not just when grant application time looms again. Many arts organisations have a representative from their local authority on their board of trustees or management. This can be an excellent way of ensuring the continuing interest and commitment of your local authority. Don't forget to maintain the interest and support of all the political parties represented on your council so that, whichever party has the majority at a particular time, those in power will always be aware of and sympathetic to your organisation.

Acknowledgements and personal thanks

And, as always, you must say thank you for any assistance you receive from them. Remember too, to credit the council in publicity material, in media interviews and in formal speeches. The council (as well as councillors who will always have one eye on the next election) needs a good press as much as you do.

ENTERPRISE/BUSINESS DEVELOPMENT AGENCIES

Regional bodies:
Regional Cultural Consortia/DCMS contacts in Government Offices
Regional Development Agencies
Government Offices for the Regions
Regional Networks for Voluntary and Community Organisations

Other:
Business Support and Advice Networks
Arts Connection
CIDA – Creative Industries Development Agency, Huddersfield
CIDS – Cultural Industries Development Service, Manchester
Creative Advantage Fund – West Midlands
Creative Industries Development Team, Bolton/Rochdale
Creative People
Cultural Business Venture (North)
Cultural Enterprise, Cardiff
Highlands and Islands Arts Ltd (HI Arts)
Inspiral, formerly ACT (Action for Business and Culture) Ltd
Merseyside ACME (Arts, Culture, Media and Enterprise)
Merseyside Music Development Agency
Phoenix Fund
The Prince's Trust
The Rural Development Council for Northern Ireland
Tower Hamlets Cultural Industries Development Agency
Youth Cultural Business Venture (North)

Regional bodies

REGIONAL CULTURAL CONSORTIA/DCMS CONTACTS IN GOVERNMENT OFFICES

The consortia aim to:
- champion the spectrum of cultural and creative industries in each region, including tourism and sport;
- forge links across this spectrum;
- create a common vision expressed in a cultural strategy for the region.

Consortia promote and speak for all the cultural sectors within a region, and advise and inform central government, Lottery distributors, local government and regional bodies such as Regional Development Agencies. One of their major tasks has been to draw up a cultural strategy for their respective regions, with a common focus drawing together the many threads and identifying priorities for the region. Consortia will be made up of various interests within regions, which could include voluntary sector organisations.

There are eight consortia with boundaries coterminous with those of Regional Development Agencies and Government Regional Offices. They can be contacted through Government Offices – see separate entry for addresses.

Instead of a consortium, London has a Cultural Strategy Group to advise the Mayor.

The consortia held a review (available May 2002) only two years after they were formed in order to be able to contribute to the White Paper on Regional Governance. This may qualify or alter the nature of their work.

DCMS representatives in Government Offices – March 2002
In most cases each is the secretary/contact point for their respective Regional Cultural Consortium.

East of England
Government Office for the East of England
Building A, Westbrook Centre, Milton Road, Cambridge CB4 1YG
Tel: 01223 345964; Fax: 01223 347544
Contact: Tim Freathy; E:-mail: tfreathy.go-east@go-regions.gov.uk

East Midlands
Government Office for the East Midlands
Belgrave Centre, Stanley Place, Talbot Street, Nottingham NG1 5GG
Tel: 0115 971 2668; Fax: 0115 971 2547
Contact: Anne Rippon; E-mail: arippon.goem@go-regions.gov.uk

London
Government Office for London
98 Riverwalk House, 157–161 Millbank, London SW1P 4RR
Tel: 020 7217 3514; Fax: 020 7217 3471
Contact: Andy Ganf; E-mail: aganf.gol@go-regions.gov.uk

North East
Government Office for the North East
Wellbar House, Gallowgate, Newcastle upon Tyne NE1 4TD
Tel: 0191 202 3878; Fax: 0191 202 3830
Contact: Jamie McKay; E-mail: jmckay.gone@go-regions.gov.uk

North West
Government Office for the North West
Sunley Tower, Piccadilly Plaza, Manchester M1 4BE
Tel: 0161 952 4341; Fax: 0161 952 4365
Contact: Janet Matthewman; E-mail: jmatthewman.gonw@go-regions.gov.uk

South East
Government Office for the South East
Bridge House, 1 Walnut Tree Close, Guildford GU1 4GA
Tel: 01483 882281; Fax: 01483 882469
Contact: Dan Chadwick; E-mail: dchadwick.gose@go-regions.gov.uk

South West
Government Office for the South West
2 Rivergate, Temple Quay, Bristol BS1 6ED
Tel: 0117 900 1839; Fax: 0117 900 1920
Contact: Barry Cornish; E-mail: bcornish.gosw@go-regions.gov.uk

West Midlands
Government Office for the West Midlands
Business and Learning Division, 77 Paradise Circus, Queensway,
Birmingham B1 2DT
Tel: 0121 212 5229; Fax: 0121 212 5301
Contact: Liz Charlton; E-mail: echarlton.gowm@go-regions.gov.uk

Yorks & Humber
Government Office for Yorkshire & the Humber
City House, PO Box 213, New Station Street, Leeds LS1 4US
Tel: 0113 283 5452; Fax: 0113 283 5303
Contact: Bernard McLoughlin; E-mail: bmcloughlin.goyh@go-regions.gov.uk

REGIONAL DEVELOPMENT AGENCIES (RDAs)

Regional Development Agencies (RDAs) were formally launched in eight English
regions in April 1999. The ninth, in London, was set up in July 2000 following the
establishment of the Greater London Authority (GLA). They aim to co-ordinate

regional economic development and regeneration, enable the English regions to improve their relative competitiveness and reduce the imbalances that exist within and between regions. They have five core areas of statutory responsibility:

- economic development and regeneration;
- competitiveness, business support and investment;
- skills;
- employment;
- sustainable development.

Their specific functions are:

- formulating a regional strategy in relation to their purposes;
- regional regeneration;
- taking forward the government's competitiveness agenda in the regions;
- taking the lead on regional inward investment;
- developing a regional Skills Action Plan to ensure that skills training matches the needs of the labour market;
- a leading role on European funding.

RDA boundaries: They have the same boundaries as the Government Offices for the Regions.

Composition of boards, appointment of chairs and board members: The boards of the RDAs are business-led, with other board members reflecting regional interests, such as the voluntary sector, rural areas, and tourism, and will include four local authority members out of a total of 13.

Regional Chambers or Assemblies

The terms 'Chamber' and 'Assembly' tend to be used interchangeably and refer to either of two different forms of regional association in the *non-London regions*. This can cause confusion. They are either:

- designated by government. bringing together elected representatives from local authorities (70%) and other regional partners, including the voluntary sector (30%), or
- organised by local authorities – groupings of local authorities which have developed in some regions and which are also known either as chambers or assemblies. Some of them work together with the designated associations.

In May 2002, the government published proposals to introduce *elected* regional assemblies throughout England. It is unclear whether these will be put in place. Certainly a whole new layer of bureaucracy would result.

The Greater London Authority (GLA) and the London Development Agency

The situation in Greater London is more complex. Here a whole new strategic body of government and democratic system has been developed. Since May 2000 the Greater London Authority has been led by an elected Mayor and Assembly. It co-ordinates and funds many basic services – the London Development Agency, Transport for London, the Metropolitan Police Authority, London Fire and the Emergency

Planning Services. The GLA has also absorbed the London Planning Advisory Committee, the London Ecology Unit and the London Research Centre. The Mayor has a Cultural Strategy Group.

The London Development Agency is responsible for the economic and regeneration strategy for London as with other RDAs but with no specific mention of responsibility for environmental sustainability (there are particular arrangements with the Mayor and the Assembly for this in London).

Regional Economic Strategies (RES)

All RDAs have been required to produce a strategy. The fundamental purpose of these is to 'improve economic performance and enhance the region's competitiveness' and address the underlying problems of unemployment, skills shortages, inequalities, social exclusion and physical decay. The RDAs are also expected to identify 'key partners' to help in the delivery of their action plans including the voluntary sector.

Regional networks of voluntary and community organisations have been formed to address these new challenges (see separate listing).

RDA contact details

One NorthEast
Great North House, Sandyford Road, Newcastle Upon Tyne NE1 8ND
Tel: 0191 261 2000; Fax: 0191 201 2021;
E-mail: Enquiries-greatnorthhouse@onenortheast.co.uk
Website: www.onenortheast.co.uk

North West Development Agency
Renaissance House, PO Box 37, Centre Park, Warrington WA1 1XB
Tel: 01925 400 100; Fax: 01925 400 400; E-mail: information@nwda.co.uk

Lancaster House, Mercury Court, Tithebarn Street, Liverpool L2 2QP
Tel: 0151 236 3663; Fax: 0151 236 3731
Website: www.nwda.co.uk

Yorkshire Forward
Victoria House, 2 Victoria Place, Leeds LS11 5AE
Tel: 0113 243 9222; Fax: 0113 243 1088 E-mail: skills@yorkshire-forward.com
Website: www.yorkshire-forward.com

Advantage West Midlands
2 Priestly Wharf, Holt Street, Aston Science Park, Birmingham B7 4BZ
Tel: 0121 380 3500; Fax: 0121 380 3501; E-mail: message@advantagewm.co.uk
Website: www.advantagewm.co.uk

East Midlands Development Agency
Apex Court, City Link, Nottingham, NG2 4LA
Tel: 0115 988 8300; Fax: 0115 853 3666; E-mail: info@emd.org.uk
Website: www.emda.org.uk

East of England Development Agency

The Business Centre, Station Road, Histon, Cambridge CB4 9LQ
Tel: 01223 713 900; Fax: 01223 713 940; E-mail: knowledge@eeda.org.uk
Website: www.eeda.org.uk

South West of England Regional Development Agency

Sterling House, Dix's Field, Exeter EX1 1QA
Tel: 01392 214 747; Fax: 01392 214 848
Website: www.southwestrda.org.uk

SEEDA

Cross Lanes, Guildford, GU1 1YA
Tel: 01483 484 226; Fax: 01483 484 247; E-mail: info@seeda.co.uk
Website: www.seeda.co.uk

London Development Agency

Devon House, 58/60 St Katharine's Way, London E1 9LB
Tel: 020 7680 2000; Fax: 020 7983 4801
Website: www.lda.gov.uk

Greater London Authority

Tel: 020 7983 4145
Website: www.london.gov.uk

Regional Development Agencies are increasingly involved in supporting activities
which can be referred to under the general banner 'creative industries'. Some examples
follow.

- RDAs are playing their part in the establishment of regional media agencies (see
 separate entries).
- SWRDA invested over a two-year period in the development of Ilfracombe's
 national youth arts festival run by the local Channel Arts Assocation.
- Advantage West Midlands is one of the founding investors in Creative Advantage
 West Midlands – a venture capital fund launched in March 2000 to invest in
 creative industries in the West Midlands.

GOVERNMENT OFFICES FOR THE REGIONS

The Regional Coordination Unit, based in the Office of the Deputy Prime Minister
in the Cabinet Office, co-ordinates the government regional initiatives and is
responsible for the staff in the nine regional offices.

**See also the entry for Regional Cultural Consortia. Addresses and contacts
are given there.**

Government Office for the East of England
Website: www.go-east.gov.uk

Government Office for the East Midlands
Website: www.go-em.gov.uk

Government Office for London
Website: www.go-london.gov.uk

Government Office for the North East (GONE)
Website: www.go-ne.gov.uk

Government Office for the North West
Website: www.go-nw.gov.uk

Government Office for the South East
Website: www.go-se.gov.uk

Government Office for the South West
Website: gosw.gov.uk/gosw

Government Office for the West Midlands
Website: www.go-wm.gov.uk

Government Office for Yorkshire and the Humber
Website: www.goyh.gov.uk

REGIONAL NETWORKS FOR VOLUNTARY AND COMMUNITY ORGANISATIONS

These networks have developed to address and mirror Regional Development Agencies and Regional Chambers. Changes will inevitably occur.

The Regional Voluntary Sector Networks Forum has been created to help the sharing of information and experiences within different RDA areas and to provide a nationwide voice. The individual regional networks are listed below.

The National Council for Voluntary Organisations (NCVO) provides information and support to voluntary organisations working within the regional agenda on its website: **www.voluntaryorganisations-regions.org.uk**

The NCVO also has a 'Regions Network' which you can join via the website.

East Midlands Voluntary Sector Forum
Engage East Midlands
7 Mansfield Road, Nottingham NG1 3FB
Tel: 0115 934 8471; Fax: 0115 934 8440; E-Mail: emvsf@hotmail.com
Contact: Wynne Garrett, Chief Executive

Eastern
COVER
Centre 4A, Gonville Place, Cambridge CB1 1LY
Tel: 01223 471 682; Fax: 01223 471 683; E-mail: office@cover-east.org.uk
Website: cover-east.org
Contact: Andrew Cogan, Chief Executive

London Region
Third Sector Alliance
c/o London Voluntary Service Council, 356 Holloway Road, London N7 6PA
Tel: 020 7700 8124; Fax: 020 7700 8108; E-mail: 3sa@lvsc.org.uk
Website: www.lvsc.org.uk
Contact: Colin Bowen

North East
Voluntary Organisations Network North East (VONNE)
Percy House, Percy Street, Newcastle upon Tyne NE15 4QL
Tel: 0191 233 2000; Fax: 0191 222 1998; E-mail: vonne@vonne.co.uk
Website: www.vonne.co.uk
Contact: Ray Cowell, Director

North West
Voluntary Sector North West c/o Greater Manchester Centre for Voluntary Organisations
St Thomas Centre, Ardwick Green North, Manchester M12 6FZ
Tel: 0161 276 9300; Fax: 0161 276 9301
Website: www.netc.org.uk
Contact: Gil Chimon, Chief Executive

South East
RAISE
Berkeley House, Cross Lanes, Guildford GU1 1UN
Tel: 01483 500 770; Fax: 01483 574 439; E-mail: mail@raise-networks.org.uk
Contact: Rob Woolley, Chief Executive

South West Forum
c/o Community Council of Devon
County Hall, Topsham Road, Exeter EX2 4QB
Tel: 01392 382822; Fax: 01392 382258; E-mail: admin@southwestforum.org.uk
Contact: Stephen Woolett, Chief Executive

West Midlands
Regional Action West Midlands
4th Floor, Daimler House, Paradise Circus, Queensway, Birmingham B1 2BJ
Tel: 0121 616 4720; Fax: 0121 616 4728; E-mail: rawm@rawm.co.uk
Contact: Chris Bonnard, Chief Executive

Yorkshire and the Humber
Yorkshire/Humberside Regional Forum for Voluntary and Community Organisations
3rd Floor Goodbard House, 15 Infirmary Street, Leeds LS1 2JS
Tel: 0113 243 8188; Fax: 0113 243 5446; E-mail: office@yhregforum.org.uk
Website: www.yhregforum.org.uk
Contact: Steve Webster, Information and Policy Officer

Other

Introduction

This section gives a selection of the agencies that have grown up at a local and regional level to support the creative industries. This area of support has developed considerably in recent years.

Impetus has been given to the film and television industries at regional level through the establishment of regional media agencies. These are listed in the Media/Moving Image section following the Film Council entry.

Please take this list as only indicative. Be sure to contact your regional arts office and most particularly your local authority to find out if there are any support agencies in your area.

BUSINESS SUPPORT AND ADVICE NETWORKS

The following national networks of business advice centres provide help for all sizes of businesses, whether starting up or looking to expand. They put enquirers in touch with the sources of support within a specific area. These vary, with different combinations of organisations and different funding opportunities from area to area. In 2001 the Small Business Service replaced the business support role of the Training and Enterprise Councils.

England
Business Links
Tel: Business Link Signpost Number 0845 756 7765
Websites: www.businesslink.co.uk www.businessadviceonline.org
A national network of 45 Business Link advice centres.

Scotland
Small Business Gateway
Tel: 0845 609 6611
Website: www.sbgateway.com
A network of business advice centres across Scotland. Phone the number above to find your local branch.

Wales
Business Connect
Tel: 08457 969798
Website: www.businessconnect.org.uk

Northern Ireland
Customer Information Point, Department of Enterprise, Trade and Investment
Tel: 028 90 529 555
Website: www.deti.ni.gov.uk

ARTS CONNECTION

PO Box 305, Huntingdon PE29 1EY
Tel: mobile: 07899 794389
E-mail: elizas@princes-trust.org.uk
Contact: Eliza Sellen, Regional Co-ordinator

Total funding: around £250,000 (2001/02–2001/04)

Arts Connection is a collaboration between East England Arts and the Prince's Trust plus European Social Fund to assist disadvantaged people aged between 18 and 30 to set up their own creative businesses. It is expected that a total of 150 businesses will be supported over a three-year period from mid-2001.

Start up loans/grants are made up to a maximum of £5,000. The average is £2,500 to £3,000.

The package of support includes start-up funds, business planning advice, practical support and mentoring.

CIDA – CREATIVE INDUSTRIES DEVELOPMENT AGENCY, HUDDERSFIELD

The Media Centre, Huddersfield HD1 1LR
Tel: 01484 483140; Fax: 01484 513739
E-mail: info@cida.org
Website: www.cida.org
Contact: Anamaria Wills, Executive Director

Information networks such as the Creativity Forum, sourcing finance through the Creativity Investment Scheme, direct and technology-based learning packages, brokering and mentoring facilities and the provision of workspace, are just some of the many initiatives on offer.

All centre around the Kirklees Media Centre.

CIDS – CULTURAL INDUSTRIES DEVELOPMENT SERVICE, MANCHESTER

1st Floor, The Department Store, 5 Oak Street, Manchester M4 5JKD
Tel: 0800 169 1143; Fax: 0161 834 3728
E-mail: enquiries @.cids.co.uk
Website: www.cids.co.uk

An information hub providing signposting for training, finance and market development for firms across Manchester's City Pride Area (which includes Manchester, Salford, Tameside and Trafford local authorities). CIDS provides a free co-ordinated range of business support services from new start and expansion to export.

CREATIVE ADVANTAGE FUND – WEST MIDLANDS

West Midlands Arts, 82 Granville Street, Birmingham B1 2LH
Tel: 0121 631 3121 x222; Fax: 0121 643 7239
E-mail: fred.brookes@west-midlands-arts.co.uk
Website: www.creative-advantage-fund.co.uk

Total capital: £1.3 million

The Creative Advantage Fund is a venture capital fund launched in March 2000 to invest in creative industries in the West Midlands Objective Two region. It is supported by the European Union Regional Development Fund, Birmingham Venture Capital, West Midlands Arts, Advantage West Midlands, the Arts Council of England, Birmingham City Council, Eversheds and Carlton.

Creative Industries include advertising, architecture, arts, craft, design, designer fashions, film, interactive leisure software, music, performing arts, publishing, business software, television and radio.

The fund makes investments of between £5,000 up to £130,000. When the businesses reach a sufficient level of profit, typically within three to seven years, it will sell its shares in them. The fund in this way aims to become a permanent revolving fund. **It does not make grants or soft loans** but invests on strictly commercial terms in the share capital of creative businesses that are capable of generating substantial profits and growth. This means that applicants must be prepared to allow the fund to share in their future profits, but the fund will not normally be seeking any security or personal guarantees.

Any profits made by the fund are reinvested in other businesses and **not** distributed to investors.

By August 2001 the fund had made 11 investments in nine companies totalling £690,000 ranging from £10,000 to £130,000. Several more investments were at various stages of completion/approval amounting to another £420,000 and making a total of £1.1 million. The fund expected to have invested all of its £1.3 million capital by the end of 2001. Successful investments by the fund include:
Her Films Ltd, Coventry, a feature film development, financing and sales company; Eureka/Inspirational Design Ltd who create exciting learning environments and *Fused* magazine.

CREATIVE INDUSTRIES DEVELOPMENT TEAM, BOLTON/ROCHDALE

The Enterprise Centre, Washington Street, Bolton BL3 5EY
Tel: 01204 336181; Fax: 01204 336196
E-mail: cidt@boltonenterprise.co.uk
Website: for Bolton: www.cidt.org.uk; for Rochdale:
www.creativerochdale.org/index2.htm

The team was set up by Bolton MBC in 1998 with funding from Government Office North West's Retex programme and ERDF. Its remit is to assist the growing

number of cultural businesses in Bolton. It has built 17 workshops with subsidised rent. It offers business advice and guidance and has assisted clients with exhibitions and trade fairs at home and abroad. In 2000 it won the contract to carry out a similar service for Rochdale MBC.

CREATIVEPEOPLE

Tel: 01883 371112/345004
E-mail: barbarabrunsdon@hotmail.com
Website: www.creativepeople.org.uk
Contact: Barbara Brunsdon, Project Manager

Funding: £3.8 million including £1 million over 2 years from the Arts Council of England

CreativePeople is a national network of 10 consortia dedicated to providing advice and guidance to support the professional development of people working in arts and craft industries and to enable them to take a more planned approach. The various consortia are geographical, artform-based, (such as community musicians, dance, craft and literature) or those that provide cross-cutting support in areas such as technology and arts management. The full-time project manager is supported by two workers serving the needs of disabled people and addressing cultural diversity.

During the initial two year period CreativePeople is not covering all art forms or geographical areas. By the end of that period, however, it will have a plan for expanding the network to cover all areas and art forms with recognised and tested means of delivery. Together the consortia will create an information resource which will provide guidance on training and professional development opportunities throughout England.

Over 70 regional and national arts organisations have joined forces to promote professional development for arts and crafts practitioners. The consortia independently and collaboratively test different ways of diagnosing and collating the professional development needs of their specific target groups.

Once the analysis of an individual's professional development needs is complete, the relevant consortium provides advice and guidance on where and how the skills identified can be obtained. The most appropriate methods for the delivery of this information are tested and include face-to-face, distance, written and technology-based delivery options.

A key part of the project will be the development of a web portal to provide collaborative support for the delivery organisations and a web-based information system for arts practitioners. All consortia members will contribute to the portal which will provide access to information relating to professional development opportunities throughout England.

Support services that the CreativePeople pilot will cover
Access Advice; Access to ITC; Accreditation; Advocacy; Archived materials; Area Gatherings; Brokerage and referrals; Bursaries support; Calendar; Career counselling;

Case studies; Champions of learning; Chat rooms; Creative business centres; Database of opportunities; Development needs analysis; Diagnostic services; e-digest; E-mail groups; E-mail helpline; E-group/on line interrogation; First Stop Shops; Funding/applications; Helpline; Information services; Legal advice; Learning activities; Learning community; Learning currency; Learning fair; Learning language; Learning workbooks; Library; Knowledge resources; Mailing lists; Map of provision; Meeting space; Mentoring; Networks; Newsletter; One-to-one surgeries; Peer learning; Phone advice; Policy debates; Preparation of personal CPD plan; Professional development advice; Reading lists; Research publications; Publications; Research new materials; Research ; Training; Web access/on-line learning.

The consortia

Partners for this pilot project are as follows.

- All Ways Learning – creating a regional hub for South East and Southern region.
- Community Artists – creating an art form hub for community artists.
- Crafts Consortium – creating an art form hub for craftspeople.
- From Survival to Success – creating an art form hub for dance.
- Knowledge Services – creating an art form hub for arts management.
- New Writing and Literature Consortium – creating an art form hub for new writers and those working with literature.
- Northern Cultural Skills Partnership – creating a regional hub for the north.
- CreativeCapital – creating a regional hub for London.
- Matrix – creating a regional hub for the South West.
- TMPL – the technology partner creating and supporting the portal.

Management Group

Chair: Kathryn Deane, Sound Sense, Tel: 01449 737 342;
E-mail: Kathryn.Deane@soundsense.org

Roger McCann, All Ways Learning, Director of Programmes,
Tel: 01425 479 643; E-mail: roger@rogersway.com

Ursula Everett, Crafts Consortium, Reference Manager, Crafts Council,
Tel: 020 7278 7700; E-mail: Ursula_Everett@craftscouncil.org.uk
Website: www.craftscouncil.org.uk

Madeline Hutchins, Knowledge Services, Director, Sam's Books, Tel: 01883 345011;
E-mail: k@sam-arts.demon.co.uk

Christina Christou, CreativeCapital, Training and Employment Officer, London Arts,
Tel: 020 7608 6115; E-mail: christina.christou@lonab.co.uk
Website: www.arts.org.uk/londonarts

Catherine Devenish, Matrix, Training Officer, South West Arts, Tel: 01392 229253;
E-mail: catherine.devenish@swa.co.uk
Website www.swa.co.uk

Paul Munden, New Writing and Literature Consortium, Director, National Association of Writers in Education (NAWE), Tel: 01653 618429; E-mail: paul@nawe.co.uk
Website: www.nawe.co.uk

Ailsa Bickley, Project Manager, Northern Cultural Skills Partnership,
Tel: 0191 230 5228; E-mail: ailsa@ncsp.co.uk

Ken Bartlett, From Survival to Success, Director, Foundation for Community Dance,
Tel: 0116 251 0516; E-mail: ken@communitydance.org.uk

Peter Cox, Managing Director TMPL Training/Consultants, Tel: 029 2025 6350; E-mail: peter@tmpl-online.co.uk
Website: www.tmpl-online.co.uk

CreativePeople contacts at key agencies

Chief Executive, Metier, Tel: 01274 738800; E-mail: duncan@metier.org.uk

Head of Employment and Lifelong Learning, Arts Council of England,
Tel: 020 7973 6115; E-mail: edwardbirch@artscouncil.org.uk
Website: www.artscouncil.org.uk

CreativePeople supporters

Arts Council of England CPD fund; Arts Council of England Live Literature & Touring Fund; Arts & Business South; Coventry and Warwick Learning Skills Council; Devon & Cornwall Learning & Skills Council; EQUAL, European Social Fund GB; Esmée Fairbairn Charitable Trust; European Social Fund; London Arts; London East Learning & Skills Council; National Lottery New Opportunities Fund,; NOF digitisation; Northern Arts; Regional Development Agency NE & NW; Scottish Arts Council; South East England Development Agency; Southern Arts; South West Arts.

CULTURAL BUSINESS VENTURE (NORTH)

Northern Arts, 9–10 Osborne Terrace, Jesmond, Newcastle upon Tyne
NE2 1NZ
Tel: 0191 255 8500 ; Fax: 0191 230 1020
E-mail: info@northernarts.org.uk
Website: www.northernarts.org

Funding: between £400,000 and £500,000 (2002/03)

The Cultural Business Venture offers grants for new and expanding cultural businesses in the North. It has been developed by Northern Arts together with One North East, the regional development agency.

The aim of the scheme is to create new jobs, safeguard existing jobs and assist new and existing cultural businesses to develop successfully. The funding through the scheme can be used for either capital or revenue costs which contribute to this overall aim.

Grants of between £1,000 and £10,000 are available for: new or established creative or cultural businesses with a bank account which employ/will employ fewer than 35 members of staff and have an annual turnover of less than £100,000.

Free advice and training is available from enterprise agencies in the region. All applicants should demonstrate that they have accessed some form of training or advice before they submit a full application. Northern Arts is supporting the

development of a network of advisers associated with Business Link who will be able to offer specialist advice.

Exclusions: Organisations with an annual turnover of more than £100,000. Applicants eligible for support under the Northern Production Fund run by Northern Arts.

Applications: Full applications (including a detailed business plan) should be sent to the Project Manager who will assess and make recommendations to the advisory committee, which meets every 6–8 weeks.

For more information, please contact: Project Manager, Cultural Business Venture, Northern Arts, Central Square, Forth Street, Newcastle NE1 3PJ
Tel: 0191 255 8500; Fax: 0191 230 1020; E-mail:info@northernarts.org.uk

CULTURAL ENTERPRISE, CARDIFF

Chapter, Market Road, Cardiff CF5 1QE
Tel: 029 2034 3205; Fax: 029 2034 5436
E-mail: mail@cultural-enterprise.com
Website: www.cultural-enterprise.com
Contact: Lucy McCall, Director

The service does not provide any funding but offers free business support to creative practitioners and cultural businesses based in Wales. One-to-one support is provided through a network of arts business mentors – successful arts business people themselves – based across Wales, supported by staff at the main office in Cardiff and a satellite office in Porthmadog.

The service also provides fee-charging consultancy and project development support.

Funding comes from the European Regional Development Fund, the Arts Council of Wales, Arts Lottery Fund and TEC South East Wales.

Exclusions: Voluntary and amateur arts.

HIGHLANDS AND ISLANDS ARTS LTD (HI ARTS)

Suites 4/5, 4th Floor, Ballantyne House, 84 Academy Street, Inverness
1VI 1LU
Tel: 01463 717 091; Fax: 01463 720 985
E-mail: info@hi-arts.co.uk
Website: www.hi-arts.org.uk
Contact: Robert Livingston, HI Arts Ltd, Director

HI Arts (Highlands and Islands Arts Ltd) was set up in the early 1990s as an independent charitable arts development company funded by Highland and Islands Enterprise (HIE) and the Scottish Arts Council to further the proactive role of HIE in arts

development, a unique initiative in the context of UK development agencies.

HI Arts supports the development of the arts and arts practitioners in a variety of ways – as an entrepreneur and catalytic agent providing business support and advice as well as engaging in specific project development. It has, for instance, been involved in the preparation of the bid for Inverness to become European Capital of Culture in 2008. The Screen Machine (its mobile cinema) had a third year of full-time operation including a significant hire to Bosnia to entertain British Armed Forces and HAIL, the Forum of Highlands and Islands Records Labels has developed internationally.

Two direct funding schemes were open to application in Spring 2002.

- **Visual Artist Award Scheme** Visual artists based in the Highlands and Islands may apply for grants of **up to £500** to support initiatives which assist them develop and extend their personal practice.
- **Highlands and Islands Producers Fund 2002/03** Support for professional theatre companies based in the Highlands and Islands, primarily for new companies, or those going through significant change or growth.

Be sure to access its website and contact the office direct to find out about HI Arts current initiatives and schemes.

INSPIRAL
formerly ACT (Action for Business and Culture) Ltd

Unit 304 The Workstation, 15 Paternoster Row, Sheffield S1 2BX
Tel: 0114 279 6511/221 6173; Fax: 0114 279 6522
E-mail: inspiral.act@workstation.org.uk
Website: www.inspiral.org.uk
Contact: Yvonne O'Donovan, Director

Inspiral, originally set up as ACT in 1999, provides business support and advice to the arts and creative industries in South Yorkshire.

MERSEYSIDE ACME (ARTS, CULTURE, MEDIA AND ENTERPRISE)

Room C8, 70 Hope Street, Liverpool L1 9LB
Tel: 0151 291 9911; Fax: 0151 291 9199
E-mail: merseyside.acme@dial.pipex.com
Website: www.merseysideacme.com

This organisation, started in 1997, is largely dependent on support from the EU. It is also supported by North West Arts, the five Merseyside local authorities and other agencies working in creative industries. In June 2002 it will know whether its latest bid to the EU hs been successful.

MERSEYSIDE MUSIC DEVELOPMENT AGENCY (MMDA)

111 Mount Pleasant, Liverpool, Merseyside L3 5TF
Tel: 0151 709 2202; Fax: 0151 709 2005
E-mail: info@mmda.org.uk
Website: www.mmda.org.uk
Contact: Ged Ryan, Development Manager

Be sure to check the current state of service directly with MMDA. Its funding has been uncertain at certain periods in its life.

Since 1998, the Merseyside Music Development Agency (MMDA), a charitable company, has supported sustainable employment in the music industry in Merseyside. MMDA is funded through the European Objective One Programme, Liverpool City Council and North West Arts as well as many in kind contributions from the public private and community sectors.

Although its direct financial support to businesses has reduced significantly from previous years, it has been developing its role in the following areas.

MerseyMusic

A portfolio of services for music-makers including the following.

- MerseyMusic Instore – placing independent CDs in the major retailer outlets in the Merseyside area.
- MerseyMusic Demo Bank – a bank of local unsigned music specifically for visiting A&R staff.
- MerseyMusic Legal and Financial Advice Seminars
- Music Expo – seminars, support and information tools and other initiatives to increase the export sales.
- Music Sector Information – primarily through a website, the MMDA newsletter and access to a library.
- Music Network Development linking business community and education activities for information, practical support and best practice exchange for the region's music sector.

MusicBIAS (Business Incubation and Acceleration Service)

Offers support to early stage music businesses. From January 2002, it is targeting *on Merseyside* young people from areas of social and economic deprivation, women, and unemployed people. *In the North West of England:* Black music creators and entrepreneurs.

This partnership initiative (bringing together the region's training and education institutions, support organisations, etc.) is backed by the Small Business Service and led by the MMDA, Liverpool Hope, LIPA and the North West Black Music Development Network.

M-Zone

The Liverpool and Merseyside music action zone set up by Youth Music, National Foundation for Youth Music (see separate entry). MMDA is a partner in this support to youth music projects.

PHOENIX FUND

Small Business Service, Department of Trade and Industry, Level 2,
St Mary's House, c/o Moorfoot, Sheffield S1 4PQ

The fund, announced in November 1999, is intended to help boost entrepreneurship in deprived areas. It will provide support, advice and access to finance in areas where these things are normally lacking.

The elements of the fund with relevance to this guide are as follows.

Mentoring

Total funding: £3 million over three years (2000/01–2002/03)

The DTI has set up a pilot network of business mentors, the Business Volunteer Mentors Association (BVMA), modelled on the US Service Corps of Retired Executives. The organisation is being developed and piloted by the National Federation of Enterprise Agencies (NFEA) and operates independently of government. The aim is to train 1,000 retired and volunteer business people to give advice and support to new enterprises in areas of high unemployment. The NFEA is a network of independent not-for-profit local enterprise agencies.

Contact: Michelle France, National Federation of Enterprise Agencies,
Tel/Fax: 01234 354 055; E-mail: michelle.france@nfea.com

Development Fund

Total funding: £35 million over four years (2000/01–2003/04)

The Development Fund is designed to encourage innovative ideas to promote and support enterprise in disadvantaged areas and in groups currently under-represented in terms of business ownership. Its purpose is to encourage experimentation, the evaluation of new ideas and the identification and spread of best practice. The fund is looking to support a limited number of high quality projects to help inform this process. The following list gives an *indication* of the sort of proposals that might be considered:

- outreach workers to encourage and develop business opportunities in hard to reach communities;
- supporting business incubators;
- promoting networking opportunities amongst businesses;
- funding individual 'enterprise champion' posts in local areas;
- building the capacity of local communities to encourage enterprise through professional training and development;
- encouraging the use of new technologies to improve business efficiency;
- local enterprise award schemes;
- support for social and community enterprises.

Mazorca Projects, East London, to be known as the Hidden Art One Stop Shop: this project intends to provide support and training for design-led businesses, with the focus on those run by women and ethnic minorities. It is a joint project by the Geffrye Museum and the Hackney and Tower Hamlets Cultural Industries Development Agency.

Eligibility: Organisations bidding for funds must demonstrate that their proposals: target specific areas or groups which are either disadvantaged or under-represented; are innovative; contribute to the development of best practice; support commercially viable businesses, or businesses with the potential to be viable; include measurable outcomes that encourage enterprise; and contain an effective strategy for disseminating best practice.

Organisations bidding for support may help either start-ups (enterprises in either their pre-trading or very early trading stage), or existing enterprises, but both must be small or medium-sized. Assisted businesses could be social enterprises or businesses with a purely economic purpose. Funding can be used to lever in other government or EU support.

Applications: Applicants may seek funding for a single year or for staged projects running over the three-year period of the fund. Contact the Small Business Service about the timing of application rounds or consult the website.

Contact: Maria Kenyon, Small Business Service, Tel: 0114 259 7453;
Fax: 0114 259 7330; E-mail: maria.kenyon@sbs.gsi.gov.uk
website: www.businessadviceonline.org/press/phoenix.asp

THE PRINCE'S TRUST

See the 'Trusts' section of the guide for the entry about loan and mentoring support for young people starting their own businesses.

THE RURAL DEVELOPMENT COUNCIL FOR NORTHERN IRELAND

Grants Department, 17 Loy Street, Cookstown, Co Tyrone BT80 89Z
Northern Ireland
Tel: 028 8676 6980; Fax: 028 7976 6922
E-mail: rdc@dnet.co.uk
Website: www.rdc.org.uk
Contact: Esmé Charles

The RDC can grant-aid disadvantaged rural communities who want to become involved in the economic and social development of their area. It is particularly interested in assisting with the costs of identifying, appraising, planning and running projects which will create employment. Training in technical and managerial skills is also eligible. Small grants are available to help communities include a wider range of people in their activities and get them working effectively as a group.

Most of the grant budget is paid *in the communities targeted for assistance* on the recommendation of the three project managers following local consultation. Groups in communities not so targeted may also receive support if they are: established as a community group; located in a disadvantaged rural area; representative of their

community; a not-for-profit organisation. Funding is only available up to a maximum of 80% of the project's costs.

 Grants relevant to this guide in past years have included a community radio station for a business plan and evaluation; a community hall, to establish and develop arts activities; an historical society, for renting and furnishing office space.

Exclusions: Capital costs involved in project start-up.

Applications: Obtain guidelines on grant-aid for full details. Advice and guidance will initially be given by the regional project managers. Applications are sent to the main office in Cookstown. Decisions on grants of less than £5,000 will be made by staff. Larger grants are decided at a full council meeting.

TOWER HAMLETS CULTURAL INDUSTRIES DEVELOPMENT AGENCY

Top Floor, Business Development Centre, 7–15 Greatorex Street, London E1 5NF
Tel: 020 7247 4710; Mobile: 07989 950112; Fax: 020 7247 7852
E-mail: emma@cida.co.uk
Website: www.cida.co.uk

An arms' length company set up by Tower Hamlets Council to encourage local artists, many from ethnic minority backgrounds, to develop their work commercially. It has five roles:
- business support, advice and information;
- education and training;
- investment and sub sector development – through small capital grants and targeted project support;
- advocacy and promotion;
- raising the profile of the cultural industries sector as a career path for young people and socially excluded groups.

YOUTH CULTURAL BUSINESS VENTURE

The Prince's Trust, The Baltic Business Centre, Salt Meadows Road, Gateshead, Tyne & Wear NE8 3DA
Tel: 0191 420 6991; Fax: 0191 420 6988
E-mail: bustwear@princes-trust@org.uk
Contact: Elaine McCartney

Donations to all causes: £100,000 a year till 2004/05

The Youth Cultural Business Venture, managed by the Prince's Trust is open to applicants aged between 18 and 30 years (inclusive).

A total of £100,000 was ring-fenced for this programme during its first year (1999/2000). The programme is expected to run until 2004/05. Support may take the following forms:

- grants, usually up to 20% of the total amount requested;
- loans of about £2,000 to £2,500 with interest charged at 3%;
- expansion loans, for previously supported businesses (50% of funding must be met by client);
- market research grants, for unemployed applicants to investigate the potential of their proposed businesses (maximum £250).

Applications: Applicants must complete an application form and also send a business plan and cash flow forecast for the first 12 months' trading.

OTHER OFFICIAL SOURCES

Adult and Comminuty Learning Fund
Coalfields Regeneration Trust
Equality Division, The Race Unit, OFMDFM
Department of Health
Landfill Tax Credit Scheme and ENTRUST

Organisations and individuals need to consider whether there could be potential support from other government departments and agencies with no direct arts interests. A couple of specific programmes are noted where groups working within the arts are supported for the educational and health purposes.

Groups should also bear in mind that support for schemes with clear potential to attract tourism should be in touch with the appropriate tourist board. This applies to new buildings as well as events such as festivals. The English Tourism Council was set up to identify opportunities where targeted funding could assist resort regeneration.

ADULT AND COMMUNITY LEARNING FUND

Department for Education and Skills, East 8d Moorfoot, Sheffield S1 4PQ
Tel: 0114 259 4199; Fax: 0114 259 3236
E-mail: jonathan.webster@dfee.gov.uk
Website: www.lifelonglearning.co.uk
Contact: Jonathan Webster

Funding available: £5 million each year for six years (1998/99–2003/04)

This excellent fund which ran for an initial four years was extended to a further two years. **However, no more bidding rounds were planned in March 2002. The editor was told that the allocated funds have largely been committed in advance.**

In addition during 2002 the fund is up for consultation. It is possible it could transfer to the Learning and Skills Council, which, via its 47 local offices, could be more responsive to local needs.

The fund was created to sustain and encourage new schemes locally that help men and women gain access to education, including literacy and numeracy. Support is available to community-based organisations, working in partnership with others, combining learning opportunities with other activities relevant to local people e.g. environmental projects, tenants' associations, childcare, crime prevention, arts, health. The fund aims to draw in new and non-traditional learners, especially people who are disadvantaged and isolated. It seeks to make a lasting impact on individuals and

communities by equipping people to improve their own lives, progress to further learning, engage with others and make a greater contribution to their neighbourhood.

Some £5 million has been allocated each financial year till March 2004. It is intended that this funding be matched pound for pound with contributions from trusts, charities and other donors which share the fund's aims. Examples of projects relevant to this guide which received support in the first round of applications:

Thornaby Reading Town, Partnership, Teesside, a theatrical production involving elderly and young people based on long-term residents' memories of the area (£9,050);

North West Disability Arts Forum, Merseyside, training disabled people in arts and theatre skills with options for further trainer-training (£81,643);

Permanent Waves, a community media association in Yorkshire, involving women returners in community radio to increase their confidence and employability (£80,000);

Spice Routes to Bath, LEA Service Somerset, compiling and publishing a cookbook reflecting participants' different cultural backgrounds, (£9,468).

Applications: Two organisations – the Basic Skills Agency (BSA) (Tel: 0171 405 4017; Fax: 0171 404 5038) and the National Institute for Adult Continuing Education (NIACE) (Tel: 0116 204 4200; Fax: 0116 285 4515) have managed the ACLF on DfES's behalf. These have been the first point of contact for enquiries and applications.

After the sixth bidding round in November 2001 further applications have not been solicited. However in view of the interest in this scheme it is worthwhile for organisations to remain aware of its existence and its future shape.

Departmental contact, Lifelong Learning Division: see above
Information will also appear on the DfES website: see above.

COALFIELDS REGENERATION TRUST

Silkstone House, Pioneer Close, Manvers Way, Wath Upon Dearne,
Rotherham, South Yorkshire S63 7JZ
Tel: 01709 760272; Fax: 01709 765599
E-mail: info@coalfields-regen.org.uk
Website: www.coalfields-regen.org.uk
Contact: Alan Wallace, Chief Executive

Total funding: £45,000,000 (2002/03–2004/05); £50,660,000 (1999/2000–2001/02)

Note: *The trust is set up as a charitable organisation. It raises funds from a variety of sources. Its income and expenditure are therefore unpredictable. The above funding comes from the DEFRA and former DETR, the Scottish Executive and the Welsh Assembly and includes operational costs as well as grants.*

The Coalfields Regeneration Trust is an independent grant-giving body created as part of the government response to recommendations made in the Coalfields Task

Force report. It is both a registered charity and a company limited by guarantee. The trust works with partners to promote and achieve social and economic regeneration in the coalfields (which includes the *ex*-coal mining areas) of England, Scotland and Wales.

Priorities

The trust has six main priorities for support:

- resourcing communities through support for community facilities, community transport, welfare and debt advice and other measures;
- creating enterprising communities, through community business development, local business compacts and support to small new start-up businesses;
- improving the natural and built environment of coalfield communities;
- supporting innovative approaches to intermediate labour market and new deal initiatives;
- contributing to lifelong learning activities;
- promoting good practice. Grant support will be available under this priority area to fund visits by community groups to different coalfield areas.

The trust funds a broad range of projects, including those that: support people in their efforts to return to work; provide facilities and opportunities for local people, including playgroups, meeting rooms, sports facilities, environmental projects, arts and cultural activities, feasibility studies and so on; provide debt and welfare advice or support for credit unions; and bring together a range of activities under one roof to create a Resource Centre or 'one stop shop'.

The trust gives grants for up to 100% of capital and revenue costs, and there are no fixed upper or lower limits.

Applicants are normally community and voluntary organisations, charities, local authorities and similar bodies, but the trust welcomes applications from any group, organisation and agency committed to the regeneration of coalfield areas and their communities.

Examples of grants relevant to this guide:

Yorkshire Arts Circus, for community print resource for local writers and community projects (£63,000);

Hi8us Projects Ltd, Yorkshire, work with young people at risk of social exclusion, making short films and developing new media skills (£57,100);

Open College of the Arts, Barnsley, towards refurbishment (£61,800);

Moira Furnace Museum Trust Ltd, for the final development phase of the museum which will provide a visitor attraction (£19,500);

New Perspectives Theatre Company, project for individuals and groups to express themselves via the visual arts (£8,100);

Lukes Lane Community Association for a new partable dance floor (£4,300).

Exclusions: The trust does not fund:

- projects that do not meet the aims and objectives of the trust;
- retrospective costs;
- projects exclusively or primarily intended to promote religious beliefs;

- projects that are properly the subject of statutory funding;
- grants to individuals.

Applications: Because organisations of varying sizes have different requirements, the trust has four different types of application:

- small applications, for less than £20,000;
- medium and large applications, for voluntary and community organisations where the application value is over £20,000;
- medium and large applications, for statutory bodies where the application value is over £20,000;
- partnership applications, for programmes initiated by national or regional charities taking place in several coalfield areas or in several locations within one coalfield area.

The trust does not require applicants to match its funds with support from other funders, although it does encourage this wherever possible. Trust funds can be used to match other funders' contributions, including those of the European Structural Fund.

There are no deadlines for applications; the trust processes applications as and when they arrive.

EQUALITY DIVISION, THE RACE UNIT, OFMDFM

Room E3.13, Castle Buildings, Stormont, Belfast BT4 3SR
Tel: 028 9052 2581
Website: www.newtsnni.gov.uk

Donations to all causes: £300,000 (2001/02)

The general aims of funding are to stimulate activity to:

- increase equality of opportunity and equal protection for people of different ethnic backgrounds in Northern Ireland;
- increase awareness and respect for Northern Ireland's ethnic diversity;
- ensure the full participation of people from minority ethnic backgrounds in social, public and economic life;
- increase good relations and mutual respect between people of different ethnic backgrounds; and
- ensure that, in accordance with their needs, members of all ethnic communities enjoy equality of opportunity and equality of treatment in accessing and benefiting from public services.

The two types of funding on offer are as follows.

- **Core Funding** The maximum award, for any proposal, is £50,000 a year. Grants may be for up to three years. This can be made up of a maximum of 90% of salary costs and 75% of other costs. Higher awards may be considered in exceptional circumstances.

- **Innovative Projects** The maximum length of funding for Innovative Projects is 18 months while the maximum award is £15,000. Higher awards may be considered in exceptional circumstances.

Applications: Applications must be made on the forms provided. In 2001/02 applications for core funding had to be made by 28 February 2001 and for project funding by 30 March 2001. Full details can be accessed on the website and obtained from the office.

DEPARTMENT OF HEALTH

Social Care Group, Section 64 Grants Administration Unit, Wellington House, 133–155 Waterloo Road, London SE1 8UG
Tel: 020 7972 4509; Fax: 020 7972 4307
Website: www.doh.gov.uk/sect64/grants.htm

Grants to national voluntary organisations – Section 64
Total Grant-aid: about £21 million annually

This entry only gives brief introductory information. Full details should be obtained direct from the grant administration unit.

The programme relates only to England with similar schemes in Scotland, Wales and Northern Ireland.

Grants can only be made to non-profit-making voluntary organisations for work in health and social care in England. The work must be of national significance (there is no funding of projects of purely local significance). The maximum period of a grant is 3 years, with the possibility of one further year for evaluation and dissemination.

Altogether, over 600 new and ongoing grants are made each year to over 400 voluntary organisations. A handful of these are to organisations using the arts to serve health and social welfare.

In 2000/01 beneficiaries included:
Age Exchange Theatre Trust (£32,000);
Theatre in Health Education Trust (£14,000).

Organisations which have received support in previous years include Arts for Health; the Pyramid Theatre Company; the Council for Music in Hospitals; and East Midlands Shape.

Exclusions: Funding is not given for research projects, or to voluntary organisations serving a particular profession or sphere of employment.

Applications: Guidance notes and application forms are available from late summer each year. The deadline for completed application forms is during September/ October for grants starting the following April. Notification of the outcome of the application can be expected around February/March.

Organisations should have or be in the process of producing an equal opportunities policy.

Contact: Becky Harrison, Tel: 0171 972 4109
Allison Noterman, Policy Manager, SC2, Room 610; Tel: 0171 972 4093

LANDFILL TAX CREDIT SCHEME AND ENTRUST

6th Floor Acre House, 2 Town Square, Sale, Cheshire M33 7WZ
Tel: 0161 972 0044; **Fax:** 0161 972 0055
E-mail: information@entrust.org.uk
Website: www.entrust.org.uk

ENTRUST Regional Offices:
Northern Office: 0141 561 0390
Central Region: 0161 973 1177
Wales and the West: 02920 869 492
Southern Area: 020 8950 2152
Scotland and Northern Ireland: 0141 561 0390
Wales: 02920 869 492

Landfill Tax contributions: £493 million between 1997 and April 2002

At the time of editing the future of the Landfill Tax (and consequently that of ENTRUST) was under consultation with replies requested by mid-June 2002. The consultation provides many variable options, from minor to major changes. However, whatever the chosen method, the government is expected to decide to shift more resources from the scheme to sustainable waste management.

The information below refers to the scheme *before* the consultation. Be sure to check the up-to-date position.

In 1996 the first green tax, the Landfill Tax, was introduced on waste disposal to UK landfill sites in the expectation that the industry would reassess and reduce waste and its associated problems. HM Customs & Excise collects the tax at variable rates depending on the type of waste. Landfill operators *may* divert up to 20% of tax liability to environmental projects. They are reimbursed for 90% of the amount contributed. (They are expected to cover the remaining 10% themselves, although in many cases another organisation may do so for them.)

ENTRUST is not a supplier of funds. Funding can only be obtained from a landfill operator and different operators have set up different ways of handling their support (see examples below).

Before any funding arrangements can go ahead, all groups interested in obtaining funding from a landfill operator must check with them if they need to be enrolled with ENTRUST, the official regulatory body of potential beneficiaries. It is essential

for groups to appreciate that registration and project approval from ENTRUST in no way assures funding from a landfill operator. The scheme leaves funding decisions entirely to landfill operators. Groups can shortcut this process by approaching the intermediary funding body set up by, or working for a company (see below for examples). These organisations are themselves registered Environmental Bodies (EBs) and are able to disburse funds to other Environmental Bodies and non-enrolled groups. Since enrolment with ENTRUST costs £100 this route presents important savings for small groups.

Organisations applying for funding must be a non-profit-distributing bodies. They have to meet criteria for approved work under this scheme which includes:
- land reclamation for economic, social or environmental use;
- pollution reduction;
- research into sustainable waste management;
- education on waste issues;
- pilot recycling schemes;
- provision of public amenity facilities in the vicinity of a landfill site;
- reclamation and creation of wildlife habitats;
- restoration of buildings of architectural and heritage interest in the vicinity of a landfill site;
- provision of financial, administration and other services to environmental bodies.

'Vicinity' is interpreted as about a 10 miles radius from the landfill site.

By April 2002 over 2,700 organisations had enrolled and over 5,787 projects throughout the country were completed.

Organisations working within the arts which have received support include:
Environmental Arts Theatre Company, Edinburgh, for a programme which ran between October 1998 and May 1999 including a school tour of East Lothian and a community project with three groups, adults, teenagers and younger children, presenting their own created show. The landfill operator, Scottish Power, gave £40,000 through the Lothian local authority;
Public Arts, Wakefield, for redesign/refurbishment of Moore Square, Castleford. Two landfill operators gave a total of £70,000. Several other projects have also received support;
Biggar Museum Trust, Lanarkshire, support for improvement to the fabric of the museum.

Some of the ways that landfill tax funding has been disbursed are listed below. This list is *illustrative and by no means exhaustive.*

Landfill companies donating directly
- e.g. UK Waste Management Limited.

Environmental organisations administering funds for a landfill company
- The Royal Society for Nature Conservation administers funds for Biffa, etc. These are not directed only at local Wildlife Trusts as some people have assumed.
- RMC Environment Fund (administered by the Environment Council).

New trusts set up by landfill companies

- Single trusts working UK wide – e.g. Onyx Environmental Trust and S.I.T.A. Environmental Trust.
- Multiple trusts working locally – e.g. Cleanaway has set up four trusts. Cory Environmental has set up at least 12 separate trusts.

Environmental Body set up by a landfill company to administer funds

- e.g. WREN, Waste Recycling Environmental Ltd, set up by Waste Recycling Group.

Intermediary organisations

- e.g. Enventure Limited; Essex Environmental Trust; South West England Environmental Trust (SWEET).

To find out about landfill operators in your area, ring the following numbers.

- **ENTRUST Regional Offices** (see contact numbers above).
- **The Environment Agency** general enquiry line: 0645 333111. The local offices of the agency maintain a public register of waste disposal and treatment sites and operators. The agency has 26 areas and a greater number of offices.
- **Landfill Tax Register** available from Customs & Excise Landfill Tax Help desk: 08459 128 484.

A Distributive Environmental Bodies Directory has been collated by ENTRUST and new applicants are strongly advised to obtain a copy.

Part two

INTERNATIONAL

This section covers:
- general information sources;
- UK programmes facilitating visits/exchanges to and from the UK;
- funding from Europe.

All organisations developing a project to take place overseas or wanting to arrange visits from other countries should be sure to be in early contact with the ministries of culture and the arts councils in those countries. Most embassies have cultural branches which can be an invaluable source of advice and contacts. Many developed countries have specific budgets for international activities. Sometimes there are associated organisations, e.g. the Japan Foundation in London, the Japanese equivalent of the British Council, which can provide support for exhibitions, film production and publications.

All readers are urged to make early approaches for the advice and information to the organisations which follow.

GENERAL INFORMATION SOURCES

Euclid
International Intelligence on Culture
Infodesk – International Arts and Culture
Wales Arts International
British American Arts Association / Centre for Creative Communities
American Fund for Charities

EUCLID

46–48 Mount Pleasant, Liverpool L3 5SD
Tel: 07000 EUCLID (382543) or 0151 709 2564; Fax: 0151 709 8647
E-mail: info@euclid.info
Website: www.euclid.info
Contact: Geoffrey Brown, Director; Mik Flood, Deputy Director

Euclid has other offices in London, Cardiff and Brussels.

Euclid, a UK-based consultancy, provides a comprehensive range of European and international information and consultancy services for the cultural sector.

Euclid was appointed by the DCMS and the European Commission as the official UK Cultural Contact Point. In particular it provides support services related to Culture 2000 (see separate entry).

Euclid's services include the following (more information, and registration or subscription details, can all be found on the Euclid website: www.euclid.info).

- **Culture-Match** Aims to provide an online database of international sources of support and potential partnerships. It provides the opportunity to search for (or submit details of) project partners, funding programmes, commissions, touring, competitions, networks, publications, services, key contacts, etc., across Europe and the world, free of charge. Launched at the end of 2001, the database is constantly enlarging.
- **Alert** A free e-mail newsletter covering European opportunities for the cultural sector.
- **Facts-Files** Summary sheets providing information and contacts on European opportunities for the cultural sector. Available free.
- **Briefing** An e-bulletin providing background information, contact lists, etc., on European and international topics relevant to the cultural sector. It is available by subscription.
- **Cultur€uro** Seminars on accessing funding from the European Union. Euclid also organises other events and conferences, in the UK and Europe, on European and international topics.

- **DICE** An e-journal documenting cultural research projects and organisations across the world – available on subscription. DICE will be augmented in 2002 by ACRONIM, an online database of cultural research: books, reports, articles, conference papers, etc. Entries to ACRONIM will be free and the search mechanism will be available to DICE subscribers.

Other services in development include **Culture Tracker**, an online database of pan-nationally funded projects.

Euclid also offers tailored European and international research and consultancy services.

INTERNATIONAL INTELLIGENCE ON CULTURE
(formerly the International Arts Bureau Ltd)

4 Baden Place, Crosby Row, London SE1 1YW
Tel: 020 7403 7001 (information service enquiry line); 020 7403 6454 (management); Fax: 020 7403 2009
E-mail: enquiry@intelCULTURE.org (information service)
Website: www.intelCULTURE.org
Contact: Sheena Barbour, Information Officer
Director: Rod Fisher; **Manager:** Kate Dixon

International Intelligence on Culture brings together an experienced multi-national group of experts to work with and for the international cultural sector. Building on the work of the International Arts Bureau under the direction of Rod Fisher, its team of policy analysts and cultural researchers provides a considerable body of expertise in the cultural sector. The range of activities undertaken include for public bodies in the UK and overseas: policy intelligence; research; consultancy; project management; training; and information services.

The company runs tailor-made workshops for cultural organisations, local government, policy-makers and practitioners on themes such as European funding, networking, cultural exchange and cultural policies worldwide. In addition, the team has extensive experience of university and higher education training in Europe and further afield, with training inputs that span single or multiple lectures to the organisation of specific modules and courses.

Since 1994, The International Arts Bureau, and subsequently International Intelligence on Culture, has been running **a free enquiry service and advice surgeries for arts practitioners** on behalf of the Arts Council of England (see the contact points above).

International Intelligence on Culture monitors funding programmes and opportunities, policy developments legislation, and emerging issues at European level and globally. Its International Cultural Compass provides affordable, speedy information, which has been fully interpreted for the cultural sector, and not merely re-packaged, on all these areas, as well as research, publications, events and other

news. Subscribers can choose between different levels of service offering a monthly journal, e-mail alert with additional individually designed services available to cultural funding agencies.

As The International Arts Bureau, the organisation researched and produced a number of **international guides and publications** for the Arts Council of England, and others. For details, contact International Intelligence on Culture or check the website: www.intelCULTURE.org

International Intelligence on Culture is the UK contact for the **European Cultural Foundation**, a long-established, independent, Dutch-based organisation which promotes cultural co-operation in Europe. It also administers the UK National Committee of the Foundation.

Co-ordinator: Daniela Paolucci, Tel: 020 7403 0777;
E-mail: ecf@intelCULTURE.org

INFODESK – INTERNATIONAL ARTS AND CULTURE

Tel: 028 9023 3440 x252; Fax: 028 9024 0341
E-mail: colette.norwood@britishcouncil.org
Website: www.britishcouncil.org/ni
Contact: Colette Norwood

The Infodesk is an enquiry service based in both Belfast and Dublin. It offers a database of constantly-updated international arts contacts and opportunities in a huge range of categories to make it easier for an arts organisation to access funds, information or creative relationships around the world.

The Infodesk is maintained jointly by An Chomhairle Ealaíon/Arts Council of Ireland, the Arts Council of Northern Ireland and the British Council in Belfast. The Infodesk is tailored now to the needs of the arts community in Ireland, north and south.

It both reflects and enhances the deepening relationships that exist along the East–West as well as the North–South axes in these islands, not only in terms of the joint initiatives of the two Arts Councils in Ireland, but also of the mutually beneficial creative commerce between artists themselves in Ireland and elsewhere.

WALES ARTS INTERNATIONAL

Arts Council of Wales, 9 Museum Place, Cardiff CF1 3NX
Tel: 029 2037 6500
Website: www.wai.org.uk
Contact: Judith Garrow, International Projects Officer

Wales Arts International is a partnership between the Arts Council of Wales (see separate entry) and the British Council (see separate entry for the British Council

Arts Group). It promotes the understanding of modern Wales abroad through its art. It creates opportunities for Welsh artists to work abroad, develops tools for international marketing, builds international arts initiatives such as festivals and supports Welsh artists' tours abroad.

BRITISH AMERICAN ARTS ASSOCIATION / CENTRE FOR CREATIVE COMMUNITIES

118 Commercial Street, London E1 6NF
Tel: 020 7247 5385; Fax: 020 7247 5256
E-mail: info@creativecommunities.org.uk
Website: www.creativecommunities.org.uk
Contact: Jennifer Williams, Director

The British American Arts Association (BAAA) promotes cultural activity and exchange between Britain and the USA. It consists of two complementary organisations: BAAA (UK) Ltd, a registered charity and BAAA (US) Inc., a tax-exempt organisation under US law.

BAAA (US) Inc. has a grant programme which aids British arts organisations in raising funds in America and encourages British-American collaboration in cultural activities. As BAAA (US) is a tax-exempt organisation, contributors may make tax-deductible donations to BAAA for its support of specific British-American cultural projects. This programme facilitates British arts organisations that have identified funds in the US for British-American cultural projects with the advantage of an umbrella tax-exempt status. BAAA (UK) offers a similar service for American cultural organisations.

In order for British cultural organisations to take advantage of the grantmaking programme the organisation must apply to become a client. A British cultural organisation wishing to take advantage of the grant programme should contact the grant programme administrator at the BAAA for details of the application procedure. An administrative fee to compensate BAAA for servicing the grant programme is made.

The Centre for Creative Communities (**CCC**, the trading name in the UK for the British American Arts Association) promotes, researches and consults on community development through collaborative projects involving the education, arts and voluntary sector. Through an extensive database, CCC assists organisations and individuals from the three sectors to match with each other for the purpose of formulating and realising culturally-based community development projects. It also maintains an extensive library of materials on the arts in education and on the role of the arts in building and strengthening communities. It publishes occasional papers and a quarterly newsletter, organises conferences and projects with educational institutions, voluntary organisations and local authority departments. Many of its activities have an international as well as a UK-wide scope. It does not give grants.

AMERICAN FUND FOR CHARITIES

The American Fund for Charities can help you obtain funding from American sources whether from trusts and foundation, companies or individuals. Considerable tax benefits are available to all these groups which encourages their benefactions but donations need to be made through a recognised, registered organisation with the magic 501(c)(3) status (how American charities are referred to for tax purposes). The fund can help in this respect. It has gone into partnership with **Chapel & York** to facilitate the service it offers.

For further information contact: Nancy Bikson, Tel: 01342 836790; Fax: 01342 836449; E-mail: nancy.bikson@chapel-york.com

VISITS/EXCHANGES

The British Council Arts Group
Visiting Arts
The Commonwealth Youth Exchange Council
Connect Youth International

THE BRITISH COUNCIL ARTS GROUP

11 Portland Place, London W1N 4EJ
Tel: 020 7389 3194; Fax: 020 7389 3199
E-mail: firstname.lastname@britcoun.org
Website: www.britcounc.org/arts/index.htm
Contact: Kate Smith
Director of Arts: Sue Harrison

The purpose of the British Council is to win recognition abroad for the UK's values, ideas and achievements, and nurture lasting, mutually beneficial relationships with other countries. Drawing on the country's intellectual capital and creativity, the British Council reinforces the UK's positive role in the international community through cultural, scientific, technological and educational co-operation.

The council works with partners in the UK and overseas to build long-term relations with people and institutions in other countries. The council is represented in 110 countries. It provides a global network of contacts with government departments, universities, embassies, professional bodies, arts organisations and businesses in Britain and overseas.

The council's 2000/01 turnover was £429 million, made up of a government grant, expenditure on behalf of Britain's international development programme and revenue from contract work, English teaching and other services. It also works with commercial sponsors in many of its programmes.

In contrast to the four national Arts Councils the British Council is not an 'arts funding body' in the straightforward sense. This means that it does not support artists and companies solely or even primarily for the purpose of developing those artists and companies. The British Council's aims in promoting UK arts abroad are integrated with its aim across all sectors: to enhance the reputation of the UK in the world as a valued partner. The council's work in the arts in a particular country is bound up with its overall aims and objectives in that country. Consequently there is instrumentality inherent in all that it does in the arts.

The principal aims of the council's work in the arts, literature and design are as follows:

- to demonstrate the innovation and excellence of British arts to overseas publics, media, opinion-formers and successor generations;
- to promote intercultural dialogue and exchange;
- to stimulate the export of British cultural goods and services;
- to create the climate for export promotion in non-arts sectors, e.g. by mounting cultural events allied to trade initiatives, or by providing international opportunities for commercial sponsors;
- to contribute to international skills development and dissemination through arts for education projects and training programmes.

Criteria for selection in international promotion

The British Council promotes work which is excellent of its type, which reflects contemporary UK achievement, which is palpably in demand or likely to stimulate demand in the target market and which contributes to the council's aims and objectives in the country concerned. Apart from fit with country objectives, the council's operational priorities are based on delivery of artistic quality; contribution to public diplomacy objectives; reflection of the UK's cultural diversity; contemporary creativity; the introduction of British work and artists which are new to the specific international market; educational and other collaborative potential; return to the UK economy; and potential for reciprocity and cultural interchange.

Structure

- An Arts Group in London comprising specialists in design, drama, dance, film, literature, music, visual arts, British studies and a Creative Industries Unit.
- International arts managers in Scotland and Wales, and a strong presence in Northern Ireland.
- Subject-specific advisory committees drawn from among nationally and internationally recognised artists, writers, producers, critics, academics and administrators.
- An overseas network of offices in 110 countries where arts managers work in close collaboration with local partners, including promoters, programmers, venues and festivals.

Activity

- Tours and exhibitions, never presented in a vacuum but always developed as a result of an evolving relationship between the overseas promoter, the local British Council office, its headquarters and the UK arts sector – in any order; there is no 'set procedure' attached to the development of a project.

- British input to major international events such as the Venice Biennale and the Cannes Film Festival.

- Showcases in the UK to which international promoters are invited, such as The Edinburgh Showcase where every two years over 200 promoters from all over the world are invited to attend specially selected theatre shows and works in progress within the Edinburgh Fringe and International Festivals. In recent years film and literature showcases have been run in Edinburgh.

- Educational and professional exchanges between British practitioners and their overseas counterparts. These might include workshops, creative residencies, programmed visits, masterclasses, etc.

- Information provision (both reactive and proactive, including specialised publications, stands at performing arts markets, targeted advice and web-based information).

The mix of activity between the above depends very much on the type of market: developed markets, as in West/South/North Europe, North America, Japan, Australia, New Zealand (a lot of proactive information work, relatively little direct British Council event management); emerging markets, as in East and Central Europe and Latin America (a mixture of information work and some management or co-management of projects); and developing markets, as in Africa south of the Sahara and South Asia (arts work in support of education and training objectives, with a dominance of council managed and financed projects).

Facts and figures

The council's total budget in 2000/01 was £429 million made up of 33% government grant, 36% non-grant income (e.g. teaching English, British examinations, educational contracts), and 29% agency funds (where the council undertakes work on behalf of government departments such as the Foreign and Commonwealth Office – their scholarships scheme – and Department for International Development – e.g. health and education projects in the Third World; and on behalf of non-government bodies such as World Bank and EU Commission).

Total arts programme expenditure in 2000/01 was £13 million. The rough breakdown is performing arts – 36%, visual arts – 22% and literature, design, creative industries and films/TV – around 10% each.

For the arts sector the council supports or manages around 2,500 events annually, reaching a live audience of 7 million, with 80% of the total cost of this activity globally coming from partner-funding.

The British Council is also one of the stakeholders in Visiting Arts (see separate entry), formerly the Visiting Arts Office of Great Britain and Northern Ireland.

Visual Arts

Director: Andrea Rose

Development of overseas knowledge and appreciation of British achievement in painting, sculpture, printmaking design, photography, the crafts, architecture and new media. Organisation of 12–15 major exhibitions a year, involving loans from national, regional and private collections, often co-curated with major overseas venues. Responsibility for British participation in recurrent international visual arts events such as the Venice Biennale, the São Paulo Bienal, the Johannesburg Biennale and Indian Triennale exhibitions. Management of a touring exhibition programme drawn primarily from the British Council's own collection and designed for long-term tours of specific geographical regions.

Management of the **Grants to Artists scheme**, where British artists who have received a firm invitation to exhibit abroad may apply for assistance in meeting the costs of transport or personal travel. Grants are rarely over £1,000. Details of the scheme, plus an application form are available on the council's website: www.britcoun.org/arts/vad/grants/grants.htm

Responsibility for the British Council Collection, started in 1938, now comprising over 7,000 works of art, including 1,500 paintings, sculptures, drawings, watercolours and other works on paper and 4,400 limited edition prints, photographs and other multiples. Visual Arts Library, specialising in material on British art and a prime source of information on post-war contemporary British art.

Exhibition enquiries: 020 7389 3009
Grants to artists: 020 7389 3045
Library and archive: 020 7389 3008
Fax: 020 7389 3101

Performing Arts

Director (and Head of Music): John Kieffer
Deputy Director (and Head of Drama and Dance): Sally Cowling

Support of overseas performances by British companies and other forms of joint activity abroad, such as co-productions, creative residencies, professional exchanges, and educational programmes. The department works in close collaboration with arts colleagues in the council's overseas network and with arts partners (including festival directors and venue managers) in the appropriate city or cities. Performing arts projects may occasionally be managed directly by the council but more usually will be managed and financed by the local arts contributing to an element only of the company or individual's touring costs, e.g. towards fees and/or travel expenses.

The department will seldom support a performance without having seen the work which is to tour, and it will only support companies or individuals with a reputation for artistic excellence in their field. There is a growing demand overseas for new British theatre writing, for contemporary dance, for physical theatre and cross-artform performance. However these are by no means exclusive categories and all forms of professional theatre and dance are in principle eligible for support.

The same is true of music in its various forms including opera, early music, classical and contemporary music, jazz, club, roots and rock music. There must be a substantial amount of British music in the tour repertoire and musicians must be of a high artistic standard with a national reputation in their field.

There is a growing preference, across the performing arts, for projects that integrate performance with collaborative, developmental, educational or cross-cultural activity to make a longer-term contribution to the artistic life of the country concerned.

Advice is regularly sought from the Arts Councils and regional arts offices.

Drama and dance enquiries: 020 7389 3010
Fax: 020 7389 3088
Music enquiries: 020 7389 3005
Fax: 020 7389 3057

Films and Television
Director: Paul Howson

No investment in film or programme production. Enters short films (fiction, animation, experimental, documentary) to international festivals. Submits selections of shorts to approximately 40 film festivals: in order to submit a film to the viewing panel please either contact the department and ask for a form or download a form from the website (www.britfilms.com) and return this with a video (no deadline for submission but usually takes 6–8 weeks for a response). Limited number of travel grants available for filmmakers whose work has been selected to attend festival screenings.

Obtains feature film prints for international festivals. Arranges international showcases of new films (features and shorts) from Britain, often with guest speakers from Britain.

Sponsors showcases of British work: FilmUK at the Edinburgh Film Festival and the First Film Foundation's *'New Directions'* showcase in the US. Provides 35mm/16mm/video screening facilities in central London for emerging filmmakers. Regularly works in partnership with other UK organisations such as British Screen Finance, British Film Commission, Scottish Screen and the BFI.

Publications: *Directory of International Film and Video Festivals:* guide for filmmakers interested in entering films into festivals produced once every two years. *British Film Catalogue:* annual guide British films. Both are available in their most up-to-date form on the website (www.britfilms.com) which also includes a directory of British filmmakers and links to a range of ther sites concerned with the British film industry.

Enquiries: 020 7389 3065
Fax: 020 7389 3041

Literature
Director: Margaret Meyer

The aim of the British Council's work in literature is to further the appreciation of British and Commonwealth literature, particularly the work of contemporary writers,

overseas. This work is undertaken by our overseas offices with the advice of the Literature Department, and in partnership with publishers and sponsors.

The British Council organises, or provides support to, a wide range of literature events overseas. These include reading tours, lecture tours, festivals, conferences, seminars, workshops and writer-in-residence schemes and cover all areas of literature, for example, playwriting, performance poetry, crime fiction, science fiction, literary biography, literary translation, children's literature and storytelling.

It provides support to the teaching of literature overseas (at secondary and tertiary levels), including the use of literature in English language teaching. It arranges for writers, critics and educationalists to visit universities and other teaching institutions overseas to advise on curriculum development and to conduct lectures, seminars and workshops.

The department regularly organises seminars in Britain and elsewhere. These include the Cambridge Seminar on contemporary British writing (held in July), the Oxford Conference on literature teaching overseas (held in March/April), the Walberberg Seminar on contemporary British writing (held in Germany in January), and a biennial seminar on trends in literature teaching. Seminars on contemporary British writing have also been held in Belgium, Brazil, Romania and Singapore.

Publications: Catalogue available on request. They include the newsletter *Literature Matters*, of which 12,000 copies are distributed overseas two or three times a year; *New Writing*, an annual anthology of contemporary British fiction, poetry, drama and criticism, published in association with Vintage; a series of bibliographies; directories of postgraduate courses and short courses in literature and creative writing; the *Contemporary Writers Database* is available on the website produced in conjunction with Book Trust and also available on disk; the *Writers and Their Work* series of books, published in association with Northcote House; and a listing of UK literature festivals.

British Studies — the interdisciplinary study of contemporary British institutions, culture and society — is a new and developing area of the council's work. British Studies teaching programmes are burgeoning overseas, particularly in Eastern and Central Europe. The Literature Department is helping to further this development by organising seminars and conferences, arranging advisory visits, and participating in the recruitment of British Studies specialists for supported posts. It also supports the field with publications: the international newsletter, *British Studies Now*, is produced in the department and *Democracy in Britain: a reader* has been co-published with Blackwells.

Literature enquiries: 020 7389 3197
British Studies enquiries: 020 7389 3171
Fax: 020 7389 3175

Design

Director: Emily Campbell

The British Council's Design Promotion Department promotes British design through a range of activities and events including touring exhibitions celebrating British

design, workshops,seminars and conferences overseas led by British designers, and study programmes in the UK for overseas visitors.The programme reflects the wide range of disciplines practised to a world class standard by British designers and includes graphic design, fashion, architecture, city planning and the built environment, interior design, digital media, industrial and product, furniture and design education.

Enquiries: 020 7389 3162
Fax: 020 7389 3164

Creative Industries

Head: Andrew Senior

Organises seminars and outward missions for small to medium-sized businesses that are interested in opportunities overseas in the creative industries. Previous missions have covered advertising, PR, branding and packaging design, film, high street fashion and cultural tourism. Also runs inward missions, bringing journalists and buyers to the UK to participate in a programme of seminars and visits that showcase the innovations of Britain's creative industries.

Enquiries: 020 7389 3037
Fax: 020 7389 3199
Website: www.creativeindustries.org.uk/

VISITING ARTS

11 Portland Place, London WIN 4EJ
Tel: 020 7389 3019; Fax: 020 7389 3016
E-mail: melissa.naylor@britishcouncil.org
Website: www.visitingarts.org.uk
Contact: Melissa Naylor, Information Manager

(based at same address as the Arts Division of the British Council)

Visiting Arts (VA), a charitable company, formerly known as the Visiting Arts Office of Great Britain and Northern Ireland, is jointly funded by the national Arts Councils (England, Scotland, Wales and Northern Ireland), the Crafts Council, the Foreign & Commonwealth Office and the British Council.

It aims to encourage the flow of international arts into the UK in order to develop cultural awareness and positive cultural relations between the UK and the rest of the world. VA's activities include advice, information, training, consultancy, publications, special projects and project development.

Project Development Awards

Total funding: £300,000 (2002/03)

These awards cover a wide range of art forms with particular emphasis on contemporary work. They are available to promoters and venues to help them present

quality foreign work with a clear country-specific dimension. The work must also demonstrate its contribution to the development of cultural awareness and cultural relations and be able to produce a continuing impact, influence or follow-up. Priority is usually given to first-time presentations of artists or companies.

Grants are given in five areas: visual, media and applied arts; performing arts; combined arts; film; and literature. Examples of grants from 1999/2000 included: The Millennium Mystery Plays, Poland (promoter: The Belgrade Theatre) £5,500; Meno Fortas Company, Lithuania (promoter: Theatre Royal, Bath) £4,200; Consolation Service (various Finnish artists) (promoter: Finnish Institute) £2,000; Al Rafif Theatre, Syria (promoter: Institute of Contemporary Arts) £2,000; Jaatra: Bangladesh Folk Opera (promoter: Tagore Arts Promotion) £1,500; Bernard Kabanda UK Tour, Uganda (promoter: WOMAD) £400.

Eligibility: Applications are open to UK-based arts organisations, promoters and venues proposing projects that take place in the UK and involve presenting or working with artists from any country overseas. Freelance curators and promoters may apply on behalf of the UK venues or organisations they are working with. Artists or arts organisations based overseas or foreign governmental institutions cannot apply directly but must identify a UK host organisation/individual wishing to work with them. The UK host organisation/individual will be responsible for presenting any application.

Funding levels: The scale per project varies between £500 to £6,000. However, the average award is between £2,000–£3,000 and only in exceptional circumstances will the award be made to the maximum amount of £6,000. VA's contribution to overall costs will normally not exceed 10%. It is assumed that for most projects multiple sources of funding will be required.

Creative Collaborations in Music Awards funds UK residencies for foreign composers or music creators to enable UK and foreign music creators to have a period of joint exploration and creation. Up to six awards (maximum £6,500 each) are available between December 2001 and April 2003.

Exclusions: Capital projects; stand-alone educational projects; publications (unless an integral part of the project); conferences/seminars/symposia; travel costs to attend events overseas; fund-raising charity events; amateur art; one-off performances or performances by children's groups; events that are not open to the general public.

Applications: There are no deadlines but applications must be made at least four months prior to the start of a project. An early approach to VA needs to be made as most successful applications are either initiated, encouraged or developed with their help. Applicants should contact the relevant member of staff to give an outline of the project proposal; if it meets VA criteria applicants are asked to send a brief project outline with outline budget. If appropriate, applicants then make a formal application with more extensive information.

Contacts: Performing Arts: Nelson Fernandes, Tel: 020 7389 3017;
Visual Arts: Camilla Canellas, Tel: 020 7389 3046.

THE COMMONWEALTH YOUTH EXCHANGE COUNCIL

7 Lion Yard, Tremadoc Road, Clapham, London SW4 7NQ
Tel: 020 7498 6151; **Fax:** 020 7720 5403
E-mail: mail@cyec.demon.co.uk
Contact: Charlotte Hastings,
Beneficial area: UK and Commonwealth

Funding available: £232,000 (1999/2000); £242,000 (1998/99)

The Commonwealth Youth Exchange Council (CYEC) is a charity financed largely by the government through Connect Youth International (see separate entry) and the Education and Employment Department via Youth Service Unit (see separate entry). It promotes two-way educational exchange visits between groups of young people in the UK and their contemporaries in all other Commonwealth countries by providing advice, information, training and grant-aid.

CYEC's funding priorities are: young people who would not normally have the opportunity to take part in an international project; exchanges with Commonwealth countries in Africa, Asia and the Caribbean; local British groups rather than national ones. Groups should normally number between five and 13 participants, excluding leaders. At least two-thirds of the group must be within the age-range 16-25. UK groups must host as well as visit. One-way visits are not eligible for funding. Return visits should take place within two years. Visits must last at least 21 days for exchanges outside Europe, and at least 14 days for Cyprus, Malta and Gibraltar. Grants are given on a per head basis and represent up to 35% of international travel or hosting costs.

A total of 93 projects were funded in 1999/2000 equally split between incoming and outgoing trips.

Applications: Detailed guidelines and application forms are available on request (SAE required). Potential applicants should make contact with CYEC as early as possible to discuss their proposals. Applications must be submitted during autumn and at least nine months prior to a visit.

CONNECT YOUTH INTERNATIONAL
formerly Youth Exchange Centre

The British Council, 10 Spring Gardens, London SW1A 2BN
Tel: 020 7389 4030; **Fax:** 020 7389 4033
E-mail: connectyouth.enquiries@britishcouncil.org
Website: www.connectyouthinternational.com
Contact: Sujata Saika, Information Officer
Beneficial area: UK and overseas

Grant total: £5 million (2000/01); £4,733,000 (1999/2000); £3,195,000 (1998/99)

Connect Youth International (CYI), formerly known as the Youth Exchange Centre, is a department of the British Council whose principal funding comes from the European Commission, the Foreign and Commonwealth Office, the Millennium Commission and the Department for Education and Skills. CYI makes grants towards exchanges of young British people aged between 15 and 25 and young people in other countries. Exchanges are intended to widen the horizons of young people and to enhance their skills and confidence. Exchanges take place with countries in all regions of the globe, although the majority are with European countries. They must be for a minimum of seven days and be theme-based.

Exclusions: Tours to several countries, or cities in one country; competitions; purely touristic visits; exchanges that are part of an educational curriculum; youth wings of political parties; individual young people proposing to live, work or study in another country.

Applications: Contact the Regional Committee, listed below.

East Midlands
Nottinghamshire County Council, Youth, Community and Play, County Hall (4th Floor), West Bridgeford, Nottingham NG2 7QP
Tel: 0115 977 4976; Fax: 0115 977 2807
Contact: Sue Andrew; E-mail: sue.andrew@nottscc.gov.uk

Eastern Region
Youth Service, Valley School, Valley Way, Stevenage, Herts SG2 9AB
Tel: 01438 219064; Fax: 01438 219050
Contact: Bernie Talbot; E-mail: bernie_talbot@hertscc.gov.uk

London
Education Department, London Borough of Richmond, Regal House, London Road, Twickenham TW1 3QB
Tel: 020 8891 7502; Fax: 020 8891 77584
Contact: Nicci Carter, Youth Officer; E-mail: n.carter@richmond.gov.uk

North
NRYCDU, Pendower Hall Education Development Centre, West Road, Newcastle upon Tyne NE15 6PP
Tel: 0191 274 3620; Fax: 0191 274 7595
Contact: Tony Halliwell, Senior Development Officer; E-mail: nrycdu@aol.com

North-West
North-West RYSU, Derbyshire Hill Youth Centre, Derbyshire Hill Road, Parr, St Helens WA9 3LN
Tel: 01744 453800; Fax: 01744 453505
Contact: Sharon Moore; E-mail: sharon@nwrysu.deomon.co.uk

South
Education Department, County Hall, Chichester, West Sussex PO19 1RF
Tel: 01243 777066; Fax: 01243 777211
Contact: Tina Saunders; E-mail: tina.saunders@westsussex.gov.uk

South-West

South-West Association for Education & Training, Bishops Hull House,
Bishops Hull, Taunton, Somerset TA1 5RA
Tel: 01823 335491; Fax: 01823 323388
Contact: Dillon Hughes; E-mail: international@swafet.org.uk

West Midlands

District Youth & Community Education Office, County Services Building,
Fountain Street, Leek, Staffordshire ST13 6JR
Tel: 01538 483267; Fax: 01823 323388
Contact: Elizabeth Harding; E-mail: connectyouth.wm@staffordshire.gov.uk

Yorkshire and the Humber

Regional Youth Work Unit, Belle Isle Open Access Centre, Enterprise Way,
Middleton Road, Belle Isle, Leeds LS10 3DS
Tel: 0113 270 3595; Fax: 0113 270 3643
Contact: Penny Robson; E-mail: pennyrobson@rywu-yandh.co.uk

Scotland

Central Bureau, 3 Bruntsfield Crescent, Edinburgh EH10 4HD
Tel: 0131 447 8024; Fax: 0131 452 8569
Conact: Jim Bartholomew; E-mail: jim.bartholomew@britishcouncil.org

Wales

Wales Youth Agency, Leslie Court, Lon-y-Llyn, Caerphilly, Mid Glamorgan
CF83 1BQ
Tel: 029 2085 5700; Fax: 029 2085 5701
Contact: Jean Reader; E-mail: jean.reader@wya.org.uk

Northern Ireland

Youth Council for Northern Ireland, Forest View, Purdy's Lane, Belfast BT8 7AR
Tel: 028 9064 3882; Fax: 028 9064 3874
Contact: Bernice Sweeney; E-mail: bsweeney@youthcouncil-ni.org.uk

FUNDING FROM EUROPE

Regional European Funding Advice Offices for the Voluntary Sector
Culture 2000
European Structural Funds
The MEDIA Programme
Euroscript
Interreg IIIA – Franco-British Interreg Programme
European Youth Programmes
UNESCO – International Fund for the Promotion of Culture
Social Risk Capital Scheme (Wales)

This section highlights some key avenues of funding in Europe. It should be regarded as an introduction to potential sources of funds, rather than an exhaustive survey of all possible schemes of assistance available. For more detailed information on the cultural role and policies of the supra-national and inter-governmental organisations, and the opportunities they may provide as sources of finance and documentation, readers are advised to contact Euclid (the body appointed the official Cultural Contact Point by the European Commission and the Department of Culture, Media and Sport), International Intelligence on Culture in London, or the international services in Wales and Northern Ireland listed at the start of this international section. Other useful sources of advice are also listed below.

The European Union

Funding for cultural projects from the European Union (EU) originates principally from the Directorate General for Education and Culture which includes Culture, Education and Training, Youth, and AudioVisual Policy amongst its responsibilities. When aid has been obtained for arts projects through the European Social Fund (Directorate General for Employment and Social Affairs) or the European Regional Development Fund (Regional Policy Directorate General) it has invariably been in fulfilment of non-arts objectives such as the training of young unemployed people, or tourism infra-structure projects which have created jobs in areas of high unemployment. Thus ingenuity is often a pre-requisite for prospective applicants to enable them to devise projects which meet different sets of criteria without losing their cultural value in the process. Normally the EU's grants are given for limited periods, usually three years. Once a grant has been agreed, the sum cannot usually be increased. For every Euro in grant the project needs to find the equivalent in match funding.

You should also consider whether there is scope for involving organisations engaged in similar work in other EU countries or for making a project more relevant to an EU policy area. A European dimension to your work will increase the chances of

receiving EU financial aid, and is essential in the case of support from the cultural and media funding programmes.

Some brief descriptions of the EU schemes and programmes of particular interest to the arts world follow.

Applications: The European Commission and the EC offices in London prefer application forms to be obtained from the relevant agencies (e.g. The Cultural Contact Point (Euclid), the MEDIA Desk, etc.) in the member country. When making a request for application forms for any of these schemes, ask for an indication of how long applications take to be processed and what the average size of grant is so you can pitch your application accordingly.

Decisions on allocation of funds are often made in January when the EU financial year starts so in those cases where no closing date is specified, it is important to submit applications by November at the latest for schemes requiring funding in the following year. However, pockets of money occasionally become available at other times during the year and, as with government departments here, sometimes unspent money needs to be allocated quickly by the end of the financial year. Euclid, the Arts Councils and International Intelligence on Culture may be able to advise you of such short-notice funding opportunities.

Offices of the European Commission in the UK

Representation for the UK
Jean Monnet House, 8 Storey's Gate, London SW1P 3AT
Tel: 020 7973 1992; Fax: 020 7973 1900

Office for Wales
4 Cathedral Road, Cardiff CF11 9SG
Tel: 029 2037 1631; Fax: 029 2039 5489

Office for Scotland
9 Alva Street, Edinburgh EH2 4PH
Tel: 0131 225 2058; Fax: 0131 226 4105

Office for Northern Ireland
Windsor House, 9–15 Bedford Street, Belfast BT2 7EG
Tel: 028 9024 0708; Fax: 028 9024 8241

The Government Offices for the Regions (see separate entry) have operational responsibility for the Structural Funds with the Regional Development Agencies (see separate entry) leading on economic strategy and policy issues.

Officers at the Regional Arts offices should be able to give advice and direct arts organisations to the officers concerned with economic development and European funding within local authority departments.

As well as the arts specific advice and information sources listed in this section, arts organisations are strongly advised also to consult the **Regional European Funding Advice Office for the Voluntary Sector** (see below) in their region for their advice and training on the European Structural Funds.

Useful Guides

An invaluably clear booklet for starters *European Funding and the UK A guide to the funding process* is available free from the European Commission Offices ISBN 92-894-1180-5 It is also accessible on the following website: www.cec.org.uk

Another useful source that shows support region by region is on the website: www.europe.org.uk

REGIONAL EUROPEAN FUNDING ADVICE OFFICES FOR THE VOLUNTARY SECTOR

These offices give advice and run training for organisations seeking to access European funding, particularly the structural funds – the Social Fund and the Regional Development Fund.

Eastern
COVER
Centre 4A, Gonville Place, Cambridge CB1 1LY
Tel: 01223 471 682; Fax: 01223 471 683; E-mail: office@cover-east.org.uk
Website: www.cover-east.org

East Midlands
CEFET
114 Mansfield Road,Nottingham NG1 3HL
Tel: 0115 911 0419; Fax: 0115 911 0418; E-mail: info@cefet.demon.co.uk
Website: www.cefet.demon.co.uk
Contact: Laurie Moran

London
LVSTC
1st Floor, 18 Ashwin Street, London E8 3DL
Tel: 020 7249 4441; Fax: 020 7923 4280; E-mail: info@lvstc.org.uk
Website: www.lvstc.org.uk
Contact: Ray Phillips

North East
ESFVON
St Cuthbert's House,West Road, Newcastle upon Tyne NE15 7PY
Tel: 0191 274 9886; Fax: 0191 274 2235; E-mail: info@esfvon.org.uk
Website: www.esfvon.org.uk
Contact: Donald Dempsey

North West
North West Network
Room 2715, Sunley Tower, Piccadilly Plaza, Manchester M1 4BD
Tel: 0161 236 6493; Fax: 0161 228 6137; E-mail: info@nwnetwork.org.uk
Website: www.nwnetwork.org.uk

South East and South West

SAVAGE

121 Winchester Road, Chandlers Ford, Hampshire SO53 2DR

Tel: 023 8026 2655; Fax: 023 8027 1811; E-mail: savage@compuserve.com

Website: www.savage-europe.org.uk

Contact: Diana Halford

West Midlands

West Midlands European Network

Unit 1–314, Custard Factory, Gibb Street, Digbeth, Birmingham

Tel: 0121 683 8890/8891; Fax: 0121 683 8892; E-mail: info@wmeuronet.co.uk

Website: www.wmeuronet.co.uk

Yorkshire & the Humber

Yorkshire/Humberside Regional Forum

3rd Floor, Goodbard House, 15 Infirmary Street, Leeds LS1 2JS

Tel: 0113 243 8188; Fax: 0113 243 5446; E-mail: sarah.cookson@yhregforum.org.uk

Website: www.yhregforum.org.uk

Contact: Sarah Cookson

Wales

Voluntary Sector European Support Unit

WCVA, Baltic House, Mount Stuart Square, Cardiff CF10 5FH

Tel: 029 2043 1700; Fax: 029 2043 1706; E-mail: enquiries@wcva.org.uk

Website: www.wcva.org.uk

Scotland

No special service now at the SCVO. Enquiries to be made direct to the governmental department dealing with this funding.

CULTURE 2000

Note: *Annual calls for applications are usually announced in the spring each year with a deadline in September.*

Euclid (see separate entry) was reappointed by the DCMS and the European Commission as the official UK contact point for Culture 2000 for the period, 2000/02. The following information has been taken from information on Euclid's website.

Background

The Education and Culture Directorate General (or DG EAC) of the EC administers initiatives directed specifically at arts and culture. From 1 January 2000, a new funding programme, Culture 2000, replaced the former Kaleidoscope, Raphael and Ariane programmes. It is a framework programme – meaning that applications can be submitted to one of several different measures.

Culture 2000 aims to promote cultural diversity by encouraging co-operation between Member States and participating countries, in particular by supporting artistic creation and preserving the common cultural heritage.

The 2002 call and the two remaining calls (for 2003 and 2004) will incorporate two new concepts:
- three broad themes – each application will need to address at least one of these themes;
- a particular focus each year on a different cultural sector.

The overall aims of Culture 2000 are:
- to provide funding for quality projects;
- to encourage innovation and creativity;
- to provide real European added value;
- to reflect the current concerns and interests of operators in the cultural field.

Three broad themes have been chosen which aim to reflect these objectives, and these will be the focus of the remaining three calls for Culture 2000, including 2002. These themes are:
- addressing the citizen;
- new technology / media / addressing creativity;
- tradition and innovation; linking the past and the future.

Annual Sectorial Approach

In 2002, 2003 and 2004, one main sector of cultural activity is highlighted each year. This aims to ensure:
- that cultural operators wishing to submit projects are informed in advance of the main sector to be supported each year. It is hoped they will be able to plan their activities better and to develop proposals that demonstrate an imaginative and creative approach and which represent real European added value; and
- that all cultural operators can be assured that their specific area of cultural activity will be given due prominence.

2002 – Visual Arts

This includes all modern and contemporary visual arts and other related forms of artistic expression, such as painting, sculpture, video art, cyber art, photography, industrial and commercial design, textile design, architecture, graphic art, the decorative arts, and arts and crafts.

2003 – Performing Arts

This includes theatre, dance, music, opera, the lyric arts, street theatre and circus.

2004 – Heritage

This includes movable heritage, built heritage, non-material heritage, historical archives and libraries, archaeological heritage, underwater heritage, cultural sites and cultural landscapes, with the exception of cultural heritage of the modern period.

Overall Criteria

The 2002 call stated that priority will be given to the following criteria:

- quality projects;
- projects which involve the largest number of cultural operators from the different participating countries;
- projects which ensure the widest dissemination of their activities to the general public using the most appropriate, and in particular new, means of communication.

Particular attention will be given to projects bringing together cultural operators for EU/EEA countries and candidates' countries.

Specific Criteria

There are two main categories of projects.

- **Annual co-operation projects** – i.e. projects lasting one year.
- **Multi annual co-operation agreement projects** – i.e. projects lasting 2–3 years, where there is a specific agreement signed between the partners committing them to the objectives and actions of the project.

In addition, there are two other categories of projects.

- Books, reading and translation.
- Cultural co-operation projects in third countries not participating in the programme.

Annual Co-operation Agreement Programmes

Projects should be specific, innovative and/or experimental. Co-organisers required from at least three participating countries. Projects had to start in 2002 and last for 12 months maximum.

EC will contribute 50–150,000 Euros – up to 50% of budget.

Visual Arts

100 projects supported in this area

Covering the field of modern and contemporary visual arts. Projects could cover (amongst other areas) co-productions, creation and dissemination, training of professionals, publications, mobility of artists, and works on themes of common European interest.

Performing Arts

15 projects supported in this area

Projects focused on either:

- **young authors, composers and interpreters of music** touring across at least two of the participating countries and facilitating their access to venues and recognised festivals (particularly those aimed at young people) in each of the two participating countries involved; or
- the **co-production and/or touring** of works in the field of theatre, dance and opera across at least two of the participating countries involved in the project.

Cultural Heritage

15 projects will be supported in this area

Projects focused on one of the following:

- the creation of **virtual cultural itineraries and/or exhibitions in digital space**;
- the implementation of **touring exhibitions** to be shown in at least two of the countries participating in the programme and which are destined for a wide audience;
- the implementation of a **conservation/safeguarding programme** concerning monuments or objects in at least two of the countries participating in the programme.

All projects should also reflect themes of European cultural interest characteristic of a particular period or of a particular European artistic movement.

Multi-annual Co-operation Agreement Programmes

These projects aimed to strengthen co-operation between cultural operators in a structured and long-lasting way. To this end, projects undertaken in this category must have an ongoing multiplier effect at the European level.

Co-organisers required from at least *five participating countries*. Projects must start in 2002 and last for 24 months minimum and 36 months maximum. *EC will contribute up to 50% of budget – made in phases up to a maximum of 300,000 Euros per year. The total EC funding may be increased by an extra 20% (of the EC's 60%) to cover administration costs for new agreements only.*

Visual Arts and Books, Reading and Translation

15 projects supported in visual arts

1 project supported in books and reading

Projects should address at least four of the following:

- co-production and international dissemination of artistic or literary works and/or events;
- organising other artistic or literary events aimed at the general public;
- organising initiatives for exchanges of experience (both academic and practical) and the further training of professionals;
- promoting the artistic and cultural elements concerned;
- organising projects to raise the public's awareness and to teach and disseminate knowledge;
- adapted and innovative use of new technologies to the benefit of participants, users and the general public;
- producing educational books, guides, audiovisual documentaries and multimedia products which aim to illustrate the theme of the co-operation agreement.

The exhibitions, artistic and literary events, publications, books and productions must be designed and produced in such a way that they are both accessible and intelligible to the widest audience (e.g. multilingual presentations adapted to the range of target audiences).

Performing Arts

1–2 projects supported in this area
Projects should focus on several initiatives, such as:
- the co-production and the international touring of artistic works and events;
- the exchange of experience and the further training of professionals;
- the use of new technologies to the benefit of participants and the general public;
- the multilingual production of books, audiovisual or multimedia products which aim to illustrate the theme of the co-operation agreement.

Cultural Heritage

1–2 projects will be supported in this area
Projects should focus on the cultural heritage of the antiquity period, with strong European significance, characteristic of a particular period and/or a particular European artistic movement and should involve a number of initiatives such as:
- co-production and international touring of exhibitions;
- restoration of monuments or objects, in at least 3 of the participating countries, that represent the heritage of the period and/or the artistic movement selected;
- highlighting of the influence/impact that the selected period/artistic movement had on Europe;
- exchange of experience and the further training of professionals;
- use of new technologies to the benefit of participants and the general public;
- production of multilingual books, audiovisual or multimedia products for the general public which aim to illustrate the theme of the co-operation agreement.

Note that all these projects must be based on a common document in a legal form recognised in one of the participating countries.

Books, Literature and Reading

Must start in 2002 and last 12 months maximum
Funding and support will be provided for the following.
- Approximately 50 projects for the translation of literary works (fiction) written by European authors after 1950; priority will be given to works aimed at children and young readers. Each project must include at least 4 and up to 10 works from this category.
- Approximately 40 projects for the translation of monographs of modern or contemporary European artists and works on art history or art theory (written by European authors). Each project must include at least 4 and up to 10 works from this category.
- Approximately 5 one-year specific, innovative and/or experimental projects involving publishers and authors aiming to explore the field of e-books and electronic publishing and their multilingual distribution. These projects must also tackle issues relating to managing copyright.
- Approximately 5 one-year specific, innovative and/or experimental projects promoting collaboration, at a European level, aimed at improving the skills of professionals in the field of translation of literary works.

Cultural Co-operation projects in third countries not participating in the programme

Projects should focus on exhibitions promoting modern and contemporary European visual arts in third countries.

5 projects supported in this area

- Must start in 2002 and last for 12 months maximum.
- The event(s) must take place in a third country not participating in the programme.
- They must be undertaken in co-operation with at least 3 cultural institutes/operators from at least 3 of the countries participating in the programme and 1 cultural institute/cultural operator in the relevant third country.
- Proposals for this action must be submitted to the EC by the relevant authorities in the project leader's country of origin through its Permanent Representative to the EU (based in Brussels).

Partner Search Mechanisms

- Partner Search Mechanism, established by the network of Cultural Contact Points which focuses solely on this call for Culture 2000.
- The Culture-Match mechanism established by EUCLID which enables anyone to search for partners for any reason – Culture 2000 or other EU funding programmes, or to develop a partnership for any other reason.

Both can be accessed by Euclid website.

Examples of projects supported:

- **European Arts of the Street** Maraworld Spain with Zap Productions, Brighton, and organisations from France and Belgium. A project increasing young people's interest in the theatre, giving young companies the opportunity to perform abroad and leading to an annual event involving all participants.
- **Young Europeans international music event** Responsible organisation: Oxford City Council; Co-organisers: Bonn City Council; Grenoble City Council; Leiden City Council; Orchestra of St John's Smith Square. A multinational youth opera production of 'Noyes Fludde' with five nations co-operating in different aspects of the project. The grant subsidised production costs and subsistence, travel and accommodation costs for the young participants.
- **Contact Art** Responsible organisation: LPDM Centro de Recursos Sociais, Portugal; Co-organisers: CanDoCo Dance Company; Coordiamento Sport Handicap. This project promoted the integration of people with disabilities through recognition of their creative and artistic skills. The organisations set up links with dance schools to design jointly a choreography to be performed live in London, Bologna and Lisbon. Both people with disabilities and dance students were targeted.
- **Migrating memories – MIME** Responsible organisation: Malmö Museer, Sweden. Co-organisers: Tampere Museum, Finland; Nottingham Trent University MIME engaged young immigrants (16–19 years) from Europe and other countries, plus their teachers and parents in Tampere, Nottingham and Malmö in realising the importance of safeguarding memories, providing inspiration through education, co-operation and a dramatised travelling suitcase exhibition in those three towns

where stories/objects from each city were added on. These stories were later presented via an interactive multilingual and open access website.

- **Bridges Community Play** Responsible organisation: Karkkila, Finland. Co-organisers: Commune de Niederanven; Comune de Bellagio; HolstebroDouzelage; Meerssen Town Council; Municipality of Prevenza; Sherbourne Town Council; Town of Kotcting. Amateur theatres prepared and performed a joint historical play. In the initial phase, each group had a period of education in theatre, drama and history, focused on their own local history. After separate group rehearsals, there were mutual rehearsals of the whole cast with final play performed in Karkkila.

Applications: It is important first to contact EUCLID, the official UK Cultural Contact Point, which can provide:

- a summary Guidance Note to the call and a summary Guidance Note to the application form, available by post or e-mail;
- it will comment on project ideas and on a draft application. Ideas, or part or all of the application form, can be e-mailed and a response will be made as quickly as possible, certainly within a week. E-mail: c2k@cwcom.net

Official EC website containing full information including links to download the official 'Call for Applications' and the application form http://europa.eu.int/comm/culture/culture2000_en.html

EUROPEAN STRUCTURAL FUNDS

Structural Funds are the European Union's main instruments for supporting social and economic restructuring across the Union. They account for over a third of the European Union budget. The UK's allocation from the Structural Funds for the period 2000/06 is over £10 billion.

A region/area must be designated as Objective 1 or Objective 2 in order to receive financial support. All regions have Objective 3 status. The aims of the funds, and the priority 'Objective' area in which they can be spent, are as follows.

The European Regional Development Fund (ERDF)

Aims to improve economic prosperity and social inclusion by investing in projects to promote development and encourage the diversification of industry into other sectors in areas lagging behind. This fund is available in Objective 1 and 2 areas. Capital and revenue projects are funded.

The European Social Fund (ESF)

Funds training, human resources and equal opportunities schemes to promote employability of people in both Objective 1 and 3 areas. In Objective 2 areas ESF may be used to complement the ERDF activities. Only revenue projects are supported.

The guidance section of the European Agricultural Guidance and Guarantee Fund (EAGGF)

Available in rural Objective 1 areas to encourage the restructuring and diversification of rural areas, to promote economic prosperity and social inclusion, whilst protecting

and maintaining the environment and our rural heritage. In areas outside Objective 1, the EAGGF (Guarantee section) provides funding within the England Rural Development Plan.

Objective 1

Aims to develop regions which are economically disadvantaged and underdeveloped. Eligible areas are those that have less than 75% of EU average GDP. It is the highest level of regional funding available from the EU. In the UK eligible areas are Merseyside, South Yorkshire, Cornwall and the Scilly Isles, and West Wales and the Valleys. In addition, the UK also has two transitional Objective 1 areas, the Highlands and Islands and Northern Ireland which also qualifies for a unique PEACE programme.

In total the UK will receive over £3.9 billion of Objective 1 money between 2000/06.

Objective 2

Aims to renew industrial, rural, urban and fisheries areas which are in decline and where unemployment is higher than the national average. It is the second highest level of funding available from the EU. In addition, some areas that had Objective 2 or 5b status in the previous programming period are eligible for transitional funding until 2005.

Including transition, Objective 2 covers well over 19 million people in the UK. In total, the UK will receive over £3.1 billion for UK Objective 2 and transitional Objective 2 areas for the period 2000/06.

Objective 2 areas are highly specific and localised. A list of the relevant wards in local authority districts is available on the DTI website. Organisations are particularly advised to contact their local Government Regional Office or the Scottish Executive.

Objective 3

This Objective involves only the European Social Fund and covers all areas except Objective 1 areas. Its aims are to: tackle long-term unemployment; help young people and those at risk from not being able to find work; improve training, education and counselling for lifelong learning; encourage entrepreneurship and adaptability in the workplace; promote equal opportunities.

The UK will benefit from just under £3 billion of Objective 3 money for 2000/06.

Community Initiatives

In addition to the priority Objective areas around 5% of the Structural Fund budget funds four Community Initiatives. The UK will receive around £916 million for these in 2000/06. The current initiatives areas follows.

- **EQUAL** Funding for training and employability schemes to combat discrimination and inequalities in the labour market; the Department for Education and Skills is responsible for this programme.
- **LEADER** Funding for rural development projects; the Department for Environment, Food and Rural Affairs is responsible for this programme.
- **INTERREG III** Funding to encourage cross border, trans-national and interregional co-operation; to encourage balanced and sustainable development

across the European Community. For further information contact the Department for Environment, Food and Rural Affairs.

■ **URBAN II** Funding for schemes in small and medium-sized towns suffering from significant economic and social conversion difficulties. The Department for Environment, Food and Rural Affairs is responsible for this programme.

How much money can be paid to a project?

The maximum contribution depends on the type of project and where it takes place. In practice, in the UK, Objective 1 projects can receive up to 50% funding from the Structural Funds, but the proportion may be lower, e.g. in a project intended to result in commercial activities and profits. It is normally the responsibility of the applicant to find the remaining funding which must usually include matching public funding. However, Government Offices and Regional Development Agencies (RDAs) can help potential applicants find match funding.

Public, private and voluntary sector bodies can all make applications. The kind of projects that are funded can vary from region to region. Each region writes a Single Programming Document which sets out what it wants the funds to achieve over the eligible period. These aims must tie in with the overall aims of the funds to promote the economic and social cohesion of the European Union. Projects are required to deliver a direct, measurable and positive impact on the economy of the area.

Administration

The Department of Trade and Industry co-ordinates overall UK government policy on the funds and takes the lead on many issues affecting more than one fund or more than one part of the UK. The Department for Work and Pensions has overall responsibility for the European Social Fund and the Department for Transport, Local Government and the Regions leads on the ERDF. Further information is available on the website: www.dti.gov.uk

Outside England implementation of the Structural Funds is devolved to the Scottish Executive, National Assembly for Wales and Department for Finance and Personnel in Northern Ireland. Further information is available on the following websites: www.scotland.gov.uk www.nics.gov.uk www.wefo.wales.gov.uk

How are applications dealt with?

The Government Offices in England, the National Assembly in Wales, the Scottish Executive in Scotland and the Department of Finance and Personnel in Northern Ireland provide the secretariat for the programmes. They publicise the programmes and invite applications for projects. The Secretariat will also issue application forms and guidance. Applications are judged against the criteria that have been previously drawn up by the Programme Monitoring Committee (PMC). The criteria reflect the priorities in the Single Programming Documents.

The Regulations require that projects are monitored and financial returns are made on a regular basis to the Commission.

Applications for funds should be made direct to the appropriate regional Government Office in England, or devolved administration in Northern Ireland,

Scotland and Wales. Application forms and guidance are available on the Government Offices for the Regions websites (see separate listing). Local projects must contact an appropriate local partnership to gain project approval before an application to the Government Office can be made.

The Regional Arts Boards/offices (see separate listing) may be able to direct potential applicants who are in eligible areas to officers in their local authorities who can assist them to develop an application. In many cases it is advisable for applicants to find a regeneration partnership programme in their area with which they can co-operate.

The Regional European Funding Advice Offices for the Voluntary Sector (see separate listing) and also provide advice and training particularly on the Structural Funds.

Examples of arts organisations which have received support from European Structural Funds

MIDA – the Moving Image Development Agency, Liverpool, has managed funds supported by the ERDF – the Merseyside Film Production Fund (Objective 1) and the North West Film and Video Production Fund (Objective 1 and Objective 2).

Merseyside ACME Arts, Culture and Media Enterprise received ERDF Objective 1 funding.

Theatre Mwldan, Cardigan, Wales, was awarded £1.6 million of ERDF Objective 1 funding in 2001 for its major restructuring and development project.

Mind the Gap Theatre Company, Bradford, has received ESF funding for three projects under Objective 3 (with the third referenced particularly to Objective 2 areas). The company works particularly with people with learning difficulties and the projects have involved capacity building, training programmes and further apprenticeship development.

Arts Connection, a collaboration between East England Arts and the Prince's Trust, received European Social Fund Objective 3 support to assist disadvantaged people aged between 18 and 30 to set up their own creative businesses.

Wrexham CBC, for multimedia youth programme, under Objective 3, ESF, 2001, (£10,075).

Lighthouse Media Centre Development, West Midlands, for enhancement of centre's facilities for small firms and self-employed people working in the application of new media technologies in the information, cultural, entertainment and leisure industries; and to extend training opportunities for the media and cultural industries. The grant offered was £252,000 of total project costs of £630,000. This was for phases one and two of a three phase project.

Contact: Frank Challenger, Manager, Tel: 01902 716 055.

THE MEDIA PROGRAMME

Directorate General for Audiovisual Media Information, Communication, Culture – DGX.

MEDIA is a five-year programme of the European Union to strengthen the competitiveness of the European film, TV and new media industries and to increase international circulation of European audiovisual product.

MEDIA Plus commenced on 1 January 2001 and will run to 31 December 2005. With a budget of 400 million Euros (around £240 million) MEDIA Plus supports professional training (screenwriting, business and new technologies), project development (single/slate), and the distribution and promotion of European audiovisual works.

MEDIA Plus's predecessor, MEDIA 2, successfully raised the proportion of European films distributed outside their country of origin from 14% in 1996 to over 22% in 1999. Over 60% of European films that are distributed outside their country of origin are supported by MEDIA.

Independent production and distribution companies can apply for development or distribution funding in the form of grants and interest free loans. Financial assistance is available for training providers and organisers of markets and festivals. Individuals may also benefit from subsidised places on training courses and international markets.

Support covers the following areas.

Development

Support is offered for:

- **Project Development** For fiction and creative documentary; animation; multimedia projects; slate funding.

Distribution

Support is offered for:

- **Automatic Cinema Support** To encourage and support the wider transnational distribution of recent non-national European films by providing funds to operators for further investment in the same area, based upon their record of generating an audience for European films.
- **Selective Cinema Support** Financial support to European theatrical distribution companies applying as a grouping for the distribution of one or several European non-national films. This funding is also for European sales agents or producers acting as the co-ordinators of such a grouping.
- **Support for the Networking of Cinemas Screening European Films** Support for European associations, companies or cinema theatres that form part of a network whose activities contribute to the creation of European networks of cinema operators running joint schemes and to encourage these cinema operators to screen a significant proportion of non-domestic European films.
- **TV Distribution** Funding for dubbing, subtitling, the production of M & E tracks and to cover personnel and assistance costs, for TV programmes that already have at least two broadcasters from two different linguistic zones on board.

- **Support to International Sales Agents of European Cinematographic Films** To encourage and support the wider transnational distribution of recent European films by providing funds to sales agents, based upon their performance on the market, for further reinvestment in new European films.

Promotion and Market Access

Grants are made to organisations or European networks that facilitate independent producers and distributors with access to international markets. The scheme also funds activities promoting European cinema and audiovisual productions targeted at the general public.

Festivals

Support is offered for:
- activities organised by networks of audiovisual festivals;
- audiovisual festivals.

Training

Grants are provided to training institutions or bodies offering initial and/or continuous vocational training courses in screenwriting, management and new technologies.

Each year new courses come on stream and others finish. Obtain up-to-date information from the Media Desk.

MEDIA Desks in the UK

These offices provide information and guidance about the MEDIA Programme projects. Guidelines and application forms as appropriate are available from them.

The website for all the desks is: **www.mediadesk.co.uk**

UK Media Desk

Fourth Floor, 66–68 Margaret Street, London W1W 8SR
Tel: 020 7323 9733; Fax: 020 7323 9747; E-mail: england@mediadesk.co.uk
Contact: Agnieszka Moody, director

Media Antenna Scotland

c/o Scottish Screen, 249 West George Street, Glasgow G2 4QE
Tel: 0141 302 1776; Fax: 0141 302 1778; E-mail: media.scotland@scottishscreen.com
Contact: Emma Valentine

Media Antenna Cymru Wales

c/o Sgrîn, The Bank, 10 Mount Stuart Square, Cardiff Bay, Cardiff CF1 5EE
Tel: 029 2033 3304; Fax: 029 2033 3320; E-mail: antenna@sgrin.co.uk
Contact: Gwawr Hughes

Media Service for Northern Ireland

c/o Northern Ireland Film Commission, 21 Ormeau Avenue, Belfast BT2 8HD
Tel: 02890 232444; Fax: 02890 239918; E-mail: media@nifc.co.uk
Contact: Cian Smyth

Applications: Deadlines for the various schemes run throughout the year. MEDIA publishes single documents known as Calls for Proposals for each strand of its funding.

Each contains both the application form, the guidelines on how to fill them in, and the application deadline. These are available from the website (www.mediadesk.co.uk) or call your local MEDIA Antenna or Service.

Applications should be submitted in the correct Euro exchange rate. This can be found in the Euro Rate section of the antenna website, or by contacting your local MEDIA Antenna or Service in the UK. All applications must be sent to the European Commission in Brussels as specified in the guidelines.

EUROSCRIPT

Suffolk House, 1–8 Whitfield Place, London WIP 5SF
Tel/Fax: 020 7387 5880
E-mail: euroscript@netmatters.co.uk
Website: www.euroscript.co.uk

Euroscript is a non-profit-making script development agency funded by the European Union's MEDIA programme. It works in 10 European countries where it can provide experienced script consultants to work with writers and producers to develop their projects.

Its services include: tailor made consultancy for screenwriters and production companies, residential workshops, script analysis and script promotion.

These include two annual competitive programmes:

- **Film Story Competition** 20 film stories are selected each year to develop to script. Selected writers are helped to develop their stories to a final draft screenplay in 9 months through a distance script development programme.

- **Assisted Writer/Producer Scheme** free development consultancy is offered to up to 10 production companies and writer/producer teams.

Applications: Deadlines are at the end of April and October. There is a £30 handling fee for every application.

INTERREG 111A – FRANCO-BRITISH INTERREG PROGRAMME

Budget: 108.2 million Euros (around £66.4 million) (2002/06)

This programme encourages the promotion of integrated inter-regional development between border areas and encompasses Nord-Pas de Calais, the Somme, Seine Maritime, Kent, Medway, East Sussex, and Brighton & Hove. Each of the three priorities has three main measures. Applications must address one measure.

Priority 1: Strengthening cross-border co-operation in the service of the citizen.

Priority 2: Promoting balanced spatial development.

Priority 3:
- promoting an attractive and welcoming region;
- co-operation in the fields of tourism and leisure;
- co-operating to develop a common approach to culture whilst celebrating diversity;
- co-operation to encourage conservation and a high-quality environment.

Contact: European Team at the relevant Government Office for your region (see separate entry).

EUROPEAN YOUTH PROGRAMMES

(see also Connect Youth International)

Website: http://europa.eu.int/comm/education/youth/youthprogram.html

The YOUTH programme is decentralised, to take action as close as possible to the beneficiaries and to adapt to the diversity of national systems and situations. National Agencies assist the Commission in the management of the YOUTH programme and are responsible for the implementation of certain of its actions. In addition they are responsible for disseminating information and giving guidance and advice.

The United Kingdom agency is:
Connect Youth International
The British Council, 10 Spring Gardens, London SW1A 2BN
Tel: 020 7389 4030; Fax: 020 7389 4033;
E-mail connectyouth.enquiries@britishcouncil.org
Website: www.britcoun.org/education/connectyouth/index.htm
or www.connectyouthinternational.com

The European YOUTH Programme divides into five actions:

Action 1 Youth Mobility

Exchanges of groups of young people which contribute to the personal development of the young participants. The exchanges are open to all **British** young people, regardless of their background, education, or socio-economic situation. They bring together groups of young people, between 15 and 25 years, from different backgrounds from two, or more countries, providing them with an opportunity to meet, discuss and confront various themes, while learning about each other's countries and cultures.

Each youth exchange has a host group and one or a number of sending groups.

The exchanges must be for a minimum of 16 and not more than 60 participants, for a duration of 6–21 days, excluding travel.

The grant is calculated on the basis of real costs for travel and lump sums for all related costs. The exact amounts are detailed in the application forms.

Applications: See general entry for Connect Youth International which covers exchanges wider than the European Union and lists of the regional committee offices to which applications should be made.

Action 2 European Voluntary Service

EVS is an opportunity open to all young people between the ages of 18 and 25, which allows them to volunteer to work in a variety of activities in the social, environmental and cultural field. Their voluntary service takes place in another county, for a minimum period of three weeks to a maximum of six months (short-term), or six months to 12 months (long-term). There are no preconditions in terms of qualifications or social background for young people taking part. Its three main aims are to:

- help young people become more integrated into society;
- develop a service that will benefit the community in humanitarian, social or cultural activities;
- link and strengthen organisations working for the good of the public throughout Europe.

There are three participants:

- **the volunteer** A young person aged between 18-25 prepared to undertake voluntary service in another YOUTH Programme Member State.
- **the sending project** An organisation that takes on the recruitment, the preparation and the sending of the volunteer.
- **the hosting project** An organisation that uses the services of the volunteer providing board, lodging and pocket money with supervision and support.

There is no cost to the young person. For more information contact the Information Unit of Connect Youth International – see address above.

Action 3 Youth Initiatives

Group Initiatives are projects created, managed and owned by young people between 15 and 25. They should be social, cultural, developmental or entrepreneurial projects rooted in the local community and should respond to the needs and interests of young people.

Each project should contain a European dimension. This can be interpreted in two ways. The project may deal with an issue which affects all young people throughout the European Union. Examples of such projects would include those dealing with such issues as drug abuse, homelessness, alcoholism, racism, HIV and AIDS.

A project may already have contacts with a project in another European Member State dealing with similar issues in another way. In this case the two projects may choose to exchange information and working methodologies which may eventually lead to meeting each other. From this contact a youth exchange may occur.

Projects can apply up to 10,000 Euros. Successful applicants will receive 50% of their grant at the beginning of their project and the remaining 30% and 20% on receipt of satisfactory completed Report Forms.

There are normally five Selection Rounds a year.

Future Capital

Future Capital gives the unique opportunity to a young person to develop their own project following on from their recent EVS experience. It can be developed individually or with another ex-EVS volunteer. 'You can be as imaginative as you

like with your project based in an environmental, cultural social or economic area. You may wish to develop a talent you have or try out a new idea. Future Capital will allow you to invent and participate in an activity that you have produced. Your project can take place either in your own country, where your volunteering took place or another country participating in EVS.'

- Funding covers a period of 12 months, although there is no time limit if the project lasts longer. Funding up to a maximum of 5,000 Euros (approximately £3,000) is available.
- Projects for added value to local community can be funded up to 100% not exceeding 5,000 Euros.
- Personal development can be funded up to 50%.

For further information, contact: Andrew Hurley, Tel: 020 7389 4738; Fax: 020 7389 4033; E-mail Andrew.Hurley@britishcouncil.org

Action 4 Joint Actions

The year 2001 is a trial year for joint actions between the Leonardo da Vinci, Socrates and YOUTH programmes. The budget for this call is 1.5 million Euros. A limited number of projects are expected to start from 1 November 2001. For more details access the website: www.europa.eu.int/comm/education/joint/jointactions_en.html

Action 5 Support Measures

Support Measures provide tools to help all those working in the youth field to develop projects related the the YOUTH programme objectives. They help organisers to:

- find partners, develop youth work skills and prepare for projects;
- exchange good practice, develop youth policy, build transnational partnerships and develop co-operation with third countries.

Grants below 15,000 Euros are submitted to Connect Youth International and those above 15,000 Euros are forwarded to the European Commission.

For more information contact the Connect Youth International Information Unit – see address above.

Partner Request

This **online partner request database** lists groups and organisations from across Europe who wish to set up exchanges with one another. It allows group/s to make direct contact. The database is available on the website: www.connectyouth international.com

UNESCO – INTERNATIONAL FUND FOR THE PROMOTION OF CULTURE

1,4 rue Miollis, 75732 Paris Cedex 15, France
Tel: 00 33 01 45 68 42 64; Fax: 00 33 1 45 66 55 99
E-mail: c.duvelle@unesco.org
Website: www.unesco.org/culture/ifpc/
Contact: Cécile Duvelle

UNESCO-Aschberg Bursaries for Young Artists

These bursaries promote the professional development of young artists mainly by providing opportunities for further training and residencies in other countries. The costs are shared by UNESCO and the host institution. The laureate does not have to pay any fees or charges.

In 2001/02 a total of 60 bursaries was offered in 29 countries in the following areas: visual arts; music; dance; creative writing; performing arts. It is believed that priority is given to applications from the less developed world. The programme is managed by UNESCO's International Fund for the Promotion of Culture from which a complete list of bursaries is available.

Applications: Consult the above website. The deadline is usually at the end of April.

SOCIAL RISK CAPITAL SCHEME (WALES)

Wales Council for Voluntary Action, Baltic House, Mount Stuart Square, Cardiff CF10 5FH
Tel: 029 2043 1700
E-mail: enquiries@wcva.org.uk
Website: www.wcva.org.uk

This three year scheme, which launched in late April 2001, is being administered by the Wales Council for Voluntary Action (WCVA). It is funded by £2.1 million of European money from both Objective 1 and Objective 3. It assists voluntary and community groups in Wales and provides 'simple and rapid access to funds to help them develop projects in some of the poorest communities'. Match funding may also be available via the assembly's local regeneration fund.

The Social Risk Capital Scheme is only open to organisations with an income of less than £100,000. The total budget for each project should be no more than £10,000. Projects advisers will assist applicants and it is hoped to turn around applications within 30 days.

Part three
SUPPORT FROM COMPANIES

INTRODUCTION

WHAT THIS GUIDE CAN DO

Over 100 major companies are given entries. They are *illustrative,* and should not be taken in any sense as a definitive list of major companies interested in relationships with arts organisations. The entries give the reader a taste of what the company could be interested in, bearing in mind that this is a swiftly moving scene and that the information could be historical by the time you read it. The information is culled (with some difficulty) directly from the companies themselves. There is huge variability in openness and transparency about their internal policies and practices. Some have clearly articulated public policies, most do not. This is particularly so with the arts and with arts sponsorship which has such a close relationship with marketing.

As far as financial information is concerned all companies **have** to note their total charitable donations for the year in their annual reports. This figure is given with each entry and includes all kinds of charitable activities. In a few cases the company was prepared to say which organisations it has supported. Most are unprepared to give financial information specifically about their arts interests.

Changing faces of large corporates

The start of the millennium has seen accelerated mergers and acquisitions between companies – transactions colourfully referred to nowadays as 'companies working their way up the food chain'.

Utilities, oil, and financial services are particular areas of rapid mobility. Some examples – Lattice Transco and National Grid are merging to become National Grid Transco, effective from autumn 2002. Texaco has merged with Chevron to become ChevronTexaco. Esso is now part of the ExxonMobil Group. The Bank of Scotland and Halifax have become HALIFAXBANKOFSCOTLAND,

With large groups there is rarely a single gateway to make approaches. The Royal Bank of Scotland has taken over NatWest but the two brands have been retained. (Indeed the NatWest Group itself comprised a group of 14 companies including Lombard.) Royal Bank of Scotland has a low presence in England compared with NatWest, and vice versa. Be sure to check a group's subsidiary companies and their separate brands e.g. the L E Group, which is involved in generation, supply and distribution, has three brands: SWEB, London Electricity and Virgin Energy. The group also includes LPN – London Power Network. With Six Continents most community support is undertaken by its individual companies which run schemes to benefit community initiatives in their particular geographical areas. Whilst Six Continents *says* that as it has withdrawn from arts sponsorship/partnership, its Bass brand has a long prestigious record of partnerships with radical contemporary art programmes at the ICA and the Tate.

BASIC GUIDANCE FOR BEGINNERS

The best advice in the first place is to make and maintain contact with the Arts & Business office local to your work. Also keep in touch with the officer dealing with business relationships in your relevant regional arts board. The seminars and training courses they run, often in conjunction, will be the best starting point.

Be particularly alert to the different ways in which companies may be prepared to offer assistance which is not financial (see below).

Relationships with companies

'Perceived value for money is key now'
'Corporate social responsibility, rather than corporate entertainment, is top of many sponsorship agendas'

Colin Tweedy, Director General of Arts & Business

As the New Partners programme run by Arts & Business illustrates (see entry following) although sponsorship is the kind of support most often connected with the arts, many other types of relationship are increasingly being developed.

Arts organisations need to use their creative thinking to look at what a company does and what it needs. What are the company's wider policies, how does it engage with the current corporate social responsibility agenda? It is essential you know about its policies in this area. They may be expressed as regeneration, social inclusion, employment, education, youth, special needs, and so on, but of course the arts can and do play a part in addressing many aspects of these concerns. Your job is to convince people who have often never thought of connections between these areas, and have no direct experience of the power of the arts to unlock creativity and harness energy in ways which have linked and positive social outcomes.

Organisations should also consider very carefully and thoroughly how they could engage directly with employees to the benefit of a company.

Donations

However, whatever your ideas, if you are a small, young organisation, a request for a straight donation may be simplest and more successful, especially if you're looking for a relatively small sum of money under £1,000. Gifts in kind are another form of support which may be easier to obtain, particularly for community arts organisations and those working with special needs groups. In all requests make links directly with the company's interests and its policies, not just your own.

Most of the major national and international companies have **corporate community affairs departments** which are responsible for charitable donations. Medium-size companies may have a **donations manager** located in any one of a number of departments, most usually the managing director's office or the company secretary's department, but possibly in the personnel, PR, or marketing department. A few of these large and medium-sized firms have clearly defined donations policies and budgets, although most give to a wide range of good cause organisations.

In smaller, local companies, there is unlikely to be any clearly defined structure or policy for giving. Some give according to the special interest of the chairman, or even the chairman's spouse. Some give in response to requests from clients who support particular causes. Some give only to local charities. Some give nothing at all. Of those that do give, most prefer to give only to registered charities.

Local subsidiaries or local plants and branches of large national companies (particularly supermarkets and banks) may have the authority to make local donations, although sometimes requests have to be routed through head office.

In general, when making donations, companies tend to favour social welfare, relief-in-need, educational, medical, and environmental charities in preference to arts organisations, but not inevitably. The *independent television companies* (see separate list) have a tradition of giving to the 'arts and sciences'. They also support a number of projects to showcase emergent talent. The development of the regional agencies (see separate entries) for the moving image (instigated by the Film Council) has also the close involvement and support of the television companies in the relevant region.

Targeting companies

Your proposal or application is sure to be up against strong competition, whichever company you decide to approach. So think very carefully about why a company might be interested in helping you. One of the best ways to start is by investigating local firms – those in your immediate neighbourhood, in your city, county, region, depending on the size of your catchment area. The local authority may keep a list of the larger employers or the larger ratepayers in the area; the local chamber of commerce may be active and, if so, should be able to supply lists of local firms; in your library you should find the appropriate regional section of the *Kompass Register of British Industry and Commerce*, or you can use a *Yellow Pages* directory. From these sources you can begin to build up a list of likely firms. The *Who owns Whom* directory will tell you if the company is part of a much larger group.

Find out as much as you can about the company. Scan the local papers for information on interesting development plans involving your target companies. Do they have a record of community involvement? What kinds of equipment/materials are part of their stock in trade? Are they likely to have a high turnover in office equipment which you could use? Remember that gifts in kind are often easier to obtain than cash and may be worth substantially more to you than a small donation.

What links do you already have with the company? Check how many local employees it has, and if you can, whether a significant number of them form part of your existing audience.

Consider, too, the companies with which you have business links: suppliers of art materials, printers, fabric and lighting manufacturers, etc. Include in this list your bank, firm of solicitors, accountants, letting agent and so on. Provided you are a good client of theirs, they could be persuaded to help you develop your work.

Investigate larger national or international firms where there is a product link or where the company has community and/or arts policies which are relevant to your work. Consult *The Guide to UK Company Giving* published by the Directory of

Social Change (see bibliography at the end of this book) which may also help you identify these companies.

During all this investigation keep asking yourself, 'What has my organisation got to offer the company?'. Business people are not called 'hard-nosed' for nothing.

Use your contacts

Whatever size or variety of company you seek to interest, personal contacts with senior staff are likely to be of the greatest importance. If one of your board of trustees or supporters is personally acquainted with a high-ranking member of the company, be it socially or through business, then a direct approach on this basis can be worth a great deal more than the carefully calculated 'cold' approach by letter. People like to give to people, particularly people they wish to please or impress. The same principle applies whether it is one neighbour asking another to sponsor their child in a charity walk, or whether it is one businessman asking another to support a charitable cause with which he's concerned.

Other forms of assistance

Business advice/consultancy/mentoring

Finance and marketing are the two most common areas where arts organisations, particularly the small and young, need more strengthening and where the expertise of commercial companies can be a vital help. Approach *Arts & Business* which has 15 regional offices for help (see entry following). It has two valuable programmes – the *Skills Bank* and the *Board Bank* which can provide links to people prepared to give their time in this kind of support.

Some of the larger national and international companies operate staff secondment schemes whereby a member of their staff with relevant skills can be 'lent' free of charge for a fixed period – say six months or even as long as one year – to a charity or voluntary organisation. It is worth exploring the secondment option if you have links with a company that operates such a system. However it is less prevalent than it was a few years ago and more companies are inclined to assist with 'mentoring' – shorter term, direct coaching of individuals. This is also an area which Arts & Business has been developing.

The arts at work

Of course secondment need not be only one-way traffic. Increasingly artists of all kinds are working for a period within business and industrial premises involving employees in their creative work. Similarly partnership arrangement with a company will usefully include programmes of performances within the work context – lunchtime concerts and plays in factories and offices. Increasingly the arrangements are going further, and directly engaging staff in the creative process, or introducing arts approaches to management problems.

Advertising

You can ask a company to buy advertising space in your mailing brochure, programme, magazine, annual report, catalogue, etc. This is obviously more in the nature of a

commercial deal with perhaps a flavour of goodwill attached to it. You will be offering a company access to a select audience through the medium of your printed materials. You will need to provide the company with accurate data on how many people the programme (or whatever) will reach and what sort of people they are, so that the company can decide whether this is a market they wish to target. Be prepared to offer the company a range of advertising options: half page, full page, back page, etc. with discounts for regular advertisements and prices for each advertisement, size and position, based on research into the cost of advertising in other printed materials with comparable circulations. Normally, if you are looking for advertising revenue, you should expect to deal with advertising or marketing managers.

Staff involvement

Many companies encourage their staff to raise money for charity and set aside small sums – £500 – to match charitable donations raised by employees.

Companies can also be interested in supporting organisations with which their employees are involved. If you have members or volunteers who work with a particular company be sure to make the most of this involvement in your approach. If a company has many employees in the area where you operate (and especially if any of them are known to your fundraising team) you could perhaps mobilise a supporters' group to raise funds for you. Again you need to be quite clear how your work interests and benefits them and their families. How do you inspire them? What can you also offer them as employees in return? Initially you do not need to consult a senior executive. Approach the employees known to you and if they are enthusiastic, they can then approach the director or manager for permission to organise some form of support.

The kind of support will depend on how inventive you are in thinking of ideas which appeal to and involve, and **inspire** the workforce. Think of active ways of reinforcing their connection to you. Helping to unlock their arts talents may be the most exciting and effective way.

Corporate membership

You might devise some form of corporate membership scheme. In return for a cash contribution, the company gets its name prominently displayed in the programme and has access to a range of hospitality benefits, possibly including free or discounted tickets, which they can make available to employees or customers.

Meetings and parties

If you have attractive or novel premises you might be able to offer these for use for meetings or for staff parties. An added attraction would be your ability to devise and lay on an entertainment to suit the event. Training and staff welfare budgets may be very much larger than charitable donations budgets, and your line of contact might well be via the personnel director or manager rather than the managing director or donations secretary.

SPONSORSHIP

Business sponsorship is a commercial transaction between two or more partners. It is not charitable donation. It is a mutually beneficial business arrangement whereby the company buys the benefits the arts organisation agrees to provide. Usually the payment is financial, but the company may also agree to provide the services of its staff, technical help, workspace or other 'gifts in kind'. Increasingly successful sponsorship arrangements include built in benefits to the company's staff and the surrounding community to demonstrate social responsibility.

It is important to remember that sponsorship is distinct from advertising. Advertising is a simple purchased transaction. The company which places advertisements in magazines or on television has control over what each advertisement consists of and when and where it appears. The company which sponsors an event or an organisation has no direct control over the publicity or lack of publicity given to it by the media, though it will usually reach an agreement with the sponsored organisation about where and how often the sponsor company's name will appear in the publicity material (programmes, catalogues, posters, etc.). If a company is aiming to sell more of its products, then the sponsorship provides a 'soft sell' rather than the 'hard sell' approach of advertising.

Why do companies sponsor?

Companies choose to sponsor for a number of reasons, which include the following.

- **To advertise a brand name** If the sponsored event is assured of major media coverage and, in particular, television coverage, sponsorship may actually be a cheaper way of advertising than using television commercials.
- **To improve their general image** The sponsoring company may feel that association with a particular organisation could raise its status in the eyes of the local community or the general public or others in the business world whom the company wishes to impress or do business with. This 'image-polishing' can be particularly useful if the company has been the subject of bad publicity for whatever reason.
- **To attract and keep high-quality staff and encourage good PR within the company** They may be offered perks in the form of free tickets to events, a chance to meet celebrities. It may give them the feeling that the company they work for is exciting, adventurous, caring. Sponsorship may offer the company the chance to involve their staff in a worthwhile project or help promote a community spirit.
- **To nurture ties with valuable clients and other influential people** Some sponsoring companies are looking principally for opportunities to offer special clients some kind of privileged or exclusive entertainment. A private view of an art exhibition, a concert performance for an invited audience of guests of the sponsor, complimentary tickets for a prestigious play, dance or opera production with perhaps a chance to meet the stars after the production – these are some of the ways in which a company may be able to thank established good clients or foster relationships with important new ones. Such events may also give the sponsor

a chance to invite people not immediately connected with their business but who, because of their position in society, can be important to the company – for example, people from the media, politics or finance.

- **To create goodwill within a local community** This aim can apply equally to a nationally-known company with branches in various parts of the country and to a smaller company with only one or two offices/factories/retail outlets in a particular region. With this aim in view the company will see the particular organisation it chooses to sponsor as providing a popular, high-profile service to the community where it operates or is based. A good relationship in the community where it operates and from which it draws its workforce may be significant for its development as a happy and successful enterprise.

What kind of companies sponsor?

All kinds and sizes of companies now get involved in sponsorship. Companies producing goods or providing services to the general public are the most likely to sponsor because they are the most likely to gain on several fronts. Sometimes this sponsorship will be undertaken by the company itself, but often it will be in the name of one of its brands or products

Is sponsorship good for you?

Obtaining sponsorship is rarely easy. Many organisations will spend expensive hours researching, applying and attempting to persuade a company to part with quite a small sum of money. It could be that this expenditure of time, effort and money would be more fruitfully used in improving your sales and marketing. Concentrating on marketing may paradoxically help turn you into a much more attractive sponsorship proposition. It will make you more professional, better organised and more aware of your commercial potential. Most of all it will make you think very carefully about what you have to offer your audience, who that audience is, how you and they can make the most of each other.

Ethical considerations

Each arts organisation has to decide for itself whether it has any moral objections to working with and being publicly associated with a particular company. And it may not just be a matter of your own ethics. There may be good practical reasons for not entering into a sponsorship arrangement – the actors or performers may refuse to play, your loyal audience might decide to stay away, your funding bodies may decide to withdraw their support or there might simply be bad publicity for both parties. This issue of course applies equally but less visibly to charitable donations. Only you and your management board can decide where to draw the line. You need to do this first before embarking on sponsorship approaches.

What have you got to offer?

Some organisations find it far easier to attract sponsorship than others. They have the status, the facilities and the product which make them desirable partners for companies. They can inspire confidence that they will be able to deliver the benefits that business

is seeking. This does not rule out the possibility of sponsorship for radical theatre groups or small presses, but it does mean that those who have more 'difficult' projects or organisations will have to think more carefully about why sponsors might be interested in them and which companies are likely to want to do so.

It will be almost impossible to persuade a company to enter into sponsorship without a reasonably informed conviction that you have something they need. The question of whether you have something to offer a sponsor does not have a once and for all answer. The situation can always be re-examined as your organisation develops.

Many of the initial stages in planning a sponsorship campaign are the same as those required for any kind of major fundraising effort.

You need to look hard at your organisation, what you have and what you require, you need to be able to quantify your assets, particularly the size and social status of your members, audiences, users, etc.

Developing sponsorship

- Don't seek sponsorship for your normal administration costs. This isn't attractive or exciting for a would-be sponsor. Think in terms of something identifiable which will bring kudos to the company – a new production, a special event, a festival, a competition, your education programme.
- Don't think of sponsorship as a long-term solution to your financial problems. Many sponsorships are one-offs, some are repeated from year to year (and the sums involved may go down as well as up) but none last forever. The decision to sponsor may be dictated by many factors completely outside your control, such as how well the sponsoring company is doing financially, changes in company personnel, rival sponsorship opportunities, and so on.
- Make sure you have the expertise, time and money (for salaries, unless using volunteers, and overheads) to make a success of the venture and provide all the promised benefits to the sponsor.
- Plan ahead as far as you can. Sponsoring companies, even if interested in your organisation, may not be able to allocate any money to you for up to two years from your initial approach, though some companies may be able to respond more quickly, particularly smaller companies or where lesser amounts of money are involved.

Armed with clear ideas about what your organisation has done, is doing and wishes to do in the future, together with properly researched information on your audiences/ users you can devise some initial ideas for 'sponsorship packages'. A 'package' comprises principally the project or projects you wish to undertake, a list of the features of this project which should appeal to your audience and to a sponsor and what you would be able to offer a sponsor in terms of publicity, client/employee entertainment and other benefits. In compiling this list of attractive features relating to your project you will probably be able to identify some which should have special appeal to certain kinds of companies. All these points should of course be noted when you begin to think about suitable sponsorship prospects.

- **Publicity** You can offer acknowledgement of the sponsorship with varying degrees of prominence on any printed material you produce in connection with the project. Be precise about what publicity you will organise. It may be as well to offer to collaborate with the sponsor on publicity, with the sponsor having a say in design, print quantity, etc. Some of the printed material, such as catalogues, can be used by the audience or on display at a gallery or theatre for a much longer period than the project itself. Make sure you point out such longer-lasting benefits to the potential sponsor. If you are confident of television, radio or newspaper coverage of your work, this will be an important selling point, even though you may never be sure that sponsor will be acknowledged verbally, or even that any banners or other material displaying the sponsor's name at the event will be in view of the television cameras. Giving the project the sponsoring company's name raises the chances that the relationship will be acknowledged by the media. In any case offer all the help you can in persuading the media to acknowledge the sponsor.
- **Entertainment** You might offer some complimentary or reduced-rate tickets, and/or a priority booking facility. Special performances or private views for audiences invited by the sponsor, a press launch or first night party can all be good 'payments' to a sponsor. Special membership schemes have proved attractive to companies.

The sponsor's payment to you, i.e. the amount of money/services which you seek from the company, must be very carefully worked out. Don't either over- or under-estimate the amount you need to finance your project. Either mistake will lose you credibility. Make known to the sponsor in the early stages of a negotiation how much money is required and be ready to back this up with detailed estimates. Remember that the sponsor may be receiving dozens of proposals, and is likely to know the 'going rate' for sponsorship.

Where and how to look for sponsors

Begin with the companies that have a presence in your locality or those larger companies where there is a very obvious link to be made between your project's theme or your organisation and their products. Remember however, that many prominent arts sponsors prefer to remain independent and do things their way.

Look at a company's concern for its corporate image as well as for its sales – you can get clues about this from the company's track record in community affairs, the presentation and content of its annual report and advertisements, etc. Look at which companies are advertising in the local or national press, and think about whether sponsorship of your organisation could offer them better value for money in promoting their products. A most important area to investigate is who are the clients/customers, employees and business partners of each potential sponsor. Then ask yourself to what degree does their 'audience' and yours 'match'. And as has been mentioned already, most companies are concerned to promote the well-being and commitment of their employees and many are prepared to look at other means as well as financial ones.

Through this time-consuming research, the names of the sponsorship prospects most suitable for you should begin to emerge. But don't be too keen to throw away

the information you've gathered on the others. Keep all this on file in case the facts and faces of any of these companies should fit with future proposals.

Tackling your target sponsors

The right person to contact initially depends very much on the size and structure of the company, whether anyone in your organisation has personal links with managers or directors of the company, how much you know about the company's policy and the private interests of its top personnel. The very large companies have **sponsorship managers**, or channel all sponsorship proposals through the **community affairs department**. Otherwise, it is best to start with the **public relations department** of the company or the manager of the particular branch that you would like to tie in to the sponsorship, unless you have special reasons for going to the managing director or chairperson.

If the company has had no previous experience of sponsorship, the first telephone conversation may well be more difficult. In any case, unless the person on the other end of the phone shows marked interest, keep this first conversation brief. Suggest that you would be interested in hearing their views on sponsorship, and say that you will be writing to them about the possibility of working together on a project which you think holds considerable potential for them. If you have been recommended to approach the company for a particular reason by a 'person of influence' whose name or position the PR manager is likely to recognise, then mention this fact, as this should immediately establish your credibility.

Even if you are speaking to a branch office of a national company with no power to authorise sponsorship, foster the local link by writing to the branch PR manager as well as to head office. Try to arrange a meeting with the local person to discuss the local benefits of a sponsored project, perhaps even before you write to head office.

A meeting with the local executive should at the very least provide you with useful information about the company's priorities, the status of the branch and, if you're lucky, some additional reasons why your sponsorship project might suit them. Equally, if the head office manager does consider your project seriously, he/she is virtually certain to consult the branch. If the branch manger is already informed, impressed and enthused by your project and your organisation then this will obviously be a great advantage.

At your first meeting with the company, at whatever level, begin by asking for advice about how your project would be viewed from a businessman's point of view. Also ask him/her general questions about the company's PR and marketing activities: what business entertainment do they undertake, have they plans to find a new market, launch a new product? Among the answers to these and similar questions may be the key to developing your discussions to a point where sponsoring your project becomes a serious proposition. You may need early on to give an outline of your organisation's size, achievements and general aims, your audience size and its composition, and your financial status. Be prepared to answer questions on these points but at this stage give only brief general answers and offer to put more detail on paper for the company. You might consider taking along some well presented, typed sheets, covering the salient facts which you can give to your contact to take away and consider. If you

have produced a promotional brochure include this as well. Or you can simply send these immediately after the meeting. In either case, say that you will ring again in about two weeks' time to hear their reactions. This will give them an added incentive not to put the papers to one side.

If it proves difficult to arrange an exploratory meeting with the PR manager, then you will have to begin with a letter and accompanying documents. This is obviously much less desirable. You have no way of finding out directly about any new developments in the company's PR policy, to discover things that your previous research into the company has not brought to light, to pick up on any interesting comments from your contact, to establish a personal rapport. So your written presentation will be vitally important. It will have to capture the imagination of someone who is probably deluged every day with mail, often of a 'selling' nature. You must ensure that what you propose makes good commercial sense and that you spell out the likely benefits of the arrangement.

Offer the company the chance to be forward-looking, imaginative, to steal a PR march on competitors. At this stage all you have to do is 'catch their eye': make the person who reads your letter interested in you and your project and aware that there may be something in it for his/her company. So keep your written presentation brief – no more than two A4 sheets plus a short covering letter.

What to include in your presentation

- Say briefly what your organisation is, what it has recently achieved (including any outstanding marks of recognition of achievement which it has received), what it aims to do in the next few years.
- List other sources of financial support as this will encourage the reader to accept you as bona fide and worthwhile.
- Describe your audience (its age, social composition, etc.) and give average sales/ attendance figures for events.
- Outline the project for which you are seeking sponsorship. Don't forget to mention when and where it is meant to happen.
- Say how much sponsorship money you need. Leave a detailed breakdown of figures till later – the total required will suffice here.
- Outline the particular attractions of your project – the benefits it offers to this particular company in terms of publicity, hospitality, etc.
- The covering letter should simply say why you are writing, what you are enclosing and that you will be phoning in two weeks' time to arrange a meeting unless you hear from them first.

At each stage of your sponsorship campaign remember to keep a record of what has taken place. Be willing to modify your ideas within reason to meet the company's requirements.

If a company seems generally well disposed towards you, but turns down a particular sponsorship proposal, don't write them off completely. Invite them to events, to see your work, keep them informed of notable successes/achievements. Keep tabs on significant personnel changes. The day may come when they may change their minds

about you. Don't forget to write and say thank you for any meeting or any trouble they have taken on your behalf.

Working with your sponsor

Once a company has accepted a sponsorship proposal in principle it is necessary to contract a written agreement as soon as possible. Some companies will want a formal contract. Others will be content with a letter setting out the terms of sponsorship, signed by both parties. In the Arts & Business *Sponsorship Manual* there are several useful sample letters of agreement and sponsorship contracts which will show you what such documents should contain. The manual also contains useful advice on working with your sponsors on the timetable for your project and the areas where you will need to co-ordinate activities with them.

BUSINESS INVESTMENT IN THE ARTS 2000/01

Arts & Business conducts an annual survey of UK arts organisations to establish the level of business investment in sponsorship and other types of partnerships with the arts. This major survey is supported by the Research Department of the Arts Council of England and the Department for Culture, Media and Sport. It is analysed by an independent statistical consultant.

Its findings show that the total UK business investment in the arts was estimated to be £114.4 million during 2000/01, a 24% drop from the previous year's grossed-up figure. This result is mainly due to the fall off in sponsorship of major capital projects i.e. those generated by the opportunities provided to major arts organisations by the capital arts funding policies of National Lottery in its early years. The figures also show that whilst general business sponsorship decreased between these two years, sponsorship in kind, corporate membership and sponsored awards and prizes increased.

The London region, not unsurprisingly, continues to generate the greatest support, followed by the West Midlands, Scotland and Yorkshire.

Grossed-up estimates of total business investment in the arts (£ millions)

Category	2000/01	1999/2000
General business sponsorship	57.6	59.6
Corporate membership	11.3	10.9
Corporate donations	4.2	12.5
Sponsorship of capital projects	9.0	45.7
Sponsorship-in-kind	18.1	11.3
Awards and prizes	7.5	7.0
Millennium projects	6.6	3.4
Total investment 2000/01	**114.4**	**150.4**

Source: Arts & Business Survey Data 2000/2001, 1999/2000

Total business investment in the arts by region and country

Region	2000/01 £	1999/2000 £
East Midlands	2,592,073	2,049,775
Eastern	716,937	1,384,449
London	50,342,562	80,040,354
North West	2,599,146	2,550,722
Northern	3,895,003	2,429,074
South East	3,399,276	3,380,397
South West	1,542,316	2,202,216
Southern	2,972,056	4,902,672
West Midlands	9,599,865	5,592,671
Yorkshire	4,147,907	3,335,740
Scotland	8,324,182	16,023,270
Wales	3,971,503	4,851,878
Northern Ireland	1,792,042	1,308,962
Other (a)	5,960,262	4,574,879
Total	**101,855,130**	**134,627,059**

Note: (a) Other organisations, including national service bodies, whose activities cannot be sensibly allocated to a region

Source: Arts & Business Survey Data 2000/2001, 1999/2000

Total business investment in the arts by artform

Artform category	2000/01	1999/2000
Arts Centres	2,895,523	1,694,936
Community Arts	1,734,742	1,475,236
Crafts	23,600	162,100
Dance	1,679,744	1,698,170
Drama/Theatre	11,288,531	15,420,589
Festivals	7,086,247	8,984,105
Film/Video	6,049,562	10,594,861
Heritage	3,602,614	3,788,811
Literature/Poetry	1,612,907	1,340,615
Museums and Galleries	25,237,797	38,746,457
Music	10,870,058	10,891,285
Opera	8,345,314	18,122,161
Photography	207,500	231,348
Services	1,331,240	1,589,362
Visual Arts	10,309,402	6,353,526
Other (inc. Local Authorities)	9,580,349	13,533,497
Total	**101,855,130**	**134,627,059**

Source: Arts & Business Survey Data 2000/2001, 1999/2000

Readers should also consult the bibliography at the end of this book for details of further useful reading.

ARTS & BUSINESS + THE NEW PARTNERS PROGRAMME

ARTS & BUSINESS

Nutmeg House, 60 Gainsford Street, Butlers Wharf, London SE1 2NY
Tel: 020 7378 8143; Fax: 020 7407 7527
E-mail: head.office@AandB.org.uk
Website: www.AandB.org.uk
Director General: Colin Tweedy

Arts & Business promotes and encourages partnerships between business and the arts to their mutual benefit and to the benefit of the community at large. It originally focused on arts sponsorship but now promotes a wider range of partnerships hence the change of its name in 1999.

Business members: Arts & Business (A&B) was initially established by business people and is principally funded by the subscriptions of its 350 business members which include half of the FTSE Top 100 companies. Members receive a range of benefits including advice and information, reference materials on sponsorship, taxation and best practice, invitations to seminars, conferences, awards, etc.

The Creative Forum for Culture and the Economy: This is the research and development wing of A&B. It debates key issues and explores new and deeper roles for the arts within companies. These include how business can benefit from bringing the skills, values and experience of the arts into the workplace and to their workforce; the role of business and the arts in regeneration; the importance of the arts in education.

Arts@Work: Arts & Business is helping businesses to embrace creativity by bringing artists into the workplace.

The Arthur Andersen Skills Bank: Business people volunteer their skills to work with arts organisations on specific, objective driven projects. The emphasis is on skills transfer and mutual benefit.

The NatWest Board Bank: This scheme has helped hundreds of arts organisations and museums to recruit talented new business people to their boards.

The Development Forum: This provides an opportunity for arts managers, fundraisers and development professionals to be in regular contact with Arts & Business, keep up-to-date with fund raising new and network with other arts organisations. Regular regional meetings are held.

Sponsorship Seminars: Arts & Business offers an intensive one-day 'Introduction to Sponsorship' course open to all arts managers. Training seminars are arranged

regularly by the A&B regional offices, usually in conjunction with the relevant Regional Arts Board.

Researching a Business Sponsorship: A&B offices nationwide can provide assistance to arts organisations researching potential business sponsors.

New Partners

Grant-in-aid from the Arts Council for England: £5,662,438 (03/04); £5,444,652 (02/03); £5,050,000 (2001/02); grant-in-aid also provided by the other three national councils for the scheme.

New Partners is the government-funded programme aimed at encouraging links between business and the arts. It succeeds the Pairing Scheme which was concerned solely with business *sponsorship* of the arts. New Partners has a far wider remit.

New Partners is in the words of A&B 'an investment programme to promote the development of new, sustainable, mutually beneficial partnerships between business and the arts…one part of our new inclusive strategy to embed the arts more deeply into individual businesses. Our ultimate goal is to increase business investment in the arts. However, for Arts & Business, encouraging sponsorship alone is no longer the most effective method of doing this. In many businesses the arts are too thinly rooted in the business soil.'

When it was first announced Arts & Business gave suggestions for the kind of projects they expected to fund: arts-based training for businesses; art collections; art commissions; artists in residence; arts clubs; performances and exhibitions on site; sponsorship; staff involvement and volunteering. Through New Partners, Arts & Business want to 'help business try something new with the arts'.

By 'new', A&B means:
- **first time** – an arts activity never undertaken by the business partner before;
- **deeper** – an arts activity that worked in one part of a business, repeated throughout the company;
- **broader** – a business that has already sponsored the arts adding another arts-based activity to its portfolio of partnerships.

Applicants need to demonstrate that their proposal fits one of the above categories. *The excellent website has a full list of the successful proposals throughout the UK.*

A successful application displays:
- a sustainable relationship between both parties;
- clear benefit to the business;
- commitment by business to developing new areas of activity with the arts;
- commitment by business to maintaining and developing current arts activity;
- appropriate plans for evaluation and follow-up;
- value for money;
- an ability to manage and deliver the partnership.

Priority is given to applications undertaking two or more new arts-based activities (except in Northern Ireland). Projects are particularly welcomed that make imaginative use of the arts involving:

- young people;
- social inclusion, access and outreach;
- the community and regeneration;
- employee access.

All forms of business/arts partnership are welcome. 'Traditional' sponsorship is still eligible. New Partners will consider investing in partnerships based on sustainable sponsorship by a business sponsoring the arts for the first time. Many types of arts organisation can apply:

- a registered charity or legally constituted non-profit distributing company;
- individual artist;
- educational establishment;
- local authority or local authority arts facility;
- projects or annual programmes funded via arts-related budgets of a public funding body;
- local or amateur organisation;
- charity or legally constituted non-profit distributing company that is undertaking an arts project as part of its core activity.

If in doubt, check with your local Arts & Business office.

Different business units, brands, zones or branches within a company can apply in their own right.

There is no limit to the projects an arts organisation can put forward for investment, except that no single arts organisation may receive more than £50,000 from the scheme in any financial year (maximum £20,000 in Northern Ireland). A business may be involved in as many partnerships as it wishes.

The minimum amount of funding to a single project is £1,000 (excluding VAT). There is no prescribed formula for how much A&B will invest. Applicants may ask for any amount between £500 and £50,000 – not normally more than the business and maybe less.

Applications: Initial proposals are considered first by a regional panel which decides whether they go forward to the second stage. At stage two, proposals are worked up into full applications and put in front of a national panel. If an application is successful, there will then be a formal contract between Arts & Business, the arts partner and the business partner. Unsuccessful applications can be resubmitted at subsequent meetings.

There are no formal submission deadlines for proposals, but if a project or idea needs to happen at a certain time applicants should consider when they need a final decision and plan accordingly.

Information should be obtained from and contact maintained with the relevant offices – either the head office, noted above, or the regional offices listed below.

Regional Offices

Arts & Business London
Nutmeg House, 60 Gainsford Street, London SE1 2NY
Tel: 020 7378 8143; Fax: 020 7407 7527; E-mail: london@AandB.org.uk

Arts & Business East
Hoste House, Whiting Street, Bury St Edmunds IP33 1NR
Tel: 01284 702242; Fax: 01284 702992; E-mail: east@AandB.org.uk

Arts & Business East Midlands
Carlton Studios, Lenton Lane, Nottingham NG7 2NA
Tel: 0115 964 5648; Fax: 0115 964 5488; E-mail: nottingham@AandB.org.uk

The Sponsors' Club for Arts & Business (Northern)
Cale Cross House, 156 Pilgrim Street, Newcastle Upon Tyne NE1 6SU
Tel: 0191 222 0945; Fax: 0191 230 0689; E-mail: northern@AandB.org.uk

Arts & Business North West
3rd Floor, St James's Buildings, Oxford Street, Manchester MI 6FQ
Tel: 0161 236 2058; Fax: 0161 236 2068; E-mail: north.west@AandB.org.uk

Arts & Business South
The Point Dance and Arts Centre, Leigh Road, Eastleigh, Hampshire SO50 9DE
Tel: 023 8061 9172; Fax: 023 8061 9173; E-mail: south@AandB.org.uk

Arts & Business South East
4 Frederick Terrace, Frederick Place, Brighton BN1 1AX
Tel: 01273 738333; Fax: 01273 738666; E-mail: south.east@AandB.org.uk

Arts & Business South West
61 Park Street, Bristol BS1 5NU
Tel: 0117 929 0522; Fax; 0117 929 1756; E-mail: south.west@AandB.org.uk

Arts & Business West Midlands
Suite 16–18, 21 Bennetts Hill, Birmingham B2 5QP
Tel: 0121 248 1200; Fax: 0121 248 1202; E-mail: midlands@AandB.org.uk

Arts & Business Yorkshire
Dean Clough, Halifax, West Yorkshire HX3 5AX
Tel: 01422 367860; Fax: 01422 363254; E-mail: yorkshire@AandB.org.uk

Arts & Business Scotland
6 Randolph Crescent, Edinburgh
Tel: 0131 220 2499; Fax: 0131 220 2296; E-mail: scotland@AandB.org.uk

HI Arts
Suites 4/5, 4th Floor, Ballantyne House, 84 Academy Street, Inverness
Tel: 01463 720 886; Fax: 01463 720 895; Email: inverness@AandB.org.uk

Arts & Business Wales/Cymru

16 Museum Place, Cardiff CF1 3BH
Tel: 029 2030 3023; Fax: 029 2030 3024; E-mail: cymru@AandB.org.uk

North Wales Office

1–2 Chapel Street, Llandudno LL30 2SY
Tel: 01492 574003; E-mail: lorraine.hopkins@AandB.org.uk

Arts & Business Northern Ireland

53 Malone Road, Belfast BT9 6RY
Tel: 028 9066 4736; Fax: 028 9066 4500; E-mail: northern.ireland@AandB.org.uk

Arts & Business – some examples of New Partners

Be sure to consult the excellent A&B website to find out the many types of partnership that have been supported. The partnerships are categorised by location as well as artform and are extremely interesting for all prospective applicants.

City of London Sinfonia (CLS) and MMC (Marsh & McLennan companies) for a four year programme – £50,000

MMC (Marsh & McLennan companies) is a global professional services firm based in New York. In the UK, group company **Marsh and Mercer** employs 9,000 staff in more than 30 locations. In February 2002, *Music in the Community*, a four-year programme of visits to schools and community centres across the UK, was launched with £1 million from MMC.

The orchestra is running creative music workshops in over 10 cities, and started in Leeds moving on to Belfast, Glasgow, London and Birmingham. Much of its community work focuses on failing schools or those in deprived or inner-city areas. CLS is using techniques it pioneered at Great Ormond Street Hospital, High Wycombe and its management training school, Drum Street, in London.

CLS is building on the links with the schools by maintaining internet contact via an interactive facility on its website allowing the children to access competitions and other activities and to continue to interact with members of the orchestra.

MMC employees are assisting CLS in its workshops. The company encourages its staff to play an active part in their local communities.

Staff is also attending CLS's management training school, Drum Street, as part of the sponsorship arrangement. The school offers new methods of management training and development through music. Its core modules include innovation and creativity, team building, stress management, leadership and communication skills.

Cumbernauld Theatre and ScottishPower Learning
£20,000

The first stage of the Project is a pilot programme supported by ScottishPower Learning called 'School to Work' as part of its strategy to deliver training and learning needs to potential future employees. For the first time arts-based training was used to develop the skills required for employment in young people.

Cumbernauld Theatre delivered the training in conjunction with Glasgow Education and Business Partnership through a series of workshops in three Glasgow

secondary schools over a period of 20 weeks (total of 50 pupils taking part). The theatre worked with freelancers to build a tailored arts-based programme for schools and groups of young people. It also enabled the theatre to build a resource to introduce arts-based training and creative solutions to businesses.

National Youth Music Theatre (NYMT) and National Association of Schoolmasters and Union of Women Teachers (NASUWT)
£18,350

A one-year sponsorship, involving NASUWT members, to improve their understanding of how they can help ensure the arts are adequately represented in schools and the influence creativity can have on the curriculum. The programme included a five-day workshop for young people from socially deprived areas of Birmingham run by NYMT at NASUWT headquarters during the Easter 2001. An evening workshop was also run by NYMT for the staff at the NASUWT headquarters.

The workshops were developmental for the young people, showcased the work of NYMT to members of the NASUWT, and involved the staff at NASUWT headquarters.

Northern Stage and Dickinson Dees
£13,000

Following seven years of sponsorship of Northern Stage productions, Dickinson Dees, the legal firm, wished to extend its involvement by supporting Doublethink, a youth conference about the law, developed with the theatrical adaptation of Orwell's *1984*. Through the use of forum theatre techniques, video and creative workshops, young citizens were brought face to face with the region's most powerful decision-makers for an event of dialogue and action, to develop a young person's charter for future legislation.

The structure and content of the project was developed with the training manager at Dickinson Dees. It hoped to further encourage lawyers at the firm to offer expertise about the language and meaning of legislation and to provide a resource to facilitate greater understanding of legal matters. It also demonstrated the benefits of forum theatre as a creative training technique for the business community.

Yorkshire Artspace Society and The Assay Office
£7,823

This partnership project supported the development of new artists in visual arts and silver crafting. Artists accessed state of the art studios and equipment, training and business advice, work experience and commercial commissions.

It aimed to improve the business skills of young artists as well as support their artistic development through mentoring, training and work experience through managed commissions and residencies. The Assay Office commissioned an artwork and an artist in residence.

Arts & Kids

In May 2002 the Millenium Commission announced that it had chosen Arts & Business as one of three partners to take part in their *Millennium Encore Scheme*

which will enable a wide range of young people to go to performing arts productions. A&B has been offered £1 million.

In late June 2002 a major campaign, **Arts & Kids**, was launched by the Prince of Wales at Buckingham Palace announcing a new Prince of Wales Arts and Kids Foundation. The same day the first corporate partner, Powergen, pledged its support to the foundation (it is developing reading initiatives to re-energise storytelling). The main focus of the campaign for Arts & Business will be 'to attract additional investment by businesses and to raise the profile of the exemplary work being carried out with young people by arts organisations throughout the UK'.

COMPANIES – GENERAL LISTING

Accountancy
Ernst & Young

Chemical/pharmaceutical
Pfizer Group Ltd

Communications
AT&T (UK) Ltd
Bloomberg L P
British Telecommunications plc
Cable & Wireless plc
Marconi plc
Orange
Telewest Broadband
WPP Group plc

Construction/development
British Land Company
Hammerson
Slough Estates

Consumables
Allied Domecq
Gallaher Group plc
Nestlé UK Ltd
Northern Foods plc
P & G
PizzaExpress
Scottish & Newcastle plc

Electronic/computing
G B Audio
IBM United Kingdom Ltd
Olympus Optical Co (UK) Ltd
Panasonic UK Ltd
Sony United Kingdom Limited
Unisys Ltd

Engineering
AEA Technology

Extraction
Amerada Hess Ltd
Enterprise Oil plc
Esso – see ExxonMobil
ExxonMobil
Hunting PLC
Rio Tinto plc
Shell UK Ltd

Financial services
3i Group plc
Barclays plc
Bradford and Bingley
Clerical and Medical Investment Group
 Ltd
Clydesdale Bank
Dresdner Kleinwort Wasserstein
Dunfermline Building Society

Family Assurance Friendly Society
Friends' Provident
HALIFAXBANKOFSCOTLAND
HSBC Holdings plc
Legal & General Group plc
Marsh Ltd
M&G Group
Morgan Stanley & Co International Ltd
NatWest – see Royal Bank of Scotland
 Group
Northern Rock plc – see Northern
 Rock Foundation
Prudential Corporation plc
N M Rothschild & Sons Ltd
Royal Bank of Scotland Group plc
Royal & Sun Alliance Insurance Group
 plc
Schroders plc
Standard Life Assurance Company
UBS Warburg
Woolwich plc – see Barclays plc
Yorkshire Bank plc
Yorkshire Building Society

Leisure/services
EMI Group plc
SIXCONTINENTS PLC

Manufacturing
Barloworld PLC
Charnos plc
Scapa Group plc
Waterford Wedgwood UK plc

Media
Economist Newspaper Ltd
Guardian and Observer
Pearson plc
Reuters
Western Mail & Echo Ltd

Television companies – see page 283.

Retailing
Dixons Group plc
HMV UK
John Lewis Partnership plc
Littlewoods Organisation plc
Menzies Distribution Ltd
J Sainsbury plc
Selfridges & Co

Transport/vehicles
Associated British Ports Holdings plc
Birmingham International Airport Ltd
GKN plc
Jaguar Cars Ltd
Manchester Airport
National Express Group PLC
Peugeot Motor Company PLC
Rolls-Royce plc
Toyota Motor Manufacturing (UK) Ltd

Utilities
British Energy
British Nuclear Fuels plc
The Kelda Group
LE Group
Manweb
Northumbrian Water
npower
SEEBOARD plc

Other
Agfa-Gevaert Ltd
Boosey & Hawkes
Foster Wheeler Energy Ltd

3i Group plc

91 Waterloo Road, London SE1 8XP
Tel: 020 7928 3131; **Fax:** 020 7928 0058
Website: www.3i.com
Company type: Venture capital
Contact: Sabina Dawson, Assistant
Company Secretary
Sponsorship: Adam Quarry, Arts
sponsorship
Membership: % Club

Donations to all causes: £555,000
(2000/01)

Charitable donations: The company
makes its donations through The 3i
Charitable Trust and favours charitable
initiatives with which members of staff
are personally involved and local charities
where 3i has an office. Its UK offices are
in Aberdeen, Birmingham, Bristol,
Cambridge, Edinburgh, Glasgow, Leeds,
Liverpool, London, Manchester,
Newcastle, Nottingham, Reading,
Solihull, and Watford. Each of these
offices is allocated a tranche of the
company's charitable budget which is
administered centrally. The company is
interested in supporting education,
science/technology and the arts. The
Royal Opera House was one of five main
beneficiaries of the trust in 1999/2000.

Arts sponsorship: The major
involvement is its sponsorship of the
senior student orchestra of the Royal
Academy of Music. The company was
one of 28 companies contributing
£25,000 each to Japan 2001.

Other support: The company matches
employee fundraising up to a maximum
of £5,000 and employee giving, under
GAYE scheme up to a maximum of
£2,400 per employee.

AEA Technology plc

329 Harwell, Didcot, Oxfordshire
OX11 0QJ
Tel: 01235 432790; **Fax:** 01235 436656
E-mail: cathy.wright@aeat.co.uk
Website: www.aeat.co.uk
Company type: Science and
engineering: technology-based
products, specialised
science,environment management,
industrial plant efficiency, risk
assessment and safety management
Contact: Mrs Cathy Wright, Corporate
Community Involvement Manager
Membership: BitC; % Club

Donations to all causes: £78,000
(2000/01)

Charitable donations: The company
supports the arts, children/youth,
education, the environment and
enterprise/training. It particularly
supports local charities close to the
company's UK locations.

Arts sponsorship: The company has
undertaken some arts sponsorship in the
past.

Other kinds of support: Gifts in kind;
staff secondment; support for employee
volunteering.

Agfa-Gevaert Ltd

27 Great West Road, Brentford,
Middlesex TW8 9AX
Tel: 020 8231 4517; **Fax:** 020 8231 4951
E-mail: agfa.brentford@agfa.co.uk
Website: www.agfa.co.uk
Company type: Photographic and
electronic imaging systems
Contact: Philip Miller, Corporate
Communications Manager

UK sponsorship policy: Only activities
connected with and involving
photography or photographic projects
and graphic design are sponsored.
Support is considered for:
- selected colleges and schools involved

in such activity and to major museums and galleries for specific exhibitions;

- individuals in the form of photographic materials on a very limited basis – applicants must have a firm offer of exhibition space or a publisher's contract and already be users of Agfa film and paper;
- community and educational projects involving photography local to Agfa offices are also supported.

Recent sponsorships have included:
Photojournalists International Competition;
Science Year 2001/02;
Science Museum;
Royal Photographic Society;
International Slide Exhibition;
International Young Designers Contest.

Charitable donations: Support is restricted to a limited number of registered charities concerned with medical research, children's healthcare and the underprivileged. Donations are mostly confined to the provision of products, services or promotional support. Preference is given to charities local to Agfa offices. The company does not support charitable activities by taking support advertising and prefers not to work with professional fund-raising companies. It is interested to support educational establishments. Donations in 2000/01 included:
Aberyswyth Arts Centre;
National Needlework Record.

Applications: The sheer number of enquiries precludes telephone applications. When writing, applicants should provide a brief summary of the project, event or cause, the cost options and the response requested from the sponsor. Only personally addressed applications will be answered.

Amerada Hess Ltd

33 Grosvenor Place, London SW1 7HY
Tel: 020 7823 2626; Fax: 020 7887 2199
Website: www.hess.com
Company type: Exploration and production of oil and gas. Main subsidiary – Western Gas Ltd
Contact: Andy Mitchell, Corporate Affairs Manager
Membership: A&B

The company prefers to support appeals relevant to company business and local charities in areas of company presence with head office (London) supporting mainly charities working in London, and the Aberdeen office dealing with appeals relevant to that region.

Art sponsorship: This is preferred to arts donations. The company has sponsored Art in the Park, part of the Silver Jubilee of Aberdeen International Youth Festival – four artists created work for the Winter Gardens in Aberdeen's Duthie Park. Sponsorship in 2000/01 included:
Heriot-Watt University, for musician in residence;
The Lemon Tree Theatre, Aberdeen for playwright in residence;
Royal Court Theatre, London production of 'Boy Gets Girl';
Royal College of Music, London, sponsorship of 2 junior fellows.

Most arts sponsorships are in the London and Aberdeen regions.

Applications: The Aberdeen office (Scott House, Hareness Road, Altens, Aberdeen AB1 4LE, Tel: 01224-243000) deals with appeals relevant to that region.

Associated British Ports Holdings plc

150 Holborn, London EC1N 2LR
Tel: 020 7430 1177; Fax: 020 7430 1384
E-mail: pr@abports.co.uk
Website: www.abports.co.uk
Company type: Port operators and property developers
Contact: Mrs M Collins, Corporate Communications Manager

Arts sponsorship: The sponsorship policy of the company is centred on the support of arts and arts-related organisations and companies in the local communities where it either owns a port or operates a business. It commends and supports the work of organisations and companies which encourage and cultivate enterprise, foster artistic talent among the youth and the citizens not only of the communities in which it operates but also elsewhere. It also supports companies and initiatives whose reach, influence and quality of work enable many people to experience and appreciate works which would normally not be readily available to them. It therefore supports national work touring to company localities and and is prepared to support local festivals in those areas.

Sponsorships in 2001 included:
Welsh National Opera, for 4 performances (£32,000);
Bournemouth Orchestras (£6,000);
English National Opera, 2000/01 season (£3,900).

Other support: This has included artists in residence and gifts in kind.

Charitable donations: The company's charitable donations policy concentrates on medical and maritime charities, with an emphasis on those operating within the locality of ABP's ports.

AT&T (European office)

Highfield House, Headless Cross Drive, Redditch, Worcs B97 5EQ
Tel: 01527 493549; Fax: 01527 493523
E-mail: pcoathup@att.com
Website: www.att.com/foundation/
Company type: Telecommunications
Contact: Phil Coathup, Public Relations

'In 1999 and 2000, AT&T's total contributions (including cash contributions and product donations) amounted to more than $130 million. The AT&T Foundation contributed more than $84 million of this total. The rest came in the form of direct contributions and product donations from AT&T business units and divisions. In addition, tens of thousands of AT&T employees and retirees contributed their volunteer efforts to charitable organizations in their local communities.'

'The AT&T Foundation invests globally in projects that are at the intersection of community needs and AT&T's business interests. Emphasis is placed on programs that serve the needs of people in communities where AT&T has a significant business presence, initiatives that use technology in innovative ways, and programs in which AT&T employees are actively involved as contributors or volunteers.'

Its focus of support is in the following areas:

'Education
We make grants to projects that support lifelong learning, teacher training and parent participation in children's education; we look for initiatives that use technology to connect students, teachers and institutions of learning; and we encourage efforts to win student interest and involvement in mathematics, science and engineering.

'Civic and Community Service
We give to initiatives that promote diversity and advance equal opportunity;

we back projects that promote economic capacity building in local communities; and we support organizations that aim to protect the environment. AT&T assists programs designed to give children a sound start in life and to equip parents to better balance the demands of work and family life; we contribute to organizations that deliver social and health services to people in need, particularly children, mothers and people living with HIV/AIDS.

'Arts and Culture
We support artistic work that fosters communication, builds diverse audiences, and inspires innovation and learning in communities; we also target initiatives that help women and artists of diverse cultures bring their work to wider audiences.'

Recent arts grants in the UK are:
Almeida Theatre Company, London, $200,000 1999; $160,000 1998; $100,000 1997;
Edinburgh International Festival, $50,000 1997;
Royal Court Theatre, $80,000 2000; $55,000 1997;
Royal National Theatre, $80,000 1997;
Tate Gallery, $75,000 1997.

Other support: 'The AT&T Foundation helps extend the reach of AT&T employees' community involvement efforts by matching employee contributions to educational and cultural organizations and by providing grants to recognize employee volunteer efforts in communities located in all areas of the country.'

Barclays PLC

Community and Social Affairs,
54 Lombard Street, London EC3P 3AH
Tel: 020 7699 5707; Fax: 020 7699 2685
Website: www.barclays.co.uk
Company type: Financial services
Contact: Alice Wilcock, Head of Community Affairs
Sponsorship: Morag Pavicj, Senior Manager, Community Affairs
Membership: A&B; % Club; BitC

Donations to all causes: £8,900,000 (2000)

In 2000 total community contributions in the UK were £26.3 million, of which £8.9 million was given in charitable donations, the remainder being in arts and good cause sponsorship.

Arts sponsorship: *This programme is entirely proactive. Unsolicited requests are not sought.* In October 2001 the bank announced a new £1.9 million sponsorship package, **Invest and Inspire**, to run for two years.

This is a partnership with four organisations: Royal National Theatre, for a season in the Olivier Theatre; and as sole sponsor of three major exhibitions at The British Museum (Queen of Sheba, in 2002), the National Gallery (Titian in 2003) and Tate Britain (Turner and Venice 2003/04).

The bank presents this programme as a model of best practice for arts sponsorship based on the following three principles.

- Increasing accessibility to the arts through variety and creativity. Barclays will be supporting innovative activities around each element of the sponsorship to encourage more people to enjoy the arts. Activity being planned includes a Public Day on the South Bank organised in conjunction with the Royal National Theatre.
- Educational activities to involve first time visitors and other community

groups in the arts. For example, under the banner of Barclays Firsts an educational programme is being developed to attract an additional 5,000 first time visitors, 3,500 school children and 3,000 students to attend productions at the National.

- Collaboration between arts organisations to encourage the sharing of resources with a view to attracting larger and more diverse audiences. Details to be announced.

Matthew Barrett, chief executive, said at the launch: 'This two year sponsorship is intended to support leading UK arts institutions and break down some of the barriers to the arts, opening it up to new audiences…we want to increase accessibility to the arts to wider communities, not least our own employees.'

Barclays Theatre Awards are presented annually by the Theatrical Management Association (TMA) to celebrate excellence in theatre nationwide. Barclays has supported the awards since 1997.

Charitable donations: The arts is included in the areas in which the bank is interested along with the key areas of education, the environment, people with disabilities and social inclusion.

A wide range of regional arts organisations and initiatives are supported through its network of 16 regional offices. Proposals are generally agreed on a reactive basis according to local need and budget availability. The budget operates on a calendar year basis and corporate hospitality is often a key benefit sought by the regional office sponsors.

Arts organisations are supported which encourage local communites to access the arts. Recent examples are:
Hijinx Theatre, Wales, for specific productions for adults with learning difficulties;
Unicorn Theatre, London, for 'Access Works' which enables children from some of the most deprived London boroughs to experience theatre.

Other support: Gifts in kind, employee volunteering.

Applications: No specific application forms are required. However, a copy of the latest annual report and audited accounts (the last two years in the case of an initial approach), full information on the project/appeal, including detailed break-down of costs, and where appropriate, full background information on the charity/voluntary organisation and cashflow projections etc., are normally required.

Barloworld PLC ♫

3rd Floor, Medici Court, 67–69 New Bond Street, London W15 1DF
Tel: 020 7629 6243; **Fax:** 020 7409 0556
Company type: Subsidiary, Barloworld, South Africa, international manufacturing and distribution group, including distribution/servicing of materials handling equipment, earth moving and other capital equipment; papermaking and converting, manufacture of scientific equipment
Contact: Carolyn Munro, Joint Secretary to the Charities committee

Donations to all causes: £88,000 (2000)

Charitable donations: The arts are included in the areas open for support along with children/youth, education, enterprise/training, environment, elderly people, medical resesarch, social welfare, health and disability.

Preference is given to projects in areas where the company has a presence and to appeals where a staff member is involved.

Applications are considered three times a year.

Sponsorship: £30,000 (2000)
Only one small arts sponsorship for £500 was arranged in 2000 with the National Arts Collection Fund.

Birmingham International Airport Ltd

Birmingham B26 3QJ
Tel: 0121 767 8043; **Fax:** 0121 767 7359
Website: www.bhx.co.uk
Company type: Airport
Contact: Brian Conway, Head of External Relations

Sponsorship: The company is interested in local and regional proposals in the arts, conservation/environment, charities/community and education. It has helped promote arts of excellence in the Central England region. Sponsorships have included:
Lichfield International Arts Festival;
Royal Shakespeare Company;
City of Birmingham Symphony Orchestra;
Symphony Hall, Birmingham;
and some community arts activities.

Bloomberg L P

City Gate House, 39–45 Finsbury Square, London EC2A 1PQ
Tel: 020 7330 7500; **Fax:** 020 7392 6000
Website: www.bloomberg.com/uk
Company type: Online financial information and multi media
Contact: Jemma Read, Head of Arts Sponsorship and Charitable Investment
Membership: A&B

Sponsorships and donations are handled together and there is no stated preference between them or for a particular artform.

The company's policy is 'to support contemporary arts projects that enrich the community and involve our employees in new and challenging cultural areas'.

Known sponsorships in 2001 included:
Tate Modern;
London Fashion Week;
Royal Court Bloomberg Mondays.

Bloomberg has a commitment to the arts and young people. It won a FT/Arts & Business Award in 2000 for youth sponsorship for its collaboration with the Royal Court. Bloomberg Mondays develop new audiences for the future by targeting 16 to 25 year olds for the theatre's £5 Monday nights. The success of this scheme led to a number of other collaborations with the theatre to promote accessibility of the arts amongst younger people.

It has also inspired other arts sponsorship programmes including the education and community outreach programme at the Almeida Theatre targeting schools in Tower Hamlets.

Boosey & Hawkes plc

295 Regent Street, London W1B 2JH
Tel: 020 7299 1919
E-mail: information@boosey.com
Website: www.boosey.com
Company type: Music publishing and musical instrument manufacturing
Contact: Anne-Marie Sizer, Assistant Company Secretary

Sponsorship: Its sponsorship budget of £60,000 a year is wholly devoted to music-related sponsorships, particularly those with a national scope targeted a young amateur musicians.

Recent sponsorships have included:
National Concert Band Festival;
Boosey & Hawkes National Brass Band Championships;
Boosey & Hawkes National Youth Brass Band Championships.

Bradford and Bingley

Community Affairs Department,
134b New Street, Birmingham B2 4NP
Tel: 0121 633 8143; **Fax:** 0121 643 6396
E-mail: mike.hammond@bbg.co.uk
Website: www.bbg.co.uk
Company type: Financial services
Contact: Michael Hammond,
Community Affairs Manager
Sponsorship: As above
Membership: A&B; BitC

Donations to all causes: £301,000
(2000)

Charitable donations: The company
focuses on homelessness projects,
disability access to financial services,
personal finance and numeracy education
in schools, social housing and
regeneration projects. It also
acknowledges 'It's important too to
enhance communities through the arts'.

Sponsorship: £1.2 million (2000) Arts
sponsorships are preferred to donations.
There are three criteria: broad family
appeal, benefit to the community and
tangible benefits for BBG employees.
Both national and local organisations may
be considered and no particular artforms
are preferred.

In 2000, 10% of its sponsorship budget
was allocated to the arts and included:
National Museum of Photography, Film
& Television (£53,500) This won the
2000 Youth Sponsorship award in the
FT/Arts & Business Awards for its
partnership with the Magic Factory – a
child-focused gallery introducing the
principles of light and giving enjoyment
to a family audience while supporting the
national curriculum.
Birmingham Symphony Hall Organ
Concert (£21,250);
Leeds Film festival (£15,000);
Harewood House (£5,000).

Other support: Gifts in kind, staff
secondments, joint promotions, matching
financial support for employee
fundraising up to a maximum of £250.

British Energy

3 Redwood Crescent, Peel Park,
East Kilbride G74 SPR
Tel: 013552 62809
E-mail: chrystall.rutherford@
british-energy.com
Website: www.british-energy.com
Company type: Generation and sale of
electricity
Contact: Chrystall Rutherford,
Communications Manager
Sponsorship: As above
Membership: A&B; BitC

Sponsorship: Some 30% (£60,000) of
the sponsorship budget of £200,000 was
allocated to the arts in 2000.

Arts sponsorships are preferred to
donations. Recent support includes:
Children's Classic Concerts;
Edinburgh's Millennium Festival Lights;
Northern Ballet's Edinburgh Season.

Short-listed by Arts & Business for its
2001 'Arts, Business and the Smaller
Budget Award' for its support of the Fly
Right Dance Company, (Scotland's only
dance company specialising in traditional
Afro-American dance) for a programme
of educational dance workshops for
schools and community groups.

British Land Company plc

10 Cornwall Terrace, Regent's Park,
London NW1 4QP
Tel: 020 7486 4466; **Fax:** 020 7467 2990
E-mail: j.rtiblat@britishland.co.uk
Website: www.britishland.co.uk
Company type: Property investment
Contact: John Ritblat, Chairman
Sponsorship: As above
Membership: A&B; BitC; % Club

Arts sponsorship and donations are
administered together.

Sponsorship policy: From its annual
report: 'British Land is strongly
committed to enhancing the
environment by investing in the future

through education, the arts and sport. Particular emphasis is given on providing support and facilities for young people and children and improvement of their quality of life and prospects. Notable initiatives include:
Royal Opera House, revival production of Prokofiev's 'Romeo and Juliet';
Tate Gallery;
National Gallery, Catalogue of British Artists;
British Museum;
Victoria and Albert Museum;
Wallace Collection;
London Philharmonic Orchestra;
English National Opera;
National Theatre;
Wigmore Hall;
Royal Shakespeare Company;
Royal Ballet School;
Regent's Park Open Air Theatre;
Founding exhibition patron of the Royal Academy of Arts.

Emergent photographers are supported e.g. 'the photographs of the sponsorship of the Museum of London were taken by Matthew Smith'.

Charitable donations: Particular support is given to charities involving young people in activity-based projects.

British Nuclear Fuels plc

Risley, H380, Warrington, Cheshire WA3 6AS
Tel: 01925 832000; **Fax:** 01925 835619
Website: www.bnfl.com
Company type: Nuclear fuel services
Contact: Robert Jarvis, Head of Corporate Community Involvement
Sponsorship: As above
Membership: A&B; BitC; % Club

Donations to all causes: £4,100,000 (2000/01)

The company's community policy is to establish long-term relationships with local communities around its sites which are in Cheshire, Annan, Warrington,

Cumbria, Preston, Essex, Somerset, Suffolk, Gloucestershire, Gwynned, Kent, Gwynedd, Ayrshire.

The company supports schemes and charities particularly in the North West (including national appeals based in the North West). Within this, there may be a preference for West Cumbria.

Arts sponsorships and donations are administered together, with no preference for either form of support or a particular artform.

Charitable donations: There is a particular interest in technology and children/youth, local organisations and 'helping the less advantaged in society or projects with some educational element'. Applications should be in writing either to the correspondent above or to the general manager of the nearest factory. A donations committee meets monthly. Donations in 2000/01 included:
Warrington Youth Orchestra;
Embassy of Ukraine in the United Kingdom & Northern Ireland;
Warrington Museum & Art Gallery;
Warrington Male Voice Choir;
Royal Northern College of Music.

Sponsorship: £30,000 total budget in 2000/01 The company is particularly interested in arts activities which target the disadvantaged or projects with an educational element. Arts exhibitions, theatre productions and musicals have all been sponsored. Those in 2000/01 included:
Vivace! Summer Song;
Octagon Theatre, Bolton, BSL Interpreted and Audio Described performances;
Reactivate.

A typical sponsorship ranges from £100 to £5,000.

British Telecommunications plc

BT Community Partnership Programme, BT Centre, 81 Newgate Street, London EC1A 7AJ
Tel: 020 7356 5638; Fax: 020 7356 5675
Website: www.bt.com
Company type: Telecommunications services
Contact: Richard Hamer, Education Programme Manager
Membership: A&B; % Club; BitC

Donations to all causes: £2,600,000 (1999)

BT's Community Partnership Programme supports projects which:
- are of positive relevance to BT;
- bring demonstrable benefit to the community;
- offer clearly understood and recorded mutual benefits;
- provide opportunites for BT people to be involved;
- enhance BT's reputation.

In 2001 BT did not have a separate policy or focus for its engagement with the arts.

Its recent support for the arts has centred on the launch of Tate Modern, and its support for the Tate's website with its complete catalogue online.

In addition BT is supporting Crag Rats Theatre, based near Hudderfield. A theatre-in-education company with 10 regional teams working UK-wide with a roadshow on IT and new technology.

Cable & Wireless plc

124 Theobalds Road, London WC1X 8RX
Tel: 020 7315 4945; Fax: 020 7315 5126
E-mail: swati.patel@cw.com
Website: www.cw.com/community
Company type: Telecommunications, main focus on IP and Data
Contact: Ms Swati Patel, Community Investment Executive
Membership: A&B; BitC

General policy: 'What all our communities have in common is the need to communicate. We believe it is our corporate duty to support these communities and to respond to their needs. We aim to support initiatives which fall into the following categories: those with a specific telecommunications requirement; those with the goal of improving access to or understanding of communications; those linked to the theme of "communication" in its broadest sense.'

'Support is focused on education, science/technology and limited support for the arts. Charities applying for support should be able to show where their interests coincide with those of the company.'

Arts sponsorship: £70,000 (7%) of total sponsorship budget of £1 million for 2000/01 was allocated to the arts in the UK.

All the criteria within the company's community investment policy have to be satisfied.

Arts sponsorships are preferred. 'Straight donations' are not made. There is no specific arts policy but national organisations, those with an international reach and carrying out educational projects for underprivileged communities are targeted. No particular artform is preferred.
Sponsorships in 2001 included:
Glyndebourne;
National Gallery;
Royal Albert Hall;
Royal National Theatre;
Royal Opera House;
Sadlers Wells;
Science Museum.

The company was one of 28 companies contributing £25,000 each to Japan 2001.

Other support: Member of the Arts & Business Board Bank project.

Applications: In writing to the correspondent or e-mail: community@ cw.com

On its website the company presents a *Step-to-Step Guide: Applying for Community Sponsorship.*

Charnos plc

Corporation Road, Ilkeston, Derbyshire DE7 4BP
Tel: 0115 932 2191; Fax: 0115 932 0722
Company type: Manufacture of hosiery and lingerie. Adria principal subsidiary
Contact: Amanda Godber, Personal Assistant to the Chairman

Donations to all causes: £31,000 (1999); £71,000 (1998)

Community involvement: The company prefers to support local charities in areas of company presence (Derby/ Nottingham areas) and proposals relevant to company business.

Donations, made through the Charnos General Charities Trust, are preferred to sponsorship. Priority areas are children and youth, medical, environment/ heritage, and the arts. No particular artforms are favoured.

Clerical and Medical Investment Group Ltd

Narrow Plain, Bristol BS2 0JH
Tel: 0117 929 0290; Fax: 01275 554181
Website: clericalmedical.co.uk/whois/ community.asp
Contact: Jane Murch, Arts sponsorship

The company prefers arts sponsorships to donations.

Arts sponsorship budget: £150,000 pa
The company sponsors national organisations. It has mainly supported music but it is looking at a broader arena.

Winner of the FT/Arts & Business Award 2000 for Strategic Sponsorship for three partnerships:
Spitalfields Festival over seven years;

Glasgow Royal Concert Hall's Celtic Connections Festival;
Bath Festivals Trust.

All three sponsorships worked particularly well at involving staff, creating closer relationships between departments and regional offices.

Recent sponsorship: Artsfest, Birmingham

Charitable donations: £50,000 (2001)
The company is interested in supporting charities in the Bristol and Clevedon areas only. No arts organisations have recently received support.

Other support: Employee fundraising matched up to a maximum of £500.

Clydesdale Bank

40 St Vincent Place, Glasgow G1 2HL
Company type: Financial services, part of National Australia Bank Group of Melbourne, along with Yorkshire Bank, Northern Bank, Belfast and National Irish Bank, Dublin and other banks particularly in Asia
Contact: Mrs Irene Swankie, External Relations Manager

At the point of compiling this guide sponsorship arrangements for both the Yorkshire Bank (see separate entry) and the Clydesdale Bank were being handled by the external relations manager based within the Clydesdale Bank.

Sponsorship policy: 'Clydesdale Bank regards sponsorship to be an important part of its business and one of its responsibilities to society. The bank has devised a community investment programme whose purpose is to put something back into the communities in which it operates and to address a wide range of issues which affect these communities.'

Further aims for the programme are that it:
- reflects the aspirations and needs of the communities in which the bank operates;

- is consistent with the bank's values;
- harnesses where possible the enthusiasm and skills of the bank's staff;
- undertakes projects that have a measurable, positive impact on society;
- demonstrates the bank's commitment to the development of vibrant and thriving communities.'

Major sponsorships within the community investment programme managed through our eternal relations team and local community sponsorships are managed at a more regional level.'

Partnership will be developed across a wide range of areas within the community with a particular focus on:

- cause-related charities; particular interest in disability provision;
- cultural;
- social exclusion; economic and social exclusion;
- youth and education/enterprise;
- learning.

Guidelines for sponsorship consideration: 'Where possible sponsorship projects should meet the following criteria.

- The sponsorship should contribute to communities.
- It should provide opportunities for the participation of customers/the community and staff.
- It should be focused on actual activity or programme delivery rather than on gala fundraising events, conferences or publications.
- The term of a sponsorship should not exceed three years and will be subject to annual reviews, measurement and evaluation.
- The bank/banks must either be sole sponsor, or have clear "ownership" of a distinctive initiative.'

Both national and local arts organisations will be considered and there is not preference for a particular artform.

Contact: Irene Swankie, External Relations Manager, Yorkshire Bank/

Clydesdale Bank, Tel: 0141 223 2553; Fax: 0141 223 2559; E-mail: irene.swankie@eu.nabgroup.com

Gifts in kind: The bank is prepared to consider these.

Charitable donations: The Clydesdale Bank expects to set up its own charitable grant-making trust.

Dixons Group plc

Maylands Avenue, Hemel Hempstead, Herts HP2 7TG
Tel: 01442 353000; Fax: 01442 354517
Website: www.dixons-group-plc.co.uk
Company type: Retailing consumer electronics, personal computer, domestic appliances, photgraphic equipment, communication products
Contact: Clare Brine, Community Relations Manager
Membership: BitC

Donations to all causes: £684,000 (2000/01)

Charitable donations: The company concentrates its support on charities concerned with education and training, medical research, crime prevention and the quality of life. All giving for the group is centralised and requests are administered by the Dixons Group Foundation. Stores do not have a budget and local requests are forwarded to head office. There is a preference for charities local to Hemel Hempstead, Sheffield, Stevenage, Nottingham and Bury.

The arts are handled within its community policy. A few small community arts projects have been supported, and funds have also been given to the Royal Opera House, the Royal Ballet School, and British Museum Development.

Other support: Gifts in kind, staff secondments, matching employee fundraising up to a maximum of £1,000 for a nominated charity.

The company say they do very little for the arts. A small contribution is made via its community funding.

Exclusions: Individuals, overseas (except in countries where the business is represented).

Applications: Guidelines and application forms are available on the group website.

Dresdner Kleinwort Wasserstein

20 Fenchurch Street, London EC3P 3DB
Tel: 020 7623 8000; **Fax:** 020 7475 9710
Website: www.drkw.com
Company type: Investment banking
Contact: Miss Jennifer A Emptage, Administrator, Kleinwort Benson Charitable Trust
Membership: BitC

Charitable donations: Grants are made through the Kleinwort Benson Charitable Trust which has a donations budget of some £500,000 a year. Arts grants total about £75,000 (15%) of this. The trust support education and outreach through the arts. Other donations are distributed widely and include medicine, welfare, youth, conservation. Arts support is national. No particular artform is preferred.

In 2000/01 arts donations included:
City of London Festival;
London Festival of Chamber Music;
National Gallery;
National Youth Orchestra;
Spitalfields Festival.

No arts sponsorship is arranged.

Other support: The company gives time off for volunteering and matches fundraising up to a maximum of £1,000.

Dunfermline Building Society

Caledonia House, Carnegie Avenue, Dunfermline, Fife KY11 8PT
Tel: 01383 627727; **Fax:** 01383 627800
Website: www.dunfermline-bs.co.uk

Company type: Financial services
Contact: Ken Dow, Community Relations Manager
Sponsorship: As above
Membership: A&B

Sponsorship: The society has changed direction with its sponsorship policy and now no longer concentrates on the arts with a far lesser involvement with sports (as noted in the previous edition of this guide). Now both areas are treated equally and in 2001 two major relationships were announced with the National Youth Choir of Scotland and the Scottish Youth Football Association. The society is interested in fostering young Scottish talent.

Donations: The society supports charity and community groups within Scotland with emphasis on young people, children and education.

Economist Newspaper Ltd

25 St James's Street, London SW1A 1HG
Tel: 020 7830 7000; **Fax:** 020 7499 9767
Website: www.economist.com
Company type: Publication of the *Economist* and other specialist publications, and supply of business intelligence
Contact: Jean Simkins, Charities Liaison Officer
Sponsorship: Daniel Franklin, Arts sponsorship

Donations to all causes: £144,000 (2000/01)

Arts sponsorship: Corporate supporter of the Tate and a patron of the Royal Academy of Arts.

Other support: It supports the visual arts by putting on art displays by independent artists in its exhibition area. It does this through its relationship with the Contemporary Arts Society which proposes artists to a staff selection committee.

Charitable donations: Donations are largely made through the Economist Charitable Trust. It responds to causes at national and international levels, concentrating on activities in some way linked to its own interests (learning and education, and business and enterprise). It focuses on projects where there is a possibility of monitoring the benefits and where there is scope for personal staff involvement.

It matches employee fundraising up to a maximum of £1,000.

Small donations may include charities related to the company by local or business connections. The small proportion of arts grants are generally for grassroots projects or those overlapping with other categories, e.g. music for disabled people.

EMI Group plc

4 Tenterden Street, London W1A 2AY
Tel: 020 7355 4848; Fax: 020 7493 0305
Website: www.emigroup.com
Company type: All aspects of music industry: recording, publishing, manufacturing, marketing, distribution
Contact: Kate Dunning, Corporate Affairs
Membership: BitC

Donations to all causes: £1,300,000 (2000/01)

The Music Sound Foundation (see under 'Trusts') was set up in 1997 to celebrate the centenary of EMI Records. It is a registered charity with an independent board of trustees. Charitable support at a group level is focused on the foundation.

Arts sponsorship: The EMI Group is a *corporate member* of major arts institutions. This is the only arts support it engages in apart from the foundation. In 2001 it was corporate member of:
English National Opera;
Glyndebourne;
National Gallery;
Royal Albert Hall;
Royal Opera House;
Tate Britain.

Applications: See the Trust Section for information on the Music Sound Foundation.

Enterprise Oil plc

Grant Buildings, Trafalgar Square, London WC2 5ES
Tel: 020 7925 4000
Website: www.entoil.com
Company type: Oil exploration and production company purchased by Shell (4/02)
Contact: Mrs Jane Stevenson, Secretary, Donations Committee

Donations to all causes: £247,000 (2000)

Arts sponsorship: The company has no specific arts policy or budget for arts sponsorship, but it has indicated an interest in this area without citing any examples.

Charitable donations: The company supports a wide range of charitable work including the arts. Its largest grants are made to organisations active in social welfare, health/disability and the environment. Its support is particularly directed at areas in which the company operates.

Other support: Employee fundraising is matched up to a maximum £15,000.

Ernst & Young

Becket House, Lambeth Palace Road, London SE1 7EU
Tel: 020 7951 2000; Fax: 020 7951 1345
E-mail: nmajor@uk.ey.com
Website: www.ey.com/uk
Company type: Accountants
Contact: Nicky Major, Senior Marketing Manager
Membership: A&B; % Club; BitC

Arts sponsorship and arts donations are administered separately with a preference

for arts sponsorships with a particular interest in the visual arts.

Arts sponsorship: The company sponsors high profile arts activities by major national institutions. It is understood that unsolicited proposals are not considered.

In 2000/01 major exhibitions included:
Lambeth Palace, opening to the public in 2000;
National gallery, Vermeer of the Delft School, 2001.

Previous exhibitions sponsored include:
Tate Gallery, Bonnard exhibition 1998;
Royal Academy, Monet exhibition, 1999;
Birmingham Museum, Burne-Jones exhibition 1998/99.

Other flagship institutions supported included:
Royal National Theatre;
Royal Opera House Trust;
English National Opera;
Scottish Opera;
CBSO, Birmingham;
Bridgewater Hall, Manchester;
The English Concert.

Some local arts events may be sponsored e.g. Coin Street Festival, Southwark.

Charitable donations: The firm supports charitable organisations on a national basis and through its network of regional offices.

'Ernst & Young supports *Life Matters*, a unique art initiative, which aims to develop and celebrate the creative talents of young people supported by NCH, one of the UK's leading children's charities.'

Esso – see ExxonMobil

ExxonMobil

Esso UK Limited, Ermyn House, Mailpoint 8, Leatherhead, Surrey KT22 8UX
Tel: 01372 222312; **Fax:** 01372 223222
Website: www.exxonmobil.com and www.esso.co.uk
Company type: Energy and petroleum
Contact: Stella Crossley, Community Affairs Adviser

Donations to all causes: £1,510,000 in the UK (2000)

The ExxonMobil Corporation is the parent company of Esso, Mobil and the ExxonMobil companies that operate in the UK. The company's UK operations span the entire oil cycle: exploration for, production, distribution and marketing of petroleum products in the UK.

Community partnerships:
'ExxonMobil strives to be a good corporate citizen and a good neighbour wherever we do business. Our success in the energy and petrochemical industry makes it possible for us to contribute to the well being of the communities where we create profits and jobs, provide products and pay taxes.

'We support programs that improve education, the environment and health care. We fund museums and the arts. We support community service groups, particularly those that work with underprivileged or underrepresented populations.

'Our action takes many forms. Sometimes it requires people commitment as well as money, and we support the efforts of our people when they become involved.'

Arts and culture: 'Since 1943, ExxonMobil has supported the cultural arts, museums and historical associations that enrich, inspire and educate.' Its affiliates worldwide support Art and Culture initiatives. [Information taken from the ExxonMobil website.]

Arts sponsorship: 'In the UK our flagship arts sponsorship is with the National Gallery in London where we [under the banner of Esso until recently, editor] have supported exhibitions since 1988. Other local arts groups may be supported in the neighbourhoods of our main employing locations at Aberdeen, Fawley, Fife and Leatherhead.'

Examples of UK arts sponsorship in 2000/01 included:
The National Gallery, London, Pisanello, Painter to the Renaissance Court exhibition;
Haddo House Choral Society;
Beatrice Royal Exhibition;
National Trust for Scotland;
Science Museum;
Scottish Ensemble;
Shakespeare's Globe Theatre.

ExxonMobil have also invested in educational programmes linked to the exhibitions it supports.

ExxonMobil proactively plans its own programmes. Unsolicited proposals are rarely supported.

Charitable donations: 'Through its programme of Neighbourhood Links, ExxonMobil actively seeks to support local communities around its four main employment sites at Fawley, Leatherhead, Fife and Aberdeen by forming effective partnerships with many local charities, not-for-profit organisations and community groups. Other areas of particular interest to ExxonMobil, are education, environment, arts, and employee volunteering, where grants may be given to not-for-profit organisations that benefit from employees' personal input.'

Other support: 'Local groups are invited to use the facilities of ExxonMobil office locations to run meetings and events. Access to many resources is given to promote local events and charity fundraising initiatives to staff and their families. ExxonMobil also donate gifts for raffles and fundraising events.'

Family Assurance Friendly Society Ltd

17 West Street, Brighton, East Sussex BN1 2PL
Tel: 01273 725272; **Fax:** 01273 736958
Website: www.family co.uk
Company type: Financial services (life assurance, savings, protection schemes)
Contact: Tony Horton, Community Affairs Manager
Sponsorship: As above

Donations to all causes: £10,000 (2000)

Arts sponsorship: The company's community involvement is largely through arts sponsorships and focuses on young people in Brighton and Hove and East Sussex. These have included:
Brighton Festival 'Family Celidh';
Brighton Youth Orchestra;
Sussex Youth Orchestra.

The company's total sponsorship budget is between £7,000 and £10,000 a year.

Charitable donations: The company has a preference for charities local to the Brighton/Sussex area and to those in which a member of staff is involved.

Foster Wheeler Energy Ltd

Shinfield Park, Reading RG2 9FW
Tel: 0118 913 1234; **Fax:** 0118 913 2333
Website: www.fwc.com
Company type: Industrial services and equipment
Contact: G J Rimer, Company Secretary

Donations to all causes: £73,000 (2000)

Arts sponsorship: The company undertakes arts sponsorship of local organisations. In 2000/01 these included:
Reading Youth Orchestra;
Hexagon Theatre, Reading (sponsorship of a concert);
Reading Museum;
Ithaca.

Charitable donations: Its support for the arts is mainly centred on Berkshire. It is also interested in supporting local charities in the other areas where the company has a presence – Teesside and Glasgow.

Other support: Gifts in kind.

Friends Provident

United Kingdom House, 72–122 Castle Street, Salisbury SP1 3SH
Tel: 01722 311447; **Fax:** 01722 325753
Website: www.friendsprovident.com
Company type: Financial services
Contact: Jim Murdoch, Communications Manager
Membership: A&B

Charitable donations: It is understood the company may consider donations to local charities in the vicinity of its two joint head offices – Dorking and Salisbury, and in Exeter and Manchester. Most of its funds are channelled to the Friends Provident Research Fellowship administered by the British Heart Foundation, Cancer Research and Barnardos.

Arts sponsorship: Sponsorships are arranged with organisations local to the company. In 2000/01 these included:
Salisbury Festival;
Salisbury Amateur Operatic Society;
Exeter Festival.

G B Audio

Unit D, 51 Brunswick Road, Edinburgh EH7 5PD
Tel: 0131 661 0022; **Fax:** 0131 661 0022
E-mail: sales@gbaudio.co.uk
Website: www.gbaudio.co.uk
Company type: Hire and sale of professional audio equipment
Contact: Graham Bodenham, Chairman

Sponsorship: helps 'adventurous Scottish projects' in the fields of the arts and education. It is understood that the company only sponsors in kind, providing free advice on technical design (and sometimes providing discounted sound equipment). It has supported:
Scottish International Children's Festival;
Edinburgh Book Festival.

Exclusions: Cash awards and funding for individual students.

Gallaher Group plc ✭

Members Hill, Brooklands Road, Weybridge KT13 0QU
Tel: 01932 859777; **Fax:** 01932 832532
E-mail: info@gallaherltd.com
Website: www.gallaher-group.com
Company type: Tobacco
Contact: Ms M McKeown, Secretary, Charities Committee
Sponsorship: As above
Membership: A&B; BitC

Donations to all causes: £352,000 (2000)

Charitable donations: The company supports national and local charities with a preference for activities in areas of company presence – Surrey, Wales, Northern Ireland, Crewe, south London. The arts are amongst the activities for which it is prepared to consider support.

Sponsorship by tobacco companies is no longer permitted.

Applications: Regional contacts for local appeals only: Ms J Kennedy, J R Freeman & Son, PO Box 54, Freeman House, 236 Penarth Road, Cardiff CF1 1RF.

J Holden, Virginia House, Weston Road, Crewe, Cheshire CW1 1GH.

W Parkinson, 201 Galgorm Road, Lisnafillan, Gracehill, Ballymena, Co Antrim, N Ireland BT24 1HS.

GKN plc

PO Box 237, West Malling, Kent
ME19 4DR
Tel: 01732 520168; Fax: 01732 520001
Company type: An international
company involved in automotive and
aerospace services
Contact: Michael Theodorou, Corporate
Appeals Administrator
Sponsorship: As above

Donations to all causes: £532,000
(2000)

Its operating companies are based in the
Redditch/Midlands area.

Arts sponsorship: The company states it
undertakes one major arts sponsorship a
year usually in the form of a concert.
It does not give arts donations.

Guardian and Observer

119 Farringdon Road, London EC1R 3ER
Tel: 020 7278 2332; Fax: 020 7837 1267
Website: www.guardian.co.uk
Company type: Newspaper and
magazine publishing
Contact: Marc Sands, Marketing
Director
Membership: A&B

Donations to all causes: £106,000
(2000)

Whilst contact details were updated by
the company for this edition of the guide,
no further information was supplied and
a brief questionnaire was ignored.
However since no changes were made to
the text of the previous entry it is
repeated.
 'Arts sponsorship and arts donations are
administered separately with a preference
for sponsorship. Preferred artforms are
visual arts, film, television, festivals and
music.

Arts sponsorship policy: A preference
is given to contemporary arts, particularly
with appeal to the target market of 17–40
year olds, and to large popular events. As

has been stated in the previous edition:'It
targets its sponsorships to reach a young
dynamic audience and prefers national
events. For this reason, the most attractive
are those that are cutting edge, fresh and
progressive.'
 Sponsorships in 1998/99 included:
Tate Gallery, Jackson Pollock exhibition;
Serpentine Gallery, Piero Monzoni
exhibition;
Glastonbury Festival;
Edinburgh Film Festival;
National Film Theatre;
London Film Festival;
Assembly Theatre, Edinburgh.

Charitable donations: Approaches
should be made to Carolyn McCall, the
Managing Director.

HALIFAXBANKOFSCOTLAND

Group Community Relations, PO Box
no 5, The Mound, Edinburgh EH1 1YZ
Tel: 0131 243 7058; Fax: 0131 243 7081
Website: www.hbosplc.com linking to
bankofscotland.co.uk
Company type: Financial services
Contact: Sarah Mackie, Director of
Sponsorship
Membership: A&B; % Club

Donations to all causes: £2,326,000
(2001)

At the point of editing, these merged
companies were developing a new
community involvement strategy for both
their brands as part of the HBOS group.

Hammerson

100 Park Lane, London W1K 7AR
Tel: 020 7887 1017; Fax: 020 7887 1137
Website: sjhaydon@hammerson.co.uk
Company type: Property investment
and development
Contact: Stuart Haydon, Company
Secretary
Sponsorship: As above

Donations to all causes: £60,000
(2000)

Within the UK, the office property portfolio is mainly in London, with retail interests in Birmingham, Brent Cross, Grimsby, Reading, Romford, Slough, Southampton and Stockport.

Charitable donations: The company has stated, 'Donations are made to a variety of social, medical and arts charities and to charities in localities where the group own property.'

The company prefers making donations to sponsorships but does not appear to rule out sponsorship – though it provided no examples of either donations or sponsorships. An interest in both national and local arts organisations was indicated with no preference for particular artforms.

HMV UK

Film House, 142 Wardour Street, London W1F 8LN
Tel: 020 7432 2000; **Fax:** 020 7534 8112
Website: www.hmv co.uk
Company type: Music, games and video retail
Contact: See below

HMV's policy on corporate social responsibility was under review at the time of editing.

Arts sponsorship: Sponsorships may be arranged where music is used to promote education and well-being. Both national and local organisations may be assisted and all partnerships are music-related. Sponsorships in 2001 included:
HMV Birmingham International Jazz;
HMV Choice Awards;
Edinburgh Fringe – support of selected events/ticket distribution, etc.

HMV has been a long-term supporter of Nordoff-Robbins Music Therapy which works with disabled and traumatised children and adults.

For national sponsorships contact: Gennaro Castaldo, Tel: 020 7432 2033; E-mail: gennaro.castaldo@hmv.co.uk

For local/regional sponsorships contact: Jason Legg, Tel: 020 7432 2236; E-mail: jason.legg@hmv.co.uk

Both are based at the above address. Arts donations are not made.

HSBC Holdings plc

10 Lower Thames Street, London EC3R 6AE
Tel: 020 7260 0500; **Fax:** 020 7260 0501
Website: www.hsbc.com
Company type: Banking and related financial services
Contact: Judith Austin, Sponsorship Manager
Membership: A&B

Donations to all causes: $24.5 million (2000) worldwide

Sponsorship and donations policy: 'HSBC supports the following six areas within its sponsorship and donations guidelines: education, the environment, culture and heritage, sport, the arts, broadcast sponsorships. Of these, the major focus is on education in primary and secondary level for underprivileged children, and the environment.'

Sponsorship and donations are administered separately. Arts sponsorships are preferred.

Arts sponsorship: Sponsorship is targeted at national youth organisations and local organisations. Arts support is likely to relate only to education and youth.

Sponsorship in 2000/01 included:
National Youth Orchestra;
National Opera Studio;
National Youth Theatre;
National Youth Ballet;
Arc Theatre Ensemble.

Short-listed by Arts & Business for its 2001 'Arts, Business and Sustainability Award' for its sponsorship of the Arc Theatre Ensemble which started in 1994 with £3,000 from the HSBC

Walthamstow branch and grew into a £2 million investment into this community youth theatre.

Arts & Business Cymru/Wales gave awards in May 2001 and named HSBC as the 'Best Established Sponsor' citing its support to:
BBC National Orchestra of Wales;
Live Music Now!;
Llangollen International Musical Eisteddfod, National Eisteddfod of Wales;
St David's Hall;
Urdd Gobaith Cymru.

The support to the extensive year-round community education programme at Spitalfields Festival by HSBC Insurance Holdings is featured as a case study in the Arts & Business 2001 publication, *Creative Connections – business and the arts working together to create a more inclusive society.*

Charitable donations: These should be forwarded to Peter Bull, Executive, HSBC in the Community.

Hunting PLC

3 Cockspur Street, London SW1Y 5BQ
Tel: 020 7321 0123; Fax: 020 7839 2072
E-mail: pr@hunting.plc.uk
Website: www.hunting.plc.uk
Company type: Oil services
Contact: Anna Blundell-Williams, Public Relations Co-ordinator

Donations to all causes: £49,000 (2000)

Charitable donations: These are made through the Hunting Charitable Trust. UK charities involved in welfare and medicine are supported. Local charities are usually only supported by subsidiaries if a member of staff has a particularly close connection with the charity.

Arts sponsorship: The company sponsors the Hunting Art Prizes Competition.

The Hunting Art Prizes Competition:
The exhibition of the finalists' paintings took place at the Royal College of Art in January 2002. The 2001 competition attracted over 1,700 works from which 111 were selected for exhibition.

Prizes: 1st Prize (£12,000); 2nd Prize (£4,000); Young Artist of the Year Prize (age limit 25) (£5,000); Runner Up Prize (age limit 25) (£1,500); Print & Drawing Award (£1,000); Outstanding Regional Entry (£1,000); Most Popular painting of the Show Prize (£500).

Enquiries in connection with the 2003 competition should be sent to the competition administrators: Parker Harris Partnership. E-mail: pr@hunting.plc.uk

IBM United Kingdom Ltd

South Bank, 76 Upper Ground, London SE1 9PZ
Tel: 020 7202 3000
Website: www.ibm.com
Company type: Provision of information technology, consultancy, services and systems
Membership: A&B

Arts sponsorship policy: 'IBM's sponsorships are focused on a small number of international activities that promote IBM e-business and IBM e-business infrastructure. IBM's sponsorships aim to reach wide audiences and demonstrate the value that IBM e-business brings to ventures through the provision of the skills of its people and the use of its products, services and industry solution. IBM's prime suppport for the arts is through provision of information technology, software and consultancy to a small number of international museum projects.'

2001 arts sponsorships in the UK:
Edinburgh International Festival, for concerts;
City of London Festival, principal sponsor.

Contact for arts sponsorships: Peter Wilkinson Associates, PO Box 9108, London SW14 8ZN, Tel: 020 8288 1845; Fax: 020 8288 4233; E-mail: prnwilkinson@aol.com

Arts donations policy: 'IBM provides information technology equipment, applications and services to leading museums and libraries including the Hermitage Museum; the Vatican Library; the Lutherhalle Wittenberg Museum; and the Archivo General de Indias, Seville. In a project for science museums, IBM is developing an international website 'Tryscience' in association with the New York Hall of Science and the Association of Science and Technical Centers. Over 470 museums and science centres are participating in the website which provides a worldwide interactive learning facility for the general public and allows museums to provide greater access to their collections and share expertise.'

2001 arts donation in the UK: The Hermitage Rooms, London.

Contact for arts donations: IBM UK Trust based in the South Bank address listed at the head of this entry. Contact: Mark Wakefield and/or Valerie Ward, administrator

Employee involvement: IBM was short-listed by Arts & Business for its 2001 'Arts, Business and Employees Award' for Trendmania, a collaborative project aimed at altering opinions and perceptions. It broke the rules of traditional corporate sponsorship and brought students from Central St Martin's College of Art & Design together with employees from IBM for an exhibition around the notion of 'trends' which became the best attended event at the college in the last 10 years. (N.B. This information came from the Arts & Business publication linked to its award ceremony, not from the company itself.)

Jaguar Cars Ltd

Browns Lane, Allesley, Coventry CV5
Tel: 024 7620 2040; Fax: 024 7640 5581
E-mail: iratcliff@jaguar.com
Website: www.jaguar.com
Contact: Les Ratcliffe, Manager Community Relations
Sponsorship: Amanda Chick, Promotions Department

Donations to all causes: £70,000 (2000)

Sponsorship: The group has a preference for prestige sports, arts and similar events. A major objective is to provide hospitality opportunities for dealers, and the group is not necessarily looking for TV exposure or press coverage. Typically, the group will spend up to £5,000 on an event sponsorship, or up to £10,000 on an exhibition. It prefers to be the sole or main sponsor.

Support in previous years has been given to:
Birmingham Royal Ballet;
British Academy of Film and Television Arts;
Royal Scottish Opera;
Royal Academy of Arts.

The company supports the Jaguar Awards for Arts & Business Adviser of the Year in association with The Birmingham Post (Arts & Business West Midlands).

Charitable donations: The company is prepared to consider approaches from arts organisations. It has a preference for activities near its plants in the West Midlands and the North West.

Other support: Gifts in kind, staff secondments.

Kelda Group

Western House, Halifax Road, Halifax
BD6 2SZ
Tel: 01274 692 586; **Fax:** 01274 692 621
Website: www.yorkshirewater.com
Company type: The group includes
Yorkshire Water and waste services
Contact: Cheryl Wright, Community
Affairs Manager

Donations to all causes: £700,000
(2000/01)

Charitable donations: The group
supports Yorkshire based charities. It
focuses on education, the environemnt,
vulnerable people, safety.

Employee fundraising is matched.

The group does not undertake arts
sponsorship but it indicates that in kind
help is given via Arts & Business.

LE Group

Templar House, 81–87 High Holborn,
London WC1V 6NU
Tel: 020 7242 9050; **Fax:** 020 7242 2815
E-mail: Catherine_Kinman@london
elec.co.uk
Website: www.london-electricity.co.uk
Company type: Energy generation/
supply/distribution in London, south
west and north east
Contact: Catherine Kinman, Community
Affairs Manager, Tel: 020 7331 3322
Sponsorship: As above
Membership: A&B; BitC; EITC; London
Benchmarking Group

The group's three brands are: SWEB,
London Electricity, Virgin Energy. It also
incorporates LPN – London Power
Network and LES – London Electricity
Services for private electrical networks.

LE Group's first Social Responsibility
Report highlighting its current
community investment and outlining its
targets for development was produced in
spring 2002.

It focuses on projects addressing:
regeneration, sustainable development,
education, homelessness, diversity, fuel
poverty.

'We … also seek to increase support and
involvement of our staff in community
projects that contribute towards staff
development and meet key community
needs. Where possible, we will seek to
work more closely with grass roots
organisations, forging partnerships that
enable us to more directly tackle key
social issues.'

Arts sponsorship and arts donations are
handled together with a preference for
sponsorship.

Arts sponsorship: A very successful
'New Audiences' scheme was arranged
with Serious at the London Jazz Festival
in 1999. Through this programme, in
essence a ticket subsidy scheme, people
from disadvantaged communities have
experienced live music at the highest
level. In 2000 the partnership developed
with the addition of an extensive
outreach workshop programme. In 2001
the partnership received the Arts &
Business Award for Arts, Business and the
Community for 'an effective partnership
stimulating community involvement and
inclusion in the arts, and/or stimulating
regeneration. In the same year it also won
the Arts & Business Employees' Award,
for their cultural diversity staff workshops:
'an effective, creative programme to
involve employees in the arts and
incorporate arts into the workplace'.

Arts sponsorships in 2000/01 included:
Bath Festival;
London Jazz Festival;
Tate Modern.

Exclusions: Donations for advertising in
brochures, etc; individuals; local charities
outside main areas of operation.

Legal & General Group plc

Temple Court, 11 Queen Victoria Street, London EC4N 4TP
Tel: 020 7528 6263; Fax: 020 7528 6226
Website: www.legalandgeneral.com
Company type: Financial services
Contact: Jackie Quantock, Social Responsibility Manager
Membership: A&B; % Club; BitC

Donations to all causes: £700,000 (2000)

Legal & General gives up to 1% of pre-tax profits to support activities which benefit the community. The long-term aim of the programme is to build a better quality of life. Legal & General believes that the best way to do this is to give significant long-term support to a small number of projects which are directly related to the group's core businesses. Local programmes are used to support the community in places where large numbers of employees live and work. The company has an established, long-term community programme which is run proactively, in that the company looks for organisations that meet its criteria. Unsolicited appeals are not welcome, although information about organisations which work in the relevant areas is always useful. The programme covers: social welfare; environment; crime prevention; equal opportunities for women.

Local programmes fund a wide range of community activities in areas where employees live and work. Preference is given to projects in which employees are involved. Local programmes are run in the following areas: Brighton and Hove, Reigate and Banstead, Cardiff and Birmingham.

The company has said it does little in terms of arts sponsorship and donations. However it is a supporter and corporate member of:
Brighton Philharmonic Orchestra;
Glyndebourne Festival Opera;
National Museums & Galleries of Wales;
Royal Albert Hall;
Royal Opera House.

John Lewis Partnership plc

171 Victoria Street, London SW1E 5NN
Tel: 020 7828 1000; Fax: 020 7828 4145
Website: www.john-lewis-partnership. co.uk
Company type: Department stores and supermarkets
Contact: Samantha Soames, Secretary to the Central Charities Committee

Donations to all causes: £1,527,000 (2000/01)

Donations: The Partnership's Central and Branch Councils are responsible for almost 60% of the total donations (£908,000 for 2000/01). They give to what can be broadly described as 'welfare' organisations, generally with charitable status. Organisations at both national (Central Council) and local (Branch Council) level are supported, preferring to give directly to the organisations concerned.

The chairman gave £392,000 in 2000/01 to organisations which, in broad terms, fall into the categories of the arts, learning and the environment. Seventy-three percent of the donations in these categories was made in support of musical activities and the arts, with the remainder being divided between educational projects, environmental and other causes.

Sponsorship: No sponsorship is arranged.

Applications: In writing to the correspondent. Applications are discussed quarterly. Local charities should deal with their local Partnership department store, production unit or Waitrose branch.

Littlewoods Organisation Plc

100 Old Hall Street, Liverpool L70 1AB
Tel: 0151 235 3319; **Fax:** 0151 476 5118
E-mail: linda.minnis@littlewoods.co.uk
Website: www.littlewoods.co.uk
Company type: Retail and distribution.
Over 300 high street outlets. Amongst
the top five UK e-commerce businesses
Contact: Jayne Moore, Community
Affairs Co-ordinator
Membership: A&B; BitC; LBG

Donations to all causes: £1,100,000
(2000/01)

Most of the company's support is
concentrated on the regeneration of
Merseyside, its HQ base for over 75 years.

Charitable donations: From May 2001
onwards its Community Investment
programme has focused on:
Regeneration; Charity of the Year;
Employee involvement.

The company has stated that it does
not make arts donations.

Arts sponsorship: Its support centres on
larger regeneration projects, e.g. its
partnership with National Museums and
Galleries on Merseyside in refurbishing
the atrium at Liverpool Museum to
which it has committed £250,000. Arts
sponsorship is fully committed until
2004/05.

It is also committed to supporting
Liverpool's bid to become European
Capital of Culture in 2008.

A senior manager sits on the Arts &
Business regional panel in the North
West.

Applications: The programme is
committed until 2003/04. Applications
are not accepted.

Manchester Airport

Wythenshawe, Manchester M90 1QX
Tel: 0161 489 3000
E-mail: trust.fund@manairport.co.uk
Website: www.manairport.co.uk

Company type: International airport
operator
Contact: Sue Jones, Arts Sponsorship
Manager
Membership: A&B; BitC

Arts sponsorship: Budget – £540,000
(2000/01)

'Manchester Airport contributes 1% of
gross operating profit to arts sponsorships
as a minimum... We particularly value the
cultural strength of the organisations in
Greater Manchester and think it is
important to support the centres of
excellence in the area. The company's
portfolio includes: Music, Dance, Theatre,
Museum and Opera and covers support
for education and community projects, as
well as production sponsorships. One of
the aims of the airport's arts sponsorship
is to make the city of Manchester more
attractive to inbound tourism.'

It supports local organisations and
national work touring to regional venues.
Arts sponsorships in 2000/01 included:

Opera and dance
Opera North;
English National Ballet.

Theatre
Bolton Octagon;
Chester Gateway;
Feelgood Theatre;
Forum Theatre, Wythenshawe;
Mossley Community Arts;
Royal Exchange Theatre;
Theatr Clwyd.

Music
Bury Met;
Chester Music Festival;
Hallé Orchestra;
Lancashire Chamber Orchestra;
Manchester Chamber Concert Society;
Music at St James;
Northern Chamber Orchestra;
Travelling by Tuba;
Quarrybank Music festival;
Wigan Jazz Festival.

Visual Arts and Miscellaneous
Cornerhouse;
Manchester Evening News Theatre
Awards;
North West Arts.

Festivals
MIA (Streets Ahead);
Festival of Oldham;
Manchester Poetry Festival;
Bolton Festival.

Airport Art – takes art out of galleries
or theatres and places it squarely in front
of the travelling public, bringing a new
artistic dimension to the lives of
customers and staff of Manchester
Airport. It started in 1997/98 and is
expected to continue indefinitely.

Charitable donations: No arts
donations made.

Employee involvement: Volunteering
of business skills through A&B North
West.

Manweb

Manweb House, Kingsfield Court,
Chester Business Park, Chester CH4 9RF
Tel: 01244 652091; **Fax:** 01244 652119
E-mail: janet.cahill@manweb.co.uk
Website: www.manweb.co.uk
Contact: Jan Cahill, Corporate
Communications Executive
Membership: A&B; Business in the
Community; % Club

'The company is a subsidiary of
ScottishPower but still administers its
own community support. Its sponsorship
programme 'to improve the quality of life
for people in our region' includes support
for business growth, energy and safety
related projects in schools and a host of
community and arts events within its
traditional area of operation – north
Wales, Merseyside and Cheshire.'

Arts sponsorship: 'Manweb's policy is
focused on proposals which involve the
local community. It helps bring a variety

of festival and arts events to the region. Its
partnership with Welsh National Opera,
which won best Arts & Business Cymru's
2001 award for best sponsorship
developing audiences, enables the opera
company to bring an annual performance
to Llandudno and a host of community
education activity and performances for
local schools and older people.'

Sponsorships in 2000/01 included:
Chester Gateway Theatre;
Live Music Now!;
Urdd Gobaith Cymru Welsh National
Opera;
National Eisteddfod;
Clwyd Theatr Cymru.

Charitable donations: 'The company's
charitable support is channeled through
the ScottishPower group's own charitable
initiative, PowerPartners, which is a
partnership with five leading charities:
The Royal National Institute for the
Blind (RNIB), The Royal National
Institute for Deaf People (RNID), NCH,
Age Concern Scotland and WaterAid.
This is a unique initiative which
encourages the partner charities to work
together with ScottishPower for the
benefit of both their clients and our
customers. The charities also advise
ScottishPower on disability policy issues
and help us to understand the needs of
their clients, which in turn will help us
improve the services we provide to our
special needs customers. The main
objectives of the partnership are as follows.

- To raise much needed funds, over a
 three year period, which will support
 new initiatives, identified by our
 partner charities;
- To work with our partners to develop
 services to customers with special
 needs and to become a model for good
 practice throughout the UK;
- To raise awareness of special needs in
 our communities.'

To enable ScottishPower effectively to
distribute funds raised for the partner

charities, a PowerPartners Charitable Trust has been established. The trustees meet on a bi-annual basis to endorse allocation of funds to projects nominated by the partner charities. The PowerPartners Charitable Trust is a registered charity in Scotland, Reg No SC029546

Marconi plc

One Bruton Street, London WIJ 6AQ
Tel: 020 7493 8484; Fax: 020 7493 1974
Website: www.marconi.com
Company type: A holding company – subsidiaries and associated companies mainly provide communications equipment/services and associated support applications
Contact: N C Porter, Secretary
Sponsorship: As above
Membership: A&B; BitC

Donations to all causes: £414,000 UK only (2000/01)

Charitable donations: The company supports both national and local charities. Its social responsibility policy states that its charitable giving is 'in support of local communities and national charities, particuarly those involving our employees in areas of science and education'.

Donations are made to a wide range of activities and include the arts as well as children/youth, education, elderly people, enterprise/training, overseas projects, science/technology. Its main benificiaries of grants in 2000/01 included:
Design and Technology Association; British Museum.

Most arts support is channelled to 'educational' arts, mainly at a local level. Arts donations and sponsorship is only likely to go to national organisations.

Other support: Staff secondments, training schemes, support to employees' volunteering and fundraising activities.

Applications: Applications for local support should be made in writing to your local Marconi operating unit. These subsidiairies and operating units have their own very small budgets.

Marsh Ltd

Aldgate House, 33 Aldgate High Street, London EC3N 1AQ
Tel: 020 7357 1000; Fax: 020 7357 1484
Website: www.marsh.com
Company type: Risk management and insurance services
Contact: Augustin de la Brosse, Community Programmes Administrator
Sponsorship: Davina Forster, Arts sponsorship
Membership: A&B; BitC; % Club

Donations to all causes: £197,000 (2000)

Arts sponsorship: An interest is expressed in 'commercial sponsorship and corporate entertainment'. It is known that the company has supported the City of London Sinfonia. No further information was made available.

Charitable donations: The company has indicated a specific interest in education, children/youth and sickness and disability. It supports national and local charities with a particular interest in those activities near its local branches which are in most major towns. It is interested in activities in which a member of staff is involved.

Arts charities supported in 2000 included:
English National Ballet School;
National Gallery Trust;
Choral Foundation of HM Tower Tower of London;
Council for Music in Hospitals;
Live Music Now!;
Lloyd's Dramatic, Operatic and Musical Society;
Music for Youth;
National Maritime Museum;
National Museums & Galleries on Merseyside;
National Musicians Symphony Orchestra;

Spitalfields Festival;
Tate Gallery Foundation;
Victoria and Albert Museum.

All appeals are considered by a committee of staff from different operating divsions.

If you wish to apply for a donation write to Marsh at CCAS, 80 Croydon Road, Elmers End, Beckenham, Kent BR3 4DF, Tel: 020 8658 4909; E-mail: Marsh@ccas.globalnet.co.uk

Other support: Staff fundraising is matched up to a maximum of £150. Individual employees can volunteer for a range of team projects.

'Not all appeals require a monetary response and Marsh offices should be prepared to offer skills and resources where appropriate. This may range from providing a venue for a meeting to giving staff time to participate in community activities.' Contact Sarah Lovett for further information.

Menzies Distribution Ltd

Hanover Buildings, Rose Street, Edinburgh EH2 2YQ
Tel: 0131 549 8159; **Fax:** 0131 459 8111
E-mail: margaret.scott@menzies group.com
Website: www.john-menzies.co.uk
Company type: Distribution services group – news and magazine distribution; aviation services
Contact: Margaret Scott, Secretary to charities committee
Membership: % Club

Donations to all causes: £299,000 (2000/01)

Charitable donations: Arts donations are preferred to sponsorship and about 11% (£15,000) of the group's general donations budget is earmarked for arts activities. (The total donations figure above includes £165,000 to the NSPCC.) The company supports Scottish charities and those in areas of company presence.

Arts donations in 2000/01:
Edinburgh International Festival;
National Museums of Scotland;
Scottish Poetry Library;
Scottish Royal Orchestra;
Perth Festival;
Pitlochry Festival Society.

Other support: Employee fundraising is matched up to a maximum of £350.

M&G Group

M&G House, Victoria Road, Chelmsford, Essex CM1 1FB
Tel: 01245 266 266; **Fax:** 01245 390 735
Website: www.mandg.co.uk
Company type: Unit and investment trust management
Contact: Vicki Chapman, Charity and Community Relations Manager

Charitable donations: 15% (£9,750) of the donations budget of £65,000 in 2001 was allocated to the arts. The company gives to charities in the areas of company presence. It will support the arts as well as social welfare, children/youth, elderly people, education and environment/ heritage. Support has been given to: National Art Collections Fund; Dulwich Picture Gallery.

Arts sponsorship: 15% (£7,500) of the sponsorship budget of £50,000 for 2001 was allocated to the arts. This is undertaken with proposals local to the company. No particular artforms are preferred. Sponsorships in 2000/01 were:
Chelmsford Cathedral Festival;
Chelmsford Civic Concerts;
Newpalm Productions;
Anglia Polytechnic University Concerts;
City of London Festival;
City Music Society;
Essex Symphony Orchestra;
Essex Dance;
The Bach Choir.

Mobil – see ExxonMobil

Morgan Stanley & Co International Ltd

25 Cabot Square, Canary Wharf,
London E14 4QA
Tel: 020 7513 8000; Fax: 020 7425 4949
Website: www.morganstanley.com
Company type: Financial services
Contact: Heather Bird, Vice President,
community matters
Sponsorship: Tim Doyne, Vice
President, Advertising and Marketing

Donations to all causes: £700,000
(2000)

Arts donations: About 6% of the total
grants of £700,000 were given to arts
based activities.

Grants are made via the Morgan
Stanley International Foundation to
charitable organisations in Tower Hamlets
and Newham. Grants are focused on
education and skills, health and hospitals
and social welfare. Arts grants, for
education purposes only, in recent
years have included:
Whitechapel Art Gallery;
Spitalfields Festival;
Age Exchange Theatre Trust;
Chisenshale Gallery;
Dance Junction Company;
Ragged Schools Museum.

Arts sponsorship: The total sponsorship
budget of £500,000 for 2000 was
allocated to the arts.

'There is a proactive policy in place
with clear aims and objectives.
Unsolicited proposals are therefore not
considered.'

Recent known projects include:
The Bach Choir;
Les Arts Florissants;
Hermitage Rooms, Somerset House;
National Gallery, Encounters: New Art
from Old exhibition.
Tate Modern for Surrealism exhibition.

National Express Group PLC

75 Davies Street, London W1K 5HT
Tel: 020 7529 2000; Fax: 020 7529 2135
Website: nationalexpressgroup.co.uk
Company type: Passenger transport
services in UK, USA, Australia
Contact: Nicola Marsden, Director of
Group Communications

General: 'The group operates a devolved
management system which means that its
subsidiary businesses have day to day
responsibilities for their operations. This
includes involvement with the
communities they serve. The group does
not consider it appropriate to control this
activity as we have a high number of
businesses spread throughout the UK.
Local community groups should contact
their nearest local National Express
Group business ... the head office selects
certain charities or sponsorships at the
time of setting its budget. In view of the
group's geographic coverage, it prefers to
select a national rather than local
initiative, although we will assess each on
their merits.'

The company is particularly interested
in proposals with is a 'transport angle'.

Charitable donations: £213,000
(2000)

Sponsorship: At head office arts
sponsorships are preferred to arts
donations. It targets national organisations
and national work touring to new or
regional venues and has no preferred
artforms. Examples of recent arts
sponsorships have not been provided.

At a local level 'a wide range of small
projects' were sponsored in 2000/01.

NatWest – part of the Royal Bank of Scotland Group

Nestlé UK Ltd

Community Relations Department,
Haxby Road, York YO91 1XY
Tel: 01904 602233; **Fax:** 01904 603461
Company type: Food manufacturers
Contact: Peter J Anderson, Community
Relations Manager
Sponsorship: As above
Membership: A&B; % Club; BitC

Donations to all causes: £1,038,000
(2000)

Arts sponsorship and arts donations are
administered alongside all other requests
and there is no stated preference for any
area of activity or type of support. No
particular artforms are preferred.

Charitable donations: Donations are
made via the company and The Nestlé
Charitable Trust in various fields which
relate to arts and culture, community
development, education, enterprise,
environment, health (medical), or young
peoples sport. Support is given to
properly managed activities of high
quality in their particular field. However,
a relevant link or connection with the
company's business is usually looked for,
this may be geographic (within the
catchment area of company factories,
there are 17 locations throughout the
UK), related to the food industry or
through connections with university
departments or employee activities.
Employees involved with local voluntary
groups may apply for a grant of up to
£1,500.

London Mozart Players and their
workshops with Kids Clubs Network
have been most successful in securing one
of the largest donations during recent
years.

Sponsorships: In recent years these have
included:
Glyndebourne Festival Society;
London Mozart Players;
York Early Music Festival;
York Millennium Mystery Play.

Other support: Gifts in kind.

Applications: Applications for support
of local good causes should be made to
the manager of the nearest Nestlé
location, but for large scale donations or
national charities the request should be
sent to Community Relations
Department.

Northern Foods plc

Beverley House, St Stephen's Square,
Hull HU1 3XG
Tel: 01482 325432; **Fax:** 01482 226136
Website: www.northern-foods.co.uk
Company type: Food manufacturer
Contact: Mrs Helen Bray, Social
Responsibility
Membership: A&B; % Club; BitC

Donations to all causes: £458,000
(2000/01)

Charitable donations: The company
has a strong operating presence in
Nottingham, Sheffield, Greater
Manchester, Batley and Lancashire. It
makes charitable donations of half of one
percent of pre-tax profits. These
donations are made primarily to
organisations local to its operating sites.

Within these local communities
Northern Foods will consider requests
which fall into one of the following
categories.

- **Help for Disadvantaged Groups**
Over half of donations are made under
this category, e.g. projects to help the
long-term unemployed to find jobs or
self-employment, enterprise agencies
for disadvantaged groups particularly
ethnic minorities, life skills training
projects for young people, project to
help disabled people into work, work
with ex-offenders.

- **Education projects** A smaller
percentage of donations are made to
projects based around education, e.g. to
address bullying, to help previously
identified local schools in particularly
deprived areas.

- **Arts projects** Limited support is given to participatory arts projects which are accessible to groups generally excluded from audiences, e.g. those in prisons, those from disadvantaged areas.

The company does not consider arts sponsorship.

Northern Rock plc – see Northern Rock Foundation in the Trusts Section

The foundation is run by an independent administration and board of trustees and has separate assets and source of income related to its formation.

Northumbrian Water

Abbey Road, Pity Me, Durham DH1 5FJ
Tel: 0191 383 2222
Website: www.nwl.co.uk
Company type: Water and sewage services in North East, Essex and Suffolk
Contact: John Mowbray, Head of Corporate Affairs
Membership: A&B

Donations to all causes: £70,000 (2000)

Charitable donations: The company is prepared to consider proposals relating to the arts, children/youth, education, enterprise/training, environment/heritage and sport. It particularly supports local charities in areas of company presences which includes Essex and Suffolk as well as the North East.

Arts sponsorship: The company has a preference for arts sponsorship rather than arts donations. Whilst no particular artform is preferred, it prefers to support organisations local to its work or national work touring to new or regional venues. Sponsorships in 2000/01 have included: Royal Shakespeare Company – Newcastle; Music Centre Gateshead and Young Sinfonia;

Skyspace at Kielder; Winter Gardens, Sunderland; Segedunum, Wallsend.

npower

Oak House, Bridgwater Road, Warndon, Worcester WR4 9FP
Tel: 01905 340628; **Fax:** 01905 340766
Website: www.npower.com
Company type: Electricity supply group including Midlands Electricity, Yorkshire and Northern Electricity and Gas
Contact: Rose Gardner, Sponsorship and Community Relations Manager

The npower group embraces Midlands Electricity, Yorkshire and Northern Electricity & Gas which have had their own community support and sponsorship policies.

'As a high profile national business npower receives many request for support and *we operate a series of high profile support projects*. We take a *proactive approach* by linking with a number of organisations to create a community programme that meets the needs of our customers, our business and the communities we serve.

'We also acknowledge and support the work that our employees do within the community in their spare time through the *npower Community Volunteer initiative*, and working with Community Service volunteers we offer staff opportunities to become volunteers.' (*Editor's italics.*)

Olympus Optical Co (UK) Ltd

2–8 Honduras Street, London EC1Y OTX
Tel: 020 7253 2772; **Fax:** 020 7250 4560
E-mail: joanna@olympus.co.uk
Website: www.olympus.co.uk
Company type: Optoelectronic equipment
Contact: Joanna Steeden, Marketing Communications Co-ordinator

Sponsorship: The company sponsors events (major photographic exhibitions) and individuals engaged in photography.

The company prefers sponsorship and does not appear to make charitable donations.

Orange ☆

50 George Street, London W1U 7DZ
Tel: 020 7984 2000; Fax: 020 7984 2001
Website: www.orange.co.uk
Company type: Wirefree telecommunications
Contact: Denise Lewis, Group Director of Corporate Affairs
Membership: A&B

Arts sponsorships and donations are administered together with a preference for sponsorship.

Arts sponsorship: 50% of the company's arts budget is allocated to the arts but no total figure was given. (In 1999 a total of £1,125,000 was allocated to arts sponsorship – 75% of the total sponsorship budget.)

'Orange sponsors three elements in the arts; literature, film and music. The properties it sponsors have "strong emotional appeal, reaching specific market segments and represent key brand attributes of innovation, style, integrity and value for money". The company sponsors national and local projects.'
Sponsorship in 2000/01 included:

- Orange Prize for Fiction, including literary festivals e.g. Hay, the Orange Word;
- Orange BAFTAs, including film festivals e.g. Edinburgh, Leeds, London Belfast and a short film award with Channel 4;
- Music – Reading, Leeds and Tea in the Park Festivals, Q Awards, Manumission, Student tour;
- regional arts/music events in areas where the company has employees.

P & G (formerly Procter and Gamble)

Cobalt 3, Silver Fox Way, Cobalt Business Park, Newcastle upon Tyne NE27 0QN
Tel: 0191 297 5000; Fax: 0191 297 6296
Website: www.pg.com
Company type: Manufacture and marketing of innovative consumer products
Contact: Tricia Dodds, Community Relations Manager, UK and Eire
Membership: A&B; BitC; % Club

Donations to all causes: £508,000 (2001)

Arts support: 'We like to help organisations using the key skills of our people and the strengths of our company. Monetary support is provided in addition when appropriate. The company particularly likes projects that are educational, help develop skills and deliver the arts to a wider audience.' Local organisations are targeted.

About 20% of the total community budget is allocated to leisure/social welfare which covers the arts. It says it does not undertake sponsorship 'in the commercial sense'.
Arts support in 2000/01 included:
Tyne & Wear Museums for Lindisfarne Gospels and Kings of the North Sea;
Laing Art Gallery – P & G Children's Gallery;
Tyneside Cinema;
Northern Stage;
Northern Sinfonia.

Charitable grants: It is understood the company only supports local charities and community groups in areas of company presence. There are 15 different sites throughout the UK. The Community Foundation for Tyne & Wear and Northumberland (see separate entry under Trusts) administers the P & G Fund for grants in its area of operation. (Contact the Community Foundation on 0191 222 0945.)

Panasonic UK Ltd

Panasonic House, Willoughby Road,
Bracknell, Herts RG12 8FP
Tel: 01344 862444; **Fax:** 01344 861656
Website: www.panasonic.co.uk
Company type: Electrical/electronic
goods
Contact: Gary Thomson, Personnel
Director

Donations to all causes: £224,000
(1999/2000)

Each office/site has its own budget to
support local charities in their area –
Bracknell and Northampton. It prefers to
donate equipment for either office use or
fundraising purposes wherever possible.
(The figure given above is the cost of
these gifts.)

Arts sponsorship: The company is a
long-term supporter of the Globe
Theatre, London and is not looking for
additional arts sponsorship opportunities.
 It is understood that unsolicited
proposals are not considered.

Pearson plc

80 Strand, London WC2R ORL
Tel: 020 7010 2000
Website: www.pearson.com
Company type: International media
group. Main subsidiaries Pearson
Education, Penguin Group, Financial
Times Group
Contact: Jo Ani, Projects Manager
Membership: BitC

Donations to all causes: £627,000
(2000) UK only

Pearson directs the majority of its giving
into the field of education, supporting
teachers where they are most needed.
Pearson's 'Teachers First' project was
launched in 2001 with a scheme inspiring
college graduates to become teachers in
the US. Similar projects will be developed
in other countries where Pearson has a
presence. Operating companies respond

to local causes with cash and in kind
donations.
 'We continue to fund our established
arts projects. The Pearson Gallery of
Living Words was opened at the British
Library in 1998 and aims to bring the
Library's collection alive to a wider
audience.'
 In addition, since the early 1990s,
Pearson has run a Playwrights' Scheme,
offering bursaries to writers working in
the theatre and awards to the authors of
plays that are staged.
 Founding corporate member of Tate
Modern.

Peugeot Motor Company PLC

PO Box 227, Aldemoor House,
Aldermoor Lane, Coventry CV3 1LT
Tel: 024 7688 4000; **Fax:** 024 7688 4001
Website: www.peugeot.com
Company type: Motor vehicle
manufacture
Contact: Steve Harris, Manager of
Sponsorships
Membership: A&B

Arts sponsorship and donations are
handled separately with a prefernece for
sponsorship.

Arts sponsorship: Whilst the major part
of the company's sponsorship is directed
at sporting activities, it has also developed
sponsorship arrangements with a number
of arts organisations and events. About
20% of its sponsorship budget is allocated
to arts which must 'offer commercial
benefits to Peugeot, its dealers or
customers'. There is a preference for
locally based initiatives but not for any
particular artform. Those known to have
been supported include:
Symphony Hall, Birmingham (founder
partners);
Warwick Arts Centre (founder partners);
Peugeot Design Awards, in association
with South Bank Management (Oxo).

Charitable donations: The company is
committed to the community of Coventry

and neighbouring Warwickshire. Applications should be directed to Polly Dickerson, secretary of the charitable trust.

Pfizer Group Ltd

Ramsgate Road, Sandwich, Kent CT13 9NJ
Tel: 01304 616161; **Fax:** 01304 616221
Company type: Worldwide research-based group including healthcare, animal health, speciality chemicals, materials science and consumer products companies
Contact: Polly Dryden, Strategic Partnerships Manager

Donations to all causes: £200,000 (2000)

The group is interested in national charities and those local to the four Pfizer regional offices in Birmingham, Manchester, Watford, Edinburgh and the new HQ in Surrey (starting December 2001).

Charitable donations: The arts are included amongst the activities the group may be prepared to support along with children/youth, education, medical research, science/technology and animal welfare.

Arts sponsorship: Proposals for national or local sponsorship should be made in writing as indicated above, and should include details of other companies being targeted.

Applications: Polly Dryden, the Strategic Partnership Manager, is responsible for national donations and arts sponsorships. She is based at 63–65 Petty France, London SW1H 9EU, Tel: 020 7654 1700; Fax: 020 7654 1708

Local donations and sponsorships in East Kent are administered by Anne Denby, based within the Kent head office.

Requests to regional offices should be directed to Polly Dryden in the first instance.

PizzaExpress

Union Business Park, Florence Way, Uxbridge UB8 2LS
Tel: 01895 618 695; **Fax:** 01895 618614
Contact: Rob Montgomery, Public Relations

Arts donations: about £121,000 for 2001 through 25p donations from the public.

The company is famous for its long-standing support (since 1975) of the Venice in Peril Fund through its sales of its Veneziana pizza. More than £1 million has been collected on behalf of its customers to help charities working to restore and reserve Venice's monuments, sculptures and buildings. Now, through its Veneziana Trust, support is also given to conservation projects in the UK. An example is:
Ely Cathedral, for Stained Glass Museum's 25th anniversary appeal (£10,000).

Art sponsorship: £50,000 budget a year specifically for its **Prospects** contemporary art prize which was launched in 1999 to encourage emerging artists and make art more accessible. Within two years more than 1,700 artists had entered the nationwide competition. The link with art comes from PizzaExpress's policy of buying original art to display on its restaurant walls.

Prospects is a national contemporary drawing prize in which the overall winner receives a cash prize of £10,000 and short-listed artists earn themselves exhibitions. In 2001 exhibitions were held in PizzaExpress restaurants between April and July with a September exhibition at the Britart Gallery, London. This sponsorship is expected to be an ongoing investment – the company plans 'to continue the art prize for the foreseeable future'.

Deadline: 28 February 2002.

Prudential Corporation plc

Laurence Pountney Hill, London
EC4R OHH
Tel: 020 7548 6184; **Fax:** 020 7548 6140
Website: www.prudential.co.uk
Company type: Life assurance, general
insurance, financial services
Contact: Liza Vizard, Head of
Community Affairs
Sponsorship: As above
Membership: BitC

Donations to all causes: £2,000,000
(2000)

'We believe that everyone should be
given the opportunity to enjoy access to
the arts and take pride in out cultural
heritage.

'As a founding corporate partner of
Tate, we are proud to have contributed
towards the building of Tate Modern and
the redevelopment of Tate Britain.
During 2000, we also sponsored 'The Art
of Bloomsbury' at Tate Britain, a new
look at the paintings of the Bloomsbury
Group.

'2000 was the final year of our
sponsorship of Creative Britons, the UK's
biggest arts prize, with £200,000 going
to arts organisations to recognise
outstanding work of arts practitioners.

'During 2001 we sponsored the Stanley
Spencer exhibition at Tate Britain. In Asia
we sponsored the Children's Theatre
Festival in Singapore. This annual event
attracts quality theatre companies from
around the world including Britain, Japan,
Canada and Australia.

'We are corporate members of:
Glyndebourne; Royal Opera House.'

Other support: Art purchase.

Reuters

85 Fleet Street, London EC4P 4AJ
Tel: 020 7250 1122
E-mail: foundation@reuters.com
Website: www.foundation.reuters.com
Company type: International news
organisation publishing general,
economic and financial news, providing
a news retrieval service
Contact: The Director of the Reuters
Foundation
Beneficial area: UK and overseas

Donations to all causes: £2,907,000
(1999)

The Reuters Foundation is the group's
charitable trust set up in 1982. It supports
'the advancement of education,
particularly in the field of journalism,
with a special reference to the developing
world, other areas of education and
humanitarian causes'. Its categories of
giving are as follows: journalism;
education other; community; medical and
healthcare; AlertNet (IT programme);
environment; arts.

Although only a small percentage of
total support goes to arts-related causes,
the foundation's level of funding is such
that this still represents a substantial
commitment.

In 1999 the foundation gave a total of
£2,907,000 in grants of up to £135,000,
most of which were between £7,500 and
£75,000. Only the 50 largest donations,
which were all greater than £7,500, were
specified in the annual report. Arts-related
funding totalled £92,494 (3% of total
grant-aid) and included the following:
Royal National Theatre (£25,000);
International Shakespeare Globe Theatre
(£10,000);
St Bride's Choir (£7,500).

Applications: Applications must be
supported by a member of Reuters staff.
**Unsolicited appeals are not
considered**.

Rio Tinto plc

6 St James's Square, London
SW1Y 4LD
Tel: 020 7930 2399; **Fax:** 020 7930 3249
Company type: Mining
Contact: Sarah Kesby, Corporate
Relations Adviser
Membership: BitC; % Club

Donations to all causes: £995,000
(2000)

The company adopted a new policy for
community engagement in the UK in
1999. Some extracts follow: 'The
programmes we support at the corporate
level ... concentrate on issues which
reflect the global nature of the mining
industry, and where our business gives us
particular responsibilities or enables us to
make a distinctive contribution. Examples
include biodiversity; the responsible use
of resources such as water; promoting
respect for human rights; and education
...We have a small community fund to
support not-for-profit organisations, and
will look most positively at proposals
which offer scope for involving our small
pool of UK-based employees.'

Prior to the adoption of this new
policy, the company had a considerable
programme of arts support, the focus of
which had been its programme with five
major arts training organisations
(Guildhall School of Music and Drama,
London Contemporary Dance School,
RADA, Royal College of Art, Royal
Academy Schools) of scholarships and
bursaries for outstanding students who
might otherwise be unable to complete
their training. Further funding has also
been provided for an annual Rio Tinto
Arts Season to showcase the talent. In
1998 this received the ABSA Award for
Strategic Sponsorship. This support for
scholarship and bursaries continued for
the academic year 2001/02 but then
ceased, with the exception of support to
the London Contemporary Dance
School.

Other arts related programmes are most
unlikely to be adopted in the future.

Rolls-Royce plc

65 Buckingham Gate, London
SW1E 6AT
Tel: 020 7222 9020
Website: www.rolls-royce.com
Company type: A global company
providing power on land, sea and air
Contact: C E Blundell, Company
Secretary
Sponsorship: Richard Turner, Group
Marketing Director
Membership: A&B; BitC

Donations to all causes: £371,000
(2000)

Charitable donations: The company's
policy on donations is to direct its
support primarily towards assisting
associations and charities with
engineering, scientific or educational
objectives, as well as objectives connected
with the group's business and place in the
wider community. National charities with
a connection to the company's business
are supported at head office level. Local
charities are supported by regional site
committees at Ansty, Bristol, Derby,
Newcastle and Glasgow, which have
independent budgets administered by
local site committees.

Arts sponsorship: This is undertaken via
the Corporate Sponsorship Committee.
Sponsorships are arranged with both
national and local organisations, with an
interest in performances by national
organisations local to the company's sites.
Arts sponsorships in 2000/01 have
included:
Goldberg Orchestra;
Viva (formerly East of England
Orchestra);
Tate Modern.

Other support: Gifts in kind may be
arranged.

N M Rothschild & Sons Ltd

New Court, St Swithin's Lane, London
EC4P 4DU
Tel: 020 7280 5000
Website: www.nmrothschild.com
Company type: Merchant banking
Contact: Secretary to the Charities
Committee
Membership: A&B

Donations to all causes: £396,000
(2000/01)

Charitable donations: Whilst social
welfare is the main area of support, grants
are given widely and include the arts.
National organisations are supported but
there is no preference for any particular
artform. Donations are not made to local
groups.

Royal Bank of Scotland Group plc

36 St Andrew Square, Edinburgh
EH2 2YB
Tel: 0131 523 4577; **Fax:** 0131 523 0131
E-mail: bellanj@rbos.co.uk
Website: www.rbs.co.uk
Company type: Banking
Contact: Jim Bellany, Head of
Sponsorship
Membership: A&B; BitC

Donations to all causes: £5,500,000
(2000)

Sponsorship policy:
- The bank should have the potential to
generate favourable public interest
which should include clear and definite
reference to the bank as sponsors.
- Ideally the event should be of broad
general interest and there should be
identifiable benefit to the bank. For
example, the event might relate to a
type of business or section of the
community with which the bank
wishes to be identified for business
development purposes.
- Sponsorship of youth activities is of
particular interest.
- Sponsorship which would attract
adverse criticism is generally avoided.
- In general the bank is not keen on
sharing events as this tends to detract
from the public relations value of the
involvement.
- Sponsorship proposals from
organisations which should be self
supporting are not encouraged.
- The bank does not wish to become
involved in a sponsorship context with
charitable fund-raising events.

Its primary arts sponsorship objectives are:
to increase name awareness with the key
market of ABC1s etc.; to promote a
professional and quality image of the
bank; to support data-base generation; to
provide business entertainment
opportunities for existing and potential
customers. The bank has sponsored most
areas of the arts and is particularly
attracted to events which have the
potential of touring throughout Great
Britain with a particular focus on the
main Scottish cities, Manchester, the
North West region, South Yorkshire, West
and East Midlands, and the South East.

The bank targets national organisations
though no particular artform is preferred.
Sponsorships and corporate memberships
in 2000 included:
BBC Scottish Symphony Orchestra;
Edinburgh Festival Theatre Trust;
English National Opera;
Friends of RSA Awards;
Hallé Orchestra;
Manchester City Art Galleries;
National Art Collections Fund;
National Galleries of Scotland;
National Youth Theatre of Scotland;
Royal Academy of Arts;
Royal Albert Hall;
Royal Lyceum Theatre;
Royal National Theatre;
Royal Scottish National Orchestra;
Scottish Ballet;
Scottish Chamber Orchestra;
Scottish Opera;
Shakespeare's Globe Theatre.

All sponsorship proposals must meet the criteria given above.

Employee support: Business skills offered via Arts & Business. Through the Group's Community Cashback Awards staff can apply for a cash award for local groups with which they are actively involved. Employee fundraising is matched up to a maximum of £500.

Charitable donations: The bank now links its charitable support clearly to its own business interests with a focus in three areas: finance and education; finance and social exclusion; finance and economic development.

Other support: Extensive art collection on display in bank offices.

Royal & Sun Alliance Insurance Group plc

UK Marketing Services Unit, PO Box 144, New Hall Place, Old Hall Street, Liverpool L69 3EN
Tel: 0151 227 4422; **Fax:** 0151 224 3787
E-mail: john.hymers@uk.royalsun.com
Website: www.royalsunalliance.co.uk
Company type: Worldwide insurance and related services
Contact: John Hymers, Marketing Services Manager
Membership: A&B; BitC

Donations to all causes: £800,000 (2000)

Sponsorships and donations are administered together.

'Our community sponsorship policy aims to help young adults through programmes of education and training, health, and environmental awareness/improvement.

'Our commercial sponsorship policy aims to raise the awareness of our brand and its values in our chosen markets.'

It supports the community, its employees, and the areas of company presence – London, Horsham, Leeds,

Birmingham, Manchester, Liverpool, Glasgow and Belfast. It prioritises: education and training; safer communities; health and safety. However other areas which may also be supported include the arts, children and youth, and disability.

Regional Staff Committees ensure closer involvement in areas of company presence. Employee support includes assignment and secondment opportunities.

Arts sponsorship: £60,000 budget in 2001 (10% of total sponsorship budget of £600,000)

National organisations are targeted with no stated preference for any artform. Sponsorships included:
Royal Liverpool Philharmonic Society;
Royal Opera House Trust;
Glyndebourne Festival Opera;
Live Music Now!;
Theatre ADAD.

Arts donations: £40,000 (5% of total donations budget of £800,000 for 2001)

Both national and local organisations may be supported with no stated preference for any artform. No detailed information has been provided from the company about its arts donations.

J Sainsbury plc

33 Holborn, London EC1N 2HT
Tel/Fax: 020 7695 8181
Website: www.j-sainsbury.co.uk/partnerships
Company type: Retail food distribution
Contact: Sophie Balch, Arts sponsorship
Membership: A&B; % Club; BitC

At Sainsbury the arts budget is handled separately from the charitable budget.

Art to You Award was created to help regional museums and galleries mount major art exhibitions. In autumn 2001 Norwich Castle Museum & Art Gallery and the Millennium Galleries, Sheffield were awarded £150,000 (the largest arts

sponsorship award to a regional gallery from a single company) for the Norwich and Sheffield FlowerPower exhibition to run in both cities in 2003. This is a pilot. It is planned to be a biennial event, depending on the success of the first exhibition.

Arts sponsorship: A third of the sponsorship budget of £2.4 million in 2000 was allocated to the arts (£700,000).

'Our mission is to build inspiring and distinctive partnerships which support the business and the wider community. Our programme operates on both a national and local level, and key features are as follows:

- Sainsbury's Pictures for Schools – giving sets of framed pictures and teachers' packs (including a BBC Education video) to schools around the country.
- Sainsbury's Checkout Theatre – announced in early 1999, worth £500,000 (with an additional £100,000 from ACE's New Audiences Fund) will run for three years and encourage and promote new theatre work for young people aged 10-14 and their families. It has enabled the commissioning of new writing and productions, encouraged Sunday performances and offered participating theatres marketing opportunities in neighbouring Sainsbury's stores. A total of seven productions has been sponsored over three years, with the last production taking place in spring 2002.
- Sainsbury's Choir of the Year – biennial amateur choral competition, televised on BBC. A new, revised competition with more youth categories started iin 2002.
- Sainsbury's Local Arts Programmes – a host of arts projects are supported around the country, in or close to areas where the company trades. Recent local sponsorships have included: Aberdeen Alternative Festival;

Fenland Colourscape Festival;
Fly Monkey, Hackney Empire, production of 'The Wig';
Little Bull Membership Scheme, Barnet Arts Centre;
Shopping Baskets – Literacy Project, East Ham;
Travelling by Tuba;
Urban Dance Theatre;
Woking Dance Festival;
Yorkshire Youth and Music.'

Corporate Memberships: Tate and Royal Opera House.

Employee support: 'The company aims to engage colleagues in all areas of the programme, creating opportunities for them to support their local community and/or become directly involved in the arts. Equally colleagues are instrumental in raising awareness of local sponsorships in their store, whether through arranging display material or through more active means, such as co-ordinating arts performances in the foyer. Store colleagues are encouraged to approach the sponsorship department with arts proposals, which we try to support if appropriate.'

Applications: All sponsorship, and other arts proposals, should be made to the Arts Sponsorship Department.

Scapa Group plc

Oakfield House, 93 Preston New Road, Blackburn, Lancashire BB2 6AY
Tel: 01254 580123; **Fax:** 01254 662360
E-mail: celia.treasure@scapa.com
Website: www.scapa.com
Company type: Manufacture and supply of technical tapes and cable products
Contact: Ms Celia Treasure, Secretary to the Chief Executive

Donations to all causes: £40,000 (2000/01)

The group has introduced the Scapa Creative Arts Performance Award to assist young people from local communities in

the North West to develop their artistic skills and talents to the full.

Arts sponsorships and arts donations are administered together.

The company has not outlined a specific arts sponsorship policy but has stated 'any major art from is considered i.e. drama, painting, dance, music, etc'.

Grants are given mainly to organisations with a local (Blackburn and the North West England), company or personnel connection. Preference for children and youth, medical research, the environment/heritage, the arts and arts education. Grants to national organisations range between £50 to £500, grants to local organisations between £50 to £5,000.

Schroders plc

31 Gresham Street, London EC2V 7QA
Tel: 020 7658 6000; Fax: 020 7658 2246
E-mail: caroline.davis@schroders.com
Website: www.schroders.com
Company type: International asset management group holding company, organised in three main operating divisions world-wide: Institutional; Retail/Unit Trusts; Private Banking
Contact: Caroline Davis, Charity Co-ordinator
Sponsorship: As above
Membership: BitC; LBG; % Club

Donations to all causes: £727,000 in UK (2000)

Charitable donations: The company has indicated it is prepared to consider support to a very wide range of charitable causes with preference to local charities. 'Donations to match staff giving are the first priority for the company. The second priority is to support charities in the communities in which we operate.'
Arts donations in 2000 included:
British Museum;
Tate Modern.

Arts sponsorship: 'We sponsor the arts in order to make use of a production/exhibition venue for entertaining our clients.'

Both national and local organisations may be targeted. Recent sponsorships have included:
English National Ballet's London performances of 'Swan Lake';
The Royal Collection's catalogue of their fan collection;
A Pavilion Opera performance of 'Rigoletto';
One night's performance of Opera North's production of 'La Boheme'.

Applications: In writing to the correspondent. Grant decisions are made by a committee, which meets quarterly.

Scottish Courage – see Scottish & Newcastle

Arts sponsorship example: Scottish Courage Ltd and Northern Lights

Newcastle Brown Ale is well known for supporting Newcastle United and also comedy but has avoided links with art that could be labelled 'elitist' in any way. However, art aimed at the ordinary person on the street fits perfectly with the brand's aspirations and in February 1996 the company was approached by local photographer Keith Pattison to sponsor a unique street level exhibition about the pride and passion of football supporters. He used poster sites in Newcastle and the North East as a highly visible public photographic gallery. The sponsorship was arranged through Northern Lights for Visual Arts UK (the 1996 Festival of Visual Arts in the North East). Ten photographs of football fans were blown up to 6 sheet poster size and displayed on Adshell sites throughout Newcastle and the region.

Scottish & Newcastle plc

33 Ellersly Road, Edinburgh EH12
Tel: 0131 528 2000; **Fax:** 0870 333 2121
Website: www.scottish-newcastle.com
Company type: Brewing and retail
Contact: Linda Bain, Corporate Affairs
Manager (at address above)
Sponsorship: Tony McGrath, Marketing
Director, Scottish Courage
Membership: A&B; BitC

Donations to all causes: £524,000
(2000/01)

Sponsorship: The company welcomes
sponsorship proposals. As appropriate (see
below also) proposals should be made to
Tony McGrath, Marketing Director,
Scottish Courage, Fountain House, 160
Dundee Street, Edinburgh EH11 1DQ,
Tel: 0131 656 5000

- Corporate sponsorship is undertaken
 by Scottish & Newcastle plc. It is a
 long-term sponsor of the Edinburgh
 International Festival.
- Individual brands undertake their own
 sponsorship (eg. Beck's Biers).
- Regional breweries undertake their
 own sponsorship (eg. Newcastle
 Breweries).

Beck's Biers
Contact: Jo Nola, Marketing Manager,
Scottish Courage Ltd, Fountain House,
160 Dundee Street, Edinburgh EH11
1DQ Tel: 0131 656 5000
Beck's Futures 2, comprising awards
and exhibitions, was the central
sponsorship in 2001. (2002 will be Beck's
Futures 3.) This major prize fund totalling
£64,000 celebrates talented artists at an
early stage in their career who are
nominated by their galleries. Ten are
shortlisted for an exhibition which in
2001 was held at the ICA, The
Fruitmarket and Sotheby's New York (the
first time the exhibition has travelled
internationally). A subdivision of the
prize fund is for a student film prize for
which application forms are on the
following website: www.becks.co.uk

Newcastle Breweries Ltd
Sponsorship contact: Paul Allonby, PR
Manager, Newcastle Breweries Ltd, Tyne
Brewery, Gallowgate, Newcastle NE99
1RA, Tel: 0191 232 5091
Events within the area of North
Yorkshire and the North East are
preferred. Sponsorships have included:
Theatre Royal, Newcastle;
Tyne Theatre and Opera House.

Charitable donations: The group gives
preference to the arts and culture, social
welfare, community services, health/
medicine, conservation/environment,
education, science and enterprise. Grants
to national organisations range from £50
to £1,000 (occasionally as high as
£50,000) and grants to local
organisations from £50 to £5,000
(occasionally as high as £10,000).
Contact Linda Bain, Corporate Affairs
Manager, at the Head Office, see address
above. A donations committee meets
quarterly. A Community Report was
published in 2001.
Written local appeals should be
directed to the regional office.

SEEBOARD plc

PO Box 639, 329 Portland Road, Hove,
East Sussex BN3 5SY
Tel: 01273 428612; **Fax:** 01273 428645
Website: www.seeboard.co.uk
Company type: Electricity and gas
supply
Contact: Zara Watkins, Community
Sponsorship Executive

Arts sponsorship: SEEBOARD
sponsorship is confined within its licensed
areas: Kent, Sussex, Surrey and South
London. The arts programme includes
support local arts festivals and small local
projects with no preference for a
particular artform. Donations are not
considered.
Arts sponsorships in 2000/01 included:
Brighton Festival;
Crawley Festival;

Arundel Festival;
Youth Drama Festival in conjunction
with Surrey County Council.

All proposals must be made in writing.

Applications: Most awards are under
£5,000. SEEBOARD makes a few major
sponsorship awards – worth between
£5,000 and £20,000 each – in each
financial year. Applications for these must
be made before the end of the previous
December. In most cases these run for
one year only, but longer programmes
may be considered with an annual review.

Smaller awards are made on a rolling
programme. These range from donations
of small gifts for fundraising events,
through donations of electrical appliances
to financial support of up to £5,000. To
apply please write, giving brief details of
your organisation and your request to the
correspondent.

The correspondent stated:
'SEEBOARD makes every effort to reply
to all appeals. We do, however, receive a
large number of applications and can
support only a small proportion of them.'

Telephone and faxed applications
cannot be considered.

Selfridges & Co

400 Oxford Street, London W1A 1AB
Tel: 020 7629 1234; **Fax:** 020 7409 3168
Contact: James Bidwell, Marketing
Director

Arts sponsorship: The company prefers
sponsorship to donations and is interested
in the contemporary arts. It is prepared to
consider both national and local
organisations. It has sponsored a number
of key cultural organisations recently.
These include:
Tokyo Life cultural event, incorporating a
programme of Japanese contemporary
visual and performance arts;
Serpentine Gallery;
Selfridges Studio at the Royal Exchange
Theatre Company, Manchester;
London Film Festival.

An inspirational project in 2001 was the
vast Sam Taylor Wood full colour
photograph wrapped around the store
facade.

Applications: It is understood that
unsolicited proposals are not considered.

Shell UK Ltd

[handwritten: ✗ Don't accept unsolicited proposals]

Shell Centre, York Road, London
SE1 7NA
Tel: 020 7934 3199; **Fax:** 020 7934 7039
E-mail: susan.saloom@shell.com
Website: www.shell.com
Company type: Oil industry
Contact: Susan Saloom, Manager UK
Social Investment
Membership: A&B; BitC

Donations to all causes: £797,000
(2000)

Arts sponsorships and donations are
handled together.

Arts sponsorship: Shell UK's support of
the arts at corporate level has been
confined to its long standing partnership
with the London Symphony Orchestra,
centred around the annual Shell LSO
Music Scholarship for young
instrumentalists. This sponsorship was in
its final year in 2001. Its sponsorship will
continue with another organisation in
2002.

Support for the arts at regional level is
on a small scale and confined to local
partnerships with arts organisations in
areas of the company's main sites e.g.
Aberdeen, North West England,
Lowestoft, Southwark and Lambeth.

Sponsorships will be carried out by
other related parts of the Shell group of
companies in the UK. For example *Shell
UK Expro (Shell Exploration and
Production)*, based in Aberdeen, sponsored
the following organisations in 2001:
Aberdeen International Youth Festival
(winner of the Arts & Business Scottish
Award for 'Festival Sponsorship');
Scottish Opera;

Scottish Chamber Orchestra;
Aberdeen Opera Company;
Aberdeen Artists Society Exhibition;
Kaleidoscope, a theatre festival for
children at Haddo House;
Woodend Barn Arts Centre, Banchory for
traditional music concert.

Shell Expro's support of 'Friday Live' at
the Lemon Tree in Aberdeen is featured
as a case study in the Arts & Business
2001 publication, *Creative Connections –
business and the arts working together to create
a more inclusive society.*

Charitable donations: The arts are
included as activities which may be
considered for support along with
environment/heritage, children/youth,
education, enterprise/training, medical
research, science/technology. Donations
are made via the Shell Foundation
CC No 1080999, Website: www.shell
foundation.org

SIX CONTINENTS PLC

20 North Audley Street, London
W1K 6WN
Tel: 020 7409 1919; Fax: 020 7409 8512
E-mail: community@sixcontinents.com
Website: www.sixcontinents.com
Company type: Global hospitality in
hotels, restaurants and pubs
Contact: Walter J Barratt, Charities
Administrator
Membership: BitC; % Club

Donations to all causes: £1,100,000
(1999/2000)

Much of the community support is
undertaken by the individual companies.
Many run community award schemes
intended to benefit community initiatives
in their particular geographical areas.

Charitable donations are preferred to
sponsorship. Policy guidelines are
available from the Charitable Donations
Committee (contact Walter Barratt or via
the website – see above). The main
funding effort is directed to four broad

areas – community, youth and education,
environment and the arts.

Arts donations: The arts absorbed 27%
of the donations total of £1.1 million in
1999/2000, along with community, youth
and education and the environment. Its
arts policy aims:

- 'to provide patronage for all visual and
 performing arts, with consideration also
 for museums, and to support the
 encouragement of public awareness of
 cultural activity by young people;
- to assist the progress and careers of
 young artists within the community.'

Its arts donations are targeted at national
organisations particularly those 'associated
with education, with the development of
young talent, and with the spread of
awareness of the arts to disabled or
disadvantaged groups and the elderly and
sick'.

A major donation was made in 2000 to
the City of Birmingham Symphony
Orchestra (£15,000).

Donations in 2000/01 included:
Royal Academy of Dramatic Art
(£5,000);
Royal Academy of Music, Foundation for
Young Musicians, Live Music Now!
(£3,000 each);
Guildhall School of Music & Drama
(£2,500);
Music in Hospitals, National Youth
Orchestra (£2,000 each);
National Youth Jazz Orchestra (£1,500);
Bristol Youth Opera, Young Vic theatre,
Children's Film Unit (£1,000 each).

A major arts donation in 2000 was made
to the City of Birmingham Symphony
Orchestra (£15,000).

Applications: Grants at head office are
decided by a donations committee which
meets quarterly. Applications, with up-to-
date audited accounts, should be
addressed to Walter J Barratt, Charities
Administrator.

All subsidiaries have authority to
support charities, while some collect and

distribute money for charity. Local appeals should be directed to the appropriate regional office

Other contacts:
Six Continents Retail Ltd, Cape Hill Brewery, PO Box 27, Birmingham B16 0PQ. Contact: R J Cartwright, Director of Communications.
Six Continents Hotels, Three Ravinia Drive, Suite 2900, Atlanta, Georgia, 30346-2149, USA. Contact: Melanie Brandman, Vice President of Corporate Affairs.

Slough Estates

234 Bath Road, Slough, Berks Sl1 4EE
Tel: 01753 537171; Fax: 01753 820585
Website: www.sloughestates.com
Company type: Industrial and commercial property development
Contact: Air Commodore N Hamilton, Manager External Affairs
Membership: BitC; % Club

Donations to all causes: £272,000 (2000)

Charitable donations: The company gives to a wide range of causes and including the arts. Both national and local organisations may be supported. There is a preference for projects in areas of company presence. In 2000/01, 4% (£12,000) of the total donations budget was allocated to arts organisations. These were:
City of London Festival (£3,525);
National Art Collections Fund (£2,500);
Slough Arts Alive (£2,500);
Slough Arts Festival (£1,000);
Windsor Festival (£1,000).

Arts sponsorship: There is no specific policy and no particular artforms.
 This is undertaken at a national level. Music and art are its main areas of sponsorship, including the annual National Art Collections Fund awards.

Sony United Kingdom Ltd

The Heights, Brooklands, Weybridge, Surrey KT13 0XW
Tel: 01932 816000; Fax: 01932 817000
Website: www.sony.co.uk
Company type: Manufacture and distribution of electronic goods
Contact: Rosemary Small, Public Affairs Department, Tel: 01932 816701
Membership: % Club; BitC

Donations to all causes: £120,000 (2000/01)

Arts sponsorships and arts donations are administered together, with no stated preference between either form of support. It sponsors arts organisations close to its business as well as those which have a link with company activities. Its arts donations favour organisations local to company facilities (Weybridge, Thatcham, Basingstoke and South Wales).
 Arts support in 2000/01 included:
Sony Radio Awards;
Design Museum;
Royal Society for the Encouragement of Arts;
Royal Opera House Trust;
Southern Sinfonia;
Brooklands Museum;
Elmbridge Arts Festival;
Elmbridge Drama Festival;
Newbury Spring Festival;
Oakshott and Cobham Music Society;
Walton & Weybridge Amateur Operatic Society;
Woking Concert Society.

These organisations also received support in 1998/99 so it appears that there could be little leeway for other organisations to develop new relationships (*Editor's comment*).

Standard Life Assurance Company

6th floor west, Standard Life House, 30 Lothian Road, Edinburgh EH1 2DH
Tel: 0131 225 2552; Fax: 0131 220 1534
Website: www.standardlife.com
Company type: Life assurance, pernsions, health insurance, investment management and banking
Contact: Fiona Fowler, Sponsorship manager
Membership: A&B; Scottish BitC

The company's head office is in Edinburgh where it is a large employer.

The company says it undertakes arts sponsorship but gives no arts donations.

Arts sponsorship: This is targeted at national organisations and used to raise name awareness and provide corporate hospitality for business contacts, customers and employees. No specific artform is preferred. Sponsorships in 2001 were:
Edinburgh International Festival;
Edinburgh International Film Festival;
Royal Military Tatoo.

TelewestBroadband

160 Great Portland Street, London W1N 5TB
Tel: 020 7299 5000; Fax: 020 7299 5494
E-mail: sally_bleddyn@flextech.co.uk
Website: www.telewest.co.uk
Company type: Broadband communications and media group
Contact: Sally Bleddyn, Head of Corporate Communications,
Tel: 020 7299 5390

This broadband communications and media group includes: Eurobell; Yorkshire Cable; Birmingham Cable; Cable London; Communications; General Cable; Flextech; Minotaur.

The company was undergoing a review of its corporate sponsorship strategy at the time of editing, so no up-to-date details could be supplied.

Contact for support by channels to independents: Jackie Skinner, Head of Talent and Programme Liaison (direct line: 020 7299 5355).

Toyota Motor Manufacturing (UK) Ltd

Burnaston, Derbyshire DE1 9TA
Tel: 01332 282121; Fax: 01332 282801
Company type: Car and engine manufacture
Contact: Sue Shakespeare, Planning and Communications
Membership: BitC; % Club

Arts sponsorships and arts donations are administered together with no stated preference for either form of support or type of artform. All requests are handled on a case by case basis and are evaluated against criteria such as the number of people to benefit, educational impact, longevity, etc.

Toyota contributes to the communities around the Burnaston and Deeside plants, together with national initiatives. The company has made contributions to its local arts centres – Derby Playhouse, Burton Brewhouse, Theatr Clwyd.

In 1999 the company launched a four-year national safety education programme in schools which using Theatre in Education.

U B S Warburg

100 Liverpool Street, London EC2M 2RH
Tel: 020 7567 8000; Fax: 020 7568 4800
Website: www.ubswarburg.com
Company type: Investment banking, securities and wealth management
Contact: Anne Drew, Global Head of Sponsorship, Communications and Marketing

Sponsorship: Its strategy 'centres on cultural and sporting events with an international perspective, to maximise the benefits of its investment. UBS Warburg concentrates its resources on a careful

selection of initiatives, each of which has the potential for long-term growth. Established areas of investment include the contemporary arts, golf and sailing.'

The company is a founding corporate partner of the Tate.

Unisys Ltd

Bakers Court, Bakers Road, Uxbridge
UB8 1RG
Tel: 01895 237137I
Website: www.unisys.com
Company type: Information technology systems and related services and supplies
Contact: Ian Ryder, Vice President, Corporate Communications

Charitable donations: The company supports both national and local charities with a particular interest in those near Uxbridge and Milton Keynes, the main company locations.

Arts sponsorship: It is understood that the company has a limited budget for this. It has no stated policy but makes its decisions based on individual cases. Its position is very open: no particular artforms are preferred and both national and local arts proposals are considered.

Other support: Gifts in kind; employee fundraising is matched up to a maximum of £500.

Waterford Wedgwood UK plc

Barlaston, Stoke-on-Trent, Staffordshire
ST12 9ES
Tel: 01782 282516; Fax: 01782 374108
Website: www.wedgwood.com
Company type: Manufacture of fine bone china and earthenware
Contact: Andrew Stanistreet, External Communications Manager
Sponsorship: As above

Donations to all causes: £177,000 (2000)

Arts sponsorship: The company has indicated it undertakes this and that it prefers sponsorship to donations.

Charitable donations: The company supports both national charities, and local charities in the Staffordshire area. The New Victoria Theatre has been a beneficiary.

Gifts in kind may be given to local charities.

Western Mail & Echo Ltd

Thomson House, Havelock Street,
Cardiff CF10 1XR
Tel: 029 2058 3583; Fax: 029 2058 3476
Company type: Newspaper publishing
Contact: Tracy Marsh, Promotions Manager

Arts sponsorship: Strategy varies between the newspapers within the company. It is understood that art and music are supported. Recent sponsorships have included:
Urdd Eisteddfod;
Brecon Jazz;
Welsh National Opera;
National Youth Arts Wales;
Cardiff Festival.

The sponsorships involve a publicity package rather than finance. There are no plans to extend the arts/music sponsorship for 2002.

Woolwich plc – see Barclays Plc

Website: www.thewoolwich.co.uk
Company type: Financial services and products

Woolwich was acquired by Barclays in late 2000. All approaches for support of any kind are now dealt with by Barclays community affairs programme and its regional managers.

WPP Group plc

27 Farm Street, London WIJ 5RJ
Tel: 020 7408 2204; **Fax:** 020 7493 6819
E-mail: fmcewan@wpp.com
Website: www.wpp.com
Company type: Communications
services worldwide. Subsidiaries
include: Ogilvy & Mather; J Walter
Thompson; Young & Rubican;
mindshare
Contact: Feona McEwan,
Communications Director
Membership: A&B Creative Forum

Donations to all causes: £200,000
approximately (2001)

'WPP plc is the lean parent company for
over 60 group companies which
specialise in communication services. Our
companies have their own links with arts
organisations which they handle directly.'

The company says its has no formal
policy for arts support and no preference
between sponsorship and donations or for
a particular artform.

Unfortunately the company has only
updated its information about its
personnel and has not given more current
information about its sponsorship or
donations to arts activities. In 1999 it
sponsored the building of a Media Arts
Centre at Charles Edward Brooke Girls
School, Lambeth and was a corporate
member of the Royal National Theatre
and the National Portrait Gallery.

Support is also provided by the
operating companies particularly the
advertising agencies:
J Walter Thompson, 40 Berkeley Square,
London W1X 6RD, Tel: 020 7499 4040
Charity Co-ordinator: Kate Cracknell

Ogilvy & Mather, 10 Cabot Square,
Canary Wharf, London E14 4QB, Tel:
020 7345 3000
Charity Co-ordinator: Steve Lepley.

Yorkshire Bank plc

20 Merrion Way, Leeds LS2 8NZ
Tel: 0113 247 2000; **Fax:** 0113 242 0733
Company type: Financial services, part
of National Australia Bank Group of
Melbourne, along with Clydesdale
Bank, Northern Bank, Belfast, National
Irish Bank, Dublin and other banks
particularly in Asia
Contact: Nicola Ashcroft, Secretary of
the Trust
Membership: A&B

Arts sponsorship and arts donations are
handled separately with no stated
preference for either.

Arts sponsorship: *See the full policy
statement and contact under the entry for the
Clydesdale Bank (external relations for both
Yorkshire Bank and Clydesdale Bank handled
together).*

Charitable donations: £63,000 (1999).
Donations are made through the
Yorkshire Bank Charitable Trust to
charities within the area of the bank's
presence – from north of the Thames
Valley to Newcastle upon Tyne. The
trust's guidelines state that beneficiaries
must:

- be within the operating area of the
 organisation;
- be well known to the general public;
- possess an established and positive
 reputation within the community;
- be a not-for-profit organisation.

Contact: Mrs Nicola Ashcroft, Secretary
of the Trust, at the address above, Tel:
0113 247 2104; 0113 234 0216; E-mail:
nicola.ashcroft@eu.nabgroup.com

Gifts in kind: The bank is prepared to
consider these.

Applications: Grants decisions are made
by a donations committee which meets
twice a month; responses may take three
or four weeks to process.

Yorkshire Building Society

Yorkshire House, Yorkshire Drive,
Bradford BD5 BLJ
Tel: 01274 472015; **Fax:** 01274 735571
Website: www.ybs.co.uk
Contact: Joanne Howarth, Campaign
Manager, Your Society
Membership: A&B

Donations to all causes: £395,000
(2001)

Charitable donations: These are made
by the Yorkshire Building Society
Charitable Foundation. Its charitable
support is wide-ranging and the society
has indicated that this may also include
the arts. However the foundation has a
defined policy to support work for the
vulnerable, the elderly and those
experiencing hardship. The maximum
donation is usually £2,000.

Contact your local branch to obtain
guidelines and discuss your application. If
you don't have a local branch contact
Joanne Howarth (details above).

Arts sponsorship: The society has
indicated it has a preference for arts
sponsorship compared to arts donations.
It has no specific policy for the arts. In
2000/01 it supported:
Bradford Architectural Competition.

Other support: Gifts in kind. Staff
volunteer to support arts organisations via
Business in the Arts.

INDEPENDENT TELEVISION COMPANIES

Anglia Television Ltd
Border Television plc
British Sky Broadcasting Group plc
Carlton Communications plc
Carlton Broadcasting
– Central Region
– West Country Region
– London Region
Channel 5 Broadcasting Ltd
Channel Four Television Corporation
GMTV Ltd
Grampian Television Ltd
Granada Television Ltd
HTV (Cymru) Wales
HTV West
London Weekend Television Ltd
Meridian Broadcasting Ltd
S4C
Scottish Media Group plc
Scottish Television – see Scottish Media Group plc
Tyne Tees Television Ltd
Ulster Television plc
Yorkshire Television

Anglia Television Ltd

Anglia House, Norwich NR1 3JG
Tel: 01603 615151; **Fax:** 01603
E-mail: emmaj@angliatv.co.uk
Website: www.anglia.tv.co.uk
Company type: East of England
television
Contact: Ruth Sealey, Community
Relations Co-ordinator

Graham Creelman, Managing Director of
Anglia TV, is chair of Screen East, the
single screen agency for the region.

Border Television plc

The Television Centre, Carlisle CA1 3NT
Tel: 01228 525101; **Fax:** 01228 541384
Website: www.border.tv.com
Company type: Borders and the Isle of
Man television
Contact: Neil Robinson, Press Officer

British Sky Broadcasting Group plc

6 Centaurs Business Park, Grant Way,
Isleworth, Middlesex TW7 5QD
Tel: 020 7705 3013; **Fax:** 020 77057600
E-mail: ben.stimson@bskyb.com
Website: www.sky.com
Company type: Satellite pay television
operator – its digital services offer 300
channels
Contact: Ben Stimson, Head of
Corporate Affairs
Sponsorship: As above
Membership: A&B; BitC

Donations to all causes: £565,000
(2000/01)

The company supports local and national
charities with a preference for activities
near its bases at Livingston, Dunfermline,
Southampton and Hounslow.

It has given long-term support to the
National Film and Television School.

Previous entry:
*Arts sponsorship and donations: These are
administered together with no stated preference*
for either. The total budget for both sponsorship
and donations was over £1 million in 1998/
99 of which 40% (£416,000) was allocated
to the arts.

The company has supported a variety of
causes particularly those aiming to support
young people in education, performing arts,
television and sport. It has pledged £12
million to the Millennium Experience which
in part will assist a dedicated, long-term
programme focusing on opportunities for young
people across the UK.

'We support organisations which promote
inclusion and which provide opportunities for
young people to develop their talents. We also
provide funding for groups which support the
television and film industry.'

National charities and charities local to the
main offices in Isleworth, Livingston and
Dunfermline are supported. Theatre and film
are the preferred artforms.

Sponsorships/donations in 1998/99 included:
National Film and Television School;
Cinema and Television Benevolent Fund;
Chicken Shed Theatre Company;
Royal Academy of Dramatic Arts;
The Actors' Centre;
Royal Court Theatre;
The Script Factory.

Carlton Broadcasting – Central Region

Gas Street, Birmingham B1 2JT
Tel: 0121 643 9898
E-mail: events@carltontv.co.uk
Website: itv.com/carltoncentral
Company type: Part of Carlton
Communications
Contact: Isabel Clarke, Sponsorship and
Community Partnerships Officer

Sponsorships are undertaken only with
organisations based within and for the
benefit of people in the East, West and
South Midlands ITV licence area.

'Our policy is centred on supporting
the arts and media industry, environment,
celebrating cultural diversity and
supporting community organisations.

'**Arts sponsorship** is principally aimed at encouraging young people to participate, through staging workshops and subsidised ticket schemes in dance, film, music and theatre. We work with national and internationally renowned companies based in the region. Current partners include:
Birmingham Hippodrome;
Birmingham Film and Television Festival;
Birmingham Repertory Theatre;
Birmingham Royal Ballet;
City of Birmingham Symphony Orchestra;
Diwali Festival – Leicester;
Out of Sight Archive Film Festival (Nottingham);
Royal Shakespeare Company.

'We support many industry bodies together with local events and organisations, including:
Birmingham Chamber of Commerce and Industry;
Birmingham Forward;
Business in the Community;
Cinema & Television Benevolent Fund;
West Midlands Creative Advantage Fund;
Newspaper Press Fund;
Royal Television Society;
Publicity Association of Central England.

'We have supported the establishment of new regional film agencies, Screen West Midlands and EMMedia. Carlton has been a regular supporter of:
East and West Midlands Screen Commissions;
Midlands Media Training Consortium;
Media Archive of Central England.

'**Community support:** In addition, we financially support many of the charitable and community activities in which Carlton staff are actively involved. Senior Carlton executives from the region chair or are on the boards and committees of several community organisations.

'In 2001, Carlton re-established *Midlander of the Year*. Formerly run by Bass, it aims to recognise the person who has done most to increase the prestige of the Midlands or who has made an outstanding contribution to the social, political, industrial, cultural or sporting life of the region.

'**Support for new filmmakers:** FIRST CUT is Carlton's broadcast initiative for new filmmakers in the Central region. Each year, we provide production funding, advice, training and give the film its first broadcast on ITV1 in the Central region in a late peak slot. The films are 5 or 10 minutes in duration and must adhere to a specified creative theme each year. The theme for the 2002 scheme is Diversity. Many filmmakers have gone on to pursue writing or directing careers in film and television. The scheme is run in association with regional film and production agencies.

'For more information, please contact the following organisations:

West Midlands
Screen West Midlands, Tel: 0121 643 9309; E-mail: info@mda-wm.org.uk

East Midlands
Intermedia Film & Video, Tel: 0115 955 6909, E-mail: enquiries@intermedia notts.co.uk

South
Lighthouse, Tel: 01273 384258, E-mail: Info@lighthouse.org.uk

Download a copy of the 2002 leaflet from our website for more information.'

'**Business Support:** *Business Breaks* provide new small businesses with an opportunity to advertise on television for the nominal sum of £1. We produce 30 second commercials free of charge and screen them twice in one week, including a single peak time slot. The scheme is run in association with the Prince's Trust and Business Link.

'For more information, details of qualifying criteria and an application pack please contact: Sam O'Sullivan, Regional Services Co-ordinator, Carlton

Broadcasting, Gas Street, Birmingham B1 2JT; E-mail: sam.osullivan@carlton tv.co.uk

Exclusions: Individuals; general appeals; the relief of statutory responsibilities; retrospective funding; distribution to other organisations.

Applications: 'We do not operate a formal application process for any of our schemes, preferring to establish key, long-term partnerships with a small number of organisations. Sponsorship and donations are made only to organisations based within and for the benefit of people in the East, West and South Midlands ITV licence area.

'Our schedule of sponsorship and community activities is usually in place around one year in advance. Our financial year currently starts in October.

'If you would like further information on current projects or would like to put forward a sponsorship proposal, please write or e-mail: Sponsorship and Community Partnerships Officer, Regional Affairs, Carlton Broadcasting, Gas Street, Birmingham B1 2JT, E-mail: events@carltontv.co.uk

Carlton Broadcasting – West Country Region

Language Science Park, Plymouth
PL7 5BQ
Tel: 01752 333333
Company type: Part of Carlton Communications
Contact: Mark Clare, Controller, Public Affairs

Sponsorship and donations are handled separately but there is no preference for either.

Charitable donations: Only applications from groups based in Cornwall, Devon, The Isles of Scilly, West Dorset and South Somerset will be considered. Their activities must also take place there.

The grants panel is chaired by a non-executive director of the company and is made up of three viewers who sit on the Regional Advisory Panel. The panel meets three times a year normally in March, June and October.

In general, the panel encourages local and regional community initiatives that involve people. These initiatives will gain most favour when they invite people to participate and learn social, cultural, and recreational skills. The panel is keener to help established and/or recognised organisations than ad hoc groups with no track record of sound administration. This does not exclude small organisations, but they must be able to demonstrate accountability.

The panel tends to spread the available funds to a large number of applicants rather than make a few larger donations.

Arts sponsorship: This targets regional and local organisations. Its numerous sponsorships across the region in 2001 included:
Exeter Festival;
Theatre Royal, Plymouth;
Golowan Festival, Penzance;
South West Academy of Arts.

South West Production Fund: a scheme for short experimental programmes made for cinema distribution and Broadcast TV. Carlton West Country and HTV West and are partners in the scheme which is run by South West Screen. Contact: Sarah-Jane Meredith, Tel: 0117 927 3226; E-mail: sarah-jane@swscreen.co.uk

Exclusions: Individuals; general appeals; the relief of statutory responsibilities; retrospective funding; distribution to other organisations.

Applications: Application forms and criteria, are available on line at carlton.com/westcountry/aboutus/index.html (details will be found in the community section) or from Samantha Hunt. For further information e-mail mark.clare@carltontv.co.uk or

samantha.hunt@carltontv.co.uk.
Alternatively you can contact either at
the above address.

Carlton Television – London Region

101 St Martin's Lane, London WC2 4RF
Tel: 020 7240 4000
Company type: Part of Carlton
Communications
Contact: Liz Delbarre

Charitable donations: See the Carlton
Television Trust in the 'Trust' section for
charitable donations within the London
franchise region.

Channel 5 Broadcasting Ltd

22 Long Acre, London WC2E 9LY
Tel: 020 7550 5555; Fax: 020 7550 5554
Website: www.channel5.co.uk
Company type: Broadcasting

Channel Four Television Corporation

124 Horseferry Road, London
SW1P 2TX
Tel: 020 7396 4444; Fax: 020 7306 6040
Website: www.channel4.com
Company type: Broadcasting
Contact: Cristina Fedi, Marketing

Channel Four concentrates its
sponsorship support on projects related to
its programmes and its role as a national
broadcaster. Arts sponsorships in previous
years have included:
The Turner Prize, at the Tate Gallery;
Serpentine Gallery;
Glyndebourne;
London, Edinburgh, Leeds and
Birmingham Film Festivals;
Edinburgh Gilded Balloon;
Cardiff Animation Festival;
also
Channel Four/MOMI Animators'
Residencies.

GMTV Ltd

The London Television Centre, Upper
Ground, London SE1 9TT
Tel: 020 7827 7000; Fax: 020 7827 7001
Website: www.gmtv.co.uk
Company type: National breakfast-time
television
Contact: Nikki Johnceline, Head of
Press

Grampian Television Ltd

Queen's Cross, Aberdeen AB15 4XJ
Tel: 01224 846 846; Fax: 01224 846 800
E-mail: gtv@grampiantv.co.uk
Website: www.grampiantv.co.uk
Company type: North of Scotland
television
Contact: Bert Ovenstone, Head of Press

Grampian was taken over by Scottish
Media (see separate entry) in 1996 and all
sponsorships and requests for charitable
donations are handled through its
corporate affairs office.

The company has supported *New
Found Land*, a first step into feature film
production, also supported by funding
from Scottish TV and the National
Lottery Fund of Scottish Screen. Scripts
and proposals were invited for two 90
minute productions with budgets of
£200,000 each. First closing date was in
March 2002.

It also co-produced *This Scotland*, 13
half-hour TV documentaries by new and
existing talent, with Scottish TV and
Scottish Screen in 2002.

Granada Television Ltd

Quay Street, Manchester M60 9EA
Tel: 0161 832 7211; Fax: 0161 827 2141
Website: www.granadatv.co.uk
Company type: Television in the North
West of England; part of Granada plc
Contact: Jane Luca, Head of Regional
Affairs

The company contributes in excess of
£200,000 annually to artistic and

educational institutions in the North West via its sponsorship budget and its charitable donations via the Granada Foundation.

Sponsorship: Arts institutions, and social and economic regeneration initiatives within its franchise area including:
Hallé Orchestra;
Royal Exchange Theatre;
Royal Northern College of Music.

Other recent media related sponsorships include:
Granada Media and Education Partnership, an association involving five institutions across the North West;
North West Film Archive;
North West Film Commission;
National Film and Television Training School;
Royal Television Society;
BAFTA;
Granada Centre for Visual Anthropology at Manchester University.

Donations: See the Granada Foundation under 'Trusts'.

HTV (Cymru) Wales

The Television Centre, Culverhouse Cross, Cardiff CF5 6XJ
Tel: 029 2059 0590; Fax: 029 2059 9108
E-mail: public.relations@htv-wales.co.uk
Website: www.htvwales.com
Company type: Television in Wales
Contact: Mari Thomas, Corporate and Community Affairs Manager

The company does very little arts sponsorship. Sponsorship is undertaken only if a direct programming link applies and HTV retains editorial decision on the suitability of the work for broadcast. Welsh organisations are targeted and recent sponsorship partnerships have included:
Welsh National Opera;
North Wales Music Festival.

HTV West

The Television Centre, Bath Road, Bristol BS4 3HG
Tel: 0117 972 2722; Fax: 0117 972 2400
E-mail: presspr@htv-west.co.uk
Website: www.htvwest.com
Company type: West of England television
Contact: Richard Lister, Head of Press and Public Relations

The company does not have a specific arts budget either for sponsorship or donations.

Sponsorship/donations are not sought and most, if not all, requests are refused apart from those which have a direct link to programming. It targets emergent media talent. For example, Bristol's Short Film Festival 'Brief Encounters' has been funded for many years (receiving £8,000 in 2001). This enables the station to have exclusive programming, access to the Festival and it programmes four 24' programmes out of it.

South West Production Fund: a scheme for short experimental programmes made for cinema distribution and Broadcast TV. HTV West and Carlton West Country are partners in the scheme which is run by South West Screen. Contact Sarah-Jane Meredith, Tel: 0117 927 3226; E-mail: sarah-jane@swscreen.co.uk

Other support: Service on various boards: Show of Strength Theatre Company; Arts & Power; Brief Encounters; Sheffield Documentary Festival Newcomers day.

London Weekend Television Ltd

London Television Centre, Upper Ground, London SE1 9LT
Tel: 020 7620 1620; Fax: 020 7261 3115
Website: www.lwt.co.uk
Company type: Television in the London area at the weekend, subsidiary of the Granada Group plc

Contact: Emma Mandley, Director of Regional Affairs
Membership: A&B

General: Arts sponsorship and donations are administered together with some preference for donations.

'The company support local arts within its transmission area (roughly within the M25), including national organisations based in the capital, and is particularly interested in arts training and education and work to increase access, particularly for the socially excluded.'

Arts sponsorship: 'We aim to build and develop relationships with the organisations we sponsor – this means we take on very few new sponsorships.' Recent sponsorships 2001 onwards include:
National Theatre;
Royal Festival Hall (Education);
Actors' Centre;
Thames Festival;
Coin Street Festival.

Arts donations: These are mostly given to community arts organisations within the transmission area. They centre on arts training, education and work to increase access, particularly for the socially excluded. Donations for 2001 included:
Artsline;
Bermondsey Carnival;
Big Foot Theatre Company;
Southwark Playhouse;
Foundation for Young Musicians;
Young Vic.

Other support: LWT runs a major televised community arts project once every two years. Its latest initiative is *Whose London?*, a partnership project for 2002, creating the opportunity for a collection of short video films to be made by community groups across the capital and giving a voice to Londoners from all walks of life, ages, abilities and cultures. LWT's television coverage (autumn 2002) should offer a fascinating glimpse into the many different worlds which make up the metropolis. For further information access the website: www.lwt.co.uk

Meridian Broadcasting Ltd

Television Centre, Southampton SO14 0PZ
Tel: 023 8022 2555; **Fax:** 023 8033 5050
Website: www.meridian.tv.com
Company type: Television in the southern region
Contact: Martin Morrall, Controller of Regional and Commercial Affairs
Sponsorship: As above
Membership: A&B

Arts sponsorship: The company supports regional and local organisations and emergent media talent. Its sponsorship includes:
Artswork, the youth arts development agency;
Taped Up – a scheme to support new filmmakers and give them their first broadcast opportunity (open to those living within the Meridian region).

Charitable donations: These are made via the Meridian Trust. It funded the opening launch of 'Anthony Caro, a Sculptor's Development' in Lewes, East Sussex in 2001. It also offers support to disabled people and related aspects of social welfare.

Support-in-kind: News or documentary coverage of various regional arts events.

S4C

Parc Busnes Ty Glas, Llanishen, Cardiff CF4 5DU
Tel: 029 2074 7444; **Fax:** 029 2075 4444
Website: www.s4c.co.uk
Company type: Transmitted on the Fourth Channel in Wales, broadcasting on average 32 hours a week in Welsh mainly during peak hours

Applications: Its sponsorship budget is allocated twice yearly, usually in the

month preceding its financial year (December to January) and around April or May.

Scottish Media Group plc

Cowcaddens, 200 Renfield Street, Glasgow G2 3PR
Tel: 0141 300 3300; Fax: 0141 300 3033
E-mail: enquiries@scottishmedia group.com
Website: www.scottishmedia.com
Company type: Broadcasting and newspaper publishing: Grampian Television, Scottish Television; *Glasgow Herald* and *The Evening Times* amongst its titles
Contact: Callum Spreng, Director of Corporate Affairs

Scottish Television Ltd – see Scottish Media Group plc

The company has supported *New Found Land*, a first step into feature film production, also funded by with funding from Grampian TV and the National Lottery Fund of Scottish Screen. Scripts and proposals were invited for two 90 minute productions with budgets of £200,000 each. First closing date in March 2002.

It also co-produced *This Scotland*, 13 half-hour TV documentaries by new and existing talent, with Grampian TV and Scottish Screen in 2002.

Tyne Tees Television Ltd

The Television Centre, City Road, Newcastle upon Tyne NE1 2AL
Tel: 0191 261 0181; Fax: 0191 261 2302
Company type: Television in the north east of England; part of Granada Group plc
Contact: Mrs Norma Hope, Head of Regional Affairs

Sponsorship for 6 half-hour dramas (£78,000) of Northern Film and Media (the new regional agency which covers

the responsibilities of the Northern Production Fund, Northern Screen Commission and Northern Media Training).

Ulster Television plc

Havelock House, Ormeau Road, Belfast BT7 1EB
Tel: 028 9032 8122; Fax: 028 9024 6695
E-mail: info@utvplccom
Website: www.utvplc.com
Contact: Orla McKibbin, Head of Public Affairs

Arts sponsorship: A preference for sponsorship of local organisations working in theatre and the visual arts.

Arts sponsorships in 2000/01 included: Grand Opera House; Corporate Art Collection, and HTV Young Artist Collection.

Yorkshire Television

The Television Centre, Kirkstall Road, Leeds LS3 1JS
Tel: 0113 243 8283; Fax: 0113 242 3867
Website: www.granadamedia.com
Company type: Part of the Granada Group
Contact: Christine Hirst, Regional Affairs Manager

Added March 2001 – Yorkshire Television New Writers scheme.

Previous entry:
The company 'has a long established policy of supporting the arts in the region, giving vitality to new and existing initiatives and raising the quality of cultural life within the community.' It has an arts committee which meets regularly.

Arts sponsorships and arts donations are administered together with no preference for either form of support. The company only supports local organisations. It has a budget for appeals from charitable organisations within its operating area. The education part of its budget is largely absorbed by the Northern Film and Television School in Leeds.

Its recent support includes:
Harrogate International Festival;
Huddersfield Contemporary Music festival;
Northern Ballet;
Opera North;
York Early Music Festival;
West Yorkshire Playhouse.

Exclusions: Organisations headquartered outside the YTV transmission area.

Applications: To the YTV Regional Affairs Committee.

Part four
CHARITABLE TRUSTS

INTRODUCTION

GENERAL ADVICE FOR THE NOVICE GRANTSEEKER

What are charitable trusts?

Charitable trusts are set up by an individual or group to distribute money for charitable purposes. They are registered with the Charity Commission, which requires that their reports and accounts are kept on public record at the Commission's offices. Usually the founder/s of a trust endows it with a capital sum, which is invested in stocks and shares or property and which benefits from charitable tax relief. The money available for grantmaking comes from the income received from those investments.

Each grant-making trust is established under a trust deed in which the wishes of the founder/s are set out. The most important parts of the deed determine how the money will be spent – the 'objects' – and where the money can be spent – the 'beneficial area'. Some trusts have tightly defined objects which only permit them to spend money on a very limited range of activities, whilst others have much wider objects and may even be permitted to support any charitable activity. Some trusts are permitted to spend their funds only to benefit people in a certain region, county, town or even parish, whereas others may be able to spend their money anywhere – locally, nationally or internationally.

Just because a trust *can* spend its money on a particular activity does not mean it *will* do so. Each trust is controlled by a group of trustees who determine the policy of the trust within what is permitted by its constitution. It is up to the trustees how the money is spent within the confines of the trust's objects.

Because of charity law, all charitable trusts can only support activities that are charitable. This normally means that they will only be prepared to give money to organisations that are established with charitable status. When an organisation that cannot or has not become a charity is seeking funds from charitable grant-making trusts, it is sensible for it to make an arrangement with a charity, so that the grant can be paid over initially to the charity, for forwarding to the arts organisation. Even where such an arrangement is made it should be remembered that money from charitable trusts may *only be spent for charitable purposes, that is for work that is of some public and community benefit.*

Raising money from trusts

Generalisations about trusts can be misleading. There are thousands of trusts in the UK and they vary greatly in their size and style of operation. Most of the largest employ professional staff, others use their lawyers or accountants to carry out their administrative work, whilst many smaller trusts are run directly by the original donor trustee or his/her family.

Most of the largest trusts are clear and open about their policies and criteria for support – they publish annual reports, prepare guidelines to assist applicants and

indicate the scale of grant they are most likely to accommodate. But the majority of trusts do not prepare guidelines for applicants. Hence the importance of using guides. Those published by the Directory of Social Change are based on examination of the trusts' schedules of grants on public file at the Charity Commission. From this the actual preferences of individual trusts (where they are apparent) *can be inferred*. Some give money to the same organisations year after year; others give one-off grants. Some welcome applications; others decide their own interests and are likely to disregard unsolicited applications.

Consult the bibliography at the end of this book for a list of published guides. The services of local Charity Information Bureaux and local funding advice services can also be very helpful. Contact your local council for voluntary service or rural community council to find out what services are available in your area. These often include access to Funderfinder, a computer program which helps voluntary groups identify appropriate trusts for particular types of activities (see address within the bibliography).

The importance of research

It cannot be too highly emphasised how important it is to research each trust as thoroughly as possible before making any approach. Use the grant guides to make a list of trusts that seem to match your interests. Find out if it has policies and priorities, the size of its grants, its beneficial area, any restrictions, and so on. Obtain all current background information – its annual report, any guidelines for applicants, and application form, if relevant. Don't start approaching trusts until you have identified a number of trusts that seem appropriate and then rank them in order of likelihood. Also don't trawl through only half a guidebook. Cover all entries. It is surprising the number of trusts near the end of the alphabet that get missed by fledgling fundraisers. (Note that the Garfield Weston Foundation, which is very large and gives money very widely, is at the end of the listing!)

This is a highly competitive field. All trusts receive far more requests than they are able to fulfil. Do not spoil your chances of success by sending hasty and vague applications.

Contact with the trust

Wherever possible try to develop a relationship with the trust in advance of any formal application. This is a delicate area. Don't be too pushy and try to override the paid administrators who, apart from their professional expertise, also act as gatekeepers and protect their trustees from importunate fundseekers. Telephone for advice, seek a meeting, invite administrators and trustees to performances, events, exhibitions, and so on. Use personal contacts if at all possible. Where a trust is based far away from your work, why not suggest with your invitation that they may like to choose someone more local to visit you 'by proxy'? It's worth a try; you have nothing to lose. But remember to bear in mind the kind of administration used by the trust. Most will not be in a position to be receptive although they may appreciate your drive and that's another bonus.

Keep your letter of application as simple and concise as possible. Necessary details can be attached. Remember to state the obvious: what your organisation does and why its work is important/effective; who you are and what you have achieved.

If you are not a charity, identify those projects or parts of your work that are charitable.

Above all, follow guidance where it is available. Nothing frustrates an administrator more than ill-prepared, inappropriate approaches (and you will be letting your organisation down).

The project

Define your project and budget your request for money clearly. Few trusts give support for general running costs. Identify an area of work which can be separately costed and which needs development. Put the emphasis on the people who will benefit from this project, how many and for how long. Far more trusts are interested in supporting young people, people with disadvantage and the disabled rather than in supporting the arts. It is wise to concentrate on those aspects of your work that open up opportunities for these people whether as audiences or as participants.

Draw up a fully budgeted proposal with a detailed breakdown. It is often an attractive 'selling-point' to show how much the project costs per individual. It emphasises the cost-effectiveness of the project, and often makes its overall cost seem less.

Pitch the size of your grant request to suit each trust. (Don't ask for £5,000 from a trust that generally gives grants of £500, or vice versa.)

Many larger trusts request a list of other sources of support being approached and may make a grant conditional on other support being obtained. Be sure to have a planned strategy.

Outline the ways in which the project will be monitored and evaluated. This emphasises your efficiency and is also a request that many of the larger trusts make of their beneficiaries.

Timing

Be clear about the timescale of your project. You need to *plan well in advance* since you may have to wait several months to hear about the results of your application. Some trusts review their applications annually, some quarterly, some monthly. Try to find out when trustees next meet. Then keep a schedule so that you can check the progress of each application if need be.

Attachments with the application

Audited accounts and annual report, constitution, project budget and full budget for the current year should be attached.

Also include clear information about your organisation, its aims and achievements, and who is involved in its management.

Put together a portfolio of reviews, endorsements of your work from well-known artists, previous funders, and so on. Photographs, plans and maps often say far more than words. If you are working with young people remember that pictures by them may give your application greater 'appeal' and far more immediacy.

Maintain contact

Maintain contact with a trust during the course of an application, inform it of any successes, invite to functions, send newsletters, and so on. Keep in touch if you receive a grant: send invitations as well as reports and latest reviews and so on showing what is being done with their help.

Note: Many smaller trusts do not give clear instructions about what they seek from applicants. It is useful to look at the application requirements of those major trusts with clear guidelines, whether of not you intend to apply to them. Suggested trusts include the City Parochial Foundation, the Paul Hamlyn Foundation, the Gulbenkian Foundation, and Henry Smith's (Kensington Estate) Charity.

Community arts organisations new to fundraising from trusts are particularly advised to look at the application requirements made by BBC Children in Need and Awards for All. These take new and small organisations and groups through all the basic requests very clearly.

THE TRUSTS INCLUDED WITHIN THIS GUIDE

Research on the trusts

The financial information about the majority of these trusts has been obtained from a direct analysis of the individual accounts and reports of each trust. Most of this work was done by looking closely at the accounts and grant schedules of trusts held on the public file at the Charity Commission. The commission covers only England and Wales.

Charities in Scotland and Northern Ireland register their legal status for tax purposes with the Inland Revenue but there is no equivalent service to the commission in those countries. There are fewer trusts in these countries, and these are more difficult to identify, trace and research.

Over 450 trusts were researched but only 320+ have been given detailed entries. These trusts give £15,000 or more annually to arts activities. Trusts devoted *solely* to supporting arts activities have also been included even if they give less than this sum. All trusts in this guide were sent a draft text for comment and amendment. Two thirds of the trusts responded and their amendments have been incorporated.

Charitable grant-making trusts and company giving

Many grant-making charitable trusts are set up within companies as part of their community relations work and as a tax-effective way of giving gifts. These trusts are usually dependent on an annual allocation from the company based on its business success. They are, typically, serviced by company staff and the board of trustees comprises top company executives. This funding is covered in the company-giving section of this guide.

Where trusts are clearly separate from the company, that is with an independent endowment and independent trustee board, they are included in this part of the

guide (for example Northern Rock, Lloyds TSB). Many trusts have names of successful companies, but are in fact independent charitable trusts, for example Laing, Wates and Sainsbury. In these cases it has been a personal decision by individual/s to set aside some of their considerable wealth for charitable purposes. This grantmaking is not directly linked to the interests of the company from which the family members derive their wealth.

Overall findings (recorded from 1999/2000 and 2000/01 annual reports and accounts)

Over £79 million was given to the arts by these 320+ trusts out of their total giving of £453 million.

Over half of this arts funding is contributed by a small number of trusts – the 19 trusts each giving £1 million or more a year to the arts. Collectively they contribute over £44 million (56%) of the arts funding covered in this guide.

TRUSTS LISTED BY SCALE OF ARTS GIVING

Trusts giving over £1,000,000 a year to arts causes – 19

The Clore Duffield Foundation
The Esmée Fairbairn Foundation
The Gatsby Charitable Foundation
The Goldsmiths' Company's Charities
The Calouste Gulbenkian Foundation (UK Branch)
The Paul Hamlyn Foundation
The Headley Trust
The Linbury Trust
The Monument Trust
The Henry Moore Foundation
The Nigel Moores Family Charitable Trust
The Peter Moores Foundation
The National Art Collections Fund
The Northern Rock Foundation
The Performing Right Society Foundation
The Royal Literary Fund
The Foundation for Sport and the Arts
The Garfield Weston Foundation
The Wolfson Foundation

Trusts giving between £500,000 and £999,999 a year to arts causes – 20

The Baring Foundation
The BBC Children in Need Appeal
The Bridge House Estates Trust Fund
The British Record Industry Trust
The Britten-Pears Foundation
The Edward Cadbury Charitable Trust
The D'Oyly Carte Charitable Trust
The Djanogly Foundation
The Dunard Fund
The John Ellerman Foundation
The Eranda Foundation
The European Cultural Foundation
The Goldsmiths' Arts Trust Fund
The Jerwood Charitable Foundation
The Kreitman Foundation
The Neil Kreitman Foundation
Lloyds TSB Foundation for England and Wales
The Mackintosh Foundation
The Pilgrim Trust
Rootstein Hopkins Foundation

Trusts giving between £250,000 and £499,999 a year to arts causes – 27

The Carnegie United Kingdom Trust
The Chase Charity
The Clothworkers' Foundation and other trusts

The Daiwa Anglo-Japanese Foundation
The Equity Trust Fund
The Robert Gavron Charitable Trust
The Holst Foundation
Jacobs Charitable Trust
The Lloyds TSB Foundation for
 Scotland
John Lyon's Charity
The Mercers' Charitable Foundation
The Countess of Munster Musical
 Trust
Musicians' Benevolent Fund
The Music Sound Foundation
Northern Ireland Voluntary Trust
The Stanley Picker Trust
The Radcliffe Trust
The Peggy Ramsay Foundation Play
 Awards
The Rayne Foundation
The RVW Trust
The Henry Smith Charity
The South Square Trust
The Stevenson Family's Charitable
 Trust
The Bernard Sunley Charitable
 Foundation
The 29th May 1961 Charitable Trust
The Woo Charitable Foundation
The Woodward Trust

Trusts giving between £100,000 and £249,999 a year to arts causes – 46

The ADAPT Trust
The Society of Authors
The Book Trust
The Bowerman Charitable Trust
The Carlton Television Trust
Sir John Cass's Foundation
CHK Charities Ltd
The City Parochial Foundation
The John S Cohen Foundation
The Ernest Cook Trust
The Cripplegate Foundation
The Elmley Foundation
The Elephant Trust

The Gannochy Trust
J Paul Getty Jr Charitable Trust
Sir Nicholas & Lady Goodisons
 Charitable Settlement
The Granada Foundation
The Great Britain Sasakawa
 Foundation
The Sir Anthony Hopkins Charitable
 Foundation
The Jerusalem Trust
The King's Fund (King Edward's
 Hospital Fund for London)
The Carole and Geoffrey Lawson
 Foundation
The Leche Trust
Lord Leverhulme's Charitable Trust
The Manifold Charitable Trust
The Mayfield Valley Arts Trust
The Michael Marks Charitable Trust
The Nikeno Trust
The Norman Trust
The Ouseley Trust
The Austin & Hope Pilkington Trust
The Quercus Trust
The Robertson Trust
The Rose Foundation
The RSA Art for Architecture Scheme
The Audrey Sacher Charitable Trust
The Summerfield Charitable Trust
The Basil Samuel Charitable Trust
The Coral Samuel Charitable Trust
The Tudor Trust
The Wates Foundation
The Weinstock Fund
The Welton Foundation
The Worshipful Company of Musicians
The Harold Hyam Wingate Foundation
The Zochonis Charitable Trust

Trusts giving between £50,000 and £99,999 a year to arts causes – 45

The 'A' Foundation
The Milly Apthorp Charitable Trust
The Arts Foundation
The Ashden Charitable Trust

The Laura Ashley Foundation
The Band (1976) Trust
The Ward Blenkinsop Trust
The John Coates Charitable Trust
The Winston Churchill Memorial Trust
The Cross Trust
The Delius Trust
The Charles Hayward Foundation
The Hinrichsen Foundation
P H Holt Charitable Trust
The Hornton Trust
The Idlewild Trust
The Sir Barry Jackson County Fund
The James Pantyfedwen Foundation
The Sir James Knott Trust
The Kobler Trust
The Ruth & Stuart Lipton Charitable
 Trust
The E D and F Man Ltd Charitable
 Trust
The Martin Musical Scholarship Fund
The Milton Keynes Community
 Foundation
J P Morgan Fleming Educational Trust
The National Manuscripts
 Conservation Trust
The Network Foundation
The Pallant Charitable Trust
The P F Charitable Trust
The Porter Foundation
Mr and Mrs J A Pye's Charitable
 Settlement
Ragdoll Foundation
The Richmond Parish Lands Charity
The Raymond and Beverly Sackler
 Foundation
The Karim Rida Said Foundation
The Archie Sherman Charitable Trust
The R C Sherriff Rosebriars Trust
Society for the Promotion of New
 Music
The Steel Charitable Trust
Community Foundation serving Tyne &
 Wear and Northumberland
The Underwood Trust

William Walton Trust
The Warbeck Fund Ltd
The Weinberg Foundation
The Weldon UK Charitable Trust

Trusts giving between £15,000 and £49,999 a year to arts causes

Angus Allnatt Charitable Foundation
The Richard Attenborough Charitable
 Trust
The Hervey Benham Charitable Trust
The Charlotte Bonham-Carter
 Charitable Trust
The Bulldog Trust
The Hon D R Burns Charitable Trust
Audrey & Stanley Burton (1960)
 Charitable Trust
The R M Burton Charitable Trust
The William Adlington Cadbury
 Charitable Trust
Edward & Dorothy Cadbury Trust
 (1928)
P H G Cadbury's Charitable Settlement
The Chapman Charitable Trust
The Clark Family Charitable Trust
The Coppings Trust
The Sidney & Elizabeth Corob
 Charitable Trust
The Crescent Trust
The Gwendoline & Margaret Davies
 Charity
Dresdner Kleinwort Wasserstein's
 Charitable Trust
The Dyers' Company Charitable Trust
The Eden Arts Trust
Gilbert & Eileen Edgar Foundation
The Elmgrant Trust
The Fenton Arts Trust
The Finchcocks Charity Ltd
The Joyce Fletcher Charitable Trust
The Four Lanes Trust
The Charles Henry Foyle Trust
The Simon Gibson Charitable Trust
The Golden Bottle Trust
Golden Charitable Trust

The Jack Goldhill Charitable Trust
The Gordon Fraser Charitable Trust
The Granada Trust
The J G Graves Charitable Trust
The Grocers' Charity
The Hadrian Trust
The Sue Hammerson Charitable Trust
The Hampton Fuel Allotment Charity
The Harding Trust
The Hobson Charity Ltd
The Inverforth Charitable Trust
The John Jarrold Trust
The Michael and Ilse Katz Foundation
The Kohn Foundation
The David Laing Foundation
The Kirby Laing Foundation
Laing's Charitable Trust
The Leathersellers' Company
 Charitable Fund
Lord and Lady Lurgan Trust
Sir George Martin Trust
The Matthews Wrightson Charity Trust
The Anthony and Elizabeth Mellows
 Charitable Settlement
The Millichope Foundation
The Theo Moorman Charitable Trust
J P Morgan Fleming Foundation
The Ofenheim Trust and The
 Cinderford Trust
The Old Broad Street Charity Trust
Old Possums Practical Trust
The Oppenheimer Charitable Trust
Oppenheim-John Downes Memorial
 Trust
The Orpheus Trust
The Nyda and Oliver Prenn Foundation
The Märit and Hans Rausing
 Charitable Foundation
The Helen Roll Charity
The Rothschild Foundation
The Rowlands Trust
The Royal Victoria Hall Foundation
The Willy Russell Charitable Trust
The Alan and Babette Sainsbury
 Charitable Trust

The Francis C Scott Charitable Trust
St Hugh's Foundation
David St John Thomas Charitable Trust
The Tillett Trust
The Trust for London
Trust Fund for the Training of
 Handicapped Children in Arts &
 Crafts
The Douglas Turner Trust
Sybil Tutton Charitable Trust
The Westminster Foundation
The Wolfson Townsley Charitable Trust

Trusts giving less than £15,000 a year

Stephen Arlen Memorial Fund
The Verity Bargate Award Trust
The Bonnie Bird Choreography Fund
The Busenhart Morgan-Evans
 Foundation
The David Canter Memorial Fund
Dancers' Career Development
Gerald Finzi Charitable Trust
The Glass-House Trust
The Robin Howard Foundation
The Nicholas John Trust
The John Kobal Foundation
The Lady Artists Club Trust
Dr Mortimer & Theresa Sackler
 Foundation
The Paragon Concert Society
The Poetry Society
Theatre Investment Fund Ltd
The Stoll Moss Theatres Foundation
Strauss Charitable Trust
The Stretford Youth Theatre Trust
Society for Theatre Research
The Michael Tippett Musical
 Foundation
Lisa Ullmann Travelling Scholarship
 Fund
The Warwick Arts Trust
Welsh Broadcasting Trust

Others, i.e. where the total grant to arts cannot be estimated, or where resources, rather than grants, are made available

The Anderson Consulting Foundation

The Arvon Foundation

The Lionel Bart Foundation

The Camelot Foundation

Charities Advisory Trust

The Early Music Network

The Federation of British Artists

The Pierre Fournier Award Fund

The Foyle Foundation

The Fulbright Commission

Garrick Charitable Trust

Gatwick Airport Community Trust

Genesis Foundation

The German Academic Exchange Service (DAAD)

The Horne Foundation

The Hugh Fraser Foundation

The Japan Festival Fund

The Jerwood Foundation

The Jungels-Winkler Charitable Foundation

The Lloyds TSB Foundation for Northern Ireland

The Lynn Foundation

The Esmé Mitchell Trust

The Museums Association

Musicians' Union

The Prince of Wales's Charitable Foundation

Prince's Scottish Youth Business Trust

The Prince's Trust

Scottish Book Trust

The Scottish International Education Trust

SHINE – Support and Help in Education

Martin Smith Foundation

The Theatres Trust Charitable Fund

The John Tunnell Trust

The ULTACH Trust

The Charles Wallace India Trust

The Wellcome Trust – Science on Stage and Screen

Trusts listed within other entries

Allcard Fund – see Worshipful Company of Musicians

The Beecroft Bequest – see Museums Association

The Daphne Bullard Trust – see Museums Association

The Kathy Callow Trust – see Museums Association

Carnwath Fund Trust – see Worshipful Company of Musicians

The Francis Chagrin Fund – see Society for the Promotion of New Music

The Cinderford Charitable Trust – see Ofenheim Trust and Cinderford Charitable Trust

The Courtauld Trust for the Advancement of Music – see Musicians' Benevolent Fund

The Dancers' Trust – see Dancers' Career Development

Henry & Lily Davis Gift – see Musicians' Benevolent Fund

Chris de Marigny Dance Writers' Award – see Bonnie Bird Choreography Fund

The John Fernald Award Trust – see Equity Trust Fund

The Ian Fleming Charitable Trust – Musicians' Benevolent Fund

The Myra Hess Trust – see Musicians' Benevolent Fund

Constant and Kit Lambert Fund – see Worshipful Company of Musicians

The Lankelly Foundation – see Chase Charity

The Professor Charles Leggett Fund – see Musicians' Benevolent Fund

Maisie Lewis Young Artists' Fund – see Worshipful Company of Musicians

Linbury Prize for Stage Design – see
 Linbury Trust
The Ludgate Trust – see Musicians'
 Benevolent Fund
The MA Benevolent Fund – see
 Museums Association
The Manoug Parikian Award – see
 Musicians' Benevolent Fund
Priaulx Rainier Fund – see Worshipful
 Company of Musicians
Geoffrey Shaw Memorial Fund – see
 Musicians' Benevolent Fund
The Trevor Walden Trust – see
 Museums Association
The Peter Whittingham Fund – see
 Musicians' Benevolent Fund

LISTING OF TRUSTS

Note: ★ recurrent grant

The 29th May 1961 Charitable Trust

CC No: 200198

c/o Macfarlanes, 10 Norwich Street, London EC4A 1BD

Tel: 020 7831 9222; Fax: 020 7831 9607
Contact: The Secretary
Trustees: V E Treves; J H Cattell; P Varney; A J Mead.
Beneficial area: UK, with a particular interest in Warwickshire and Coventry.
Grant total: £2,923,000 (2000/01)
Arts grants: £271,500
This trust has a wide range of charitable concerns. Most grants are given to national bodies or organisations in London or the Midlands, in fields including the arts, leisure, youth, health and social welfare.

In 2000/01 the trust gave a total of £2,923,000 in 326 grants of up to £295,000, 'some one-off, some recurring and others spread over two years'. Most grants were, however, under £10,000. Arts-related grants amounting to £271,500 (nine per cent of total grant-aid) were made to 16 beneficiaries. These included:
University of Warwick (£180,000);
★Sadler's Wells Trust (£60,000);
★Martin Musical Scholarship Fund (£42,500);
★Royal National Theatre (£15,000);
★Dulwich Picture Gallery; ★Museum of British Road Transport; ★National Art Collections Fund; ★Royal Shakespeare Theatre (£10,000 each);
★Foundation for Young Musicians; Almeida Theatre; Coventry Watch Museum (£5,000 each);

★Living Paintings Trust (£2,500);
★Musicspace (£1,000).
Exclusions: Individuals; non-registered charities.
Applications: In writing to the correspondent, enclosing a copy of the most recent accounts. Unsuccessful applications are not acknowledged. Trustees meet to consider applications in February, May, August and November.

The 'A' Foundation

CC No: 1071488

c/o MacFarlane & Co, Cunard Building, Water Street, Liverpool L3 1DS

Tel: 0151 709 7444
Contact: Paul Kurthousen
Trustees: James Moores; Louise White; Portia Kennaway.
Beneficial area: UK, primarily Liverpool.
Grant total: £64,000 (1998/99)
Arts grants: £64,000
This trust was established in February 1998 with the principal aim of 'helping Liverpool to establish itself as a centre being at the cutting edge of the art world'. The 1998/99 report, the latest available at the Charity Commission, shows that the trust gave a total of £64,000 in the following three arts-related grants:
The Liverpool Biennial Trust (£45,000);
The Liverpool Biennial of Contemporary Art Ltd (£15,000);
The Liverpool Biennial Fringe (£4,000).
Applications: In writing to the correspondent.

The ADAPT Trust

CC No: SC020814

8 Hampton Terrace, Edinburgh
EH12 5JD

Tel: 0131 346 1999; Fax: 0131 346 1991
E-mail: adapt.trust@virgin.net
Website: www.adapttrust.co.uk
Contact: Stewart Coulter, Director
Trustees: Dr Gillian A Burrington,
Chair; Michael Cassidy; Mrs Elizabeth
Fairbairn; Gary Flather; John C Griffiths;
Alison Heath; Trevan Hingston; Robin
Hyman; C Wycliffe Noble; Maurice
Paterson; Rita Tushingham.
Beneficial area: UK.
Grant total: £137,000 (2000)
Arts grants: £137,000
The ADAPT (Access for Disabled People
to Arts Premises Today) Trust aims to
improve accessibility for disabled and
older people to arts and heritage venues.
This is achieved through grant-aid,
awards, training and a consultancy service.
Sightline Grants – These grants,
sponsored by Guide Dogs for the Blind
Association, are focused on improving
facilities in arts venues in the UK for
visually impaired and blind people. These
grants are increasingly in demand as more
venues attempt to comply with the terms
of the Disability Discrimination Act.
Grants are available up to a maximum of
£4,500.

In 2000, Sightline Grants were made to
improve facilities at 12 venues. These
included Citizen's Theatre, Glasgow;
Theatre Royal, York; Trestle Theatre, St
Albans; and Torquay Museum.
ADAPT Awards – These awards
'recognise best practice in access for
disabled people' and are made within the
following categories: cinemas; concert
halls; heritage venues; libraries; museums
and galleries; theatres. Applications are
invited from UK venues operating within
these categories and having installed
effective facilities for disabled people.
Main Awards of £2,000 and Highly

Commended Awards of £250 are made
in each category, to be used for the
furtherance of accessibility. Closing date
for entries is the end of July.
Training – The trust provides 'a variety
of training courses which help raise
awareness and promote best practice'.
Courses are tailored to the needs of those
taking part and encourage the
consideration of a wide range of factors
involved in the implementation of
policies for improving access to the arts
for people with disabilities. Training is
available for arts and heritage
organisations and amongst those
benefiting in 2000 was the Royal
Shakespeare Company.

Training schemes were accompanied by
the trust's interactive guide on CD-
ROM, entitled 'Open Sesame: The Magic
of Access and Pocket Guide'.
Access Consultancy – In 2000 the trust
completed 44 access audits, mainly
through existing contracts with architects
and venue managers with which it has
previously worked. However, it is
anticipated that this service will diminish
as a result of the reduction in lottery
funding and the increasing number of
independent access consultants.
Beneficiaries in 2000 included:
Edinburgh City Council; Burrell
Collection, Glasgow; Inverness Museum
& Art Gallery; Northern Ballet Theatre,
Leeds; and Jorvic Centre, York.
Exclusions: From grants (not the
awards): work already commenced or
completed; staff costs; stately homes,
heritage centres, crafts centres; halls
designed and used for other purposes
such as church halls, hospitals or
educational establishments even though
they sometimes house the arts; festivals,
unless at a permanent arts venue.
Applications: Full guidelines must be
sought from the trust prior to any
application.
Sightline Grants: Applications should
be for specific items although these can
be part of a larger project. Improvements

can include: audio-description equipment; tactile floor surfaces; stair nosings; handrails; voice announcements/tactile controls in lifts; lighting; seating; signage; and publicity material. Innovatory facilities are welcome. Consultation with disabled people or access groups is recommended. Applicants must provide at least 25% of costs from their own or donated sources. Costs may include a proportion of architect and advisory fees but not staff costs. Grants are paid on work completion and submission of invoices.

Applications should be signed by the appropriate official to indicate approval for the project and should include estimate(s) of project costs; plan of the work with measurements; and examples of current publicity including details of access.

The Sightline committee meets twice a year. Applications must be submitted by 31 March and 30 September.

Allcard Fund – see The Worshipful Company of Musicians

CC No: 264303

Angus Allnatt Charitable Foundation

CC No: 1019793

34 North End Road, London W14 0SH

Contact: Calton Younger, Trustee
Trustees: Rodney Dartnall; Anthony Pritchard; Calton Younger; Marian Durban.
Beneficial area: UK.
Grant total: £30,000 (1999/2000)
Arts grants: £19,530
This foundation gives to 'charitable organisations involving young people in either music or water-based activities', but 'not when these activities are used primarily for therapeutic or social purposes'.

The annual report for 1999/2000 shows that the foundation gave a total of over £30,000 in 39 grants of between £250 and £1,200; most were under £1,000. Of this total, £19,530 (64% of grant-aid) was given in 25 grants relevant to this guide. These included:
Harringey Young Musicians Symphony Orchestra (£1,200);
London Master Classes (£1,050);
Tower Hamlets Youth & Community Band; Dorset Opera; Northern Sinfonia Trust; Westmorland Youth Orchestra (£1,000 each);
Royal Scottish National Orchestra (£800);
Manchester Camerata; Queen's Hall, Edinburgh; Sounds New (£750 each);
Opera North; Leicestershire Chorale (£500 each).
Exclusions: Individuals.
Applications: Trustees meet three times a year to consider applications.

The Andersen Consulting Foundation

CC No: 1057696

2 Arundel Street, London WC2R 3LT

Contact: Stephen Walker, Secretary
Trustees: David Mowat; Andrew Middleton; David Thomlinson; Tim Gbedemah; Nat Sloane; Stephen Walker.
Beneficial area: UK.
Grant total: £796,000 (1998/99)
This foundation is personally funded by the UK partners of Andersen Consulting. It makes substantial donations to charities with educational, medical, community and cultural purposes.

Funding is principally given via a focused programme of long-term grants so as to maximise the benefit of donations. Amongst those receiving support through this scheme are the British Museum Education Programme and English National Opera (Baylis Programme). Further 'ad hoc donations' are made to other charitable causes.

In 1998/99 the foundation made grants totalling £796,000. No further details were featured in the annual report.

The Milly Apthorp Charitable Trust

CC No: 284415

c/o BDO Stoy Hayward, 8 Baker Street, London W1M 1DA

Tel: 020 7486 5888
Contact: The Secretary
Trustees: John D Apthorp; Lawrence S Fenton.
Grant total: £531,000 (1999/2000)
Arts grants: £70,483
This trust funds a variety of charitable causes in Barnet and surrounding areas. Each year around £500,000 is designated to the three following funds administered by the London Borough of Barnet: Administered Fund, for wide needs; Holiday Fund, for holidays for disabled people; Apthorp Adventure Fund, providing character-building activities for youth. The remainder of the trust's grants are given via its general income fund.

The trust also funds an educational loan scheme 'whereby students receiving grants for educational purposes are required to pay back a proportion of these after completing their courses'.

One of the trust's annual commitments is the Apthorp Fund for Young Artists, through which prize money is awarded to artists. This provides recognition of achievement but also acts as payment for the purchase of their work. Work may be submitted by young artists resident in Barnet, Brent, Enfield, Haringey and Harrow for judging in consideration for prize money ranging from £100 to £5,000.

The trust has also set aside £250,000 over five years to fund a major arts centre in Barnet which will serve as a performance venue and house an art gallery. Work started on this project in early 2001, with a likely opening date in autumn 2002.

In 1999/2000 a total of over £531,000 was given by the trust. This was distributed as follows:
- London Borough of Barnet (administered fund) – £435,000;
- London Borough of Barnet (holiday fund) – £30,000;
- London Borough of Barnet (Apthorp adventure fund) – £20,000;
- General Income Fund – £46,500.

A total of £70,483 was given to organisations and individuals in 34 arts-related grants or loans, all of which were made through the LBB Administered Fund. These included:

Apthorp Fund for Young Artists, prizes/ purchase of art work (£20,000);
Grahame Park Childminding Network Toy Library (£2,550);
Artsreach, disability arts conference (£1,800);
Theatre Rites, for public performance of a play; Ahkom, multicultural 'Teenfest' event (£1,000 each);
3rd New Barnet Scout Group Band, for musical instruments (£600);
Child's Hill School Centenary Trust, purchase of musical instruments (£500);
Exiled Writers Ink, literature and creative writing (£350).

Exclusions: Projects outside designated area.

Applications: Application forms for grants from the Administered Fund may be obtained from: Mrs Angela Corbett, Chief Executive's Office, London Borough of Barnet, The Town Hall, The Burroughs, London NW4 4BG.

Artists submitting pieces for the Apthorp Fund for Young Artists should telephone the appropriate number from the following list for necessary addresses and guidelines:
Barnet: 020 8359 3152;
Brent 020 8459 5381;
Enfield: 020 8379 3659;

Haringey: 020 8365 7500;
Harrow: 020 8424 1242.

Stephen Arlen Memorial Fund

CC No: 268553

c/o English National Opera, London
Coliseum, St Martin's Lane, London
WC2N 4ES

Tel: 020 7845 9355; Fax: 020 7845 9274
E-mail: thowell@eno.org
Website: www.eno.org
Contact: Dawn Bowman, Administrator
Trustees: Iris Arlen; Val Bourne; Lord
Harewood; Rodney Milnes; Rupert
Rhymes.
Beneficial area: UK.
Grant total: £3,000 (2001)
Arts grants: £3,000
The fund provides a non-educational
bursary to help individuals aged 18–30
years and resident in the UK with their
development in any area of the arts.

In 2001 the Stephen Arlen Bursary of
£3,000 was given to a director for a new
play in Croydon. In 2000 the bursary was
awarded to a pianist for a solo
composition and performance at
Wigmore Hall. The 1999 bursary was
made jointly for a soprano, and a
director/performer, each of whom
received £1,500.
Applications: In writing to the
correspondent. Trustees meet once a year
to consider applications. Application
deadline is the end of February for awards
in the autumn.

The Arts Foundation

CC No: 1007208

2nd floor, 6 Salem Road, London
W2 4BU

Tel: 020 8229 3813; Fax: 020 8229 9410
E-mail: artsfound@hotmail.com
Contact: Shelley Warren, Director
Trustees: Diana Donovan, Chair; Lord
Gowrie; Ed Victor; Mathew Prichard;

Nelson Woo; David Campbell; Herschel
Post; Professor Margaret Buck; Valerie
Eliot.
Beneficial area: UK.
Grant total: £50,000 (1999)
Arts grants: £50,000
The foundation funds artists living and
working in England, Scotland or Wales
who have demonstrated commitment to
and proven their ability in their chosen
art form.

A minimum of five annual fellowships
is awarded worth £10,000 each in five
specific art forms that change each year.
Arts forms chosen have included cross-
disciplinary work, installation, jazz
composition, music – general
composition, painting, photography,
screenwriting, sculpture, theatre design,
and digital art.

The programme is not open to
applications. Some 70 established artists
and other professionals nominate
individual artists who are then invited to
make an application.
Applications: No unsolicited
applications are accepted.

The Arvon Foundation

CC No: 306694

2nd Floor, 42a Buckingham Palace
Road, London SW1W 0RE

Tel: 020 7931 7611; Fax: 020 7963 0961
E-mail: london@arvonfoundation.org
Website: www.arvonfoundation.org
Contact: Centre Directors
Trustees: Council of Management:
Prudence Skene, Chair; Alan Brownjohn;
Sandy Brownjohn; Susan Burns; Alastair
Campbell; Berlie Doherty; Maura
Dooley; James Furber; Barbara Hughes;
David Hunter; James Long; Pete Morgan;
John Sewell; Sue Stewart; Sue Teddern.
Beneficial area: UK.
This foundation's principal activity is the
running of a wide range of writing
courses. It attracts more than a thousand
people each year onto its open courses

and also runs closed courses for schools, colleges and other groups.

Courses last for four and a half days and cover many disciplines, including poetry, fiction, stage drama, and writing for TV and radio. They are open to anyone over the age of sixteen with a desire to write. Each course is tutored by two professional writers, with a mid-week guest reader and up to sixteen students. The courses take place at the foundation-owned centres in Devon and West Yorkshire and at a centre it supports in Inverness-shire. The Hurst, a new centre in Shropshire, is due to open in 2002.

Courses receive financial support from the Arts Council of England, the Scottish Arts Council and some regional arts boards. It is the Arvon Foundation's firmly held conviction that its courses should be open to anyone with an interest in writing, regardless of their means. Grants are therefore available for people unable to afford the full fee. These grants and bursaries come from a wide range of contributors, as well as from the Arvon Foundation's own Bursary Endowment Fund. Contact the foundation or visit its website for details. **Applications:** For full details about the competition, grants and bursaries contact the foundation.

The Ashden Charitable Trust

(see also the Sainsbury Family Charitable Trusts)

CC No: 802623

9 Red Lion Court, London EC4A 3EF

Tel: 020 7410 0330
Contact: Michael Pattison, Director
Trustees: Mrs S Butler-Sloss; R Butler-Sloss; Miss J S Portrait.
Beneficial area: UK and overseas.
Grant total: £730,000 (1999/2000)
Arts grants: £60,761
This trust is one of the Sainsbury Family Charitable Trusts which share a common

administration. The trust supports initiatives, often over a number of years, within the following categories: environmental projects in the UK; environmental projects overseas; homelessness; urban rejuvenation; community arts; general.

Support for community arts is focused on grassroots activities, particularly projects involving marginalised groups for which modest grants can have a considerable impact. The trust also has a continually developing interest in environmental drama and is funding an internet-based 'Directory of Environment and Drama'.

In 1999/2000 the trust gave a total of over £730,000, which was distributed as follows:

- environmental projects UK – £221,651 (30%);
- environmental projects overseas – £215,779 (30%);
- homelessness – £128,453 (18%);
- urban rejuvenation – £91,092 (12%);
- community arts – £48,761 (7%);
- general – £23,566 (3%).

A total of 61 grants were made, 11 of which were for arts-related causes. Funding relevant to this guide amounted to £60,761 (8% of total funding) and was given to the following beneficiaries:
Under 'urban rejuvenation' –
*Right Angle Productions, Oxford, to pay for a member of staff for video project engaging young people (£10,000).
Under 'community arts' –
*Environmental Drama, for the development of the Ashden Directory of Environment and Drama (£11,091);
*Sound It Out, Birmingham, towards 'Musical Connections' project to alleviate isolation (£6,400);
Academy of St Martin in the Fields, London, for music workshops for homeless people (£5,400);
*Artlink, Edinburgh, for an art project working with people with learning difficulties; Channel Arts Association

Ilfracombe, for National Youth Arts Festival; Death by Theatre Ltd, London; ★Kneehigh Theatre, Truro, developing bases for Cornish arts; ★Nutmeg, Suffolk, for schools tour of a play (£5,000 each);

★University of Greenwich, towards initial developmental stages of a pilot primary schools drama project (£870).

Under 'general' –

Rise Phoenix, towards touring theatre project working with young people in Kosovo (£2,000).

Exclusions: Individuals.

Applications: 'Proposals are generally invited by the trustees or initiated at their request. Unsolicited applications are not encouraged and are unlikely to be successful.'

The Laura Ashley Foundation

CC No: 288099

3 Cromwell Place, London SW7 2JE

Tel: 020 7581 4662
Website: www.laf.uk.net
Contact: Mrs Annabel Thompson, Administrator/Company Secretary
Trustees: Sir Bernard Ashley; Ms Jane Ashley; Martyn Gowar; Professor Susan Golombok; Lord Queensbey; Martin Jones.
Beneficial area: UK, predominantly Wales and rural England.
Grant total: £280,000 to organisations; £76,000 to individuals (1999/2000)
Arts grants: £55,575
The foundation gives assistance to 'talented individuals aged thirty and upwards to achieve their full potential through education and design, and to help sustain rural life'. Funding is limited to England and Wales, with a particular emphasis on mid Wales.

Annually, the foundation provides bursary funding to 'leading centres of higher education'. Recipients have included the Royal College of Art, Welsh College of Music and Drama and RADA.

It also funds the Laura Ashley Fellowship Awards, which are given to between two and four people each year 'who have innovative ideas in the arts and the sciences'.

In 2000 the foundation gave a total of almost £356,000. Out of this, £76,000 was given in 90 grants and fellowships for individuals and an unspecified number of donations to institutions totalling £280,000. Of the grants to institutions, only those of £1,000 or more were listed in the annual report. The largest of these was for £19,000, although most were £10,000 or less. Specified arts grants, amounting to £55,575 (15% of total grant-aid), were disbursed to the following six beneficiaries:
★Royal College of Art (£19,000);
★City & Guilds of London Art School (£10,475);
★Royal Academy of Music; ★Welsh College of Music and Drama (£10,000 each);
★City Literary Institution (£3,600);
★Mid Wales Opera (£2,500).

Exclusions: Grants will not be made to organisations outside Wales for: buildings; drug-related causes; expeditions; publications; making tapes/videos; exhibitions.

Grants are not given for individuals' courses for dance; drama; trips or study abroad; home study; degree courses; alternative medicine; counselling; career guidance; MBA; or art or dance therapy. No childcare or equipment costs.

Applications: Applications for music conservatoires, conservation & restoration, and postgraduate courses must come through a college, not from individuals.

Send a SAE for an information sheet, which gives examples of funding, exclusions, dates of trustees' meetings and an application form.

The foundation replies only to applications that it wishes to consider further.

The Richard Attenborough Charitable Trust

CC No: 259186

Beaver Lodge, Richmond Green, Surrey
TW9 1NQ

Tel: 020 8940 7234
Contact: Lady Attenborough, Trustee
Trustees: Lady Attenborough; Lord
Attenborough.
Beneficial area: UK.
Grant total: £139,000 (1998/99)
Arts grants: £45,450
This trust gives to a wide range of causes
with particular interest in human rights,
health, education and disability. Arts
grants, mainly for established
organisations and on a one-off basis, are
also made each year.

The annual report and accounts for
1998/99, the most recent on file at the
Charity Commission, shows that the trust
gave a total of £139,000 in 43 grants.
Over half of this total was disbursed in
one grant of £74,755 to the Greater
London Fund for the Blind. The
remaining donations were between £100
and £21,000, although most were under
£5,000. A total of £45,450 (33% of total
grant-aid) was given in 10 arts-related
grants. These were:
★Royal Academy of Dramatic Art
 (£21,000);
Tate Gallery (£10,000);
Royal Academy of Arts; Toynbee Hall
 (£5,000 each);
Chicken Shed Theatre Company (£1,500);
National Film and Television School
 (£1,000);
★Whitechapel Art Gallery (£350);
National Youth Music Theatre; ★Actors'
 Charitable Trust (£250 each);
Guild Film Production Executives
 (£100).

The Society of Authors

84 Drayton Gardens, London SW10 9SB

Tel: 020 7373 6642; **Fax:** 020 7373 5769
E-mail: info@societyofauthors.org
Website: www.societyofauthors.org
Contact: Dorothy Sym, Awards Secretary
Trustees: The society is not a charity.
Baroness James, President; Philip Pullman,
Chair; Mark le Fanu, General Secretary.
Beneficial area: UK.
Grant total: Around £190,000 annually
in prizes, awards and grants
Arts grants: £190,000
The society administers a number of
schemes for awards, prizes or grants.
Further information sheets are available
from the society. Awards are also made for
translations from French, Italian, Dutch,
and German. The following schemes are
administered by the society:

Prizes

Application forms and guidelines are
available from the society. Entry is by
publisher where prizes are for published
works.
Cholmondeley Awards – for poets.
These were endowed by the late Dowager
Marchioness of Cholmondeley in 1966.
They are made on the strength of a poet's
body of work and submissions are not
accepted. Four awards, of £2,000 each,
were made in 2001.
Encore Award – for a second published
novel. In 2001 the winner received
£10,000. Closing date for entries: 30th
November.
Eric Gregory Awards – for promising
poets under the age of 30. A total of
£24,000 was distributed to six poets in
2001 in grants ranging from £3,000 to
£5,000. Closing date: 31 October.
Tom-Gallon Award – a biennial prize
for a short story. In 2001 £1,000 was
awarded. Closing date: 20 September.
Richard Imison Memorial Award –
an award of £1,500 is for the best
dramatic work broadcast by a writer new
to radio.

McKitterick Prize – for a first novel, published or unpublished, by an author over the age of 40. In 2001 a prize of £4,000 was awarded to one author. Closing date: 20 December.

Sagittarius Prize – given for a published first novel by an author over the age of 60. A prize of £2,000 was given to one author in 2001. Closing date: 20 December.

Somerset Maugham Awards – for British authors under the age of 35 to enrich their writing by foreign travel, given on the strength of a published book. A total of £12,000 was awarded to two authors in 2001. Closing date: 20 December.

Translation Prizes – for published translations of full-length works. Prizes range from £1,000 to £2,000. Closing date: 20 December.

Betty Trask Prize and Awards – for first novels (published or unpublished) by writers under the age of 35. A total of £25,000 is given for works of a romantic or traditional, but not experimental, nature. In 2001 the winner of the prize received £6,000; the five further award winners received £5,000, £4,000 or £2,500. Closing date: 31 January.

Travelling Scholarships – annual awards made to enable British writers to keep in touch with colleagues abroad. They are non-competitive and submissions are not required. Awards of £1,500 each were given to four writers in 2001.

Sunday Times Writer of the Year Award – for a full-length published work of fiction, non-fiction or poetry by an author under the age of 35. In 2001 the award was for £5,000. Closing date: 20 December.

Grants

The Authors' Foundation – gives grants to authors who need funding while working on a book, fiction or non-fiction, commissioned by a British publisher. It is supported by authors and charitable trusts, including, in particular, the Royal Literary Fund. A total of about £60,000 is usually awarded each year. Application is by letter. Closing dates: 30th April and 31st October.

The K Blundell Trust – for British authors under the age of 40 to assist them with research, travel or other expenditure. Applicants must submit a copy of their latest published book and their work must 'contribute to the greater understanding of existing social and economic organisation'. Fiction is not excluded. Grants are for a maximum of £4,000 each. Application is by letter. Closing dates: 30 April and 31 October.

Benevolent Funds

Application forms are available for:

Authors' Contingency Fund – small grants to professional authors with sudden financial difficulties or for the financial relief of their dependants. Grants total about £8,000 each year.

Francis Head Bequest – grants to authors over 35 whose main source of income is from their writing and who are unable to write due to accident, illness or other causes. Priority will be given to authors who are ill or disabled, but the trustees do consider more general applications for help. A total of about £20,000 a year is given.

John Masefield Memorial Trust – occasional small grants to professional poets, or their immediate dependants, who are faced with sudden financial problems. Grants total around £500 per year.

Applications: Contact the society for more details.

The Band (1976) Trust

CC No: 279802

Macnair Mason, Chartered Accountants,
John Stow House, 18 Bevis Marks,
London EC3A 7ED

Tel: 020 7469 0550; Fax: 020 7469 0660
Contact: R J S Mason, Trustee
Trustees: Hon. Mrs Nicholas Wallop; R J
S Mason; B G Streather; Hon. Nicholas
Wallop.
Beneficial area: UK.
Grant total: £612,000 (1999/2000)
Arts grants: £52,925
This trust has a range of charitable
interests, which are supported through
the following categories: medical; legal;
disabled; children; arts; educational; ex-
employees; elderly; church; miscellaneous
up to £2,000; miscellaneous over
£2,000.

In 1999/2000 the trust gave a total of
£612,000 in 78 grants ranging from
£250 to £100,000; most were under
£25,000. Out of this, a total of £52,925
(9% of total grant-aid) was given in 12
grants relevant to this guide. These were:
Under 'arts' –
Vivat Trust (£15,000);
Music for Living; Royal Opera House;
 Stanley Spencer Museum (£5,000
 each);
Pleasance Theatre Festival (£1,500).
Under 'educational' –
Yorkshire Ballet Seminars (£5,000).
Under 'disabled' –
Arts Dyslexia Trust (£5,000).
Under 'medical' –
Chelsea and Westminster Hospital Arts
 Project (£2,000).
Under 'children' –
National Association of Toy and Leisure
 Libraries (£5,000).
Under 'miscellaneous up to £2,000' –
Friends of the V&A; Chelsea Festival
 (£2,000 each);
Grange Park Opera (£425).
Applications: 'Unsolicited applications
are not desired.'

The Verity Bargate Award Trust

CC No: 295099

c/o The Soho Theatre Company,
21 Dean Street, London W1N 6NE

Tel: 020 7287 5060; Fax: 020 7287 5061
E-mail: mail@sohotheatre.com
Contact: Sara Murray, Literary Assistant
Beneficial area: UK.
Grant total: £1,500 (1998)
Arts grants: £1,500
This biennial award, created as a
memorial to the founder of the Soho
Theatre Company, is made to the writer
of a new and previously unperformed
full-length play. The prize of £1,500
represents an option on a full production
by the Soho Theatre Company.
Shortlisted plays are provided with
workshop facilities to assist their further
development. Previous winners include
Judy Upton, Fraser Grace, Adrian Pagan
and, in 1998, Toby Whithouse.
Exclusions: Playwrights with three or
more professional productions to their
credit.
Applications: The award is usually
launched in the spring. For full details
write to Sara Murray at the above
address.

The Baring Foundation

CC No: 258583

60 London Wall, London EC2M 5TQ

Tel: 020 7767 1348; Fax: 020 7767 7121
E-mail:
baring.foundation@ing-barings.com
Website: www.baringfoundation.org.uk
Contact: Toby Johns, Director
Trustees: Nicholas Baring, Chairman;
Tessa Baring; R D Broadley; Janet Lewis-
Jones; Lady Lloyd; Sir Crispin Tickell;
Martin Findlay; Anthony Loehnis; Dr
Ann Buchanan; J R Peers; Christopher
Steane.
Beneficial area: England and Wales.
Grant total: £3,147,000 (2000)

Arts grants: £697,000

The foundation runs three distinct programmes: Arts; Strengthening the Voluntary Sector; International. These each have their own criteria and detailed guidelines, which should always be checked prior to any application. The Arts Programme is directly relevant to this guide, whilst applications to the Strengthening the Voluntary Sector Programme must be concerned with organisational improvements. The International Programme has very specific aims which are not relevant to this guide. The following guidelines for Arts and Strengthening the Voluntary Sector were brought into effect in January 2002:

Arts Programme
Aims and priorities

This programme contributes to the cost of small-scale projects taking place in an educational or community context. Support is given to a wide range of activities in England and Wales and encompasses all art forms. The foundation has simplified the scheme by combining the previously operating Small Grants Fund and Knowledge and Skills Exchange Fund into one programme. Its objectives are to support:

- access to the arts and create opportunities for people whose access is limited;
- work by arts organisations which improve people's quality of life;
- education in and through the arts for people of any age, ability or educational background;
- the exchange of knowledge and skills within the arts sector.

Applications for the Arts Programme

Each year around 65 grants worth between £1,000 and £7,000 are made to not-for-profit arts organisations of all sizes through this programme. The total budget for any project must not exceed

£25,000. Collaborative projects involving other sectors are welcomed but the application must be made by a 'legally constituted arts organisation'. Priority will be given to applicants who can demonstrate that the proposed project has been adequately planned. Projects are more likely to receive support if commencing no sooner than eight weeks after the grants committee meets. Only one application may be made within a 12 month period.

All applications must be made on the Arts Programme application form which is available in Word document format from the website or postally upon telephoned or e-mailed request. The following details must be included with the form:

- a detailed budget for the proposed activity;
- an example of publicity for, or documentation of, your organisation's work;
- accounts for the most recent financial year;
- if relevant, evidence of the involvement of other organisations in the planning of the project.

Applications are considered three times a year. Deadlines are as follows:
Last day of February for consideration in the last week of May; last day of June for consideration in the last week of September; last day of October for consideration in the last week of January.

Exclusions from the Arts Programme

- organisations not constituted as arts organisations;
- organisations and projects outside England or Wales;
- unconstituted or for-profit arts organisations, individual artists, local authority departments, events or venues, playgroups, schools, colleges, universities, youth clubs or non-arts community groups;

- projects with a budget in excess of £25,000;
- projects scheduled to start before the foundation meets to make its decision;
- running costs of existing projects, events or organisations;
- a repeat of a regular event or activity;
- capital costs;
- academic or vocational training courses;
- participation in a conference, seminar, festival or competition;
- organisation of a training course, conference, seminar or competition;
- website development;
- research trips to develop a creative product, for example exhibitions, plays, films, compositions;
- general fundraising appeals.

Strengthening the Voluntary Sector Programme

The objective of this programme is to improve the organisational effectiveness of voluntary organisations. It is open to constituted not-for-profit voluntary organisations working nationally across England and/or Wales, throughout London, on Merseyside, in Devon, in Cornwall and to international development organisations based in the UK.

The foundation aims to fund work leading to significant and lasting change in the effectiveness of organisations through improvements in strategy, structure, systems or skills. For example:

- the introduction of organisational strategy and business planning or fundamental reviews of existing strategies and plans;
- a more effective management structure;
- enhanced coordination and collaboration between organisations;
- formal combined working or mergers;
- improvements to systems such as information technology, finance, personnel and training;
- appropriate assessment of quality and effectiveness;
- introducing new skills or knowledge;
- making organisations more responsive to the needs of their users.

These are merely examples; other work improving the effectiveness of an organisation will be considered.

The ways in which grants have been used include:
- freeing up the time of existing staff to undertake the work;
- feasibility studies;
- pilot studies;
- training;
- buying in external advice and expertise;
- meeting the costs of seminars or conferences;
- exchanging skills and knowledge between organisations.

Applications for the Strengthening the Voluntary Sector Programme

Applications for grants of up to £30,000 are considered for work spanning up to two years. The average grant is, however, for £8,710 and only 23% of donations are over £10,000. The foundation may fund entire projects or provide support in conjunction with other funders.

Requests must be made using the programme's application form available from the website in Word 6.0 format or by e-mailing the foundation. Applications must be accompanied by:
- a brief description of the current work and experience of your organisation including details of staffing, organisational structure and use of volunteers;
- an outline description (not exceeding two pages) of:
 – what is proposed and will be achieved with the grant
 – the need that will be tackled and how it was assessed
 – how long the activity will take to complete

– who will carry out the work and who will benefit

– why your organisation is equipped for the project

– how the activity will be documented and evaluated

– why the proposed activity cannot be funded from elsewhere and what, if any, other funding might be attracted if the initiative is successful;

- the detailed brief, if funding is requested for a consultancy;
- a detailed budget for the activity;
- the income/expenditure projection of the organisation for the current year;
- the organisation's most recent audited accounts or financial report;
- the latest annual report, if one is published.

When an application concerns more than one organisation, it can be made jointly or by a lead organisation. In the latter case a copy of the accounts and annual reports of the other organisations will also be required. One of the organisations will need to adopt the responsibilities of the grant recipient. Applications involving joint activities or mergers should indicate whether details of grants can be made public.

Applications may be sent at any time and are considered five times a year. Decisions take between four and six months. All will be acknowledged and the outcome will be notified by letter. Applicants may be visited by foundation staff or advisors as part of the application process.

Exclusions from the Strengthening the Voluntary Sector Programme

- running costs, including salaries of new staff;
- cost of existing or increased services;
- work already completed, taking place or due to start while the application is considered;
- repeat of an activity that took place in a previous year;
- routine staff training;

- costs of employing fundraisers;
- general fundraising appeals;
- purchase, conversion, refurbishment of buildings, gardens or playgrounds;
- general office equipment including IT hardware;
- vehicles;
- medical research or equipment;
- bursaries or scholarships;
- expeditions;
- religious activity.

Distribution of grant-aid

Around one quarter of grants tend to be awarded to projects based in London. However, the geographical spread of grants is reflective, not of targeting by the foundation, but of the number of applications received from each region.

In 2000 the foundation gave a total of £3,147,000 in 178 grants. Out of this, £697,000 (22% of total grant-aid) was given in 74 arts-related grants, all of which were made through the Arts Programme.

A full annual report was not available for 2001 at the time of writing but the foundation is reported to have funded 63 arts projects with grants totalling £224,000. These included:

Cross Border Arts, towards a research project into the benefits of audio-visual productions (£6,700);

London Sinfonietta, music and drama project for prisoners at HMP Maidstone (£6,000);

Mu-Lan Arts Ltd, towards a pilot education programme exploring themes of race and inclusion, linked to theatre performances in Deptford (£5,628);

Bamboozle Theatre Company, to provide opportunities for young people with learning difficulties in Leicester to discover their potential through educational theatre experiences; Heads Together Productions Ltd, for community video project addressing the realities of social exclusion in Leeds;

Greenwich & Docklands Festivals, preparatory training for disabled adults (£5,000 each);

Kali Theatre Company, creative writing workshops for Asian women who have experienced domestic violence; Bloominarts, towards a street banner project in Oxford; Royal Liverpool Philharmonic Society, to produce the scheme of work to accompany the orchestra's schools concerts (£4,000 each);

Union Chapel Project, for a programme of performing arts activity to celebrate Refugee Week; London International Festival of Theatre, towards a skill-based project for young black and Asian men who are considering a creative career; Hope Street Ltd, arts education projects for people in Liverpool who may feel excluded from the arts (£3,000 each);

Deal Summer Music Festival, towards arts administration training for disadvantaged young people (£2,500);

2 Faced Dance Company, to support two weeks of breakdancing performances involving young people in the West Midlands; London Shakespeare Workout, towards a workshop and performance of original verse involving professional actors and inmates at HMP The Mount (£2,000 each);

Cuckoo Farm Studios, for a festival of exhibitions, workshops and demonstrations for schoolchildren in Colchester; Physical Recall Dance Company, to support an artist–led exchange to develop creative and education skills (£1,500 each);

Gloucestershire Dance, to enable new dance leaders to shadow artists in working with youth dance groups (£1,300).

Exclusions: *General:* appeals or charities to support statutory organisations; animal welfare charities; grant-maintained, private or LEA schools or their PTAs; individuals. For more details see above.

Applications: All prospective applicants should always obtain a copy of the foundation's guidelines and application forms. There is no provision for 'general' applications that lie outside the foundation's specific programmes.

Applications should be returned with the supporting materials listed on the last page of the form.

A list of grants already made from this fund is available on request from the foundation or from its website.

Foundation staff in August 2001 were:
Director: Toby Johns.
Administration Officers: Mrs B Allerhand; Miss Z A Kaye; Mrs T Skelhorn.
Information Officer: Anne Murray.
Special Advisers: Phyllida Shaw; Esther Salamon; Deborah Sathe (Arts); Julia Unwin (Policy); Lucy Ball; Nikki Eastwood; Berry Rance; Barbara Riddell; Judith Thompson; Claire Walters (Voluntary Sector); John Twigg (International).

The Lionel Bart Foundation

CC No: 1086343

55 Drury Lane, London WC2B 5SQ

Tel: 020 7379 6080
Contact: John Michael Roth Cohen
Trustees: John Michael Roth Cohen; Malcolm Webber; Michael Pruskin.
Beneficial area: UK.

This new foundation was registered in April 2001 in memory of Lionel Bart, the entertainer and musician, best-known for 'Oliver!', who died in 1999. Its objective is the advancement of education through the funding of scholarships for individuals. Funding is aimed at professional actors, composers, lyricists, book writers, playwrights, designers, choreographers, directors and persons who wish to make the theatre their career but cannot afford educational fees.

The BBC Children in Need Appeal

CC No: 802052

PO Box 76, London W3 6FS

Tel: 020 8576 7788; Fax: 020 8576 8887
E-mail: pudsey@bbc.co.uk
Website: www.bbc.co.uk/cin
Contact: Roz Jones, Office Manager
Trustees: Roger Jones, Chairman; Tim
Cook; Will Day; Lorraine Heggessey;
Diane Louise Jordan; Michelle Kershaw;
Neena Mahal; Simon Milner; Liz Rylatt;
Angela Sarkis; Pippa Wicks; Terry Wogan;
Andy Duncan.
Beneficial area: UK.
Grant total: £20,700,000 (2000/01)
Arts grants: £560,000 but see below
**The figure for arts grants recorded
above is only an estimate. It is
anticipated that the level of funding
given to projects within the broad
scope of this guide, which includes
activities where the arts are used as a
tool for social welfare, was
significantly higher.**

The appeal supports projects which seek
to benefit children with mental, physical
or sensory disabilities; children with
behavioural or psychological disorders;
and children living in poverty or in
situations of deprivation; and children
suffering through distress, abuse or
neglect. It makes grants of all sizes for
both one-off expenditure and for up to
three years for specified running costs. It
assists with capital costs and equipment
purchase but rarely with new buildings.
*Any grants for arts-related activities are made
strictly to meet the above aims.*

 In 2000/01 the charity gave a total of
£20,700,000 in 1,830 grants to
organisations around the UK. Out of this,
a total of £560,000 was estimated to have
been disbursed to arts-related
beneficiaries. Recipients included:
In South East England –
Sound Base Studios Trust (£72,585 over
 3 years);

Africans Children's Club (£8,065);
Corali Dance Company (£5,500);
Springfield Youth Project (£1,500).
In South West England –
Wolf & Water Arts (£46,673 over 3
 years);
Current Account Theatre Project
 (£2,600);
Magic Carpet (£2,360);
Lewes Youth Centre (£1,620).
In North West England –
Manchester Youth Theatre (£10,500);
Liverpool & Merseyside Theatres Trust
 (£6,500);
Royal Exchange Theatre Company Ltd
 (£5,000);
Brooklyn Belles (£600).
In Midlands & East England –
Community Business Trust Village
 Playhouse (£12,000);
Birmingham Repertory Theatre
 (£5,831);
Stage 2 (£3,460);
Rethink Disability (£1,000).
In North East England –
Grimethorpe and District Band
 (£4,885);
Stickie Fingers (£2,200).
In Scotland –
Stills (£20,000).
In Wales –
South Riverside Community
 Development Centre (£4,884);
Llanelli Youth Theatre (£3,000);
Ely Play Centre Association (£1,250).
In Northern Ireland –
Education Through Arts & Culture
 (£7,500);
Down Community Arts (£3,920);
Dance Devotion (£1,950).

Exclusions: The appeal does not
consider applications from private
individuals or the friends or families of
individual children. In addition, grants
will not be given for trips and projects
abroad; medical treatment or medical
research; unspecified expenditure; deficit
funding or repayment of loans;
retrospective funding projects which will

take place before applications can be processed (see note on closing dates below); projects which are unable to start within 12 months; distribution to other organisations; general appeals or endowment appeals; or the relief of statutory responsibilities.

Applications: Clear comprehensive grant guidelines are available.

Note: Applications for minibuses or other vehicles must explain why it wouldn't make more sense to borrow, share or hire transport, and must detail the running costs and show how these would be met.

There are two closing dates for applications – November 30 and March 30. Organisations may submit only one application and may apply to only one of these dates. Applicants should allow up to five months from each closing date for notification of a decision. (For summer projects applications must be submitted by the November closing date or be rejected because they cannot be processed in time.)

The Beecroft Bequest – see The Museums Association

The Hervey Benham Charitable Trust

CC No: 277578

3 Cadman House, off Peartree Road, Colchester, Essex CO3 5NW

Contact: J Woodman, Clerk
Trustees: M Ellis, Chair; A B Phillips; M R Carr; K E Mirams.
Beneficial area: UK, with particular emphasis on Colchester and surrounding areas.
Grant total: £24,000 (1999/2000)
Arts grants: £24,000
The trust's primary aims are to support the following:

- 'artistic (particularly musical) activities which benefit the people of Colchester and district';

- 'individuals with potential artistic (especially musical) talent who are held back by physical, environmental or financial disability';
- 'preservation of the heritage from the past of Colchester and district and of the maritime traditions of the Essex/Suffolk coast';
- 'local history and conservation affecting the heritage and environment of the area'.

In 1999/2000 the trust gave a total of over £24,000 in 15 arts-related grants ranging between £372 and £10,000; most were under £2,700. These included nine educational bursaries or scholarships for individuals and the following donations to organisations:

Kingsway Hall Trust, property purchase appeal (£10,000);

Colchester Engineering Society, history of local engineering display at Museum of East Anglia Life (£2,700);

Braintree District Museum Trust, exhibition programme (£500);

Kingsway Hall Arts and Theatre Community Trust, refurbishment costs (£500);

St Botolph's Music Society, 1999 Hervey Benham Young Soloists Concert sponsorship (£372).

The trust has also been a regular supporter of the Headgate Theatre, which is due to open in February 2002.

Exclusions: Purposes outside the trust's aims or outside the designated geographical area.

Applications: Trustees meet quarterly to decide on applications.

The Bonnie Bird Choreography Fund

CC No: 328615

c/o Laban Centre London, Laurie Grove, New Cross, London SE14 6NH

Tel: 020 8692 4070; Fax: 020 8694 8749
E-mail: m.morris@laban.co.uk

Contact: Margaret Morris, Chair of Trustees
Trustees: Margaret Morris, Chair; Stuart Hopps; Gill Clarke; Marion North; Richard Matchett; Anthony Bowne; Graham Hutton, Treasurer; Ellie Beedham, Secretary.
Beneficial area: UK (also USA & Canada, but see below).
Grant total: £6,359 (1999/2000)
Arts grants: £6,359
This fund supports choreography through the following: awards; commisioning of dance works; supporting international exchanges; funding dance research; assisting with dance-related publication; sponsoring the teaching of dance; support for inter-related arts projects; other dance-related grants.

In 1999/2000 the fund gave a total of £6,359, all of which was relevant to this guide. Of this, £4,500 was given in three awards to British choreographers, £1,250 was given through the annual Chris de Marigny Dance Writers Award, £500 was donated to Dance Base, Edinburgh, in support of a mentoring scheme, and £109 was given to Dance UK to assist with travel expenses.
Exclusions: Educational fees.
Applications: For awards: An application form is available from the fund from December, to be completed and returned before selection in February. Award winners are notified in May.

The Charlotte Bonham-Carter Charitable Trust

CC No: 292839

Messrs Farrer & Co., 66 Lincoln's Inn Fields, London WC2A 3LH

Contact: Sir Matthew Farrer, Trustee
Trustees: Sir Matthew Farrer; Norman Bonham-Carter; Nicolas Wickham-Irving.
Beneficial area: UK, particularly Hampshire; also overseas.
Grant total: £90,000 (1999/2000)

Arts grants: £29,000
The trust principally supports charities with which Lady Charlotte Bonham-Carter was particularly associated during her life or other causes in Hampshire, although national charities also receive funding.

In 1999/2000 the trust gave a total of over £90,000 in 54 grants ranging from £250 to £15,000; most were between £500 and £7,000. A total of £29,000 (32% of total grant-aid) was given to arts-related beneficiaries in the following 15 grants:
*Ashmolean Museum (£7,000);
Tate Gallery (£5,000);
Gilbert White Museum (£4,500);
British Museum (£2,500);
Dulwich Picture Gallery; Ballet Rambert (£2,000 each);
Natural History Museum; *Royal Academy of Arts; Lindley Library (£1,000 each);
Hampshire Museums Trust; Hampshire Music 2000; Music Space Trust; Royal Air Force Museum; William Herschell Museum; Winchester Theatre Fund (£500 each).

Exclusions: Organisations which are not registered charities.
Applications: In writing to the correspondent. The trust states that it is 'not anxious to receive unsolicited general applications as these are unlikely to be successful and only increase the cost of administration of the charity'.

The Book Trust

CC No: 313343

Book House, 45 East Hill, London SW18 2QZ

Tel: 020 8516 2981
E-mail: deborah@booktrust.org.uk
Website: www.booktrust.org.uk
Contact: Deborah Hallford
Trustees: Eric Bolton, Chairman.
Beneficial area: UK, Commonwealth countries.

Grant total: £101,000 (1996/97 – prizes only)

Arts grants: £101,000

The Book Trust exists to administer a portfolio of prizes which are for published works submitted via publishers. These prizes (followed by their value in 1996/97) are:

Booker Prize for Fiction – (£20,000).

David Higham Award – for a first novel/book of short stories (£1,000).

BP Conservation Book Prize – formerly Sir Peter Kent Conservation Book Prize (£5,000).

The Mail on Sunday/John Llewellyn Rhys Prize – (£5,000, shortlisted authors receive £500).

Kurt Maschler Award – for books combining text and illustration for children (£1,000).

Smarties Book Prize – for books for children in three age categories: 5 and under, 6 to 8 years and 9 to 11 years (Gold Award £2,500, Silver Award £1,500, Bronze Award £500 in each age category).

The Saga Prize – for an unpublished novel in manuscript form written by a person born in the UK or the Republic of Ireland with black African ancestry. Sponsored by the Saga Group. Entrance fee £10.00. (£3,000 prize plus publication by Virago Press).

Orange Prize for Fiction – for novels in English by women (£30,000).

Commonwealth Writers' Prize and Festival – (Best Book £10,000, Best First Book £1,000, 8 regional winners £1,000 each).

The Bowerman Charitable Trust

CC No: 289446

Champs Hill, Coldwaltham, Pulborough, West Sussex RH20 1LY

Tel: 01789 831 205
Contact: Mr D W Bowerman, Trustee
Trustees: Mr David W Bowerman; Mrs

Clarice M Bowerman; Mrs J M Taylor; Miss K E Bowerman; Mrs A M Downham.

Beneficial area: UK, with a particular interest in West Sussex.

Grant total: £366,000 (1999/2000)

Arts grants: £155,261

This trust's chief charitable concerns are 'church activities, the arts, medical charities, youth work, relief of poverty and resettlement of offenders'.

In 1999/2000 the trust donated a total of £366,000 in 44 grants, over half of which was given in 2 grants of £100,000. Only grants of over £1,000 were listed in the annual report and nine of these, amounting to £155,261 (42% of total grant-aid), were given to arts-related causes. These were:

Elgar Foundation (£100,000);
★English Chamber Orchestra and Music Society (£17,950);
★Royal College of Music (£10,000);
Theology Through the Arts (£5,000);
Chelsea Festival (£8,100);
★Music at Boxgrove (£5,211);
Royal Philharmonic Society;
★Arundel Festival (£4,000 each);
Orchestra of St John's Smith Square (£1,000).

The majority of donations are given anonymously and David Bowerman has stated that 'publicity for these items would be disastrous, both for myself and the trust, and I wish most strongly that they should not be included'. Applicants should note that the trust neither invites nor replies to unsolicited applications.

Applications: The trustees normally make donations anonymously and accept **no unsolicited applications.**

The Bridge House Estates Trust Fund

CC No: 1035628

Grants Unit, PO Box 270, Guildhall, London EC2P 2EJ

Tel: 020 7332 3710; Fax: 020 7332 3720
E-mail:
bridgehousetrust@corpoflondon.gov.uk
Website: www.bridgehousegrants.org.uk
Contact: Clare Thomas, Chief Grants Officer
Trustees: The Corporation of the City of London. Membership of the grants committee: Peter Rigby, Chair; Geoffrey Lawson, Deputy Chair; Sir Alan Traill; Nicholas Anstee; Wilfred Archibald; William Fraser; Joyce Nash; Barbara Newman; Joseph Reed; John Holland; Esmond Roney; Michael Cassidy; Richard Scriven; John Bird; Richard Agutter; John Barker.
Beneficial area: Greater London.
Grant total: £16,745,000 (2000/01)
Arts grants: £805,420

This fund was originally set up to mend and replace bridges over the Thames in the City of London. The growth of its funds over the years has resulted in a surplus being made available by the Corporation of the City of London, which controls the fund. Funds are designated for causes in the Greater London area and used towards the provision of transport, and access to it, for elderly or disabled people and for other general charitable purposes. Unusually for a grant-making trust, the grants committee holds its meetings in public in order to maintain the transparency of its funding.

Grants are made over one to three years and are given to specific areas, none of which directly target the arts. However, arts activities are considered if meeting the trust's community-based aims.

Transport and access for older and disabled people

The awards are made in three priority areas.

Access to transport:
- community transport schemes;
- projects demonstrating maximum or shared usage of vehicles;
- schemes improving transport services through better coordination.

Access to buildings:
- projects improving access to buildings in the voluntary and community services;
- schemes improving access to the built environment;
- schemes increasing access awareness, information and design.

Access to opportunities:
'The trust welcomes applications from organisations providing:
- training, employment, arts, sports and leisure activities;
- information, advocacy and community support;
- training for independent living;
- specialist aids, equipment or communication facilities, signing;
- disability equality training;
- increased social participation and integration.'

Environmental conservation

This programme aims to help:
- maintain, protect and enhance the natural environment;
- maintain London's biodiversity.

The trust welcomes applications from organisations which are working to:
- develop environmental education work;
- protect and improve the natural environment;
- maintain London's biodiversity or variety of life;
- raise awareness and knowledge of environmental issues within the wider community;
- ensure that resources are used in the least harmful and most efficient way.

Children and young people

This programme has three main themes:

Preventative work:

This includes work with families, individuals and groups, particularly:

- work preventing homelessness or drug and alcohol misuse;
- advice, counselling and information services;
- life skills and personal development projects;
- work breaking cycles of violence, abuse, crime and mental illness.

Active involvement:

Encouraging work that will:

- enable young people to realise their potential;
- encourage young people to take responsibility;
- involve young people actively in their communities, including intergenerational work;
- developing personal and emotional skills, especially in areas of parenting, life skills and relationships.

Young people in crisis:

Applications are welcome from:

- projects tackling drug and alcohol problems and homelessness;
- groups supporting young parents, young carers or those with mental health problems;
- projects offering fresh opportunities to those who are living in poverty or deprivation.

Technical assistance

'Technical assistance is defined by the trust as the provision of information, advice, training and consultancy to help voluntary organisations to develop. The programme aims to:

- strengthen the voluntary sector;
- assist voluntary organisations in long-term development and financial planning.

'The trust welcomes applications from groups which are working to:

- improve the delivery of services by second tier organisations to other voluntary organisations, especially smaller voluntary organisations;
- assist voluntary organisations with their organisational development, for example, training for management committees or volunteers, advice on funding matters and legal advice;
- provide specialist training and information to non-specialist organisations, for example, training and information on disability equality, HIV/AIDS or substance misuse;
- develop councils for voluntary services in boroughs which lack coordinating bodies;
- support organisations which promote volunteering.

'Principles of good practice: the foundation also wishes to encourage applications that will:

- encourage collaboration amongst organisations and better coordination of services;
- promote the sharing of best practice;
- minimise unnecessary duplication.'

Older people in the community

This programme supports a range of services which improve the lives of older people. The aims are to:

- support older people to remain in their own homes;
- improve the care and support of older people;
- promote the health and well-being of older people;
- give older people greater choice and control over services they receive;
- focus on those in greatest need, particularly disadvantaged or marginalised groups.

'The trust highlights the following priorities and welcomes applications from organisations that are working to:

- represent and empower older people without a strong or clear voice;
- enable older people to make informed choices;

- address the needs of older people affected by depression and other mental health problems;
- enable older people in residential or nursing home care to maintain their involvement in the wider community.

'Principles of good practice:
The trust wishes to support applications from organisations that demonstrate a commitment to:

- respect for privacy and dignity;
- maintenance of self-esteem;
- fostering independence;
- choice and control (including the involvement of older people in the management and planning of services where possible);
- recognition of diversity (including ethnic, cultural, religious and social diversity) and individuality;
- safety of older people who use services;
- responsible risk taking;
- citizens' rights;
- sustaining relationships with friends and relatives;
- opportunities for leisure activities.'

Exceptional grants

'Occasionally grants are made outside the above priority areas. Applications will be considered from organisations which demonstrate that they are one of the following:

- demonstratively hard to fund;
- proposing innovative projects;
- responding to new needs and circumstances which may have arisen since the trust fixed its priorities (e.g. a major catastrophe impacting on London);
- requiring short-term assistance to cope with unforeseen circumstances enabling them to adapt to change and move forward (need arising from poor planning will not be considered).

Small Grants Scheme

The aim of this programme is to broaden the trust's giving to include 'small local organisations doing grassroots work'.

Grants are mainly for equipment, running costs and improvements to buildings. The scheme covers 11 boroughs of Greater London each year and supports projects for:

- people with disabilities;
- environmental conservation;
- children and young people;
- older people.

In 1999/2000 the trust gave a total of £16,745,000 in 521 grants. Funding was distributed as follows:

- Transport and access for older and disabled people – £5,869,000 in 103 grants;
- Environmental conservation – £2,522,000 in 23 grants;
- Children and young people – £2,853,000 in 54 grants;
- Technical assistance – £2,361,000 in 37 grants;
- Older people in the community – £1,511,000 in 35 grants;
- Exceptional grants – £812,000 in 5 grants;
- Small grants scheme – £817,000 in 264 grants.

Grants ranged from £500 to £723,000, although most were under £150,000. A total of £805,420 (5% of total funding) was given in 38 grants relevant to this guide. These included:

Under 'Transport and access for older and disabled people'
Access to buildings:
Hackney Empire Appeal, access improvements (£100,000);
Almeida Theatre Company, access improvements; Blackheath Conservatoire of Music and the Arts, access improvements; Contemporary Dance Trust, accessible lift (£50,000 each).

Access to opportunities:
Chisenhale Gallery, arts project for disabled children (£37,500 over 3 years);

Half Moon Young People's Theatre, provision of theatre workshops for young disabled people; London Mozart Players, towards a series of musical performances in the community for older and disabled people (£24,000 each over 3 years);

Strathcona Theatre Company, presentation of a theatrical production by people with learning difficulties (£15,000);

Greenwich & Docklands Festivals, arts training programme and performance costs to enable disabled people to participate (£8,000).

Under 'Children and young people'
Young people in crisis:

Royal National Theatre, towards an intensive theatre project for young offenders (£15,000).

Under 'Older people'

Open Age Project, for a coordinator of an arts and health centre for older people (£37,500 over 3 years);

Paintings in Hospitals, for an artist-in-residence scheme for older people in residential care settings (£17,000);

Time of Our Lives Community Music Theatre, towards a programme of musical theatre for older people (£7,050).

Under 'Small grants scheme'

South Island Children's Workshop (£4,680);

Independent Photography Project (£4,500);

Balagan Theatre Company (£3,800);

Arts Council Bexley (£3,500);

Art House Charity (£1,500).

Exclusions: Individuals; schools or other educational establishments; academic research; religious purposes; relief of responsibility for any local authority or other statutory organisation.

The trust does not normally fund organisations which have received a large proportion of their income from central or local government or the London Boroughs Grants Unit, unless the application relates to a new initiative.

Applications: Applicants should first obtain the fund's full guidelines and application form. Applications should be accompanied by: a copy of the constitution; most recent annual report; latest audited accounts; current budget; any business plan for the proposed project.

The British Record Industry Trust

CC No: 1000413

British Phonographic Industry (BPI), 25 Savile Row, London W1X 1AA

Tel: 020 7851 4002; Fax: 020 7851 4010
E-mail: kelly.coxall@bpi.co.uk
Website: www.brittrust.co.uk
Contact: Kelly Coxall, Administrator
Trustees: Directors: Sam Alder; Paul Burger; John Craig; Rob Dickins; Rupert Perry; Andrew Yeates
Beneficial area: UK.
Grant total: £762,000 (1999)
Arts grants: £737,000

This trust was established in 1989 and is funded mainly by contributions from Brit Awards Ltd and Music Industry Trust Ltd. Its principal aim is 'to encourage young people in the exploration and pursuit of educational, cultural or therapeutic benefits emanating from music'. The trust is run from the offices of British Phonographic Industry Ltd, who provide staff free of charge to administer the trust.

In 1999 the trust gave a total of £762,000. Out of this, £737,000 (97%) was given in grants relevant to this guide. Some of these grants were recurrent. The trust has a large ongoing commitment to the BRIT School for Performing Arts & Technology, to which it gave £260,000 (34% of total grant-aid) in 1999 and £120,000 in 1998. This is a non-fee-paying school jointly funded by the government and other sponsors. The school had its first intake of students in

September 1991 and provides a curriculum of academic and performing arts subjects for its students.

The trust also 'continues to seek other projects where it may be of assistance'. The trust's total arts-related charitable expenditure was as follows:

*BRIT School for Performing Arts & Technology; *Nordoff Robins (£260,000 each);
*National Foundations of Youth Music (£200,000);
Heart 'n' Soul (£7,000);
Fairbridge in Kent; Avenues Youth Project (£5,000 each).

Exclusions: Capital grants; student bursaries.
Applications: In writing to the correspondent.

The Britten-Pears Foundation

CC No: 295595

Unit 4G, Leroy House, 436 Essex Road, London N1 3QP

Tel: 020 7359 5552; Fax: 020 7288 0252
E-mail: britten@verger.demon.co.uk
Contact: The General Director
Trustees: Marion Thorpe, Chair; Dr Donald Mitchell; Dr Colin Matthews; Noel Periton; Hugh Cobbe; Peter Carter; Sir John Tooley; Michael Berkeley; Sir Robert Carnwath; Professor Rhian Samuel; Mark Fisher.
Beneficial area: UK, with a preference for East Anglia.
Grant total: £638,000 (1998/1999)
Arts grants: £580,000
The foundation's objectives are as follows:
- the promotion of public knowledge and appreciation of the musical works and writings of Benjamin Britten and Peter Pears, and the tradition and principles of musical education and performance developed by them;
- the operation and enhancement of the foundation-owned Britten-Pears Library;
- the promotion of knowledge and appreciation of music and other arts generally;
- support for local, educational, environmental and humanitarian charities.

Funding is also made available annually for the preservation of The Red House, Britten's former home. In addition, ongoing assistance is given to Aldeburgh Productions, with a particular emphasis on the annual Aldeburgh Festival of Music and the Arts, and to the Britten-Pears School for Advanced Music Studies. Educational grants have been given to other musical organisations, educational establishments, music festivals and small local groups.

In 1998/1999 the foundation gave a total of £638,000, of which £210,000 was for the Britten-Pears Library and almost £28,000 was disbursed to The Red House. The remaining funding was given through a more general programme, in grants ranging from under £1,000 to £110,000. Only grants of over £1,000 were listed in the annual report, leaving £51,000 in unspecified donations. There were 41 listed grants, 5 of which (totalling £231,608) were designated for Aldeburgh Productions, including donations to the Britten-Pears School and the contemporary music centre, and to subsidise opera. All but two of the listed beneficiaries were arts-based, mainly receiving grants of under £5,000. Specified arts-related grants totalled £580,000 (91% of total grant-aid). Recipients included:
Jubilee Hall, redevelopment (£20,000);
Northern Sinfonia Trust (£5,000);
Tanglewood (£4,655);
*London Sinfonietta (£4,000);
Yehudi Menuhin School (£3,000);
Drake Music Project; Performing Arts Lab (£1,500 each);
Foundation for Young Musicians; National Society of Youth Orchestras (£1,250 each);

Bingham String Quartet; Cambridge Opera Group (£1,000 each).

Exclusions: General charitable projects; general support for festivals other than Aldeburgh; individual scholarships, bursaries and course grants other than for the Britten-Pears School; purchase or restoration of musical instruments or equipment and of buildings other than at Snape Maltings or Aldeburgh.

The foundation does not consider applications for support for performances or recordings of the works of Benjamin Britten, of whose estate the foundation is the beneficiary. The foundation's annual income is derived largely from the royalties from the performance worldwide of the works of Britten, and is channelled by deed of covenant to the foundation through its trading subsidiary the Britten Estate Ltd. Subsidy for works by Britten which, in the estate's view, need further promotion, can be sought from the Britten Estate Ltd.

Applications: Trustees meet in January, April, July and October. Five copies of any application should be sent for consideration by the end of the preceding month.

The Daphne Bullard Trust – see The Museums Association

The Bulldog Trust

CC No: 326292

Messrs Hoare Trustees, 37 Fleet Street, London EC4P 4DQ

Contact: Richard Hoare, Trustee
Trustees: Richard Hoare; Messrs Hoare Trustees.
Beneficial area: UK.
Grant total: £152,000 (2000/01)
Arts grants: £20,550
This trust has general charitable interests, supporting a wide range of causes including the arts.

In 2000/01 the trust gave a total £152,000 in grants ranging from under £1,000 to £5,000. Donations totalling £20,550 (14% of total grant-aid) were made to arts-related causes. Only grants over £1,000 were listed in the annual report and, of the funding detailed, nine grants amounting to £19,250 were relevant to this guide. These were:
National Theatre; Trinity College of Music (£5,000 each);
Chicken Shed Theatre Company (£2,250);
New Shakespeare Company; Chethams School of Music (£1,500 each);
The Drama Centre; RADA; Winchester Music Festival; Webber Douglas Academy of Dramatic Arts (£1,000 each).

The Hon D R Burns Charitable Trust

(formerly the Dorothy Burns Charity)

CC No: 290497

c/o Fladgate Fielder, 25 North Row, London W1R 1DJ

Contact: A J M Baker, Secretary
Trustees: Lady Balfour of Burleigh; Christopher Campbell; Professor Bernard Cohen; Miss E Ann Minogue; Lady Winifred Tumim.
Beneficial area: UK and overseas, particularly Jamaica.
Grant total: £168,000 (1999/2000)
Arts grants: £48,000
The charity supports education, the arts, youth and projects in Jamaica, making grants between £1,000 and £16,500 but mainly under £5,000. It gives a number of annual travelling scholarships to students at Slade School of Art.

In 1999/2000 it donated nearly £168,000 in 30 grants, mostly to previous beneficiaries. Of this total, £48,000 (28% of total grant-aid) was

given in 12 arts-related grants including the following:

*Slade School of Art (£16,500);
*Royal College of Music (£5,000);
Camden Arts Centre (£2,400);
*Live Music Now! (£2,000);
*City & Guilds London Art School (£1,500).

Exclusions: Applications from individuals are not considered.
Applications: Unsolicited applications are unlikely to be successful.

The Audrey & Stanley Burton (1960) Charitable Trust

CC No: 1028430

Trustee Management Ltd, 19 Cookridge Street, Leeds, West Yorkshire LS2 3AG

Tel: 020 7274 9630
Contact: The Secretary
Trustees: Mrs A R Burton; Miss A C Burton; P E Morris; Mrs D M Hazan; D J Solomon; Raymond Burton.
Beneficial area: UK, especially Yorkshire.
Grant total: £683,000 (1999/2000)
Arts grants: £37,730
This trust's grants cover health, arts, education and special needs, with a preference for charities in Yorkshire.

The level of funding given by the trust has increased consistently since 1995/96 and by 1999/2000 total grants had more than doubled to £683,000. Grants in 1999/2000 ranged from under £1,000 to £70,000 but most were below £5,000. Only grants over £1,000, of which there were 118, were listed in the annual report. Of these, 13 donations were for arts-related causes, amounting to £37,730 (six per cent of total grant-aid). These were:
*Contemporary Dance Trust (£8,490);
Harrogate International Festival (£8,000);
York Millennium Mystery Plays (£6,000 in two grants);
Yorkshire & Humberside Arts (£5,000);

Dance Umbrella; Society for the Promotion of New Music (£2,000 each);
*Live Music Now! (£1,240);
English Touring Opera; Handel House Museum; Harrogate Anne Frank Exhibition; Phoenix Dance; Oriental Ceramic Society (£1,000 each).

A total of £67,000 (10% of total funding) was given in unspecified grants of under £1,000.
Exclusions: Individuals.
Applications: In writing at any time. Trustees try to reach a decision within a month; unsuccessful applicants are not necessarily informed.

The R M Burton Charitable Trust

CC No: 253421

c/o Trustee Management Ltd,
19 Cookridge Street, Leeds LS2 3AG

Contact: R M Burton, Trustee
Trustees: Raymond Montague Burton; Pamela N Burton; Arnold J Burton.
Beneficial area: UK, with a preference for Yorkshire, esp. Leeds, and Humberside; also Israel.
Grant total: £218,000 (1999/2000)
Arts grants: £47,316
The trust funds a wide range of health, education and social welfare projects, in addition to numerous arts-based causes. Preference is given to smaller charities, with particular consideration for Jewish causes. Capital funding is only likely to be considered for the conservation of important buildings or acquisitions by museums and galleries.

In 1999/2000 the trust gave a total of £218,000 in 265 grants, ranging from £5 to £20,000, most of which were under £2,000. Some of the smaller donations appear to be payments for annual subscriptions rather than grants. A total of £47,316 (22% of total grant-aid) was given in 44 grants relevant to this guide.

Recipients included:
Foundling Museum Appeal (£10,000);
*Royal Opera House Trust (£9,288 in
 two grants);
*York Early Music Foundation (£4,000);
*Ryedale Festival (£3,500 in two grants);
*Yorkshire & Humberside Arts, ballet
 seminar (£3,000);
*British Museum Society (£1,400 in two
 grants);
*Textile Conservation Centre; Ripon
 Museum; Jewish Music Heritage Trust
 (£1,000 each);
Yorkshire Back Choir; Huddersfield
 Contemporary Music Festival; Chicken
 Shed Theatre Company; Old Farmstead
 Arts Project (£500 each);
Phoenix Dance; Yorkshire Wind
 Orchestra (£250 each).

The trust has stated, however, that its
accounts for 2000/2001 'indicate an
enormous reduction in income and
donations. Specifically, the total incoming
resources for the year amounted to
£124,130 and the charitable donations
amounted to £85,004'.
Exclusions: Local charities outside
Yorkshire. 'With limited resources the
trustees have decided to restrict very
closely the support given for individuals.'
Applications: In writing at any time.
Trustees try to reach a decision within a
month; unsuccessful applicants are not
necessarily informed.

The Busenhart Morgan-Evans Foundation

CC No: 1062453

Brambletye, 455 Woodham Lane,
Woodham, Surrey KT15 3QG

Tel: 01932 343908; **Fax:** 01932 344806
Contact: Mr John F Bedford, Trustee
Trustees: John F Bedford.
Beneficial area: UK.
Grant total: £14,179 (1999/2000)
Arts grants: £14,179
The foundation is a capital endowed

trust, which distributes income annually
as follows:
- support to English choral music
 through endowment of a cathedral
 choral scholar;
- support for opera;
- support for young musicians at the
 outset of their professional careers
 through an award administered by the
 Worshipful Company of Musicians
 from candidates recommended by
 music colleges and universities;
- grants for special needs of the local
 community.

In 1999/2000 the foundation gave a total
of £14,179 in support of the above
objectives.
Applications: In writing to the
correspondent. No formal application
procedures are required and each
application is considered on its merits
within the above objectives.

The William Adlington Cadbury Charitable Trust

CC No: 213629

2 College Walk, Selly Oak, Birmingham
B29 6LQ

Tel: 0121 472 1464
E-mail: info@wa-cadbury.org.uk
Website: www.wa-cadbury.org.uk
Contact: The Correspondent
Trustees: Brandon Cadbury; James
Taylor; Rupert Cadbury; Katherine van
Hagen Cadbury; Margaret Salmon; Sarah
Stafford; John C Penny; Adrian D M
Thomas.
Beneficial area: UK and overseas, but
the main area of giving is the West
Midlands.
Grant total: £605,000 (2000/01)
Arts grants: £34,450
The trust's policy is to assist 'charities
working in the West Midlands, or where
the projects have a national impact'. In
addition to the arts, the trust gives to a
range of causes relating to health, social

welfare, education, preservation, medical research and penal affairs. The trust encourages applications from ethnic minority groups and women-led initiatives.

A total of £605,000 was given in 2000/01 in 256 grants; most were £3,000. Of this, £34,450 (six per cent of total grant-aid) was donated to 20 arts-related causes, £21,200 of which was placed within a specific category for the arts, with a further £13,250 listed elsewhere. Beneficiaries included:

Under 'the arts' –

Big Brum Theatre in Education; Aberystwyth Arts Centre; Orchard of St John Smiths Square; Hereford Three Choirs Festival (£3,000 each);

Drake Music Project; Banner Theatre Company, Birmingham (£2,000 each);

Belgrade Theatre, Coventry (£1,000);

Crescent Theatre; National Youth Orchestra; Birmingham Centre for Arts Therapies (£500 each).

Under 'preservation' –

Ironbridge Gorge Museum (£10,000); Avoncroft Museum (£3,000).

Under 'Ireland' –

Share Music (£250).

Exclusions: No grants to individuals or to organisations which are not registered charities, or to projects concerned with travel or adventure.

Applications: Application forms are available on-line from the trust's website or postally upon telephoned request. Applications should include clear details of the project together with a financial statement or budget. Applications will be acknowledged if a SAE is enclosed. Trustees meet in May and September.

The Edward Cadbury Charitable Trust

CC No: 227384

Elmfield, College Walk, Selly Oak, Birmingham B29 6LE

Tel: 0121 472 1838
Contact: Mrs M Walton, Secretary
Trustees: Charles E Gillett, Chairman; Christopher S Littleboy; Charles R Gillett; Andrew S Littleboy; Nigel R Cadbury.
Beneficial area: UK and overseas, but with a special interest in the West Midlands.
Grant total: £1,129,000 (1999/2000)
Arts grants: £542,500

The trust gives in the following areas: the voluntary sector in the West Midlands; Christian mission, the ecumenical movement and interfaith relations; the oppressed and disadvantaged in this country and overseas; the arts; and the environment.

In 1999/2000 the trust gave £1,129,000, almost half of which was disbursed in an exceptional grant of £500,000 to Ironbridge Gorge Museum Trust for its Coalbrookdale Project. It is the trust's aim to afford such a level of support to one project annually. The trust also gave £58,230 as part of an ongoing commitment to Selly Oak Colleges Endowment Trust. A further 159 grants were made, ranging from £25 to £39,600; most were below £10,000. A total of £542,500 (48% of total grant-aid) was given in eight grants relevant to this guide. These were:

Ironbridge Gorge Museum Trust (£500,000);

Birmingham Hippodrome (£25,000);

Birmingham Symphony Hall; Project Library; Royal Birmingham Society Artists (£5,000 each);

Birmingham Museum & Art Gallery; Book Aid International (£1,000 each); Droitwich Concert Club (£500).

Exclusions: Individuals; organisations not registered as charities.

Applications: In writing at any time, but allowing three months for a response. Applications should include clear information about the project and its benefits, with an outline budget and details of how the project is to be funded initially and in the future. The organisation's latest annual report and up-to-date accounts are also required.

Applications are not acknowledged unless an SAE is enclosed.

Edward & Dorothy Cadbury Trust (1928)

CC No: 221441

Elmfield, College Walk, Selly Oak, Birmingham B29 6LE

Tel: 0121 472 1838
Contact: Mrs M Walton, Secretary
Trustees: Mrs P A Gillett, Chairperson; Dr C M Elliot; Phillipa S Ward.
Beneficial area: UK, with a preference for the West Midlands; also overseas.
Grant total: £89,000 (2000/01)
Arts grants: £16,700
This trust has general charitable purposes but gives particular attention to community and social welfare projects. Arts organisations also regularly receive grants with an apparent preference for music, although museums, theatre and literature have also received support. Funding is often recurrent and directed at the West Midlands area of England.

In 2000/01 the trust gave £89,000 in 123 grants ranging from £50 to £10,000, most of which were under £1,000. Arts causes received £16,700 (19% of total grant-aid) in 26 grants including:
*Bromsgrove Festival (£3,750);
Birmingham Royal Ballet (£3,000);
Three Choirs Festival (£1,000);
Bromsgrove Concerts; *Catshill Music Festival (£900 each);
Birmingham Early Music Festival (£600);

Birmingham Art Therapy; Rubery Youth Marching Band; *Droitwich Concert Club; *Midland Youth Orchestra (£500 each);
Big Brum Theatre (£350);
*Avoncroft Arts Society; Birmingham Music Festival; Felicity Belfield Music Trust; Lichfield Cathedral Music; National Youth Orchestra (£250 each).

Exclusions: Individuals.
Applications: In writing, clearly giving relevant information concerning the project's aims and benefits. Where available, up-to-date accounts and annual reports would be helpful.

P H G Cadbury's Charitable Settlement

CC No: 327174

PO Box 4UD, London W1A 4UD

Contact: Derek Larder
Trustees: D Larder; P H G Cadbury; S Cadbury.
Beneficial area: UK.
Grant total: £21,000 (2000/01)
Arts grants: £15,710
This charitable settlement has general charitable purposes, including conservation and cancer-related causes, but with a particular emphasis on the arts. Most of the supported arts causes are well-established charities which are either museum-based or in the field of opera.

In 2000/2001 a total of £21,000 was given in 36 donations ranging from £25 to £3,000. Arts-related funding totalling £15,710 (73% of total grant-aid) was given in 15 grants including:
Royal Academy of Arts (£3,000);
National Art Collections Fund (£2,500);
Victoria & Albert Museum; English National Opera (£2,000 each);
British Museum Fund (£1,850 in 2 grants);
Garsington Opera (£1,600 in 2 grants);
Royal Opera House Trust; Natural History Museum (£1,000 each);
British Museum Society (£500).

Exclusions: Individuals; organisations not registered as charities.
Applications: The trust does not usually respond to unsolicited appeals and it is unlikely that any new applications will be considered.

The Kathy Callow Trust – see The Museums Association

The Camelot Foundation

CC No: 1060606

University House, 11–13 Grosvenor Place, London SW1W 0EX

Tel: 020 7828 6085
E-mail: selizabeth@camelotfoundation.org.uk
Contact: Susan Elizabeth
Trustees: Caroline Pickering, Chair; Richard Brown; David Bryan; Frances Hasler; Tim Holley; Lord Imbert; Baroness Prasher; Sue Slipman.
Beneficial area: UK.
Grant total: £1,243,000 (1999/2000)
The foundation's income is derived from donations from Camelot Group plc, which usually provides £2 million each year, and interest gained through investments.

Its particular focus has been on 'organisations that help disabled and disadvantaged people play a fuller role in the workplace and in the community', although other causes benefiting communities are considered. Grants have been made within three programmes: community support; charitable projects; and employee participation.

In 1999/2000 the foundation gave a total of £1,243,000 in 425 grants. This was distributed as follows:

- community support – £838,524 in 233 grants;
- charitable projects – £85,873;
- employee participation – £318,886 in 192 grants.

At the time of writing, the foundation's funding programmes were under review and, as a result, no indication of the level of future arts-related support was available. Applicants should contact the foundation for up-to-date guidelines, which should be available from March 2002.
Applications: Applicants should obtain guidelines and application forms from the foundation.

The David Canter Memorial Fund

CC No: 800221

c/o Devon Guild of Craftsmen, Riverside Mill, Bovey Tracey, Devon TQ13 9AF

Tel: 01626 832223
E-mail: jenny@crafts.org.uk
Contact: Jenny Plackett, Secretary
Trustees: Devon Guild of Craftsmen.
Beneficial area: UK.
Grant total: £3,000 (1998)
Arts grants: £3,000
The trust's main charitable purposes are the promotion of education in the crafts; development of the crafts to promote and improve public appreciation; and to encourage and develop the work of an individual craftsperson or group.

Applications are invited from craft workers who have completed their training for financial assistance for special projects, such as setting up a workshop or buying materials and equipment, or for research and travel. A different craft is focused upon each year. Since 1998 the chosen crafts have been as follows:

- 1998 – automata and hatmaking;
- 1999 – furniture;
- 2000 – ceramics;
- 2001 – printmaking.

In 2002 the focus is on jewellery and metalwork.

Grants are usually made in the autumn and range from £500 to £1,000. Around £3,000 is given each year in total.

Exclusions: Students; fine art; photography.

Applications: Guidelines and applications are available from the above address in April. A SAE must be enclosed. Short-listed candidates will be asked in July to send further information about current or recent work, together with six colour slides as illustration. Those not short-listed will be notified by letter. Successful applicants will be notified in September.

The Carlton Television Trust

CC No: 1019628

101 St Martin's Lane, London WC2N 4RF

Tel: 020 7615 1641
E-mail: ctvtrust@carltontv.co.uk
Website: http://www.carlton.com
Contact: Liz Delbarre, Administrator
Trustees: Clive Jones, Chair; Erica De'Ath; Michael Green; Baroness Jay of Paddington; Karen McHugh; Colin Stanbridge.
Beneficial area: Greater London, and *part* of the counties of Berkshire, Buckinghamshire, Essex, Hampshire, Hertfordshire, Kent, Oxfordshire, Surrey, East & West Sussex.
Grant total: £595,000 (2000)
Arts grants: £122,973
Carlton Television commits in the region of £500,000 per year to finance and administer this trust throughout the period of the company's broadcasting licence. 'Support is given only to groups and projects within Carlton's London transmission region.' All causes supported are for the benefit of disadvantaged children or young people and arts-related grants are only awarded to projects sharing this charitable purpose. The trust is not involved in general arts sponsorship or with individual artists.

There is a strong emphasis on providing educational opportunities, with after-school groups, toy libraries, play associations, youth sports and community arts projects among the beneficiaries. Arts-related recipients have also included performing arts groups working in schools or with children with special needs or disabilities.

In 2000 the trust gave a total of over £595,000 in 121 grants ranging between £500 and £49,400, most of which were under £6,000. Out of this, £122,973 (21% of total grant-aid) was given in 29 donations relevant to this guide. These included:

*RADA, fourth and final annual donation (£30,000);

Trestle Theatre Company; Foundation for Young Musicians; Camden People's Theatre (£5,000 each);

National Youth Theatre of Great Britain (£4,940);

Royal Court Theatre (£4,500);

Maya Productions Ltd; Guildhall School of Music & Drama; Camden Arts Centre (£4,000 each);

Independent Photography Project (£3,840);

Corali Dance Company (£1,500).

Exclusions: Projects outside the Carlton London transmission area (contact the trust if you are uncertain); individuals; trips abroad; conferences/seminars; general appeals; unspecified expenditure; retrospective funding; ongoing salaries and running costs; relief of statutory responsibilities.

Applications: The trust is open from April until the closing date of 7th June only, when application forms and other information are available by sending an A4 size SAE (postage for 75 grammes) to the administrator. Funds are disbursed once a year only. Applications received after the closing date will not be considered. Organisations may submit only one application per calendar year for projects due to take place from November onwards. All applicants will be notified of the outcome of their appeals by 30th November.

Grants may be considered for individual children and young people if an organisation that can speak about the family's financial circumstances, applies on their behalf. (Private individuals, parents, teachers and other welfare professionals are not acceptable applicants.) Further details regarding equipment are given with the application form and guidelines.

Grants for two to three years are exceptional. Applicants for salary costs for up to three years must be registered charities and grants should establish new ways of meeting need or new levels of effectiveness.

The Carnegie United Kingdom Trust

CC No: 12799

Comely Park House, Dunfermline, Fife KY12 7EJ Scotland

Tel: 01383 721445; Fax: 01383 620682
Website: www.carnegieuktrust.org.uk
Contact: John Naylor, Chief Executive
Trustees: William Thomson, Chairman; Alexander A H Lawson (Vice-Chairman); George R Atkinson; Linda P Brown; Sir Neil Cossons; Sheriff John Stuart Forbes; Lady Anthony Hamilton; Joy Kinna; Janet A Lewis-Jones; L E Linaker; Rosie Millard; Anthony Pender; Anthony M Mould; Sandy Saddler; James I Scott; Jessie T R Spittal; David J Stobie; C Roy Woodrow; Dame Gillian Wagner.
Beneficial area: UK and Republic of Ireland.
Grant total: £1,291,000 (2000)
Arts grants: £438,000
In 2000 the trust gave a total of £1,291,000 to a wide range of beneficiaries. Out of this, £438,000 (34%) was allocated to arts-related causes. However, new funding guidelines have since been introduced, which run for the quinquennium 2001–2006. At the time of writing, the first financial year relevant to the current guidelines had not been

completed and, as a result, full annual funding details were not available. The trust did, however, indicate that grants totalling £890,000 were made up to November 2001, out of which £214,000 (24% of grant-aid) was given to the arts. Examples of grants made within the trust's current schemes are listed below.

General guidance

'Normally the trust only considers applications from registered charities or in Scotland those recognised by the Inland Revenue. The trust's remit is for the United Kingdom and the whole of Ireland. Preference is given to proposals which are innovative and developmental; have potential to influence policy and practice more widely; and are undertaken in partnership with others.' Grants usually range from £1,000 to £30,000 and may be for one year or spread over up to three years.

In March 2001 the trust implemented the following new grant-making policies:

Rural community development

Grants to stimulate community activity in rural areas, building on the trust's long-standing commitment to supporting village halls. This programme is open to village bodies registered as charities, which will give support to a village initiative. 'Ultimate recipients will be motivators, pacesetters and enablers in villages. They could be in groups such as the WI, village hall committee, young farmers' club, church, youth club or in an informal group.'

Grants would usually be 'up to £10,000 p.a. but this could rise in exceptional circumstances'. Grants are also available to 'widen the use of village halls as centres of services for the community' and are open to village hall committees where the population is below 5,000. **Village Hall application forms should be obtained from the trust**.

Creativity and imagination

Supporting 'creative ideas from small organisations and groups, although larger organisations are not excluded. The trust will be especially interested in proposals which cross traditional boundaries and bring together disparate disciplines in the arts, environment, heritage, science and the community'. Priority will be given to organisations at an early stage of their development, although established charities with innovative proposals will be considered.

Grants may be for a feasibility study of up to £500 and/or up to £30,000 which could be for a single year or phased over a period of three years.

Applicants must check the trust's specific guidelines before submitting written applications.

Young people's active participation in society

Support will be aimed at enhancing the role of young people in education, health and the wider community. This policy is designed to give a 'grant giving dimension at the grass-roots to the trust's major strategic policy – the Carnegie Young People Initiative', which is a research project promoting young people's participation in public decision-making.

Examples of grants in 2001

Under 'creativity' –

Broli, a three-year programme for rural cultural development in North Wales (£20,000);
Deaf Blind UK, for displays at the new centre and headquarters to demonstrate the science of sight, hearing, taste, touch and smell in the context of the deaf-blind experience; Common Ground, to extend to other parts of the country, Confluence, a project to explore and celebrate rivers using art, music, drama, environmental projects, reminiscence, poetry, and heritage (£10,000 each).

Under 'rural' –

Grizedale Association, towards Jo's Journeys, a project for radio broadcast and photography and writing to reduce isolation in the rural community; Graemsay Community Association, to convert a disused school building into a heritage centre (£5,000 each).

Under 'young people' –

Greater East Belfast Partnership, using IT to communicate imaginatively, bringing together young people's organisations and improving services (£20,000).

Exclusions: Individuals; retrospective grants; general appeals; endowment funds; closed societies; debt clearance; replacement of statutory funding; purchase, restoration, conversion, or repair of buildings; formal education; students of organisations for personal study, travel or expeditions; research, publications, conferences or exhibitions (except where following up existing grants or where trustees wish to initiate certain work); animal welfare; sports; medical or healthcare; holidays, adventure centres and youth hostels; residential care, daycare centres and housing; conciliation and counselling services; care in the community; arts centres, professional arts companies and festivals, including performances and workshops; libraries; pipe organs in churches or other buildings.

Applications: First check that the proposal falls within the guidelines, which should be obtained by sending an A5 SAE. Application is usually by letter, except where an application form is indicated.

All applications need the information listed below:

- brief description of the organisation – its history, work, budget, management and staffing;
- description of the project including its purpose, timescales incorporating any

milestones during the programme; expected outcomes; number of people who will benefit; and how the project will be managed;

- budget for the project, including details of funds already raised and other sources being approached.
- amount requested from the trust;
- plans for monitoring and evaluating the project (the trust attaches great importance to this);
- how the work will continue after the trust's grant has been completed (if appropriate, how it is proposed to share information about the project and what was learnt from it with others in the field);
- last annual report, audited accounts, the main part of the signed constitution, charity registration number and committee membership;
- contact name, postal and e-mail addresses, telephone and fax numbers. This should normally be the person directly responsible for the work, not a fundraiser. The application letter must be signed by the senior person responsible, such as the chairman or the director.

Deadlines are 30 January for the March trustees' meeting; 30 April for the June meeting; 30 September for the November meeting. However, applications can be submitted at any time and early preliminary submissions are particularly welcome. Applications are acknowledged upon receipt. The trust aims to inform applicants of trustees' decisions by the end of the month in which the meeting is held.'

A grant offer requires formal minuted acceptance by the applicant organisation's governing body. Phased payments and final grants are usually only made on the receipt of satisfactory progress reports which may be followed up by letter, telephone and/or visit.'

Carnwath Fund Trust – see The Worshipful Company of Musicians

CC No: 287310

Sir John Cass's Foundation

CC No: 312425

31 Jewry Street, London EC3N 2EY

Tel: 020 7480 5884; Fax: 020 7488 2519
Contact: Colin Wright, Clerk to the Governors
Trustees: M Venn, Treasurer; P D Minchin, Deputy Treasurer; Mrs L Barlow; Mrs L Borthwick; Mrs I Buckman; K M Everett; Rev B J Lee; Mrs J Lomax; P D Minchin; D Smith; M R Streatfeild; Mrs C Turney; Billy Dove; Tom Peryer; Geoffrey Lawson; P Wade.
Beneficial area: City of London, Camden, Greenwich, Hackney, Hammersmith & Fulham, Islington, Kensington & Chelsea, Lambeth, Lewisham, Newham, Southwark, Tower Hamlets, Wandsworth, Westminster.
Grant total: £963,000 for organisations; £143,000 for individuals (1999/2000)
Arts grants: £187,000
This foundation is solely concerned with educational advancement within the 14 inner London boroughs. Annual funding is given to the two Cass Foundation schools and London Guildhall University. Support for capital projects at voluntary aided Church of England schools also forms a core part of the foundation's funding programme. The foundation 'is not an arts funder as such but does support arts activity in State Maintained schools in inner London that enhance the National Curriculum'. Funding is given to 'a small number of individual undergraduate students at designated institutions' in response to the government's abolition of student grants.

All further grants are made to organisations or schools within the following categories: arts activities;

employment training; environmental education; literacy and numeracy; science and technology; social science and humanities; miscellaneous.

In 1999/2000 the foundation made grants totalling £1,106,000. Of this, £963,000 was given to schools or organisations and £143,000 was disbursed to individuals. Grants to individuals were not specified in the annual report. There were 38 grants to organisations, ranging from £2,000 and £100,000, most of which were between £10,000 and £25,000. Funding amounting to £187,088 (17% of total grant-aid) was given in 11 grants relevant to this guide. These were:

Under 'arts activities' –

Stoke Newington School, to achieve Arts College Status (£50,000);

Archbishop Tenison's School, to achieve Arts College Status (£25,000);

British Federation of Young Choirs, choral project (£20,500);

Hackney Music Development Trust, for musical residencies in 10 primary schools (£12,300);

Clio's Company, history in education project (£10,000);

Central Foundation Boys' School, after school music club (£2,508);

Grasmere Primary School, music classes (£2,000).

Under 'literacy and numeracy' –

National Literacy Trust, support for reading in primary schools (£26,780);

Volunteer Reading Help, recruitment and training of volunteer readers across London (£10,000).

Under 'social science and humanities' –

Horniman Public Museum and Park Trust, salaries for education staff (£20,000);

Clio's Company, Aldgate Festival (£8,000).

'Foundation governors wish to encourage and, where appropriate, support applications which:

- incorporate structured educational content related, where appropriate, to the teaching and learning of the relevant key stage(s) of the national curriculum.
- demonstrate a realistic likelihood of continuing after the expiry of the foundation's grant.
- are innovative, in the sense of identifying and meeting educational needs not met by other grant making bodies.

'Within these parameters, governors particularly favour applications which:

- promote the teaching of science, maths, engineering and technology.
- develop programmes that improve access to the curriculum and prepare beneficiaries for the world of work.
- develop curricula or activities outside the normal school day.

'Preference is given to original developments, not yet part of the regular activities of an organisation; to developments that are either strategic, such as practical initiatives directed toward addressing the root causes of problems; or seminal, because they seek to influence policy and practice elsewhere.'

Exclusions: Individuals over 25; causes outside the beneficial area; performances, exhibitions, festivals or sporting events; basic equipment or salaries that are the responsibility of education authorities; the purchase, repair or furnishing of buildings; stage, film, publication or video production costs; independent schools; local youth and community projects; conferences or seminars; university or medical research; establishing funds for bursary or loan schemes; supplementary schools or mother tongue teaching; retrospective grants to help pay off overdrafts or loans, nor will the foundation remedy the withdrawal or reduction of statutory funding; the purchase of vehicles, computers or sports equipment; pre-school, nursery education or toy libraries; one-off music, drama,

dance or similar productions, or tours of such productions; ticket subsidy schemes; holiday projects, school journeys, trips abroad or exchange visits; general fundraising campaigns.

Applications: There are several stages in the application process.

1. An initial letter outlining the application should be addressed to the clerk to the governors. It should include some basic costings of the project and background details of the organisation.

2. If the project falls within the foundation's current policy and its basic criteria are satisfied, you will be invited to submit an application under headings that the foundation will provide, together with an annual report and audited accounts.

3. Upon receipt of the completed application, foundation staff will discuss your proposal with you and may arrange to visit.

4. Completed applications are considered by governors (who meet quarterly).

5. Applicants are notified in writing within seven days of a meeting.'

Throughout the application process, the foundation's staff will be happy to clear up any questions you might have and are available to receive initial telephone enquiries.'

The Francis Chagrin Fund – see the Society for the Promotion of New Music

The Chapman Charitable Trust

CC No: 232791

Messrs Crouch Chapman & Benedict McQueen, 62 Wilson Street, London EC2A 2BU

Tel: 020 7782 0007; Fax: 020 7782 0939
E-mail: cct@crouchchapman.co.uk

Contact: Roger S Chapman, Trustee
Trustees: Roger S Chapman; W John Chapman; Richard J Chapman; Bruce D Chapman; Guy J A Chapman.
Beneficial area: Eastern and South East England, including London, and Wales.
Grant total: £185,000 (2000/01)
Arts grants: £26,500

The trust's main supported areas are social services, culture and regeneration, education and research, health, environment and heritage. Grants are made from income to recognised charities, particularly those in which the late settlor had, or the trustees have, a personal interest.

In 2000/01 the trust gave a total of £185,000 in 142 grants ranging between £500 and £20,000, 114 of which were for £1,000 or less. Out of this total, £26,500 (14%) was given in 11 grants to arts organisations. These were:

★Aldeburgh Productions (£20,000 in two grants);

★Criccieth Festival; ★Royal Cambrian Academy; London Sinfonietta; Soundabout (£1,000 each);

Arts Interest Group; Gilbert White's House & The Oates Museum; Listening Books; ★Living Paintings Trust; ★Porthmadog Maritime Museum (£500 each).

Exclusions: Individuals; local branches of national charities; animal welfare; sports tours; research expeditions; sponsored adventure holidays.
Applications: In writing at any time. The trustees meet at the end of March and the end of September. If no communication is received within six months then the application has been unsuccessful.

The Charities Advisory Trust

CC No: 1040487

Radius Works, Back Lane, London
NW3 1HL

Tel: 020 7794 9835; Fax: 020 7431 3739
E-mail:
charities.advisory.trust@ukonline.co.uk
Contact: Hilary Blume, Director
Trustees: Dr Cornelia Navari; Dr
Carolyne Dennis; Prof. Bob Holman; Ms
Dawn Penso.
Beneficial area: UK.
Grant total: £392,000 (2000/01)
The proactive trust's main aims are to
'relieve poverty throughout the world;
advance education; preserve buildings and
monuments of architectural merits; assist
charities so that they may make better use
of their assets and resources'.

The trust's main work is carried out
through the following services: museum
development unit; card aid; training;
publications and research; advisory
service; charity shops groups. However,
direct grants are also made in accordance
with the trust's general charitable
purposes, which include the support of
museums.

'No large arts grants to the arts were
given in 2000/01. More recently a small
grant was given for the educational
programme of the Royal Opera House.
The trust has, in the past, supported the
educational work of the National Theatre,
Tricycle Theatre and of the Royal Festival
Hall.' A grant of £100,000 was given to
the British Museum for work with
primary school children, although this
was a one-off.

The trust's main interest in arts funding
is giving access to live arts to young
people who would for cultural or
economic reasons not generally go.
Applications: Unsolicited applications
are not welcomed.

The Charities Aid Foundation

CC No: 268369

Kings Hill, West Malling, Kent ME19 4TA

Tel: 01732 520 000; Fax: 01732 520 001
E-mail: enquiries@caf.charitynet.org
Website: www.charitynet.org
Contact: Grants Administrator
Trustees: Sir Brian Jenkins, Chairman;
Kenneth G Faircloth, Vice Chairman;
Roger A Barnes; Peter F Berry; Sir
Patrick Brown; Rodney S Buse; Sir Tim
Chessells; Lord Dahrendorf; Sylvia E
Denman; Stuart Etherington; Ian
Macgregor; Rt Revd Alan W Morgan;
Professor Naomi Sargent; Lady Tumin.
Beneficial area: UK.
Grants are made to enable charities to
improve their management and
effectiveness. These help a charity to:
- improve its effectiveness in meeting its
 objectives;
- improve its use of financial resources,
 facilities, members, staff or volunteers;
- improve its stability or effectiveness;
- to move into new areas of need.

Grants are normally made to small or
medium-sized charities with a proven
track record. The maximum grant is
£10,000. The average grant is £4,000
and only two-thirds of applications are
successful. Grants are seldom for the full
amount requested. Applications are
encouraged from black and ethnic
minority groups.

In 1997/98 10 grants totalling £46,000
(eight per cent of total grant-aid) were
made in CAF's category of 'Arts/
Humanities', five less than in the previous
year when the total was £55,400.

Grants relevant to this guide included:
Living Paintings Trust (£8,708);
Radio Lollipop (£7,500);
Battersea Community Arts Centre Trust;
 Foundation for Community Dance
 (£5,000 each);
Lyric Theatre Hammersmith (£4,500);

Chisenhale Gallery (£3,000);
Drake Music Project, Northern Ireland
(£2,000).

Exclusions: No grants to assist with
Lottery bids. No grants to organisations
which are not registered charities or
approved for charitable status by the
Inland Revenue. No grants to individuals,
or for capital building projects, general
appeals, general funds, debt clearance, or
start-up costs. Applications for
retrospective funding are not considered.
Applications: In writing to the
correspondent. The grants council meets
quarterly to consider applications.

The Chase Charity

CC No: 207108

2 The Court, High Street, Harwell,
Didcot, Oxfordshire OX11 0EY

Tel: 01235 820 044
Contact: Ailsa Holland, Secretary
Trustees: Dodie Carter; Gordon
Halcrow, Chair; Mrs R A Moore; Ninian
Perry; Alexander Robertson; Ann
Stannard.
Beneficial area: UK, excluding London
and Northern Ireland.
Grant total: £526,000 (2000/2001)
Arts grants: £274,300
This charity's three main areas of interest
are the arts, heritage and social welfare. A
commitment to helping the
disadvantaged permeates most areas of the
charity's programme for giving, with a
preference demonstrated for assisting
causes in poorly supported regions of the
UK, particularly in rural areas. Grants are
usually made for specific purposes and
very occasionally the charity will help
with running costs or salaries to meet a
shortfall. Funding is given within the
following categories: arts/community arts;
young people; conservation and
museums; historic buildings; almshouses;
elderly; physical and learning disabilities;
homelessness; neighbourhood work;

mental health; families and children; penal
affairs.

The Lankelly Foundation, with which
the Chase Charity shares its
administration, makes £250,000 available
to the charity on an annual basis for the
support of heritage and the arts. Arts
funding is distributed across a broad
spectrum, operating on the principle that
people should have access to artistic
activity irrespective of geographical
location, economic status, disability or
any other form of disadvantage.

In 2000/2001 the charity gave a total
of £526,000 in 63 grants ranging from
£1,000 to £30,000, most of which were
under £10,000. While grants made in the
arts/community arts category amounted
to £215,100, donations relevant to this
guide were also recorded in the annual
report under the headings of conservation
and museums, and disability and special
needs. This brought total arts-related
funding to £274,300 (52% of total grant-
aid), disbursed in 22 grants. Donations
included:

Under 'arts/community arts' –
Paragon Ensemble, Glasgow, to employ a
 community education officer; Wyeside
 Arts Centre, Powys, to support salaries;
 ★Central School of Ballet, two-year
 bursary; Frome Memorial Hall,
 Somerset, assisting with capital cost of
 extending theatre (£30,000 each);
★Kirckman Concert Society (£15,000
 annual grant plus £10,000 additional
 one-off donation);
Square Chapel Trust, Halifax, two-year
 grant towards cost of a marketing
 development officer; Birds of Paradise
 Theatre Company, Glasgow, two-year
 grant for training disabled people; City
 of Canterbury Symphony Orchestra
 (£10,000);
Gloucestershire Dance Project; Psappha
 Ltd, Manchester, to support a tour
 (£5,000 each);
Ludus North West Dance-in-Education
 Ltd, Lancaster, towards arts project
 (£4,000);

Llandovery Theatre Company, for arts workshop (£1,100).

Under 'conservation and museums' –

University of Hull Maritime History Trust, towards building restoration (£20,000);

Hafod Trust, Nr Aberystwyth, for restoration work; Kilmartin House Trust, Argyll, for Archaeology Education Building (£10,000 each).

Under 'disability and special needs' –

Quaker Youth Theatre, Birmingham, integrated workshops for deaf-hearing project (£3,000).

Exclusions: Individuals; projects in London or Northern Ireland; large, widely circulated appeals; retrospective funding; adaptations to improve access to buildings; advancement of religion; animal welfare; conferences or seminars; endowment funds; festivals; hospices; individual youth clubs; large capital projects; medical research; other grant-making bodies; publications, films or video; sport; special needs schools; travel, expeditions or holidays; vehicles; formal education.

Applications: An initial letter should be sent describing who you are; what you do; why you are seeking help; how success will be measured; how much money you need to raise; how soon you need funds; who else you have asked for help; and what support you have already attracted.

In addition, you should attach brief information about the origins and current company/charitable status of your organisation; a copy of your most recent annual report and full audited accounts; an itemised income and expenditure budget for your organisation; an itemised income and expenditure budget for the work to be funded; and your Equal Opportunities policy.

Trustees meet quarterly, in February, May, September and November, but agendas are planned in advance and a period of six months between initial application and formal consideration is usual.

All letters receive a written reply.

CHK Charities Ltd

CC No: 1050900

PO Box 191, 10 Fenchurch Street, London EC3M 3LB

Tel: 020 7475 6246
Contact: N R Kerr-Sheppard, Administrator
Trustees: David Peake, Chair; D A Acland; Mrs S E Acland; Mrs K S Assheton; Mrs L H Morris; Mrs S Peake; Mrs J A S Prest; Mrs C S Heber Percy.
Beneficial area: UK, especially Gloucestershire and Oxfordshire.
Grant total: £1,728,000 (2000/2001)
Arts grants: £142,240

Originally called the Sir Cyril Kleinwort Charitable Trust, this trust has particular interest in the following: education; job creation; conservation; arts; population control; crime prevention; youth development. Beneficiaries are usually charities known or local to the trustees and substantial national charitable bodies (see also exclusions below).

In 2000/2001 the trust gave a total of £1,728,000 in 199 grants of between £1,000 and £150,000, most of which were under £10,000. Out of this, £142,240 (eight per cent of total grant-aid) was given in 17 grants relevant to this guide. These included:

Museum of London (£50,000);

★Royal Shakespeare Theatre, Stratford upon Avon (£16,300);

Royal College of Music (£11,400);

★Chipping Norton Theatre Trust (£10,000);

Almeida Theatre Company Ltd; British Youth Opera; National Library for the Blind; ★National Portrait Gallery; ★Royal Academy of Arts (£5,000 each);

British Architectural Library Trust;
 ★Nordoff–Robbins Music Therapy
 (£3,000 each);
Garsington Opera Ltd (£2500);
Cheltenham International Festival of
 Music; Gloucester Three Choirs
 Festival Association; New London
 Orchestra (£2,000 each);
★British Museum (£1,540).

Exclusions: No grants to individuals or
to small local charities, for example
individual churches, village halls, and so
on, where there is no special connection
to the trust. Appeals from local branches
or offshoots of national charitable bodies
are normally not considered.

Applications: 'Appeals will usually be
considered within three months, but may
be referred for further consideration at
board meetings which are held twice a
year, normally in March and October.'
Only successful applicants are notified of
the trustees' decision.

The Winston Churchill Memorial Trust

CC No: 313952

15 Queen's Gate Terrace, London
SW7 5PR

Tel: 020 7584 9315; Fax: 020 7581 0410
E-mail: office@wcmt.org.uk
Website: www.wcmt.org.uk
Contact: Sue Matthews
Trustees: Lady Soames, Chairman; plus
11 other trustees.
Beneficial area: UK.
Grant total: £610,000 (2001)
Arts grants: £95,000
Travelling fellowships are awarded
annually which 'enable men and women
from all walks of life and every corner of
the United Kingdom to acquire
knowledge and experience abroad. In the
process, they gain a better understanding
of the lives and cultures of people
overseas and, on their return, their
expertise is enhanced greatly as is their

effectiveness at work, and their
contribution to the community'. All
British citizens of any age and occupation
are eligible and qualifications are not a
necessity.

Grants cover all fellowship expenses for
an overseas stay of between 4 and 8
weeks and are offered in about 10
different categories each year, one of
which is generally in an arts-related area.
Average grants are between £5,000 and
£6,000.

In 2001 the trust gave a total of
£610,000 in 106 fellowships, 17 of
which, amounting to £95,000 (16%),
were relevant to this guide. These were
distributed as follows:
- Teachers of the Arts – 11 grants;
- Artists and Craftsmen – 6 grants.

Exclusions: Courses and academic study.
Applications: Any British citizen with
an individual project to undertake
overseas, which matches one of the
specified categories for the year, may
apply for a grant. Selected applicants will
be expected to make their own plans and
arrangements for projects.

Application forms and guidelines are
available: please send a SAE (23 cm x 11
cm).

The closing date for completed
applications is usually late October.
**Applications received after the
closing date will not be considered**.

The Cinderford Charitable Trust

*(see Ofenheim Trust and The
Cinderford Charitable Trust)*

CC No: 286525

Baker Tilly, Iveco Ford House, Station
Road, Watford, Hertfordshire WD1 1TG

Tel: 01923 816400
Contact: G Wright

The City Parochial Foundation

(see also Trust for London)

CC No: 205629

6 Middle Street, London EC1A 7PH

Tel: 020 7606 6145; Fax: 020 7600 1866
E-mail: info@cityparochial.org.uk
Website: www.cityparochial.org.uk
Contact: Bharat Mehta, Clerk
Trustees: 21 trustees nominated by 10 bodies including the Crown, the University of London, the Church Commissioners, the Bishopsgate Foundation and the Cripplegate Foundation. Chair, Prof Gerald Manners; Vice-Chair, Ms Maggie Baxter.
Beneficial area: London Metropolitan Police District, City of London.
Grant total: £4,986,000 (2000)
Arts grants: £160,121
The foundation exists 'to benefit the poor of London', including the 'socially, culturally, spiritually, environmentally and financially disadvantaged'. In achieving these aims, support is given to a wide range of projects including the arts. **However, arts organisations are not a priority and arts applications for funding will only be considered where the arts are employed as a medium for work with those who clearly fall within the foundation's current priorities**.

In 2000 the foundation gave a total of £4,986,000 in 196 grants ranging from £1,800 to £95,438; most were under £50,000. Out of this, a total of £160,121 (three per cent of total grant-aid) was given in seven arts-related grants. These were:

Pan Centre for Intercultural Arts, salary for artistic director (£35,343);
London Disability Arts Forum, core costs; North Kensington Video/Drama Project, salary of video trainer and running costs (£30,000 each);
Royal National Theatre, costs of Streets Alive Company (£20,000);
Lyric Theatre Hammersmith Limited, costs of Linking Out Project (£19,000);
Artsline, for an arts training project (£15,778);
Studio Upstairs, core costs (£10,000).

Applicants should note, however, that the foundation's funding policies operate on a five-year basis and that the donations listed above were made under the guidelines for the previous quinquennium. Details of the current guidelines are listed below.

Grant-making priorities for 2002–2006

Applications are welcomed from registered charities or charitable organisations that aim to: tackle the causes of poverty; and help poor Londoners to cope with, and find ways out of, poverty.

The foundation prioritises work which helps to reduce discrimination, isolation and violence, with a particular emphasis on projects focusing on:

- black, Asian and minority ethnic communities;
- disabled people;
- established communities in areas of long-term poverty;
- lesbians and gay men;
- refugees and asylum seekers;
- young people aged 10–25.

Types of work funded

- 'Organisations providing advice, information and individual advocacy – especially those organisations that are user-led or those that encourage user involvement, participation, and which lead to user empowerment.
 For example:
 – an organisation managed by parents to provide an independent advice, information and support service to parents of pupils from black and

minority ethnic communities who have been excluded (suspended or expelled) from school;
– an organisation working with benefit claimants who have a history of mental illness, to support them in applying for their benefits.'

- 'Organisations developing, promoting and providing education, training and employment schemes.
For example:
– organisations aiming to give refugees and asylum seekers access to IT training courses;
– an organisation seeking to promote training as mentors amongst middle-aged unemployed people in an area of long-term poverty.'

- 'Organisations that are attempting to develop initiatives that tackle violence and hate crimes against the target groups.
For example:
– an organisation working with local people and the local police to tackle vandalism on an estate;
– an organisation providing support to victims of domestic violence, racist or homophobic harassment and violence.'

Applications will be considered for work with people who commit crimes and violence as well as victims.

Other areas of interest

- 'Work that aims to change policy' – organisations working with relevant groups to instigate policy changes relating to discrimination, isolation and violence, with the aim of improving people's lives.
For example:
– work that is led by disabled young people that results in greater provision of integrated services for disabled people in the area.'

- 'Second tier and infrastructure organisations.
For example:
– a Council for Voluntary Service that wishes to provide financial

management training and consultancy for refugee community organisations.'

- 'Working with others' – encouraging collaboration between organisations.
For example:
– a refugee organisation and a lesbian and gay group working together on issues of community safety with the local police.'

- 'Small Grants' – small one-off grants of up to £10,000 for any organisation working with the priority groups.

The City Parochial Foundation also administers the Trust for London (see separate entry).

Exclusions: Endowment appeals; individuals; purchase or building of premises; medical research and equipment; organisations currently receiving funding from Trust for London; replacing public funds; trips abroad. Core funding is only given in exceptional cases.

Applications: There are no application forms. The first step should be to read the full guidelines available from the foundation (and on the website) to check that the organisation and its work fits within the grant-making priorities. Initial enquiries should be made either by telephoning a field officer to talk about projects and funding, or by sending written details of the planned work and funding needs (no more than two sides of A4 paper), accompanied by the organisation's constitution, most recent accounts and latest annual report. This should be done at least three months before the relevant deadline. If the work fits the priorities, a field officer will arrange to meet applicants to discuss the appeal further. Once the field officer and applicant have agreed on what should be applied for, a full written application must be submitted. This should be on no more than three sides of A4 paper in a format given by the field officer. Full applications must be submitted by:

- 31 January for April meeting;

- 15 April for July meeting;
- 15 August for October meeting;
- 15 November for January meeting.

Finalised applications are presented to the grants committee by the field officer for consideration. Notification of success/failure will be sent in writing following the trustees' board meeting.

The Clark Family Charitable Trust

CC No: 1010520

PO Box 1704, Glastonbury, Somerset BA16 0YB

Tel: 01458 842374; Fax: 01458 842022
E-mail: jactrust@ukonline.co.uk
Contact: Mrs P Grant, Secretary
Trustees: Lancelot Pease Clark; John Cyrus Clark; Thomas Aldham Clark; Caroline Pym; Aidan J R Pelly.
Grant total: £158,000 (1998/99)
Arts grants: £20,250
This trust's scope for charitable giving includes causes for the disabled, the arts, and alcohol and addiction. Education is also a priority, with bursaries and scholarships awarded annually.

In 1998/99 a total of £158,000 was given in 27 grants, ranging from £200 to £34,779 in an annual donation to the trust's sister organisation, the Cyrus Clark Charitable Trust. Most grants were, however, under £10,000. A total of £20,250 (13% of total grant-aid) was given in 5 grants to the arts. These were:
Street Theatre Workshop Trust (£10,250 in two grants);
Street Symphony UK; Watershed Arts Fund (£4,000 each);
Child's Classic Concerts (£2,000).

Applications: The trust did not wish to be included in this guide as its expenditure is fully committed for the foreseeable future and, as a result, no new applications will be considered.

The Clore Duffield Foundation

CC No: 1084412

Studio 3, Chelsea Manor Studios, Flood Street, London SW3 5SR

Tel: 020 7351 6061; Fax: 020 7351 5308
E-mail: cloreduffield@aol.com
Website: www.cloreduffield.org.uk
Contact: Sally Bacon, Executive Director
Trustees: Dame Vivien Duffield, Chair; David Harrel; Sir Mark Weinberg; Sir Jocelyn Stevens; Caroline Deletra; Michael Trask.
Beneficial area: UK.
Grant total: Up to £8 million per year – see below
Arts grants: £3,900,000
In December 2000 the Clore Foundation and the Vivien Duffield Foundation merged to become the Clore Duffield Foundation. The new foundation 'will allocate charitable donations totalling up to £8 million a year and will concentrate its support on the arts, museums and galleries, education, health and social welfare'. Particular emphasis is placed on supporting children, young people and society's most vulnerable individuals, through the work of charitable organisations.

In addition to its general programme of donations, the foundation manages two main grant-giving/awards programmes: Artworks – Young Artists of the Year Awards, a scheme to encourage schools to visit local and national museums and galleries, and to promote innovative teaching and learning in art; and the £1 million Clore Small Grants Programme, which funds educational work at museums and galleries.

The two previous foundations have been major supporters of 'a substantial number of large and small education, arts and social welfare institutions, including the Royal Opera House, Tate Britain, Eureka and the NSPCC ... Clore Education Centres have been created

within many small regional museums and at the British Museum, Tate Modern the Natural History Museum.'

As a result of the recent merger outlined above, it is only possible to provide an estimation of the level of arts support, based on grants previously disbursed by the former Clore Foundation and Vivien Duffield. In 1997 the Clore Foundation gave a total of £3,062,000, out of which £511,000 (17%) was relevant to this guide; the Vivien Duffield Foundation gave £2,131,000 in 1997, £2,049,000 (96%) of which was arts-related. Using these figures as a guide, it may be estimated that around £3.9 million (49%) will be given annually to arts causes.

Exclusions: No grants to individuals, whether for education or any other purpose, or to organisations which are not registered charities.

Applications: Small Grants Programme guidelines and application forms are available from the foundation and on the website.

Other applications should be made in writing on no more than two sides of A4, accompanied by a SAE. If interested, the trustees will request more detailed information and organise a meeting with the applicants. Final decisions on the awarding of grants are made only at formal meetings of the trustees. These are not on a fixed schedule; there is an ongoing process of assessment that allows the trustees to meet as and when there are sufficient applications.

The Clothworkers' Foundation and other Trusts

CC No: 274100

Clothworkers' Hall, Dunster Court, Mincing Lane, London EC3R 7AH

Tel: 020 7623 7041
Contact: Mr Andrew Blessley, Secretary
Trustees: The Governors of the Foundation (including Peter Rawson, Chair; Richard Jones, Deputy Chair).
Beneficial area: UK.
Grant total: £3,905,000 (2000)
Arts grants: £424,400

Grants are made within the following categories: clothworking; medicine and health; relief in need and welfare; children and youth; education and the sciences; the arts; the church; heritage/the environment; overseas.

The foundation makes donations from its own funds and also administers the grants of 17 other trusts, working in the fields mentioned above. This includes the arts but excludes clothworking and heritage and environment.

'Preferential consideration is given to appeals received from self-help organisations and to charities requiring support to 'prime the pumps' for development and more extensive fund-raising initiatives' and to 'textiles and kindred activities'.

In 2000 the foundation and its associated trusts gave a total of £3,905,000 in grants to 166 causes. Funding was distributed as follows:

- clothworking – £600,200 (15%);
- medicine/health – £806,500 (21%);
- relief in need and welfare – £544,920 (14%);
- children/youth – £261,833 (7%);
- education/sciences – £581,882 (15%);
- the arts – £156,350 (4%);
- the church – £93,232 (2%);
- heritage/environment – £398,700 (10%);
- overseas – £461,300 (12%).

Grants ranged from £1,000 to £350,000, although most were under £50,000. Support for arts–related causes was not restricted to 'the arts' category and a total of £424,400 (11% of total funding) was given in 22 grants relevant to this guide. These included:

Under 'the arts' –

Royal Shakespeare Theatre, redevelopment of costume manufacturing area and textile skills training (£31,000);

High Peak Theatre Trust Limited, repair and refurbishment of Buxton Opera House (£30,000);

London Symphony Orchestra Ltd, music education centre at St Luke's, London (£20,000);

Royal Artillery Museums Limited, conservation of museum's collection of textiles (£10,000);

London Bach Society (£4,000).

Under 'clothworking' –

National Museum of Science and Industry, display conservation and education work relating to textiles (£50,000);

Royal School of Needlework, support for apprenticeships (£16,700);

Bradford Textile Society, fabric design competition (£4,100).

Under 'relief in need and welfare' –

Fine Cell Work, for expansion of craft work in prisons (£6,000).

Under 'education and the sciences' –

Sobriety Project, for education and training at Waterways Museum (£19,500);

Royal Orchestral Society for Amateur Musicians, for musical education (£4,000).

Under 'heritage/environment' –

National Trust, for textile conservation studio (£100,000);

Ironbridge Gorge Museum Development Trust, for mechanical and electrical costs (£54,000).

Exclusions: Individuals; organisations not registered charities; activities which are the responsibility of statutory funding; sponsorship; general maintenance, repair of restoration of ecclesiastical buildings or schools/colleges in the primary or secondary sector of education, unless they have an existing and long-standing connection with The Clothworkers' Company; organisations or groups whose main objects are to fund or support other charitable bodies.

Applications: In writing on the applicant charity's official headed notepaper, having first obtained a copy of the foundation's guidelines for applicants. All applications must be accompanied by a completed Data Information Sheet, latest annual report and full accounts. In the course of application letters, applicants should:

- introduce the applicant's charity's work; state date established; describe its aims and objectives; define what it does and who benefits from its activities;
- comment upon the charity's track record since its inception, including achievements/successes; 'endeavour to provide an interesting synopsis of the organisation';
- describe the project requiring funding fully and comment on the charity's plans for the future;
- provide full costings/budget for the project in separate appendix/ appendices;
- give details of all other applications to other sources and indicate precisely what funds have already been raised for the project.

Telephone calls to discuss proposals are welcomed. Applications are processed continuously as meetings are held six times a year. Successful applicants are expected to provide periodic progress reports. A period of at least five years must elapse before a further grant will be considered for an organisation receiving funds.

The John Coates Charitable Trust

CC No: 262057

40 Stanford Road, London W8 5PZ

Tel: 020 7938 1944; Fax: 020 7938 2390
Contact: Mrs P L Youngman, Trustee
Trustees: Mrs McGregor; Mrs Kesley;
Mrs Lawes; Mrs Youngman.
Beneficial area: UK.
Grant total: £313,000 (1999/2000)
Arts grants: £62,500
This trust supports medical,
environmental and educational
organisations as well as a number of arts
organisations. Grants tend to be given to
large national organisations and small
local charities 'which are of local or
personal interest to one or more of the
trustees', and many grants are recurrent.

In 1999/2000 the trust gave a total of
£313,000 in 49 grants ranging from
£500 to £20,000, most of which were
below £10,000. Out of this, £62,500
(20% of total grant-aid) was given to 13
arts-related causes. These were:
Ironbridge Gorge Museum; Shakespeare's
 Globe Theatre (£10,000 each);
Gilbert White Museum; South Bank
 Centre; National Youth Orchestra;
 Royal Academy; String of Pearls
 Millennium Festival; Weald and
 Downland Museum; Welsh National
 Opera (£5,000 each);
Handel House Museum (£3,000);
Dulwich Picture Gallery; The Sixteen
 (£2,000 each);
Chelsea and Westminster Arts Trust
 (£500).

Exclusions: Individuals.
Applications: Trustees' meetings are held
in January and July.

The David Cohen Family Charitable Trust – see John S Cohen Foundation entry

CC No: 279796

The John S Cohen Foundation

CC No: 241598

PO Box 21277, London W9 2YH

Tel: 020 7286 6921; Fax: 020 7286 7841
Contact: Diana Helme, Secretary
Trustees: Dr David Cohen, Chairman;
Mrs Elizabeth Cohen; Richard Cohen;
Ms Imogen Cohen; Ms Olivia Cohen;
Jolyon Cowan.
Beneficial area: Mainly UK, some
overseas.
Grant total: Unknown due to merger
but see below.
Arts grants: £200,000
At the time of writing this foundation
was in the process of merging with its
sister organisation, the David Cohen
Family Charitable Trust. This process is
expected to be completed by 31 March
2002. The new amalgamated organisation
will retain the name and registered
charity number of the John S Cohen
Foundation. Its charitable aims will
include some of the previous objectives,
principally those of arts, conservation, the
environment and education.

As an indication of the type and size of
projects that the foundation may fund,
examples of the support provided by the
previously separate organisations are
given below.

The David Cohen Family Charitable
Trust gave support exclusively to the arts,
with a particular focus on visual arts,
theatre, literature, education and music,
including opera. In 1998 grants totalling
£40,000 were made to 21 arts-related
beneficiaries. Included in this was a
donation of £15,000, made on an annual
basis to the Arts Council of England to
administer the David Cohen British
Literature Prize. Grants were generally
under £4,000. Other recipients included:
Serpentine Gallery, education programme
 for deaf visitors (£3,470);
Webber-Douglas Academy, training of
 young talent (£2,500);

National Children's Orchestra, for
bursaries and concerts; Monteverdi
Choir and Orchestra, towards the
musicological programme for Bach
2000; Camden Arts Centre, talk and
seminar series (£2,000 each);
British Library, towards performance at
inaugural concert (£1,500);
Royal Opera House Trust; Memorials by
Artists, for 'The Art of Remembering'
exhibition; Young Vic, for education
and community work with young
people in London (£1,000 each);
Edward Barnsley Educational Trust,
furniture apprenticeship; Live Music
Now! (£500 each).

The John S Cohen Foundation has been
particularly active in supporting music
and the arts, Jewish charities, education
and the natural and built environment.
Within the arts field, the foundation's
policy was to encourage innovative and
contemporary work and young artists and
musicians.

In 1997/98 the foundation gave a total
of £382,000. The annual report featured
no overall breakdown by category and
listed only the 50 largest grants, which
ranged between £1,123 and £50,000;
most were for up to £5,000. These grants
totalled £367,000 out of which
£191,000 (50% of total grant-aid) was
given in 23 grants relevant to this guide.
Arts grants listed for 1997/98 included:
British Museum (£50,000);
Welsh National Opera (£25,000);
National Gallery (£20,000);
Tricycle Theatre (£15,000);
South Bank Centre (£10,800);
Royal National Theatre (£10,000);
London String Quartet Foundation
(£5,750);
Garsington Opera; Handel House
Museum; Institute of Contemporary
Arts; Tate Gallery (£5,000 each);
Guildhall School of Music and Drama
(£3,480);
Jewish Book Week; Adapt Trust (£3,000
each);

English Concert (£2,000);
Forward Poetry Trust (£1,625).

Based on the previous arts funding of the
formerly separate trusts, it may be
estimated that around £200,000 will be
given in grants relevant to this guide each
year.
Exclusions: Individuals; social welfare;
health; medical support; organisations
which are not registered charities;
equipment costs.
Applications: In writing to the
correspondent. Only successful
applications receive a response.

Community Foundation serving Tyne & Wear and Northumberland

*(for other community foundations
see end of trust section)*

CC No: 700510

5th Floor, Sun Alliance House, 35
Mosley Street, Newcastle upon Tyne
NE1 1YF

Tel: 0191 222 0945; Fax: 0191 230 0689
E-mail:
general@communityfoundation.org.uk
Website:
www.communityfoundation.org.uk
Contact: Maureen High
Trustees: Board Members: His Grace the
Duke of Northumberland, President;
Sally Black; Steve Brown; Pamela
Denham; Barbara Dennis; Alan Ferguson;
George Gill; John Hamilton; Joy
Higginson, Deputy Chair; Robert
Hollinshead, Chair; Roy McLachlan; John
Mowbray; Chris Parkin; Guy Readman;
Brian Roycroft; Colin Sinclair; Derek
Smail; Derek Walker; Tricia Webb; Hugh
Welch; Jan Worters; Mike Worthington.
Beneficial area: Tyne & Wear and
Northumberland.
Grant total: £2,326,000 (2000/2001)
Arts grants: £83,138
The foundation 'comprises a growing
family of funds set up by individuals,

companies and trusts for different charitable purposes which all benefit the communities of Tyne & Wear and Northumberland'. Those funded include groups representing children, young adults, the disabled, the elderly and disadvantaged areas.

In 2000/2001 the foundation gave a total of £2,326,000 in grants of up to £250,000, most of which were under £10,000. The smallest grants were not listed in the annual report. A total of £83,138 (four per cent of total grant-aid) was given to organisations and individuals in 38 listed arts-related grants. These included:

Under 'Akzo Nobel International Coatings Fund' –
Tyne & Wear Museums (£1,000).

Under 'Canford Audio Fund' –
Grants to individuals for audio equipment to help with disability or community arts (£1,423 in two grants).

Under 'Chapman Fund' –
North Tyneside Steel Band (£2,200).

Under 'Coal Fields Community Chest for South Tyneside' –
South Tyneside Art Studios (£4,935).

Under 'Samuel Johnson Memorial Fund' –
Bubble Eye Productions (£1,000).

Under 'Linden Fund' –
Open Clasp Theatre Company (£1,000).

Under 'P & G Fund' –
Northern Arts (£8,000);
Northern Stage (£6,000);
Dance City; Northern Sinfonia (£5,000 each).

Under 'Joseph Rowntree Charitable Fund' –
Northern Disability Arts Forum (£13,000).

Under 'Sponsors Club' –
Pilgrim Films (£5,000 in two grants);
Laing Art Gallery; Hardwick Young People's Project (£2,500 each).

Under 'Young Musicians' Fund' –
Grants to individual musicians (£1,967 in eight grants).

Although many of the above funds are for general community purposes, the Canford Audio Fund, Samuel Johnson Memorial Fund, Sponsors Club and Young Musicians' Fund are wholly relevant to this guide. In addition, the foundation launched two new funds in 2001 – the David Goldman Awards and the North Music Trust – both of which are exclusively music-related.

Exclusions: Capital projects.

Applications: Applicants are advised to discuss their work before completing an application form. Full guidelines and annual review are available from the foundation. The foundation states: 'You do not need to identify a fund when applying, as we will match your request to the most appropriate fund we manage.' Applications are registered and an acknowledgement sent within 10 days. There are no closing dates for applications and most applicants should receive a decision within three months. Those taking longer will be considered by more than one fund; applications are registered with one fund at a time.

The Ernest Cook Trust

CC No: 313497

Fairford Park, Fairford, Gloucestershire GL7 4JH

Tel: 01285 713273; Fax: 01285 711692
E-mail: grants@ernestcooktrust.org.uk
Website: www.ernestcooktrust.org.uk
Contact: Mrs Antonia Eliot, The Grants Administrator
Trustees: Sir William Benyon, Chairman; S A J P Bosanquet; A W M Christie-Miller; M C Tuely; P S W K Maclure; T R E Cook.
Beneficial area: UK, with a special interest in counties where the trust owns land – Gloucestershire; Buckinghamshire; Leicestershire; Dorset.
Grant total: £629,000 (2000/01)
Arts grants: £169,000

This trust focuses its giving on charitable or not-for-profit organisations, which must be concerned with education in one of the following areas: conservation and the rural environment; the arts, crafts and architecture; the encouragement, through education, of young people; research devoted to these main areas of work.

In 2000/01 the trust gave a total of almost £629,000 in 175 grants ranging from £150 to £25,000; most were under £7,000. Arts-related funding totalled £169,900 (27% of total grant-aid) in 48 grants. These included:

Under 'rural and environment' –
Kilmartin House Trust, support for the museum's education service (£15,000);
Sobriety Project, for tutors to teach traditional crafts (£6,000);
Kelham Island Museum, for educational resources (£5,000).

Under 'arts, crafts and architecture' –
Holburne Museum of Art, to develop 'Living Landscape' courses (£20,000);
Bleddfa Centre, towards the appointment of a new director (£10,000);
Jackdaws, for projects combining the skills of classically trained musicians with other artists to engage disadvantaged children in music; Kids at Art, placing artists in schools across the country (£5,000 each);
Edward Barnsley Trust, towards apprentice bursaries (£4,000);
Building of Bath Museum, towards educational materials for the new Interiors Gallery; Cornwall Crafts Association, towards the production of brochures (£3,500 each);
London Opera House, for Adopt a School pilot scheme (£2,000);
Dorset Opera, for residential workshops; Ely Cathedral, translation of historic documents written in Latin (£1,000 each);
European Union Youth Orchestra, for tuition and British auditions (£500);
Age Concern, Northumberland, for a community arts workshop (£300).

Under 'youth' –
Sir Henry Floyd Grammar School, towards a bid for art college status (£20,000);
Avoncroft Museum of Historic Buildings, to fund outreach officer; Children's Laureate, towards an appointment to honour a writer or illustrator of children's books (£5,000 each);
St Mary's School Aylesbury, to purchase books for new Ernest Cook Library (£3,000).

Under 'other awards lying outside specific categories' –
Banbury Museum, to help with educative displays (£5,000).

The trust wishes to make it clear that the grant to Sir Henry Floyd Grammar School is unusually large for the 'youth' category and that this level of funding is unlikely to be repeated for other projects.

Exclusions: Individuals; work overseas; projects applied to medicine, health or social work; retrospective appeals; general appeals; building work; sports and recreation; community projects; publications; agricultural colleges; relieving the responsibilities of public bodies; Wildlife Trusts and Farming & Wildlife Advisory Groups in counties where the trust does not own land.

Applications: Only applications for educational projects are considered. Most grants are considered at meetings in March and October, although grants under £2,000 are assessed more frequently. Applications for main meetings must be finalised by 31 January and 31 August. Requests should be presented clearly on a maximum of four sides of A4 paper, enclosing a SAE.

Further details are available from the trust's website.

The Coppings Trust

CC No: 1015435

44a New Cavendish Street, London
W1M 7LG

Tel: 020 7486 4663
Contact: Clive M Marks, Trustee
Trustees: Clive Marks; Dr R M E Stone;
T P Bevan.
Beneficial area: UK and overseas.
Grant total: £159,000 (1999/2000)
Arts grants: £23,500
This trust's charitable interests are
'centred around human rights, be it for
immigrants aid, the welfare of prisoners,
and the victims of anti-personnel mines'.
Care for disadvantaged youth, the aged
and refugees are also the concern of the
trustees, as well as literary and educational
causes.

In 1999/2000 a total of £159,000 was
given in 13 grants of between £1,000
and £25,000. Of this, £23,500 (15% of
total grant-aid) was given in three grants
relevant to this guide. These were:
*Ebony Steel Band Trust (£20,000);
Amadeus Scholarship Fund (£2,500);
Jewish Museum (£1,000).

Projected commitments to 'arts-literature'
(£11,000 for 2001 and £10,000 for
2002) suggest that, in future, less priority
will be given to arts-related projects.
Applications: Trustees meet quarterly
but **'the trustees are concentrating on
those projects already known to
them'**.

The Sidney & Elizabeth Corob Charitable Trust

CC No: 266606

62 Grosvenor Street, London W1K 3JF

Contact: Ms S A Wechsler, Trustee
Trustees: S Corob; E Corob; C J Cook; J
V Hajnal; Ms S A Wechsler.
Beneficial area: UK.
Grant total: £271,000 (1999/2000)
Arts grants: £39,788

The chief objects of this trust are the
relief of poverty and advancement of
public education, although other projects
are considered from time to time.

In 1999/2000 the trust gave a total of
£271,000 in grants ranging from under
£1,000 to £40,000. Only grants of over
£1,000 were listed in the annual report.
There were 52 of these, most of which
were under £10,000.

Arts-related funding amounting to
£39,788 (15% of total grant-aid) was
given in the following 10 grants:
British Museum (£25,000);
Royal Opera House Trust (£5,288);
Royal College of Music (£2,000);
British Museum Development Trust
(£1,500);
Jewish Book Week; Jewish Museum; Live
Music Now!; Royal Court Theatre;
Soho Theatre; Old Vic Theatre Trust
(£1,000 each).

The Courtauld Trust for the Advancement of Music – see Musicians' Benevolent Fund

CC No: 207604

The Crescent Trust

CC No: 327644

27a Sloane Square, London SW1W 8AB

Tel: 020 7730 5420
Contact: Ms C Akehurst
Trustees: John Carl Sebastian Tham;
Richard Anthony Finlayson Lascelles.
Beneficial area: UK.
Grant total: £58,000 (1999/2000)
Arts grants: £36,553
This trust has general charitable purposes,
with a current policy to concentrate on
the arts, heritage and ecology.

In 1999/2000 the trust gave a total of
£58,000 in 19 grants ranging from £100
to an exceptional sum of £20,000 given
to the Victoria & Albert Museum. Most
donations were, however, below £5,000.
A total of £36,553 (63% of total grant-

aid) was given in the following six arts-related grants:

*Victoria & Albert Museum (£20,000);
*The Wallace Collection (£7,937);
*Attingham Trust (£4,616);
Royal Court Theatre; National Museums (£1,500 each);
British Museum (£1,000).

Applications: The trust states that it does not respond to unsolicited applications.

The Cripplegate Foundation

CC No: 207499

76 Central Street, London EC1V 8AG

Tel: 020 7336 8062; Fax: 020 7336 8201
E-mail: david@cripplegate.org.uk
Contact: David Green, Clerk
Trustees: Grants committee: Roger Daily-Hunt, Chair; John Broadbent; Roger Daily-Hunt; Cllr Carol Powell; Maxine Roberts; Barbara Riddell; Angela Agard-Brennan; Rosemary Boyes-Watson; Paula Kahn; Jack Sheehan; Rachel Panniker.
Beneficial area: The Ancient Parish of St Giles, Cripplegate, an area extending from the Barbican in the City to Highbury Corner, Islington.
Grant total: £1,046,000 (2000)
Arts grants: £138,496
The foundation principally provides facilities for recreation and leisure in the interests of the social welfare of people resident or employed in the designated area, with the aim of relieving hardship or distress through grantmaking and the provision of services. Emphasis is also placed on education, with a budget of £200,000 per annum allocated for projects in local schools which 'enrich the curriculum, improve opportunities for young people and help raise achievement'. Funding is also given to more general charitable purposes within the area of benefit. Grants can be made to both individuals and organisations.

The original area of benefit is the ancient parish of St Giles, Cripplegate, to which was added in 1974 the ancient parish of St Luke's, Old Street. In modern terms these two parishes run from the Barbican in the south nearly up to the Angel, Islington, and this area has to be given preference in making grants. Since September 1998 there is an additional area of benefit which extends further into the London Borough of Islington, to Highbury Corner, and includes the Islington Council Wards of Barnsbury, Bunhill, Clerkenwell, Canonbury East, Canonbury West, St Mary, St Peter and Thornhill.

In 2000 the foundation gave a total of over £1,046,000 in 463 grants. Of this, £136,708 was given in 370 small grants to individuals and £909,966 was disbursed to 93 organisations. Grants to organisations ranged from £200 to £119,726; most were under £30,000. Out of these, 28 grants totalling £138,496 (13% of total grant-aid) were given to arts-related causes. These included:

Under 'schools and work with schools' –
Central Foundation Boys School, towards the cost of improving the school's drama facilities (£10,592);
Laycock Primary School, music for early years unit with the LSO (£7,837);
Prior Weston Primary School, for 'surprise snowballs' arts project, work with Transisters music group and work with Adzido Pan African Dance Ensemble (£6,800 in three grants);
Islington Green School, towards the cost of 'muck and literacy week' and holidays related to this theme (£4,800 in two grants);
Almeida Theatre, towards costs of two productions involving local schools (£3,306 in two grants).

Under 'arts, leisure and environment' –
London Symphony Orchestra, towards the costs of a development worker for three years (£35,000);

Grand Union Orchestra, towards cost of
subsidised tickets (£12,500);

Canal Museum Trust, towards cost of
redesigning museum displays to make
them accessible to all; Union Chapel,
towards cost of Access All Areas arts
programme (£10,000 each);

Islington Music Centre, towards salaries
and running costs (£5,000);

Angel Canal Festival, running costs for
entertainment (£3,300);

An Angel for the Angel Exhibition,
towards costs for an exhibition of angel
designs by students from Central St
Martin's College of Art & Design;
Clerkenwell Festival, running costs
(£1,000 each).

Under 'health and mental health' –

Studio Upstairs, towards the cost of local
residents using a mental health arts
project (£6,000).

Exclusions: National charities and
organisations, or organisations outside the
area of benefit, unless they are carrying
out a piece of work in the area of benefit;
grants for concerts or other events held in
the Church of St Giles-without-
Cripplegate; schemes or activities which
would normally be statutorily funded;
medical research; specifically religious
based activities.

With regard to schools: purchase, repair
or maintenance of buildings; playground
improvements; purchase, repair or
maintenance of vehicles; fundraising
events; mainstream teaching staff salaries;
day-to-day running costs; textbooks;
retrospective funding; after-school
activities; computers.

Applications: 'The area of benefit
connection is an essential criterion
that all applications must meet.'
Preliminary enquiries by telephone or
letter are welcome to establish eligibility.
Application forms should be obtained
from the clerk to the governors at the
above address. Applications are considered
throughout the year and will be
responded to within 2–3 weeks.

With regard to projects in local schools,
the foundation has made the following
statement:

'We do fund quite a lot of arts work in
the local schools, but this is part of a
programme to enhance the curriculum in
those schools. The way it works is that
they have a budget over two years and if
they can come up with good
programmes for spending the allocation
we will approve it. Therefore the
application from an arts organisation for
work in schools must come via the
school and with their agreement. Too
often arts groups send us a bid as a punt
and then try to get schools interested
afterwards, and this almost never works in
our experience as the piece of work has
not developed from work that the school
wants to do.'

Over two academic years, schools in
the Cripplegate area can receive up to
£10,000 per year for primary schools;
£25,000 per year for secondary schools;
and £20,000 per year for special schools.
In addition, £10,000 each over two
academic years for Richard Cloudesley
and Rosemary School for specialist
equipment for children with disabilities.

The foundation is particularly
interested in encouraging applications in
the following areas: support for work
with other organisations; cross-curricular
activities; work with more than one
school; initiatives in schools' own priority
areas; behaviour; school journeys and
residential activities.

Schools should contact the foundation
before submitting applications to discuss
proposals. Applicants need to:

- complete an application form;
- demonstrate how the application will
 raise achievement, how achievement
 will be measured and how the project
 fits with the school development plan;
- provide income and expenditure
 accounts;
- provide a copy of the latest OFSTED
 report and school improvement plan.

All schools are expected to contribute to the cost of projects. *Full details of the policy for schools are available.*

The Cross Trust

CC No: 8620

25 South Methven Street, Perth
PH1 5ES Scotland

Tel: 01738 620451
Contact: Mrs Dorothy Shaw, Assistant Secretary
Trustees: Rev R D Buchanan-Smith, Chairman; Mrs C M Orr; Mr D R G Philip; Dr A R MacGregor; Mr M Webster; Dr R H MacDougall.
Beneficial area: Scotland.
Grant total: £164,000 (2000/01)
Arts grants: £80,000
This trust's purpose is to provide educational opportunities for young Scottish people. The majority of its support is given to distinguished individuals for study or other undertakings in various recognised disciplines. Funding priorities include the visual and performing arts and music. Arts-related grants available for individuals include awards for vacation studies. Special consideration is given to those experiencing financial hardship as a result of the studies or projects they have undertaken.

The trust also makes donations to a small number of institutions.

In 2000/01 the trust gave a total of £164,000. £133,949 of this was distributed to 160 individuals and £30,200 was given to 13 organisations. The largest grants made were for £5,000 but the vast majority were for £1,000 or less. Although the purposes of grants to individuals were not stated in the annual report, it can be assumed that a significant proportion of funding was allotted for arts-related study. Of the four funded organisations listed, which received a combined total of £10,500, three were

relevant to this guide. They were:
Dance Base (£5,000);
Byre Theatre (£3,000);
★National Youth Orchestras of Scotland (£2,500).

Based on the trust's objectives, it is estimated that around £80,000 may have been given for arts-related purposes.

The D'Oyly Carte Charitable Trust

CC No: 265057

1 Savoy Hill, London WC2R 0BP

Tel: 020 7420 2600; Fax: 020 7240 8561
Contact: Mrs Jane Thorne, C.E.O. and Secretary to the Trustees
Trustees: E J P Elliott; J Leigh Pemberton, Chairman; Sir John Batten, Deputy Chairman; Francesca Radcliffe; Julia Sibley; Dr R K Knight; Henry Freeland.
Beneficial area: UK.
Grant total: £1,700,000 (2000/01)
Arts grants: £787,710
'The income of the trust is used to support charitable causes connected with the arts, medical welfare and the environment.' The trust's 1999/2000 report outlines its priorities with regard to the arts as 'a promotion of access, education and excellence in the arts for young people'. Preference is expressed for lower profile registered charities and the majority of donations are made on a one-off basis, although some grants are recurrent.

It is understood that the trust's near tenfold increase in funds available for charitable expenditure since 1996/97 is attributable to the sale of its shares in the Savoy Hotel.

In 2000/01 the trust gave a total of £1,700,000 in 242 grants ranging from £250 to £121,635; most were for £10,000 or less. Out of this, £787,710 (46%) was given in 88 grants relevant to this guide. These included:

Kent Music School; ★Koestler Award
Trust; Music for Youth; National
Children's Orchestra; ★National Youth
Music Theatre; National Youth
Orchestra of Great Britain (£50,000
each);
Orpheus Trust (£28,000);
Handel House Museum; ★Royal Academy
of Dramatic Arts (£20,000 each);
★Abbotsbury Music Festival (£19,500);
★Crafts Council; ★Royal Ballet School
(£15,000 each);
★Arts Education London Schools;
Alderburgh Production; Classical
Opera Company (£10,000 each);
★Birmingham Centre for Arts Therapies;
★Clonter Farm Music Trust; Blackpool
Grand Theatre Trust (£5,000 each);
★Dorset Opera; Edinburgh International
Festival (£3,000 each);
★Young Vic; Survivors' Poetry Scotland
(£2,500 each);
Scottish Traditions of Dance Trust
(£2,000);
Federation of Artistic and Creative
Therapy; Oundle International Organ
Festival; Hopeful Monsters Theatre
Company (£1,000 each).

Exclusions: Individuals; non-registered
charities; overseas organisations; popular
causes; individual schools; medical
research.

Applications: Write to the secretary to
the trustees with outline proposal.
Applications qualifying for consideration
will then be required to complete an
application form. Applicants for specific
projects will need to include details of
project needs, budget outline and
accounts. The trustees meet three times a
year, in February, June and October, to
consider applications. The list of
applications for consideration closes one
month in advance of each trustees'
meeting.

The Daiwa Anglo-Japanese Foundation

CC No: 299955

5 King William Street, London
EC4N 7AX

Tel: 020 7486 4348; Fax: 020 7486 2914
E-mail: office@daiwa-foundation.org.uk
Website: www.daiwa-foundation.org.uk
Contact: Prof. Marie Conte-Helm,
Director General
Trustees: Sir David Wright, Chairman;
Mr Y Chino, Vice Chairman; Lord Roll
of Ipsden; Lady Adrian; Professor Alec
Broers; Lord Carrington; Nicholas Clegg;
H Fujii; T Kusuda.
Beneficial area: UK and Japan.
Grant total: Grants £681,656;
scholarships £330,983; bursaries £32,385
(2000/01)
Arts grants: £310,400
The foundation's principal objective is to
advance the education of Japanese and
UK citizens in each other's way of life.
Scholarships or maintenance allowances
are awarded 'to enable students and
academics at schools, colleges and
universities in the UK and Japan to travel
abroad to pursue their education'. Grants
are made to charitable institutions
promoting education and for research
into cultural, historical, medical and
scientific subjects. Projects funded have
included a number of exchanges, tours,
visits and workshops as well as costs of
staging exhibitions, events and festivals.
Within the broad policy of mutual cross-
cultural education, various arts grants are
made each year.

In 2000/2001 the foundation gave a
total of £1,045,000, which was
distributed as follows:
- grants – £681,656;
- scholarships – £330,983;
- bursaries – £32,385.

The level of grant funding was
significantly higher in 2000/2001 than in
previous years as a result of donations

(totalling £253,000) for special projects in support of *Japan 2001*. Grants ranged between £500 and £35,200; most were under £5,000. Arts grants totalled £310,400 (46% of total grant-aid) and were given to 90 beneficiaries. Grants were disbursed within the following categories:

UK-side grants

Total £149,400; Arts £119,400.

Under 'professional, academic and other exchanges' –

University of Surrey Roehampton, exhibition of children's book illustrations (£5,000);

Royal Holloway College, two month art residency (£2,000);

Victoria & Albert Museum, demonstration tour of calligraphy, Zen and swordsmanship (£1,750).

Under 'culture, art and sport' –

Polka Theatre for Children, tour of new children's play (£5,000);

Surrey Institute of Art, touring exhibition of contemporary Japanese textile artists; Japan Residents Association, touring photographic exhibition *A Visual History of the Japanese in Britain* (£3,000 each);

Birmingham Museums and Art Gallery, conservation and mounting of a rare album of 81 Japanese actor prints by Kunisada from the 1820s (£2,500);

Orchestra of the Age of Enlightenment, for a series of concerts comparing 17th century Japanese and English music (£2,000);

Keele University, *Artworks as a Stepping Stone for Closeness* exhibition; Village Voice, for a Mugenkyo Taiko drumming tour of rural village halls (£1,500 each).

Japan-side grants

Total £112,600; Arts £58,500.

Under 'culture, art and sport' –

Gekidan Minwa Za, for shadow puppet theatre performance in the UK (£3,000);

Association for the Introduction of Japanese Culture, for UK tour of Japanese classical dance (£2,000);

Delphi Inc, exhibition of Fumihiko Maki's architectural works at the Victoria & Albert Museum (£1,500);

U Stage, UK performance tour of Japanese street performers (£1,000).

Proactive grants

Total £171,406; Arts £17,500.

Arts and Humanities Research Board (AHRB), to support two three-year fellowships in the Japanese Creative and Performing Arts (£17,500).

Japan 2001 special projects

Total £253,000; Arts £115,000.

Cambridgeshire County Council, towards development of an exhibition of Joman Archaeology at the Fitzwilliam Museum (£34,000);

Sheffield Theatres Trust, to support an exchange programme involving youth theatre leaders and artists from Sheffield and Kijo (£30,000);

Visual Learning Foundation, for an art exhibition by British children on Japanese themes at Kew Gardens (£20,000).

Further arts funding is likely to have been given via scholarships and bursaries but the beneficiaries of such donations were not specified in the foundation's annual report. It is worthy of note that the bursary programme is no longer in operation, although support for research travel has been maintained through general grants. Daiwa scholarships remain as a key element of the foundation's funding programme.

Exclusions: Applications not related to Japan; buildings and equipment; retrospective applications.

Applications:

General grants

Using the foundation's general grants application form. Applications accepted from British and Japanese institutions or individuals. Japanese citizens who are

temporarily in the UK should submit applications through the Tokyo office of the DAJF. Within the foundation's objectives, relevant causes are the following: all fields of Japan-related research; professional and academic exchange; cultural, artistic and sporting activities. Repeat applications will be given a lower priority.

'In calculating air fares and per diem rates, please check with the DAJF for standard allowances.' Applicants may need to attend an interview in advance of the grants meeting. Deadlines for applications: 30 November for January meeting; 31 March for May meeting; 31 July for September meeting. Applicants will be informed in writing of decisions after the appropriate meeting.

Scholarships

Applicants must check with the foundation for up-to-date guidelines and obtain an application form. Original completed forms must be submitted by post, accompanied by two photocopies. Each must have a photograph attached. Candidates must be British citizens who are normally resident in the UK or have been educated there; be aged between 20 and 35; and have completed their first degree (2.1 or above), in a subject other than Japanese, prior to commencing the scholarship. Short-listed candidates are interviewed in April and may be asked to take a medical examination. Candidates will be expected to convince selectors of their commitment to 'adding a Japanese dimension to their lives'.

Dancers' Career Development

(formerly Dance Companies Resettlement Fund incorporating Independent Dancers Resettlement Trust)

CC No: 327747

Rooms 222–227, Africa House, 64 Kingsway, London WC2B 6BG

Tel: 020 7404 6141; Fax: 020 7242 3331
E-mail: dancers.resettlement@virgin.net
Contact: Linda Yates, Executive Director
Grant total: £13,000 per year
Arts grants: £13,000

This restructured organisation came into effect in August 2001. It incorporates the Dance Companies Resettlement Fund and The Dancers' Trust. Financial support is administered through two funds:

The Dancers' Trust

The Dancers' Trust is funded by the Equity Trust Fund, the Arts Council of England and the Society of London Theatre. It supports independent freelance dancers in Britain approaching the end of their professional performing careers in whatever field, style or genre.

The Dancers' Trust helps with this period of transition by offering advice, careers counselling and grants towards the cost of retraining. Regular awards of up to £2,000 are granted towards retraining and business start-up equipment. Bursaries of up to £3,000 are usually available every alternate year.

The Fund

The purpose of this fund is to make grants to professional dancers who have been employed by contributing companies in order to assist them with re-training for new careers. Eligibility requirements for applicants are listed under 'Applications' below.

Applications: For The Dancers' Trust:

Applicants should have completed at least eight years' employment as a dancer, of

which at least six years should have been in the UK. In addition, at least 16 weeks in each of the last two years must have been worked as a dancer. Contracts or other proof of employment will be necessary.

First contact the administrator by telephone, fax or e-mail (see the contact details above). A member of staff will help in the preparation of a retraining plan and with the details of the financial outlay. The application will be considered by trustees at one of their regular meetings. Applicants will be contacted as to whether awards have or have not been approved. If successful, the retraining programme will be monitored by the trust's staff.

Full application guidelines are available from the trust.

For 'The Fund': Applicants must have at least eight years' professional dance experience and have completed six years' employment with one or more of the following: Royal Ballet; Birmingham Royal Ballet; English National Ballet; Scottish Ballet; Rambert Dance Company; Richard Alston Dance Company; Northern Ballet Theatre; Adzido; Phoenix Dance Company.

The Dancers' Trust – see Dancers' Career Development

CC No: 288321

The Gwendoline & Margaret Davies Charity

CC No: 235589

Perthybu Offices, Sarn, Newtown, Powys SY16 4EP

Tel: 01686 670404; Fax: 01686 670404
Contact: Mrs S Hamer
Trustees: Hon. I E E Davies; Dr J A Davies; Baron Davies; Dr D Balsom.
Beneficial area: UK, primarily Wales.

Grant total: £293,000 (2000/01)
Arts grants: £28,450
This charity makes grants from investment income for the benefit of a range of causes in Wales, including the following: the arts, particularly music; museums; health; youth groups; village halls. Its funding level varies from year to year. A significant proportion of its charitable expenditure is forward-committed and many grants are made on a recurrent basis.

In 2000/01 the charity gave a total of over £293,000 in 51 grants ranging from £50 to £30,000; most were under £5,000. Out of this, a total of £28,450 (10%) was given to 16 arts-related causes. These included:
★Theatr Mwldan (£8,000);
★Abertillery & District Museum Society (£5,000);
★Gregynog Festival; Public Monuments & Sculptures (£3,000 each);
★North Powys Youth Orchestra; (£2,000);
Hereford Three Choirs Festival (£1,500);
Machynlleth Tabernacle Trust (£1,000);
★Montgomery County Music Festival (£750);
The Bleddfa Trust (£500);
★Guild for the Promotion of Welsh Music (£300).

In previous years the charity has given substantial support to Welsh National Opera (£50,000 in 1999/2000).
Exclusions: Individuals; organisations not registered as charities.
Applications: In writing to the address above. Guidelines are available.

Henry & Lily Davis Fund – see Musicians' Benevolent Fund

CC No: 2280890005

Chris de Marigny Dance Writers Award

(see The Bonnie Bird Choreography Fund)

One award of £1,250 is given. For further information contact the Bonnie Bird Choreography Fund (see separate entry).

The Delius Trust
(see also Musicians' Benevolent Fund)

CC No: 207324

16 Ogle Street, London W1W 6JA

Tel: 020 7436 4816; **Fax:** 020 7637 4307
E-mail: Delius_Trust@compuserve.com
Website: www.delius.org.uk
Contact: Marjorie Dickinson, Secretary
Trustees: Musicians Benevolent Fund (representative: Helen Faulkner); David Lloyd-Jones; Martin Williams.
Beneficial area: UK and overseas.
Grant total: £60,000 (2000)
Arts grants: £60,000
The trust's objects are the advancement of the musical works of composer Frederick Delius by contributing towards the cost of performances, publications, recordings and the purchase of manuscripts. The trust does not assist with any capital funding such as equipment costs.

In 2000 the trust gave a total of £60,000 in 27 grants to organisations and individuals ranging from £20 to £10,000; most were under £3,000. Funding was categorised as follows:

- performances – £26,339 in 12 grants;
- recordings – £20,000 in 2 grants;
- publications – £8,689 in 7 grants;
- books, manuscripts, other information – £2,246 in 5 grants;
- extended objects – £3,000 in 1 grant.

Applications: In writing to the secretary. Guidance notes are available.

The Djanogly Foundation

CC No: 280500

57 Broadwick Street, London W1F 9QS

Tel: 020 7302 2309
Contact: Christopher Sills
Trustees: Sir Harry Djanogly; Michael S Djanogly.
Beneficial area: UK, with a special interest in Nottinghamshire; also overseas.
Grant total: £1,365,000 (1999/2000)
Arts grants: £618,163
This foundation states that its policy 'is to sponsor developments in medicine, education, social welfare and the arts' and to 'relieve distress and to promote the welfare of the aged and the young'. Support is given to a wide range of causes including a number of Jewish charities; several grants are recurrent. The foundation is a major supporter of higher education in Nottingham.

In 1999/2000 the foundation gave a total of over £1,365,000 in 65 grants ranging from £35 to a sum of £350,000 donated to the Tate Gallery; most were for under £10,000. Out of the total allocated, over £618,000 (45% of total grant-aid) was given in 20 grants relevant to this guide. These included:
- ★Tate Gallery (£350,000);
- ★Royal National Theatre Trust (£79,630);
- ★Nottingham Theatre Trust (£75,000);
- ★Royal Academy of Arts Trust (£28,846);
- Jewish Music Festival (£25,250);
- Victoria & Albert Museum (£25,000);
- Royal Opera House Trust (£10,500);
- National Portrait Gallery (£5,000);
- ★Hampstead Theatre Trust (£4,680);
- National Galleries of Scotland (£3,000);
- ★Garsington Opera Trust (£2,091);
- ★British Friends of the Art Museums of Israel (£1,250);
- ★Chicken Shed Theatre Trust; Aylesbury Music Centre (£1,000 each).

The foundation is committed to a large number of causes until 2005 via a 'designated fund' which is likely to

account for around half of expected funding. Applicants will, however, be considered for grants from the remaining unrestricted funds.

Applications: In writing at any time to the correspondent.

Dresdner Kleinwort Wasserstein's Charitable Trust

CC No: 278180

Dresdner Kleinwort Wasserstein's Charitable Trust, PO Box 560, 20 Fenchurch Street, London EC3P 3DB

Tel: 020 7623 8000
Website: www.drkw.com/aboutdrkw/ community/trust
Trustees: Kleinwort Benson Trustees Ltd.
Beneficial area: UK.
Grant total: £241,000 (2000) see below
Arts grants: £38,000
The trust states that 'support for national charities is divided into four categories, one of which is arts related – "education and outreach through the arts". The trust's new policy was launched at the beginning of 2001. The trust welcomes applications for support from arts organisations engaged in education and outreach work with all sections of the community'.

In 2000 the trust gave a total of £241,000. No further funding details were provided. The latest available breakdown of the trust's giving was featured in the annual report for 1999. In this year the trust gave a total of £290,000 in 161 grants ranging from £100 to £16,232, most of which were under £2,000. Out of this total, £46,332 (16%) was donated in 13 grants relevant to this guide. These included:

*National Youth Orchestra of Great Britain (£11,000);
*English National Opera (£8,000);
*Royal Academy of Arts (£7,050);
*Glyndebourne Festival Society (£5,520);

*National Art Collections Fund;
 *Spitalfields Festival (£2,500 each);
*City of London Festival (£1,762);
Bridewell Theatre (£1,000);
Bushey Symphony Orchestra; National Isis Strings Academy; *National Literacy Trust (£500 each).

Judging by the level of arts funding in 1999, it may be estimated that around £38,000 was given to arts-related projects in 2000.

Applicants should, however, take note of the trust's new arts policy outlined above.
Exclusions: Individuals; organisations not registered as charities.
Applications: Applications should be within the trust's guidelines. Applicants should check details on the website prior to any appeal.

Dunard Fund

CC No: 295790

4 Royal Terrace, Edinburgh EH7 5AB

Tel: 0131 556 4043
Contact: Mrs Carol Hogel
Trustees: Carol Hogel; Catherine Hogel; Colin Liddell; Elisabeth Hogel.
Beneficial area: UK, particularly Scotland.
Grant total: £1,324,000 (1999/2000) see below
Arts grants: £500,000
The fund's 1999/2000 report states that donations are given 'for the benefit of charitable purposes or charitable institutions or charitable foundations, specifically in the training and performance of classical music and in the field of visual arts'.

In 1999/2000 a total of £1,324,000 was given in grants to causes in the UK, double the level of funding recorded for 1998/1999 (£636,000). No further funding details have been given in an annual report since 1994/95. In 1994/95 the fund gave a total of over £601,000 in 33 grants ranging from £100 to an exceptional sum of £233,395 for Findlay

Court. Out of this, a total of £258,387 (43% of total grant-aid) was given in 16 arts-related grants. These included: Scottish Chamber Orchestra (£82,633); Scottish Opera (£60,000); Museum of Scotland Project (£40,000); Promenade Productions (£30,000); Edinburgh International Festival (£29,374); John Currie Singers and Orchestra (£5,000); English National Opera (£1,000).

Based on the level of arts funding in 1994/ 95, it may be expected that funding relevant to this guide in 1999/2000 amounted to around £500,000.

Applications: It is understood that unsolicited applications will not be considered.

The Dyers' Company Charitable Trust

CC No: 289547

Dyers Hall, Dowgate Hill, London EC4R 2ST

Tel: 020 7236 7197
Contact: The Clerk
Trustees: The court of The Dyers' Company.
Beneficial area: UK, particularly London.
Grant total: £240,000 (1999/2000)
Arts grants: £43,000
This trust makes a 'large number of individual grants in support of general charitable purposes'. Grants are made within the following categories: the arts; 'the craft'; local community/city/inner London; education and the young; the church; the Services; health and welfare.

In 1999/2000 the trust gave a total of £240,000 in 61 grants, ranging from £50 to £123,000, but mostly between £500 and £3,000. Of these, 26 grants amounting to £43,000 (18% of total grant-aid) were relevant to this guide. These included:
Under 'the arts' –
National Maritime Museum (£2,500); Chelsea Opera Group; Grange Park

Opera; Heritage of London Trust; Macclesfield Silk Museum Project (£1,000 each); Young Concert Artists Trust (£500).
Under 'the craft' –
Textile Conservation Centre (£10,000); Heriot-Watt University (formerly Scottish College of Textiles) (£9,000 p.a. for three years); City & Guilds of London Institute (£2,073); U.M.I.S.T. (three-year commitment of £3,000); Royal School of Needlework (£300).
Under 'local community/city/inner London' –
Guildhall School of Music and Drama (£1,000 p.a. over three years); Dreamwork Youth and Arts (£250).

The trust has stated that it does not wish to be featured in this guide.
Exclusions: Individuals; organisations not registered as charities.
Applications: Trustees meet twice a year to consider and approve grants.
Unsolicited applications are not welcomed.

The Early Music Network

31 Abdale Road, London W12 7ER

Tel: 020 8743 0302
E-mail: glun@earlymusicnet.demon.co.uk
Contact: The Administrator
The Early Music Network makes modest grants with the principal aim of increasing the number of high quality early music performances throughout England, in order to provide opportunities for performers and develop new audiences. Funding is intended to support additional activities which are not funded by other bodies. Promoting organisations may apply for up to £2,500 per year, for a maximum of three years.

A specific programme for 'innovative educational projects' provides grants, in the range of £500 to £2,000, for

activities with well-developed strategies for the creation of informed future audiences. Support is not usually aimed at institutions where such activities might be regarded as part of their normal work, although they may be involved in collaborative projects.

Applications: Applications should be sent to the administrator. The EMN welcomes telephone enquiries. Deadlines for applications are in early December.

Eden Arts Trust

CC No: 1000476

2 Sandgate, Penrith, Cumbria CA11 7TP

Tel: 01768 899444; Fax: 01768 895920
E-mail: edenarts@aol.com
Website: www.edenarts.co.uk
Contact: N Jones
Trustees: Lady Inglewood, Chair.
Beneficial area: The Eden District.
Grant total: £28,000 (2000/2001)
Arts grants: £28,000

The trust's main objectives are the following: 'to support, promote and develop arts and arts projects involving the benefit of community groups in the Eden District; to initiate training in arts skills for community use'. Support is also considered for projects which encourage interest in local culture and traditions and other constructive use of leisure time.

The annual report for 2000/2001 indicates that the trust gave a total of over £28,000, all in grants relevant to this guide. Only grants over £1,000 were listed and the largest of these was for £2,000. The specified grants were as follows:

North Pennine Rural Touring (£2,000); Appleby Jazz Society (£2,000); Penrith Music Festival; Eden Millennium Festival; North Pennine Storytelling Festival (£1,000 each).

Applications: In writing to the correspondent.

The Gilbert & Eileen Edgar Foundation

CC No: 241736

c/o Chantrey Vellacott DFK, Prospect House, 58 Queens Road, Reading, Berkshire RG1 4RP

Tel: 0118 952 4700
Website: www.cvdfk.com
Contact: Penny Tyson
Trustees: A E Gentilli; J G Matthews.
Beneficial area: UK, and a few international appeals.
Grant total: £70,000 (2000)
Arts grants: £25,750

The foundation has a preference for the following:

- promotion of medical and surgical science;
- helping the young, the old and the needy;
- raising the public's artistic taste in music, drama, opera, painting, sculpture and the fine arts;
- promoting education in the fine arts;
- promoting academic education;
- promoting religion;
- promoting conservation, facilities for recreation and youth.

Since 1997 grant-aid for 'education in the fine arts' has been solely provided by way of scholarships to the extent of £20,000 awarded by institutions.

In 2000 the trust gave a total of over £70,000 in 110 grants ranging from £250 to £9,000, most of which were under £1,000. Arts support totalling £25,750 was given in the following 12 grants:

Under 'fine arts' –
Royal National Theatre (£3,000); English National Ballet (£1,000); Amadeus Scholarship Fund; Artists' General Benevolent Institution; Newbury Spring Festival; Living Paintings Trust (£500 each); Lincoln Cathedral; Live Music Now! (£250 each).

Under 'education in fine arts' –
Royal College of Music, junior fellowship
(£9,000);
Royal Academy of Arts, scholarship;
Royal Academy of Dramatic Art,
scholarship (£5,000 each);
Elizabeth Harwood Memorial Trust,
scholarship (£1,000).

Applications: In writing to the
correspondent.

The Elephant Trust

CC No: 269615

PO Box 5521, London W8 4WA

Contact: Julie Lawson
Trustees: Dawn Ades; Anthony Forwood;
Matthew Slotover; Richard Wentworth;
Nicos Stangos; Sarah Whitfield.
Beneficial area: UK.
Grant total: £131,000 (1999/2000)
Arts grants: £131,000
The trust's objects are to 'advance public
education in all aspects of the arts and to
develop artistic taste and the knowledge,
understanding and appreciation of the
fine arts'. Support is principally given to
individuals, art galleries and other
organisations in furtherance of these aims.

In 1999/2000 the trust gave a total of
over £131,000, all of which was to arts-
related beneficiaries. Over one-third of
this total was given in an exceptionally
large grant of £50,000 to the Scottish
National Gallery. The remaining grants
were made to institutions and 14
individuals in sums ranging from under
£1,000 to £9,000. Only grants of
£1,000 and above were listed in the
trust's annual report. These included:
Scottish National Gallery (£50,000);
*Tate Gallery (£9,000);
Whitechapel Art Gallery (£2,500);
*English National Opera; Mercer Gallery;
Norwich School of Art and Design;
Royal Academy of Arts; Almeida
Theatre; Sadler's Wells Arts Trust;
*Camden Arts Centre (£2,000 each);

Eagle Gallery; Dartington Hall (£1,000
each).

Exclusions: Students and any other
study-related funding.
Applications: In writing together with
an SAE. Guidelines are issued. Trustees
meet quarterly.

The John Ellerman Foundation

CC No: 263207

Aria House, 23 Craven Street, London
WC2N 5NS

Tel: 020 7930 8566; Fax: 020 7839 3654
E-mail:
postmaster@ellerman.prestel.co.uk
Website: www.ncvo-vol.org.uk/jef.html
Contact: Eileen Terry, Appeals Manager
Trustees: Peter Pratt, Chairman; Angela
Boschi; Richard J Edmunds; Dr John H
Hemming; David Martin-Jenkins; Vice-
Admiral Anthony Revell; Lady Riddell;
Beverley Stott.
Beneficial area: UK and overseas,
except Central and South America.
Grant total: £4,116,000 (2000/01)
Arts grants: £767,000
The foundation is a general grantmaking
trust, 'distributing around £4 million
each year to a wide variety of charitable
organisations'. Support is allocated to
charities doing work of national
significance in the following categories:
medical practice and disability;
community development and social
welfare; the arts; conservation.

Funding is principally given to UK-
based causes, although some overseas
work, mainly in South Africa, is
considered if applicant charities have a
UK office.

The foundation has a commitment to
core funding, in recognition of the day-
to-day needs of charities and the
importance of a strong infrastructure to
attracting further funding. It is
particularly interested in organisations
carrying out collaborative projects

involving two or more charities. Funding is provided for umbrella bodies or headquarters organisations, but not for local charities.

In 2000/01 the foundation gave a total of £4,116,000 in 199 grants ranging from £3,750 to an exceptional grant of £150,000 to English National Opera. Most grants were between £10,000 and £30,000. Funding relevant to this guide totalled £767,000 (18% of total grant-aid) and was given in 33 grants. These included:

English National Opera, capital funding for restoration project (£150,000) and core funding contribution (£50,000);

Shakespeare Globe Trust, towards construction cost of the Globe exhibition; Victoria & Albert Museum, towards redesign of British Galleries (£50,000 each);

National Gallery, costs for Travelling Companion Programme (£25,000);

Welsh National Opera, core funding; Royal Over-Seas League Golden Jubilee Trust, cost for annual music competition and open exhibition (£20,000);

Royal Academy of Music, Music Box employment service for students; Almeida Theatre Company Ltd, capital cost of theatre improvements; Handel House Trust, capital costs (£15,000 each);

Association of British Choral Directors, to fund an education and development officer; Foundation for Young Musicians, core funding; Live Music Now, expansion of work in North East England and the home counties; National Youth Dance Trust, funding to secure post of executive director (£10,000 each);

Poetry Archive, expansion of recording programme (£5,000).

Exclusions: Individuals; organisations which are not registered charities; hospices; branches of national organisations; 'friends of' groups; education or educational establishments; medical research; religious causes; conferences and seminars; sports and leisure facilities; purchase of vehicles; direct replacement of public funding; deficit funding; domestic animal welfare; circulars. The foundation is not permitted to make grants for any purpose related to areas in the continents of America south of the USA.

Applications: Initially in writing to the correspondent on no more than two sides of A4, giving concise details of the charity and its current funding requirement. There is no need to send annual reports or background material at this stage. Trustees will decide from this letter whether they want to invite a formal application; if so, an application form and further details will be sent. Whatever the decision, all letters will receive a reply. Applicants must wait one year before reapplying, whether they have been successful or not.

The foundation states 'we are happy to discuss potential applications by telephone; please ask for the appeals manager (Eileen Terry)'. Trustees meet regularly throughout the year and there are no deadlines.

Further information, including the annual report, is available on the foundation's website.

The Elmgrant Trust

CC No: 313398

The Elmhirst Centre, Dartington Hall, Totnes, Devon TQ9 6EL

Tel: 01803 863160
Contact: Angela Taylor, Secretary
Trustees: Martin Ash, Chairman; Sophie Young; Paul Elmhirst.
Beneficial area: UK, especially Devon and Cornwall.
Grant total: £118,000 (2000/01)
Arts grants: £22,351
The funds of this trust are used for general charitable purposes but, in

particular, for the encouragement of local life through education, the arts and social sciences.

In 2000/01 the trust made grants totalling almost £118,000, which was distributed as follows:

- retraining grants – £35,920 (31%);
- education and educational research – £22,432 (19%);
- arts and arts research – £22,351 (19%);
- social sciences and scientific grants – £21,650 (18%);
- pension donations and compassionate grants – £15,534 (13%).

Only grants of over £1,000 were listed in the annual report, making it difficult to elaborate further as to the level of funding relevant under the broad arts-related scope of this guide. Specified arts grants were:
Dartington Arts (£2,270);
Beaford Arts (£2,000).

Exclusions: Postgraduate study; expeditions/travel; applications for fellowships from outside Devon and Cornwall.

Applications: Initial telephone calls for advice are welcome. Guidelines are issued. Please send a SAE. Meetings are held quarterly. Applications should be sent to the correspondent listed above.

The Elmley Foundation

CC No: 1004043

West Aish, Morchard Bishop, Crediton, Devon EX17 6RX

Tel: 01363 877433; Fax: 01363 877433
Contact: John de la Cour
Trustees: Diana Johnson; S Driver White; John de la Cour.
Grant total: £238,000 (2000/01)
Arts grants: £238,000
The foundation's principal aim is 'the advancement of education by promoting the appreciation, knowledge and study of the arts and of artistic achievement in all their forms in the counties of Herefordshire and Worcestershire'.

Generally, arts grants are made within the following categories: combined arts; dance; film and media; literature; music; theatre; visual arts and crafts; students. Donations are also made through the Elmley Small Grants Arts Fund, which is administered by the Community Council of Hereford and Worcester.

Annual funding is also given to Herefordshire & Worcestershire Arts Education Agency for arts projects within schools and to Madresfield Court, the ancestral home of the Earls Beauchamp.

In 2000/2001 the foundation gave a total of over £238,000 in 75 grants ranging from £92 to £22,924; most were for £10,000 or less. Donations were all relevant to this guide and included:

Under 'music' –
Elgar Foundation (£30,000);
Hereford Three Choirs Festival (£18,000);
Countess of Huntingdon Hall (£12,500);
Elgar School of Music (£3,750);
Worcester Cathedral Arts; Midland
 Sinfonia (£1,000 each).
Under 'theatre' –
Malvern Theatres Trust (£10,000).
Under 'literature' –
Hay Festival of Literature (£12,500);
Ledbury Poetry Festival (£10,500).
Under 'film and media' –
Rural Media Company (£10,000).
Under 'visual arts and crafts' –
Worcester City Art Gallery (£6,625);
Herefordshire Flying High Crafts Festival
 (£4,000).
Under 'dance' –
ECHO, Leominster (£4,000).
Madresfield Court (£30,014 in 3 grants).
Herefordshire & Worcestershire Arts
 Education Agency (£7,000).
Elmley Small Grants Fund (£23,583) –
Administered via Community Council of Hereford and Worcester to 35 beneficiaries including Kilpeck Youth Theatre; Other Voices Theatre Company; Eastnor Pottery; Georgian Singing Workshop; Worcester Concert Club; and Golden Valley Singers.

Applications: 'Considered on merit.'

The Equity Trust Fund

CC No: 328103

222 Africa House, 64–78 Kingsway, London WC2B 6AH

Tel: 020 7404 6041; Fax: 020 7831 4953
E-mail:
keith@equitytrustfund.freeserve.co.uk
Contact: Keith Carter, Secretary
Trustees: Colin Baker; John Barron; Derek Bond; Annie Bright; Nigel Davenport; Peter Finch; Graham Hamilton; Frank Hitchman; Barbara Hyslop; Milton Johns; Harry Landis; Hugh Manning; Ian McGarry; Roy Marsden; Peter Plouviez; Frederick Pyne; Gillian Raine; John Rubenstein; Rosalind Shanks; Josephine Tewson; Jeffry Wickham; Frank Williams; James Bolam; Imogen Claire; Ian Talbot; Johnny Worthy.
Beneficial area: UK.
Donations to all causes: £308,000 (2000/01)
Arts grants: £308,000
This trust was established in l989 with funds from British Actors Equity. Its principal activities are the maintenance and promotion of the performing arts and the provision of education and welfare for professional performers.

In furtherance of its objects, in 2000/01 the trust gave a total of £308,000. This was distributed as follows:

Welfare and benevolence
£87,732 (28%) in 80 grants
Applications are invited from either individuals and third parties on behalf of professional performers or stage managers who are in genuine need of financial, medical or other assistance. The trust has helped purchase electric wheelchairs, stairlifts, convalescent holidays, TV licences; and telephone bills. As part of this service the trust also runs a service for people in overwhelming debt.

Education grants
£134,688 (44%) in 20 grants
The trust has a fund for professionals with a minimum of 10 years adult experience.

The main aim of this scheme is to provide opportunities for people to gain qualifications and skills in new areas to enable them to pursue a new career outside of the profession.

Theatre grants
£76,090 (25%)
The trust has 'a modest fund available for professional theatres or theatre companies who face an unexpected crisis which threatens the production'. *The trust does not help with production costs.* Requests for essential capital items might be considered as long as the company is fully recognised by Equity or some other professional trade body.

The John Fernald Award Trust
£5,900 (2%)
The John Fernald Award Trust, which existed to help trainee directors to gain professional experience in the theatre, was wound up in 1997. Its assets of £48,000 were subsumed into The Equity Trust Fund, which now administers awards which reflect the objects of the original charity.

Loans – provisions and write-offs
£3,909 (1%)
In 2000/01 there were seven outstanding interest-free loans to theatres, in addition to welfare and education loans totalling £22,748. This produced a combined debt of £165,448 in outstanding loans of between £5,000 and £112,500.

Exclusions: Amateur players and companies; revenue and production costs, including tour and production costs; companies who do not use Equity or similar approved contacts; actors and stage managers who have not worked on professional contracts; students wishing to enter the profession; any organisation which does not help actors or stage managers.
Applications: In writing to the correspondent enclosing an A5 SAE. 'In all cases it is most strongly advised that the applicant contact the office first by

telephone to establish eligibility – this saves time and resources for all concerned.'

Theatre companies who wish to apply should send their details on no more than four sides of A4 paper, including a brief history of the organisation, its current funders, what the money is needed for and a concise breakdown of costs relevant to the application.

Applications for funds under £5,000 are considered by the executive committee, who meet approximately every six weeks. Applications for £5,000 and above are considered by the full board who meet approximately every three months.

The Eranda Foundation

CC No: 255650

New Court, St Swithin's Lane, London EC4P 4DU

Tel: 020 7280 5000
Contact: Rebecca Mellotte, Secretary
Trustees: Sir Evelyn de Rothschild; Anthony de Rothschild; Miss Jessica de Rothschild; Mrs Renée Robeson; Leopold de Rothschild; Sir Grahame Hearne.
Beneficial area: UK.
Grant total: £1,750,000 (2000/01)
Arts grants: £548,000
The foundation supports charitable work in the areas of the arts; health, welfare and medical research; and education. Grants are mainly given for specific projects rather than for general funding. Grants may be given over up to three years and may cover both capital and revenue costs.

In 2000/01 the foundation gave a total of £1,750,000 in an unspecified number of grants, none of which were listed in the annual accounts. The following breakdown of grant-aid was given:
- the arts – £548,000 (31%);
- health, welfare and medical research – £524,460 (30%);
- education – £699,400 (39%).

The most recent year for which a list of grants was available was 1995/96 when £370,000 was given in nine grants relevant to this guide. These were:
Under 'the arts' –
RSA (£170,000);
NH Trust (£165,000);
Buckingham City Museum (£10,000);
World Monument Fund; Chicken Shed Theatre Company; London City Ballet (£5,000 each);
Wallace Collection (£4,000).
Under 'education' –
Youth Cable TV (£5,000).
Under 'health, welfare and medical research' –
NH Music and Disability (£750).

Exclusions: Individuals; non-registered charities.
Applications: In writing to the correspondent.

The European Cultural Foundation

CC No: 257273

Jan Van Goyenkade 5, 1075 HN, Amsterdam, Netherlands

Tel: 00-3120 676 02 22;
Fax: 00-3120 675 22 31
E-mail: eurocult@eurocult.org
Website: www.eurocult.org
Contact: Vanessa Reed, Grants Co-ordinator
Trustees: Chairman: Lord MacLennan. Joint Directors: Rod Fisher; Simon Mundy.
Grant total: Approximately £990,000 annually – see below
Arts grants: £990,000
The European Cultural Foundation (ECF) is an independent, non-profit organisation that promotes cultural cooperation in Europe. It develops new projects and programmes, acts as a centre for a network of independent associated research institutes and runs a grant programme related to its priorities. It

operates throughout Europe and its bordering regions.

The ECF grants programme, launched in 2002, is expected to disburse about €1.5 million per year to 'contribute to an open and democratic Europe which respects the basic human rights and cultural diversity of its people'.

Four types of grants are available:

Individual travel grants
The ECF will award between 60 and 80 grants to enable professionals in the cultural sector to travel within Europe, with the aim of meeting and working with colleagues in complementary institutions.

Project grants for organisations
Between 30 and 45 grants will be disbursed to non-government organisations for projects that encourage dialogue between different cultural groups. The participation of the project's beneficiaries in its development and implementation is particularly encouraged.

Evaluation and communication grants
Support will be given to between 4 and 10 projects which evaluate and communicate new approaches and working methods within the cultural sector at European level. Grants are intended to enable people to analyse their work and share the lessons learned.

Partnership grants for advocacy projects
The ECF offers to co-finance and co-develop projects which champion the role of culture within Europe. *There is no special application form for partnership grants – interested organisations are invited to send a proposal to the Funding Unit.*

ECF priority themes
To be eligible for funding, projects must fit one of three priority themes. For each theme there are several budget lines, that is, amounts of money earmarked for a specific type of grant. Each budget line has specific application criteria and a special application form. The priorities are as follows:

Encouraging intercultural dialogue
This theme is concerned with initiatives which facilitate dialogue and understanding between diverse cultures, particularly in relation to Mediterranean cultures and new cultural groups in Europe. Initiatives are chosen which involve culturally mixed teams working towards a common goal.

The following types of activities are eligible for ID (intercultural dialogue) grants:

- ID travel grants for individual professionals, such as journalists, artists, writers and translators. The professional will travel within Europe and the Mediterranean as part of a project which promotes intercultural understanding or dialogue.
- ID project grants for independent cultural organisations. The applicant will set up a culturally mixed team of professionals. The result of the project must contribute to intercultural understanding.

Stimulating social participation through the arts
Supporting artists who work with people in the community, helping to build their self-esteem and effecting positive social change.

The following types of ACE (artists, community and empowerment) grants are available:

- ACE job-shadowing grants for individual professional artists from across Europe. The aim is to enable artists to travel to another European country in order to exchange ideas and skills with fellow professionals in the field of participative art-making;
- ACE study grants for individual opinion multipliers such as researchers, policymakers and media professionals to travel to another European country

in order to document or study participative art projects. The work produced must focus specifically on participative art work in the community;

- ACE project grants for independent cultural organisations across Europe. Professional artists will develop an art project with people in the community. Projects are judged on the degree of community participation, the dialogue between different groups and according to artistic standard;
- ACE evaluation and community grants for organisations across Europe. The objective of these grants is to analyse or document participative art work in order to evaluate or advocate new ways of using the arts for community development.

Strengthening the cultural sector

In supporting the development of an infrastructure for European cultural cooperation, the ECF will fund NGOs which set new regional standards in cultural management in addition to individuals and projects which practice participative policymaking.

MAP (management and policy) grants take the following forms:

- MAP travel grants for cultural policymakers and cultural managers from Central, Eastern and South Eastern Europe;
- MAP project grants for independent cultural organisations in Central and South Eastern Europe which have developed an innovative project involving partnership between the independent cultural sector and policymakers. Projects must set new standards and have a 'prototype function' for the sector;
- MAP evaluation and communication grants are available to organisations across Europe. Professionals with a background in evaluation or communication/media can obtain a grant to study, document or advocate

best practice in organisational development and policymaking in the cultural sector.

Exclusions: Individuals; revenue and capital funding; visual and performing arts; projects in the field of social welfare; school, student and youth exchanges; recurring academic events and highly specialised academic research; scholarship, individual research projects and travel grants; publication or translation of single titles; restoration or exploitation of cultural heritage; creation of new centres or institutions.

Applications: The ECF Funding Unit can be contacted at all times for assistance or for information on the status of your proposal. Applicants are, however, advised to visit the ECF website before making further enquiries.

The ECF Funding Unit is situated at the address listed above. Correspondence is also possible by e-mail: Vanessa Reed, Grants Coordinator – vreed@eurocult.org Esther Claassen, Grants Administrator – eclaassen@eurocult.org

Applications may be submitted in English or French.

Enquiries concerning the work of the ECF or the suitability of a project for funding can also be made to: Daniela Paolucci, Co-ordinator of the UK National Committee, 4 Baden Place, Crosby Row, London SE1 1YW, Tel: 020 7403 0777; Fax: 020 7403 2009; e-mail: ecf@intelCULTURE.org

The Esmée Fairbairn Foundation

CC No: 200051

11 Park Place, St James's, London SW1A 1LP

Tel: 020 7297 4700; Fax: 020 7297 4701
E-mail: info@esmeefairbairn.org.uk
Website: www.esmeefairbairn.org.uk
Contact: See 'applications' below

Trustees: John S Fairbairn, Chairman; Jeremy Hardie, Vice-Chairman and Treasurer; Sir Antony Acland; Ashley G Down; Penelope Hughes-Hallett; Roderick Kent; Kate Lampard; Martin Lane-Fox; Baroness Linklater; Lord Rees-Mogg; Lady Milford; William Sieghart.
Beneficial area: UK.
Grant total: £25,289,000 (2001)
Arts grants: £5,451,000 (figure for 2000 when total giving was £1m less)
The foundation's priorities are derived from its striving towards social justice and the eradication of disadvantage. It has an interest in moving practice forward and 'influencing policy development', and is proactive in its approach to four selected areas: arts and heritage; education; social development; environment. Applied research projects are also occasionally funded but applicants should telephone to discuss any such proposals.

The trust publishes extensive guidelines for applicants, who should obtain the most recent copy before applying. Its general funding aims are:
- obtaining maximum value from grants 'in bringing about practical and lasting improvements in people's lives and the communities in which they live';
- supporting excellence and quality;
- focusing on 'prevention by addressing the root causes of problems rather than coping with the consequences of them';
- welcoming proposals which fulfil priorities in more than one of the supported sectors;
- creativity and flexibility;
- equal opportunities for applicants.

Priorities in Arts and Heritage

This programme will fund projects offering 'the most imaginative, high quality arts experiences to audiences, visitors and participants, or that add to the preservation of the national heritage'. There is particular interest in the following:

Arts provision in under-served geographical areas
- 'proposals which expand and improve arts provision in parts of the country less well-served than others, for example while touring';
- 'proposals for touring across national borders where sensible, for the creation of touring circuits, and for second runs of productions';
- while good projects in all the arts may be funded, particular attention will be given to those less well funded, for example, contemporary dance;
- 'proposals which include plans for education or reaching out to new audiences'.

Innovation and emerging talent
- 'enabling organisations to commission new and risk-taking work and supporting initiatives which encourage emerging talent, including bursary schemes run by independent national or regional arts development organisations.'

Heritage
Priority is given to projects outside London. Generally, preference is given to proposals that:
- 'provide a contemporary use for buildings of architectural or historic significance;
- 'provide for public access, are significant to the local community, or are linked to wider regeneration or community development objectives.'

Arts education
Consideration will only be given to arts education or arts projects with young people which are genuinely developmental and in under-served geographical areas.

Festivals
Consideration will only be given to regional festivals, particularly those in under-served geographical areas and those interested in commissioning new work.

Arts and health

Arts in healthcare settings are a low
priority.

Arts capital funding

Capital projects in the arts are a low
priority, but there is some flexibility to
support the exceptional proposal –
telephone before you make an application
for capital funding.

The trust's grant-making capacity has
increased substantially following the sale
of its holding in M&G Group PLC in
April 1999. In 2000 the trust approved
funding of £24,134,000 (compared with
£15 million in 1998), in 794 grants
ranging from £1,000 to £1,329,000.
Grants over £10,000 numbered 377,
while there were 416 donations for under
this amount. Grant-aid was distributed as
follows:

Arts and heritage £4,418,000 (18%)
Education £3,237,000 (13%)
Environment £3,075,000 (13%)
Social development £12,599,000 (51%)
Research £1,105,000 (5%)
(Less £300,000 in withdrawn grant
offers)

Out of this, a total of £4,007,000 (17%
of total grant-aid) was given 185 grants
relevant to this guide. These included:

Under 'arts and heritage' –

City of London Sinfonia, supporting staff
posts (£100,000 each);
Northern Stage Limited, training costs
(£60,000);
National Art Collections Fund, towards
arts acquisitions (£50,000 each);
Huddersfield Contemporary Music
Festival, running costs; Ocean Music
Trust, for music training; Integrated
Music Projects, towards developing
musical communities (£30,000 each);
Opera North, to fund an educational
administrator (£24,000);
Pegasus Opera Company, running costs;
International Centre for Performing
Arts, development costs; Scottish
Sculpture Workshop, for an

environmental arts project (£20,000
each);
Brinkburn Summer Music; Buxton Arts
Festival Limited; Clonter Farm Music
Trust (£10,000 each);
Classical Music Society; Castleword
Opera; National School Band
Association (£5,000 each);
Psappha (£1,500).

Three major capital grants totalling
£650,000 were made also.

Grants relevant to this guide were also
made in 2000 under 'Social development',
under 'Environment' and under
'Education'. They have been omitted at
the request of the foundation as
apparently arts-related grants in its other
areas of grantmaking 'is a complex issue
at present and the grants [the examples
given, editor] could be misleading for
people'.

The foundation has an impressive
website.

Exclusions: The foundation does not
support applications: that directly replace
statutory funding; from individuals or for
the benefit of one individual; for work
that has already taken place; which do not
directly benefit people in the UK; for
medical research; for standard health
services and day/residential care; for
animal welfare; for expeditions and
overseas travel; for endowment funds; that
are part of general appeals or circulars;
from applicants who have applied within
the previous 12 months.

The foundation is unlikely to support:
large national charities which enjoy wide
support; branches, members and affiliates
of large national charities; capital projects
– building or major refurbishment costs;
conferences and seminars; counselling
services; holidays/respite care; hospices;
individual schools, nurseries and
playgroups; information and advice
services; items of equipment; maintenance
of individual religious buildings
(including parish churches) or projects
that promote religious beliefs; sport;

vocational training. *For proposals in these categories telephone the appropriate sector number to discuss whether an application is worthwhile.*

Applications: First, contact the appropriate department by telephone to talk through whether an application will be worthwhile:

Arts and heritage – Alison Holdom (Tel: 020 7297 4719);

Environment and education – Rachel Faulkes (Tel: 020 7297 4722);

Social development – Tania Joseph (Tel: 020 7297 4727).

Application details and guidelines are available from the foundation. Applicants need to complete the 'application cover sheet' which is attached to the guidelines. This must be submitted together with a written proposal covering the following.

- 'What do you want to do? When will the work happen and where will it take place?
- How do you know there is a need for the work?
- How does your proposal fit the foundation's sector priorities? If it meets more than one please explain how.
- What will be the benefits of the work? Who are the people who will benefit, including numbers?
- How will you know whether you have been successful in delivering the benefits?
- How will you attract and involve the people who you are trying to benefit?
- Who will do the work and how will the activities be supervised and managed?
- Describe any plans to continue, develop and share the results of your work after the foundation's grant ends. How will you fund these plans?'

In addition, the following financial information must be included:

- income and expenditure budget for the proposed work showing itemised costs

of carrying out the work for each year, making clear the funding you are seeking from the foundation; any income already secured from other sources; and income still to be raised and from where you plan to raise it;

- the current year's summary income and expenditure budget for the organisation as a whole;
- the organisation's most recent annual report and full accounts.

Applications will be acknowledged within five working days of receipt. Ineligible or low priority applicants will be told so at this point. Appeals receiving further consideration may require meetings and other consultation. Grants of under £10,000 are considered on an ongoing basis, whereas applications for sums of over £10,000 are examined at quarterly trustees meetings and usually produce decisions within five months.

The Federation of British Artists

CC No: 200048

17 Carlton House Terrace, London
SW1Y 5BD

Tel: 020 7930 6844; Fax: 020 7839 7830
Website: www.mallgalleries.org.uk
Contact: John Sayers, Secretary
Trustees: Tom Muir, Chair; Ronald Maddox; Thomas Coates; Daphne Todd; James Cooper; Julia Easterling; Romeo Di Girolano; Andrew Stock; Simon Whittle; Bert Wright; Richard Sorrell.
Beneficial area: UK.
Grant total: £482,000 (1999)
Arts grants: £482,000
The FBA is the umbrella organisation for nine of the country's leading art societies. Its objects are to 'aid, promote, assist, extend, and encourage the study and practice of the fine and applied arts'. These aims are met primarily through the organisation of, and provision of facilities for, public art exhibitions on behalf of

member societies and other organisations and individuals. In addition, the federation also supports workshops, lectures, demonstrations, seminars and educational activities.

In 1999 the federation gave a total of £482,000, which was distributed as follows:

- exhibitions by member societies (£255,564);
- non-society exhibitions (£116,526);
- commissioned work (£86,892);
- grants payable to member societies (£14,880);
- membership costs (£8,163).

No further breakdown was available in the 1999 annual report.

Applications: For details of the exhibitions and associated prizes, and how to submit work, please send a large SAE to the Mall Galleries at the above address.

The Fenton Arts Trust

CC No: 294629

PO Box 63, Arundel, BN18 9TE

Contact: Shelley Baxter, Administrator
Trustees: Richard Ward, Chair; Susan Logan; Susan Davies-Scourfield; Stephen Morris; David Wheeler.
Grant total: £40,000 (expected 2002/2003)
Arts grants: £40,000
This trust aims to 'give encouragement and financial support to those actively contributing to the creative arts', principally painting and drama, in the UK.

The trust's available funds have been greatly increased as a result of a substantial inheritance from the estate of its recently deceased founder, Shu–Yao Fenton. The trust expects to award a total of £40,000 in 2002/2003 in the field of creative arts. This is a significant increase on the figures for 1998/1999 and 1999/2000, in which total grants amounted to £2,700 and £1,000 respectively.

The trust's giving takes the form of:

- final year or postgraduate scholarships/bursaries (for a one-year period);
- grants for individual works, activities, performances or prizes.

Applications: Applications for scholarships/bursaries are invited only from institutions providing appropriate programmes of study and seeking financial assistance for students. Grant applications may come from individuals, groups or institutions and are considered three times a year. All applications should be made to the administrator, in writing only.

The John Fernald Award Trust – see entry for The Equity Trust Fund

The Finchcocks Charity Ltd

CC No: 289155

c/o Deeks Evans Registered Auditors, 3 Boyne Park, Tunbridge Wells, Kent TN4 8EN

Tel: 01580 211 702
Contact: Mrs K Burnett, Secretary
Trustees: Council of Management: Richard Burnett; Sir David Burnett; Katrina Burnett, Secretary; Marion Dow; William Dow; Laurence Peskett; Theophilus Peters; William Salaman; David Steed; Lord Wakehurst; David Ward.
Beneficial area: UK and overseas.
Grant total: £20,472 (1999/2000)
Arts grants: £20,472
The charity's principal aims are 'to develop the resources of the Finchcocks Museum of Historical Keyboard Instruments in the most effective way, the promotion of musical education and the financing of those musical activities which cannot, by their nature, be self-supporting'.

In 1999/2000 the charity gave a total of £20,472, all of which was directed

towards activities connected with the museum, which is a centre for the performance and study of period keyboard instruments.

Exclusions: Any person or event not connected with Finchcocks Museum, music centre and related institutions and the musical activities held there.

Applications: In writing to the correspondent, but note the above.

Gerald Finzi Charitable Trust

CC No: 313047

Hillcroft, Shucknall Hill, Hereford HR1 3SL

Contact: Elizabeth Pooley
Trustees: Nigel Finzi; Jean Finzi; Andrew Burn; Robert Gower; J Dale Roberts; Paul Spicer; Christian Alexander.
Beneficial area: UK.
Donations to all causes: £11,000 (1998/99)
Arts grants: £11,000
The aims of the trust reflect the ambitions and philosophy of the composer Gerald Finzi (1901–56), which included the general advancement of twentieth century British music, through assistance with and promotion of festivals, recordings and performances. A limited number of modest grants are also offered to young musicians towards musical training, though not for diploma, first degree or postgraduate study.

In 1998/99, the most recent year for which accounts were available at the Charity Commission, the trust gave a total of just over £11,000 in 18 arts-related grants to 16 organisations and 2 individuals. Donations ranged from £30 to £3,500 but were mostly below £1,000. Beneficiaries included:
★Finzi Singers (£2,343);
★Gloucester Three Choirs Festival; Royal College of Organists (£1,000 each);
Oxford Bach Choir (£500);
Stratford upon Avon English Music Festival (£470);

Gloucester Symphony Orchestra (£200);
Oundle International Organ Festival (£140);
Chester Bach Singers (£100).

Applications: Organisations should send all relevant material to the correspondent, including full background and artistic information with a detailed breakdown of budget.

The Ian Fleming Charitable Trust – see Musicians' Benevolent Fund

Arts grants: £140,000

The Joyce Fletcher Charitable Trust

CC No: 297901

17 Westmead Gardens, Upper Weston, Bath BA1 4EZ

Tel: 01225 314 355
Contact: R A Fletcher, Trustee
Trustees: R A Fletcher; W D R Fletcher.
Beneficial area: UK, with a particular interest in Bath and the South West of England.
Grant total: £60,000 (1999/2000)
Arts grants: £40,400
This trust supports 'institutions and organisations specialising in music performance and education, and children's welfare, a particular interest being the role of music in the lives of the disabled and disadvantaged'. The trust may make grants outside of these objects, in which case 'applications from within the South West tend to be considered'.

In 2000/01 the trust gave over £60,000 in 64 grants ranging from £50 to £6,000; most were for £1,000 or less. Of this total, £40,400 (67% of total grant-aid) was given in 36 grants relevant to this guide. These included:
Share Music Courses (£6,000);
★Live Music Now! (£5,000);
★Drake Music Project (£2,000 in 2 grants);

*Bath Festivals Trust (£2,500);
*National Trust, composer in residence;
 *Buxton Festival; Bath International
 Guitar Festival; Bath Mozartfest;
 Children's Laureate; Schubert Ensemble
 (£1,000 each);
*Friends of Music at Wells Cathedral
 School; Abbotsbury Music Festival;
 National Musicians Symphony
 Orchestra (£500 each);
*Bath Baroque (£250).

Exclusions: Individuals; students; areas
which are the responsibility of local
authority funding; purely professional
music/arts promotions.
Applications: By letter to the
correspondent before 1st November each
year, including the following details:
purpose for grant; history and viability of
the organisation; summary of accounts.
Unsuccessful applicants will receive a
reply only if a SAE is enclosed.

The Four Lanes Trust

CC No: 267608

5 Caithness Close, Oakley, Basingstoke,
Hants RG23 7NG

Tel: 01256 781978; Fax: 01256 781978
E-mail: fourlanes@treglown.idps.co.uk
Website: www.basingstoke.org.uk/
fourlanestrust
Contact: Len Treglown, Trust Director
Trustees: D W Makins; E I Roberts;
Virginia Makins; Mrs G Evans.
Beneficial area: Administrative County
of Hampshire and in particular the
Basingstoke District.
Grant total: £48,000 (2000)
Arts grants: £25,341
The trust aims to advance education,
including education in the arts, and to
promote social welfare within Hampshire,
especially the Basingstoke district. Sports
and leisure and recreation activities are
also supported.

In 2000 the trust gave a total of over
£48,000 in 39 grants, the majority of

which were under £1,000. Out of this,
the trust gave a total of £25,341 (52% of
total grant-aid) in grants covering 11
different arts organisations. These were:
Testbourne Community School, for stage
 equipment (£15,000);
Artisans – Shaw Trust, for tools and stock
 (£4,500);
Vyne Community School, for sprung
 dance floor (£2,200);
Basingstoke Concert Club, artists' fees for
 Family Fundays (£750);
Music Therapy, arts centre room rental
 (£650);
Helping Hands, costs for art and craft
 scheme for autistic children (£600);
Open Studio Scheme, costs of design and
 art work (£500);
John Hunt Community School, music
 tuition (£450);
Reactivate, theatre performance at a
 special needs school (£300);
Millennium Brass, for new music (£250);
WEA – Oakridge Outreach Project, art
 and craft materials (£141).

Exclusions: Individuals.

The Pierre Fournier Award Fund

CC No: 1062846

18c Lambolle Place, London NW3 4PG

Tel: 020 7813 3539; Fax: 020 7813 3539
E-mail: vividee@compuserve.com
Contact: Vivienne Dimant
Trustees: Ralph H Kirshbaum; David A
Sigall; Raphael S Wallfisch; Moray M
Welsh.
Beneficial area: UK.
The Pierre Fournier Award is offered
every three years to an exceptional young
cellist to assist with the cost of a London
debut recital and an accompanying CD.

The fund is administered
independently. The age limit for
candidates is 28. Selection of candidates is
by audition and is reserved for 'cellists
native to or studying in Great Britain'.

The size of the award varies from year-to-year and is dependent upon the costs of the recital and of the CD production.
Applications: Contact the trust for further details.

The Foyle Foundation

CC No: 1081766

1st Floor Rugby Chambers, 2 Rugby Street, London WC1N 3QU

Tel: 020 7430 9119; Fax: 020 7430 9830
E-mail: information@foylefoundation.org.uk
Website: www.foylefoundation.org.uk
Contact: David Hall, Chief Executive
Trustees: Silas Krendel, Chair; Michael G Smith; Katryn Skoyles.
Beneficial area: UK.
Grant total: £1.8 million a year.
Registered in July 2000, this foundation supports charities in the UK where their core remit is learning, the arts or health. The trustees are particularly interested in projects where their grant will 'make a difference'. The foundation also supports state schools.

The majority of grants are made for one year and are in the range of £5,000 to £50,000; the average grant is for £15,000. To keep administration costs to a minimum, grants of less than £5,000 will not generally be considered. Occasional grants of up to £300,000 for large national charities will be considered (payable over three years).

Beneficiaries in 2001/02 have included:
Under Learning –
The British Museum Development Trust; The Guildhall School of Music and Drama; The Poetry Society.
Under Arts –
Aldeburgh Productions; Almeida Theatre; Buxton Festival; Dorset Opera; English National Opera; London Philharmonic Orchestra; Music Theatre Wales; Northern Ballet Theatre; Pershore Theatre Arts Association (PTAA); Spitalfields Festival; The Arvon Foundation Ltd; The Constable Trust; The Fruitmarket Gallery; The Opera Group; The Queen's Hall Edinburgh; The Wordsworth Trust; Yorkshire Women Theatre.
Under Other –
Chelmsford Cathedral; Dechert Charitable Trust.

No grants are given to individuals or non-registered charities.
Applications: Application forms are available from the correspondent and via the foundation's website. All applicants will be acknowledged within two weeks and all eligible applications should be processed within four months. Once a major grant has been made the foundation will not normally accept further applications from the same charity for three years.

Larger grants
Applicants will need to provide the following supplementary information: name of project; name of contact and telephone number; total cost of project (provide a project budget); amount of grant required; amount to be raised from other sources and how this will be raised; the date the project starts/started; how long it will take; when funding is required; who will manage the project from within the organisation; project description; why project is needed; whether the project will proceed without funding from the foundation; when and by what instalments is the funding required; how the project will be monitored, evaluated and reported to the foundation; other projects that the applicant has carried out and their results.

Building projects
Applications should also answer the following:
- Has the project obtained planning permission and, if required, listed building consent?

- Has a professional technical team been recruited? How were they chosen? Were EU regulations followed?
- To what level of the RIBA design stages has the project progressed?
- What is the indicative project time-scale?
- Has a robust budget with adequate levels of contingency been allowed for?
- Can an adequate project management structure be demonstrated?
- Has a realistic strategy/timescale for raising the project funding been devised?
- Who are or will be the architects and technical team; the project managers; and the main contractors?

The chief executive may request further information and visit the project. Trustees meet four times a year to consider applications. Applications may take up to four months to fully process. Appeals will be acknowledged within two weeks and ineligible requests will be rejected at this stage.

Once a major grant has been awarded, further applications will not be considered for three years.

The Charles Henry Foyle Trust

CC No: 220446

c/o Boxfoldia Ltd, Merse Road, Redditch, Worcestershire B98 9HB

Tel: 01527 64191
Contact: Trust Administrator
Trustees: Prof. David Thomas, Chair; Roger K Booth; Mrs Bridget Morris; Cllr Michael Francis; Paul R Booth.
Beneficial area: UK, with a clear preference for Birmingham and the West Midlands.
Grant total: £90,000 (1999/2000)
Arts grants: £16,675
This trust's purposes include the provision of medical, dental and nursing facilities; the assistance of junior or adult

education; the encouragement of educational travel; and the elderly. In furtherance of its arts-related aims, the trust funds awards/prizes in addition to more general charitable donations.

In 1999/2000 the trust gave a total of £90,000 in 216 grants ranging from £30 to £7,500; most were under £500. Only grants over £1,000 were specified in the annual report. Of the total funding, £16,675 (19%) was given in seven listed grants relevant to this guide. These were:
★Stitched Textile Award and School Prizes (£6,800);
Educational Theatre Services Limited/ Dance Alive, dance and movement education programme (£3,300);
CSBO, music education project for autistic children and those with partial hearing (£2,000);
Birmingham Conservatoire, individual student's fees (£1,575);
Midlands Art Centre, millennium production; Now and Then Productions, costumes for 'Twelfth Night'; Birmingham Symphony Hall, free event for secondary school children (£1,000 each).

Exclusions: Established bodies; running costs.
Applications: In writing.

The Gordon Fraser Charitable Trust

CC No: 260869

Holmhurst, Westerton Drive, Bridge of Allan, Stirling FK9 4QL

Contact: Mrs M A Moss, Trustee
Trustees: Mrs Margaret Moss; W F T Anderson.
Beneficial area: UK, with a particular interest in Scotland.
Grant total: £130,000 (1999/2000)
Arts grants: £37,300
The trust has general charitable objects and gives to a wide range of causes, with many recurrent beneficiaries. Its arts

funding objectives are broad and include projects benefiting young people, orchestras, opera, choirs, theatre, dance and museums. Preference is given to charities in Scotland but not to the exclusion of appeals from elsewhere.

In 1999/2000 the trust gave a total of almost £130,000 in 196 grants ranging between £100 and £6,000, most of which were under £1,000. Out of this, a total of £37,300 (29% of total grant-aid) was given in 34 grants to the arts. These included:

★Ballet West (£6,000);
★Scottish Museum Council (£5,500);
★MacRobert Art Centre (£5,000);
★Royal Scottish National Orchestra (£3,000);
Byre Theatre (£2,500);
★Scottish Opera (£1,500);
Fife Youth Music Activities; Scottish National Portrait Gallery; ★James Paterson Museum (£1,000 each);
★Northlands Festival Ltd (£700);
★Children's Classic Concerts; National Youth Orchestra of Scotland; Cumbria Art in Education; Elgin Museum; Glasgow Sculpture Studies (£500 each);
Textile Conservation Centre (£400);
Arts is Magic (£300);
★Rosenethe Singers (£200).

Exclusions: Individuals; organisations which are not registered charities.
Applications: In writing to the correspondent. Applications are considered by the trustees in January, April, July and October. All applicants are acknowledged and a SAE is therefore appreciated.

The Hugh Fraser Foundation

CC No: SC009303

Turcan Connell, Princes Exchange, 1 Earl Grey Street, Edinburgh EH3 9EE Scotland

Tel: 0131 228 8111; Fax: 0131 228 8118
E-mail: ht@turcanconnell.com
Website: www.turcanconnell.com
Contact: Heather Thompson
Trustees: Dr Kenneth Christie, Chair; Miss Ann Lewis Fraser; Patricia Lydia Fraser; Blair Smith.
Beneficial area: Scotland.
Grant total: £1,178,000 (2000/01)
This foundation was established in 1960 by Sir Hugh Fraser and endowed by him with shares in House of Fraser and Scottish and Universal Investments (SUITS). The trust funds stood at £31.2 million on 31st March 2001.

The trustees favour smaller, more focused causes rather than large highly publicised appeals, and tend to make grants to charitable bodies to assist with their charitable work. Grants are often made in successive years in order to maintain their momentum and effectiveness.

The foundation's objects cover a range of areas, but are concentrated principally on the following: hospitals; schools and universities; arts organisations; organisations working with the handicapped, the underprivileged and the aged.

In 2000/2001 the foundation gave a total of £1,178,000 in 290 grants, the sizes and beneficiaries of which were unspecified. Three major grants were listed. These were:
★Scottish Science Trust (£100,000);
South Ayrshire Council (£100,000);
Capability Scotland (£50,000).

The grant of £100,000 to South Ayrshire Council was of specific relevance to this guide as it was given for Alexander Goudie paintings.

The remaining grants were mainly distributed within the following fields: medical facilities and research; relief of poverty and assistance with the aged and infirm; education and learning; the encouragement of personal development and training of young people; the provision of facilities for the less privileged and vulnerable; the encouragement of music and the arts.

Due to current arrangements for trusts in Scotland, we were unable to obtain any further details of arts funding.

Exclusions: Individuals.

Applications: The trustees meet quarterly to consider applications.

The Fulbright Commission

Fulbright House, 62 Doughty Street, London WC1N 2LZ

Tel: 020 7404 6880; Fax: 020 7404 6834
E-mail: education@fulbright.co.uk
Website: www.fulbright.co.uk
Contact: Ms Heather Topel, British Programme Manager
Beneficial area: UK residents studying in the USA.

The Fulbright Commission offers a programme of academic awards for study and research in the United States. The Fulbright Awards Programme selects outstanding candidates with leadership qualities for its programme of awards for EU citizens who are residents of the UK. The following awards were available in 2002 and are relevant to this guide:

- *Postgraduate Student Scholarships* – for individuals who wish to study at postgraduate level at an educational institution in the United States;
- *Grants for Visiting Lecturers, Postdoctoral Research Scholars and Professional Fellowships* – postdoctoral or professional fellowships for individuals who wish to lecture or research at an educational institution in the United States.

Applications: Additional details, as well as application forms, are available on the website or by post (send a written request accompanied by a large SAE with postage for 100 grammes).

If you wish to apply for the 2003/04 academic year, information will be available in June 2002.

The Gannochy Trust

CC No: 3133

Kincarrathie House Drive, Pitcullen Crescent, Perth PH2 7HX Scotland

Tel: 01738 620653
Contact: Mrs Jean Gandhi, Secretary
Trustees: Russell Leather, Chair; Mark Webster; James McGowan; Neil MacCorkindale; Dr James Kynaston.
Beneficial area: Scotland, with a particular interest in Perth
Grant total: £3,213,000 (2000/01)

The trust was founded in 1937 by Arthur Bell, the Perth whiskey distiller who also built the Gannochy Housing Estate in Perth. The trustees maintain this estate and other properties.

'Prime objects for which donations are made ... are the needs of youth and recreation, but the trustees are not restricted to these objects.'

Grants exceeding two per cent of gross income in 2000/01 which were relevant to this guide:
Perth Theatre, for refurbishment and upgrading of theatre (£105,000);
Pitlochry Festival Theatre (£100,000).

Grants totalling £2.3 million were not listed in the accounts so it is impossible to give a full picture of the trust's interest in the arts.

Garrick Charitable Trust

CC No: 1071279

c/o The Garrick Club, 15 Garrick Street, London WC2E 9AY

Tel: 020 7836 1737
Beneficial area: UK.
This new trust was established by members of the Garrick Club in London, and registered as a charity in August 1998.

In 2001 it is understood that the trust received an endowment of around £4 million from the family of A A Milne (a part of their proceeds from selling the Winnie the Pooh copyright to the Walt Disney corporation). It is anticipated that the revenue raised from this endowment is to be allocated to causes within the trust's objectives, which it defines as 'the general patronage of theatre, music, literature and dance'.

Arrangements for the funding activities were unclear at the time of writing (November 2001). The likely total annual funding was not known. However, the trust expects to make a limited number of grants, with £25,000 as the maximum for any donation.
Applications: Contact the trust for more details.

The Gatsby Charitable Foundation

(see also the Sainsbury Family Charitable Trusts)
CC No: 251988

Tel: 020 7410 0330; Fax: 020 7410 0332
Website: www.gatsby.org.uk
Contact: Michael Pattison, Director
Trustees: Mr C T S Stone, Chairman; Mr A T Cahn; Miss J S Portrait.
Beneficial area: UK and overseas.
Grant total: £20,732,000 (2000/01)
Arts grants: £1,102,000
The settlor of this massive foundation is Lord Sainsbury of Turville (David Sainsbury). Although he has never served directly as a trustee, and has said he will not take any part in its decisions while he is a government minister, it has consistently followed his particular interests since he founded it in the late 1960s. It funds far-reaching projects concerned with technical education, plant science, cognitive neuroscience, mental health, disadvantaged children, social renewal, developing countries, the arts, and economic and social research. It also gives itself considerable leeway to donate to other interests.

The foundation has featured a specific category for the arts in its annual report since 1997/98, accounting for around five per cent of total annual funding. Arts-related support, most of which is recurrent, is exclusively given 'to support the fabric and programming of institutions with which Gatsby's founding family has long connections'. Regular grants have been made in recent years to the Robert and Lisa Sainsbury Charitable Trust, the trust of David Sainsbury's father and mother. The Sainsbury Centre for Visual Arts was set up by them and incorporates their original collection. The Royal Shakespeare Theatre has also been a major beneficiary, receiving substantial recurrent funding.

In 2000/01 the foundation made grants totalling £20,732,000. Out of this £1,102,000 (five per cent of total support) was given to the following arts-based beneficiaries:

* Sainsbury Centre for Visual Arts at the University of East Anglia (UEA) (£464,259);
* Royal Shakespeare Theatre, towards its redevelopment and to support the post of redevelopment director (£282,760);
* Robert and Lisa Sainsbury Charitable Trust (£270,000);
* Sainsbury Institute for the Study of Japanese Arts and Cultures, towards core costs (£84,467);

Young Musicians at Tabernacle (£500).

Exclusions: Individuals.
Applications: Unsolicited applications are not considered.

However, it is also said that an application to one of the Sainsbury family trusts is an application to all. See the entry for the Sainsbury Family Charitable Trusts for their address and further advice.

Gatwick Airport Community Trust

CC No: 1089683

PO Box 102, Crawley, West Sussex RH10 9WX

Tel: 01293 449147
Beneficial area: Parts of Sussex, Surrey and Kent, from Reigate in the north to Haywards Heath in the south, Tunbridge Wells in the east and Cranleigh in the west.
Grant total: £100,000 per year
This trust will have £100,000 to distribute each year in support of environmental and community projects until March 2009. Its funding activities will generally take place in those areas directly affected by operations at Gatwick Airport. This specific area of benefit covers parts of Sussex, Surrey and Kent, from Reigate in the north to Haywards Heath in the south, Tunbridge Wells in the east and Cranleigh in the west.

A wide range of causes will be supported, including:

- projects that help the young, the disabled or the elderly;
- projects that support community life and improve community facilities;
- arts, cultural and sports projects;
- environmental and conservation schemes.

Priority will be given to applications with strong community support and which will result in long-term enhancement and enable applicants to attract other sources of funding.

Projects both large and small can qualify for support. There is no fixed minimum or maximum but grants are unlikely to be for less than £250 or more than £15,000.
Applications: Application forms and guidelines are available from the trust. Applications will be acknowledged if accompanied by a SAE or an e-mail address. Trustees meet twice a year to consider proposals and applicants will be informed of the outcome by letter.

The Robert Gavron Charitable Trust

CC No: 268535

44 Eagle Street, London WC1R 4FS

Tel: 020 7400 4301
Contact: Mrs Dilys Ogilvie-Ward, Secretary
Trustees: Lord Gavron; Charles Corman; Lady Gavron; Jessica Gavron; Sarah Gavron.
Beneficial area: UK.
Grant total: £630,000 (2000)
Arts grants: £321,000
The trust's 'principal fields of interest continue to include the arts, education, social policy and research and charities for the disabled'. The 2000 report states that 'trustees prefer to make grants to organisations whose work they personally know and admire', although small charities working in areas which do not easily raise funds are also viewed sympathetically.

The trust generally makes a small number of substantial grants together with a larger quantity of smaller donations. A number of significant beneficiaries receive regular and substantial support including the National Gallery, of which Lord Gavron is a trustee, and the Royal Opera House Trust.

In 1999/2000 the trust gave a total of £630,000 in 97 listed donations of between £50 and £200,000, including

£208,000 to fulfil commitments from the previous year. Most grants were, however, below £5,000.

Funding relevant to this guide was made in 18 grants totalling £321,000 (51% of grant-aid), the majority of which was given in large donations to the Royal Opera House Trust and the National Gallery Trust. Beneficiaries included:

★Royal Opera House Trust (£200,000);
★National Gallery Trust (£101,500);
★Royal Academy of Arts (£5,000);
Royal National Theatre; Common Ground Sign Dance Theatre; Book Trust (£1,000 each);
Camberwell College of Arts (MAP) (£250);
Cavatina Chamber Music Trust (£150).

Applications: In writing only to the correspondent, enclosing a SAE and latest accounts. **However, the 2000 report states that 'the trust is fully committed to its existing areas of interest and the trustees would have difficulty in considering further appeals'.** Trustees meet about eight times a year.

Genesis Foundation

(formerly the John Studzinski Foundation)

PO Box 32815, London N1 1GE

Tel: 020 7603 9237; Fax: 020 7603 9237
E-mail:
operaprize@genesisfoundation.org.uk
Website: www.genesisfoundation.org.uk
Contact: Harriet Capaldi
Grant total: see below
This foundation seeks to identify young men and women of talent in various art forms and springboard their careers. In recent years funding has been provided for a variety of causes, including the Royal Court Theatre, Schubert Ensemble, Space Studios in the East End of London and Almeida Opera.

The foundation is presently engaged with two major initiatives: the Genesis

Prizes for Opera, in association with Almeida Opera; and International Playwrights at the Royal Court Theatre.

- **The Genesis Prizes for Opera** scheme is a competition for composers and librettists of chamber opera which aims to 'foster the development of chamber opera, to encourage composers and writers to develop the unique skills associated with writing successful works for the stage'. This initiative involves commissioning fees; mentoring and support for the teams throughout the development of the projects; workshops; and professional production for three finalists. In addition, there is a first prize of £20,000 for the overall winners.
- **The International Playwrights' Season** is a series of new works presented bi-annually at the Royal Court Theatre in London. The focus of the 2002 season, which will include two fully staged productions, is human rights.

Applications: For further information, and to arrange interviews, contact Harriet Capaldi.

The German Academic Exchange Service (DAAD)

34 Belgrave Square, London SW1X 8QB

Tel: 020 7235 1736; Fax: 020 7235 9602
E-mail: info@daad.org.uk
Website: www.daad.de/london
Contact: The Administrator
Beneficial area: UK academic staff, researchers and HE or research students studying or undertaking research in Germany.
DAAD is a self-governing organisation of higher education institutions in Germany which promotes international academic relations and cooperation through a series of exchange programmes. It produces a brochure to draw attention to a variety of scholarships and funding schemes available, mainly for study and research in

Germany. These are for academic staff and students at institutions of higher education and research institutes in the United Kingdom.

A variety of awards are available including one-year and short-term grants for individual postgraduate study and research in Germany and a writers-in-residence scheme enabling British universities to benefit from working visits by German writers for between three and four weeks.

Candidates for arts-related scholarships should have a good command of the German language and must have attained at least an upper second class degree and not be older than 32 years of age.

The DAAD's brochure also refers to schemes run by other organisations.
Applications: Copies of the brochure, application forms and programme guidelines are available from the above address. The deadline for study during 2002/2003 for art, music and architecture students was 23 November 2001.

Applications must be returned by mail. Applications by e-mail, incomplete applications and applications postmarked after the deadline cannot be processed.

J Paul Getty Jr Charitable Trust

CC No: 292360

1 Park Square West, London NW1 4LJ

Tel: 020 7486 1859
Contact: Ms Bridget O'Brien Twohig, Administrator
Trustees: Sir Paul Getty; Christopher Gibbs; James Ramsden; Vanni Treves; Lady Getty.
Beneficial area: UK, but with a preference for less prosperous parts of the country.
Grant total: £1,238,000 (2000)
Arts grants: £133,800
'The trust aims to fund projects to do with poverty and misery in general, and unpopular causes in particular, within the

UK.' There is a strong emphasis on constructive, self-help projects which utilise volunteers, focus on the disadvantaged and operate within local communities. The trust considers applications from across the UK but priority is given to projects 'outside London and the South East', with the South West, Yorkshire, the North East and East Anglia being the most regularly targeted.

The trust gives to causes within the following categories:

Social welfare
'**Mental Health**, in a wide sense. This includes projects for: mentally ill adults; mentally handicapped adults; drug, alcohol and other addictions, and related problems; support groups for people under stress, e.g. battered wives, victims of abuse, families in difficulties, etc.; counselling, especially young people; mediation.

'**Offenders**, both in and out of prison, men and women, young offenders, sexual offenders.

'**Communities** which are clearly disadvantaged, trying to improve their lot, and organisations enabling them, particularly projects to do with helping young people in the long-term.

'**Homelessness**, particularly projects which help prevent people becoming homeless or resettle them.

'**Job Creation**, projects or ones aimed at making long-term constructive use of enforced leisure time, particularly ones set up by unemployed people.

'**Ethnic Minorities** involved in above areas, including refugees, particularly projects aimed at integration.'

Arts
'Only the following will be considered:
- therapeutic use of the arts for the long-term benefit of the groups under Social Welfare;
- projects which enable people in these groups to feel welcome in arts venues,

or which enable them to make long-term constructive use of their leisure.'

Conservation

'Conservation in the broadest sense, with emphasis on ensuring that fine building, landscapes and collections remain or become available to the general public or scholars. Training in conservation skills. Not general building repair work.'

Environment

'Mainly gardens, historic landscape, wilderness.'

The vast majority of the trust's funds are awarded to social welfare and with regard to arts, support is primarily available for projects specifically concerned with producing long-term benefits for disadvantaged groups within this category.

In 2000 the trust gave a total of around £1,238,000 in 183 grants ranging in size from £250 to £20,000. Of this total, £133,800 (over 10% of total funding) was donated in 24 grants relevant to this guide. These included:

Dove Designs, Liverpool, running costs for workshop for mentally ill people (£15,000);

Full Potential Arts, art classes for mentally ill people (£12,000);

David Glass Ensemble, London, drama tutor for prisons (£9,000);

Orchestra of St John's Smith Square, Blackbird Leys estate project in Oxford (£7,500);

Aldeburgh Productions/HMP Hollesley Bay, arts project for young offenders; BROLI/Cat's Paw Theatre, N Wales, drama therapy for offenders (£6,000 each);

Escape Artists, Cambridge, salary to assist ex-prisoners' theatre company; Handel House Trust, support in setting up museum; World Monuments Fund in Britain, preservation of fine buildings (£5,000 each);

Gallowgate Family Support Group, art therapy for families of addicts;

Kirkleatham Old Hall Museum, Redcar, purchase of local artist's war drawings (£3,000 each);

Council for the Prevention of Art Theft, Yorkshire; Tricycle Theatre Trust, London (£1,000 each);

Ragged School Museum Trust, London (£500).

Exclusions: Music or drama, except therapeutically; the elderly; children; education; conferences/seminars; research; animals; churches or cathedrals; schools; national appeals; medical equipment; grant-giving trusts, such as community trusts. Residential or large buildings projects are unlikely to be considered. No grants to individuals. Also 'community projects set up and managed by representatives of statutory authorities, even if they are registered as charities'.

Applications: In writing to the administrator at any time. Guidelines are available from the trust, and are essential reading for successful applicants. An initial letter **of no more than two pages** should be sent to the trust, giving an outline and detailed costing of the project, existing sources of finance of the organisation, other applications, including those to statutory sources and any other or previous applications to the trust. 'Please do not send videos or bulky reports, etc. as they will not be returned!'

'Applicants should hear whether their proposals are being taken forward or not within 4–6 weeks, and should have a decision within 2–4 months.' Annual accounts will be asked for if the application is going to be taken further. The project will be visited before consideration by the trustees.

All letters of appeal will be answered.

The Simon Gibson Charitable Trust

CC No: 269501

Wild Rose House, Llancarfan, Vale of Glamorgan CF62 3AD

Tel: 01446 781004; Fax: 01446 781004
E-mail: bryan@marsh66.fsnet.co.uk
Contact: Bryan Marsh, Trustee
Trustees: Bryan Marsh; Angela Homfray; George Gibson.
Beneficial area: East Anglia, South Wales and the London area, as well as national charities.
Grant total: £483,000 (1999/2000)
Arts grants: £26,000
A wide range of charities are supported by the trust and many beneficiaries are recurrent. The proportion of funds given to the arts varies each year, with between 1% and 10% of total grant-aid since 1993/94 given in grants relevant to this guide.

In 1999/2000 the trust gave a total of nearly £483,000 in 127 grants ranging from £1,000 to £50,000, most of which were under £10,000. Out of this, a total of £26,000 (five per cent of total grant-aid) was given in seven arts-related grants. These were:
Royal Academy of Music (£12,000);
Abertillery & District Museum Society;
 ★Bookaid International (£3,000 each);
Farmland Museum; ★London Welsh
 Chorale; ★National Music for the
 Blind; ★Talking Books for the
 Handicapped (£2,000 each).

Exclusions: Individuals.
Applications: In writing to the correspondent. The trust has no application forms. Applicants should not telephone the trust. All applications are acknowledged but no further correspondence is carried out unless a grant is to be made. Applications should be received in March for the trustees' meeting in May.

The Glass-House Trust

(see also the Sainsbury Family Charitable Trusts)

CC No: 1017426

Tel: 020 7410 0330; Fax: 020 7410 0332
Contact: Michael Pattison, Director
Trustees: Alexander Sainsbury; T J Sainsbury; Miss J M Sainsbury; Mrs Camilla Woodward; Miss Judith Portrait.
Beneficial area: UK.
Grant total: £532,000 (1999/2000)
Arts grants: £11,500
This is one of the Sainsbury Family Charitable Trusts which share a joint administration. 'The trustees prefer to support innovative schemes that can be successfully replicated or become self-sustaining.' Grants are often recurrent and are made within the following categories: parenting, family welfare and child development; art/architecture; general.

In 1999/2000 the trust gave a total of over £532,000 in 32 grants ranging from £1,500 to an exceptional donation of £123,167 to the Institute of Education; most were under £27,000. Out of this, £11,500 (two per cent of total grant-aid) was given in four grants relevant to this guide. These were:
★Whitechapel Art Gallery (£4,000);
Art Circuit Touring Exhibition (£3,000);
★South London Gallery (£2,500);
★Public Art Patronage Trust (£2,000).

Exclusions: Individuals.
Applications: 'Proposals are generally invited by the trustees or initiated at their request.' Unsolicited appeals are, therefore, unlikely to be successful. The trust has 'substantial forward commitments'.

The Golden Bottle Trust

CC No: 327026

37 Fleet Street, London EC4P 4DQ

Tel: 020 7353 4522
Contact: The Secretary
Trustees: Messrs Hoare Trustees.

Beneficial area: UK.
Grant total: £434,000 (1999/2000)
Arts grants: £17,000
Beneficiaries of past grants made by this trust have included a wide range of medical, environmental, social welfare, arts and other causes.

In 1999/2000 funding totalled £434,000 but no list of beneficiaries has accompanied the accounts made available to the Charity Commission since 1993/94. In 1993/94 the trust gave a total of £169,000 in over 175 grants, ranging from £100 to £10,000; the majority were small and under £1,000. Out of this, a total of £7,250 (four per cent of total grant-aid) was given in 11 arts-related grants, ranging between £250 and £2,500, to a wide variety of beneficiaries. Based on the proportion of arts-related support in 1993/94, funding relevant to this guide in 1999/2000 may have amounted to about £17,000.

Applicants should note that the trust's funds are usually largely committed, and **applications from sources not already known to the trustees are unlikely to be successful**.
Exclusions: Individuals; organisations which are not registered charities.
Applications: Trustees meet on a monthly basis, but it is understood that the funds are already largely committed, and therefore, applications from sources not already known to the trustees are unlikely to be successful.

Golden Charitable Trust

CC No: 263916

Little Leith Gate, Angel Street, Petworth, West Sussex GU28 0BG

Tel: 01798 342434
Contact: Lewis Golden, Secretary to the Trustees
Trustees: Mrs S J F Solnick; J M F Golden.
Beneficial area: UK.
Grant total: £29,000 (1999/2000)

Arts grants: £19,761
The trust has general charitable purposes and gives a small number of grants, some of which are recurrent, to a variety of causes each year.

Its total charitable expenditure varies from year to year, as demonstrated by the following annual grant totals:
- 1998/99 – £93,370;
- 1999/2000 – £29,000;
- 2000/01 – £183,500.

In 1999/2000, the most recent year for which a funding breakdown was available at the Charity Commission, the total of almost £29,000 was made up of nine grants ranging from £100 to £15,000. Out of this, £19,761 (68% of total grant-aid) was given in two grants relevant to this guide. These were:
★London Library (£15,000);
★Petworth Festival (£4,761).

The Jack Goldhill Charitable Trust

CC No: 267018

85 Kensington Heights, Campden Hill Road, London W8 7BD

Contact: Jack Goldhill, Trustee
Trustees: Jack A Goldhill; G Goldhill.
Beneficial area: UK.
Grant total: £68,000 (1998)
Arts grants: £30,000
This trust mainly supports health and welfare causes, as well as the arts.

In 1998, the most recent year for which an annual report was on file at the Charity Commission, the trust gave a total of £68,000. Unfortunately, the report did not feature a grants listing. In 1997 a total of £78,054 was given in 77 grants ranging from £30 to £27,000; most were for £3,500 or less, including a number of 'Friends of…' payments. A total of £34,000 (44% of total grant-aid) was given in 17 grants relevant to this guide, most of which were less than £1,000. Grants to the arts were:

Jack Goldhill Sculpture Award Fund
(£27,000);
Tate Gallery; Tricycle Theatre Company
(£2,000 each);
Royal Academy of Arts (£1,000);
Ben Uri Art Society (£600);
Glyndebourne Arts Trust; Glyndebourne
Festival Society (£300 each);
Artists' General Benevolent Institution;
★Royal National Theatre; Wigmore
Hall Trust (£250 each);
Israel Music Foundation (£200);
Jewish Museum (£100).

Exclusions: Individuals; new applications
(see below).
Applications: The trustees have a
restricted list of charities to whom they
are committed, and **no unsolicited
applications can be considered**.

The Goldsmiths' Arts Trust Fund

(see also the Goldsmiths' Company's Charities)

CC No: 313329

The Goldsmiths' Company, Goldsmiths'
Hall, Foster Lane, London EC2V 6BN

Tel: 020 7606 7010; Fax: 020 7606 1511
E-mail: the.clerk@thegoldsmiths.co.uk
Website: www.thegoldsmiths.co.uk
Contact: Mr R D Buchanan-Dunlop
Trustees: The Wardens and
Commonality of the Mystery of
Goldsmiths of the City of London and
Mr N G Fraser.
Beneficial area: UK.
Grant total: £740,000 (1999/2000)
Arts grants: £740,000
The trust fund gives regular support to
London Guildhall University, the
Goldsmiths' Craft and Design Council
and students to assist with training or
artistic use of precious metals. Although
all of its grantmaking is relevant to this
guide, funding is directed not at the arts
in general, but towards causes of specific

interest to goldsmiths and related trades.

The trust's resources are provided by an
annual donation from its parent
organisation, the Goldsmiths Company
Charities (see separate entry).

In 1999/2000 the trust fund gave a
total of £740,000, all of which was
relevant to this guide. This level of
funding is almost £300,000 higher than
in previous years, largely as a result of
support given to a major exhibition
entitled 'Treasures of the 20th Century',
which was designed to be a celebration of
the millennium. The remainder of the
fund's giving followed the pattern of
previous years. Arts-related funding
included:
★Exhibitions (£486,952);
★London Guildhall University (£50,000);
★Introduction to Business Course, for
graduates seeking to become
silversmiths or jewellers (£47,447);
★Bursaries and grants to colleges/students
(£42,162);
★Goldsmiths Craft and Design Council
(£25,500);
★Jewellery entry for Youth Skill Olympics
(£21,963);
★Educational Video on Silversmithing
(£11,340);
★Prizes (£9,440)

Exclusions: Areas not connected with
the goldsmiths' and silversmiths' trades.
Applications: In writing to the
correspondent.

The Goldsmiths' Company's Charities

CC No: 1088699

Goldsmiths' Hall, Foster Lane, London
EC2V 6BN

Tel: 020 7606 7010; Fax: 020 7606 1511
E-mail: the.clerk@thegoldsmiths.co.uk
Contact: R D Buchanan-Dunlop, Clerk
Trustees: The Goldsmiths' Company.
Charity Committee: Lord Cunliffe, Chair;
Sir Edward Ford; S A Shepherd; Miss J A

Lowe; Dr M P Godfrey; Revd P D Watherston; G P Blunden.
Education Committee: Lord Tombs, Chair; Prof. D N Dilks; Prof. K J Gregory; Prof. R L Himsworth; Prof. Sir Robert Honeycombe; Sir Robert Balchin; Mrs C Bowering; R W Threlfall; Sir Michael Wilshaw; Sir Peter Redwood.
Beneficial area: UK, with a special interest in London charities.
Grant total: £1,777,000 (1999/2000)
Arts grants: £1,021,000
The Goldsmiths' Company's Charities comprise one major and six minor charitable trusts. The principle trust is the Goldsmiths's Company's Charity, which was recently formed from three other associated charities. Support is given only to London-based and/or area national charities, with the majority of beneficiaries receiving grants over the course of three years. Grants are usually for revenue but are sometimes given for capital costs, mainly equipment purchase, building renovation and new buildings. 'Grant-making policies fall into three main areas:

- General charitable work from welfare to culture and heritage, but excepting education which is dealt with separately and medical research, animal welfare, memorials to individuals and overseas projects;
- Education in the broader sense;
- Education in the support of the Goldsmiths' Company's craft of silversmithing and the making of precious metal jewellery.'

Grants are made within the following categories: general welfare; medical welfare and disabled; youth; heritage; church; arts; education; support of the craft.

In 1999/2000 the charities made 367 grants totalling over £1,777,000. Out of this, £799,000 was designated for the Goldsmiths' Arts Trust Fund (see separate entry). The remaining grants ranged from £100 to £57,857, most of which were under £3,000. A total of over £1,021,000 (57% of total funding) was given in 58 grants relevant to this guide. These included:

Under 'general welfare' –
Toynbee Hall, for core funding (£3,000).

Under 'medical welfare and disabled' –
Council for Music in Hospitals; Drake Music Project (£1,000 each).

Under 'youth' –
The Roundhouse, for educational project (£2,500).

Under 'heritage' –
Ashmolean Museum, towards purchase of the Mildmay Monteith (£5,000);
Hackney Empire Appeal, for refurbishment; Royal Air Force Museum, for education facilities (£3,000 each);

Under 'arts' –
London International String Quartet, towards competition costs (£20,000);
City Music Society, sponsorship of a concert series (£17,625);
National Youth Orchestra of Great Britain, towards core funding (£4,000);
Dulwich Picture Gallery, for education department; English National Opera, for Baylis Programme (£3,000 each);
Actors Professional Centre, for capital work; Lyric Theatre Hammersmith, for Linking Out Programme (£2,000 each);
Half Moon Young People's Theatre, youth theatre work; Insight Arts Trust, work with young offenders; Paintings in Hospitals Scotland, towards general funds (£1,000 each).

Under 'education' –
Guildhall School of Music & Drama (£55,903 in three grants);
Central School of Ballet, for student bursaries; JC 2000 Millennium Arts Festival for Schools, core funding (£3,000 each).

Under 'support of the craft' –
Goldsmiths Arts Trust Fund (£799,000 in three grants);

Goldsmiths' Craft & Design Council, for awards ceremony (£15,000).

Exclusions: Students; provincial local appeals; overseas projects; endowment appeals; memorials to individuals; medical research; animal welfare.

Applications: By letter, stating the aims and objectives of the charity including an outline of current work, details of staffing, organisational structure and use of volunteers; and the specific purpose for the requested grant. The letter must be accompanied by a fully completed application form and latest annual report and audited accounts.

Trustees meet monthly except during August and September. No organisation, whether successful or not, will have more than one appeal considered every three years.

Sir Nicholas & Lady Goodisons Charitable Settlement

CC No: 1004124

PO Box 2512, London W1A 5ZP

Contact: Sir N Goodison, Trustee
Trustees: Sir Nicholas Goodison; Lady Judith Goodison; Miss Katharine Goodison.
Beneficial area: UK.
Grant total: £156,000 (2000/01)
Arts grants: £132,000
This trust's policy for charitable giving is to 'concentrate on educational and arts institutions'.

In 2000/01 the trust gave a total of £156,000. This level of funding is significantly higher than in previous years, largely as a result of a donation of £100,000 to the Wallace Collection. The majority of funding was distributed in 20 grants relevant to this guide. Only six arts-related grants were specified by the trust. These were:
Wallace Collection (£100,000);
Fitzwilliam Museum (£15,000);

Marlbrough College Music & Drama Centre (£10,000);
English National Opera (£3,000);
National Life Story Collection; Victoria & Albert Museum (£2,000 each).

The Granada Foundation

CC No: 241693

c/o Bridgegate House, 5 Bridge Place, Lower Bridge Street, Chester CH1 1SA

Tel: 01244 403305
Contact: Mrs Irene Langford, Administrator
Trustees: Advisory Council: Sir Robert Scott, Chair (trustee); Lord Bernstein (trustee); Prof. Denis McCaldin; Mrs Margaret Kenyon; Miss Vivienne Tyler; Philip Ramsbottom; Miss Kathy Arundale; Dr J Patrick Greene; Christopher Kerr.
Beneficial area: Mainly North-West England; some of North Wales.
Grant total: £142,000 (2000/2001)
Arts grants: £137,250
The foundation seeks to 'encourage and promote the study, practice and application of the fine arts' and advance education and the sciences, as well as providing recreational facilities in the interests of social welfare. Both one-off and recurrent grants are given to non-statutory projects. General running costs are not usually funded and the foundation tends to support registered charities, with a clear preference for new projects.

In 2000/2001 the trust gave a total of over £142,000 in 30 grants ranging from £500 to £25,000, most of which were for under £5,000. A total of £137,250 (96% of total grant-aid) was given in 28 grants relevant to this guide. These included:
Manchester Camerata, towards 'big breakwater challenge' (£25,000);
Foundation for Art and Creative Technology, towards capital cost of FACT centre and subsequent exhibition programme (£20,000);

*Buxton Festival (£13,000);
Royal Exchange Theatre, towards new play project (£12,500);
Brouhaha International, for Merseyside International Street Festival; Psappha, for Stravinsky Night at the Lowry and development of Spring Series in Liverpool (£5,000 each);
Storey Gallery, for education and exhibition programme; High Peak Theatre Trust, for restoration of Buxton Opera House (£4,000 each);
Crosby Community Cinema, towards a festival; Drake Music Project; Feelgood Theatre Productions Limited, for an exhibition (£2,000 each);
Gateway Theatre, towards writers' group project; Royal National Theatre, towards a residency at Contact Theatre (£1,500 each);
Lake District Summer Music, three-year commitment to classical music outreach programme; Live Music Now! North West (£1,000 each).

Exclusions: Individuals; courses of study; youth clubs; community associations; expeditions; overseas travel; general appeals.

Applications: In writing to the administrator, giving brief details of the project. Application forms and guidelines are available. The advisory council meets three times a year to consider applications. All letters are acknowledged.

Granada Trust

CC No: 1062513

The London Television Centre, Upper Ground, London SE1 9LT

Tel: 020 7261 3061
E-mail: htautz@granada.co.uk
Contact: Mrs H J Tautz, Assistant Secretary
Trustees: G J Robinson; C J Allen; G J Parrott.
Beneficial area: UK.
Grant total: £71,000 (2000)

Arts grants: £33,000
This trust, registered in 1997, makes grants to charities for community development; tourism; arts and arts facilities; conservation and the environment; education; training and job creation; and children and young adults.

In 2000 the trust gave a total of over £71,000 in 24 grants ranging from £100 to £25,000, most of which were for £5,000 or less. Out of this, £33,000 (46% of total grant-aid) was given in the following four arts-related grants:
Hampstead Theatre Trust (£25,000);
Trestle Theatre Company Ltd (£5,000);
*Choral Workshop (£2,000);
Children's Film Unit (£1,000).

The trust has expressed a reluctance to be included in this guide.

Applications: Deadlines for applications – the end of March, June, September, December.

The J G Graves Charitable Trust

CC No: 207481

Knowle House, 4 Norfolk Park Road, Sheffield S2 3QE

Tel: 0114 276 7991
Contact: R H M Plews, Secretary to the Trustees
Trustees: G F Young; R S Sanderson; T H Reed; R T Graves; S Hamilton; D S W Lee; Mrs A C Womack; G W Bridge; P Price; Mrs J Lee; Dr D R Cullen.
Beneficial area: Sheffield area.
Grant total: £178,000 (2000)
Arts grants: £24,700
The trust's 2000 annual report outlines its objects as 'provision of parks, open spaces, libraries and art galleries, the advancement of education, the general benefit of the sick and poor' and other selected causes. In 2000 the trust gave a total of £178,000. This included 80 listed grants of between £1,000 and £10,000 and a number of unspecified donations

amounting to £18,790. Out of this total, £24,700 (14%) was directed at six arts-related causes. These were:

*Sheffield Industrial Museum Trust;
 Millennium Galleries (£7,500 each);
Words & Pictures (£5,000);
Friends of the City of Sheffield Youth
 Orchestra (£2,000);
Sheffield Festival Project (£1,500);
Bright Green Arts (£1,200).

Exclusions: Individuals.
Applications: In writing to the correspondent by 31 March, 30 June, 30 September, 31 December for consideration at quarterly meetings of the trustees. Accounts must be enclosed. Guidelines available from the trust.

The Great Britain Sasakawa Foundation

CC No: 290766

43 North Audley Street, London
W1Y 1WH

Tel: 020 7355 2229; Fax: 020 7355 2230
E-mail: gbsf@gbsf.org.uk
Website: www.gbsf.org.uk
Contact: Michael Barrett, Chief Executive
Trustees: Council: Prof. Peter Mathias, Chair; The Hon Yoshio Sakurauchi; Michael French; Baroness Brigstocke; Jeremy Brown; The Earl of St Andrews; Sir John Boyd; Kazuo Chiba; Prof. Harumi Kimura; Yohei Sasakawa; Akira Iriyama; Professor Shoichi Watanabe.
Beneficial area: United Kingdom and Japan.
Grant total: £355,000 (2001)
Arts grants: £150,000
The foundation awards grants only for initiatives which 'improve relations between the UK and Japan by furthering a better understanding between the peoples of both nations'. Towards these aims, grants are given to a wide range of causes within the following categories: arts and culture; schools and education;

youth exchange; humanities and social sciences; Japanese language; science and technology; medicine; environment; sport.

In 2001 the foundation gave a total of £355,000 in 191 grants ranging from £300 to £30,000; most were around £1,500. Out of this, about £150,000 (42% of total grant-aid) was disbursed in grants to arts-related causes. A full list of grants for 2001 was not available at the time of writing. Beneficiaries in 2000 included:

Under 'arts and culture' –
Abbot Hall Art Gallery & Museum, Japanese craft exhibition, seminar and workshops; Electrify Productions, London, research and development for a documentary film on the life of Hokusai (£10,000);
Fine Art Consultancy, exhibition of a collaborative piece of art by British and Japanese artists; Globe Exhibition Coordinating Committee, exhibition at the Globe Theatre highlighting the similarities between Kabuki and Shakespearean theatre (£6,000 each);
Crafts Council, exhibition of contemporary Japanese jewellery; Creative Arts Net, Kabuki Story 2000, continuation of pilot project; Design Museum, London, schools project in Lambeth and Southwark as part of Japan 2001 Isamu Noguchi exhibition (£5,000 each);
Brighton Festival, dance work with Kim Itoh premiered in Brighton; Candoco Dance Company, collaborative dance project in Tokyo; London Butoh Network, butoh dance workshops (£3,000 each);
Mind Your Own Music, debut tour by a Japanese jazz pianist; Keele University, painting, photography and sculpture exhibition by three Japanese artists (£2,000);
Mafuji Gallery, London exhibition of young Japanese artists and gallery talk (£1,000).

Under 'humanities and social sciences' –
Creative Art Executive Committee, study
 of community art activities in Britain
 (£6,000).
Under 'schools and education' –
Japan Festival Education Trust, travelling
 photographic exhibition showing the
 lifestyles of young Japanese people
 (£17,500).

Exclusions: Individual applications are
not accepted, but applications by
organisations on behalf of individuals may
be considered. The beneficiary
organisation must either be British or
Japanese and any individual benefiting
through a grant must be a citizen of the
UK or Japan.

Applications: Organisations applying
should be recognised educational or
cultural institutions, local or regional
authorities, or other competent arts
promoters. Applications must be made on
a form available from the address above.
The awards committee meets three times
a year, in February, May and October.
Completed forms should outline the
project and give full information on the
total cost, what other funding may
contribute to meet this, and what specific
sum is requested of the foundation.

The Grocers' Charity

CC No: 255230

Grocers' Hall, Princes Street, London
EC2R 8AD

Tel: 020 7606 3113; Fax: 020 7600 3082
E-mail: anne@grocershall.co.uk
Website: www.grocershall.co.uk
Contact: Miss Anne Blanchard, Charity
Administrator
Trustees: Directors of The Grocers' Trust
Company Ltd.
Beneficial area: UK.
Grant total £502,000 (2000/01)
Arts grants: £42,250
The charity has wide charitable aims
including relief of poverty, disability,
medicine, the arts, heritage, the church

and the elderly. Most years around a third
of its annual expenditure is committed on
an ongoing basis in the field of education,
by way of internal scholarships and
bursaries at schools and colleges with
which the Grocers' Company has historic
links. Consideration is given to request
for grants towards capital costs.

In 2000/01 the charity gave a total of
£502,000 in 158 grants ranging from
under £1,000 to £50,000, most of which
were below £7,000. Out of the specified
donations, a total of £42,250 (eight per
cent of total grant-aid) was given in 19
arts-related grants. These included:
Under 'education' –
★City & Guilds of London Art School,
 bursaries (£6,600);
★St Paul's Cathedral Choir School
 (£5,500);
★Ashmolean Museum, research fellowship
 (£5,000);
Royal College of Art, bursary (£3,000);
★Guildhall School of Music & Drama
 Foundation (£2,500).
Under 'heritage' –
Royal Albert Hall Trust (£3,000);
Imperial War Museum, the Normandy
 Experience, Duxford (£1,000).
Under 'the arts' –
Almeida Theatre Company, London,
 auditorium wheelchair facilities
 (£2,500);
National Youth Dance Trust; Welsh
 National Opera (£2,000 each);
English Touring Opera (£1,500);
Live Music Now!; Oundle International
 Festival, Northamptonshire; Shaftesbury
 Arts Centre, Dorset (£1,000 each).
Under 'elderly' –
Age Exchange Theatre Trust (£1,000).

Exclusions: Organisations which are not
registered charities; individuals (except
through registered charities). Unless there
is a specific close or long-standing
connection with the Grocers' Company:
churches and cathedrals; hospices; schools
or other educational establishments;
research projects.

Applications: In writing at any time, on the charity's official headed paper. Appeals should be accompanied by full details of the project together with a copy of latest audited accounts and annual report. All applications are considered and receive notification of the outcome in due course. Trustees meet quarterly, in January, April, June and November, and applications for a given period must be submitted at least two months prior to the appropriate meeting. Informal enquiries to the administrator by telephone or e-mail are encouraged. Grants are made on a one-off basis and are not generally given in successive years.

The Calouste Gulbenkian Foundation (UK Branch)

CC No: 46

98 Portland Place, London W1B 1ET

Tel: 020 7636 5313; Fax: 020 7908 7580
E-mail: info@gulbenkian.org.uk
Website: www.gulbenkian.org.uk
Contact: Paula Ridley, The Director
Trustees: The foundation's Board of Administration in Lisbon. UK resident trustee: Mikhael Essayan.
Beneficial area: UK and Ireland.
Grant total: £2,328,000 (2001); £2,206,000 (2000) see below
Arts grants: £1,159,000
The Calouste Gulbenkian Foundation is registered in Portugal. The UK branch of the foundation deals with grant applications for projects in the UK and the Republic of Ireland. (Other applications should be addressed to: The International Department, Calouste Gulbenkian Foundation, Avenida de Berna 45A, 1067-001 Lisbon, Portugal).

The foundation's four key areas of activity are arts, education, social welfare and an Anglo-Portuguese Cultural Relations programme, which aims to support Portuguese projects in the UK and Ireland.

Policy

Readers should note that the policy priorities within each of the foundation's main sectors of giving can change in some respects each year.

Applicants should obtain a copy of the foundation's free *Advice to Applicants for Grants* leaflet, available by post, or view its contents on the website, prior to any application.

Arts

Contact: Assistant Director, Sian Ede
The arts programme deals with arts for adults and young people out of formal education settings. There are three priority areas within the arts programme.
For both professional and non-professional practitioners:
1. The Spoken Word – 'This programme is designed to heighten an awareness of the richness and variety of spoken language in contemporary Britain. Applications are invited for innovative projects which principally involve non-professional practitioners, especially groups which demonstrate social need. Projects may involve any of the following media: oral history collection, community radio, poetry to be spoken aloud or the development of dialogue in drama, fiction and documentary.'
For professional arts organisations:
2. The Arts and Science – 'Designed to encourage professional arts organisations to establish projects which engage with new thinking and practice in science and technology. The foundation will also support initiatives that encourage science institutions to engage with artists or to introduce regular arts initiatives. The programme is linked to the foundation's publication *Strange and Charmed: Science and the Contemporary Visual Arts*, although applications are welcome from within any art form.'
3. Try-out and Experiment – Supporting early research and development activities in the creation of new artworks. The programme offers a

small number of grants to 'groups of practitioners to try out ideas in the closed studio or rehearsal room, well in advance of the normal rehearsal or preparation process.' Priority is given to original ventures.

Applications: 'Brief outlines of potential applications should be submitted to the Assistant Director for consideration at least three months before the starting date of the project.'

Education
Contact: Assistant Director, Simon Richey
1. Educational Innovations and Developments –
Helping Schools, Helping Parents
'This programme aims to help primary and secondary schools:
- assist "hard to reach" parents who have difficulty in accessing educational opportunities;
- offer support to all parents at significant stages in their child's development.'

The Emotional Well-being of Children and Young People
- 'promoting 'the emotional well-being of primary school children who are causing concern';
- promoting 'the emotional literacy of young people of secondary school age either in schools, after-school clubs or in youth service settings'.

All applications should demonstrate how projects will be monitored and evaluated, and 'indicate a commitment to disseminating the lessons and benefits of the project'.

Out of School Services
'Help with the development of out of school services and facilities which redress the educational and social disadvantages of children in deprived neighbourhoods in an innovative way.'
2. Arts for Young People –
Pupil Referral Units and In-school Learning Support Units
Support for residencies by artists or

companies and for the cost of evaluating the initiatives in question.

Access to Cultural Venues
Linked to the foundation's report *Crossing the Line: Extending Young People's Access to Cultural Venues*, this programme is open to cultural venues for 'support towards new incentives that help teenagers become familiar with and enjoy cultural venues local to them'. Preference is given to initiatives that 'genuinely attempt to create new ways of working'.

With all the above priorities, preference will be given to projects sharing the example of their work with others. Ways in which this may be done should be indicated in the application.

Social Welfare
Contact: Director, Paula Ridley
1. Grants under this programme in 2002 will be strongly focused on 'capacity building in local groups and neighbourhoods, and exploring new forms of area management and service delivery'. In particular, support is intended:
- 'for community groups in both urban and rural areas, who are developing new responses to neighbourhood and area regeneration, including new strategies for service delivery and social enterprise;
- for communities and professionals working together to develop effective skills and capacity building in any of the following areas: neighbourhood management, housing management, neighbourhood services, health, crime, education and employment.'

2. 'The programme will also consider:
- research which contributes to exploration and knowledge of new policy options to reduce social exclusion, including new forms of service delivery';
- some projects which do not fall easily within the list of exclusions set out below.

Anglo-Portuguese Cultural Relations
Contact: Assistant Director, Miguel Santos
This programme supports Portuguese cultural projects in the UK and Ireland. (British cultural projects in Portugal are the responsibility of the British Council.) 'Cultural relations' are taken to include social welfare as well as the arts, crafts and education. The programme includes:

- activities in the UK and Republic of Ireland concerned with the language, culture or people of Portugal – performances, festivals and exhibitions may be considered;
- cultural and educational interaction between British or Irish and Portuguese people;
- the educational, cultural and social needs of the Portuguese immigrant communities (but not individual Portuguese immigrants or visitors) in the UK or Ireland.

However, grants are not normally given for projects focused upon sporting activities, tourism, holidays; full-time teaching or research posts or visiting fellowships; the maintenance, salary or supervision costs of researchers; fees or expenses of individual students pursuing courses of education and training, or doing research; or UK cultural or other work in Portugal.

An interesting characteristic of this foundation, and one which gives it public influence greater than the scale of its grant-making, is its commissioning of reports and studies. Over the years some of these have been seminal, for example the *Robinson Report* on arts and education. The foundation also co-publishes with other organisations.

Distribution of grant-aid

In 2001 the foundation gave a total of almost £2,328,000. However, the appropriate grants listing was still in the process of being collated at the time of writing. In 2000 the foundation's grants totalled £2,206,000 in 240 grants. Out of

this, £1,159,000 (52% of total grant-aid) was given in 134 grants relevant to this guide. A selection of arts beneficiaries taken from the 2000 annual report follows. This is no substitute for obtaining a copy of the most recent annual report, available free of charge from the foundation.

Under 'The Arts and Science' –
Arts Catalyst, for arts-science collaborative research (£30,000);
Drake Music Project, towards the development of an electronic musical toolkit for the use of children and adults with disabilities (£10,000, first of two annual payments);
London School of Hygiene and Tropical Medicine, towards visual arts programme; ARTLab at Imperial College of Science, Technology and Medicine, to develop arts policy and programme (£10,000 each);
Organisation and Imagination (Camden Arts Centre), towards costs of inter-collegiate research and development for artists with quantum physicists (£8,000);
Healing Arts, for resident artist to work with scientists at hospitals in the South of England (£5,000).

Under 'Participatory Music' –
Community Music East Ltd, for participatory music programme in the Norwich area (£10,000);
Child and Sound, to provide musical activities for children with autism in South-East London (£4,500).

Under 'Time to Experiment' –
Artangel, for research costs of international artists for site-specific work in Britain (£15,500);
Kazzum Arts Project, for development costs of a touring production for under-five year olds involving the use of Vietnamese water puppetry (£5,000).

Under 'The Spoken Word' –
Laura Wright with Thames Living History, for eventual sound-based

artwork, 'Walbrook – River of Voices'
(£5,000).

***Under 'Republic of Ireland Programme'* –**

Opera Theatre Company, towards
establishment of an opera theatre studio
to train young Irish singers (£15,000).

***Under 'Arts for Young People'* –**

Extending Young People's Access to
Cultural Venues, establishing a scheme
to encourage schools to take pupils to
cultural venues on a regular basis
(£30,000);

The Learning Circuit (University of
Surrey Roehampton), to help expand a
scheme that facilitates young people's
access to cultural venues and enables
them to prepare for, and reflect upon,
the experience through the use of web
technology (£10,000).

***Under 'Educational Innovations and Developments'* –**

Futures Theatre Company, towards the
costs of 'Hitting Home', a drama
project for secondary school pupils
with emotional and behavioural
difficulties (£6,200).

***Under 'Director's Grants'* –**

National Museums and Galleries on
Merseyside, for a demonstrator and
support materials for 'Treasure House'
scheme (£12,650, first of three annual
instalments).

Exclusions: The purchase, construction,
repair or furnishing of buildings;
performances, exhibitions or festivals;
conferences or seminars; university or
similar research; science; medicine or
related therapies; holidays; religious
activities; funds for scholarships or loans;
drug-abuse or alcoholism; animal welfare;
sports; equipment, including vehicles or
musical instruments; stage, film or
television production costs; commercial
publications; basic services or core costs
(as opposed to imaginative new projects);
overseas travel, conference attendance or
exchanges; housing; the education,
training fees, maintenance or medical
costs of individual applicants.

Applications: First obtain a copy of the
foundation's *Advice to Applicants* leaflet or
view its contents on the website. This sets
out clearly the information required in a
written application. Applications should
include:

- the exact purpose of the required funds
 and what difference the grant might
 make;
- the amount required, with details of
 how the budget has been arrived at;
- details of other sources of income
 sought or secured;
- aims and functions of the organisation
 and details of its legal status (grants are
 usually only for registered charities;
 include the charity registration
 number);
- latest annual report and audited
 accounts;
- any plans for monitoring and
 evaluating the work.

Preference is often given to original
developments and to practical initiatives
designed to tackle the causes of problems,
as well as those likely to influence policy
and practice. 'There is a notional limit of
£10,000 to any one grant.'

Apply in writing, NOT by telephone,
or e-mail. Fully prepared proposals are
considered by trustees at meetings usually
held in the first week of February, April,
July and November. Applications should
be submitted at least ten weeks in
advance.

The Hadrian Trust

CC No: 272161

36 Rectory Road, Gosforth, Newcastle-
upon-Tyne NE3 1XP

Tel: 0191 285 9553
Contact: John Parker, Trustee
Trustees: P R M Harbottle; Brian J
Gillespie; John B Parker.
Beneficial area: The boundaries of the
old counties of Northumberland and
Durham. This includes Tyne and Wear and
Cleveland (North of the Tees).

Grant total: £178,000 (2000/01)
Arts grants: £21,500
The majority of this trust's funding goes towards the running costs of social welfare and other organisations in the beneficial area. The trust gives both capital and revenue grants in the following categories: churches; social services; youth; women; elderly and disabled; education; environment; the arts; individuals; ethnic minorities.

In 2000/01 the trust gave a total of over £178,000 in 141 grants ranging from £250 to £5,000, most of which were £2,000 or less. Out of this, a total of £21,500 (12% of total grant-aid) was given in nine grants relevant to this guide. These were:

Under 'the arts' –
★Brinkburn Summer Music; ★Northern Sinfonia Development Trust; Young Sinfonia (£5,000 each);
20,000 Voices, Ashington (£2,000);
★NTC Touring Theatre Company Alnwick (£1,000);
Durham University Chamber Choir; Newcastle Music Group (£500 each).
Under 'disabled/elderly' –
Dimensions Arts Studio (Blackfriars Arts) (£500).
Under 'environment' –
Greater Community Development Trust (£1,000).

Exclusions: General appeals from large national organisations; organisations working outside the beneficial area; individuals.
Applications: In writing together with a copy of latest annual report and accounts. Meetings are usually held at quarterly intervals, in January, April, July and October.

The Paul Hamlyn Foundation

CC No: 327474

18 Queen Anne's Gate, London
SW1H 9AA

Tel: 020 7227 3500; Fax: 020 7222 0601
E-mail: information@phf.org.uk
Website: www.phf.org.uk
Contact: Patricia Lankester, Director
Trustees: Paul Hamlyn; Helen Hamlyn; Michael Hamlyn; Jane Hamlyn; Robert Gavron; Mike Fitzgerald.
Beneficial area: UK and continental Europe, Third World, especially Indian sub-continent.
Grant total: £3,213,000 (2000/01)
Arts grants: £2,009,000
The foundation is due to receive more than £200 million from the estate of Lord Hamlyn who died in August 2001. This will inevitably influence the nature of its funding programmes and applicants should be sure to check details of the foundation's schemes from 2002 onwards.

The foundation's support is concentrated on issues of inequality and disadvantage, with particular emphasis on young people. Its aims are achieved through arts and education projects which work towards the alleviation of such social problems.
Arts funding is centred on four areas:

Increasing access to the arts
Support is given to address inequality of access to arts, particularly in relation to young people. 'Priority is given to exemplary arts projects' which:

■ raise awareness of, and access to, high-quality arts for new audiences at theatres, galleries, museums and other venues across the UK;
■ are relevant to young people 'at risk';
■ 'open up the arts to prisoners and young offenders';
■ promote audience development in previously untargeted areas;
■ provide an effective new approach to the expansion of audiences.

Arts in education

Priorities are:

- collaborative projects involving schools and other organisations to promote the arts for pupils;
- schemes giving teachers access to best practice in the performing and creative arts in order to enhance the learning of pupils;
- out-of-school activities in under-served areas.

Awards for artists

The award is currently for 'visual artists, with a strong emphasis on experiment, innovation and cross arts collaboration'. Five awards are made annually to nominated artists.

Student bursaries

Hardship bursaries are provided only to 'selected institutions for students on a small number of courses which are outstanding in their field'.

In addition to the projects supported within these four categories, arts funding is also given under the headings of education and publishing, as well as within the small grants programme. Small awards are made, up to a maximum of £5,000, to support local schemes and initiatives that fall within the main areas of concern.

In 2000/2001 the foundation gave a total of £3,213,000 in 468 grants, ranging from under £2,000 to an exceptional donation of £500,000 for the British Museum Development Trust; most grants were under £30,000. Out of this, arts–related funding totalling £2,009,000 (63% of total grant-aid) was given in 88 grants of over £3,000 and an unspecified number of smaller donations. Beneficiaries included:

Under 'arts projects' –

⋆Tate Gallery, education at Tate Gallery of Modern Art (£217,000);

⋆Royal National Theatre, Paul Hamlyn Nights (£81,437);

Education Extra, promoting arts in primary schools (£40,000);

BBC Music Live, new audiences for opera (£25,000);

ch programme; Hackney Music Development Trust, singing project (£20,000 each);

London Sinfonia, opera for Tower Hamlets (£14,500);

Eden Court Theatre, Inverness (£12,000);

East London Dance; ⋆Yorkshire Youth & Music (£10,000 each);

City of Birmingham Symphony Orchestra; Galloglass Theatre Company, Tipperary (£8,000 each).

Under 'arts bursaries' –

National Film and Television School (£15,000);

City & Guilds of London Art School (£10,515);

⋆Bristol Old Vic Theatre School; LAMDA (£6,500);

University of Westminster (£5,000).

Under 'education projects' –

British Museum Development Trust, for the Paul Hamlyn Library in the Round Reading Room (£500,000);

National Museums & Galleries on Merseyside, celebrating diversity (£36,250);

Association of Colleges Charitable Trust (Beacon Awards), PHF Performing Arts Award (£6,000).

Under 'publishing: access and awareness' –

Book Trust (£17,500);

Traverse Theatre, Edinburgh, Playwrights in Partnership (£9,370);

Edinburgh International Book Festival (£7,200);

Bath Festivals Trust, Babel Project (£5,000).

Awards totalling £204,335, included in the arts grants total above, were given to an unspecified number of individuals within the 'Individual Artists' category.

Exclusions: Projects outside the areas of interest; general appeals or endowments; capital projects; purchase, maintenance or refurbishment of property or equipment;

individuals, except where the foundation has established a special scheme; general support for individual organisations (schools, theatre companies, productions and so on); education projects concerned with a particular issue such as the environment or health; large national charities; retrospective funding; organisations which do not have charitable purposes.

Applications: Firstly, obtain guidelines from the trust, then contact the correspondent to discuss the application. Applications should be made on no more than five sides of A4 paper, with a further page for the budget. 'Supporting information may be supplied in appendices, but the main statement should be self-contained and provide the essential information required by the trustees.' This should include the sort of organisation; the general aim of the project and its specific objectives; how work is to be done and by whom; anticipated problems; who and how many will benefit; when it will start and how long it will take; the amount required and for what; how other interested parties will be informed of the outcome; how will its success be judged; which other funders have been approached and with what success; and if funding is needed beyond the grant, where will it come from. A copy of the most recent annual report, financial statements and details of the management and staffing structure, including trustees, must accompany the application. Applications by post only.

Applications will be acknowledged upon receipt. Grants for £5,000 or less are handled by a committee which meets monthly, except August and December. Grants are for one year only and appeals in successive years are not considered. A second committee meets four times a year to deal with larger grants, which are usually between £5,000 and £30,000. These meetings are normally in March, June, September and November and

applications should reach the foundation in the first week of the preceding month.

The Sue Hammerson Charitable Trust

(also known as Sue Hammerson Trust 'G')

CC No: 235196

H W Fisher & Co, Acre House, 11–15 William Road, London NW1 3ER

Tel: 020 7388 7000
Contact: Tim Brown, Senior Manager
Trustees: Sir Gavin Lightman; Patricia Beecham; Anthony J Bernstein; Anthony J Thompson.
Beneficial area: UK.
Grant total: £212,000 (2000/01)
Arts grants: £33,360

This trust affords particular attention to 'the advancement of medical learning and research and to the relief of sickness and poverty'. The first funding priority is the Lewis W Hammerson Memorial Home, which is the major beneficiary each year. Over half of the trust's annual charitable expenditure is allocated to the Home, with the remaining donations made mainly in the fields of social welfare, medicine, Jewish charities and arts.

In 2000/01 the trust gave a total of almost £212,000 in 274 grants ranging from £10 to £6,000, and one exceptional grant of £107,600 (to the Lewis W Hammerson Memorial Home). Most grants were under £600. A total of £33,360 (16% of total grant-aid) was given in 48 grants relevant to this guide, the great majority of which were to past beneficiaries. Arts grants included:
★Royal Academy Trust (£5,650);
★Royal Opera House Trust (£5,250);
★English National Opera (£4,400);
National Theatre (£3,000);
Royal Albert Hall (£2,000);
★New Shakespeare Company (£1,250);
Roundhouse Trust (£1,000);
Royal Academy of Arts (£660);

Three Legged Theatre Company (£600);
*Dulwich Picture Gallery;
 *Glyndebourne Arts Trust; *Friends of
Tate Gallery; *Friends of Tate Gallery
Liverpool; *Friends of the Victoria &
Albert Museum (£500 each);
*Live Music Now! (£300);
*Jewish Museum; *National Portrait
Gallery; Saddler's Wells Trust Limited
(£250 each);
*Royal College of Music; National Art
Collections Fund; Musicians
Benevolent Fund (£100 each).

Exclusions: Individuals; organisations
which are not registered charities.
Applications: In writing to the
correspondent. **However, applications
are not encouraged by the trust
because its funds are fully
committed for the foreseeable
future**.

The Hampton Fuel Allotment Charity

CC No: 211756

15 Hurst Mount, High Street, Hampton,
Middlesex TW12 2SA

Tel: 020 8941 7866
Contact: M J Ryder, Clerk
Trustees: J A Webb, Chair; A G Cavan;
Mrs M J M Woodriff; H A Wood; H E
Severn; Dr D Lister; Mrs M T Martin; P
W Simon; A D Smith; Revd W D F
Vanstone; Revd D Winterburn.
Beneficial area: Hampton, the former
borough of Twickenham, and the
borough of Richmond.
Grant total: £1,344,000 (1999/2000)
Arts grants: £49,000
This large local trust outlines its
objectives as:
- relief of need, hardship or distress;
- support for the sick, disabled,
 handicapped or infirm;
- promoting education of children and
 young persons;

- provision and support for recreation
 and other leisure-time occupations in
 the interests of social welfare.

The trust has a major programme of
support for individuals and organisations,
making grants amounting to £1,344,000
in 1999/2000. However, funding given to
individuals, a total of £527,000 (39% of
total grant-aid), was solely for the
provision of fuel and essential equipment
and is not applicable to this guide. The
remainder of the trust's charitable
expenditure (£751,000) was distributed
in general, often recurrent, grants to
organisations in the following categories:
hospital and hospices; organisations
assisting those with disabilities; social
welfare; housing; organisations providing
additional educational support;
organisations involved in community
activities.

Grants ranged from £125 to £55,000
and, although most donations were for
under £7,000, substantial grants were not
uncommon.

Out of the total donations, £49,000
was given in 13 grants to arts-related
causes working within the above
categories. These included:
*Richmond Music Trust, fee reductions
 for the disadvantaged (£25,000);
Clarendon School, for an arts suite
 (£7,600);
London Borough of Richmond upon
 Thames Leisure Services, for literary
 project (£5,000);
*Hampton Choral Society (£2,000);
*Richmond upon Thames College, arts
 festival (£2,000);
Maddison Clinic, Teddington, support for
 dance therapy classes (£1,600);
*Teddington & Hampton Music Festival
 (£1,500);
*Shape London, ticket scheme for the
 disabled (£1,000);
Pod Charitable Trust, providing shows for
 children in West Middlesex Hospital
 (£540);

Richmond upon Thames Performing Arts
Festival (£800);
Youth Action Theatre (£500).

Exclusions: Grants to individuals other
than for fuel and related equipment;
anything which is the responsibility of a
statutory body; national general charitable
appeals; religious groups, unless offering a
non-religious service to the community;
commercial and business activities;
endowment appeals; political projects;
retrospective capital grants.
Applications: General application forms
are available from the correspondent.
'Initial discussions concerning major new
projects are encouraged prior to the
submission of an application.' Trustees
meet quarterly but there is a separate
grants panel that meets every two
months. Larger awards will be considered
by both bodies.

The Harding Trust

CC No: 328182

c/o Messrs Brabners, 1 Dale Street,
Liverpool L2 2ET

Tel: 0151 236 5821; Fax: 0151 600 3333
Contact: The Administrator
Trustees: James S McAllester; Geoffrey
G Wall; John Paul C Fowell; Michael N
Lloyd.
Beneficial area: Staffordshire and
surrounding areas.
Grant total: £65,000 (2000/01)
Arts grants: £62,000
This trust's purposes are 'to promote,
improve, develop and maintain public
education in, and appreciation of, the art
and science of music mainly, but not
exclusively, in Staffordshire and
surrounding areas by sponsoring or by
otherwise supporting public concerts,
recitals and performances by amateur and
professional organisations'.

In 2000/01 the trust gave a total of
£65,000 in 23 grants ranging between
£500 and £17,500, most of which were

between £1,500 and £3,000. Out of
this, a total of £62,000 (95% of total
grant-aid) was given in 21 grants to arts
causes, many of which were previous
beneficiaries. Arts grants included:
*Stoke and Newcastle Music (£17,500);
Stoke on Trent Festival (£10,000);
Lichfield Festival (£4,000);
North Staffordshire Symphony
Orchestra; Stoke on Trent Music
School; Keele Concerts Society
(£3,000 each);
Stoke on Trent Organ Society; Bilston
Operatic; Clonter Farm Music Trust
(£2,000 each);
Dudley Millennium Piano Competition;
Goldberg Ensemble; Orchestra da
Camera (£1,500 each);
Nantwich Choral Society; Keele Bach
Choir (£1,000 each);
Wolverhampton Youth Music Theatre;
Barbara Walton Singers (£500);
London Mozart Players (£17,077);
*Stoke & Newcastle Music (£6,000);
*BBC Philharmonic Education Project
(£3,000);
Civic Hills Opera; *Clonter Farm Music
Trust (£2,000 each);
*Keele Concerts Society; Royal Academy
of Music; *Orchestra da Camera;
*Staffordshire County Youth Orchestra;
*Lichfield Festival; Stoke on Trent
Music School; *Nantwich Choral
Society (£1,000 each);
*Penkhull Festival (£500).

Applications: In writing to the
correspondent.

The Charles Hayward Foundation

CC No: 1078969

Hayward House, 45 Harrington
Gardens, London SW7 4JU

Tel: 020 7370 7063
Contact: Mark Schnebli, Administrator
Trustees: I F Donald, Chair; Mrs J M
Chamberlain; Sir Jack Hayward; Sir

Graham Hearne; Mrs S J Heath; Prof Sir William Asscher; B D Insch; J N van Leuven; A D Owen; Miss A T Rogers; Ms J Streather.
Beneficial area: UK, some overseas.
Grant total: £1,626,000 (2000)
Arts grants: £57,650

This new foundation, established 8 December 1999, is an amalgamation of the former Hayward Foundation and Charles Hayward Trust. It runs a number of programmes including 'one for national and larger charities, a community grant programme and an overseas funding programme'. Grants are concentrated in the following areas: special needs; youth and community projects; medical and medical research; elderly; art, education, preservation and environment; general welfare.

Grants are usually, but not exclusively, of a capital nature and are most likely to be given for projects which are preventative or provide early intervention; developmental or innovative; promotional or continuation of good practice; and value enhancing to existing services.

In 2000 the foundation gave a total of almost £1,626,000 in 169 grants ranging from £100 to £77,000; most were under £30,000. These were categorised as follows:

- special needs – £409,422 (25.2%);
- youth and early intervention – £398,450 (24.5%);
- medical research – £267,790 (16.5%);
- general welfare and social change – £162,458 (10%);
- community – £97,875 (6%);
- overseas – £88,015 (5.4%);
- the elderly – £85,091 (5.2%);
- art, preservation and environment – £54,000 (3.3%);
- hospices – £27,000 (1.7%);
- small grants/miscellaneous – £35,781 (2.2%).

A total of £57,650 (4% of total grant-aid) was given in eight arts-related grants. These were:

Under 'special needs' –
Beannacher Camphill Community, Aberdeen, building new craft workshop (£20,000).
Under 'general welfare and social change' –
Live Music Now!, regional funding of administration (£15,000).
Under 'art, preservation and the environment' –
National History Museum Development Trust, publication of new title in Art of Nature series (£15,000).
Under 'youth and early intervention' –
Keyhole Trust, Wales, conversion of hay barn to drama studio (£5,000).
Under 'small grants/miscellaneous' –
Allround Music Project, Lanarkshire (£800);
Singalong, Kent (£750);
Wolf and Water Arts Company, Devon (£600);
Camtrust Design Studio (£500).

The trust expressed a reluctance to be included in this guide, fearing that it may be inundated with appeals to which would not be able to respond. Applicants should note that grants made to the arts are 'very small indeed compared with the overall grant-making programme'.
Exclusions: Projects not meeting the foundation's objectives; individuals.
Applications: See above.

The Headley Trust

(see also the Sainsbury Family Charitable Trusts)

CC No: 266620

Tel: 020 7410 0330; Fax: 020 7410 0332
Contact: Michael Pattison, Director
Trustees: Sir Timothy Sainsbury; Lady Susan Sainsbury; Mr T J Sainsbury; Mr J R Benson; Miss J S Portrait.
Beneficial area: UK and overseas.
Grant total: £4,306,000 (2000)
Arts grants: £1,602,000

The settlor of this trust is Sir Timothy Sainsbury. His co-trustees include his wife, eldest son and legal adviser. The trust shares a common administration with the other Sainsbury Family Charitable Trusts. Innovative proposals are considered within the following categories:

Arts and the environment (home)

Support is given to 'a wide variety of conservation projects, as well as arts projects with an educational element'. The trust has also made 'substantial grants towards partnership funding for major National Lottery grants, particularly for museums, galleries, libraries and theatres'. Additional inclusions in this category are annual budgets for fabric restoration and repair work in cathedrals and churches of historical importance.

Arts and the environment (overseas)

Funding is directed at 'art conservation projects of outstanding artistic or architectural importance, particularly the restoration of buildings, statuary or paintings', primarily in central and Eastern Europe.

Medical

Support for research, particularly into ageing and osteoporosis.

Developing countries

Focus areas include water projects; forestry projects; education and literacy projects; and health projects.

Education

The main focus is on bursary support, particularly for artistic or technical skills training. Support has also been given to 'encourage high standards of literacy in children and young people'.

Health and social welfare

Contributions are made to a wide range of projects, including charities supporting carers of ill or disabled relatives and those assisting 'elderly people of limited means'.

In 2000 the trust gave a total of £4,306,000. Only the largest 50 paid donations were listed in the annual report and accounts. These ranged from £20,000 to £1,000,000 but were generally under £75,000. Specified arts funding totalling £1,602,000 (37% of total grant-aid) was given in 15 grants, which fell within a number of the above categories. These were:

Under 'arts and the environment (home)' –
Victoria & Albert Museum (£1,000,000); National Maritime Museum (£100,000); Royal Ballet School (£50,000); British Library (£40,000); Bowes Museum Trust (£30,000); Gilbert White's House and The Oats Museum (£25,000).

Under 'arts and the environment (overseas)' –
World Monuments Fund (£95,500); Rundale Palace Museum, Latvia (£25,000).

Under 'health and social welfare' –
Living Paintings Trust (£35,000).

Under 'education' –
Welsh National Opera (£40,000); Jewish Museum; South Eastern Museums Service (£25,000 each); Orpheus Trust (£24,000); Design Dimension Educational Trust (£22,500); Children's Music Workshop (£20,000).

Exclusions: Individuals.

Applications: It is said that an application to one of the Sainsbury family trusts is an application to all. See the entry for the Sainsbury Family Charitable Trusts for the address and further advice. However, the trust says, like all the other trusts, that it is proactive in its choice of beneficiaries and that 'unsolicited applications are rarely successful'.

The trustees met five times in 2000.

The Myra Hess Trust

(see entry for Musicians'
Benevolent Fund)

CC No: 248778

Beneficial area: UK.
Exclusions: Grants are given only to
pianists and string players between the
ages of 20 and 28. The trust's policy is
currently not to make grants for 5th and
further years of study, nor for the
purchase of instruments for students in
the first four years at college.
Applications: In writing to the
correspondent by the middle of May in
any year. Awards are subject to successful
audition. The committee meets
biannually to audition candidates.

The Hinrichsen Foundation

CC No: 272389

10–12 Baches Street, London N1 6DN

Contact: Mrs Lesley Adamson, Secretary
Trustees: Professor Arnold Whittel; Mrs
C Hinrichsen; P Strang; K Potter; P
Standford; Stephen Walsh; J Dyer; Dr J
Cross; Miss L Hirst; M Willams; T Berg.
Beneficial area: UK.
Grant total: £74,000 (1999/2000)
Arts grants: £74,000
This trust focuses on the 'written' areas of
music, which it defines as 'contemporary
composition and its performance' and
musical research.

In 1999/2000 the trust approved 53
donations totalling over £74,000, all of
which was for arts-related causes,
including 10 individuals. Grants ranged
between £150 and £15,000, with most
for £2,000 or less. Beneficiaries
included:
Huddersfield Contemporary Music
 Festival (£15,000);
Wingfield Arts, Hinrichsen Composition
 Bursary (£10,000);
London Sinfonietta (£3,000);
Bath Festival; Ensemble QTR (£2,000
 each);

Hoxton New Music Days; Spitalfields
 Festival (£1,500 each);
New Music Players; Brighton Festival;
 York Spring Festival of Music; Sounds
 New (£1,000 each);
Music at Leasowes Bank (£830);
Portsmouth New Music Orchestra; W11
 Children's Opera (£500 each).

Exclusions: Commissioning of new
works; recordings; degree courses;
purchase of musical instruments and
equipment; retrospective grants.
Applications: Guidance notes on
application procedures are available from
the secretary. Trustees meet quarterly to
consider formal applications.

The Hobson Charity Ltd

CC No: 326839

21 Bryanston Street, Marble Arch,
London W1A 4NH

Tel: 020 7499 7050
Contact: Mrs Deborah Clarke, Trustee
and Secretary
Trustees: R F Hobson; Mrs P M
Hobson; Sir Donald Gosling; Mrs
Deborah Clarke.
Beneficial area: UK.
Grant total: £1,610,000 (1999/2000)
Arts grants: £31,000
This charity makes grants to charitable
institutions, with the following objectives:
the relief of poverty, suffering and distress
among the aged, impotent and poor; the
advancement of education; other
purposes of benefit to communities
within the UK.

In 1999/2000 the charity gave a total
of £1,610,000 in 41 grants. The majority
of this was accounted for by the
following three grants:
St Mary & St Anne School (£555,000);
John Grooms Association (£507,000);
Samuel Johnson Prize (£110,000).

The remaining grants ranged from £250
to £50,000, although most were under
£25,000. A total of £31,000 (two per

cent of total grant-aid) was given in three grants relevant to this guide. These were:
Royal Opera House Development Appeal (£25,000);
Hendon Salvation Army Band (£5,000);
Pentland Finchley Carnival (£1,000).

Applications: In writing.

The Holst Foundation

CC No: 283668

Verulam Gardens, 70 Grays Inn Road, London WC1X 8NF

Tel: 020 7404 5566
Contact: Peter Carter, Secretary
Trustees: Rosamund Strode, Chair; Noel Periton; Prof. Arnold Whittall; Peter Carter; Andrew Clements; Julian Anderson.
Beneficial area: Mainly UK.
Grant total: £281,000 (1999/2000)
Arts grants: £281,000
The foundation's objects are the promotion and encouragement of new music, together with the promotion of public knowledge and appreciation of the musical works of Gustav and Imogen Holst, and the study and practice of the arts. In pursuing these aims the foundation makes substantial annual donations to the NMC recording label, along with further recurrent grants to the annual Aldeburgh Festival and the Britten-Pears Library.

In 1999/2000 grants totalling £281,000 were made, mainly on a one-off basis. Only grants over £1,000 were listed in the report at the Charity Commission, all of which were relevant to this guide. There were 43 of these in all, the largest of which was £96,000, although donations tended to be under £3,000. Donations included:
*NMC, to support new recordings (£96,000);
Brunel Ensemble (£30,000);
*Aldeburgh Productions (£10,000);
*Cheltenham Festival (£3,000);

*Spitalfields Festival (£2,000);
Roehampton Institute (£1,750);
Brodsky Quartet; London Concert Choir; *Soundpool; Oxford Festival; *Britten-Pears Library; Schubert Ensemble (£1,000 each).

Exclusions: No support for recordings or performances of the works of Gustav and Imogen Holst that are already well supported. No funding for individual educational costs.
Applications: In writing to the correspondent.

P H Holt Charitable Trust

CC No: 217332

India Buildings, Liverpool, Merseyside L2 0RB

Tel: 0151 473 4693; Fax: 0151 473 4663/93
Contact: Roger Morris, Secretary
Trustees: Ken Wright, Chair; John Allan; Tilly Boyce; Derek Morris; Christopher Stephens; John T Utley.
Beneficial area: UK, primarily Merseyside; also overseas.
Grant total: £283,000 (1999/2000)
Arts grants: £81,100
This trust was established in 1914 by Philip H Holt, co-founder of the Ocean Group plc. The trust gives grants under these headings: 'Merseyside', to local charities; 'the Holt tradition' to causes relevant to the life and interests of the trust's late founder, including maritime, heritage and educational charities; 'elsewhere', primarily to encourage past and present employees of the Ocean Group plc to play an active part in charitable work in their communities.

Within these broader categories, the trust supports causes in the fields of community, welfare, education, arts, heritage, environment and medicine. Grants can be given in the form of recurrent gifts (usually around two-thirds of the total number of donations), one-off donations and grants spread over a limited

period of, for example, three years. In 1999/2000 'Merseyside' causes were given 82% of total grant-aid, 'the Holt tradition' was allocated 12%, and charities 'elsewhere' received 6%.

In 1999/2000 the trust gave a total of £283,000 in 146 grants ranging from £100 to an exceptional sum of £75,000 for St George's Hall Charitable Trust. Most donations were under £2,000. Grants relevant to this guide totalled £81,100 (29% of total funding) in 33 donations. These included:

Under 'Merseyside' –

*National Museums & Galleries on Merseyside, for improvement of facilities (£20,000);

Royal Liverpool Philharmonic Society, towards community education projects (£7,500);

Brouhaha International, for the development of Merseyside International Street Festival (£4,500);

*North West Arts Board, for various activities on Merseyside (£4,000);

Liverpool Institute of Performing Arts, research into healthcare possibilities for performers (£3,000);

*Merseyside Dance Initiative, towards the development of dance on Merseyside (£2,500);

Rushworth Trust, to help with costs of Liverpool International Saxophone Festival (£2,000);

Merseyside Black Music Initiative; Merseyside Youth Theatre (£1,000 each);

*Mockbeggar Theatre Company; Live Music Now!; *Bluecoat Arts Centre (£500 each).

Under 'Holt tradition' –

*National Museums & Galleries on Merseyside, for restoration work at 'Sudley', former home of George Holt (£10,000);

Campaign for Museums, to support archives; *National Maritime Museum, to assist with purchase of artefacts (£4,000 each);

National Art Collection Fund (£500).

Exclusions: Individuals, apart from in exceptional circumstances for education; work which should be statutorily funded; sectarian causes, except Unitarianism under certain circumstances.

Applications: In writing to the correspondent, at any time; there is no application form. Applicants should send a short letter explaining about the project with, where appropriate, a budget, annual report and accounts, and indications of who else is willing to support or recommend the work. The letter should also include the amount hoped for from the trust and the reason for it; the trust prefers to make smaller grants, so if larger grants are made, it is usually after a series of meetings and discussions. 'Grants have to be for activities which are charitable in law; wherever possible, grants are paid to or through registered charities.'

'Above all, remember that the trustees will want your application to answer five simple questions: What are you trying to do? How does it fit in with the rest of your work? How does it fit in with what other organisations are doing? How will you and we know if you have achieved your aims? And why do you need support from the trust, rather than anyone else, for this piece of work?'

It is helpful if applicants include a telephone contact so the trust can follow up any queries. The trust aims to make an initial assessment of an application within four weeks. Contacting individual trustees about applications is discouraged, but the trust welcomes enquiries, even at the early stage before making an application.

The Sir Anthony Hopkins Charitable Foundation

CC No: 1018638

c/o The Peggy Thompson Office,
296 Sandycombe Road, Kew, Surrey
TW9 3NG

Tel: 020 7589 2827; Fax: 020 7589 9770
Contact: Lady Jennifer Hopkins, Chair
of Trustees
Trustees: Sir Anthony Hopkins; Lady
Jennifer Hopkins, Chair; Mark Jonathan
Musgrave; Mrs Barbara Simpson.
Beneficial area: UK.
Grant total: £126,690 (1998/99)
Arts grants: £116,690
The foundation's principal aims are 'to
assist acting students to meet the fees of
accredited drama schools when no
government grant is available; to sponsor
alcoholic and drug rehabilitation projects;
where funds permit, assistance may be
given to student filmmakers for their
graduation film production costs'.

In 1998/99 the foundation gave
£126,000 in 21 grants and scholarships
ranging from £500 to £20,000. A total
of £116,690 (93% of total grant-aid) was
given in 17 grants relevant to this guide.
These grants were directly to designated
drama schools to assist with the payment
of fees for students taking acting courses.

The foundation's 1998/99 report, the
most recent on file at the Charity
Commission, indicated that future arts-
related funding will be restricted to the
following drama schools: RADA; Bristol
Old Vic Theatre School; The Drama
Centre; Birmingham School of Speech &
Drama; East 15 Acting School; Guildford
School of Speech & Drama; LAMDA;
Mountview Theatre School; Webber
Douglas Academy.

The report also outlined the
foundation's committed levels of funding
for these institutions as follows:
- 1999/2000 – £64,600;
- 2000/2001 – £60,000;
- 2001/2002 – £58,000.

The availability of funds after 2001/2002
was not stipulated due to uncertainty
over Sir Anthony Hopkins' future
involvement with the foundation.
Exclusions: 'Stage management courses,
professional instructors' courses and other
specialised fields such as drama therapy or
any other discipline such as dance, art,
counselling or sport.'
Applications: 'The student must apply
to the foundation in writing and the
school s/he wishes to attend must be
accredited by the National Council of
Drama Training and/or be a member of
the Conference of Drama Schools.
Confirmation of acceptance by the
school must be enclosed.

'The student must be already on or
about to commence a three-year acting
course or a one-year (four-term)
postgraduate course. Priority is given to
students who are not in receipt of any
government grant and who have not
already had a government grant for other
purposes' and to students who have
'successfully overcome difficult personal
or family circumstances to gain a place at
drama school'.

A reference for each applicant will be
sought from the relevant school.

The Horne Foundation

CC No: 283751

Suite 33 Burlington House,
369 Wellington Road, Northampton
NN1 4EU

Tel: 01604 629748
Contact: Mrs R M Harwood, Secretary
Trustees: E J Davenport; Mrs R M
Harwood, Secretary; C A Horne.
Beneficial area: UK, local causes in
Northamptonshire and national charities.
Grant total: £690,000 (1999/2000)
This foundation is a major supporter of
education and welfare building projects. It
favours local causes in Northamptonshire,
especially youth and arts projects, and also
gives to national appeals.

In 1999/2000 the foundation gave a total of over £690,000 in an unspecified number of grants. The breakdown of giving was listed in the annual report as follows:

- major building projects – £454,858;
- student bursaries – £70,412;
- local youth/arts projects – £101,500;
- national appeals – £34,430;
- local support – £29,126.

No further details concerning the foundation's giving were available at the Charity Commission.

Exclusions: Local appeals from charities outside Northamptonshire; organisations with religious affiliation; individuals.

Applications: In writing to the correspondent, at any time.

The Hornton Trust

(also known as The Hornton Charity)

CC No: 266352

c/o PricewaterhouseCoopers, Cornwall House, 19 Cornwall Street, Birmingham B3 2DT

Tel: 0121 200 3000
Contact: Mrs June Downes
Trustees: A C S Hordern; S M Wall; S W B Landale; A R Collins.
Beneficial area: UK, with a preference for the Midlands, especially Birmingham.
Grant total: £95,000 (1998/1999)
Arts grants: £61,000

The trust has given to a wide range of causes, especially in the Midlands area. The 1999/2000 annual report states that 'the trustees are intending to distribute all the capital towards the development of talent in children and young people in Birmingham and the West Midlands, particularly in the arts'. Grants will only be available until 2003, the year in which the trust winds up.

Every year a number of arts grants have been given, with a preference for the performing arts, particularly theatre and music. In 1999/2000 the trust made 49 grants, ranging between £250 to £20,000, and amounting to £95,000. Of these, 45 donations of up to £500 were made from the general fund, whilst the remaining four were recurrent grants drawn from the designated fund for much larger projects. Arts-related support totalled £61,000 (64%), made in 10 grants. These were:

From 'designated fund' –
★City of Birmingham Symphony Orchestra (£20,000);
★Sir Barry Jackson Trust (£12,000);
★City of Birmingham Symphony Orchestra Youth Chorus; ★Birmingham Royal Ballet (£10,000 each).
From 'general fund' –
Lichfield Cathedral Choir (£5,000);
★Lichfield Arts Festival (£2,000);
Birmingham School of Speech & Drama (£1,000);
Brant Pianoforte Competition (£500);
★Language Alive; Sound it Out (£250 each).

Exclusions: Individuals.
Applications: In writing to the correspondent.

The Robin Howard Foundation

CC No: 1008590

The Place, 17 Duke's Road, London WC1H 9AB

Contact: Ms J Eager, Secretary
Trustees: Robert Cohan, Chair; Peter Lumsden, Honorary Treasurer; Richard Alston; Janet Eager; Emma Russell; Lord Russell of Liverpool.
Beneficial area: UK.
Grant total: £12,600 (1998/99)
Arts grants: £12,600

The foundation's principal aims are to 'promote the advancement and improvement of general education in relation to all aspects of the art of dance and the development of public appreciation of such art'.

In 1998/99, the latest year for which an annual report was on file at the Charity Commission, total funding amounted to £12,600 and was disbursed to 21 individual dance artists to further artistic development. The size of each award was not specified in the annual report.

The majority of available funds have recently been expended on the establishment of a theatre in the name of Robin Howard. As a result of this, the foundation stated that it is uncertain as to whether further grants will be available after 2002 and expressed a wish not to be included in this guide.

Exclusions: Capital grants.

Applications: Contact the secretary for details.

The Idlewild Trust

CC No: 268124

54/56 Knatchbull Road, London
SE5 9QY

Tel: 020 7274 2266; Fax: 020 7274 5222
Contact: Mrs A Freestone, Administrator
Trustees: Lady Judith Goodison, Chair;
Mrs A S Bucks; M H Davenport; J C
Gale; Mrs A C Grellier; Mrs F L
Morrison-Jones; A Ford.
Beneficial area: UK.
Grant total: £118,000 (2000)
Arts grants: £90,000

The trust's objects are:

- advancement of education and learning and encouragement of music, drama and the fine arts;
- preservation for the benefit of the public of lands, buildings and other objects of beauty or historic interest of national importance.

This trust is administered from the same offices as The Peter Minet Trust (see separate entry), which also funds arts-related causes but favours social welfare, youth and community projects and a more specific geographical area.

The trust categorised grants in its 2000 report as follows: museums and galleries (10% of total grant-aid); education (14%); performance arts (26%); preservation and restoration (28%); fine art (10%); conservation (12%).

In 2000 the trust gave a total of £118,000 in 49 grants ranging from £600 to £5,000, of which £90,000 (76% of total grant-aid) was given in 37 grants relevant to this guide. These included:
Ironbridge Gorge Museum; Constable Trust (£5,000 each);
Springboard Concerts; Handel House Trust; Weald and Downland Open Air Museum (£4,000 each);
AMICI Dance Company (£3,000);
Amadeus Scholarship Fund; National Youth Music Theatre; Association of Teachers of Singing; Clonter Farm Music Trust; Welsh National Opera; Sounds New (£2,000 each);
National Portrait Gallery; York Opera School (£1,500 each);
Derby Chamber Music Society (£1,350);
Dunblane Cathedral City Museum (£600).

Exclusions: Individuals; organisations not registered charities; grant-making charities; repetitive national appeals; overseas appeals; 'parochial appeals', that is for projects only benefiting the applicant's immediate vicinity. No grants repeated within 12 months of a previous grant.

Applications: In writing, enclosing audited accounts. Unsuccessful applications will not be acknowledged unless SAE has been enclosed. Trustees' meetings are usually held in April, August and December.

The Inverforth Charitable Trust

CC No: 274132

The Farm, Northington, Alresford, Hampshire SO24 9TH

Tel: 0870 7702657
Contact: Mr Adam Lee, Secretary and Treasurer
Trustees: Elizabeth Lady Inverforth; Rt Hon. Lord Inverforth; Hon. Mrs Jonathan Kane; Michael Gee.
Beneficial area: UK.
Grant total: £209,000 (2000) but see below
Arts grants: £37,000

The trust's emphasis is on physical and mental health care (35% of total grant-aid in 2000), music and the arts (18%), handicapped and aged (16%), youth and education (8%), churches and heritage (5%), hospices (2%), with the balance made up with 'sundry, including (very few) international' (16%).

The trustees like to support smaller **national** charities and are willing to make grants towards administrative costs as well as, occasionally, for projects. *The trust does not consider applications from local arts or music causes or small charities.* Many grants are made to previous beneficiaries, with new applications struggling to secure funding. However, no commitments for more than a year are made to any charity.

In 2000 the trust gave £209,000 in grants to 206 charities. With the exception of a donation made to National Asthma Campaign for £15,000, grants ranged between £500 and £2,000. A total of £37,000 (18% of total grant-aid) was given in 43 grants relevant to this guide. These included:

*Spitalfields Festival (£2,000);

*Clonter Music Farm Trust; *Live Music Now; Music For Youth; National Youth Orchestra of Great Britain; Tricycle Theratre (£1,500 each);

*City of London Festival; *English National Opera; *Garsington Opera; London Handel Society; National Opera Studio; National History Museum (£1,000);

City of Birmingham Symphony Orchestra; *Classical Opera Company; *Dulwich Picture Gallery; English Touring Opera (£500 each).

Although annual accounts for 2001 had not been published at the time of writing, the trust was able to state 'traditional grant levels were halved to reflect the falls in the stock market'. It was indicated that in 2001 grants totalled £85,500, out of which £16,250 was given to the arts.

Exclusions: Individuals; organisations not registered as charities; unconnected local churches, village halls, or schools; small or localised charities; branches, affiliates or 'subsidiary' charities; animal charities; repeat applications within a year. 'Charities with the word 'community' or a relevant place name in their title are unlikely to qualify as national charities within the guidelines of the trustees.'
Applications: In writing to the correspondent, including accounts, at least a month before meetings. A summary is prepared for the trustees, who meet quarterly, in March, June, September and early December. Replies are normally sent to all applicants. Allow up to four months for answer. **There is a very high failure rate for new applicants**.

The Sir Barry Jackson County Fund

CC No: 517306

c/o H L B Kidsons, Bank House, 8 Cherry Street, Birmingham B2 5AD

Tel: 0121 631 2631
E-mail: sgill@kibham.hlbkidsons.co.uk
Contact: Stephen J Gill, Secretary to the Trustees
Trustees: R S Burman, Chair; Cllr J E C Alden; A N Allan; C R G Winteringham;

L A Chorley; D B Edgar; Ms J Hytch; Ms K Horton; Prof J H Kaplan; A R Collins; B W Tanner.
Beneficial area: West Midlands.
Grant total: £53,000 (1999/2000)
Arts grants: £53,000
This fund gives grants to improve education in drama and theatrical production along with the development of public appreciation of such art. Funding is disbursed to theatre projects within the West Midlands area, often to previous beneficiaries. A major share of annual grant-aid is given to Birmingham Repertory Theatre.

In 1999/2000 the fund gave a total of over £53,000 in seven grants, all of which were relevant to this guide. These were:
*Birmingham Repertory Theatre Company (£24,000);
*Big Brum Theatre in Education Company Ltd (£15,000);
*Theatre Absolute (£7,000);
Belgrade Theatre (£3,600);
Stage 2 (£2,000);
*Banner Theatre Company Ltd (£1,000);
Deep Impact Theatre (£500).

Exclusions: Buildings or equipment.
Applications: In writing to the correspondent.

Jacobs Charitable Trust

CC No: 264942

9 Nottingham Terrace, London
SW1 4QB

Tel: 020 7486 6323
Contact: Rt Hon Lord Jacobs
Trustees: Lord Jacobs, Chair; Lady Jacobs.
Beneficial area: UK and Israel.
Grant total: £555,000 (1999/2000)
Arts grants: £279,365
This trust has general charitable objects, although its giving tends to be focused on established Jewish causes and arts organisations. It usually makes one or two

substantial grants of over £50,000 along with between 30 and 50 smaller grants. Many grants are recurrent.

The vast majority of the trust's income is derived from donations and, as a result, annual charitable expenditure varies from year to year (£120,000 in 1997/97; £322,000 in 1997/98; £539,000 in 1998/99).

In 1999/2000 the trust had an income of £319,000 and made 47 grants totalling £555,000. The two largest grants were for Haifa University (£188,079) and the Tate Gallery (£175,000). The remaining grants ranged from unspecified donations of under £1,000 to £67,500; most were for £10,000 or less. Arts-related grants totalling £279,365 (50% of total funding) were given to the following nine beneficiaries:
*Tate Gallery (£175,000);
Royal Opera House (£67,500);
Norton Museum of Art (£11,615);
*Imperial War Museum, Holocaust Exhibition; *Royal National Theatre (£10,000 each);
*Israel Philharmonic Orchestra (£2,000);
*British Friends of the Art Museums of Israel (£1,250);
*Hampstead Theatre Trust; New Shakespeare Company (£1,000 each).

Applications: In writing.

The James Pantyfedwen Foundation

CC No: 1069598

Pantyfedwen, 9 Market Street, Aberystwyth SY23 1DL

Tel: 01970 612806; Fax: 01970 612806
E-mail: pantyfedwen@btinternet.com
Contact: Richard H Morgan, Executive Secretary
Trustees: There are 24 trustees in all. A full list is available in the annual report. It includes Mr Emrys Wynn Jones, Chair.
Beneficial area: Wales, or the Welsh elsewhere.

Grant total: £333,000 (1999/2000)
Arts grants: £72,300

This foundation was formed in April 1998 when the John and Rhys Thomas James Foundation amalgamated with its larger sister organisation, the Catherine and Lady Grace James Foundation.

In 1999/2000 the foundation gave a total of £333,000 in grants ranging from £17 to £8,000, most of which were £2,000 or less. Support was given within the following categories:

- Eisteddfodau (music and poetry festivals celebrating Welsh culture and language) (£69,300);
- educational purposes, including students (£108,250);
- religious purposes (£26,800);
- religious buildings (£92,950);
- books (£1,950);
- registered charities (£69,300).

Grants are exclusively directed at Welsh causes. Only the 71 grants to Eisteddfodau plus one donation to the Beaumaris Band for £3,000, made within the registered charity category, were relevant to this guide. These totalled over £72,000 (22% of total grant-aid). Students may have been beneficiaries of arts-related bursaries given in the educational purposes category but subjects of study were not listed in the annual report.

Exclusions: Organisations which are not registered charities.

Applications: The trust is unlikely to make arts-related grants other than to support an Eisteddfod. Applications should be made on forms available from the correspondent. Applications from churches and registered charities can be submitted at any time. Student applications should be submitted before 31 July in the academic year for which the application is being made. Trustees meet in March, May, July, September and December. All applicants, whether successful or not, receive a reply.

The Japan Festival Fund

CC No: 328701

Swire House, 59 Buckingham Gate, London SW1E 6AJ

Tel: 020 7630 5552; Fax: 020 7931 8453
Contact: Shuko Noguchi, Executive Director
Trustees: Directors: Richard Large, Chair; Graham McCallum; Sir Peter Parker; Lew Radbourne.
Beneficial area: UK.
Grant total: £77,000 (1999/2000)

The Japan Festival Fund was established as a lasting reminder of the Japan Festival 1991. Each year awards are made for recent outstanding achievements in furthering the understanding of Japanese culture in the United Kingdom. Both organisations and individuals are eligible for these awards, which are made retrospectively. For the purpose of the award the term 'culture' covers the visual and performing arts, music, literature, sports, media and education, but is not intended to extend to science, technology, medicine and business studies. The number and value of prizes each year is entirely at the discretion of the directors who judge the entries.

The fund also supports the Japan Festival Education Trust which promotes the teaching of Japanese culture in UK schools.

In 2000 the fund gave a total of £77,000 in 16 awards (totalling £27,000) and one grant of £50,000 for the Japan Festival Education Trust. The level of arts funding was unclear because only a small number of beneficiaries were specified. The top award was shared between Visual Learning Foundation, for a pilot programme in primary schools, and Thelma Holt, for facilitating the RSC production of King Lear. An honorary award was given to Lady Sainsbury for the establishment of the Sainsbury Institute for the Study of Japanese Arts and Cultures.

Applications: Candidates may be nominated by an independent party or may nominate themselves. In either case their application must be supported by two referees (one of whom may be their nominator). The event/project must have taken place in the 12 months preceding the deadline (31 March).

Application forms must be used. The finalists are selected in May with the winners announced in June/July.

The John Jarrold Trust

CC No: 242029

Messrs Jarrold & Sons, Whitefriars, Norwich NR3 1SH

Tel: 01603 660211
Contact: Brian Thompson, Secretary
Trustees: A C Jarrold, Chairman; R E Jarrold; P J Jarrold; Mrs D J Jarrold; Mrs J Jarrold; Mrs A G Jarrold; Mrs W A L Jarrold.
Beneficial area: UK, especially Norfolk and surrounding areas.
Grant total: £187,000 (2000/2001)
Arts grants: £35,167
This trust places emphasis on education and research in the natural sciences but also makes grants for more general charitable purposes, including a wide range of arts causes.

In 2000/2001 the trust gave a total of £187,000 in 262 grants ranging from £25 to £10,000; most were £1,000 or under. Out of this, a total of £35,167 (19% of total grant-aid) was given in 34 arts-related grants. These included:
East Anglia Arts Foundation (£10,000);
Norfolk & Norwich festival (£6,000);
Norwich Playhouse (£3,000);
Maddernarket Theatre; Friends of Norwich Museums (£2,000 each);
Norfolk County Music Festival; St Gregory's Arts Centre; Wingfield Arts (£1,000 each);
Lowestoft Arts Ltd; Community Music East; New Professionals Opera (£500 each);

Broadland Youth Choir; Norwich & District Photographic Society (£300 each);
City of London Sinfonia; Pilgrim Players; Thetford Music & Drama Society (£250 each);
Poetry-next-the-Sea (£100).

The Jerusalem Trust

(see also Sainsbury Family Charitable Trusts)

CC No: 285696

Tel: 020 7410 0330
Contact: Michael Pattison, Director
Trustees: Lady Susan Sainsbury; Sir Timothy Sainsbury; V E Hartley Booth; Canon Gordon Bridger; Mrs Diana Wainman.
Beneficial area: UK and overseas.
Grant total: £3,569,000 (approved 2000)
Arts grants: £200,900
This trust is one of the Sainsbury Family Charitable Trusts which share a joint administration. Its giving is focused solely on activities within the Christian religion, with grants being made within the following categories: Christian evangelism and relief work overseas; Christians in the media; Christian education; Christian art; Christian evangelism and social responsibility work at home. The Christian art category is mainly focused on 'a small number of pro-active commissions of works of art for places of worship'.

In 2000 the trust approved 209 grants totalling £3,569,000. Donations ranged from under £5,000 to an exceptional £507,000 for Jerusalem Productions. The average donation was £17,000 but only the largest grants were specified. A total of £200,900 (six per cent of total funding), was approved for 17 arts grants. These included:
Under 'Christian art' –
Ely Cathedral Trust, 'Virgin in Stone' by David Wynne (£25,000);

Art & Christianity Enquiry Trust, to support part-time director; Art 2000, towards artist-in-residence schemes in cathedrals and churches in the South East of England (£10,000 each);

Wayside Cross Appeal, towards a wayside cross erected in Battersea Park in celebration of the Millennium (£7,500).

Under 'Christians in the media' –

New Scottish Choir & Orchestra, for an administrative director (£36,000);

Arts Centre Group, to support Young Artists Mentoring Coordinator (£14,000).

Under 'Christian education' –

Cre8.ed, teacher training workshops to encourage schools to use the arts to explore the Christian message (£60,000);

National Gallery Trust, for the production of educational packs relating to the 'Seeing Salvation' exhibition (£15,000).

Exclusions: Individuals.

Applications: An application to one of the Sainsbury Family Charitable Trusts is an application to all. See the separate entry for the umbrella organisation for the address and guidelines.

The Jerwood Charitable Foundation

CC No: 1074036

22 Fitzroy Square, London W1P 5HQ

Tel: 020 7388 6287; Fax: 020 7388 6289
E-mail: info@jerwood.org
Website: www.jerwood.org.uk
Contact: Roanne Dods, Director
Trustees: Alan Grieve, Chair; Edward Paul, Vice-Chair; Viscount Chilston; Lady Harlech; Dr Kerry Parton; Julia Wharton; Barbara Kalman; Anthony Palmer; Timothy Eyles; Andrew Knight.
Beneficial area: UK and some overseas, especially Nepal.
Grant total: £685,000 (2000)
Arts grants: £500,000

This foundation was registered in 1999 as a grant-making trust by its parent organisation, the Jerwood Foundation, from which its entire income is derived. The new foundation has taken over the responsibility for revenue awards, donations and sponsorship, leaving the Jerwood Foundation to concentrate on capital projects. It is dedicated to rewarding excellence in the visual and performing arts, and to education. A small proportion of funding is also allocated to conservation, environment, medicine, science and engineering. The trust's strategy is to support 'outstanding national institutions', along with projects in their early stages which are unable to secure funding from other sources.

Grants vary from up to £10,000 in the lower range to more substantial grants of up to £50,000. The level of funding allocated is decided according to need.

The following are extracts from the charitable foundation's guidelines:

Funding policy

'In every case the foundation seeks to secure tangible and visible results from its grants and sponsorships. Influence and effect beyond the immediate recipient of a grant is encouraged. We aim to monitor the chosen projects closely and sympathetically, and are keen to see recognition of the foundation's support.

'The strategy is to support outstanding national institutions while at the same time being prepared to provide seed corn finance and financial support at the early stages of an initiative when other grant-making bodies might not be able or willing to act. The foundation may wish to be sole sponsor (subject to financial considerations) or to provide partnership funding.

'The Jerwood Charitable Foundation has the benefit of association with capital projects of the Jerwood Foundation. These include the Jerwood Space, the Jerwood Theatres at the Royal Court Theatre, the Jerwood Gallery at the

Natural History Museum and the Jerwood Sculpture Park at Witley Court, Worcestershire. The support for these initiatives by the Jerwood Foundation will be a factor when considering any applications.

'Although the foundation normally funds projects based within the United Kingdom, it will also consider a small number of applications from UK organisations working overseas, especially in Nepal.

'The foundation believes that it should not be merely the passive recipient of requests for grants but should identify areas to support and develop projects with potential beneficiaries.'

Types of grants

The foundation makes revenue donations on a one-off basis. 'There is a strong element of challenge funding', whereby the foundation will make a grant provided the recipient or another interested party can match it. The foundation will rarely commit to funding over a fixed number of years, yet will be prepared in many cases to maintain support if consistency and partnership will secure better results.

Areas of special interest

'The Jerwood Charitable Foundation has certain primary fields of interest, although these are constantly being reviewed and developed.

'In the performing arts, the foundation has developed a particular role: the support and reward of young people who have demonstrated achievement and excellence, and who will benefit from a final lift to their careers. This special role is intended to open the way forward for young achievers and give them the opportunity to flourish.

The arts –'The foundation is a major sponsor of all areas of the performing and visual arts. We are particularly interested in projects which involve rewards for excellence and the encouragement and recognition of outstanding talent and

high standards, or which enable an organisation to become viable and self financing.'

The foundation funds a number of arts prizes and awards, which are often linked to its association with the capital projects of its parent organisation. These include the Jerwood Painting Prize, Jerwood Applied Arts Awards, the Jerwood Choreography Awards, the New Playwrights Season at the Royal Court Theatre and Jerwood Young Directors at the Vic.

Active support is also given for the conservation of artistic and architectural heritage, although not towards building restoration projects.

Education –'The foundation aims to support projects which are educational in the widest sense. Currently, preference is given to initiatives benefiting young people who have completed school and university but are continuing their vocational educational development.'

Other fields –The foundation retains a 'small allocation for projects and award schemes within the fields of science, engineering, environment and conservation'.

Distribution of grant-aid

In 2000 the Jerwood Charitable Foundation gave a total of almost £685,000, mainly to arts-related causes. Examples of its sponsorships and initiatives are listed below:

Under 'visual arts' –

The Jerwood Painting Prize, an open award for excellence in painting in the UK. The exhibition took place at the Jerwood Space;

The Jerwood Prize for Applied Art, offered jointly with the Crafts Council of England, the theme for 2000 was jewellery;

Jerwood Arts Commissions, two paintings commissioned to hang in the Great Chamber of the Royal College of Paediatrics and Child Health;

Jerwood Prison and Community Art
Award, made for an outstanding piece
of public art produced by prisoners.

Under 'dance and choreography' –

Jerwood Dance for the Camera
Traineeships, funding for young
choreographers to train alongside
experienced colleagues working on the
BBC series 'Dance for the Camera';

Jerwood Choreography Award, for
choreographers under the age of 35, in
two awards of £8,500;

Choreographers and Composers
Masterclasses, held at the South Bank
Centre for the benefit of young
choreographers and composers;

JazzXchange, a significant grant to help
develop dancers' technique and
understanding of this style of
contemporary dance.

Under 'drama' –

Jerwood New Playwrights, supporting
promising new British writing at the
Royal Court;

Jerwood Young Designers at The Gate,
providing opportunities for creative
theatre designers at The Gate Theatre;

Regional Theatre Young Directors
Scheme, funding awarded by selection
to a young director to undertake a
year's training at the Royal Court.

Under 'music' –

ENO Jerwood Young Singers
Programme, providing young singers
with the opportunity to develop skills
via training and performance;

Garsington Opera Understudy Scheme,
supporting six understudies;

Mendelssohn on Mull, 'seed-corn
funding' for a week-long series of
masterclasses and performances.

Under 'film' –

First Film Foundation, early stages
funding for inaugural series of script
development workshops;

National film and television school, grant
to the most outstanding screenwriter
graduating from the National Film and
Television School.

Under 'education (literature)' –

Jerwood/Arvon Young Writers'
Apprenticeships, mentoring scheme for
professional writers under the age of 35
who have undertaken research by
studying Creative Writing to MA or
MPhil level.

Exclusions: Individuals; buildings or
capital costs (including purchase of
equipment); projects in the fields of
religion or sport; animal rights or welfare;
general fundraising appeals which are
likely to have wide public appeal; appeals
to establish endowment funds for other
charities; appeals for matching funding for
National Lottery applications; grants for
the running and core costs of voluntary
bodies; projects which are of mainly local
appeal or identified with a locality;
medical research without current clinical
applications and benefits; social welfare,
particularly where it may be considered a
government or local authority
responsibility; retrospective awards.

'The Board of Trustees may, where
there are very exceptional circumstances,
decide to waive the exclusion.'

Applications: 'Applications should be by
letter, outlining the aims and objectives of
the organisation and the aims and
objectives of the specific project or
scheme for which assistance is sought.'
Also to be included: a detailed budget for
the project, identifying administrative,
management and central costs; details of
funding already in place for the project,
including any other trusts or sources
which are being or have been approached
for funds. If funding is not in place, details
of how the applicant plans to secure the
remaining funding; details of the
management and staffing structure,
including trustees; the most recent annual
report and audited accounts of the
organisation, together with current
management accounts if relevant to the
project.

The foundation 'may wish to enter into
discussions and/or correspondence with

the applicant which may result in modification and/or development of the project or scheme'. This will in no way commit the foundation to funding that application.

Successful applicants report to the trustees at the completion of their project and to provide the charitable foundation with photographs of the work or project supported.

Preliminary meetings to discuss possible support *before* a written application is made cannot be held due to the volume of applications.

The Jerwood Foundation

(see also The Jerwood Charitable Foundation)

Trustees: Foundation Council: Alan Grieve, Chairman; Dr Peter Marxer; Dr Peter Marxer Jnr; Barbara Kalman, Secretary to the Council. UK Advisory Board: Viscount Chilston; Lady Harlech; Dr Kerry Parton; Edward Paul; Julia Wharton; Anthony Palmer.

The Jerwood Foundation was established in 1977 as a private foundation in Lichtenstein. It is dedicated to imaginative and responsible funding and sponsorship of the arts, education, design, conservation, medicine, engineering, science and other areas of human endeavour and excellence.

The newer Jerwood Charitable Foundation has taken over provision of revenue funding, sponsorship and awards from the Jerwood Foundation. This leaves the highly proactive original foundation to concentrate on funding specific capital projects, a decision prompted by changes in Lottery policy.

Since 1999 the foundation commitments have included the following:
Natural History Museum, London:
£900,000 for the Jerwood Gallery;
Trinity Hall, Cambridge: £1.4 million for the Jerwood Library;

Witley Court, Worcester: Jerwood Sculpture Park;
The Jerwood Space, Southwark:
£1.4 million to establish this new venue, offering young dance and theatre companies affordable spaces and facilities to develop their work;
Royal Court Theatre, for the Jerwood Theatres: £3 million;
Royal Academy of Dramatic Art:
£1.2 million for The Jerwood Vanbrugh Theatre;
St Luke's church in London's EC1:
£1 million to provide a home for the London Symphony Orchestra's comprehensive and pioneering education programme, which is dedicated to bringing music to people of all ages and from every walk of life.

Applications: The foundation no longer considers unsolicited applications.

The Nicholas John Trust

CC No: 1059847

Old Stables, Juniper Hill, Mickleham, Dorking, Surrey RH5 6DB

Tel: 01372 372542
Contact: Mr L F John
Trustees: Leslie Francis John, Chairman; Elizabeth Anne Brimelow, Treasurer; Constance Margaret John; Nicholas Ernest Cronk; Mark Edgar Walter Studer.
Beneficial area: UK.
Grant total: £4,648 (1998)
Arts grants: £4,648
This trust was set up in memory of Nicholas John who spent much of his working life with the English National Opera. Its main purpose is the promotion of operatic art, in particular by awarding an annual scholarship to a chosen student preparing for a career in opera. In addition to its support for students, the trust provides assistance for publications, lectures, seminars or other means of promoting or encouraging operatic art.

In 1998, the latest year for which an

annual report was available at the Charity Commission, the trust gave a total of £4,648. This was disbursed as follows: National Opera Studio, to fund the Nicholas John Scholarship (£3,750); Tete a Tete Productions, to support production of *The Flying Fox* (£500); London Library, hardback binding of opera guides (£398).

The JP Morgan Fleming Educational Trust

(formerly Save & Prosper Educational Trust)

CC No: 325103

Finsbury Dials, 20 Finsbury Street, London EC2Y 9AQ

Tel: 020 7742 6332
Contact: Duncan Grant, Director
Trustees: Trustee is the Save & Prosper Group Limited, which has appointed the following Managing Committee: C J Rye, Chairperson; S E C Dyer; Mrs M L Bassett; D Grant.
Beneficial area: UK, with a special interest in the London Borough of Havering and in Edinburgh, and their surrounding areas.
Grant total: £759,000 (1999/2000)
Arts grants: £80,926
The trust supports educational projects under the following headings: special needs education; community and children at risk; schools, universities and museums; arts education.

The trust establishes, where possible and appropriate, a relationship with successful applicants, particularly those of larger grants. Although commitments are not usually for more than two years, support may be continued in exceptional cases, on a year to year basis without a commitment to any definite period.

The trust's income, derived from a school fees planning service run by Save & Prosper Group Ltd, is projected to diminish to zero by the year 2014, but another charity, the JP Morgan Fleming Foundation (see following entry) is being built up as the original one declines. As most of its grants cover the same fields as the present trust, and are administered in common, applicants can generally regard an application to one as an application to both. There is a large annual transferral of funds (£200,000 in 2000) from this trust to the new foundation.

In 2000 a total of £759,000 was given in 184 grants. The donation to the trust's sister foundation aside, grants ranged between £50 and £20,000, although most were under £5,000. Out of this total, £80,926 (11%) was given to 31 arts-related causes including:
University of Dundee, to provide chair of Scottish Art; Who Cares? Trust, for literacy programme; English National Opera, to support Baylis Programme administrator (£10,000 each);
National Museums & Galleries of Wales (£5,000);
Magpie Dance, for integrated projects in special needs schools (£4,500);
Tiebreak Touring Theatre, to fund theatre in education; Trading Faces, funding literacy theatre in education; Volunteer Reading Help; Streatham Youth Centre, to fund photographic club (£2,000 each);
★Magic Lantern, for painting workshops in London schools (£1,500);
Shenfield High School, for library equipment; Drake Music Project, residential music project; Drama Practice, arts education in Edinburgh hospital (£1,000 each);
Havering Music School, for annual junior musicians competition (£500);
Pinewood Primary School, to support reading programme (£300);
St Alban's Roman Catholic Primary School, for annual poetry competition (£100).

Exclusions: Open appeals from national charities; charity gala nights and similar events; appeals by individuals; building appeals; anniversary appeals.

Applications: The initial approach should be addressed in writing to the director (a brief letter of not more than two A4 sides), setting out the reason for the application and enclosing any relevant publicity material and accounts.

Applications are always acknowledged. Those supported by a member of Save & Prosper's staff may be particularly welcome. Unsuccessful applicants should wait a year before re-applying. Trustees meet in March, May, August and December. Applications need to arrive at least a month before the meeting.

The JP Morgan Fleming Foundation

(formerly Save & Prosper Foundation)

CC No: 291617

Finsbury Dials, 20 Finsbury Street, London EC2Y 9AQ

Tel: 020 7742 6332
Contact: Duncan Grant, Director
Trustees: Save & Prosper Group Limited has appointed the following Managing Committee: C J Rye, Chairperson; D Grant; Mrs M L Bassett; S E C Dyer.
Beneficial area: UK.
Grant total: £184,000 (1998/99)
Arts grants: £48,000
The foundation gives to a wider range of charitable causes than its sister organisation, the JP Morgan Fleming Educational Trust, but retains a strong emphasis on education. In 2000 a sum of £200,000 was transferred from the trust to this foundation, in keeping with an ongoing process which will lead to the foundation eventually becoming the organisation's sole charitable body.

The report for 1998/1999, the latest on file at the Charity Commission, states that the foundation gave a total of £184,000 in grants ranging from £250 to £20,000, most of which were for less than £5,000. Of this total, £48,000 (26% of total grant-aid) was given in nine grants

relevant to this guide. These included:
*Glyndebourne Productions Ltd (£20,000);
*Barbican Art Gallery; Sadlers Wells (£5,000 each);
*Royal Academy Trust; *London Philharmonic; Community Music (£3,000 each);
Southend Choral Society (£750).

Applications: See advice for the JP Morgan Fleming Educational Trust. It is acceptable to make one application to both charities, which share a common administration.

The Jungels-Winkler Charitable Foundation

CC No: 1073523

Herbert Smith, Exchange House, Primrose Street, London EC2A 2HS

Tel: 020 7374 8000; Fax: 020 7374 0888
Contact: Jonathan Wood, Trustee
Trustees: Gabrielle Jungels-Winkler; Jonathan Wood; Alexandra Jungels-Winkler; Christophe Jungels-Winkler.
Beneficial area: UK.
Grant total: £127,000
This foundation makes grants for the benefit of the visually impaired. In 1999 it made grants totalling £127,000. No breakdown was featured in the annual report for 1999, the first year of its funding activity, but an entry for the foundation in the *Directory of Grant Making Trusts* indicates that there is 'some preference for arts-related charities'.

The foundation has made the following statement:
'The trustees of the foundation would prefer that an entry for the Charity should not apear in the Arts Funding Guide. The charity's funds are already substantially committed and the trustees have received a great deal of unsolicited applications for funding each year, which they have been regretfully forced to turn down.'

The Michael and Ilse Katz Foundation

CC No: 263726

11 Martello Towers, Canford Cliffs, Poole, Dorset BH13 7HX

Contact: A D Foreman, Trustees' Accountant
Trustees: Norris Gilbert; Osman Azis.
Beneficial area: UK and overseas.
Grant total: £110,000 (1998/99)
Arts grants: £19,050

The foundation supports 'as wide a range of charitable objects as possible'. Many grants go to Jewish charities but the arts receives some funding each year, with an apparent preference for music. While most grants are small, some large grants are also given annually.

In 1998/99 the trust gave a total of £110,000. Grants for less than £1,000, totalling £12,000, were not listed. There were 18 grants listed, ranging from £1,000 to £25,000, with most grants not exceeding £5,000.

Out of this, £19,050 (17%) was given in the following three grants relevant to this guide:
*Bournemouth Orchestra (£17,750); Jewish Music Heritage (£2,000); Wiener Library Endowment (£1,300).
Applications: In writing to the correspondent.

The King's Fund

(King Edward's Hospital Fund for London)

CC No: 207401

11–13 Cavendish Square, London W1M 0AN

Tel: 020 7307 2495; Fax: 020 7307 2801
E-mail: grants@kehf.org.uk
Contact: Susan Elizabeth, Grants Director
Trustees: The Management Committee under the authority of the President and General Council, including Sir Graham Hart, Chairman.

Beneficial area: Mainly London.
Grant total: £2,070,000 (1999)
Arts grants: £137,600

This fund's principal aims are to promote equality in health and health care, while improving the patients' experience of health service provision. The fund states that 'although the funding priorities within programmes change over time, they are all aimed at improving public health care, with a general emphasis on innovative and potentially influential projects'. The fund's work is influential in London's health care sector and its recent Declaration for Health publication, which outlines priorities for the city's mayor and the GLA, has stimulated much debate.

The fund has a holistic approach to health which looks at the whole individual, acknowledging the value of family relationships, community and patient environment. *The fund has previously operated an 'arts and health development grants' programme, but from 2001 onwards arts-related causes are no longer a specific priority.* Arts-related grants are only given within a health care context, for projects working towards the aims of the fund.

In 1999 the fund gave a total of £2,070,000 in 100 grants to organisations, 26 educational bursaries and 22 travelling fellowships. Almost a quarter of this total (£475,000) was given in one donation to Health Advocacy for Ethnic Minority Communities in London. The remaining grants were for between £442 and around £40,000 for the larger development grants. A total of £137,600 (seven per cent of total grant-aid) was given in 11 grants relevant to this guide. These were:

Under 'arts and health' (development grants) –
National Network for the Arts in Health (£40,000);
Community Groundwork (£38,000);
Rosette Life (£35,000);
Gateshead Central Library (£4,500).

Under 'stimulus grants' –
Arts Inform (£3,600);
Futures Theatre Company (£3,000);
Arts in the Park; Bedford Hill Gallery &
 Work Shops Ltd (£2,000 each);
Arts line (£1,500);
Arts Project (£1,000).
Under 'evaluation grants' –
Arts Project (£7,000).

Exclusions: Individuals; capital projects
(buildings and equipment); general
appeals; local work outside London; long-
term funding (maximum period is three
years); holidays and outings; projects
where the work has already started;
projects seeking ongoing funding after a
statutory grant has run out; vehicles.
Applications: Please note the fund was
changing its policy regarding the arts at
the time of writing (Feb 2002). Detailed
guidelines available from the fund.
Applications are considered at least five
times a year, in February, May, July,
September and November, but must be
submitted three months before the
meeting concerned and at least four
months before the project starts. The fund
suggests that prospective applicants first
contact the Grants Department, either to
make sure the project fits the priority
areas or if help is needed in putting the
application together.

The Sir James Knott Trust

CC No: 1001363

16–18 Hood Street, Newcastle upon
Tyne NE1 6JQ

Tel: 0191 230 4016
Contact: Brigadier John F F Sharland,
Trust Secretary
Trustees: Viscount Ridley; Mark
Cornwall-Jones; Prof. Oliver James;
Charles Baker-Cresswell.
Beneficial area: Northumberland, Tyne
& Wear and County Durham only.
Grant total: £1,312,000 (2000/01)
Arts grants: £53,000

This trust makes grants from income to
registered charities in the North East of
England and to national charities which
either operate within this area or whose
work is beneficial to its inhabitants.
Support is commonly given to the young,
the elderly, seamen's and service charities,
the disabled and disadvantaged, as well as
education, health, the environment and
the arts.

 In 2000/01 the trust gave a total of
£1,312,000 in 323 grants ranging from
unspecified donations of less than £1,000
to an exceptional £100,000 given to
Durham University. Most grants were
under £10,000. Arts funding amounting
to £53,000 (four per cent of total grant-
aid) was given in nine donations. These
were:
Bowes Museum, Barnard Castle
 (£25,000);
★Alnwick District Playhouse Trust;
 Ireshopeburn Literary Inst.; Brinkburn
 Summer Music Festival; ★Northern
 Sinfonia (£5,000 each);
British Federation of Young Choirs;
 ★Hexham Abbey Festival; ★NTC
 Touring Theatre, Alnwick; ★Opera
 North, Newcastle (£2,000 each).

Exclusions: Individuals; organisations
not registered as charities.
Applications: Applications must be in
writing, quoting the applicant's registered
charity number and providing full
supporting information, including details
of the connection with the North East of
England, steps taken to raise funds and
the amount already raised. Trustees meet
three times a year to consider
applications.

The John Kobal Foundation

CC No: 1014275

PO Box 3838, London WC1X 0NP

Tel: 020 7383 2979; Fax: 020 7383 2979
Contact: Simon Crocker, Secretary
Trustees: Simon Crocker, Chairman;
Clive Crook; Angela Flowers; Angela

Grant; Rupert Grey; Michael Hoppen; Elizabeth Jobey; Monika Kobal; Liz Jobey; Terence Pepper; John Russell Taylor; Yolanda Sonnabend; June Stanier.
Beneficial area: UK.
Grant total: £5,500 award (1999)
Arts grants: £5,500
The foundation exists to increase awareness of photographic portraiture. It funds the John Kobal Photographic Portrait Award and Exhibition at the National Portrait Gallery, London and a subsequent UK tour.

Funding is also available for photographers, educationalists, gallery owners and art centres to mount exhibitions or publish publications promoting portrait photography. No single grant is in excess of £1,000.
Applications: Funding is only given to projects directly relevant to portrait photography. Applicants must be 18 years or older. Fuller criteria are available with a SAE.

The Kobler Trust

CC No: 275237

Lewis Silkin, 12 Gough Square, London EC4A 3DW

Contact: Ms J L Evans, Trustee
Trustees: A Xuereb; Andrew H Stone; Ms J L Evans; J W Israelsohn.
Beneficial area: UK.
Grant total: £141,000 (1999/2000)
Arts grants: £61,000
This trust has general charitable purposes, supporting a wide range of causes, including a number of Jewish charities. The trust's overall level of funding varies from year to year. Its arts grants are diverse and some are recurrent.

In 1999/2000 the trust gave a total of £141,000 in 43 grants of between £500 and £22,000; most were for less than £5,000. Out of this total, £61,000 (43% of total grant-aid) was given in 10 grants relevant to this guide. These were:

*Chicken Shed Theatre Company (£22,000);
Covent Garden Festival Limited; Welsh National Opera (£10,000 each);
Royal Opera House, Chance to Dance (£8,800);
*Mountview Theatre School (£3,200);
National Children's Orchestra; London Concert Choir (£2,000 each);
Jewish Museum London; Wigmore Hall; Young Vic (£1,000 each).

Exclusions: Individuals, except in exceptional circumstances.
Applications: In writing to the correspondent.

The Kohn Foundation

CC No: 1003951

14 Harley Street, London W1N 1AA

Contact: Dr R Kohn, Chair to the Trustees
Trustees: Dr Ralph Kohn, Chair; Zahava Kohn; Anthony A Forwood.
Grant total: £355,000 (1998)
Arts grants: £37,000
This foundation primarily supports 'science and medical projects, the arts, particularly music, education and Jewish charities'.

In 1998, the last year for which an annual report was on file at the Charity Commission, the foundation gave a total of £355,000 to causes generally within the areas stated above. Only grants over £1,000 were listed. There were 14 of these, amounting to £347,000, of which £37,000 (10% of total grant-aid) was given in the following two arts-related grants:
*Wigmore Hall International Song Competition (£36,000);
The Medical Art Society (£1,000).

Applications: Few grants are made to arts-related causes.

The Neil Kreitman Foundation

CC No: 267171

Citrôen Wells, Chartered Accountants,
1 Devonshire Street, London W1N 2DR

Tel: 020 7637 2841
Contact: Eric Charles, Trustee
Trustees: Roger A Kreitman; Hyman Kreitman; Mrs S Irene Kreitman; Eric A Charles.
Beneficial area: UK and Israel.
Grant total: £949,000 (1999/2000)
Arts grants: £863,519

This foundation states that it 'generally supports projects in the fields of culture, education, health and welfare'. Support is often given to Jewish charities and arts-related causes. Most recipients have been previously funded by the foundation. The larger grants, which tend to account for most of the annual grant-aid, are usually made to cultural institutions concerned with history and learning, especially museums.

In 1999/2000 the foundation gave a total of £949,000, the majority of which was disbursed in one major grant of £814,569 (86% of total grant-aid) to Ashmolean Museum. The foundation made a further 22 grants between £200 and £30,000; most were under £10,000. Out of the total funding, £863,519 (91%) was given in seven grants relevant to this guide. These were:
*Ashmolean Museum (£814,569);
*British Library (£30,000);
*Victoria & Albert Museum (£8,500);
*British Museum; Friends of Wigmore Hall (£5,000 each);
Friends of Wigmore Hall (£250);
Music Therapy Group (£200).

Exclusions: Individuals; non-charitable and non-exempt organisations.
Applications: In writing to the correspondent.

Kreitman Foundation

CC No: 261195

Citrôen Wells (Chartered Accountants), Devonshire House, 1 Devonshire Street, London W1N 2DR

Tel: 020 7304 2000
Contact: Mr H Charles
Trustees: Hyman Kreitman; Mrs Irene Kreitman; Eric Charles.
Beneficial area: UK and Israel.
Grant total: £790,000 (1998/99)
Arts grants: £629,550

This foundation 'principally supports projects in the fields of education, culture, the environment, health and welfare'. Many grants are recurrent, including regular substantial donations to Jewish charities and arts activities.

In 1998/99 the foundation gave a total of £790,000, the majority of which was disbursed in three major recurrent grants: Tate Gallery Foundation (£451,750); Royal National Theatre (£164,100); Ben-Gurion University Foundation (£102,488).

The foundation made a further 18 grants of between £1,000 and £18,500 as well as an unspecified number of grants of under £1,000 each, totalling £15,771; most grants were for £5,000 or less. Out of the listed grants, a total of £629,550 (80% of total grant-aid) was given in seven grants to the arts. These were:
*Tate Gallery Foundation (£451,750);
*Royal National Theatre (£164,100);
*Royal Academy Trust (£5,000);
*British Friends of the Arts Museums of Israel (£4,700);
*British Museum Development Trust; Wigmore Hall Trust (£1,500 each);
Friends of the Jerusalem Rubin Academy of Music & Dance (£1,000).

The trustees have stated that they do not invite applications, preferring to concentrate on long-standing projects of personal interest to enable the monitoring of projects.

The trustees do not want to be inundated with requests for funding that they cannot consider and expressed a wish to be excluded from this guide.

This is all the more disappointing since the foundation is a generous supporter of the arts, giving major large grants. This guide is not just to support fundraisers but to help chronicle the major benefactors. The results of the foundation's recent support to Tate Britain opened to the public in spring 2002. Its new research centre brings together its existing library and archive collections. This was made possible by a £2.2 million donation from the foundation.

Exclusions: Individuals.

Applications: The foundation does not invite applications (see above).

The Lady Artists Club Trust

c/o McGrigor Donald Solicitors (Reference EMK), 70 Wellington Street, Glasgow G2 6SB

Tel: 0141 248 6677; Fax: 0141 204 1351
Contact: The Administrator
Beneficial area: Glasgow and the surrounding area.
Donations to all causes: £500 approx (1999)
Arts grants: £500
The trust supports the work of women visual artists born, educated, trained or residing within 35 miles of George Square, Glasgow. Each year the trustees give an award to one (or more) woman artist who, in their opinion, makes a real contribution to the promotion of the visual arts in the West of Scotland.
Exclusions: Students.
Applications: Application forms and further details available from the above address. The trustees consider completed work and, in particular, future projects.

The David Laing Foundation

CC No: 278462

The Studio, Mackerye End, Harpenden, Hertfordshire AL5 5DR

Tel: 01582 643126
Contact: David E Laing, Trustee
Trustees: David Eric Laing; John Stuart Lewis; Richard Francis Barlow; Frances Mary Laing.
Beneficial area: UK.
Grant total: £156,000 (1999/2000)
Arts grants: £17,500
This foundation uses income derived from investments to fund a wide range of grants to charitable bodies, with an emphasis on youth, disability, mental health and the arts.

Its smaller gifts are distributed out of the funds it deposits with the Charities Aid Foundation.

In 1999/2000 the foundation gave a total of over £156,000 in 10 grants to individual organisations and the annual donation (£65,000 in 1999/2000) to the Charities Aid Foundation. Out of the specified grants, £17,500 (11% of total grant-aid) was given to in three arts-related donations. These were:
New Shakespeare Company (£10,000); Harpenden Music Foundation (£5,000); Cheltenham Arts Festival (£2,500).

The Kirby Laing Foundation

CC No: 264299

PO Box 1, 133 Page Street, London NW7 2ER

Tel: 020 8238 8890
Contact: Miss Elizabeth Harley
Trustees: Sir Kirby Laing; Lady Isobel Laing; David E Laing; Simon Webley.
Beneficial area: UK and overseas.
Donations to all causes: £2,790,000 (1999)
Arts grants: £49,104
The foundation makes grants to registered charities within the following

categories: child and youth; cultural and environmental; health and medicine; overseas aid; religion; social welfare. The majority of grants are given on a one-off basis and normally range between £1,000 and £25,000, though larger grants may be awarded. Each year a large proportion of grant-aid is given in grants made through the Charities Aid Foundation. *The arts are not a main area of giving.*

In 1999 the foundation gave £2,790,000 in 88 grants including a donation of £230,000 to the Charities Aid Foundation. Total funding doubled since the previous year, largely as a result of an exceptional grant of £1,250,000 to Cheltenham and Gloucester College of Higher Education for the purpose of endowing a Chair in New Testament Theology. Very substantial grants were also given for Faith Zone at the Millennium Dome (£250,000) and King Edward VII Hospital (£150,000). Most grants were, however, under £10,000. A total of £49,104 (two per cent of total grant-aid) was given in 10 arts-related grants. These were:

Under 'health and medicine' –
Chelsea & Westminster Hospital Arts (£5,000).

Under 'child and youth' –
★Floating Point Science Theatre (£5,000).

Under 'culture and environmental' –
★Dulwich Picture Gallery (£10,000); Royal Society of Portrait Painters (£7,000);
★Royal Academy Trust (£6,000);
★National Art Collections Fund; Royal Air Force Museum, Cosford; Royal School of Needlework; ★Sir John Sloane's Museum (£5,000 each);
★Glyndebourne Arts Trust (£1,104).

Exclusions: Individuals; travel; running costs; educational grants.
Applications: The staff rely almost entirely on written applications in selecting appeals to go forward to the trustees. Each application should be concise and contain all the information needed to allow such a decision to be reached. Specifically, each application should say what the money is for; how much is needed; how much has already been found and where the rest is to come from. Unless there is reasonable assurance on the last point, the grant is unlikely to be recommended. A non-response should be considered as a negative reply; if more is sought, a SAE must be sent with the application. Decisions are made on an ongoing basis.

Laing's Charitable Trust

CC No: 236852

133 Page Street, London NW7 2ER

Tel: 020 8959 3636
Contact: Michael Hamilton, Secretary
Trustees: C M Laing; Sir Martin Laing; D C Madden; G D Gibson; R I Sumner.
Beneficial area: UK.
Grant total: £863,000 for individuals; £805,000 for institutions.
Arts grants: £18,000
This trust uses its income to make grants to individuals and institutions encompassing a wide range of causes. Areas supported include the homeless, health, welfare, education, the elderly and the arts.

In 2000 the trust gave a total of £1,668,000, of which £805,000 went to organisations and £863,000 was for approximately 1,000 individuals. Only the largest fifty donations to institutions, ranging from £3,000 to £50,000 and amounting to £555,000, were specified in the annual report. Out of these, a total of £18,000 (three per cent of specified funding) was given in three grants relevant to this guide. These were:
★Royal Opera House Trust (£10,000);
★Royal Air Force Museum, Hendon (£5,000);
Royal Engineers Museum (£3,000).

The trust has stated that 'arts projects form a tiny proportion of our donations and it is unlikely that the trust will respond positively to any unsolicited requests'.

Applications: Trustees meet to consider grants as required.

Constant and Kit Lambert Fund – see The Worshipful Company of Musicians

CC No: 31004023

The Lankelly Foundation – see The Chase Charity

CC No: 256987

The Carole and Geoffrey Lawson Foundation

CC No: 801751

Stilemans, Munstead, Godalming, Surrey GU8 4AB

Tel: 01483 420757
Contact: Geoffrey Lawson, Trustee
Trustees: Geoffrey Lawson; Carole Lawson; Harold Connick.
Beneficial area: UK.
Grant total: £310,000 (2000/01)
Arts grants: £114,320
This foundation's policy is to consider appeals from charitable causes with a previous track record covering the welfare of children, relief of poverty, advancement of arts and education. Arts funding is generally directed towards established national organisations, as shown by the annual donation to Royal Opera House Trust, which is usually for between £50,000 and £60,000.

In 2000/01 the foundation gave a total of almost £310,000 in 13 grants ranging from £500 to £135,000; most were between £5,000 and £40,000. Grants relevant to this guide totalled £114,320 (37% of total grant-aid) and were

disbursed to the following three recipients:
*Royal Opera House Trust (£56,820);
Barbican Centre (£40,000);
London Symphony Orchestra (£17,500).

The overall level of funding outlined above is higher than in previous years, as a result of a donation received for £323,000. The foundation's income is usually significantly lower and solely derived from dividends receivable on UK equities and bank interest.

The Leathersellers' Company Charitable Fund

CC No: 278072

15 St Helen's Place, London EC3A 6DQ

Tel: 020 7330 1444
Contact: Captain J Cooke, Clerk
Trustees: The Wardens and Society of the Mystery or Art of the Leathersellers of the City of London ('The Leathersellers' Company').
Beneficial area: UK.
Grant total: £2,160,000 (1999/2000)
Arts grants: £34,000
The fund supports 'registered charities associated with the Leathersellers' Company, the leather and hide trades, education in leather technology and for the welfare of poor and sick former workers in the industry and their dependants. Thereafter financial support is provided to registered charities associated with the City of London and its environs. Support is provided to charitable objectives of education and sciences, relief of those in need, welfare, disabled, children and youth, medicine and health, the arts, the advancement of religion and the environment'.

Three types of grant are available:
- single grants;
- guaranteed annual grants: a fixed sum paid for a period of four years;
- recurrent grants: fixed or variable annual payments made for an indefinite

period or variable annual sums paid for a fixed period.

In 1999/2000 the fund gave a total of almost £2,160,000 in 169 grants to institutions (totalling £2,157,000) and 41 grants to individuals (totalling £2,451). Grants of £5,000 or more, 65 in all, were listed in the annual report and accounted for nearly half of total funding. The recipient of the largest grant, Colfe's Educational Foundation, is a connected charity of the Leathersellers' Company Charitable Fund which receives annual support. The grant of £764,000 was, however, exceptional and largely accounts for a substantial rise in the fund's overall charitable expenditure. The remaining specified grants ranged between £5,000 and £200,000, the majority of which were under £30,000. Out of the total specified grants, £34,000 (two per cent of total grant-aid) was given in the following three arts-related donations:

★Guildhall School of Music and Drama (£19,000);
★Lambeth Palace Library (£10,000);
★National Art Collection Fund (£5,000).

All of the grants over £5,000 were disbursed to previous beneficiaries.

Exclusions: Organisations not registered as charities.

Applications: In writing to the correspondent. 'It should, however, be noted that before an award is made, the charity is thoroughly investigated and visited which, of necessity, limits the number of appeals capable of being processed in any one year.'

The Leche Trust

CC No: 225659

84 Cicada Road, London SW18 2NZ

Tel: 020 8870 6233; Fax: 020 8870 6233
Contact: Mrs Louisa Lawson, Secretary
Trustees: Mrs Primrose Arnander, Chair; Dr Ian Bristow; Mrs Felicity Guinness; Mr Simon Jervis; Mr John Porteous; Sir John Riddell; Mr Simon Wethered.

Beneficial area: UK.
Grant total: £167,000 (1999/2000)
Arts grants: £104,869

This trust gives priority to the following charitable purposes:

- preservation of buildings and their contents, primarily of the Georgian period;
- repair and conservation of church furniture, including such items as monuments or bells, but not for structural repairs to the fabric; preference is given to objects of the Georgian period;
- assistance to the arts and for conservation, including museums;
- assistance to organisations concerned with music and drama;
- assistance to students from overseas during the last six months of their doctoral postgraduate studies in the UK.

In 1999/2000 the trust gave grants, which were one-off rather than recurrent, within the following categories: arts; historic buildings; churches; education (institutions/museums); education (individuals); overseas students. Grants totalled £167,000 in 71 donations ranging from £170 to £10,000, although most were between £1,000 and £5,000. Out of this total, £50,588 was awarded in 25 grants within the arts category, with a further 17 art-related donations listed under other headings. This brought total funding relevant to this guide to £104,869 (63% of total grant-aid). Arts-related grants included:

Under 'arts' –
Royal Academy of Music; English National Opera (£6,000 each);
Yolande Snaith Theatredance (£3,000);
Clonter Opera; Aestas Musica; Tete a Tete Production (£2,000 each);
★Companie of Dansers; Women's Playhouse Trust; Arts Development in East Cambridgeshire (£1,000 each);
Lionel Tetris International Viola Competition (£500).

Under 'education (individuals)' –
Central School of Ballet; Aldeburgh,
Britten–Pears Baroque Orchestra, first
of three annual donations (£5,000
each);
★National Youth Orchestra (£1,000).
*Under 'education (institutions and
museums)'* –
Tate Gallery; Fitzwilliam Museum; Sir
John Sloane's Museum (£5,000 each);
Dulwich Picture Gallery (£4,850);
European Opera Centre, Manchester
(£3,000).

Exclusions: British students other than
postgraduate music students; religious
bodies; overseas missions; schools or
school buildings; social welfare; animals;
medicine; expeditions.
Applications: In writing to the
correspondent. Trustees meet three times
a year, in February, June and October.
Bursaries are usually awarded to favoured
institutions rather than directly to
individuals.

The Professor Charles Leggett Fund – see Musicians' Benevolent Fund

CC No: 228089/0001

Lord Leverhulme's Charitable Trust

CC No: 212431

Plumtree Court, London EC4A 4HT

Contact: The Trustees
Trustees: A E H Heber-Percy; A H S
Hannay.
Beneficial area: UK, especially Cheshire
and Merseyside.
Grant total: £857,000 (1999/2000)
Arts grants: £108,700
This trust has general charitable purposes.
Support is given to major national appeals
and other charities, with preference given
to those in Cheshire and Merseyside
where Viscount Leverhulme had resided.
There are no guidelines for applying for

grants, but all applications are said to be
reviewed by Viscount Leverhulme and the
trustees.

The trust operates two specific funds in
addition to a general fund: one generates
£30,000 a year which is paid to the
National Museums and Galleries on
Merseyside, the trustees of the Lady Lever
Art Gallery; the second is the Lord
Leverhulme's Youth Enterprise Scheme,
the income from which is used to
reimburse the Prince's Youth Business
Trust with money loaned to young
people in the Wirral and Cheshire areas.

In 1999/2000 the trust gave a total of
£857,000, including the two donations
detailed above, and a further 149 grants
ranging between £25 and £101,000.
Most grants were for £15,000 or less.
Out of this total, £108,700 (13% of total
funding) was given in 19 arts-related
grants, including four individuals assisted
under the Youth Enterprise Scheme.
Grants included:
★Lady Lever Art Gallery Annuity Fund
(£30,000);
London String Quartet Foundation
(£15,000);
★National Museums and Galleries on
Merseyside (£12,000);
Clonter Farm Music Trust; Grosvenor
Museums Society; Shropshire
Regimental Museum (£10,000);
Mountview Theatre School (£1,925);
★Little Singers of St Joseph Society
(£1,000);
Shakespeare Globe Trust (£200).

Exclusions: Individuals; organisations
not registered as charities; general appeals.
Applications: In writing, addressed to
the trustees, setting out details of the
appeal, including brochures or related
literature.

Maisie Lewis Young Artists' Fund – see The Worshipful Company of Musicians

CC No: 264433

Linbury Prize for Stage Design – see Linbury Trust

The Linbury Trust

(see also the Sainsbury Family Charitable Trusts)

CC No: 287077

Tel: 020 7410 0330
Contact: Michael Pattison, Director
Trustees: Lord Sainsbury of Preston Candover; Lady Sainsbury; Miss J S Portrait.
Beneficial area: UK and overseas.
Grant total: £5,734,000 (2000/01)
Arts grants: £1,718,000
'The trust is one of the Sainsbury Family Charitable Trusts which share a common administration, but are otherwise independent of each other.' Its grants are given within the following categories: arts and art education; chronic fatigue syndrome research; drug abuse; education; environment and heritage; medical; social welfare; third world education and social welfare. Priority is given to charities with which trustees have a particular interest, knowledge or experience.

In 2000/2001 the trust gave a total £5,734,000 in revenue and capital grants. This was distributed as follows:

- arts and art education – £1,548,000 (27%);
- chronic fatigue syndrome research – £345,000 (6%);
- drug abuse – £95,000 (1%);
- education – £2,065,000 (36%);
- environment and heritage – £324,000 (6%);
- medical – £125,000 (2%);
- social welfare – £553,000 (10%);
- third world education and social welfare – £679,000 (12%).

Although the trust is committed to supporting flagship national institutions in the visual and performing arts, funding relevant to this guide in 2000/01 was not restricted to the arts and art education category. Support was also given to arts

projects performing social welfare functions or concerned with heritage. A total of £1,718,000 (30% of total funding) was given in 39 arts-related grants. The size of donation was only specified for grants of over £10,000, which included:

Under 'arts and art education' –
★Tate Britain, towards new temporary exhibition galleries (£1,000,000);
Dulwich Picture Gallery, for development programme (£125,000);
★Royal Opera House, towards a revival of Swan Lake, securing archives from Dame Margot Fonteyn's estate, and towards the Anthony Dowell gala (£88,645);
★Linbury Biennial Prize for Stage Design (£73,859);
★South African Rambert Dance Scheme, for students from South Africa to study at the Rambert School of Dance (£49,617);
Wimbledon School of Art, Linbury Teaching Fellowship in Life Drawing and towards Centre for Drawing (£49,200);
Foundation for Young Musicians, to help talented children in London with music tuition (£25,000);
Chamber Music 2000 Trust, for project to commission new music (£10,000).

Under 'environment and heritage' –
Foundling Museum, to underwrite the museum's capital appeal and conserve six major 18th century paintings (£100,000).

Under 'social welfare' –
London Connection, towards ArtSpace project coordinator's salary (£45,000);
Heart and Soul, supporting arts activities for young people in South London (£15,000);
Age Exchange Theatre Trust, reminiscence and theatre work with the elderly (£10,000).

Linbury Prize for Stage Design

It is worth giving readers some more information about this prize, which is

administered separately by Kallaways on a biennial basis. Lady Sainsbury chairs the selection committee. Young designers at the start of their careers work with professional directors to realise new productions with a design commission worth £3,000 and production support of £6,000.

From 150 graduating stage designers, about 20 are chosen in July for an exhibition at the Royal National Theatre in August. Of these, 12 are then selected to work through the summer with four companies, before exhibiting their work at the Royal National Theatre in November. The three prize winners and commission holders are chosen to work with four companies on actual productions in the following year.

Exclusions: Individuals.

Applications: The trustees met 10 times in 2000/01. Although unsolicited applications are only successful occasionally, all applications are considered on their merits. 'Applicants are always required to provide a detailed budget for their proposal and up to date audited accounts with a copy of the most recently published annual report.' See the entry under Sainsbury Family Charitable Trusts for address and application procedure.

The Ruth & Stuart Lipton Charitable Trust

CC No: 266741

Lewis Golden & Co, 40 Queen Ann Street, London W1M 0EL

Tel: 020 7580 7313
Contact: N W Benson, Trustee
Trustees: Mr N W Benson; Mr S A Lipton; Mrs R K Lipton.
Beneficial area: UK.
Grant total: £62,000 (1998/99)
Arts grants: £50,025

The trust has general charitable objects but tends to focus its giving on the arts and Jewish causes. Its founder and trustee,

Stuart Lipton, is a director of both Royal Opera House Covent Garden Limited and Royal Opera House Developments Limited. These personal interests are reflected in the trust's recurrent grants to its major beneficiary, the Royal Opera House.

In 1998/99, the latest year for which an annual report was on file at the Charity Commission, the trust gave a total of over £62,000 in 16 grants of between £25 and £33,500; most were under £1,000. Out of this, £50,025 was given to the following four arts causes:

*Royal Opera House (£33,500);
*Royal National Theatre (£16,025);
Chicken Shed Theatre; London
　Philharmonic Orchestra (£250 each).

The Lloyds TSB Foundation for England and Wales

CC No: 327114

PO Box 140, St Mary's Court, 20 St Mary at Hill, London EC3R 8NA

Tel: 020 7204 5276; Fax: 020 7204 5275
E-mail: guidelines@lloydstsbfoundations.org.uk
Website: www.lloydstsbfoundations.org.uk
Contact: Kathleen N Duncan, Director General
Trustees: Joanna Foster, Chair; Prof. Murray Stewart, Deputy Chair (South West); Revd Rachel Benson (North East and Yorkshire); Virginia Burton (South East); Jacqueline Carr (London); Dr Christine Kenrick (West Midlands); Dr Pauleen Lane (North West); John Penny; Howard Phillips (East of England and East Midlands); Linda Quinn (Wales); Karamjit Singh; Colin Webb.
Beneficial area: England and Wales.
Grant total: £22,156,000 (2000)
Arts grants: £712,482

This foundation gives support to voluntary organisations assisting disabled and disadvantaged people. Core funding accounts for around half of its annual

charitable expenditure. *Support is given to the arts only where projects improve participation in, and access to, the arts and the national heritage, particularly for disabled people, as well as for those disadvantaged by youth, age, infirmity, poverty or social and economic circumstances.*

The majority of the foundation's support is allocated to ten regional areas with representative trustees and coordinators. These are East Midlands; East of England; Greater London; North East; North West; South East; South West; Wales; West Midlands; and Yorkshire. The foundation can provide potential applicants with contact details for the relevant coordinator, with whom projects should be discussed before submitting an application.

The foundation also makes donations through its national programme for England and Wales, which includes a 'new initiatives' budget for pilot or developmental work. 'The trustees are keen to support collaborative work (organisations working together) within the sector and have set aside funds specifically for this purpose.'

The foundation's general concerns are defined as follows:

Social and Community Needs
A wide range of activities including advice services; community relations; community services; cultural enrichment; disabled people; and promoting health.

Education and Training
Aiming to 'improve learning opportunities for disabled and disadvantaged people of all ages'. Examples include lifelong learning; reading and writing skills; pre-school education; promoting skills that help people to live independently; and training for disabled and disadvantaged people.

Areas of Special Interest
In addition to its general priorities, the foundation has the following three 'Areas of Special Interest':

Family Support
Helping to 'develop and strengthen organisations, programmes and projects which improve the quality of family life'. This programmes' aims are to:
- 'help men play a more active role in parenting and caring;
- develop and improve relationships between people of different generations;
- help young people, especially those who are in or leaving care, to develop skills they will need throughout their life;
- support families who have to cope with challenging behaviour'.

Challenging Disadvantage and Discrimination
Focusing on work raising awareness of these issues and encouraging involvement. The foundation aims to:
- 'help disadvantaged people take part in decision-making processes which affect their lives;
- promote understanding and encourage solutions which deal with disadvantage and discrimination;
- challenge disadvantage and discrimination within the area of mental health'.

Helping to Make the Voluntary Sector More Effective
Focusing on work to 'improve management skills and to encourage charities to work together and share good practice'. Grants are given to:
- 'support the development of regional voluntary sector networks;
- encourage people to communicate and work together;
- support the training of trustees, management, staff and volunteers;
- encourage organisations to review and assess how effective they are'.

In 2000 the foundation gave a total of £22,156,000 in 3,871 grants ranging from £100 to £150,000. Regional support was generally for up to £5,000 for projects outside the areas of special

interest and up to £10,000 for those within them. Funding for national causes was mainly between £10,000 and £30,000 and often given on a recurrent basis. A total of £712,482 (three per cent) was given in 173 arts-related donations. These included:

Under 'East Midlands' –

Musicspace Trust, for music therapy work (£8,500);

J R B Arts Foundation, arts and music classes for people with disabilities; New Perspectives Theatre Company, audience development programme (£5,000 each).

Under 'East of England' –

Dance East, dance development programme (£8,000);

Norwich Arts Centre, opportunities for artists with disabilities (£4,000);

Iceni Orchestra, music workshops in disadvantaged areas (£3,000).

Under 'Greater London' –

Studio Upstairs, education programme (£10,000);

Chicken Shed Theatre Company, inclusive children's and youth theatre (£5,000);

Independent Photography Project, photographer and tutor's costs (£1,400).

Under 'North East' –

North Tyneside Art Studio, core funding (£6,000);

ISIS Arts, transportation costs (£4,500);

Spotlight Film and Drama, core funding and equipment costs (£2,500).

Under 'North West' –

Theatre in Prisons and Probation Centre, manager's salary (£10,000);

Northern Kids Theatre Company, core funding (£5,000);

Chester Summer Music Festival (£1,000);

Toxteth Educational Trust, theatre workshops (£250).

Under 'South East' –

Music for Change, core funding (£8,000);

Generation Arts Project, training for disaffected young people (£5,000);

Arts in Healthcare, project evaluation costs (£1,500).

Under 'South West' –

Current Account Theatre Project, drama workshops on discrimination (£9,000);

Disabled Actors Theatre Company, tour of actors with disabilities (£3,000);

Gloucestershire Dance Project, core funding (£2,000).

Under 'Wales' –

Mid Wales Opera, touring productions in isolated areas (£2,500).

Under 'West Midlands' –

Albatross Arts Project, residencies in prison (£10,248);

Deep Impact Theatre Company, solo dance; Burntwood Bluebirds Marching Display Band (£1,000 each).

Under 'Yorkshire' –

Ilkley Literature Festival, for creative writing video; Music and the Deaf, core funding; Arts Cool, core funding (£10,000 each);

Griffin Youth Theatre, core funding (£2,000).

Under 'England and Wales' –

Victoria & Albert Museum, salary for community arts worker (£28,000);

English Touring Opera, performances for special needs groups (£20,000);

Institute of International Visual Arts, digital art resource for CD-ROM (£4,500).

A further £1,000,000 was given in 3,194 donations of up to £500 through the Staff Matched Giving Scheme.

Exclusions: Organisations not recognised as charities; individuals, including students; general appeals; overseas appeals; sponsorship or marketing appeals; activities which would normally be statutorily funded; schools, universities and colleges, except for projects specifically to benefit disabled students; environment; corporate subscription or membership of a charity; animal welfare; endowment funds; fabric

appeals for places of worship; hospitals and medical centres; loans or business finance; promotion of religion; other grant-giving bodies; fundraising events or activities; expeditions; travel.

Applications: Applicants must obtain a copy of the foundation's guidelines leaflet and an application form. Advice should be sought from the foundation prior to completing the form. For advice about regional funding, contact the appropriate regional office, details of which can be obtained by telephone or from the website. Completed application forms should be sent to the regional office, together with latest annual report and full accounts and a copy of the most recent bank statement.

Trustees meet every three months but forms may be submitted, by post only, at any time. All applications receive a response. Successful applicants may not request further funding for another two years and those not securing funding have to wait one year before reapplying.

The Lloyds TSB Foundation for Northern Ireland

The Gate Lodge, 73A Malone Road, Belfast BT9 6SB

Tel: 028 9038 2864; Fax: 028 9038 2839
Contact: Mervyn Bishop, Secretary
Trustees: Lady McCollum, Chair; Mrs Ann Shaw, Deputy Chair; Mrs B Callaghan; Mr Ian Doherty; Mrs Briege Gadd; Mrs Dawn Livingstone; Mr Roy MacDougall; Mr David Magill; Mrs Angela McShane; Mr David Patton; Mr Denis Wilson.
Beneficial area: Northern Ireland.
Grant total: £1,727,000 (2000)
The Lloyds TSB Foundation for Northern Ireland's income is derived from a shareholding in Lloyds TSB but remains independent from the group. It supports the Northern Ireland community, with a particular emphasis on underfunded charities which enable

people, especially disadvantaged or disabled people, to play a fuller role in the community. Its three main objectives are social and community needs; education and training; and scientific and medical research.

In 2000 the trust gave a total of just over £1,727,000 in 401 grants, the average value of which was £4,307. The trust was not able to provide a list of grants, making it impossible to ascertain the level of funding available to arts causes. Potential applicants should contact the trust directly.

Exclusions: Individuals, including students; applicants outside Northern Ireland; Inland Revenue; animal welfare; environment; activities normally the responsibility of central or local government or any other responsible body; schools, universities and colleges; hospitals and medical centres; sponsorship or marketing appeals; fabric appeals for places of worship; promotion of religion; activities which collect funds for subsequent redistribution; endowment funds; fundraising activities; corporate affiliation or membership of a charity; loans or business finance; expeditions or overseas travel; building work.

Applications: On the trust's application form, together with one additional page of supporting text. Do not send original documents but copies only. Trustees meet quarterly to approve donations. Guidelines are available.

The Lloyds TSB Foundation for Scotland

CC No: SC09481

Henry Duncan House, 120 George Street, Edinburgh EH2 4LH

Tel: 0131 225 4555; Fax: 0131 260 0381
E-mail: karen.l.toughill@lloydstsb.co.uk
Website: www.ltsbfoundationforscotland.org.uk
Contact: Mrs Karen L Toughill, Trust Administrator

Trustees: J D M Robertson, Chairman; A Robb, Deputy Chairman; Prof Sir Michael Bond; Mrs F M W Crighton; Ms R Dhir; Revd R Ferguson; A D F Findlay; Ms S R Moody; J D Scott; Mrs C M A Simpson.

Beneficial area: Scotland.

Grant total: £5,696,000 (2000)

Arts grants: £276,956

The foundation is an independent trust which makes grants to recognised charities in Scotland. Its support is aimed at grassroots causes which enable people to play a fuller role in society, with a particular emphasis on the disabled and disadvantaged. Grants are awarded to a wide range of community groups including the following priority areas: the alleviation of homelessness; rural deprivation; young people; elderly people; creating positive opportunities for people who are mentally or physically disadvantaged; drug and alcohol abuse; minority groups; the infrastructure of the voluntary sector.

The foundation operates a standard grant scheme, which includes 'multi-year awards' and 'one-off awards', and a capital building grant scheme, which provides funding for 'voluntary organisations to access a panel of independent consultants'.

In 2000 the foundation gave a total of £5,696,000 in approximately 600 grants ranging from £280 to an exceptional donation of £100,000 to the Royal Society of Edinburgh; most grants were under £15,000. Arts-related grants totalled £276,956 (five per cent of total grant-aid) and were disbursed to 27 beneficiaries. These included:

Under 'Standard Grant Scheme – Multi-Year Awards' –

National Museums of Scotland, 3rd of 4 payments to fund the Discovery Bus (£50,000);

Project Ability Ltd, 1st of 3 payments towards new artist post (£17,000);

Sense Scotland, 3rd and final payment to meet costs of an arts development officer (£14,257);

Drake Music Project, 1st of 3 payments towards senior tutor's salary (£10,000);

Airborne Initiative Ltd, 1st of 2 payments to part-fund an arts and recreational officer (£9,000);

Survivor's Poetry Scotland, 2nd of 2 payments for salary costs (£7,938);

Children's Classic Concerts, 3rd of 3 payments towards the secretary's salary (£6,000).

Under 'Standard Grant Scheme – One-Off Awards' –

Edinburgh Festival Society, for the salary of the education programme development manager (£25,000);

Borders 1996 Co Ltd, towards the installation of a multi-purpose arts facility (£20,000);

Byre Theatre of St Andrews Ltd, to provide disabled access (£15,000);

Out of the Darkness Theatre Company, project coordinator and musician's fees (£10,000);

Sounds of Progress, towards an opera project involving disabled singers and musicians (£7,350);

Orkney Folk Festival, for tutoring at a special needs school (£2,671);

Edinburgh Puppet Company, for workshop materials (£2,000).

The foundation also encourages staff of the Lloyds TSB Group to raise funds through a Matched Giving Scheme. The foundation will match staff fundraising initiatives up to £500, for community causes which are registered charities that meet the foundation's grant-giving policy. In 2000 an additional £140,000 was given through this scheme.

Exclusions: Organisations not recognised as a charity; individuals, including students; mainstream activities of schools, universities and colleges; sponsorship or marketing appeals; activities primarily the responsibility of central or local government; activities which collect funds for subsequent

redistribution to others; general appeals, endowment funds; loans; expeditions or overseas travel; historic restoration.

Applications: Using the foundation's application pack which can be obtained by contacting the administrator or from the website and includes full guidelines.

Standard Grant Scheme – Only one A4 double-sided supplementary sheet of supporting information will be viewed by the trustees. Applications may be submitted at any time; the trustees meet six times each year, usually in the first week of February, April, June, August, October and December. Applications should be submitted at least three months in advance.

Capacity Building Grant Scheme – Areas funded include financial management; fundraising planning; good governance; IT; marketing; strategic planning; and staff development. Applications are considered at three of the trustees six meetings. In 2001 these were in April, August and December.

The Ludgate Trust – see Musicians' Benevolent Fund

CC No: 259109

Lord and Lady Lurgan Trust

CC No: 297046

45 Pont Street, London SW1X 0BX

Tel: 020 7591 3333; Fax: 020 7591 3300
Contact: Pemberton Greenish (Ref SMB)
Trustees: S D H L Staughton; A J F Stebbings; D S Graves.
Beneficial area: UK, including Northern Ireland; South Africa.
Grant total: £75,000 (2000)
Arts grants: £16,000
The trust's objects are:
- relief and medical care of aged persons;
- medical research, in particular cancer research and the publication of results of such research;

- advancement of education, including education in the arts for the public benefit, through educational and artistic bursaries;
- other charitable purposes.

In 2000 the trust gave a total of over £75,000 in 44 grants, of which 24 were for UK-based causes and 20 went to projects in South Africa. Grants ranged from £713 to £9,000; most were below £5,000. A total of £16,000 (21% of total funding) was given in these three arts-related grants:
★Royal College of Music, bursary for a singer (£9,000);
★Royal Academy of Music, to fund a junior fellowship post (£5,000);
ENO (£2,000).

The Lynn Foundation

CC No: 326944

Blackfriars, 17 Lewes Road, Haywards Heath, West Sussex RH17 7SP

Tel: 01444 454773; Fax: 01444 456192
Contact: Guy Parsons, Trustee
Trustees: Guy Parsons, Chairman; Dr P E Andry; J F Emmott; P R Parsons; Sir David Wilson.
Beneficial area: UK.
Grant total: £117,000 (2000/01)
This foundation supports charities working for:
- the promotion and encouragement of music;
- the promotion and encouragement of art;
- the relief and care of disabled persons;
- the relief and care of aged persons.

Funding is also given in support of masonic charities.

In 2000/01 the foundation gave a total of £117,000. Unfortunately, it was impossible to determine the level of arts funding because there was no breakdown of the distribution of this funding in the annual report. However, given the foundation's charitable objects it is likely

that grants relevant to this guide represented a significant proportion of overall funding.

John Lyon's Charity

CC No: 237725

45 Pont Street, London SW1X 0BX

Tel: 020 7589 1114; Fax: 020 7589 0807
E-mail: jlc@pglaw.co.uk
Contact: Cathryn Pender, Grants Manager
Trustees: The Keepers and Governors of the Possessions, Revenues and Goods of the Free Grammar School of John Lyon.Grants Committee: Prof. M M Edwards, Chair; Prof. D M P Mingos; Mrs G Baker; N Stuart. Co-opted member: David Lindsay-Rea.
Beneficial area: London Boroughs of Barnet, Brent, Camden, Ealing, Hammersmith and Fulham, Harrow, and the Royal Borough of Kensington and Chelsea, and the Cities of London and Westminster.
Grant total: £1,834,000 (2000/01)
Arts grants: £317,850
This charity has general purposes 'for the benefit of the inhabitants of the London Boroughs of Barnet, Brent, Camden, Ealing, Hammersmith and Fulham, Harrow and the Royal Borough of Kensington and Chelsea, and the Cities of London and Westminster'. It particularly focuses on enhancing the lives of young people via grants made within the following categories: education and training; promotion of youth issues; youth clubs and youth services; sport; child care and support for families; special needs/disability; the arts; counselling; housing and homeless. The charity also operates a small grants scheme which supports the above areas but on a smaller scale.

In 2000/01 the charity gave a total of over £1,834,000 in 119 listed grants ranging from £200 to an exceptionally high sum of £622,000 to be given over seven years to the Peter Beckwith Trust

for scholarships. Most grants were below £20,000. Out of this total, £277,250 was within the arts category, though further grants relevant to this guide were made under other headings. Only new grants were specified in the charity's annual report, but taking the additional listed arts-related grants into account, total arts funding for 2000/01 amounted to £317,850 (17% of total grant-aid). The 19 listed arts-related grants included:

Under 'education and training' –
British Library, bookmaking workshops
 for schools (£8,000 p.a. for 3 years);
Drama Workhouse, for workshops
 (£5,000).

Under 'special needs/disability' –
Ealing Music Therapy Trust, running costs
 (£10,000);
Common Ground Sign Dance Theatre,
 sign dance theatre youth festivals
 (£5,000 p.a. for 3 years).

Under 'the arts' –
English National Opera, schools access
 scheme (£30,000 p.a. for 3 years);
Royal Academy of Arts, arts access
 programme (£25,000 p.a. for 2 years);
Byam Shaw School of Art, for bursaries
 (£20,000);
Camden Arts Centre, revenue grant
 (£16,000 p.a. for 3 years);
Foundation for Young Musicians,
 bursaries (£5,000);
Salamander Theatre, project costs
 (£4,500).

Under 'counselling' –
Medical Foundation for the Care of
 Victims of Torture, music therapy costs
 (£6,300).

Under 'small grants scheme' –
Royal College of Art (£1,000);
Dance Junction Company; Complete
 Works Theatre Company (£800 each).

Exclusions: Individuals; organisations not registered as charities; causes outside the geographical area detailed above.

The MA Benevolent Fund – *see The Museums Association*

The Mackintosh Foundation

CC No: 327751

1 Bedford Square, London WC1B 3RA

Tel: 020 7637 8866
Contact: The Appeals Secretary
Trustees: Sir Cameron Mackintosh, Chair; Martin McCallum; Nicholas Allott; D Michael Rose; Patricia MacNaughton; Alain Boublil.
Beneficial area: UK and overseas.
Grant total: £1,109,000 (1999/2000) – see below
Arts grants: £500,000

The foundation concentrates its support on charitable causes in the following fields: 'theatre and the performing arts; the homeless; children and education; medical; community projects; the environment; Bui-Doi Fund; others'. However, the Bui-Doi (meaning 'Dust of Life') Fund, which has used the profits from the musical 'Miss Saigon' to help refugees from Vietnam and other South-East Asian countries, is currently being dwindled down.

The foundation has endowed the study of contemporary theatre at Oxford University (£1.25 million) and continued to finance the provision of accommodation for visiting professors. In addition, up to £1 million has been committed over thirteen years from 1991 to the Royal National Theatre Musical Fund for revivals of classical stage musical productions.

In 1992 the foundation set up a Drama School Bursary Scheme, for which annual auditions are held. Applicants, who must be students on accredited drama courses, should apply through their drama schools. In 1999/2000 six students were funded.

In November 1998 the foundation pledged £500,000 over the following five years, in conjunction with the Arts Council of England and the regional Arts Councils' 'Arts 4 Everyone' (A4E) scheme (the main scheme and not the 'Express' scheme for grants of £5,000 or less). The Arts Councils refer suitable applicants for partnership funding to the foundation for consideration.

In 1997/98 the foundation gave a total of over £1,109,000 in 306 grants. The annual report shows that 238 of these were for £5,000 or less but only the most substantial grants were specified, preventing a full assessment of arts funding. Taking into account the specified support, it may be estimated that grant-aid may have totalled over £500,000. Listed grants included the schemes detailed above and the following:
Almeida Theatre Company Ltd (£50,000);
National Youth Music Theatre; National Student Drama Festival Ltd (£30,000 each).

Exclusions: Religious or political activities.
Applications: Trustees meet in May and November, but 'procedures are in place for grant approval without necessarily having to wait to the half-yearly plenary meetings of the trustees'; a small grants committee meets weekly.

The E D and F Man Ltd Charitable Trust

CC No: 275386

E D & F Man Ltd, Sugar Quay, Lower Thames Street, London EC3R 6DU

Tel: 020 7285 3000
Contact: Miss Anne Cuttill, Administrator/Secretary
Trustees: M J C Stone, Chair; D Boehm; C Brumpton; K R Davis; H A McGrath; S J Nesbitt; A H Scott.
Beneficial area: UK, with a particular interest in London.
Grant total: £245,000 (1999/2000)

Arts grants: £51,000

This trust supports a range of causes including social welfare, medical research and art charities. Its objects are:

- 'to give enhanced support to selected charities'. In 1999/2000 £113,000 (46% of available money) was given to 12 selected charities;
- 'to support charities where members of the staff, pensioners and/or their spouses have a direct personal interest or involvement'. In 1999/2000 £68,365 (28%) was given to 62 charities;
- 'to support the arts in London, particularly where there are reciprocal benefits to members of staff'. In 1999/2000 £41,190 (17%) was given to seven organisations;
- 'to support educational projects'. In 1999/2000 £22,950 (nine per cent) of the available money was given to two organisations'.

In 1999/2000 the trust gave a total of £245,000 in 87 grants ranging from £35 to £12,950, most of which were under £1,000. Out of this total, over £51,000 (21% of total grant-aid) was given in eight arts-related donations. These grants, all of which were recurrent, were as follows:

★Royal College of Arts (£10,000);
★London Philharmonic Orchestra (£7,990);
★Royal Academy of Arts; ★Royal National Theatre; ★Almeida Theatre Company Ltd (£7,050 each);
★Royal Opera House Trust (£5,287);
★Whitechapel Gallery (£5,000);
★City of London Festival (£1,762).

Applications: In writing to the correspondent. Trustees meet quarterly. The trust favours recurrent grants to established causes, limiting the scope for new applications.

The Manifold Charitable Trust

CC No: 229501

Shottesbrooke House, Maidenhead
SL6 3SW

Tel/Fax: 01628 820159
Contact: Miss C C Gilbertson
Trustees: Sir John Smith; Lady Smith.
Beneficial area: UK.
Grant total: £1,330,000 (2000)
Arts grants: £201,000

The trust is particularly concerned with the preservation of buildings, especially parish churches. In addition, grants are made to arts and education, including museums; the environment; and other causes.

The trust normally distributes around £850,000 each year but in 2000 an exceptional £1,330,000 was given in 256 grants, ranging from £50 to a donation of £240,000 to Historic Churches Preservation Trust. The majority of grants were between £1,000 and £5,000. Funding was categorised as follows:

- churches and other historic buildings – £955,000 (72%);
- arts and education, including museums – £306,000 (23%);
- environment – £42,000 (3%);
- other – £21,000 (2%).

A total of £201,000 was given in 16 grants relevant to this guide. These included:

Bodleian Library (£65,000);
Royal Artillery Museums (£50,000);
St Deiniol's Library (£30,000);
★Avoncroft Museum of Buildings (£7,500);
St Just Amateur Operatic Society (£7,000);
Almeida Theatre; ★British Empire & Commonwealth; Gravesham Arts Council; Imperial War Museum; London Symphony Orchestra (£5,000 each);

Kingsway Hall Arts & Theatre
Community Trust; York Early Music
Foundation (£2,000 each);
Pitt Rivers Museum (£1,500).

Exclusions: Individuals; organisations
not registered as charities.
Applications: The trust does not issue
application forms. All applications or
general enquiries should be made in
writing only, by post or by FAX.
Applicants should include the following: a
description of the cause or project; the
amount of money required; how much is
already available or promised; a list of
other sources of funding to which
applications have been made; a copy of
the latest accounts. If the project involves
the conservation of a building, send a
photograph of it and a note about its
history.

'A reply is sent to most applicants
whether successful or not.' Applications
are considered twice a month.

The Michael Marks Charitable Trust

CC No: 248136

5 Elm Tree Road, London NW8 9JY

Tel: 020 7286 4633; Fax: 020 7289 2173
Contact: The Secretary
Trustees: Lady Marks; Prof. C White; Dr
D MacDiarmid.
Beneficial area: UK.
Grant total: £359,000 (1998/99)
Arts grants: £208,045
This trust favours charitable activities
concerned with the environment and the
arts. Funding is mainly given to
established or national charities, often on
a recurrent basis.

In 1998/99 the trust gave a total of
£359,000 in 34 grants ranging from
£200 to £60,000; most were under
£30,000. Out of this, a total of £208,045
(58% of total grant-aid) was given in 13
grants relevant to this guide. These were:
Scottish Poetry Library (£60,000);

*Ashmolean Museum; Bodleian Library,
Oxford; Victoria & Albert Museum
(£25,000 each);
*British Museum; Royal Collection Trust
(£20,000 each);
Courtauld Institute of Art Fund
(£10,000);
Sir John Soane's Museum (£6,500);
*London Choral Society; Theatre
Museum; Vassari Singers (£5,000 each);
English Chamber Choir Society
(£1,245);
Almeida Theatre (£300).

Exclusions: Individuals.
Applications: In writing before July.
Include audited accounts, information on
other bodies approached and details of
funding obtained.

The Martin Musical Scholarship Fund

CC No: 313937

76 Great Portland Street, London
W1N 5AL

Contact: Martyn Jones, Administrator
Trustees: Council of Management of the
Philharmonia Orchestra Ltd: Vincent
Meyer, President; Keith Bragg, Chair;
Mark David, Vice Chair; David Whelton,
Managing Director/Secretary; Peter Fry;
Michael Hurwitz; Justin Jones; Daniel
Salem; Susan Salter; Neil Tarlton; John
Wates.
Beneficial area: UK and overseas.
Grant total: £55,000 (1999)
Arts grants: £55,000
The fund aims to assist exceptional young
musical talent with specialist and
advanced study and to help in bridging
the gap between study and fully
professional status. The upper age limit for
support is 25. The fund supports
individuals with preference given to UK
citizens. Practising musicians as well as
students are eligible but these should be
instrumental performers, including
pianists, preparing for a career on the

concert platform either as a soloist or orchestral player.

Awards are made in the form of tuition fees and/or maintenance grants while studying, both in this country and abroad.

In 1999 the fund gave a total of over £55,000 in grants, including an annual donation for £10,000 to Philharmonia Ltd, whose council of management controls the fund. The remaining £45,550 was distributed in grants to 64 candidates under the fund's awards schemes.

Exclusions: Individuals over the age of 25. It is not the present policy of the fund to support: organists, singers, conductors, composers, or academic students.

Applications: Selection of candidates is by audition. Application forms are sent to prospective candidates during summer. Application forms must be submitted by autumn for consideration for an award for the following financial year beginning in April. Preliminary auditions are held in October or November. Final auditions are held in March. Awards to successful candidates are payable from April. *Prospective applicants are advised to contact the trust for up-to-date application details.*

Sir George Martin Trust

CC No: 223554

76 Main Street, Addingham, Ilkley, West Yorkshire LS29 0PL

Contact: Secretary
Trustees: T D Coates, Chair; M Bethel; R F D Marshall; P D Taylor.
Beneficial area: UK, with preference for Yorkshire, particularly Leeds, Bradford and the old West Riding.
Grant total: £332,000 (2000/2001)
Arts grants: £17,000
The trust gives in the following categories: arts projects; the environment; church restoration schemes (for all types of denominations); church outreach projects (also multi-denominational); youth projects; play groups, scouting, Yorkshire School's Exploring Society, toy libraries; the aged; education; medical schemes; medical research; general.

Capital rather than revenue grants are preferred, as are charities which have not previously been recipients of state funding.

In 2000/2001 a total of £332,000 was given in over 170 grants of up to £33,000. Only grants of over £5,000 were listed in the trust's annual report even though most grants were for less than this amount. Grants relevant to this guide accounted for 5.2% of total funding, although only two donations were specified. These were National Coal Mining Museum and Yorkshire Ballet Seminars (£5,000 each).

Note: *The trust is constantly inundated with requests for arts, and particularly music-based, support and, as a result, this area of funding has now been severely curtailed and related applications are unlikely to be successful.*

Exclusions: Individuals; education in areas supported by the state; postgraduate courses; publications; seminars; organisations without charitable status. The trust does not like to fund projects which were formerly statutorily funded and 'prefers to adopt a one-off policy in terms of its giving'.

Applications: In writing to the correspondent. Applicants should note the above guidelines on the trust's policy for giving to music and the arts, where there is very little scope for new applicants. Occasionally, however, arts-related grants have been made in other categories, **but only where arts are employed as a medium for work within the primary subject area of these categories, rather than arts for arts' sake**. Guidelines are available from the trust.

The trustees meet in the middle of June and December each year. Only applications qualifying for consideration by the trustees will be acknowledged. Telephone calls are not encouraged.

The Matthews Wrightson Charity Trust

CC No: 262109

The Farm, Northington, Alresford, Hampshire SO24 9TH

Contact: Adam Lee, Secretary
Trustees: Miss Priscilla W Wrightson; Anthony H Isaacs; Guy D G Wrightson; Miss Isabelle S White.
Beneficial area: UK and some overseas.
Grant total: £116,000 (2000)
Arts grants: £25,950
This trust favours smaller charities seeking funds of less than £25,000 and does not usually support large national charities. It has a preference for 'innovation, Christian work and organisations helping the disadvantaged to reintegrate into the community'.

Donations are also occasionally made to individuals, particularly students. Grants are generally made in 'units' which in 2000 were £400, although a larger, recurrent grant is given to the Royal College of Art for student bursaries.

In 2000 the trust gave a total of £116,000, which was classified in the annual report as follows:

- arts – £25,950 (22%);
- Christian causes – £12,200 (10%);
- handicapped etc. – £15,000 (13%);
- individuals – £6,450 (6%);
- medical – £17,850 (15%);
- old etc. – £800 (1%);
- rehabilitation – £8,550 (7%);
- worldwide – £5,200 (4%);
- youth – £21,970 (19%);
- miscellaneous – £3,000 (3%).

Although all beneficiaries were listed, the purpose of each grant was not specified, making it difficult to determine the precise distribution of arts-related support. Grants relevant to this guide included:

*Royal College of Art, hardship and industrial production awards (£13,000);

Pro Corda, the national school for young string players (£10,000);

Arts Interest Group; Boilerhouse Theatre Company; GridIron Theatre Company; *Live Music Now!; Parasol Theatre for Children (£400 each);

*H H H Concerts (£250);

Wells Museum (£200).

The trust states that 'apart from the two large donations, arts is not a major funding priority and new charities to receive donations are few'.

Exclusions: Unconnected churches, village halls, schools; animal charities.

Applications: In writing, including latest report and accounts. *No telephone enquiries regarding the donations policy should be made. If in doubt, applicants should first make a written enquiry before applying.* The trustees are sent covering letters only (1–2 pages) monthly, and meet at six-monthly intervals for policy and administrative decisions.

Non-qualifying applications are not reported to the trustees. Replies are only sent to successful applicants or if a SAE is enclosed. Allow up to three months for an answer.

The Mayfield Valley Arts Trust

CC No: 327665

c/o Irwin Mitchell, St Peter's House, Hartshead, Sheffield S1 2EL

Tel: 0114 276 7777
Contact: J M Jelly, Administrator
Trustees: A Thornton; J R Thornton, Treasurer; Priscilla M Thornton; D Whelton; D Brown.
Beneficial area: UK, with a preference for the Sheffield area.
Grant total: £115,000 (1999/2000)
Arts grants: £115,000
This trust was 'established for the advancement of education by the encouragement of art and artistic activities of a charitable nature, with particular reference to music and the

promotion and presentation of concerts and other musical events and activities'. The trust directs its support towards recurrent beneficiaries. Any remaining funds may be available to causes specifically concerned with chamber music.

In 1999/2000 the trust gave a total of over £115,000 in eight grants, all of which were relevant to this guide. These were:
* Wigmore Hall (£48,000);
* Sheffield Chamber Music in the Round (£41,500);
Glyndebourne, for a production (£20,000);
* York Early Music (£17,500);
* Live Music Now! (£8,600);
* International Musicians Seminar, Prussia Cove (£5,000);
* Amadeus Summer Course (£2,000);
Jessie's Fund, performance of Haydn's 'Creation' (£1,000).

Applications: Unsolicited applications are not considered.

The Anthony and Elizabeth Mellows Charitable Settlement

CC No: 281229

22 Devereux Court, Temple Bar, London WC2R 3JJ

Tel: 020 7353 6221
Contact: Prof. A R Mellows, Trustee
Trustees: Prof. Anthony Mellows; Mrs Elizabeth Mellows.
Beneficial area: UK.
Grant total: £73,000 (1999/2000)
Arts grants: £21,462
This trust supports charities in four areas: the arts and national heritage; churches of the Church of England; hospitals and hospices; training and development of children and young people. It should be noted, however, that 'grants for the arts and national heritage are made only to national institutions' and are generally recurrent.

In 1999/2000 a total of over £73,000 was given in 29 grants, ranging from under £500 to £28,656; most were under £5,000. Only grants of over £500 were specified in the trust's annual report. Out of these, a total of £21,462 (29% of total grant-aid) was given in the following four arts-related donations:
* Royal Opera House Trust (£12,925);
* Royal Academy Trust (£6,500);
* Royal Academy (£1,038);
* The Sixteen (£999).

Exclusions: Individuals, including students.
Applications: The trust does not use application forms. Only UK institutions are considered. Grants are made three times a year following trustees' meetings.

The Mercers' Charitable Foundation

CC No: 326340

Mercers' Hall, Ironmonger Lane, London EC2V 8ME

Tel: 020 7726 4991
Contact: H W Truelove, Grants Manager
Trustees: The Mercers' Company.
Beneficial area: UK.
Grant total: £3,277,000 (1999/2000)
Arts grants: £300,000
The foundation makes grants to a very wide range of charities within the following categories: arts; education; heritage; welfare; church. Although, the majority of grants are for under £10,000, major grants are given each year to educational institutions connected with the Mercers' Company and to a small number of church, welfare and arts causes.

In 1999/2000 the foundation gave a total of £3,277,000 in an unspecified number of grants. This level of funding is, however, exceptional and in previous years the grants total has been significantly lower (£1,692,000 in 1998/99; £1,102,000 in 1996/97). Most of the

grants in 1999/2000 were between £1,000 and £15,000, with the majority being for £5,000 or less. Grants over £5,000 were listed in an annual review and included a number of very substantial donations, the largest of which was a donation of £725,000 to Dauntsey's School. A total of £213,000 was given in 15 specified arts-related grants. These were:

Under 'education' –

Royal Ballet School, towards a new senior school in Covent Garden (£100,000).

Under 'arts' –

English National Opera, sponsorship of 'The Pearl Fishers' and a contribution to the benevolent fund (£30,000);

Tate Modern, for an education programme (£15,000);

Glyndebourne Arts Trust, toward the chorus scheme; Museum of the Port of London and Docklands, development costs; Royal School of Needlework, for bursaries (£5,000 each).

Under 'general' –

Textile Conservation Centre, towards bursaries for students taking an MA in textile conservation (£10,000);

Roundhouse Trust, towards a creative writing project for school children; Royal Academy of Arts, towards school guide sheets and workshops; Tate Modern, towards education programme (£5,000 each).

Under 'heritage' –

Civic Trust, towards photographic archive (£8,000);

Bath Museum, towards new exhibition; British Museum, towards the conservation of the Round Reading Room; Royal Artillery Museums, towards establishment of a new museum; St James' Garlickhythe, London, to restore a 1697 organ (£5,000 each).

Since the majority of grants were for under £5,000 and, subsequently, unlisted, it is likely that further donations relevant to this guide were also made. Based on knowledge of funding in previous years, it may be estimated that around £300,000 was given to arts-related causes in 1999/2000.

Exclusions: Circular appeals and unsolicited general appeals; individuals, except in the form of educational support.

Applications: In writing to the correspondent. The trustees meet every quarter.

The Millichope Foundation

CC No: 282357

Millichope Park, Munslow, Craven Arms, Shropshire SY7 9HA

Tel: 01584 841 234
Contact: Mrs S A Bury, Trustee
Trustees: Mrs S A Bury; L C N Bury; Mrs B Marshall.
Beneficial area: UK, especially Birmingham and Shropshire.
Grant total: £187,000 (1999/2000)
Arts grants: £26,350

The foundation funds a wide range of charities with a preference for medical research; disability; the environment; youth; social welfare; and the arts (especially music). Donations are made in response to applications on a one-off basis. Grants are often made over a five-year period in order to allow recipients to forward plan their projects.

In 1999/2000 the foundation gave a total of £187,000 in 168 grants ranging from £50 to £5,000, most of which were under £3,000. Some beneficiaries received more than one donation. Arts funding amounting to £26,350 (14% of total grant-aid) was given in 22 grants. These included:

Trinity College of Music (£5,000);

*Shropshire Heritage Trust (£2,500 in two grants);

*English National Opera (£2,000);

*Royal Academy of Music; *Live Music Now, Scotland; Birmingham

Hippodrome Theatre Development Trust (£1,000 each);
*Ludlow Festival; *Mid Wales Opera; *Sadler's Wells Trust; Midland Youth Orchestra (£500 each);
Jura Music Festival (£100).

The foundation monitors all grants to ensure that funding is used as specified.
Exclusions: Individuals; organisations not registered charities.
Applications: In writing to the correspondent, stating why money is required, how much has been raised already, if any other grants have been given or applied for. Trustees meet twice a year. Applicants are asked not to follow up written requests by phone. Replies will be sent only to those who enclose a SAE.

The Milton Keynes Community Foundation

(for other community foundations see end of trust section)

CC No: 295107

Acorn House, 381 Midsummer Boulevard, Central Milton Keynes, Buckinghamshire MK9 3HP

Tel: 01908 690276; Fax: 01908 233 635
E-mail: information@mkcommunityfoundation.co.uk
Website: www.mkcommunityfoundation
Contact: Grants Manager
Trustees: Stephen Norrish; Michael Murray; Andrew Jones; Francesca Skelton; Juliet Murray; Lady Tudor Price; Peter Kara; Brian Hocken; Simon Ingram; Walter Greaves; Eleanor Milburn; Dorothy Cooper.
Beneficial area: Milton Keynes Unitary Authority Area.
Grant total: £293,000 (1999/2000)
Arts grants: £89,156
This foundation's grants are administered through four main funds: the arts fund; small grants fund; general grants fund; and the development grants fund. Total resources for grants are split fairly evenly between unrestricted and restricted funds.

In 1999/2000 grants were made to the following areas:
- community development (27%);
- youth (17%);
- physical disability (16%);
- arts (15%);
- arts and disability (10%);
- special needs (6%);
- ethnic minorities (3%);
- elderly (3%);
- other (3%).

In 1999/2000 the trust gave a total of £293,000 in 91 grants ranging from £150 to £17,993, most of which were under £5,000. Out of this, £89,156 (30% of total grant-aid) was given to 17 arts-related beneficiaries. These included:
Music Project Milton Keynes (£17,993);
Inter-Action Milton Keynes Limited (£15,800);
Milton Keynes City Orchestra (£7,330);
Living Archive Project (£5,900);
**Arts Association Milton Keynes (£5,150);
Arts Committee Milton Keynes General NHS Trust; Cornelius & Jones Productions (£5,000 each);
Faye Gilbert Production (£4,500);
Heart of England Opera (£4,350);
Bucks Dance (£4,000);
Silbury Group of Artists (£3,400);
Stantonbury Campus Theatre Company (£603).

**paid as part of an umbrella grants programme to be passed on by the association to smaller arts groups and projects.*

Applicants should note that some of the beneficiaries listed above received the specified support in more than one grant and that the maximum award from the arts fund is generally £5,000.
Exclusions: Musical instruments; travel expenses; commercial publications; conferences or seminars; university or similar research, formal education or training; promotion of religion. Individual awards are rare.

Applications: Application forms and guidelines can be obtained from and projects may be discussed before submission with the arts fund consultant.

Deadlines for arts fund applications are 4 January, 3 May, and 6 September.

The Esmé Mitchell Trust

CC No: 48053

The Northern Bank Executor & Trustee Co. Ltd, PO Box 183, Donegall Square West, Belfast BT1 6JS

Tel: 028 9024 5277; Fax: 028 9024 1790
Trustees: P J Rankin; R P Blakiston-Houston; Mrs F Jay-O'Boyle.
Beneficial area: Principally Northern Ireland.
This trust has general charitable purposes, principally in Northern Ireland, with a particular emphasis on cultural and artistic projects. Grants are usually made on a one-off basis to charitable organisations.

Part of the trust fund is designated for certain heritage bodies.
Exclusions: Individuals; routine running costs.
Applications: Applicants should send a description of the proposed project; latest statement of accounts; a copy of the constitution; tax and legal status details; latest annual report; a list of committee officers; details of other income; and contact address and telephone number. Three copies of the above should be supplied. The Inland Revenue Charities Division reference number should accompany the original application.

The Monument Trust

(see also the Sainsbury Family Charitable Trusts)

CC No: 242575

Tel: 020 7410 0330
Contact: Michael Pattison, Director
Trustees: S Grimshaw; Linda Heathcoat-Amory; R H Gurney; Sir Anthony Tennant.

Beneficial area: UK and overseas, with a probable special interest in Sussex.
Grant total: £4,916,000 (2000/01)
Arts grants: £1,761,352
This trust is one of the Sainsbury Family Charitable Trusts which share a joint administration. It was endowed by Simon Sainsbury in 1965, although he has never been a trustee.

The trust makes both capital and revenue grants to 'help prove new ideas or methods that can be replicated widely or become self-sustaining'. Major support is given to arts and environmental projects of 'national or regional importance'. Over many years the trust has also been a consistent supporter of AIDS/HIV related work. Its latest funding policies covered the following: health and community care; AIDS; the environment; the arts; social development; general.

Since most of the trust's grants are made over a number of years, forward commitments are considerable with very limited funding available for new projects.

In 2000/01 the trust gave a total of £4,916,000. Only the largest 50 grants were listed in the annual report and accounts. These ranged from £17,500 to £513,000, although most were under £90,000. Listed arts-related grants totalled £1,761,352 (36% of total funding) in 13 donations. These were:
Under 'the arts' –
★Royal Opera House Trust (£513,000);
★Victoria & Albert Museum (£500,000);
British Museum Development Trust (£200,000);
Cambridge Foundation (£146,000);
★Royal Ballet School (£125,000);
Fitzwilliam Museum (£80,000);
★Royal Academy of Arts (£60,893);
★Wallace Collection (£25,000);
★National Gallery Trust (£20,000);
University of Westminster (£17,500).
Under 'social development' –
★Clean Break Theatre Company (£30,000);

Arts Factory (£18,000).
Under 'the environment' –
Horniman Museum (£25,000).

Exclusions: Individuals.
Applications: 'Proposals are generally invited by the trustees or initiated at their request. Unsolicited applications are discouraged and are unlikely to be successful, even if they fall within an area in which the trustees are interested.'

However it is also said that an application to one of the Sainsbury trusts is an application to all. See the entry for the Sainsbury Family Charitable Trusts for the address and further advice.

The Henry Moore Foundation

CC No: 271370

Dane Tree House, Perry Green, Much Hadham, Hertfordshire SGI0 6EE

Tel: 01279 843333; **Fax:** 01279 843647
E-mail: curator@henry-moore-fdn.co.uk
Website: http://www.henry-moore-fdn.co.uk
Contact: Timothy Llewellyn, Director
Trustees: Sir Ewen Fergusson, Chair; Patrick J Gaynor; Sir Alan Bowness; Marianne Brouwer; Professor Andrew Causey; Joanna Drew; Sir Ernest Hall; Margaret McLeod; Lord Rayne; Sir Rex Richards; Greville Worthington; Henry Wrong.
Beneficial area: Worldwide, mainly UK.
Grant total: £1,957,000 (2000/01)
Arts grants: £1,957,000
The foundation was established 'to advance the education of the public by the promotion of their appreciation of the fine arts and in particular the works of Henry Moore. It concentrates its support on sculpture, drawing and printmaking'. The foundation promotes exhibitions and publications about Henry Moore, both nationally and internationally, utilising its own resources of both works of art and archival material.

The foundation makes grants towards exhibitions around the world (at established galleries only); conferences, workshops, symposiums; museum and gallery acquisitions of sculpture; conservation work and research; publications which encourage public interest in sculpture; and minor capital projects, primarily those designed to provide improved facilities for the exhibition of sculpture. Grants to exhibitions comprise the largest element in the donations programme. Grants are usually one-off, though support over two or three years is possible. The foundation funds fellowships and bursaries for artists and art historians at appropriate institutions, concentrating on post-doctoral research projects.

The foundation also works in conjunction with Leeds City Council to operate the Henry Moore Institute, which 'curates the city's sculpture collections and promotes the study of sculpture through exhibitions in its galleries, publications and research'.

In Autumn 2000 a contemporary projects programme was established, through which the foundation initiates collaborative work in association with key contemporary arts organisations.

In 2000/01 the foundation gave a total of £1,957,000 in an unspecified number of grants, bursaries, awards and scholarships. Projects supported included:
Under 'sculpture fellowships' –
Two-year fellowships for individuals at Derby University; Newcastle University; Ruskin School of Art, Oxford; British School at Rome; and Duncan of Jordanstone College of Art and Design, Dundee.
Under 'post-doctoral research fellowships' –
Two-year fellowships for scholars who have recently completed doctoral theses

on sculptural topics. Given to individuals at University of York; Courtauld Institute of Art; University of Essex; and University College London.

Under 'postgraduate bursaries' –

Individuals at Leeds University and Courtauld Institute of Art.

Under 'research projects' –

Courtauld Institute of Art; National Life Story Collection, Artists' Lives Project; Royal Academy of Arts, student research projects; Royal College of Art, student research; Scottish Sculpture Trust, archive cataloguing.

Under 'conservation' –

National Museums and Galleries on Merseyside, collection of African sculpture; Tate Gallery, London, William Turnbull's 'Transparent Tubes'; University College London, restoration of the Flaxman Gallery.

Under 'conferences' –

Victoria & Albert Museum, Oak, Box, Pear, Lime: Sculpted Wood 1500–1900.

Under 'acquisitions' –

Pieces of work for: Leeds Museums and Galleries; Scottish National Gallery of Modern Art; and Contemporary Art Society, London.

Under 'sculpture commissions' –

Beneficiaries included Royal Society of Arts and North Kesteven District Council.

Under 'publications' –

Grants towards the production of books on sculpture to publishers including Association for Cultural Change; Public Monuments and Sculpture Association; Yorkshire Sculpture Park; Victoria & Albert Museum; and Ruskin School of Drawing and Fine Art.

Under 'exhibitions' –

Ikon gallery, Birmingham; Design Museum, London; Fruitmarket Gallery, Edinburgh; Centre for Contemporary Art, Glasgow; Bleddfa Centre for the Arts, Powys; Camden Arts Centre, London.

No indication was given as to the size of the above grants.

Exclusions: Grants are not made to individual artists, except for fellowships. The foundation 'cannot fund on a regular basis revenue expenditure of galleries and other publicly supported institutions'. In addition, 'no grant (or part of any grant) may be used to pay any fee or to provide any other benefit to any individual who is a trustee of the foundation. Please advise whether it is envisaged that any trustee will have an interest in the project in respect of which a grant is sought'.

Applications: In writing to the correspondent, from whom guidelines are available. There are no application forms; 'all applicants should however cover the following points:

- the aims and functions of the organisation;
- the precise purpose for which a grant is sought;
- the amount required and details of how that figure is arrived at;
- details of efforts made to find other sources of income, whether any firm commitments have been received, and what others are hoped for;
- details of the budget for the scheme and how the scheme will be monitored.

'Applications may include supporting material, which will be returned if requested. (It should be noted that brevity is welcomed.)'

Applications should not be made by telephone or in person. The trustees meet in January, April, July and October for which applications need to be sent two months in advance.

The Nigel Moores Family Charitable Trust

CC No: 1002366

c/o Macfarlane & Co., 2nd Floor, Cunard Building, Water Street, Liverpool L3 1DS

Contact: P Kurthausen, Accountant
Trustees: J C S Moores; Mrs L M White; Mrs P M Kennaway.
Beneficial area: UK and overseas.
Grant total: £1,233,000 (1999/2000)
Arts grants: £1,198,905

This foundation aims to raise the artistic taste of the public 'whether in relation to music, drama, opera, painting, sculpture or otherwise in connection with the fine arts'. It also promotes education in the fine arts and academic education in general, as well providing support for environmental causes, the provision of recreation and leisure facilities, and the promotion of religion. The foundation has supported institutions which benefit children and young adults; actors and entertainment professionals; musicians; students; and textile workers and designers.

In 1999/2000 the foundation gave a total of £1,233,000 in nine grants – ten times its typical level of funding. This exceptional grant total was largely a result of the receipt of a donation for £1 million. Grants were made to nine beneficiaries, five of which were specifically relevant to this guide. The majority of funding was given in a single donation of £1,109,796 to the A Foundation, while the remaining grants ranged between £500 and £50,000. Arts grants totalling £1,198,905 (97% of total grant-aid) were:

A Foundation (£1,109,796);
New Contemporaries Ltd (£50,000);
Liverpool Biennial of Contemporary Art Ltd (£20,000);
Liverpool Fringe (£16,664);
National Museums and Galleries on Merseyside (£2,445).

In November 2001 the trust stated that it was committed to a number of projects and, as a result, will not consider unsolicited applications in the foreseeable future.

Applications: In writing at any time, enclosing a synopsis of aims and funds required, together with financial statements. However, the trust has usually committed its funds for designated projects, making unsolicited applications unlikely to succeed. Trustees meet three times a year.

The Peter Moores Foundation

CC No: 258224

c/o Messrs Wallwork Nelson and Johnson, Derby House, Lytham Road, Fulwood, Preston, Lancashire PR2 8JF

Contact: Peter Saunders, ref. M139/MJ
Trustees: Mrs Barbara D Johnstone; Trevor Conway; Peter Egerton-Warburton; Ludmilla Andrew; Eileen R Ainscough.
Beneficial area: UK and Barbados.
Grant total: £4,110,000 (1999/2000)
Arts grants: £3,683,000

The foundation's principal aim is 'the raising of the taste of the public whether in relation to music, drama, opera, painting, sculpture or otherwise in connection with the fine arts'. Causes which promote education in the fine arts, academic education or the Christian religion also attract support from the foundation, as does the provision of facilities for recreation and leisure.

Activities supported tend to reflect the personal interests of its founder and patron, Peter Moores, a director of The Littlewoods Organisation, the pools and mail order company. Mr Moores received musical training at university and then worked in opera production at Glyndebourne and the Vienna State Opera. He has sponsored many complete recordings in English of a wide range of

operas, has been a trustee of the Tate Gallery and a governor of the BBC.

Grants are made in the following categories: music (performance); music (recording); music (training); fine art; heritage; youth/race relations; social; health; environment; Barbados.

In 1999/2000 the foundation gave a total of £4,110,000 in 212 grants. Of this, £3,683,000 (90% of total grant-aid) was given in 153 donations to arts-related recipients. Only the major beneficiaries, most of which were concerned with opera or other classical music, were specified in the foundation's annual report. The majority of these received recurrent grants as part of the foundation's ongoing programme. Grants included:

Under 'music (performance)' –
★Royal Opera House (£150,000);
★Glyndebourne Productions (£60,000);
★Almeida Theatre (£50,000);
Wildbad Opera (£25,000).

Under 'music (recording)' –
★Opera Rara, numerous classical recordings including: *La Romanzesca* (£46,751); *Nelly Minciou* (£143,415); *Otello* (£279,517); ★Chandos, recording including: *Carmen* (£190,838); *Il Trovatore* (£207,946); 'Cav and Pag' (£25,830); EMI, for Classics–Masters series (£106,383).

Under 'music (training)' –
★Royal Northern College of Music Scholarship (£68,750);
★Guildhall School of Music (£7,000).

Applications: Prospective applicants should note that the foundation '*will normally support projects which come to the attention of its patron or trustees through their interests or special knowledge. General applications for sponsorship are not encouraged and are unlikely to succeed.*'

The Theo Moorman Charitable Trust

CC No: 283050

14a Oakfield Road, Clifton, Bristol
BS8 2AW

Tel: 0117 973 2380
Contact: Mrs L Harms, Administrator of Awards
Trustees: Miss E Chadwick; Mrs B Cox; Mrs P S Johnstone; Sue Hiley Harris.
Beneficial area: UK.
Grant total: £17,250 (2000)
Arts grants: £17,250

This trust was set up to 'promote the exercise of and maintain the standards of the craft of weaving' through education of students, practitioners and the public in the craft, and to promote knowledge, interest, research and experimental work in the craft.

The trust makes grants biennially. In 2000 the trust gave a total of £17,250 in seven grants to individuals, all of which were relevant to this guide. These were for the following purposes:

- to puchase sample loom (£3,360);
- to create two tapestries for a special project (£3,500);
- three-month sabbatical to develop work (£3,000);
- time to develop work with a calligrapher (£2,390);
- to help finance own weaving archive; to purchase Damask/Harnesk loom (£2,000 each);
- to study linen weaving in Sweden (£1,000).

Exclusions: Non-weavers; applicants who are still studying weaving, or who have worked for less than two years following a course of study; applicants outside the UK.

Applications: Application forms and guidelines are available from the above address. **Applications are only considered in even-numbered years**; the deadline is usually early March.

The Countess of Munster Musical Trust

CC No: 1031783

Wormley Hill, Godalming, Surrey
GU8 5SG

Tel: 01428 685 427; Fax: 01428 685 064
E-mail: munstertrust@compuserve.com
Website:
www.munstertrust.ukgateway.net
Contact: Mrs Gillian Ure, Secretary
Trustees: Leopold de Rothschild, Chair;
Mrs P Arnander; Dame Janet Baker; H
Bean; N Berwin; Viscount Chandos; Sir
George Christie; Dr J Glover; Dr I
Horsburgh; P Jones; Sir John Manduell;
Dr J Ritterman; Anthony Pay; Miss
Louise Williams.
Beneficial area: UK and overseas.
Grant total: £376,000 (2000/01)
Arts grants: £376,000
The trust's primary aim is to support 'the
advancement of education in all branches
of music in any part of the world'. This is
mainly achieved through educational
grants to help music students with the
costs of study. However, assistance is also
given by means of interest-free loans and,
for concert performances, via the trust's
recital scheme.

In 1999/2000 the trust gave a total of
over £376,000, all of which was for
music-related causes. Out of this,
£72,591 was given to support 136
concerts though the recital scheme, and
£303,687 was donated in an unspecified
number of educational grants. In addition,
interest-free loans totalling £40,900 were
offered, following audition, to five young
musicians for the purchase of musical
instruments.
Applications: Contact the secretary for
detailed guidance notes and an
application form. Awards are made for
one year at a time. Auditions take place in
spring and early summer each year for
which applications have to be submitted
between 1 November and 31 January.

Awards commence in the following
September.

Age limits, 'as at 1 September in the
year of their intended studies', are as
follows: over 18 years and under 25 for
instrumentalists; 27 for female singers; 28
for male singers. Upper age limit for
instrument loans is 28 years.

The Museums Association

CC No: 313024

24 Calvin Street, London E1 6NW

Tel: 020 7426 6970; Fax: 020 7426 6961
E-mail: lucie@museumsassociation.org
Website: www.museumsassociation.org
Contact: Lucie Slight, Head of Finance
and Administration
The association administers a number of
funds 'designated to enhance collections
and to aid Museums Association members
and their families in unexpected financial
distress'. These are:
The Beecroft Bequest – Support
deriving from the investment of this
bequest is distributed as grants to art
galleries and museums in the British Isles
for the purchase of pictures and works of
art (furniture and textiles can be
considered) not later than the eighteenth
century in date.
**The Museums Association
Benevolent Fund** – 'The purpose of the
fund is to alleviate financial distress of
members of the Museums Association
and their immediate dependants.'
Applications will be considered for family
related matters such as childcare while a
member or dependant re-skills; respite
care for member or dependant; school
fees; specialist equipment for disabled
living; nursing home fees; following
bereavement or serious illness.
The Daphne Bullard Trust – The
purpose of this trust is 'to promote the
conservation of dress and textiles of all
periods and their display'. It was set up in
1973 on the initiative of the family of the

late Mrs Daphne Bullard, Keeper of Worcestershire County Museum at Hartlebury Castle, to promote the work of dress and costume conservation, display and publication. The trust considers applications from students of or persons engaged in the conservation and study of dress and textiles of any period and their display.

The Kathy Callow Trust – This trust's objective is 'to provide awards with a long-term benefit for the conservation of social history artefacts and evidence in small museums'. It makes awards to small museums for the purposes of assisting with the costs of conservation projects. Such projects might include an exhibition, improving stored collections or running workshops for people connected with museums.

The Trevor Walden Trust – The trust exists to advance the education and training of museum and gallery personnel. It makes four awards to individual members undertaking activities to support continuing professional development leading to the Associateship of the Museums Association. Preference will be given to those paying their own expenses rather than to those subsidised by an employer.

For further information about these funds contact the Museums Association.

Exclusions: Beecroft Bequest: items costing less than £100; grants for items already purchased. Daphne Bullard Trust: living costs; course fees.

Applications: Beecroft Bequest: Aid is restricted to smaller galleries and museums with an annual gross revenue expenditure, net of any debt charges or loan repayments, of £600,000. Grants of 75% can be awarded towards items costing between £100 and £2,000. Grants of 50% can be awarded towards items costing between £2,001 and £4,000. Any single grant cannot exceed £4,000. Grants should represent not less than 25% of the total purchase price.

Items in auction sales are eligible but the trustees cannot guarantee to consider applications at short notice. Applicants should give at least five working days notice. Applications can be made at any time.

Museums Association Benevolent Fund: Applicants must have been an individual member of the Museums Association for three of the previous five years or an individual member for at least 20 years or a dependant of a person satisfying one of these requirements. Application is by letter and decisions will be made quickly.

Daphne Bullard Trust: The maximum grant is £300. Preference will be given to projects aimed at conservation or display of dress or textiles where there is a long-term material benefit to a collection or project. Within 12 months of the date of the award, a progress report on the work assisted by the grant must be made to the trustees. The closing date for applications is 31 May.

Kathy Callow Trust: Aid is restricted to smaller galleries or museums with an annual gross revenue expenditure of less than £600,000. The total sum available each year is approximately £300. The sum awarded will be influenced by the long-term value of the project and the degree of preparatory thought which has been put into determining the content of the work and its costs. The trustees particularly welcome applications on the following aspects of social history conservation: the disadvantaged in society; women; the sea; industrialisation; small localities. Applicants should make clear whether the full cost or part is being sought as a grant. Any other funding bodies who have been or will be approached should be mentioned. Within twelve months of the date of the award, a progress report on the work assisted by the grant must be made to the trustees. The closing date for applications is 31 May.

The Trevor Walden Trust: Deadlines for applications are published in *Museums Journal*.

The Music Sound Foundation

CC No: 1055434

c/o EMI, 4 Tenterden Street, Hanover Square, London WIA 2AY

Tel: 020 7355 4848; Fax: 020 7493 0305
Contact: Jane Orr, Administrator
Trustees: Sir Colin Southgate; Jim Beach; Leslie Hill; David Highes; Steven O'Rourke; Rupert Perry; John Deacon; Jason Berman; John Hutchinson; Richard Holland.
Beneficial area: UK.
Grant total: £433,000 (1999/2000)
Arts grants: £433,000
This foundation, established in 1996, focuses on 'the education of the public and in particular young people in all aspects of music'.

One of the foundation's key activities is carried out in association with the Technology Colleges Trust, through a specialist schools scheme to assist secondary schools to acquire arts college status. 'As a potential arts college, secondary schools are required to raise a minimum £50,000 sponsorship, and the Music Sound Foundation elects to be the major sponsor in each case. Successful schools then receive a capital grant from the DfES of £100,000 and an additional annual grant of £123 per pupil (to a maximum of £120,000) for four years.'

In response to a rising number of tuition fee applications, the foundation moved to 'formalise this area of its activity by providing £5,000 bursaries to a number of key music colleges in Britain'. All future applications for course fees will be referred to relevant institutions. These are Royal Scottish Academy of Music & Drama, Glasgow; Welsh College of Music & Drama, Cardiff; Royal Academy of Music, London; University of Liverpool (Institute of Popular Music); and Birmingham Conservatoire.

In 2000/01 funding totalled £433,000, all of which was arts-related. This included:

- specialist schools scheme – £160,000;
- grants to 'students for purchase of musical instruments, and schools to fund music education' (£165,000).

Exclusions: Music therapy; community projects.
Applications: On a form available from the correspondent. Trustees meet in March and September to consider applications.

The Worshipful Company of Musicians

CC No: 310040

2 London Wall Buildings, London EC2M 5PP

Tel: 020 7496 8980
Contact: S F N Waley
Beneficial area: UK.
Grant total: About £100,000 (2001)
Arts grants: £100,000
The company's main purpose is to administer a number of funds and awards to support musicians. These include:
Carnwath Fund Trust – This trust gives a supplementary prize to the Maggie Teyte Singing competition and a scholarship for an advanced pianoforte student. The scholarship is usually for £4,000 and the donation to the Maggie Teyte prize £500.
Maisie Lewis Young Artists' Fund – The fund assists young artists who could not otherwise afford the expense of attending concerts. A total of about £5,000 is usually allocated.
Allcard Fund – As well as funding scholarships, this fund gives grants to individual musicians. Donations normally total around £15,000.
Priaulx Rainier Fund – The fund gives grants, usually amounting to £10,000,

and an annual Priaulx Rainier Prize of £1,000.

Constant and Kit Lambert Fund – This fund 'provides, at the Royal College of Music, for up to 12 annual prizes of £1,000 each to the most promising students in various specified fields, a fellowship of £12,500 tenable for one or two years and a prize for £7,500 for further research. Surplus income may be applied at the company's discretion in other ways to benefit the Royal College of Music'.

All other trust funds – The Worshipful Company of Musicians also administers 14 Medal Funds and 17 Scholarship and Prize Funds.

Since 2000 the company has also operated the Funding A Future programme in conjunction with Making Music. This scheme, to which the company contributed around £8,000 in 2001, is intended to assist students at the start of their careers. Following successful auditions, young musicians are given the opportunity to perform at music society venues throughout the country. This platform provides invaluable performance experience and, in addition, the chance to establish contacts.

Applications: Further details about any of these funds and how to apply can be obtained from the correspondent.

Musicians' Benevolent Fund (Awards and Trusts Committee)

CC No: 228089

16 Ogle Street, London W1W 6JA

Tel: 020 7636 4481; Fax: 020 7637 4307
E-mail: info@mbf.org.uk
Website: www@mbf.org.uk
Contact: Susan Dolton, Awards and Trusts Administrator
Trustees: MBF Awards and Trusts Committee: Christopher Yates, Chair; Lady Barbirolli; Emma Chesters; Philip Jones; Ron Corp; Dr Philip Cranmer; Ian Fleming; Michael Gough Matthews; Anthony Payne; Frank Renton; Joeske van Walsum; Thea King.
Beneficial area: UK.
Donations to all causes: £250,000
Arts grants: £250,000

The Awards and Trusts committee of the Musicians' Benevolent Fund (MBF) administers a number of schemes to assist musicians with musical education, postgraduate studies, and with specific projects. Support is also available towards the purchase of instruments.

A number of schemes are listed below. However, this is not a complete list and full information should be sought from the fund.

Courtauld Trust for the Advancement of Music

Grant total: (see below)
The Awards & Trusts Sub-Committee of the Musicians' Benevolent Fund administers this trust, which was established in 1945 with the object of 'the encouragement, study, practice and development of the art of music in Great Britain & Northern Ireland'. However, since 1994, no grants have been made, and the most recent report (for 1997) stated: 'The committee has considered the use of this trust and has decided that in future a grant will be made every three years for a string quartet project at a university or conservatoire.' *The MBF are not currently inviting applications to this trust.*

Henry and Lily Davis Fund

Grant total: £20,000 (1999)
This fund's objects are to benefit young musicians by the granting of awards for postgraduate study and sponsoring performance opportunities for young professionals in the instrumental and vocal musical arts. In 1999 awards were made to the National Opera Studio, Clonter Opera Farm and British Youth Opera.

Ian Fleming Charitable Trust
Arts grants: £140,000
The trust provides funding for 'outstanding young instrumentalists and singers at the outset of their performing careers' and to encourage 'outstanding candidates under the age of 28 wishing to undertake a postgraduate musical theatre course'. These objectives are funded via the Ian Fleming Charitable Trust's Music Education Awards and its Musical Theatre Awards respectively. Awards are for up to £5,000 and are made subject to audition.

Myra Hess Trust
Grant total: £13,600 (1999)
This trust is administered from the office of The Musicians Benevolent Fund, which also acts as one of its trustees. Its primary aim is 'the advancement of the education of the public in music, in memory of Dame Myra Hess' who was a distinguished pianist. The trust is managed by a committee whose 'present policy is to make grants to students and young musicians at the beginning of their professional careers for: fees and maintenance at music colleges; private study; the purchase of instruments; debut recital costs'. Recipients are musicians selected by annual audition. In 1999 donations, ranging from £500 to £3,000, were made to nine individuals.

Professor Charles Leggett Trust
Grant total: £13,075 (1999)
The trust aims to benefit needy classical music students through a series of annual awards for young brass and woodwind players. In 1999 awards were made to London Symphony Orchestra Wind and Brass Training Scheme, Royal Scottish Academy of Music and Drama for a Brass Masterclass and individual brass/woodwind players.

Ludgate Trust
Grant total: £30,000 (1999)
The trust's main aims are to provide the following for students: hostel facilities; scholarships, endowments or grants; books, musical instruments and other equipment. These provisions are specifically intended 'for the benefit of students at the Royal Academy of Music or other similar establishments and to assist students to come from abroad to study in the UK'.

The majority of the funding each year has gone to LSO String Experience Scheme and Live Music Now!. In 1999 grants were made to *London Symphony Orchestra String Experience Scheme, *Live Music Now!, Opera Lab and Society for the Promotion of New Music.

Manoug Parikian Award
Grant total: £3,500 (1999)
This annual award is for violinists of any nationality and under 21 years of age and may be used for any purpose. In 1999 awards were made to three individuals.

Geoffrey Shaw Memorial Fund
Grant total: £40,000 (1999)
The fund gives grants to advance the musical education of primary or secondary school children. The current policy is to give modest help to talented young instrumentalists (but not singers) aged under 18 years. The maximum grant is £1,000 towards the cost of an instrument, private tuition or fees at the specialist music schools or the junior departments of the music colleges.

Peter Whittingham Fund
Grant total: £5,000 (1998)
This fund was set up in 1989 to make an annual award in the memory of Peter Whittingham, whose 'particular interest was in the music of Gershwin, Porter, Kern and others. The award is for a project in the creation, performance, teaching, research or study of popular music of quality'. In 1998 three awards were approved.

Applications: The various trusts have different application dates and processes. Contact the administrator for further details.

Musicians' Union

Benson House, Lombard Street,
Birmingham, B12 0QN

Tel: 0121 622 3870; Fax: 0121 622 5361
E-mail: dw1@musiciansunion.org.uk
Website: www.musiciansunion.org.uk
Contact: Deirdre Wilson, Music
Promotions Officer/Secretary to the
Music Promotions Committee
Beneficial area: UK.
The Musicians' Union (MU) plays a
significant role in the promotion of
music, both by compensating for
deficiencies in funding from public
sources and by stimulating entirely new
initiatives.

The MU has been responsible for
assisting musicians to earn their livelihood
through a wide range of musical activity.
In any typical year direct financial
assistance will be granted to around 400
different music organisations, with the
consequent creation of jobs for thousands
of MU members.

The National Art Collections Fund

CC No: 209174

Millais House, 7 Cromwell Place,
London SW7 2JN

Tel: 020 7225 4800; Fax: 020 7225 4848
Contact: Mary Yule, Assistant Director
and Head of Grants
Trustees: Committee: Sir Nicholas
Goodison, Chair; David Barrie, Director;
Rupert Hambro, Treasurer; and 17 others.
Beneficial area: UK.
Grant total: £3,292,000 (2000)
Arts grants: £3,292,000
This fund is Britain's largest independent
art charity and was established in 1903
with the goal of preserving public
collections of art in museums, galleries
and historic properties. The fund also
gives grants 'towards the purchase of
works of art of all kinds, and presents to

museums and galleries works it receives as
gifts or bequests'. It also 'promotes greater
awareness of the importance of art in
everyone's lives'.

The fund receives no government
funding and is entirely dependent on the
support of over 100,000 members. Since
its launch the fund has helped hundreds
of galleries, museums and historic houses
to buy more than 10,000 works of art.
Priority is given according to quality of
art works, relevance to the collections
policy, condition, national, historic or
local importance, and accessibility to the
public.

The fund has also been at the forefront
of many campaigns to save major works
of art from British collections from going
overseas.

In 2000 the fund gave a total of
£3,292,000 to 73 museums and galleries
across the UK towards the acquisition of
works of art. Grants ranged from under
£3,750 to over £370,000 and included:
Ashmolean Museum, Oxford
 (£372,555);
Fitzwilliam Museum, Cambridge
 (£293,000);
National Museum & Gallery, Cardiff
 (£212,282);
National Galleries of Scotland, Edinburgh
 (£175,000);
British Museum, London (£140,813);
Museum of Hartlepool (£27,500);
Walker Art Gallery, Liverpool (£22,600);
National Portrait Gallery, London
 (£21,000);
Aberdeen Art Gallery (£15,876);
Wolverhampton Art Gallery (£8,750);
Dove Cottage, Grasmere (£4,500);
Shipley Art Gallery, Gateshead (£4,132).

Exclusions: Capital costs.

The National Manuscripts Conservation Trust

CC No: 802796

National Preservation Office,
The British Library, 96 Euston Road,
London NW1 2DB

Tel: 020 7412 7048; Fax: 020 7412 7796
E-mail: npo@bl.uk
Website: www.bl.uk/npo/
Contact: The Secretary
Trustees: Lord Egremont; B Naylor; C Sebag-Montefiore.
Beneficial area: UK.
Grant total: £79,000 (2000)
Arts grants: £79,000
The trust's objects are to advance the education of the public through the provision of financial assistance towards the cost of conserving manuscripts of historic or educational value.

In 1999 the trust gave a total of almost £79,000 in 12 arts-related grants, ranging from £475 to £28,290. These were:
Robinson Library (University of Newcastle), towards restoration of the Charles Edward Trevelyan and George Otto Trevelyan papers (£28,290);
*Shropshire Records and Research Service, towards conservation of Bridgnorth Borough collection (£12,000);
Oldham Local Studies and Archives, conservation of Mellodew collection (£10,000);
Somerset Archive and Record Service, for repair of Bath and Wells Diocesan faculty plans for the period 1854-1900 (£9,686);
Cumbria Archive Service, preservation of the Thomas Hayton Mawson archive (£5,000);
Petrie Museum of Egyptian Archaeology (University College London), conservation of Egyptian Books of the Dead (£4,885);
University of North London, conservation and binding of manuscript items from the collections

of the TUC and the Workers' Educational Association (£3,984);
Cambridge University Library, to conserve the Taylor-Schechter Genizah Collection (£3,132);
University of Aberdeen, towards conservation of 16th century Chinese manuscript (£2,500);
Glasgow University Archives and Business Records Centre, conservation of Clerk's Press collection (£1,516);
*Museum of Domestic Design and Architecture (Middlesex University), preservation of the Silver Studio of Design archives (£636);
Library of the Society of Friends, conservation of Books of Ministering Friends (£475).

Exclusions: Individuals; projects outside the trust's objectives.

The Network Foundation

CC No: 295237

3 Churchgates, Church Lane,
Berkhamsted, Hertfordshire HP4 2UB

Contact: Vanessa Adams, The Administrator
Trustees: M Schloessingk; John S Broad; Oliver Gillie; Dr F Mulder; J McClelland; A Bergbaum.
Beneficial area: UK and overseas.
Grant total: £845,000 (1999/2000)
Arts grants: £51,344
The foundation supports 'hopeful, cutting edge projects that will promote social change', which are exclusively researched and selected by members. Grants are made to activities effecting social change in five categories: arts for change; education; health and wholeness; human rights; peace and planet.

In 1999/2000 the foundation gave a total of nearly £845,000 in an unspecified number of grants. The largest 50 donations, ranging from £5,100 to £109,480, were detailed in the annual report; most were £15,000 or less. Although only one arts grant was listed,

for £6,000 to All Change Arts Ltd, the report shows that nine arts causes were supported in all, to a total of £51,344 (six per cent of total funding).

Applications: *The network chooses the projects it wishes to support and does not solicit applications. Unsolicited applications are not considered and cannot expect to receive a reply.*

The Nikeno Trust

CC No: 1043967

PO Box 216, Wadham, East Sussex
TN5 6LW

Tel: 01892 782755
Contact: Elaine Owen, Secretary to the Trustees
Trustees: M M E Rausing; Lisbet Rausing; S M E Rausing; E L Rausing.
Beneficial area: UK.
Grant total: £478,000 (1999)
Arts grants: £120,700
This trust gives grants, mainly on a one-off basis, for a variety of purposes including the arts, education, helping disabled and disadvantaged people and health. Arts-related beneficiaries tend to be well-established national charities, particularly museums.

In 1999 the trust gave a total of £478,000 in 37 grants ranging from £500 to £100,000, most of which were under £5,000. A total of £120,700 (25% of total grant-aid) was given in three grants relevant to this guide. These were: Victoria & Albert Museum (£100,000); Wiener Library (£20,000); Friends of Art Museums of Israel (£700).

Applications: In writing to the correspondent. Only successful applicants will be notified.

The Norman Trust

CC No: 327288

62 Gloucester Crescent, London
NW1 7EG

Tel: 020 7482 4338
Contact: Torquil Norman, Trustee
Trustees: Torquil P A Norman; Mrs E Anne Norman; Caspar J Norman.
Beneficial area: Camden.
Grant total: £138,000 (2000)
Arts grants: £138,000
The trust's main objectives are concerned with the renovation of the Roundhouse in Chalk Farm, Camden 'to provide a performance venue and creative centre for young people' and the provision of help for the disadvantaged through an encouragement of the arts. The trust's operational activities were transferred to the Roundhouse Trust in January 2000 and the vast majority of funding is now designated for the Roundhouse or associated projects.

In 2000 the trust gave a total of £138,000, primarily to the Roundhouse. No further breakdown of funding was given by the trust.

Applications: The trust states that '*for the foreseeable future the Norman Trust is unable to give grants to outside causes, as we are maintaining our resources for the Roundhouse and a limited number of prior commitments*'.

The trust cannot acknowledge the large number of applications it receives.

The Northern Ireland Voluntary Trust

Community House, Citylink Business Park, 6a Albert Street, Belfast BT12 4HQ

Tel: 028 9024 5927; Fax: 028 9032 9839
E-mail: info@communityfoundation.org
Website: www.nivt.org
Contact: Avila Kilmurray, Director
Trustees: Mary Black, Chair; Vivienne Anderson; Maureen Armstrong; Baroness May Blood; Mark Conway; Sammy Douglas; Mari Fitzduff; Jim Flynn; Philip

Mc Donagh; Angela Paisley; Mike Hills; Noreen Kearney.
Beneficial area: Northern Ireland.
Grant total: £13,805,000 (1999/2000)
Arts grants: £404,898

The trust (which was due to change its name in August 2002) aims primarily to fund projects which support community development; initiatives to combat poverty, social exclusion and disadvantage; and the promotion of equity and social justice. Its income is generated by a capital endowment and donations provided by other trusts, the private sector, statutory bodies and individuals. Since 1995 a very high proportion of the trust's resources have been derived from European Union funding under the European Union Peace and Reconciliation Programme.

The Northern Ireland Voluntary Trust (NIVT) currently administers the following funds:

Telecommunity – This programme targets work with 'older people, young people and people with disabilities in community-based organisations in areas of disadvantage'. Grants are usually under £1,000 and total about £50,000 per year.

Northern Ireland Fund for Reconciliation – This fund has an annual budget of around £100,000 and provides small grants of up to £3,000 for peace building and reconciliation.

Social Justice Fund – This fund supports work on human rights, equality and social justice undertaken by voluntary and community groups. Grants total about £100,000 a year in donations of up to £5,000.

NIVT Millennium Awards – These awards, funded by the Millennium Commission, are for an average of £3,000 and given to 300 individuals to build their capacity and use new learning for the benefit of their community. The budget for these awards is £1.1 million over three years.

Youthbank – This is a pilot scheme for a grants programme run by and for young people (under 25). Projects are managed by young people and the programme has a panel of young people who do the assessments and make the decisions. The grants theme in 2002 is citizenship. A total of at least £30,000 will be given in small grants.

EU Programme for Peace and Reconciliation (2000–2004)
The initiatives currently administered through this EU funded programme are as follows:

Pathways to Inclusion – a European Social Fund (ESF) measure for projects 'building the capacity of individuals and communities to deal with the transition to peace by identifying and providing skills gaps which may impede the transition'. Indicative grant levels are for up to £10,000 for 'time-limited' projects and for up to £50,000 a year for a maximum of three years.

Integration and Reconciliation of Victims – an ESF measure to provide support for people most affected by the 'troubles', with a particular interest in projects which encourage the 'empowerment and reintegration' of victims/survivors of the conflict. Funding is available for training, staffing and running costs and support services which enable victims to take part in activities. Indicative grants levels are for up to £10,000 for 'time-limited' projects and for up to £50,000 per annum for a maximum of three years.

Active Citizenship – a European Regional Development Fund (ERDF) measure to 'provide support for people involved in the governance of their communities under the themes of: ICT; civic governance; community led volunteering; and the development of skills of voluntary committees to enhance sustainability of local organisations/ projects'. There is an emphasis on new approaches to building active and

engaged communities. Indicative grant levels: for projects with an IT theme up to £100,000 (closing date: March); demonstration project grants range from £10,000 to £30,000 for up to three years (closing date: June); small grants are up to £10,000 and made on a one-off basis (closing date: March).

Developing Weak Community Infrastructure – an ERDF measure to provide support for 'community involvement and building community confidence. It will focus on geographical areas of high social need characterised by the absence of formal and community activity'.

The programme also administers two major cross-border measures in which the NIVT is a partner:

Developing Cross-Border Reconciliation and Understanding – an ERDF initiative aiming to provide a framework for supporting cross-border projects which 'will make a positive contribution to peace building and reconciliation and promote mutual respect and understanding'. Priority areas include projects promoting social inclusion and diversity in language, cultures and traditions.

Promoting Joint Approaches to Social, Educational, Training and Human Resource Development – an ESF measure for projects making a positive contribution to peace building and reconciliation and developing opportunities for those who have been prevented from fulfilling their potential. Activities aimed at enhancing training, education and social inclusion receive particular emphasis.

In 1999/2000, the latest year for which an annual report was available, the NIVT gave a total of £13,805,000 in 1,094 grants ranging from £160 to £142,522; most were under £20,000. Out of this, £404,898 (three per cent of total grant-aid) was given in 54 grants to arts-related

causes. These grants were made under different policy guidelines to those detailed above. However, they should give some indication as to the current level of arts-related funding and the kind of projects supported. Grants relevant to this guide in 1999/2000 included:

Under 'Regional Community Support Programme' –
Ulster Association of Youth Drama (£1,500);
Enniskillen Photographic Society (£675).

Under 'Cross-Border Community Reconciliation' –
South Belfast Cultural Society (£47,455);
Drake Music Project (£27,500);
Newry Storytelling Group (£450).

Under 'Developing Grass Roots Capacities and Promoting the Inclusion of Women' –
Shankill Community Arts Network (£16,500);
Andersonstown Traditional & Contemporary Music School (£15,000);
Plain Speaking Community Art Initiative (£10,000);
Derry Repertory Theatre Company (£3,000);
Community Arts Forum (£2,800).

Under 'Promoting the Inclusion of Vulnerable Groups' –
Open Arts (31,000 in two grants);
Northern Ireland African Cultural Centre (£30,000);
Northern Ireland Music Therapy Trust (£23,208);
Lilliput Theatre Co. (£2,700).

Under 'Accompanying Infrastructure and Equipment' –
Bright Lights Dance & Drama Group (£1,500);
Arts and Disability Forum (£500).

Exclusions: The trust does not normally fund proposals submitted by individuals; activities where statutory funding is clearly available or where funding difficulties have arisen due to direct cut-back in statutory support; ongoing running costs of established organisations;

major capital building costs; general appeals; travel outside Northern Ireland; work carried out prior to the commencement of the programme; debt repayment; retrospective applications; promotion of political parties or religious denomination.

Applications: The various funds have their own application procedures. Applicants should request information from the correspondent. Up-to-date information is available on the NIVT website (see above).

The Northern Rock Foundation

CC No: 1063906

21 Lansdowne Terrace, Gosforth, Newcastle upon Tyne NE3 1HP

Tel: 0191 284 8412; Fax: 0191 284 8413
E-mail: generaloffice@nr-foundation.org.uk
Website: www.nr-foundation.org.uk
Contact: Fiona Ellis, Director
Trustees: P R M Harbottle, Chairman; D F Baker; D Faulkner; F Nicholson; Lady Russell; J P Wainwright; L P Finn; The Lord Howick of Glendale; Ms J Shipley; J Ward.
Beneficial area: Durham, Northumberland, Teesside, Tyne and Wear, North of England, Scotland.
Grant total: £11,000,000 (2001)
Arts grants: £1,618,879
This large foundation's grant programme is concentrated on the North of England – especially Northumberland, Tyne & Wear, Durham and Teesside – as well as Scotland. Its grant budget has increased since 1998, its first year of funding activity, from £5.79 million to over £11 million in 2001. This is reflective of the 'continued profitability' of its benefactor, Northern Rock plc, from which its funding resources are derived.

The primary concern is the benefit of disadvantaged people, addressing, in particular, 'the causes of social ills as well as their effects'. The foundation endeavours to make donations, over one to three years, that will not only help individual causes but also have an impact on 'the future thinking and planning of regional and national policy makers'. To these ends, 408 grants totalling over £11,000,000 were made in 2001, through the following programmes (figures approximate):

- Empowering People with Disabilities – £2,225,000 (20%);
- Urban and Rural Regeneration – £2,200,000 (19%);
- Helping the Very Young – £850,000 (7.5%);
- Quality of Life in the Third Age – £1,350,000 (12%);
- Creative Communities – £650,000 (6%);
- Outside In – £127,000 (1%);
- Penal Reform – £1,000,000 (10%);
- Big Projects Fund – £1,200,000 (10.5%);
- Exceptional Grants – £1,000,000 (9%);
- Living in the North East – £600,000 (5%);
- Grants for Small Organisations – £250,000 (2%);
- Repeat Grants – £650,000 (6%);
- Other – £220,000 (2%).

A total of £1,618,879 was given in 69 grants relevant to this guide. These were made within the following programmes:

Creative Communities
£639,956 in 41 arts-related grants
The trustees launched this programme in 2000. It was created to encourage the use of the arts and skills of artists in helping communities to grow and develop. The foundation believes that 'involvement in the arts can impact upon a community in real and positive ways' and, through this arts-based programme, supports projects working to help people deal with change and loss; instil confidence and self-worth; promote understanding between different

people and groups; support communities; or improve health. Likely successful applications could include:

- projects combating crime and social exclusion;
- projects giving skills and confidence to young people;
- creative work with prisoners;
- work by artists with youth groups, in factories or other workplaces;
- projects involving the arts in health;
- creative approaches to teaching literacy;
- help for people on low incomes to enjoy the arts as a cultural right.

Arts-related grants included:

Northern Recording, towards the costs of a community music project in County Durham (£70,000);

Ashton Group Contemporary Theatre, towards the cost of a programme leading to the production of 25 community plays in Barrow in Furness (£40,000);

Artransmit, for a programme of arts workshops with disadvantaged young people in and around Greater Manchester (£19,090);

Open Clasp Theatre Company, for a drama project involving young women exploring the issues around teenage pregnancy (£10,000);

Triangle Residents Association, to employ artists to work with residents on a deprived housing estate (£7,000);

West End Resource Centre, to employ an artist to work with the community to redesign the play area (£6,000).

Living in the North East

£467,600 in 10 arts-related grants

Although its primary concern is with people who are in some way disadvantaged, the foundation also aims to make the North East a better place for all the people who live there and, subsequently, more likely to attract new employers and skilled workers.

Applications are invited from charitable organisations helping to contribute to the cultural and environmental well-being of the region. The majority of applicants are expected to be arts and cultural bodies, museums, organisations working on public spaces and environmental projects which benefit a wide public. The programme is intended to maximise public access to projects, not only for the benefit of the inhabitants of the region, but also to encourage visitors to share in its culture and heritage.

This programme is only for the core area of the North East – Durham, Northumberland, Teesside and Tyne & Wear.

Arts grants included:

Brinkburn Music, towards core costs (£150,000);

Northern Stage, to enhance the company's programme (£90,000);

Avison Charitable Trust, for core costs of a North East early music ensemble (£70,000).

*An additional £200,000 has been allocated to support a five-year programme of awards for three writers.

Big Projects Fund

£87,095 in seven arts-related grants

In light of the distress caused to the rural economy by the foot and mouth disease epidemic, the foundation allocated 2001's Big Project Fund towards those affected by the outbreak.

Arts related grants included:

Eden Arts, towards an arts project with schoolchildren dealing with the effects of foot and mouth disease (£25,000);

Wordsworth Trust, to make up loss of income through lower visitor numbers (£20,000);

Sedburgh and District Buildings Preservations Trust, to cover financial losses (£15,000);

Blaize, towards commissioning a play dealing with the impact of foot and mouth (£10,000);

Jack Drum Arts, towards financial losses due to cancelled performances (£4,564).

Empowering People with Disabilities
£67,670 in one arts-related grant
This programme is focused on improving the quality of life of people with learning disabilities and mental health problems. One arts-related grant was made, to Headway Theatre (£67,670) to employ a drama worker to work with learning disabled people.

This programme is only for the core area of the North East – Durham, Northumberland, Teesside and Tyne & Wear.

Helping the Very Young
£128,103 in five arts-related grants
This programme's age range extends from 0 to 11. It is designed to support children to thrive and develop based on the foundation's belief that 'invest in them now and you should ensure brighter prospects tomorrow'. Funding is intended to combat the effects of social disadvantage.

Arts-related grants included:
Children's Warehouse, to promote the use of low-cost materials for creative activities specifically for 0–7 year-olds (£44,652);
Teesside Play and Education Resource Centre, core support for low-cost materials promotion (£40,551);
Monster Theatre Productions Ltd, towards performance costs for a production aimed at the very young (£30,000);
Royal Scottish National Orchestra, towards a project with nursery schools (£10,000).

Outside In – a programme to combat the effects of discrimination on lesbians and gay men
£18,205 in two arts-related grants
This programme is intended to help organisations that try to educate the public and which deal with the consequences of discrimination.

Arts-related grants were:
GALA Scotland, towards a video project involving young lesbians (£9,395);
Black Arts Alliance, to employ artists to work with Black lesbians and gay men (£8,810).

Grants for Small Organisations
£10,250 in two arts-related grants
This programme is designed to support small or new organisations with a current annual turnover of less than £25,000 per year. Applications for amounts between £1,000 and £10,000 will be considered to be used for:
- projects with a limited life-span;
- core funding lasting up to four years where the total amount does not exceed £10,000;
- capital or equipment purchase.

Arts-related grants were:
Beeston Festival and Mela (£9,000);
Newbiggin by the Sea Community Fayre Association (£1,250).

The foundation also operates a further two programmes, within which grants relevant to this guide are possible but were not awarded in 2001. These are:
Urban and Rural Regeneration – intended to help charitable voluntary organisations to contribute towards the regeneration of their local neighbourhood.
Quality of Life in the Third Age – using the experience of older people to enrich communities and the lives of others.
Exclusions: Organisations not registered charities or which do not have purposes recognised as charitable in British law; individuals and organisations distributing funds to individuals; charities which trade, have substantial reserves or are in serious deficit; national charities without a regional office or other representation in the North East; grant-making bodies seeking to distribute grants on our behalf; open ended funding agreements; general appeals, sponsorship and marketing

appeals; corporate applications for founder membership of a charity; loans or business finance; retrospective grants; endowment funds; replacement of statutory funding; activities primarily the responsibility of central or local government or Health Authorities; animal welfare; mainstream educational activity; medical research, hospitals (other than hospices) and medical centres; environmental projects which do not accord with the main objectives of the foundation; buildings and fabric appeals for places of worship and so on; promotion of religion; expeditions or overseas travel; minibuses and other vehicles; holidays and outings.

Applications: *Full up-to-date guidance must first be obtained from the foundation.* Guidelines and an application form are available from the foundation or on the website. Applications are only accepted on the foundation's forms.

Applications are acknowledged and applicants informed straight away if ineligible. Eligible applicants will be told the name of their contact, who will assess the application and prepare a short report for one of the regular trustee meetings. For the main grants schemes the foundation aims to give a response within four months, or within two months for the Small Organisations programme; some applications necessarily take longer. The foundation states 'please avoid telephoning to enquire about progress. However do let us know by letter or e-mail if there are material changes to the project or if, for example, another funder has agreed to contribute'.

The Ofenheim Trust and The Cinderford Charitable Trust

CC No: 263751

Baker Tilly, 1st Floor, Centinal, 4b Clarendon Road, Watford, Hertfordshire WD17 1HE

Tel: 01923 816 400
Contact: Geoffrey Wright
Trustees: Rory Jackson Clark; Rory McLeod.
Beneficial area: UK.
Grant total: £264,000 (1999/2000)
Arts grants: £36,250

The Ofenheim Trust 'is run in conjunction with the Cinderford Charitable Trust which has the same founder and trustees'. All donations are made jointly, for general charitable purposes but particularly in support of well-established organisations of personal interest to the trustees. Most grants are made in the fields of health and welfare and the environment and many are recurrent.

In 1999/2000 the Ofenheim Trust made grants totalling £66,500, while the Cinderford Trust gave £197,750. The combined total given, in 40 grants ranging from £300 to £12,000, was over £264,000. Out of this total, over £36,000 (14% of total grant-aid) was given in five grants relevant to this guide, all of which were recurrent. These were:
★Musicians' Benevolent Fund (£12,000);
★National Youth Orchestra of Great Britain; ★Glyndebourne Arts Trust; ★National Art Collections Fund (£7,500 each);
★Royal Academy of Music (£1,750 each).

Applications: In writing to the correspondent. Unsuccessful applications will not be acknowledged. Trustees meet in February/March and applications need to be received at least one month in advance.

The Old Broad Street Charity Trust

CC No: 231382

Eagle House, 110 Jermyn Street, London SW17 6RH

Tel: 020 7451 9000; Fax: 020 7451 9090
Contact: S P Jennings, Secretary to the Trustees
Trustees: P A Hetherington; A T J Stanford; Mrs M Cartier-Bresson; C J Sheridan; Mrs E J Franck.
Beneficial area: UK and overseas.
Grant total: £153,000 (1998/99)
Arts grants: £29,502
The trust has general charitable purposes, which include the annual awarding of a small number of educational scholarships.

In 1998/99 the trust gave a total of over £153,000 in 19 grants to organisations, ranging from £650 to £30,000, in addition to five Louis Franck Scholarships for individuals. Most donations were for £10,000 or less. Out of this total, £29,502 (19% of total grant-aid) was given in the following six arts grants:
Royal College of Music (£10,000);
Art for the World (£8,703);
International Menuhin Music Academy (£4,352);
★Victoria & Albert Museum Trust (£2,500);
National Youth Wind Orchestra of Great Britain (£2,000);
★Tate Gallery Foundation (£650).

Old Possums Practical Trust

CC No: 328558

Baker Tilly, 5th Floor, Exchange House, 446 Midsummer Boulevard, Milton Keynes, Buckinghamshire MK9 2EA

Tel: 01908 687800; Fax: 01908 687801
Contact: Judith Hooper
Trustees: Mrs Esme Eliot; Graham Willett; Brian Stevens.
Beneficial area: UK and overseas.
Grant total: £142,000 (1999/2000)

Arts grants: £48,500
The trust's primary aim is to 'increase knowledge and appreciation of any matters of historic, artistic, architectural, aesthetic, literary, musical or theatrical interest'. Other causes are also considered.

In 1999/2000 the trust gave a total of almost £142,000 in 39 grants ranging from £200 to £20,000; most were under £10,000 or less. Out of this, a total of £48,500 (34% of total grant-aid) was given in the following six arts-related grants:
Newham College Library (£20,000);
Friends of the National Libraries (£10,000);
Garsington Opera (£8,000);
Royal National Theatre; Sacred Earth Drama Trust (£5,000 each);
Grant to an individual for musical instrument purchase (£500).

Exclusions: Sport; overseas travel for postgraduate students.

Oppenheim-John Downes Memorial Trust

CC No: 278844

Bircham Dyson Bell, 1 Dean Farrar Street, London SW1H 0DY

Tel: 020 7222 8044
E-mail: Brianweaver@bdb-law.co.uk
Website: bdb-law.co.uk
Trustees: Michael Parker; John Talbot.
Beneficial area: UK.
Grant total: £25,000 (1999)
Arts grants: £25,000
This trust gives grants to 'deserving artists, including writers, dancers, painters, musicians, sculptors, inventors or craftsmen, who are unable to pursue their vocation due to poverty'.

In 1999 the trust made awards totalling almost £25,000 to arts-related beneficiaries. No further details were given in the annual report.
Exclusions: Under 30; those born overseas.

Applications: Closing date 14 November. Application form available from the trust.

The Oppenheimer Charitable Trust

CC No: 200395

17 Charterhouse Street, London EC1N 6RA

Tel: 020 7404 4444
Contact: Nicholas Staley
Trustees: T W Capon, Chair; Sir Christopher Collett; G I Watson.
Beneficial area: UK.
Grant total: £70,000 (1999) see below
Arts grants: £33,000
The trust gives to a very wide range of charitable activities, and makes a number of arts grants each year. Accounts are on file at the Charity Commission up to 1999.

In 1999 the trust gave a total of £70,000 in 47 unspecified donations. Unfortunately, no grants listing has accompanied the annual accounts for several years. However, based on previous funding levels, it may be estimated that about £33,000 was given in grants relevant to this guide.

In 1995, the most recent year for which a grants list is available, a total of £84,000 was given in 120 grants ranging from £100 to £25,000; most were £500 or less. Out of this, a total of £40,000 (47% of total grant-aid) was given in 14 grants to the arts. These included:
Victoria & Albert Museum, Jain Exhibition (£25,000);
Benefactors of the Victoria & Albert Museum (£5,000);
Royal Opera House Trust (£4,500);
British Museum; National Art Collection Fund; Contemporary Art Society (£1,000 each);
Council for Music in Hospitals; Abbeyfield Reading Society (£500 each);

Friends of the Victoria & Albert Museum; Windsor Festival Society; Artsline; (£250 each).

Exclusions: Individuals for education; organisations not registered charities.
Applications: In writing to the correspondent. The trustees meet in January, April, July and October.

The Orpheus Trust

CC No: 292501

Trevereux Manor, Limpsfield Chart, Oxted, Surrey RH8 OTL

Tel: 01883 730 600; Fax: 01883 730 800
Contact: Richard Stilgoe, Trustee
Trustees: Rev Donald Reeves; Esther Rantzen, Alex Armitage; Andrew Murison; Annabel M Stilgoe; Holly M J Stilgoe; Jack E Z Stilgoe; Joseph R I Stilgoe; Dr Jemima R Stilgoe; Rufus N A Stilgoe.
Beneficial area: UK.
Grant total: £42,000 (2000/2001)
Arts grants: £42,000
'The trust's objects are to relieve mentally and physically handicapped adults and children through the provision of recreation and leisure time facilities, in particular to provide music and musical entertainment. This is achieved by:
- providing training, teachers and other facilities for the disabled to learn and perform music;
- bringing a wider appreciation of and involvement in live music and musical entertainments by improving facilities and access in public music venues (planned or existing).'

In 2000/2001 the trust gave £42,000 in five grants, all of which were relevant to this guide. Most grants were recurrent. A grant of £250 was given to an individual while the remaining donations, for between £8,500 and £16,000, were made to the following causes:
★Share Music (£16,000);
Peripatetic Teaching (£12,250);

St Piers (£8,500);
*Drake Research Project (£5,000).

In addition, the trust states in its 2000/
2001 report that it ran eight courses with
Share Music in various locations and that
it offers 'arts skills–development courses'
for young people at its Orpheus Centre
in Godstone, Surrey.
Applications: The trust does not accept
unsolicited applications.

The Ouseley Trust

CC No: 527519

127 Coleherne Court, Old Brompton
Road, London SW5 0EB

Tel: 020 7373 1950; Fax: 020 7341 0043
E-mail: 106200.1023@compuserve.com
Website: www.ouseleytrust.org.uk
Contact: Martin Williams, Clerk to the
Trustees
Trustees: Prof Brian W Harvey; Dr J A
Birch; C J Robinson, Chair; R J
Shephard; N E Walker; Rev A F Walters;
Sir David Willcocks; N A Ridley; Dr S J
Darlington; Dr J Rutter.
Beneficial area: UK and Ireland
(excluding Scotland).
Grant total: £109,000 (2000)
Arts grants: £109,000
This trust's object is to 'promote and
maintain to a high standard the choral
services of the Church of England, the
Church in Wales or the Church of
Ireland'. All applications must be directly
concerned with the achievement of this.

Funding is given for courses (only
awarded where an already acceptable
standard has been reached and will be
raised); endowment grants; choir school
fees; purchase of music (new or
replacement); and repair of organs (only
for an instrument of particular
significance and integral to a high
standard of choral service). Beneficiaries
tend to be independent choral groups
and church or cathedral choirs or schools,
seeking funding for choristers or

equipment. The trust also states that
unique imaginative ventures will receive
careful consideration.

In 1999 the trust gave a total of
£109,000 in 25 grants ranging from
£100 to £25,000 most were under
£10,000. Funding was given in five
categories:
- endowments (£60,000);
- fees (£14,000);
- organs (£18,000);
- music (£3,000);
- other (£18,000).

Grants included:
Under 'endowments' –
Chelmsford Cathedral Music Trust
(£25,000);
Peterborough Cathedral (£10,000).
Under 'fees' –
Salisbury Cathedral School (£4,800);
Wells Cathedral School (£3,500).
Under 'music' –
Bristol Cathedral (£1,500);
Cavendish Choir (£250).
Under 'organs' –
St Matthew, Northampton (£2,000).
Under 'other' –
Royal School of Church Music (£2,670).

Exclusions: Buildings; commissions;
recordings; furniture; outside vocal
tuition; pianos; robes; tours or visits;
projects that will be largely complete by
the closing date; purchase of chants
books, hymnals or psalters. Grants to
individuals are only made through an
institution.
Applications: Requests for application
forms should be accompanied by a SAE
(at least 9" x 6 3/8"). Applications must
be submitted by an institution and be
accompanied by its up-to-date audited
accounts, particulars of the choir and
organist/musical director, and a short
description of the church's musical
tradition and aspirations. Further grants
are not normally awarded to successful
applicants within a two-year period.

Courses – Grants will be awarded only when there is a clear indication that an already acceptable standard of choral service will be raised. Under certain circumstances, grants may be awarded for organ tuition.

Endowments – Enclose a short (not more than 150 words) statement setting out how the capital sum required is calculated, the scale and frequency of the use of the choral liturgy and the forces in the choir.

Fees at choir schools – Support only for children who are or will be choristers, for a maximum of two academic years. State annual fees and whether they are for boarding or day pupils. Parents (or guardians) must complete a statement of their financial resources. The organist or choirmaster of the cathedral or choral foundation must act as a referee.

Choristers at Rochester, Ely and St Alban's cathedrals are unlikely to receive further assistance with fees.

Music – Grants only for replacement of old or purchase of new music to promote high choral standards.

Organs – Grants seldom considered and only if the organ is of particular significance and integral to a high standard of choral service. Applications should be accompanied by a statement of no more than 250 words, setting out the instrument's history, the work required and its cost and timing, the use of choral liturgy and the forces in the choir.

Closing dates are 31 January and 30 June for trustees' meetings usually held in March and October.

The P F Charitable Trust

CC No: 220124

Ely House, 37 Dover Street, London W1S 4NJ

Tel: 020 7409 5600

Contact: Mrs Val Richards, The Secretary

Trustees: Robert Fleming; Rory D Fleming; Valentine P Fleming; Philip Fleming.

Beneficial area: UK, with apparent special interest in Oxfordshire area and Scotland.

Grant total: £1,610,000 (1999/2000)

Arts grants: £90,000

The trust usually makes several hundred donations a year to a wide range of UK registered charities, both on a one-off and recurring basis. Arts beneficiaries tend to be in the fields of music, opera, and museums and galleries. Many of those receiving more substantial grants are national bodies and support is given to a number of recipients each year in Scotland.

In 1999/2000 the trust gave a total of £1,610,000 in an unspecified number of grants, of which the top 50 (amounting to £844,200) were listed in its annual report and accounts. 'Other donations' totalled £766,233. Of the listed grants, five donations, totalling £90,000 (11% of specified grant-aid), were for arts-related causes. These were:

Foundling Museum (£45,000);

British Museum (£25,000);

Royal Academy of Arts; Scottish Division of British Federation of Young Choirs (£10,000 each);

St Mary's Music School (£5,000).

Many of the smaller, unspecified grants are also likely to have been made to causes relevant to this guide.

Exclusions: Individuals; non-registered charities; individual churches.

Applications: To the correspondent at any time. Replies will be sent to unsuccessful applications if a SAE is enclosed. Trustees meet monthly.

The Pallant Charitable Trust

CC No: 265120

5 East Pallant, Chichester, West Sussex
PO19 1TS

Tel: 01243 786111; **Fax:** 01243 532001
Contact: The Clerk to the Trustees
Trustees: W A Fairbairn; R F Ash; A J
Thurlow; S A E Macfarlane.
Beneficial area: UK.
Grant total: £67,000 (1999/2000)
Arts grants: £67,000
The trust's aim is to 'promote mainstream
church music both in choral and
instrumental form'. Support takes the
form of cash donations to assist with
choristers' school fees and salaries for
church musicians or musical advisors,
most of which are part of ongoing
commitments.

'The trustees are always prepared to
give serious consideration to requests
which are in line with their objectives'
but it is understood that the trust's
resources are already fully committed.

In 1999/2000 the trust gave a total of
over £67,000 in grants to eight
beneficiaries, all of which were arts-
related. These were:
Sarum College, for church musician
 (£24,000 in 4 grants);
Church Music Advisor Project, towards
 salary of appointee (£22,379 in 11
 payments);
Four individuals at Prebendal School
 (£4,034 each in 3 grants each p.a.);
St Peter's Brighton Choral Foundation
 (£3,000);
Dean and Chapter of Chichester, award
 to organ scholar (£1,995).

Exclusions: Causes outside trust
objectives.

The Paragon Concert Society

CC No: 280203

29 Castle Hill, Banwell, North Somerset
BS29 6NX

E-mail:
paragonconsoc@btopenworld.com
Contact: Andrew Tyrrell, Trustee
Trustees: Mrs J V Pritchard; C J Brisley;
Miss L Leschke; A Tyrrell; Mrs N Sager; A
Mackenzie; J A Farnill.
Beneficial area: Bristol and surrounding
district.
Grant total: £11,000 (2000)
Arts grants: £11,000
The society's objects are defined as the
promotion of 'the knowledge and
performance of serious music for small
combinations of instruments, for string
orchestras, with or without voices and
instrumental soloists, and its choice of
work for performance shall at all times be
consistent with its purpose of educating
its members and the general public in
music of the highest standard, the
emphasis being on music local to Bristol'.

In 2000 the society made music-related
grants totalling almost £11,000. However,
the latest annual report available on file at
the Charity Commission was for 1999. In
this year the society gave a total of
£8,676 in 16 grants, all of which were
relevant to this guide. Donations ranged
from £250 to £1,500 and included:
St George's Music Trust (£1,500);
★Chantry Singers; ★Bath Opera; Bristol
 Bach Choir (£750 each);
★Nova Corda (£600);
★City of Bristol Choir (£500);
Clevedon Choral Society (£400);
Bristol Brass Ensemble (£355);
Cadbury Wind Band (£320);
★Bristol Music Club (£250).

Exclusions: No grants for tuition fees.
Applications: In writing to the
correspondent.

The Manoug Parikian Award
– see Musicians' Benevolent Fund

CC No: 228089/0004

The Performing Right Society Foundation

CC No: 1080837

The Performing Right Society Ltd, 29/33 Berners Street, London W1T 3AB

Tel: 020 7306 4044
E-mail: rachel.nelken@prs.co.uk
Website: www.prsf.co.uk
Contact: Rachel Nelken
Trustees: David Bedford; Anthony Mackintosh; Anne Dudley; John Michael Sweeney; Nigel Elderton; Michael Noonan.
Beneficial area: UK.
Grant total: £1,500,000 annually
Arts grants: £1,300,000
This new foundation, registered in May 2000, was formed to replace the Performing Right Society's donations and awards programme. Its overall objective is to increase the public's understanding and appreciation of new music and to encourage, promote and sustain music creation and its performance across all genres and at all levels of activity. It is now the UK's largest independent funder for new music.

The foundation aims to achieve its aims through the following:

- provision of financial assistance to organisations, composers and songwriters in order to encourage composition and performance of new music of high quality;
- furtherance of education and training through educational awards and scholarships and the provision of equipment and facilities for individuals and educational establishments;
- promotion of public performance through the support of concerts, recitals and festivals.

It is expected that a total of £1,300,000 will be made available annually to arts-related causes, out of a total predicted charitable expenditure of £1,500,000.
Applications: Full application guidelines are available. All applications will be considered on their own merit by an advisory group of experts specialising in all genres who will then make their recommendations to the board of trustees.

The Stanley Picker Trust

CC No: 271185

1 Warren Park, Kingston Hill, Surrey

Tel: 01722 412412
Contact: Peter Lawson, Trustee
Trustees: Peter Lawson; A Safir; Mrs J Arden Safir; R P G Voremberg.
Beneficial area: UK, with a preference for Kingston, Surrey and the South East.
Grant total: £260,000 (1999/2000)
Arts grants: £260,000
The trust primarily supports the arts, giving annual grants and fellowships to the arts faculties at the University of Kingston and bursaries to selected schools of music and drama. The trust-owned Warren Park, Surrey, used as a gallery to display the trust's own art works, is also a major beneficiary, annually receiving the trust's largest grant. Funding is also given in the fields of music, writing, acting, printing and sculpture and a few grants to arts organisations. Specifically, the trust provides 'an award or prize to a meritorious postgraduate student in each year to pursue his or her studies in any branch of the fine arts' and 'other prizes and awards for the study of painting and sculpture (and in particular for travel in pursuit of such studies)'.

In 1999/2000 the trust gave all of its total of £260,000 grant-aid to arts causes. These were:

*Warren Park, running, maintenance and other costs (£91,000);

*Bursaries at 11 music and/or drama schools (£66,000);
*University of Kingston (£12,500);
*Individuals at University of Kingston (£33,500);
*General Education Grants to individuals (£30,000);
Special awards for other arts causes:
British Friends of Art (£7,500);
Early English Organ Project; *Salisbury Festival (£6,000 each);
London Sinfonietta (£2,500);
*Whitechapel Gallery; Amadeus Scholarship Fund (£2,000 each);
British Federation of Festivals (£1,000).

Applications: In writing to the correspondent.

The Pilgrim Trust

CC No: 206602

Cowley House, Little College Street, London SW1P 3XS

Tel: 020 7222 4723; **Fax:** 020 7976 0461
E-mail: georginanayler@thepilgrimtrust.org.uk
Contact: Georgina Nayler, Director
Trustees: Mrs Mary Moore, Chair; Nicolas Barker; Lord Armstrong; Neil MacGregor; Lord Bingham; Eugenie Turton; Lord Cobbold; Dame Ruth Runciman; Sir Richard Carew Pole.
Beneficial area: UK, excluding the Channel Islands and the Isle of Man.
Grant total: £2,600,000 (2000)
Arts grants: £689,770
The trust's current funding priorities lie in art and learning, social welfare, preservation and places of worship. Grants made within the art and learning category are for the 'promotion of scholarship, academic research, cataloguing and conservation within museums, galleries, libraries and archives, particularly those outside London'. The trustees do not exclude acquisitions for collections, but funds for this purpose are strictly limited.

Generally, grants are between £5,000 and £50,000, although 'the trust also operates a small grants fund for applications under £5,000 and the director has discretion to award grants of up to £500 for projects costing less than £1,000'.

In 2000 the trust made 137 grant commitments totalling £2,600,000, some of which were for more than one year. The distribution of these grants was as follows: preservation (£737,000); social welfare (£1,176,000); art and learning (£687,000). A total of £689,770 (59% of total grant-aid) was given in 39 arts-related grants. These included:
Under 'art and learning – museums and galleries' –
National Gallery, research grants for curators, payable over three years (£91,260);
Hackney Empire, towards the restoration of the fabric of the building (£45,564);
Fitzwilliam Museum, towards purchase of John Linnel's archive; National Library of Women, for conservation of Suffrage Banners; National Trust, for facilities at Blickling Hall textile conservation centre (£20,000);
Women's Playhouse Trust, for archival material and equipment (£10,000).
Under 'art and learning – libraries, manuscripts and archives' –
University of Sheffield, for Fairground Photographs Project, payable over two years (48,100);
British Library, to purchase Lord Olivier's archive (£20,000);
Royal Naval Museum, for conservation and development of Wright & Loan photographic collection (£12,850).
Under 'art and learning – miscellaneous' –
British Institute of Organ Studies, for further development of National Pipe Organ Register (£15,000).
Under 'small grants – theatre, music and ballet' –
North West Playwrights, towards historical cataloguing (£5,000);

Buxton Opera House, towards restoration
project (£4,944).
**Under 'small grants – museums and
galleries' –**
An Iodhlann, Isle of Tiree, towards
reading room extension; Museum of
Richmond, for costume conservation
project (£5,000 each);
Rye Castle Museum, for conservation of
19th century paintings (£1,000);
Chelmsford Museum, towards acquisition
of Iron Age coins (£200).
Under 'social welfare – youth projects' –
Streets Alive, London, towards costs of
director for artistic programme
(£15,000).
Under 'preservation – ecclesiastical' –
The Constable Trust, towards purchase of
The Risen Christ by John Constable
(£5,000).
Under 'preservation – secular' –
Highlands Buildings Preservation Trust,
towards restoration of Forss Mill by
Thurso (£30,000);
Royal West of England Academy, for
conservation of Walter Crane Murals
(£10,000).

Exclusions: Individuals; projects outside
the UK; general appeals; major capital
projects and major appeals, particularly
where partnership funding is required
and where any contribution from the
Pilgrim Trust would not make a
significant difference; one-off events such
as exhibitions, festivals, seminars and
theatrical and musical productions;
activities considered by the trustees to be
primarily the responsibility of central or
local government; medical research,
hospices, residential homes for the elderly
and people with learning disabilities;
projects for people with physical
difficulties and schemes to improve their
access to public buildings; drop-in centres,
unless the specific work falls within one
of the trustees' current priorities; youth
and sports clubs; travel or adventure
projects; community centres or children's
play groups; reordering of churches or

places of worship for wider community
use; education, assistance to individuals
for degree or post-degree work, school,
university and college development
programmes.

Applications: Include latest annual
report and audited accounts; aims and
objectives; and track record and support it
enjoys from other organisations working
in the same field.

The project: description including a
budget and, if relevant, a projected
income and expenditure account for the
organisation as a whole; the problem to
be tackled, its urgency, and the solution to
be provided by the project; for projects
involving salary costs, include relevant job
descriptions, proposed salaries and
management structure; how the project
will be monitored and evaluated; other
organisations approached for funding,
details of any offers received; if requesting
grants of less than £5,000, two references
must be sent from organisations with
which you work; for historic building
repairs, include details of scheme's costs;
for cataloguing and conservation projects,
demonstrate how the people who will
undertake the work were chosen and give
details of their relevant expertise;
photographs should be sent where
appropriate.

Application forms and guidelines are
available from the trust.

The Austin & Hope Pilkington Trust

CC No: 255274

PO Box 124, Stroud, Gloucestershire
GL6 7YN

Contact: Karen Frank, Administrator
Trustees: Mrs J M Jones; Ms P S
Shankar; Ms D Nelson.
Beneficial area: UK.
Grant total: £547,000 (1998/99) see
below
Arts grants: £190,992

The trust has given to a wide range of charities with an interest shown in organisations working for the disabled, social and medical welfare, the environment and overseas aid, as well as the arts. From 1996 the trust has focused its funding in specific areas which change annually, on a three-yearly cycle which will continue until at least 2005. This cycle is as follows:

- 2002 – music and the arts, famine/ overseas;
- 2003 – community, poverty and religion;
- 2004 – children and youth, medical and the elderly.

In 1998/1999 the trust gave a total of over £547,000 in 117 grants ranging from £500 to £21,000, with a larger grant of over £49,000 to recurrent beneficiary Purcell School. Out of the total given, more than £190,000 (35% of total grant-aid) was given to 54 arts causes, generally in grants between £1,000 and £5,000. These included:

★Purcell School, purchase of flute and two scholarships (£49,262);

★Royal Academy of Music, tuition fees and living expenses for students (£12,730);

Almeida Theatre; British Youth Opera; Wigmore Hall (£5,000 each);

Birds of Paradise Theatre Company; Buxton Festival; English Touring Opera; Garsington Opera Ltd; Opera North; Oxford School of Contemporary Music (£3,000 each);

Gloucestershire Community Theatre Society; Gregynog Festival Masterclass; National Youth Wind Orchestra of Great Britain; Menai Bridge Band; Meadows Toy and Leisure Library (£1,000 each).

Exclusions: Individuals; non-registered charities; purely local organisations.
Applications: In writing to the correspondent, including full budgets and annual accounts where appropriate. The trust does not publish guidelines or have an application form. Please note the selected subject areas for each year as stated above.

The Poetry Society

CC No: 303334

22 Betterton Street, London WC2H 9BU

Tel: 020 7240 9880; Fax: 020 7240 4818
Website: www.poetrysoc.com
Contact: Christina Patterson, Director and General Secretary
Trustees: President: Paul Muldoon. Vice Presidents include Fleur Adcock; Carol Ann Duffy; Lord Gavron; Seamus Heaney; Roger McGough; Andrew Motion; Les Murray; Alastair Niven; Michael Rosen; Simon Schama; Derek Walcott; Norman Willis.
Beneficial area: UK.
Grant total: £7,000 per annum in prizes
Arts grants: £7,000
The Poetry Society exists to help poets and poetry thrive in Britain today. It has around 3,500 members, including teachers, librarians, booksellers, journalists and readers and writers of poetry from all over the world.

The society runs the annual National Poetry Competition, open to anyone aged 18 and over. Poems can be on any subject and the entry fee is £5 for the first poem submitted and £3 for subsequent entries. The competition is launched in April and open until the end of October each year. Prize money is awarded as follows: first prize £5,000; second prize £1,000; third prize £500; 10 commendations £50. The winners will be published in the *Independent on Sunday*, *Poetry Review* and on the Poetry Society's website.
Applications: Contact the society or visit its website to obtain up-to-date details of the competition or the numerous other schemes with which it is associated.

The Porter Foundation

CC No: 261194

PO Box 229, Winchester, Hampshire
SO23 7WF

Contact: Paul Williams, Director
Trustees: Dame Shirley Porter; Sir Leslie
Porter; David Brecher; Steven Porter.
Beneficial area: UK, Israel; some USA.
Grant total: £968,000 (2000/01)
Arts grants: £66,349
The foundation focuses upon education,
culture, the environment and health and
welfare causes. Much of the foundation's
charitable expenditure has been directed
at Jewish organisations but not
exclusively. Beneficiaries often receive
grants over the course of a number of
years.

In 2000/01 the foundation gave a total
of £968,000 in over 35 grants ranging
from under £1,000 to an exceptional
grant of £511,677 for the annually
funded Tel Aviv University Trust. The
annual report only lists grants of over
£1,000. There were 35 of these, ranging
from 'large capital donations to small gifts
to community organisations'. A total of
£66,349 (seven per cent of total grant-
aid) was given in 12 arts-related grants.
These were:
New Israel Opera (£17,881);
★British Friends of the Art Museums of
 Israel (£12,698);
★Oxford Centre for Hebrew and Jewish
 Studies, Porter Fellowship in Yiddish
 Language and Literature (£10,000);
★Royal Opera House Appeal (£7,500);
Tel Aviv Foundation, Vocal Arts Institute
 (£6,849);
Friends of the Israel Opera Trust
 (£3,000);
★Royal National Theatre; Books Abroad;
 Friends of the Jerusalem Academy of
 Music and Dance; North West London
 Orchestra; Weiner Library (£1,000
 each).

Exclusions: Individuals; non-charitable
organisations; circular appeals; general
running costs.
Applications: In writing to the
correspondent. Guidelines for applicants
are available. An initial letter summarising
the application should include basic
costings and details such as the
organisation's annual report and accounts.
A mass of documentation at this stage is
not encouraged.

Suitable proposals falling within the
foundation's current interests will be
contacted for further information and,
perhaps, a staff visit.

Trustees meet in March, July and
November. Shortlisted applications will
be informed within a week. However, the
foundation does not answer unsolicited
requests for funding unless they are
successful.

The Nyda and Oliver Prenn Foundation

CC No: 274726

Moore Stephens, 1 Snow Hill, London
EC1A 2EN

Contact: T Cripps
Trustees: O S Prenn; Mrs N M
McDonald Prenn; S Lee; Mrs C P
Cavanagh; A D S Prenn; N C N Prenn.
Beneficial area: UK and overseas.
Grant total: £82,000 (1999/2000)
Arts grants: £21,200
This foundation has a wide range of
charitable interests, including the arts,
education and health.

In 1999/2000 it gave a total of nearly
£82,000 in 25 grants ranging from £150
to an exceptional sum of £30,000; most
donations were below £10,000. Out of
this, a total of £21,200 (26% of total
grant-aid) was given in six grants to the
arts. These were:
Rambert Dance Company (£10,000);
Royal National Theatre (£6,750);
Amadeus Scholarship Fund (£3,000);

LAMBDA (£1,000);
Almeida Theatre (£300);
Serpentine Trust (£150).

Exclusions: Local projects outside London.

Applications: Unsolicited applications are not acknowledged.

Priaulx Rainier Fund – see The Worshipful Company of Musicians

CC No: 310040/11

The Prince of Wales's Charitable Foundation

CC No: 277540

The Prince of Wales Office, St James's Palace, London SW1A 1BS

Contact: Stephen Lamport
Trustees: Rt Hon. Earl Peel; Sir Michael Peat; Stephen Lamport; Mrs Fiona Shackleton; Mark Bolland.
Grant total: £500,000 (1999/2000)
This foundation has general charitable purposes and in 1999/2000 made grants within the following categories:

- animals (£14,800);
- armed services (£14,500);
- children and youth (£1,750);
- culture (£122,500);
- education (£67,046);
- environment (£76,250);
- hospices and hospitals (£62,500);
- medical welfare (£32,500);
- overseas aid (£29,500);
- restoration of churches and cathedrals (£58,000);
- social welfare (£20,250).

Grants totalled almost £500,000. Since only the five donations over £10,000 were listed in the annual report, the level of arts funding is unclear. Given that 'culture' grants amounted to £122,500 (24% of total grant-aid), it can be expected that arts-related causes received a significant proportion of the foundation's charitable expenditure. Of the specified donations, the following two were arts-related:
Temenos Academy (£15,000);
Mariinsky Theatre (£13,500).

Prince's Scottish Youth Business Trust

Mercantile Chambers, 6th Floor, 53 Bothwell Street, Glasgow, G2 6TS

Tel: 0141 248 4999; Fax: 0141 248 4836
E-mail: firststep@psybt.org.uk
Website: www.psybt.org.uk
Contact: Ann Scott, Director of Operations
Beneficial area: Scotland.
Grant total: Loans only – up to £5,000 each.

The charity helps young people in Scotland aged 18 to 25 inclusive to set up and continue in business. It provides loans, grants and professional support and has a particular concern for disadvantaged people. Applicants may be up to 30 years old if they are disabled. Loans of up to £5,000 are available for setting up or expanding, with setting up grants of up to £1,000 per person for unemployed applicants or those with limited means.

The charity operates in 18 regions, each with its own manager. Applicants can obtain contact details for each regional manager, as well as guidelines for application, from the above address, telephone number or website.

Applications: Contact the above address for further information and guidance. Assistance will be provided to help applicants put together a business plan to accompany their application.

The Prince's Trust

CC No: 1018177

18 Park Square East, London NW1 4LH

Tel: 020 7543 1234; Fax: 020 7543 7373
E-mail: rupalsha@princes-trust. org.uk
Website: www.princes-trust.org.uk
Contact: Rupal Shah
Trustees: Sir William Castell, Chairman;
Rod Aldridge; Major-General Arthur
Denaro; Charles Dunstone; Sir David Fell;
Fred Goodwin; Heather Hancock;
Stephen Lamport; Peter Mimpriss; Sir
Angus Ogilvy; Pat Passley; John Rose;
Manon Williams.
Beneficial area: UK and the
Commonwealth.
(See also entries for Arts Connection and
Youth Cultural Business Venture, which
are run by the Prince's Trust in
collaboration with East England Arts and
Northern Arts respectively.)

The Prince's Trust is the UK's leading
youth charity. Its work enables 14–30
year olds to develop skills and move
forward with their lives and is targeted at
those who need help most.

The trust's programmes include:
Business start-up – offering financial
and practical support to 18–30 year olds
with a good business idea that has been
rejected by other lenders. Applicants
receive low-interest loans plus a volunteer
business mentor and aftercare support.
Personal development – bringing
employed and unemployed 16–25 year
olds together in teams to gain self-
confidence and life-skills, and to improve
their employment prospects. The course
involves work placements and
community projects.
Financial awards and training:
- *Development Awards* to help young
 people access education, employment
 and training and Millennium Awards to
 groups of young people for projects
 that benefit their local community.
- *Sound Live* giving young people a start
 in the music industry.

- *xl network*, helping students at risk of
 being excluded from school.
- *World Youth Millennium Awards* and
 European programme, enabling young
 people to do voluntary work overseas.
- *Leaving Care Initiative*, training mentors
 to help young care leavers to adapt to
 independent adult life.

Exclusions: Core costs or capital
projects.

Mr and Mrs J A Pye's Charitable Settlement

CC No: 242677

c/o Sharp Parsons Tallon, 167 Fleet
Street, London EC4A 2EA

Contact: The Secretary
Trustees: G C Pye; D S Tallon; J S
Stubbings.
Beneficial area: UK, particularly the
Oxford area and, to a lesser extent,
Reading, Cheltenham and Bristol.
Donations to all causes: £583,000
(2000/01)
Arts grants: £99,500
The trust gives to 'charities concerned
with nutritional and medical research,
mental health, education, child welfare,
conservation, and the arts as well as
national and local need in various fields'.
Arts-related support falls within a number
of these categories.

In 2000/01 the trust gave a total of
£583,000 in 244 grants, the major
proportion of which was allocated in 11
large grants ranging from £10,000 to
£121,000. Most donations were, however,
for between £250 and £5,000. This
lower grant range offers greater
opportunities for new applicants, as many
of the largest grants were awarded to
previous beneficiaries. Out of the total
given, £99,500 (11% of total grant-aid)
was given in 19 arts-related grants. These
included:
★Music at Oxford (£65,000);
World International Piano Competition
(£10,000);

*Listening Books (£6,000);
Hereford Three Choirs Festival; *Royal
 Court Theatre (£2,500 each);
*Museum of Modern Art; *Pegasus
 Opera Company; Shakespeare's Globe
 Trust (£2,000 each);
Ashmolean Museum; English Touring
 Opera; *Oxfordshire Touring Theatre
 Company (£1,000 each);
London Sinfonietta; Roke & Benson
 Brass Band (£500 each);
*Lambeth Children's Theatre; *Southern
 Arts (£250 each).

Exclusions: Individuals; non-charitable
organisations.

Applications: In writing to the
correspondent, including registered
charity number/proof of tax-exempt
status, brief description of activities and
details of project seeking funding. Also
detail the cost of the project and a
breakdown, where appropriate, along
with methods for other funding raised
and to be raised. The latest trustees' report
and audited/independently examined
accounts must be sent.

All applications are acknowledged.
Trustees meet quarterly to decide on
distribution and only successful applicants
are informed of the outcome.

The Quercus Trust

CC No: 1039205

Chantrey Vellacott, Russell Square
House, 10–12 Russell Square, London
WC1B 5LF

Tel: 020 7509 9000; Fax: 020 7436 8884
Contact: Mr A C Langridge, Trustee
Trustees: Lord Bernstein of Craigweil;
Thomas H R Crawley; Alan C Langridge;
Kate E Bernstein; Lady Bernstein.
Beneficial area: UK and Israel.
Grant total: £221,000 (1997/98)
Arts grants: £142,100
This trust makes between 20 and 30
grants each year, mainly to the arts and a
small number of Jewish causes. Many

grants are recurrent and recipients are
usually major national or regional
organisations.

In 1997/98, the latest year for which a
report was available at the Charity
Commission, the trust gave a total of
£221,000 in 21 grants ranging from
£250 to £50,000; most were under
£20,000. Out of this, a total of £142,100
(64% of total grant-aid) was given to 15
arts causes. These included:
*Royal National Theatre (£45,500);
*Tate Gallery Foundation (£31,750);
Birmingham Royal Ballet Trust; Royal
 Exchange Theatre Company (£20,000
 each);
Artangel Trust (£10,000);
Royal Opera House Trust (£4,000);
*British Friends of the Art Museums of
 Israel (£1,200);
Actors Centre; Chelsea & Westminster
 Arts Project; *National Gallery Trust
 (£1,000 each);
Almeida Theatre (£500).

**Applications: 'The trustees are
unlikely to make donations to
applicants who apply for funding, as
their funds are normally fully
commmited to organisations known
to them. They are unable to
acknowledge approaches in every
case as they wish to keep
administration costs to a minimum.'**

The Radcliffe Trust

*(formerly known as Dr Radcliffe's
Trust)*

CC No: 209212

5 Lincoln's Inn Fields, London
WC2A 3BT

Tel: 020 7405 1234
Contact: John Burden, Secretary to the
Trustees
Trustees: Lord Cottesloe, Chair; Lord
Quinto; Lord Balfour of Burleigh;
Christopher John Butcher; Ivor Forbes
Guest.

Beneficial area: UK.

Grant total: £354,000 (1999/2000)

Arts grants: £350,000

This trust has a 'policy of making grants principally for craft and music education to charitable organisations rather than direct to individuals'. In 1999/2000 the trust gave a total of £354,000 in the following categories:

- crafts, £212,770 (60%) in 33 grants;
- music, £117,313 (33%) in 27 grants;
- miscellaneous, £24,815 (7%) in 9 grants.

Grants ranged from £425 to £25,500 but were mostly for less than £5,000. All of the grants in the categories of crafts and music, along with four more under the miscellaneous category were relevant to this guide. Total arts-related funding amounted to £350,000 (99% of total grant-aid) in 64 grants. These included:

Under 'crafts' –

Iona Cathedral Trust (£11,250);

★Scottish Maritime Museum (£8,500);

★Avoncroft Museum of Buildings; Royal College of Art; Historic Chapels Trust (£5,000 each);

Devon Guild of Craftsmen (£4,000);

Worcester College (£2,000).

Under 'music' –

Allegri String Quartet (£18,088);

Live Music Now (£4,000);

Drake Music Project (£3,000);

Isle of White Oboe Competition (£2,000).

Under 'miscellaneous' –

Dance Research Committee (£10,000);

Clifton Handbell Ringers (£3,750).

Exclusions: Sponsoring of musical and theatrical performances; construction, conversion, repair or maintenance of buildings; individuals for education fees or maintenance; support of expeditions; to clear deficits.

Applications: Music applicants need to apply by the end of January and August. Applications are shortlisted in March and October for the trustees' final consideration in June and December. Craft and all other applications should be made before the end of March and September each year for trustees to examine in June and December. All applications in writing to the correspondent.

Ragdoll Foundation

CC No: 1078998

Russell House, Ely Street, Stratford upon Avon CV37 6LW

Tel: 01789 773059; Fax: 01789 773059

E-mail: info@ragdollfoundation.org.uk

Website: www.ragdollfoundation.org.uk

Contact: Lydia Thomas, Director

Trustees: Anne Wood; Mark Hollingsworth; Katherine Wood; Ann Burdus.

Grant total: About £100,000 a year

Arts grants: £50,000

The foundation supports projects in the UK, with a particular emphasis on the North East of England and the Midlands, and internationally which:

- promote the education and development of children through the arts;
- promote the use of the arts as a healing or developmental tool for the benefit of children;
- encourage innovation and innovative thinking by the promotion of best practice in the use of the arts in the development of children;
- encourage and ensure effective evaluation of projects to promote best practice.

There is a preference for creative and innovative projects which show an understanding of how to listen to children and allow the 'voices' of the children themselves to be heard. Support is mainly for projects involving children aged 0 to 8 years, but activities developing the potential, progress and well-being of older children may also be considered.

Grants, mostly in the £500 to £2,000 range, total about £100,000 a year. Based on the foundation's charitable objects it may be estimated that at least £50,000 is given in grants relevant to this guide each year.

Exclusions: Work that has already started or will have been completed while the application is being considered; promotion of religion; animal welfare charities; vehicles; emergency relief work; general fundraising or marketing appeals; open-ended funding arrangements; loans or business finance; retrospective grants; replacement of statutory funding; charities which are in serious deficit; holidays of any sort; any large capital, endowment or widely distributed appeal.

Applications: A leaflet detailing guidelines and the application process is available in standard and large-scale print, and on audio cassette.

Applications should be in writing and should include the precise purpose for the grant and how it will make a difference; full budget details (including how the budget has been determined); total grant required; information about potential partners from whom other sources of income are being sought, where relevant, including any firm commitments of support; full information about the aims and purposes of your organisation or project including your legal status and registered charity number; latest annual report and audited accounts; and a clear indication of how the project will be monitored and evaluated.

The trustees meet in April and October to review applications; applications should be submitted by 1 March for a decision by 1 July, and by 1 September for a decision by 1 December. The trust aims to issue a letter of acknowledgement within 14 days of receipt of an application.

The Peggy Ramsay Foundation Play Awards

CC No: 1015427

Harbottle & Lewis Solicitors, Hanover House, 14 Hanover Square, London W1S 1HP

Tel: 020 7667 5000; Fax: 020 7667 5100
E-mail: Lawrence.harbottle@ harbottle.com
Contact: G Laurence Harbottle, Trustee
Trustees: Laurence Harbottle; Simon Callow; Michael Codron; Sir David Hare; John Tydeman; Baroness McIntosh of Hudnall; Harriet Walter, John Welch.
Beneficial area: British Isles.
Grant total: £252,000 (2000)
Arts grants: £252,000

This foundation is principally concerned with the following:

- 'advancement of education by the encouragement of the art of writing for the stage;
- relief of poverty among those practising the arts, together with their dependants and relatives, with a special reference to writers;
- charitable purposes that may contribute to achieving the above.'

Specific emphasis is placed upon writing for the stage. Each year the foundation has given up to £50,000 for the Peggy Play Award to an organisation in the British Isles. This award has now ceased to exist but the foundation has retained the priorities listed above.

In 2000 the foundation gave a total of £252,000, of which £63,000 was disbursed as part of ongoing commitments. Grants ranged from £500 to £35,000, although most were under £6,000. Of this total, all of which was relevant to this guide, 44 grants were awarded to unspecified individuals and 28 to organisations. These included:

Tron Theatre (£35,000);
Cleanbreak Theatre Company (£20,000);

Warehouse; London Live; Big Brum;
 Bristol Old Vic; Talassa; Royal Court
 Theatre; TAPS (£5,000 each);
Stella Quines (£4,000);
Birmingham Stage Company; Theatre
 and Beyond (£2,000 each);
Chipping Norton Theatre; Society of
 Authors (£1,500 each);
Traverse Theatre (£500).

Exclusions: Fees; production costs;
writing not for the stage.
Applications: Applicants should submit
a short letter of application.

Grants are considered at four or five
meetings during the year, although urgent
appeals can be considered at other times.

The Märit and Hans Rausing Charitable Foundation

CC No: 1059714

39 Sloane Street, London SW1X 9LP

Tel: 020 7235 9580; Fax: 020 7235 9580
E-mail: mhr@arcticnet.com
Contact: Elaine Owen, Administrator
Trustees: Lisbet Koerner; Sigrid
Rausing; J Mailman; Tara Kaufman.
Beneficial area: UK and occasionally
overseas.
Grant total: £269,000 (1999)
Arts grants: £21,238
This foundation gives to a wide range of
causes including science, wildlife, the
disadvantaged and the arts. Grants are
generally made on a one-off basis.

In 1999 the foundation gave a total of
£269,000 in 26 grants ranging from
£500 to £89,500. Out of this, arts-
related grants totalling £21,238 (eight
per cent of total grant-aid) were given to
three beneficiaries. These were:
Royal Navy Submarine Museum
 (£10,000);
Russian Arts Help (£6,238);
Listening Books (£5,000).

Exclusions: Individuals.
Applications: By letter to the trustees.
Only successful applicants will receive a
reply.

The Rayne Foundation

CC No: 216291

33 Robert Adam Street, London
W1U 3HR

Tel: 020 7935 3555
Contact: Robert Dufton
Trustees: Lord Rayne, Chair; Lady
Rayne; R A Rayne; Lord Bridges; Lord
Greenhill of Harrow; Sir Claus Moser;
Prof. Dame Margaret Turner.
Beneficial area: UK, esp. England and
Scotland; some overseas, mainly Israel.
Grant total: £1,777,000 (1999/2000)
Arts grants: £256,500
This foundation's objectives are 'to
sponsor developments in medicine,
education and social welfare and the arts,
and to relieve distress and to promote the
welfare of the aged and young'. Grants
are given in the categories of medicine,
education, civic and sociological and arts
and the environment, and are
concentrated in England, Scotland and
Israel.

The foundation's arts interests have
included major national organisations in
all art forms; smaller beneficiaries tend to
be London-based. Museums and galleries,
theatres, educational institutions, festivals
and organisations working in music and
opera have all been arts beneficiaries. The
foundation has also funded a number of
youth-related causes.

In 1999/2000 the foundation gave a
total of £1,777,000 in grants ranging
from £75 to £200,000, most of which
were under £25,000. Only grants over
£7,500 were specified in the annual
report. A total of 53 grants were listed,
many of which were recurrent. Of these,
17 were for arts-related causes, with
funding relevant to this guide amounting
to £256,500 (14% of total grant-aid). Arts
grants included:
★British Museum Development Trust
 (£50,000);
★Sadler's Wells Theatre Appeal Fund;
 Royal Opera House Trust (£25,000
 each);

*Chicken Shed Theatre Trust (£24,500);
*Tate Gallery (£20,000);
*RADA (£12,000);
Ballet Rambert; Almeida Theatre; Royal Albert Hall Trust; *National Art Collections Fund; *National Gallery (£10,000 each);
City & Guilds London Art School; Courtauld Institute of Art Foundation; *Bristol Old Vic Theatre School (£7,500 each).

Exclusions: Individuals; organisations not registered as charities.
Applications: In writing to the correspondent at any time.

The Richmond Parish Lands Charity

CC No: 200069

The Vestry House, 21 Paradise Road, Richmond, Surrey TW9 1SA

Tel: 020 8948 5701
Contact: Penny Rkaina, Clerk to the Trustees
Trustees: The Mayor of Richmond (ex-officio); Cllr Eleanor Stanier; Cllr Mary Weber; Marian Mollett; Richard Jeffries; Christopher Powell-Smith; Frank James; David Shaw; Mrs Margaret Dangoor; Geoffrey Guinness; Robert Clark; Mrs Gillian Marshall-Andrews; Mr Nick Tarsh; Mrs Penny Wade; Peter Willan.
Beneficial area: Richmond, Kew, North Sheen, Ham, Petersham. Also, for small grants, education fund and heating vouchers, East Sheen and Palewell.
Grant total: £771,000 (2000/01)
Arts grants: £50,652
The trust provides financial support exclusively to causes in the specific geographical area detailed above. Grants are given within the following categories: relief of poverty; social and medical welfare; mental health and learning disability; physical disability; youth/community/sport; music and the arts; welfare of the elderly; education projects; community centres/general; one-off grants. Many of the trust's grants are made to previous beneficiaries.

In 2000/01 the trust gave a total of £771,000 in an unspecified number of grants, ranging from £25 to £35,000 with most less than £6,000. Out of this, £50,652 (seven per cent of total funding) was given in 19 arts-related grants. These included:

Under 'music and the arts' –
*Richmond-upon-Thames Arts Council (£6,947);
Richmond Theatre (£3,000);
Richmond Orchestra (£1,250);
Richmond-upon-Thames Music Festival; Richmond Concert Society (£750 each);
Barnes Choir (£500);
*Kew Sinfonia (£455).
Under 'community/sport/youth' –
*St Matthias Arts Festival (£2,250);
Orleans House Gallery (£1,200).
Under 'welfare of the elderly' –
*Orange Tree Theatre, for concert parties (£2,500).
Under 'education projects' –
*Richmond Music Trust (£11,137).
Under 'community centres/general' –
*Orange Tree Theatre, for community programme (£3,500).
Under 'one-off grants' –
Twickenham Museum (£1,000).

Exclusions: Residents or organisations outside the beneficial area; an organisation located outside the area 'may still qualify for a grant if a significant part of its work covers the area or if a number of its members are resident there'.
Applications: Telephone enquiries to the clerk are welcomed before an application is made. Application forms and guidelines are available from the trust. Trustees meet eight times a year to consider applications received up to 14 days in advance. Applicants are advised by telephone or letter within 10 days of the meeting as to whether or not the application has been successful.

The Robertson Trust

CC No: SC02970

PO Box 15330, Glasgow G1 2YL

E-mail: admin@therobertsontrust.org.uk
Website: www.therobertsontrust.org.uk
Contact: Sir Lachlan Maclean, Secretary
Trustees: John Good, Chairman;
Richard Hunter; Thomas Lawrie; Sir
Lachlan Maclean, Secretary; David
Stevenson.
Beneficial area: UK, with a particular
interest in Scotland.
Grant total: £4,795,000 (2000/01)
Arts grants: £140,000
The trust's priority categories are care;
education; medical; and drug prevention
and treatment. The trust also has an
interest in the arts and national heritage.

In 2000/01 the trust gave a total of
£4,795,000 in 380 grants. Although most
grants were below £10,000, 72 were for
more than this amount. Funding was
allocated within 12 categories, one of
which was specifically for the arts. A total
of £164,000 (three per cent of total
grant-aid) was given to 31 causes within
the arts category. These included:
Dancebase Scotland, for a new dance
 centre (£30,000);
Dundee Repertory Theatre (£20,000);
★Children's Classic Concerts (£12,000);
Scottish Opera (£10,000);
★Queen's Hall; Scottish Borders
 Community Orchestra (£5,000 each);
Perth Festival of the Arts (£2,500);
Orkney Heritage Society; ★Northlands
 Festival (£2,000 each).

Exclusions: Individuals.
Applications: In writing, including
charity number and a copy of the latest
accounts. The trustees meet in February,
March, May, July, September and
November.

The Helen Roll Charity

CC No: 299108

3 Worcester Street, Oxford OX1 2PZ

Contact: Frank Richard Williamson,
Trustee
Trustees: Jennifer Williamson; Frank
Richard Williamson; Paul Strang;
Christine Chapman; Terry Jones.
Beneficial area: UK, with a particular
interest in Oxfordshire and the South
East.
Grant total: £104,000 (1999/2000)
Arts grants: £25,000
This trust makes grants to a wide variety
of registered charities, with an emphasis
on causes which struggle to secure
funding from other sources. Funding,
usually in the form of capital grants, may
be given on a 'start-up' basis or as part of
longer term commitments. There is an
apparent preference for causes in
Oxfordshire and the South East of
England. Some of the beneficiaries have
links to the charity through its trustees.

In 1999/2000 the charity gave a total
of almost £104,000 in 26 grants ranging
from £300 to £10,205, most of which
were under £6,000. Out of this, £25,000
(24% of total funding) was given in the
following four arts-related grants:
★Oxford University Bodleian Library;
 ★Trinity College of Music (£8,000
 each);
★Oxford University Ashmolean Museum
 (£7,000);
★Playhouse Theatre Trust (£2,000).

Exclusions: Individuals.
Applications: *Applicants should note that
most beneficiaries are long-standing and
recurrent and that 'only one in one hundred
new applications is successful'.*

Rootstein Hopkins Foundation

CC No: 1001223

PO Box 14720, London W3 7ZG

Tel: 020 8746 2136
Contact: Graham Feldman, Trustee
Trustees: Ms J Morreau; G L Feldman; M J Southgate; Ms J Hartwell; Mrs D Hopkins.
Beneficial area: UK.
Grant total: £584,000 (2000) but see below.
Arts grants: £584,000
This foundation may make grants to general causes, but its main charitable purposes are:

- to promote the fine and applied arts for the benefit of the public by the provision of grants, bursaries and other financial assistance to: schools of art and other art educational establishments; art organisations; artists; art students; art teachers and lecturers; and bodies which run art schools or promotes the development, study, research and practice of art, particularly painting, drawing, sculpture, photography, fine and applied art;
- to promote for public benefit the study and research of fine arts, particularly painting and drawing;
- to develop the study of and research into improved methods of display and visual merchandising.

Grants are made under the following headings: travel grants; sabbatical award; mature student grant; exchange students grant; project grants; capital grants.

In 2000 the foundation gave a total of £584,000 in 11 grants ranging from £750 to an excepional donation of £500,000 for British Museum; most were under £12,000. All funding appeared to be related to arts and arts education. Donations were listed as follows:
British Museum, for the acquisition of contemporary prints and drawings (£500,000);

Royal College of Art, grant for PhD courses over three years (£37,000);
Kingston University, capital funding (£20,000);
Teachers' sabbatical funding (£12,000);
Travel scholarship; student travel grant; project grants, for two individuals (£5,000 each);
Mature student funding (£2,500);
Special award (£750).

It should be noted that the above level of support is exceptional, largely as a result of the sum given to the British Museum, and the foundation's annual giving usually amounts to around £75,000.
Applications: On an application form available from the correspondent.

The Rose Foundation

CC No: 274875

28 Crawford Street, London W1H 1PL

Tel: 020 7262 1155; Fax: 020 7724 2044
Contact: Martin Rose
Trustees: John Rose; Paul Rose; Martin Rose; Alan Rose.
Beneficial area: UK, principally London and the Home Counties; USA.
Grant total: £997,000 (committed in 2000)
Arts grants: £167,138
The main emphasis of the foundation's work is to finance building projects for other charities. The foundation's policy is to provide between £5,000 and £30,000 towards self-contained schemes of less than £100,000. Projects supported are usually located in London or the Home Counties so that their progress can be monitored. The foundation becomes involved, in an advisory capacity, with the design and construction process, so that costs are minimised and designs are effective.

Grants are made across a wide range of causes including work benefiting the disabled; social welfare; health; the arts; education; and Jewish charities.

In addition to its general policy, the foundation also, in conjunction with Ability, provides annual support to two charities: the Crawford Street Centre, a gymnasium and therapy centre for both disabled and able bodied people, which includes a gallery where works produced by disabled artists are displayed and sold; and the New Amsterdam Charitable Foundation, which allocates funding to causes in the USA.

In 2000 the foundation committed a total of £997,000 in grants to over 35 causes. The two largest donations were made to Crawford Street Centre (£337,000) and New Amsterdam Charitable Foundation (£115,078). The rest of the grants ranged from unspecified donations of under £2,000 to £50,000; most for under £20,000. A total of £167,138 (17% of grant-aid) was given in nine listed donations relevant to this guide. These were:

Hampstead Theatre (£50,000);
Royal National Theatre (£42,638);
Finchley Arts Centre (£20,000);
Weavers Community Trust; New
 Shakespeare Company (£15,000 each);
Almeida Theatre Company; Courtauld
 Institute of Art Fund (£10,000 each);
★MediCinema (£2,500);
★Soho Theatre and Writers Centre
 (£2,000).

In previous years, major support has also been given to Royal Academy of Arts (£125,000 in 1999) to assist with the gallery restoration.

Applications: Applicants should apply by the end of March each year. The next two months are used to inspect the shortlisted projects and the trustees usually commit to the following year's schemes around mid-June. It is stipulated that 'the project should not have commenced before the end of the year, but will nevertheless begin in the first six months of the following year.' All proposals receive a reply.

The Rothschild Foundation

CC No: 230159

The Dairy, Queen Street, Waddesdon, Aylesbury, Buckinghamshire HP18 0JW

Tel: 01296 653235
Contact: Miss Fiona Sinclair
Trustees: Lord Rothschild; Lady Rothschild; Hannah Rothschild; Sir Edward Cazalet.
Beneficial area: UK; overseas, particularly Israel.
Grant total: £678,000 (1999/2000)
Arts grants: £33,000

The foundation has a wide range of charitable interests, including the arts, conservation, medicine and health, education and research. In 1999/2000 the foundation gave almost £678,000, the majority of which was given in an exceptional grant of £600,009 for the restoration of Waddesdon Manor, a former Rothschild family residence. A further 49 grants were made, ranging from £11 to £15,000, although most were under £2,000. A total of £33,000 (five per cent of total grant-aid; 43% of available funding after Waddesdon Manor grant) was given in nine arts-related grants. These were:

National Museums and Galleries on
 Merseyside (£15,000);
Friends of the Kirov Appeal (£11,600);
★Royal Opera House Trust (£2,500);
Leeds Art Collection Fund; Theatre
 Royal Winchester; ★Yehudi Menuhin
 Memorial Concert (£1,000 each);
★Chicken Shed Theatre Company
 (£500);
★Artists General Benevolent Association;
 Music Therapy Company (£200 each).

Applications: In writing, enclosing a SAE.

The Rowlands Trust

CC No: 1062148

c/o Wragg & Co., 55 Colmore Row, Birmingham B3 2AS

Tel: 0121 233 1000; Fax: 0121 214 1099
Contact: Mrs Teresa Priest, Clerk to the Trustees
Trustees: A C S Hordern, Chairman; G B G Hingley; K G Mason; Mrs A M I Harris; Mrs F J Burman.
Beneficial area: West Midlands and South Midlands, including Hereford and Worcester, Gloucester, Shropshire and Birmingham.
Grant total: £601,000 (2000)
Arts grants: £44,000

This trust was established to 'encourage research, education and training in the broadest sense'. Charities providing for medical and scientific research, the services, the sick, the poor, the handicapped, the elderly, music, the arts, the environment and the maintenance of Anglican churches are also considered for funding. The trust is primarily focused on projects in the West Midlands and South Midlands, including Hereford and Worcester, Gloucester, Shropshire and Birmingham.

In 2000 the trust gave a total of £601,000 in 62 grants ranging from £375 to an exceptional donation of £350,000 for the Charles Hastings Education Centre. Most grants were, however, under £15,000. A total of £44,000 (seven per cent of total funding) was given in nine grants relevant to this guide. These were:

Hereford Light Infantry Museum Trust; Worcestershire Regiment Museum Trust (£15,000 each);
Ledbury Poetry Festival (£7,500 in two grants);
★Elgar School of Music (£2,500 in two grants);
★Colwall Players (£2,000);
Hereford Three Choirs Festival (£1,500);
Dore Abbey Music Festival (£500).

Exclusions: Causes for which statutory funding is available; animal charities; individuals; unregistered charities.
Applications: Trustees meet quarterly. Appeals should be made on the application form available from the trust.

Royal Literary Fund

CC No: 219952

3 Johnson's Court, London EC4A 3EA

Tel: 020 7353 7150; Fax: 020 7353 1350
E-mail: rlitfund@globalnet.co.uk
Contact: Eileen Gunn, Secretary
Trustees: President and Chairman: Sir Stephen Tumim.
Vice-Presidents: Arthur Crook; Nicholas Baring; Margaret Drabble; Michael Gilbert; Michael Holroyd; Doris Lessing; Claire Tomalin; Philip Ziegler.
General Committee: Peter Janson-Smith; Derek Parker; John Roberts; Sir Stephen Tumim; Hilary Spurling; Jill Black; Richard Holmes; Kate Pool; Paul Bailey; Douglas Matthews; Anthony Thwaite; Ronald Harwood; Alexandra Pringle; Euan Cameron; Simon Brett; Frances Fyfield; Susan Cordingley; Bruce Hunter; Paula Johnson; Michael Ridpath.
Beneficial area: UK.
Donations to all causes: £3,107,000 (2000/01)
Arts grants: £2,874,435

The fund was established in 1790 with the main objective of assisting published writers of several works of literary merit and their dependants in times of need. This main body of support takes the form of grant-aid and, for elderly writers, pensions.

In 2000/2001 the fund gave a total of over £3,107,000 which was distributed as follows:

- grants and pensions for individuals – £2,002,993 to 204 beneficiaries;
- Royal Literary Fund Fellowships – £455,942 to 27 beneficiaries;
- grants to institutions – £648,500 to 17 beneficiaries.

Out of this, £2,874,435 was given to causes specifically relevant to this guide. This included £415,500 disbursed in grants to nine institutions. These were: National Library Trust (£136,000); Arvon Foundation (£100,000); Taliesin Trust (£50,000); ★PEN (£42,000); Listening Books (£32,500); Writers and Community Publishing Federation (£23,000); ★Threshold Prize; ★National Life Story Centre (£15,000 each); Royal Society for Literature (£2,000).

The majority of these grants were made on a one-off basis. Notable recipients in 1999/2000 included:
Book Aid International; Friends of National Libraries (£150,000); Authors Foundation (£132,000); Centre for Children's Books (£50,000); Poetry Library (£35,800).

However, the Royal Literary Fund has stated that from 2002 it will no longer be making grants to institutions.

Exclusions: Institutions.
Applications: 'Writers who apply to the fund must submit samples of their work. These are read by two members of the general committee, who then report at the monthly meeting and recommend whether or not the criterion for literary merit is satisfied.'

General grants and pensions are administered by the secretary. Applicants for fellowships should contact Steve Cook (fellowships officer) on 020 7353 7160.

The Royal Victoria Hall Foundation

CC No: 211246

111 Green Street, Sunbury on Thames, Middlesex TW16 6QX

Tel: 01932 782341
E-mail: rvhf@xalt.co.uk
Contact: Mrs C Cooper, Clerk
Trustees: Valerie Colgan, Chair; Dilys Gane; David Russell; Anne Stanesby; Michael Redington; Sam Walters; David Collier; Annie Castledine; Gerald Lidstone.

Beneficial area: Greater London area only.
Grant total: £44,000 (2000/01)
Arts grants: £44,000
The foundation's objectives are to provide facilities in Greater London for the education of the socially and economically disadvantaged, primarily in music and drama.

In 2000/01 a total of over £44,000, made up of 42 grants, was given in two categories:
Lilian Baylis Awards to individual students – Grants of £1,200 each (£13,200 in total) are given to 11 students each year on the recommendation of accredited drama schools in London.
Grants to support theatrical groups and to encourage experience of the theatre – One-off grants ranging from £150 to £2,500, most of which were between £500 and £2,000. There were 31 of these, totalling £31,075.
Beneficiaries included:
Royal Court Theatre; Unicorn Theatre (£2,500 each);
White Knight Pictures; Chicken Shed Theatre Company (£2,000 each);
White Bear Theatre Club; Mu-Lan Arts; Theatre Nomad; I'm A Camera (£1,500 each);
Camden People's Theatre; Half Moon Young People's Theatre; Pascal Theatre Company; In Tandem Theatre

Company; Empty Space Theatre
Company (£1,000 each);
Hopeful Monsters (£750);
Gogmagogs; Eve Productions; Kettle of
Fish Theatre (£500 each);
Action Space (£375).

These grants are generally given to
different causes each year.
Exclusions: Individuals; retrospective
grants; dance projects which are not in a
theatrical context.
Applications: In writing to the
correspondent by 1 February and
1 August prior to trustees' meetings.
No replies without a SAE. No repeat
applications within two years.

The RSA Art for Architecture Scheme

8 John Adam Street, London WC2N 6EZ

Tel: 020 7451 6871/6865;
Fax: 020 7839 5805
E-mail: jes.fernie@rsa.org.uk
Website: www.rsa.org.uk/afa
Contact: Jes Fernie, Project Manager
Trustees: Patron: Lord Palumbo.
Chairman: Hugh Pearman. Panel: Renato
Benedetti; Theresa Bergne; Nathan Coley;
Clare Cumberlidge; Alan Haydon; Alicia
Pivaro; Katherine Shonfield; Chris Wise;
Katherine Clarke.
Beneficial area: UK.
Grant total: £100,000 per annum
Arts grants: £100,000
This scheme, managed by the RSA, aims
to create a visually stimulating urban
environment by providing funds for
artists to work with architects and other
design professionals from the initial stages
of a project's development. Collaboration
is the key element of any supported
project, with artists becoming involved in
'the development of the overall
masterplan' and using their own abilities
to influence the basic design strategy.

Project grants range from £2,000 to
£15,000 and cover the artists' fees only.

Applications are assessed by the Art for
Architecture advisory panel, whose most
recent panel meeting (at the time of
writing) awarded a total of £26,000 in
project grants to four artists.
Exclusions: Artist commissions;
installation costs; feasibility studies; long
established partnerships between artists
and architects are unlikely to receive
funding.
Applications: Project grants cover the
design fees of artists working directly
with one other design professional, such
as an architect, a landscape architect or an
engineer, on building projects; projects
using new technologies (electronic and
digital media, virtual space and so on);
landscape projects; and short-term or
experimental projects. Applications may
be made by anyone involved in the
project, for example the artist, architect,
local authority officer, public art agent or
client. Artists must be selected or
shortlisted, although not necessarily
appointed, prior to submission of an
application. The project must be
accessible to the general public. Evidence
that other funds are being sought is
regarded favourably. The outcome of the
collaboration must be in place for at least
four months and lead to longer term
development.

Applications must be completed before
any design work has begun and must be
made using the scheme's application form
which is avilable from the website or by
post.

The advisory panel meets three times a
year. Successful applicants are required to
include the Art for Architecture funding
mark in their publicity material.

For further information contact Jes
Fernie or Lizzie Tulip on 020 7451 6865/
6871.

The Willy Russell Charitable Trust

CC No: 1003546

Malthouse & Co, Chartered Accountants, America House, Rumford Court, Rumford Place, Liverpool L3 9DD

Tel: 0151 284 2000
Contact: John Malthouse, Trustee
Trustees: Willy Russell; Ann Russell; John Malthouse.
Beneficial area: UK.
Grant total: £51,000 (1999/2000)
Arts grants: £16,000
This trust, established by the well-known playwright in 1992, sponsors students at theatre and drama schools and at university, as well as making donations to arts and other charitable causes.

In 1999/2000 the trust donated a total of £51,000. This comprised 21 grants of over £1,000 detailed in the trust's annual report, including one to an individual student, and nine smaller donations totalling £3,875. The largest grant was for £8,000, although most were below £5,000. A total of £16,000 was given in four listed arts-related donations relevant to this guide. These were:
Liverpool Lunchtime Theatre; Khulani Literary Centre; Production Line (£5,000 each);
The Library Company (£1,000).

A trustee stated that Willy Russell is 'most concerned about anonymity and maintaining a low, not to say invisible, profile' and indicated that the trust was reluctant to appear in this guide, fearful of the adverse effects of publicity.
Applications: See above.

The RVW Trust

(see also Musicians' Benevolent Fund)

CC No: 1066977

16 Ogle Street, London W1W 6JA

Tel: 020 7255 2590; Fax: 020 7255 2591
Contact: Helen Faulkner, Secretary/Administrator
Trustees: Michael Kennedy, Chair; Lord Armstrong of Ilminster; Sir John Manduell; Mrs Ursula Vaughan Williams; Musicians Benevolent Fund.
Beneficial area: UK.
Grant total: £266,000 (2000)
Arts grants: £266,000
This trust, formerly the Vaughan Williams Musical Trust, supports 'the advancement of public appreciation of and education in music' and the relief of poverty among musicians, their widows and children.

The trust's current specific grant-making policies are as follows:
- 'To give assistance to British composers who have not yet achieved a national reputation.
- To give assistance towards the performance and recording of music by neglected or currently unfashionable 20th Century British composers, including performances by societies and at festivals which include works by such composers in their programmes.
- To assist national organisations which promote public knowledge and appreciation of 20th and 21st century British music.
- To assist education projects in the field of music.'

In 2000 the trust authorised a total of £266,000 in grants within the following categories:
- public performance – £43,500;
- music festivals – £47,745;
- public education – £131,700;
- education grants – £43,412.

The trust's annual reports only give more extensive summaries of grants made in

the preceding year. In 1999 donations of between £300 and £20,000, made to 57 beneficiaries, amounted to almost £212,000. Examples are listed below.

Under 'public performances' –

New London Orchestra; English Chamber Orchestra and Music Society (£5,000 each);

Lontano (£3,500);

Broadheath Singers; Cheltenham Music Society (£1,500 each);

John Currie Singers and Orchestra; Music Past and Present; Chamber Music Exchange (£1,000 each);

Opera 20 (£500).

Under 'music festivals' –

Huddersfield Contemporary Music Festival (£20,000);

Brighton Festival; Chester Summer Music Festival; Oxford Festival of Contemporary Music Festival (£5,000 each);

Lower Machen Festival (£1,000).

Under 'public education' –

British Music Information Centre (£15,000);

Society for the Promotion of New Music (£12,500);

Barbirolli Society (£2,000).

Under 'education grants' –

William Walton Foundation, Ischia Summer School; National Opera Studio (£10,000 each);

Royal College of Music, R V W Fellowship (£6,000);

National Opera Studio (£5,000);

London Guildhall University Department of Music and Technology (£3,000);

Jackdaws Educational Trust (£2,000);

Yfrah Neaman Summer School (£1,250).

Applications: In writing. Meetings are held three times a year, in November, February/ March and June/July (the last is mainly devoted to composition students).

The Audrey Sacher Charitable Trust

CC No: 288973

c/o H W Fisher, 11–15 William Road, London NW1 3ER

Contact: Mr P Samuel
Trustees: Michael H Sacher; Nichola Sacher.
Beneficial area: UK.
Grant total: £198,000 (2000/01)
Arts grants: £158,000

The trust is interested in institutions or bodies with general charitable aims, but usually supports a small number of arts causes. **Grants are usually recurrent and directed towards large organisations known personally to the trustees**.

In 2000/01 the trust recorded a total charitable expenditure of £198,000. Out of this, £158,000 was given in two grants to the arts. This arts-related total comprised an exceptional donation of £123,000 to the Royal Opera House and a grant of £25,000 for the National Gallery Trust.

Exclusions: Individuals; organisations not registered as charities.
Applications: In writing to the correspondent, but note the above.

Dr Mortimer & Theresa Sackler Foundation

CC No: 327863

15 North Audley Street, London W1Y 1WE

Tel: 020 7493 3842
Contact: Christopher B Mitchell, Solicitor
Trustees: Dr Raymond Sackler; Dr Richard Sackler; Jonathon Sackler; Christopher Mitchell; Dr Ronald Miller; Paul Manners; Raymond Smith.
Beneficial area: UK.
Grant total: £61,000 (1997)
Arts grants: £14,000

The foundation's interests are the arts, science and medical research.

The most recent information available is for 1997 when the foundation gave a total of £61,000. This comprised 12 donations over £1,000 and an unspecified number of grants under £1,000, which were not listed in the annual report but amounted to £3,950. All but one grant, for £37,403 to Oxford University, were under £5,000. Of the listed grants, £14,000 (23% of total grant-aid) was given to five arts beneficiaries. These were:

National Arts Collection Fund; Young Musicians Symphony Orchestra Society (£5,000 each);
Poole Study Gallery Appeal (£2,000);
British Friends of the Art Museums of Israel; Royal School of Needlework (£1,000 each).

The foundation's annual report for 1997 states that 'the trustees have under consideration further donations in the coming year and up to the date of this report have donated £128,384 including £70,000 to the Dulwich Picture Gallery, £8,334 to Sadlers Wells (Theatre) and £30,000 to The Royal National Theatre Board'. Arts beneficiaries in 1996 included the Louvre Museum in Paris (£158,943), the Serpentine Gallery (£50,000), the Royal Opera House Trust (£15,580) and the Natural History Museum's Down House Appeal (£5,000).

Applications: In writing to the correspondent, but note above.

The Raymond and Beverly Sackler Foundation

CC No: 327864

15 North Audley Street, London W1K 6WZ

Tel: 020 7493 3842
Contact: Mr C B Mitchell
Trustees: Dr Raymond R Sackler; Dr Richard S Sackler; Jonathon D Sackler;

Christopher B Mitchell; Dr Ronald B Miller; Paul Manners; Raymond M Smith.
Grant total: £410,000 (1999)
Arts grants: £80,000
This foundation concentrates its giving on 'the advancement of the education of the public of the United Kingdom and elsewhere in the fields of the arts, science and medical research'. Its support is exclusively directed at a short list of regular beneficiaries.

In 1999 the trust gave a total of £410,000 in two grants. The largest of these was a sum of £330,000 donated to Cambridge University for an unspecified purpose. The remaining grant of £80,000 (20% of total funding) was specifically relevant to this guide and was made to the British Museum. Both of these donations were recurrent and these causes have annually received either all or the vast majority of the foundation's support.
Applications: Unsolicited appeals are not considered.

The Karim Rida Said Foundation

CC No: 1073096

4 Bloomsbury Place, Second Floor, London WC1A 2QA

Tel: 020 7691 2772; Fax: 020 7691 2780
E-mail: admin@krsf.org
Website: www.krsf.org
Contact: Mark Long, Director
Trustees: Wafic R Said, Chair; Mrs A Rosemary Said; Mr Khaled Said: Mr Ghayth Armanazi; Dr Peter Clark; Mrs Sirine Idilby; Lord Powell; Ms Catherine Roe.
Beneficial area: Syria, Lebanon, Jordan, Palestine, Iraq, Egypt and Saudi Arabia.
Grant total: £950,000 (1999/2000)
Arts grants: £57,215
This foundation supports three broad categories of activities. 'It grants scholarships to students from the Arab world; it supports projects in the Arab

world in the fields of health, disability and education and for children 'at risk'; and it supports activities which seek to promote a better understanding in the UK of the Arab culture and language.' The 'Arab world' is specified as Syria, Lebanon, Jordan, Palestine, Iraq, Egypt and Saudi Arabia.

In 1999/2000 a total of £950,000 was given in grants ranging from £2,938 to £197,801. The largest grants were generally made to educational institutions for the provision of scholarships, some of which may have been relevant to this guide. Of the specified grants, £57,215 (six per cent of total grant-aid) was given in the following arts-related donations:

British Museum, fourth of five annual payments for its Arab World Education Programme (£50,000);

Ibda Foundation for Culture and Arts, for after-school educational and cultural activities (£7,215).

Exclusions: General appeals; sponsorship events; conferences; newsletters; individuals.

Applications: On a form available from the foundation. If a project is eligible it will be visited. Applicants for scholarships should apply through the offices of the British Council in Damascus, Amman, Beirut, East Jerusalem or Gaza City (by end of February) if not already in the UK. If in the UK, direct to the foundation (by end of April). If planning to study at Oxford or Cambridge, apply directly to them (by end of September).

The Alan and Babette Sainsbury Charitable Trust

(see also the Sainsbury Family Charitable Trusts)

CC No: 292930

Tel: 020 7410 0330
Contact: Michael Pattison, Director
Trustees: Hon. Simon Sainsbury; Miss J S Portrait.

Beneficial area: UK and overseas.
Grant total: £416,000 (1999/2000)
Arts grants: £30,500
Support is concentrated on a small number of programmes intended to build on the themes of earlier funding activities, including 'ethnic minority and refugees groups, community-based mental health initiatives, human rights and access to the arts for disadvantaged people'.

In 1999/2000 the trust gave 17 grants totalling over £416,000. These were distributed as follows:

- education – £254,592 in two grants;
- health and social welfare – £64,463 in ten grants;
- overseas – £25,000 in one grant;
- scientific and medical research – £22,095 in one grant;
- the arts – £30,500 in two grants;
- religion – £20,000 in one grant.

A total of £30,500 (seven per cent of total grant-aid) was given in arts-related grants to the following beneficiaries:
Young Concert Artists Trust (£16,000); Artsline (£14,500).

Exclusions: Individuals.
Applications: 'Proposals are likely to be invited by the trustees or initiated at their request. Unsolicited applications are unlikely to be successful.'

The Sainsbury Family Charitable Trusts

9 Red Lion Court, London EC4A 3EF

Tel: 020 7410 0330
Contact: Michael Pattison, Director
The Sainsbury Family Charitable Trusts are unique among grant-making trusts in this country: 18 separate charitable trusts covering three generations of the Sainsbury family share a common administration. Another unusual feature is that in most cases the settlor who endowed the trust is also an active trustee. This means that the policies and practices of these trusts are led by the settlors and

reflect their interests in a close and intimate way. In most cases other near relatives also serve as trustees. However, each trust is independent of the others and has a clear and separate identity in its grantmaking. This needs to be emphasised. Each trust is as distinct as its own individual name despite the fact that there are areas where its interests may be mirrored by or sometimes overlap with others.

Nine of the Sainsbury Family Charitable Trusts give donations relevant to this guide:

- The Ashden Trust;
- The Gatsby Charitable Foundation;
- The Glass-House Trust;
- The Headley Trust;
- The Jerusalem Trust;
- The Linbury Trust;
- The Monument Trust;
- The Alan and Babette Sainsbury Charitable Fund;
- The Woodward Trust.

Unsolicited applications

It is important for would-be applicants to realise that all the trusts, except Woodward, declare firmly that they are proactive and do not solicit applications. On the other hand the door is not completely shut. The common denominator for the general public is the joint administration, a staff of 25 led by their director, Michael Pattison. This administration fields about 20,000 applications a year. All these approaches are read and acknowledged. They are told that if their approach is of interest they will hear within six weeks, but that if no follow through occurs, to accept that the trusts will not be able to help. About 1,000 grants are made each year and only a very small proportion of these result from 'cold' applications.

Internally taken initiatives are the mainspring of their operations.

Exclusions: None of the Sainsbury Family Charitable Trusts listed here gives grants direct to individuals.

Applications: The trusts, except for the Woodward, do not provide any guidelines for applicants or application forms. Applicants should apply in writing including details of the organisation, its project, costs and planned outcomes.

The Coral Samuel Charitable Trust

CC No: 239677

c/o Great Portland Estates plc, Knighton House, 56 Mortimer Street, London W1N 8DB

Tel: 020 7580 3040
Contact: Mrs Coral Samuel, Trustee
Trustees: Coral Samuel; P Fineman.
Beneficial area: UK.
Grant total: £198,000 (1999/2000)
Arts grants: £154,000
This trust tends to make a few substantial grants of £10,000 or more to educational, cultural and socially supportive charities, many of which have previously received support. In addition, it makes a number of smaller donations for other causes.

In 1999/2000 the trust gave a total of nearly £198,000 in 28 grants ranging from £500 to £25,000; most were under £15,000. Of this total, £154,000 (78% of grant-aid) was given in the following 11 arts grants:

★British Museum Development Trust;
 ★Dulwich Picture Gallery; ★English National Opera; ★Sir John Soane's Museum (£25,000 each);
★Royal Opera House Trust (£20,000);
National Maritime Museum (£15,000);
★Natural History Museum (£10,000);
Ayelsbury Music Centre (£5,000);
Chicken Shed Theatre Company (£2,000);
★Courtauld Institute of Art; Ashmolean Museum (£1,000 each).

Exclusions: Individuals.
Applications: Registered charities only. Applications in writing to the correspondent.

The Basil Samuel Charitable Trust

CC No: 206579

c/o Great Portland Estates plc, Knighton House, 56 Mortimer Street, London W1W 7RT

Tel: 020 7580 3040
Contact: Mrs Coral Samuel
Trustees: Coral Samuel; Richard Peskin.
Beneficial area: UK and overseas.
Grant total: £478,000 (1999/2000)
Arts grants: £165,000
This trust makes 'a limited number of grants for £25,000 or more to medical, socially supportive, educational and cultural charities', plus a number of smaller donations for other causes. Most grants are made to previous beneficiaries.

In 1999/2000 the trust gave a total of over £478,000 in 26 grants ranging from £1,000 to £50,000; most were under £25,000. Out of this, a total of £165,000 (35%) was given to seven arts causes. These were:
★Royal Academy of Arts; Old Vic (£50,000 each);
★Victoria & Albert Museum (£25,000);
★National Maritime Museum (£15,000);
Lyric Theatre, Hammersmith; Museum of London (£10,000 each);
★Attingham Trust (£5,000).

Exclusions: Individuals; organisations not registered as a charity.
Applications: In writing to the correspondent. Only registered charities may apply.

The Francis C. Scott Charitable Trust

CC No: 232131

3 Lambrigg Terrace, Kendal, Cumbria LA9 4BB

Tel: 01539 741613; Fax: 01539 741611
Website: www.fcst.org.uk
Contact: Donald Harding, Director

Trustees: R W Sykes, Chair; Miss M M Scott; F A Scott; Mrs S E Bagot; W Dobie; F J R Boddy; C C Spedding; I H Pirnie.
Beneficial area: Cumbria and Lancashire only.
Grant total: £1,314,000 (1999/2000)
Arts grants: £23,025
The trust's priorities are local charities working with underprivileged and disadvantaged people in Cumbria and Lancashire. The principal geographical area for giving is described as 'Cumbria and North Lancashire as far South as Morecambe and Heysham', with most of the remaining funding directed towards causes in 'the rest of the Administrative County of Lancashire'.

In 1999/2000 the trust gave a total of £1,314,000 in 203 grants ranging from £100 to £60,000, most of which were below £20,000. Arts grants vary from year to year but in 1999/2000 a total of £23,025 (two per cent of total grant-aid) was given to nine arts-related beneficiaries. These were:
★Dukes Playhouse (£5,000);
Royal Society of Arts, for Francis Scott Memorial Lecture (£3,525);
★Ashton Group Contemporary Theatre;
 ★Quondom Arts Trust (£3,000 each);
Action Factory Community Arts Limited; Prism Arts; Mid Pennine Arts (£2,000 each);
Wyndham Youth Centre (£1,500);
Live Music Now! (£1,000).

Exclusions: Individuals; organisations not registered as charities; projects formerly statutorily funded; church restoration; expeditions; scholarships and applications from schools.
Applications: On a form available from the correspondent; the completed form has to be returned with the latest set of accounts. The trustees meet three times a year in March, June and November. Applications need to arrive one month prior to each meeting. The whole process, from application to receipt of grant, may

take up to four months. The director or his assistant will happily discuss requirements with potential applicants over the telephone.

Scottish Book Trust

Scottish Book Centre, 137 Dundee Street, Edinburgh EH11 1BG

Tel: 0131 229 3663; Fax: 0131 228 4293
E-mail: scottish.book.trust@dial.pipex.com
Contact: Lindsey Fraser
Beneficial area: Scotland.
The trust makes the annual Fidler Award to encourage new writing. This award is given in the form of publication, plus a £1,000 advance, for an unpublished novel for children aged 8–12 years. The work should be the first attempt to write for this age group.

The trust also administers The Writers in Scotland Scheme, which was founded in 1972 by the Scottish Arts Council. The scheme 'supports registered writers, and storytellers listed in the Scottish Storytelling Directory, by subsidising their visits to schools, libraries, writers groups, prisons and community and literary organisations throughout the country'. The scheme's committee allocates a specific number of sessions for the forthcoming financial year, depending on available funds. 'These allocations are awarded to event organisers on the basis of their application. Where an allocation has been granted, the organiser is liable for half of the visitor's fee. The Writers in Scotland Scheme provides the other half, as well as expenses up to pre-set levels. An allocation covers one writer's session. The length of a session varies according to the writer in question and should be confirmed between the organiser and writer in advance of the visit to assist accurate budgeting.

In previous years the trust had also administered the Scottish Writer of the Year award. This award is, however, no longer in existence.

Applications: Contact the trust for further details about the above awards. Applicants for the Writers in Scotland Scheme should obtain an application form from the trust.

The Scottish International Education Trust

CC No: SC09207

22 Manor Place, Edinburgh EH3 7DS

Tel: 0131 225 1113; Fax: 0131 225 1113
Contact: E C Davison, Director
Trustees: J D Houston, Chair; W Menzies Campbell; Sir Sean Connery; Tom Fleming; Lady Gibson; Alexander Goudie; Andy Irvine; Prof. Sir Alistair Macfarlane; J F McClellan; Kenneth McKellar; Sir Jackie Stewart.
Beneficial area: Scotland.
Grant total: £125,000 (2000/01)
This trust is a charitable organisation set up in 1971 on the initiative of actor Sean Connery. It makes grants to organisations and individuals contributing to the cultural, economic and social development of Scotland. Grants are given on a one-off basis and range between £400 and £2,000.

The trustees regard their primary purposes to be:
- to assist young Scots who have demonstrated excellence in their initial course of higher education and wish to take their studies or professional training further;
- to support projects which seem especially valuable in contributing to the cultural, economic or social development of Scotland or the improvement of the Scottish environment.

In 2000/01 the trust's assets stood at £1.76 million, generating income of £23,000. It made grants totalling £125,000.
Exclusions: Commercial organisations; capital work; general maintenance;

courses for which there is support from statutory bodies/public funds.

Applications: In writing to the director.

Geoffrey Shaw Memorial Fund – see Musicians' Benevolent Fund

CC No: 228089/0002

The Archie Sherman Charitable Trust

CC No: 256893

27 Berkeley House, Hay Hill, London W1 7LG

Tel: 020 7493 1904
Contact: M J Gee, Trustee
Trustees: M J Gee; AHS Morgenthau; E Charles.
Beneficial area: UK and overseas.
Grant total: £1,300,000 (1999/2000)
Arts grants: £92,000

'The policies of the trust are almost exclusively to benefit health and educational purposes.' The trust is supportive of Jewish causes but not exclusively so. Grants are generally made to registered charities with which the trustees are acquainted.

In 1999/2000 the trust gave a total of £1,300,000 in 58 grants ranging from £250 to £178,000 and expects to maintain this level of funding for the next five years. Of this total, four grants amounting to over £92,000 (seven per cent of total funding) were given to arts-related causes, all of which have previously received the trust's support. These were:

* The Royal Opera House Trust (£52,320);
* Imperial War Museum Trust (£27,000);
* Royal National Theatre (£12,500);
* North West London Orchestra (£250).

Grants have also been given in previous years to such arts organisations as the Royal Academy Trust (£36,000 in 1996/97, £35,000 in 1995/96); Zemel Choir (£5,000 in 1996/97); Israel Music Foundation; British Israel Arts Foundation (£5,000 each in 1997/98); London Philharmonic Orchestra (£1,200 in 1996/97); Windsor Festival Society (£250 in 1997/98); British Friends of the Art Museums of Israel (£100 in 1997/98).

Applications: In writing to the correspondent. Trustees meet on a regular basis and 'review all commitments on a forward four year basis'. Regular progress reports are sent to the trustees and on-site visits are also made.

The trust is usually committed to long-term projects spread over between one to six years and, as a result, unsolicited applications are unlikely to be successful.

The R C Sherriff Rosebriars Trust

CC No: 272527

Civic Centre, High Street, Esher, Surrey KT10 9SD

Tel: 01372 474 566
E-mail: grants@rosebriars.org.uk
Website: www.rosebriars.org.uk
Contact: Beccy Jones, Director
Trustees: Elmbridge Borough Council.
Beneficial area: Borough of Elmbridge in Surrey.
Grant total: £65,000 (2000)
Arts grants: £65,000

The trust's purpose is 'developing, promoting and supporting amateur and professional arts within the Borough of Elmbridge by administering a grant support system, by initiating projects to complement and extend existing arts provision, and by offering advice and information to the arts community and members of the public'.

In 2000 the trust disbursed a total of over £65,000 in 58 grants, all of which were for arts activities. This was divided

into £10,776 for 'schools funding', £27,183 for 'annual grant aid', £16,000 for 'venue enhancement', £10,000 for 'three-year funding' and £1,887 for 'training bursaries'.

Annual grant aid (general programme)

A total of 33 grants were made. The largest donation was for £12,500 towards raked seating for the local playhouse. Most were under £3,000 and included: Claygate Choral Society (£2,500); Weybridge Male Voice Choir (£1,800); Ember Players; Cabaret Now (£1,000 each); Cobham Band (£700); Promenade (£500); Riverhouse Contemporary Dance Group (£250); Desborough Players (£200).

The trust's projected funding for grants in 2001 was approximately £60,000, rising to approximately £70,000 in 2002.

Exclusions: Individuals and organisations residing or operating outside the Borough of Elmbridge.

Applications: Ring for an informal discussion and to request an application pack.

SHINE – Support and Help in Education

CC No: 1082777

1 Cheam Road, Ewell Village, Surrey KT17 1SP

Tel: 020 8393 1880; Fax: 020 8394 2570
E-mail: info@shinetrust.org.uk
Website: www.shinetrust.org.uk
Contact: Stephen Shields, Director of Programmes
Beneficial area: UK, especially London and the South East of England.
Grant total: £962,000 (2001)

This new trust, established in 2000, supports education initiatives which encourage children and young people to raise their achievement levels by funding organisations working with under-achieving 7–18 year olds from disadvantaged areas in Greater London.

The trust operates a Learning Through the Arts programme. This initiative, led by Education Extra, a national charity developing and implementing out of school hours learning programmes with schools and other partners, aims to advance education through projects linking schools with local arts organisations. It will develop six arts partnership schemes with professional artists offering a wide range of creative and performing arts opportunities to 120–150 primary or secondary pupils. 'The programme will target young people who are not engaging in school life or who are at risk of exclusion from school, by developing strategies which will seek to re-engage disaffected young people with mainstream education. It is expected that with increased self-confidence and improved attitudes towards school, higher achievement amongst participants will be possible.' This initiative was intended to run for three years from 2000, providing a total of £48,500.

Please note: since June 2001 SHINE has focused more on the core educational subjects of mathematics, English, science and ICT. Some projects in these fields may have an arts element but it is not usually the main purpose.

Exclusions: Individuals; replacement of statutory funding; schools or other educational establishments, except for activities which are clearly additional; short-term programmes; specific subject or beneficiary groups; parenting programmes where the parent is the primary focus; promotion of political or religious beliefs.

Applications: Telephone after viewing the website.

The Henry Smith Charity

(amalgamation of the former Henry Smith Charity [Kensington Estate] and Henry Smith Charity [General Estates])

CC No: 230102

5 Chancery Lane, Clifford's Inn, London EC4A 1BU

Tel: 020 7242 1212; Fax: 020 7404 0087
Website: www.henrysmithcharity.org.uk
Contact: Miss Judith Portrait, Treasurer
Trustees: Julian J L G Sheffield, Chair; Mrs A E Allen; Lord Egremont; Countess of Euston; Viscount Gage; J D Hambro; Lord Hamilton of Dalzell; T D Holland-Martin; Sir John James; Lord Kingsdown; G E Lee-Steere; Ronnie Norman; P W Urquhart; Miss M J Gallyer; Mrs C Godman Law; Ms M Lowther; T J Millington-Drake; M R Newton; P W Smallridge. There are two distribution committees, each with eight members; Julian Sheffield is chair of both.
Beneficial area: UK, but a high proportion of the charity's local grants are made in London, East or West Sussex, Kent, Surrey, Hampshire, Gloucestershire, Leicestershire and Suffolk.
Grant total: £22,302,000 (2000)
Arts grants: £281,000
This charity is the result of a Charity Commission scheme in January 2001 amalgamating the Henry Smith Charity (Kensington Estate) and the Henry Smith Charity (General Estates). 'The new charity retains the trusts of the former charities with two entirely distinct funds, the former General Estates which is now renamed the Estates Fund and the former Kensington Estate which is now renamed the Main Fund.'

The Main Fund makes grants within the following categories:

- medical: hospitals and medical care; hospitals and palliative care; medical research;
- disabled: physical; mental; multiple (physical and mental);
- social service and moral welfare: elderly; young people; drugs and alcohol; community service; counselling and family advice; general; homelessness; clergy widows and children.

Four types of donations are made:

- **Special List** – 'made on a one off basis in response to appeals and relate to a specific project for which applicants have requested support';
- **General List** – 'annual grants made for a fixed period, usually three years. These are also made in response to appeals and are generally applicable to a specific item in the applicant's budget or to a particular project, although in many cases they are applicable towards the core costs and general work of the charity';
- **Major Grants** – each year trustees select a 'special area which will be the subject of a Major Grant consisting of a programme of grants paid over a period of three years, with the aim of making a significant impact in the chosen field'. In 2000, exceptionally, two major grants of £500,000 were awarded, both to help the elderly: Abbeyfield's Integrated Care Project; and Extra Care – Village Life Project;
- **Small Grants** – 'made to grass-root organisations in counties with which the charity has a traditional connection', although there is also a programme for the rest of the UK.

In 1998 the charity gave a total of £22,302,000 via the Main Fund: 601 general and special donations ranging from £1,300 to £400,000 (most were between £20,000 and £75,000), and 654 small grants of between £100 and £25,000 (mainly under £6,000). Out of this, £281,000 (one per cent of total grant-aid) was given in 17 grants relevant to this guide, comprising 11 general and

special grants (totalling £265,650) and 6 small grants amounting to £15,350. These included:

General and Special Grants
Under 'physical disability' –
Listening Books, towards a digital recording studio (£30,000).
Under 'multiple disability' –
Camphill Community Beannachar, costs for craft workshop (£50,000);
Community Music East Ltd, final year of three-year grant to develop workshop for children and adults with physical and mental disabilities (£25,000);
Drake Music Project, final year of three-year grant for salary payment (£20,457);
Artsline Limited, second instalment of three-year grant for a multi-cultural project (£20,000);
Royal Opera House Trust, first of three yearly grants towards the salary of a disabled apprentice (£12,000);
Ealing Music Therapy Project, second year of a three-year salary grant (£11,000).
Under 'community service' –
Arts Factory, first of three grants towards the salary of a Job Search Manager (£20,000).
Under 'major grants for projects in south Yorkshire' –
C V S Rotherham & District (Alzheimer's Disease & Carers Forum), second part of three-year grant towards a music therapy project (£52,404).

Small Grants
Under 'mental disability' –
South Tyneside Art Studio (£1,000).
Under 'multiple disability' –
Brighton Youth Theatre (£750).
Under 'the elderly' –
Art Shape (£5,000).
Under 'young people' –
Leeds Animation Workshop (£2,500).
Under 'drugs and alcohol' –
Daylight Theatre (£6,000).

With regard to arts projects the charity's treasurer has made the following statement: **'It should be noted that the only arts projects which the trustees can fund are those specifically for the rehabilitation and/or training of the disabled. Very occasionally, the trustees will fund arts projects for deprived and disadvantaged children from the Small Grants Programmes.'**

Exclusions: Individuals; education; care or restoration of buildings; general arts projects.

Applications: See above for policy on arts-related funding.

In writing to the treasurer. The charity does not use application forms but offers the following guidelines to applicants for grants:

1. Applications should be no longer than four A4 sides (plus budget and accounts) and should incorporate a short (half page) summary.

2. Applications should state clearly who the applicant is, what it does and whom it seeks to help; give the applicant's status (e.g. registered charity); describe the project for which a grant is sought clearly and succinctly; explain the need for it; say what practical results it is expected to produce; state the number of people who will benefit from it; show how it will be cost effective and say what stage the project has so far reached; enclose a detailed budget for the project together with a copy of the applicant's most recent audited accounts (if those accounts show a significant surplus or deficit of income, please explain how this has arisen); name the applicant's trustees/patrons and describe the people who will actually be in charge of the project giving details of their qualifications for the job; describe the applicant's track record and, where possible, give the names and addresses of two independent referees to whom Henry Smith's Charity may apply for a recommendation if it wishes to do so;

state what funds have already been raised for the project and name any other sources of funding to whom the applicant has applied; explain where the ongoing funding (if required) will be obtained when the charity's grant has been used; state what plans have been made to monitor the project and wherever possible to evaluate it and, where appropriate, to make its results known to others; and ask, where possible, for a specific amount.

3. Please keep the application as simple as possible and avoid the use of technical terms and jargon.

Trustees meet in March, June, September and December, and applications must be received at least two months before these meetings.

Martin Smith Foundation

CC No: 1072607

4 Essex Villas, London W8 7BN

Trustees: Martin Gregory; Elsie Becket Smith; Jeremy James Gregory Smith; Katherine Elsie Gregory Smith; Elizabeth Faith Currer Buchanan; Michael Robert Macfadyn.
Beneficial area: UK.
Grant total: £118,000 (1999/2000)
This trust, established in memory of musician, composer and actor Martin Smith, supports the arts, education and sports.

In 1999/2000 a total of £118,000 was given to organisations and individuals within these fields. No further funding details were available but, given the foundation's objects, it is likely that the proportion of arts-related funding was significant.

The Society for the Promotion of New Music

CC No: 1055754

4th Floor, 18–20 Southwark St, London SE1 1TJ

Tel: 020 7407 1640; Fax: 020 7403 7652
E-mail: spnm@spnm.org.uk
Website: www.spnm.org.uk
Contact: Jo-Anne Naish, Administrator
Trustees: The charity no longer has trustees.
Beneficial area: UK.
Grant total: £95,000 (1999/2000)
Arts grants: £87,787
This trust's principal aim is to support the composition and performance of new music and dance. In 1999/2000 the trust gave a total of £95,000 in 10 grants ranging from £1,213 to £17,500; most were between £8,000 and £15,000. Out of this total, £83,787 (88% of total grant-aid) was given in eight general arts grants. These were:
*RVW Trust (£17,500);
*Performing Right Society Foundation (£15,500);
Alan Fluck Fund of Musicians Benevolent Fund (£15,000);
*Esmee Fairbairn Charitable Trust (£9,000);
*Holst Foundation (£8,500);
Year of Opera (£8,000);
North West Arts (£2,000).

In addition a restricted fund entitled the Francis Chagrin Fund is available to provide limited grants for British composers and composers resident in the UK. This fund is intended to assist with expenses incurred in reproducing original performance materials for unpublished works.

Only the following costs are eligible for grant-aid from this specific fund:
■ reproduction of scores and parts (including vocal scores if appropriate) by photocopying or other reprographic means;

- covering and binding of scores and parts;
- reproduction of tapes for use in performance.

Applications: Guidelines and application forms are available from the above address. If an award from the Francis Chagrin Fund is made it must be suitably acknowledged in the score and/or tape insert and on concert programmes for future performances.

The South Square Trust

CC No: 278960

PO Box 67, Heathfield, East Sussex
TN21 9ZR

Tel: 01435 830778; Fax: 01435 830778
Contact: Mrs Nicola Chrimes, Clerk to the Trustees
Trustees: C R Ponter; A E Woodhall; W P Harriman; C P Grimwade; D B Inglis.
Grant total: £256,000 (1999/2000)
Arts grants: £256,000
Since its establishment in 1979, the trust has set up various bursaries with schools connected with the fine and applied arts. The trust also makes general donations to registered charities working in the following fields: arts, culture and recreation; health; social welfare; medical; disability; conservation and the environment.

Annual support is given to:
- 'the governors of St Paul's School, Barnes, for the purpose of the establishment of one or more bursaries for the benefit of a pupil or pupils of the school specialising in art disciplines;
- the Goldsmith's Art Trust Fund, for the establishment of one or more three year research scholarships for a student or students of the Goldsmith's craft in all its branches or for the provision of overseas travel for such students or for the study of applied arts;
- the promotion of education in the Goldsmith's craft or any such applied

arts or by applying the same towards the publication of an education work on such subjects'.

In 1999/2000 the trust gave a total of over £256,000, which was distributed as follows:
- annual donations to charities – £26,000;
- general charitable donations – £59,500;
- directly aided students – £48,651;
- bursaries to schools – £122,420.

No further breakdown was featured in the annual report.
Exclusions: Individuals under 18; expeditions; travel; courses outside the UK; short courses; courses not connected with the fine and applied arts; grants to individuals where a bursary has been set up with a school.
Applications:
Individuals: in writing, stating the course and the school and requesting standard application form. Forms are sent out between January and April and must be returned by the end of April for assistance for the following academic year. Final decisions made by July. Applications are not considered at any other time of year.
Registered charities: in writing, with details about the charity, the reason for requested funding and enclosing summarised accounts. Applications are considered three times a year, in March, June and November.

The Foundation for Sport and the Arts

CC No: 00104

PO Box 20, Liverpool L13 1HB

Tel: 0151 259 5505; Fax: 0151 230 0664
Contact: Grattan Endicott, Secretary
Trustees: Sir Tim Rice, Chair; Lord Brabazon; Nicholas Allott; Lord (Richard) Attenborough; Nicholas Allott; Dame Janet Baker; Sir Christopher Chataway;

Lord Faulkner; Lord Grantchester; Clive Lloyd; Steve Roberts; Gary Speakman.

Beneficial area: UK.

Grant total: £8,258,000 (2000/01)

Arts grants: £1,443,000

The foundation's purpose is 'to channel funds from the football pools into sport and the arts'. The decline in pools participation resulting from the introduction of the National Lottery in 1994 has led to a dramatic reduction in the foundation's total charitable expenditure. Grant-aid totalled £8,258,000 in 2000/01 compared with £56,875,000 in 1994/95. Funds may decline further as a result of Vernon's pools company's decision to limit its future contributions to the foundation. Nevertheless, the foundation remains one of the major sources of funding for sport and the arts beneficiaries throughout the UK.

Grants are made to 'support and promote sports and the arts in their many forms, and to help people at every level of attainment to pursue their interests in these fields'. Grants can range from £50 to a maximum of £75,000 and are made on a one-off basis.

In 2000/01 the foundation approved a total of £8,258,000 in grants ranging from £150 to £50,000. The majority of grants were for under £10,000, though over 70 donations were for more than this amount. Arts funding totalled £1,443,000 (17% of total funding) and was distributed across a broad range of causes. Although not all grants were specified in the annual report, an extensive selection of beneficiaries were listed. Arts grants included:

Glyndebourne Touring Opera; Royal Albert Hall Trust; Royal Northern College of Music; Tate Gallery London (£50,000 each);

Richard Attenborough Centre (£30,000);

English National Opera; Citizens Theatre Limited (£20,000 each);

Royal Academy of Music (£15,000);

London Sinfonietta (£14,000);

Manchester Jazz Festival (£10,000);

Star Brewery Workshops and Studios (£8,000);

Hebridean Celtic Festival Trust (£6,600);

Highcliffe Junior Choir (£5,000);

Bolton Institute; Dedham Players (£3,000 each);

Calderdale Theatre School Association; Music Box Children's Opera Group; Mull of Kintyre Music & Arts Association; Windsor Fringe Festival (£1,000 each).

Exclusions: Activities outside the foundation's chosen fields; individuals, apart from exceptional cases, 'almost always because trustees fear real potential may be blighted by the difficult financial background of the persons concerned'; musical instruments and uniforms for brass and silver bands; film production; top-up grants; non-UK participants; museums which are not specifically arts-based; awards which would result in a reduced lottery grant.

Applications:

Arts team: Carla Roberts, Leader; Lesley McBride.

Full applications packs are available from the telephone number above.

'It is requested that applications be submitted with information in the following order:

- Completed questionnaire;
- Synopsis of key elements set out on a single sheet of A4 paper;
- Detailed description of the purpose for which a grant is sought. Where applicable this should be backed up with reports of consultants and professional advisors;
- Full details, including quotations if applicable, of the cost of the project;
- A statement of the way in which it is proposed to fund the project, with information on other money which will, or may, be committed alongside that of the foundation;

- Latest financial statements of the enterprise to be assisted, including audited accounts if applicable. N.B. It may be appropriate to include statements of any parent organisation;
- In the case of a club or organisation a potted history of its funding, development and future aims; the number of people who can be accommodated in the auditorium or spectator accommodation; the precise nature of the ownership of the club, society, premises, trustees, members' committee or the like;
- Information as to the persons who will be involved in the realisation of the plan. Where available and applicable, facts as to suppliers and contractors who will be, or may be, invited to give effect to the proposals.'

It does not matter if information is repeated that has been included on the questionnaire. Cases are delayed if there is no questionnaire. Videos and books are not encouraged. 'A photograph or two may be helpful in some cases.'

Projects should benefit the general community. Projects in which the foundation will be the lead funder are preferred.

Processing applications

1. There is a 'conveyor belt' system with cases on it at every stage of the process. This moves along daily at a speed determined by the availability of funds. This procedure involves:
- acknowledgement of receipt;
- obtaining independent comment;
- referral to trustees for individual opinions;
- assembly of trustees' opinions and referral for final decision;
- if trustees' consensus is not obtained, deferral until bid can be considered at a meeting.

2. Unsuccessful applicants are notified as soon as a decision is made. When a case is approved and put in the queue of potential grant offers, a letter of intent is sent. *This does not commit the trustees to a grant and applicants are 'warned not to go too far in acting upon the content of the letter'.* When a letter of intent has been issued the release of an offer is dependent on the funding situation.

3. Until a letter of intent is issued, the final decision may be to refuse the application. No applicant should assume that prolonged consideration implies eventual success.

All offers are subject to conditions.

St Hugh's Foundation

CC No: 1003333

Andrew & Company, Solicitors, St Swithin's Square, Lincoln LN2 1HB

E-mail: sthughesfoundation@lineone.net
Contact: Julia Fox, Administrator
Trustees: Clive Fox, Chair; Dr George V Cooke; Roger Bush; Dr Ron D A Crafter; Major Clixby Fitzwilliams; Ian S Fraser; Peter J Moss; Alan Newton, Honorary Treasurer; Ms Judith A Robinson; Dr J Peter Sproston; Mrs Anne Turner.
Beneficial area: Lincolnshire and areas of former Humberside.
Grant total: £7,500–£15,000 (2002)
Arts grants: £15,000
This foundation was established to benefit innovative arts projects in the old Lincolnshire & Humberside Arts (LHA) region, using the sum raised from the sale of LHA's former office building known as 'St Hugh's'. The principal aim of the foundation is to enable artists from the old region to have a national impact and provide benefits for the local community.

The foundation's four-year arts awards programme comprises two distinct schemes, which will be alternated annually until 2004. In 2002 and 2004 the St Hugh's Commissioning Award for between £7,500 and £15,000 will be given towards a corporate arts project. In

2003 the award will be distributed to one or two individuals. The corporate award is 'expected to act as a catalyst in encouraging corporate organisations to conceive and carry out innovative and developmental arts projects, relevant to the needs and aspirations of communities'. Projects must make a lasting contribution to the quality of public experience.

Exclusions: Attendance at established academic or vocational courses; supplementing or replacing responsibilities of public bodies.

Applications: Applicants must contact the foundation for further details, guidelines, cover sheet and an application form prior to any appeal.

Applications to be received by 1 May in the relevant year: corporate awards (2002 and 2004); individual awards (2003).

The Steel Charitable Trust

CC No: 272384

Bullimores, 3 Boutport Street, Barnstaple, Devon EX31 1RH

Tel: 01271 375 257; Fax: 01271 323121
Contact: The Secretary
Trustees: N E W Wright, Chair; A W Hawkins; J A Childs; J A Maddox.
Beneficial area: UK, with some preference for Bedfordshire.
Grant total: £1,000,000 (2000/01)
Arts grants: £64,500

This trust makes both capital and revenue grants to a range of charitable causes. In 2000/01 it gave a total of £1,000,000, which was distributed as follows:

- social services – £445,400 (45%);
- health – £165,000 (16%);
- environment and preservation – £117,000 (12%);
- culture and recreation – £87,500 (9%);
- medical research – £163,100 (16%);
- international aid and activity – £22,000 (2%).

A total of 253 grants were made, ranging from £500 to £50,000; most were for £10,000 or less. Funding relevant to this guide amounted to £64,500 (six per cent of total grant-aid), disbursed in 18 grants. These included:

Under 'culture and recreation' –
Royal Academy of Arts (£18,000);
Cheltenham International Festival of Music (£8,000);
Blackpool Grand Theatre Trust Ltd; Philharmonia Chorus Ltd (£5,000 each);
Battersea Arts Centre (£4,000);
British Youth Opera; Luton Music Club (£3,000 each);
High Peak Theatre Trust Ltd (£2,500);
Beaford Arts; Lancaster Grand Theatre; Pegasus Opera Company (£2,000 each);
Scottish Chamber Orchestra (£1,000).
Under 'social services' –
Share Music; Traverse Theatre (£1,000 each).

Exclusions: Individuals, students, expeditions.
Applications: In writing to the correspondent including statement of purpose for which the grant is required; full latest accounts showing all other sources of funding; and statement of existing funding for the purpose of the grant application.

Meetings are held in January, April, July and October. Applications are not acknowledged.

The Stevenson Family's Charitable Trust

CC No: 327148

33 St Mary Axe, London EC3A 8LL

Tel: 020 7342 2874
E-mail: hugh.stevenson@equitas.co.uk
Contact: Hugh A Stevenson, Trustee
Trustees: Hugh A Stevenson; Mrs Catherine M Stevenson; Jeremy F Lever.
Beneficial area: UK and overseas.

Grant total: £1,548,000 (1999/2000)
Arts grants: £332,406

The trust gives to a wide range of causes, usually over periods of several years. Its funding capacity has increased greatly in recent years but resources are always heavily committed to designated projects and **applicants should note that unsolicited applications are not considered** (see 'Applications' below).

In 1999/2000 the trust gave a total of almost £1,548,000 in 39 grants ranging from £100 to £250,000; most were less than £10,000. Out of this, a total of £332,406 (21% of total grant-aid) was given in seven grants relevant to this guide. These were:

★British Museum Development Trust (£201,500);
Royal Opera House Trust (£55,288);
Foundling Museum; ★National Gallery Trust; Textile Conservation Centre (£25,000 each);
Philharmonica Trust (£500);
★Glyndebourne Arts Trust (£118).

Applications: No unsolicited applications can be considered.

The Stoll Moss Theatres Foundation

CC No: 801744

Manor House, 21 Soho Square, London W1V 5FD

Tel: 020 7494 5200
Contact: Richard Johnston, Secretary of the Foundation
Trustees: Mrs Janet Homes á Court; Sir Michael Clapham; Derek Williams; Richard Johnston.
Beneficial area: UK.
Grant total: £14,269 (1998)
Arts grants: £14,269

The primary focus of the foundation has been the 'advancement and development of theatrical arts'.

In 1998 the foundation gave a total of £14,269 in 19 grants ranging from £50 to £2,300 to arts-related causes, with a particular emphasis on theatre. Of the causes supported, nine also received funding in the previous year. In 1998 grants included:
London New Play Festival (£2,300);
Vivian Ellis Prize Ltd; London Palladium (£1,500 each);
The Chicken Shed Theatre Co (£1,000);
London Contemporary Dance School (£750);
Royal Court – Young People's Theatre; Chain Reaction Theatre (£500 each);
Theatre Royal Drury Lane (£385).

Exclusions: No funding for capital costs.
Applications: The foundation has written that it **'maintains a limited programme of support for projects of its own initiation and does not provide funding in response to applications'**.

Strauss Charitable Trust

CC No: 259029

17 Broadwalk House, London SW7 5DZ

Tel: 020 7589 0898
E-mail: charity@richardarmstrong.net
Contact: Mr Richard Armstrong, Trustee
Trustees: Lady Benita Strauss; Richard A Armstrong.
Beneficial area: UK; mainly London and the Home Counties.
Grant total: £2,700 (1998/99)
Arts grants: £2,700

This trust makes a small number of modest grants each year for the promotion of the fine arts, which can include the performing arts as well as the visual arts.

In 1998/99 the trust gave a total of just over £2,700 in three grants, all of which were relevant to this guide. These were:
North Kensington Arts (£1,300);
London Concert Choir (£800);
Southwark Playhouse (£600).

Exclusions: Individuals; students; organisations not registered as charities.

Applications: In writing to the correspondent.

The Stretford Youth Theatre Trust

CC No: 1040374

33 Fulmar Drive, Sale, Cheshire
M33 4WH

Contact: Sheila Kathleen Watt, Secretary and Trustee
Trustees: John Terence Lamb, Chair; Sheila Kathleen Watt, Secretary; Martin Bede Massey, Treasurer; Edna Pugh.
Beneficial area: Greater Manchester Area.
Grant total: £1,000 (1998)
Arts grants: £1,000
The trust was established in 1994. It gives grants to advance the education of young people under the age of 30 in the dramatic and allied performing arts. Grants total between £500 and £2,000 per year and are disbursed to causes within the Greater Manchester area.

In 2001 the trust gave a total of £1,000 in a single grant to Northern Kids Theatre Company for its production of 'Mary' at the Lowry Centre.

In previous years grants have included:
Stretford High School, towards Arts
 Theatre Development (£1,000 in
 1997);
Foreword Theatre Company, production
 of *Jesus Christ Superstar* (£1,000 in
 1998);
Foreword Theatre Company, for *Joseph
 and the Amazing Technicolour Dreamcoat*
 (£500 in 1999);
Foreword Theatre Company, for
 production of *Oh What a Lovely War*
 (£600 in 2000).

Exclusions: Those outside the geographical area.
Applications: In writing to the correspondent.

The Summerfield Charitable Trust

CC No: 802493

PO Box 4, Winchcombe, Cheltenham, Gloucestershire GL54 5ZD

Tel: 01242 676774; Fax: 01242 677120
E-mail: admin@summerfield.org.uk
Website: www.summerfield.org.uk
Contact: Mrs Lavinia Sidgwick, Administrator
Trustees: Dr Gilbert Greenall; Mrs Rosaleen Kaye; Mrs Rachael Managhan; Charles Fisher; Richard Wakeford.
Beneficial area: Gloucestershire.
Grant total: £400,000 (2000)
Arts grants: £114,000
This trust publishes an annual report containing a full listing of grants, with in-depth commentary and analysis. In its 2000 report the trust states that 'charities applying to the trust must either be based in Gloucestershire or they must be engaged in a project that is of specific benefit to residents of the county'.

In 2000 the trust gave £400,000 across a variety of areas in the form of 86 grants, most of which were between £500 and £10,000. A total of £73,750 (18%), consisting of 13 grants, was awarded by the trust within the category of 'arts and museums'. In addition, arts-related grants amounting to over £40,300 were made in other categories, bringing the giving relevant to this guide to a total of around £114,000 (28% of total grant-aid). Grants included:
Under 'arts and museums' –
Everyman Theatre; Gloucestershire
 Dance Project (£15,000 each);
Cheltenham Arts Festivals Ltd; Holst
 Birthplace Museum Trust (£10,000
 each);
Forest of Dean Music Centre; Live Music
 Now! (£5,000 each);
Playhouse Theatre (£4,000);
Cheltenham Music Society; English
 Touring Opera; Newham Players
 (£1,000 each);

Brewery Arts (£750).
Under 'community work' –
Cinderford Artspace (£1,000).
Under 'conservation of the built and natural environment' –
Crickley Hill Archaeological Trust
 (£6,000);
Association for the Study & Preservation
 of Roman Mosaics' (£5,000).
Under 'education' –
Cheltenham & Gloucester College
 Development Trust, Fine Art
 Department (£6,000);
Trinity College of Music, towards fees of
 a postgraduate student of Performance
 Studies (£3,000);
Folk South West, raising the profile of
 folk music, dance and traditions in the
 South West England (£2,000);
Haresfield C. of E. Primary School, for an
 'Arts Week' (£250).
Under 'elderly' –
Art Shape Ltd, arts opportunities and
 training for the elderly;Prestbury
 Memorial Trust, art and craft classes for
 elderly residents (£822).
Under 'recreation and sport' –
Gloucestershire Resource Centre, helping
 to provide art studios along with
 exhibition and rehearsal space
 (£8,285);
Our Town Millennium Project, assisting
 with workshop and transport costs for a
 musical production (£2,000).

Exclusions: Any projects not based in
Gloucestershire or of specific relevance to
its residents. Private organisations and
individuals are very rarely supported.
Applications: The trustees prefer to
award one-off grants to help fund specific
projects. Guidelines and a comprehensive
annual report are available from the trust.
After studying the guidelines, applicants
are welcome to telephone the trust to
discuss the eligibility of an application.
Written applications should be made,
stating what is required and the purpose
of the application. Applicants should also
mention any other funders approached,
or to be approached.

Meetings are held quarterly, usually in
January, April, July and October when all
applications received before the end of
the preceding month are considered. All
new applications are acknowledged and
all applicants are informed of the trustees'
decisions. SAEs are welcomed.

The Bernard Sunley Charitable Foundation

CC No: 213362

4th Floor, 20 Berkeley Square, London
W1J 6LH

Tel: 020 7408 2198; Fax: 020 7499 5859
E-mail:
asstdirbsunleycharfund@ukgateway.net
Contact: Dr B W Martin, Director
Trustees: John B Sunley; Mrs Joan M
Tice; Mrs Bella Sunley; Sir Donald
Gosling.
Beneficial area: UK and overseas.
Grant total: £2,771,000 (2000/01)
Arts grants: £350,680
The foundation has unrestricted general
interests, covering most fields of charity,
including the arts. Its 2000/01 annual
report categorised funding as follows:
- education – £345,000;
- culture – £364,000;
- professional and public bodies –
 £178,000;
- community – £498,000;
- youth – £297,000;
- elderly – £120,000;
- religion – £175,000;
- health – £612,000;
- service centres – £22,000;
- environment – £160,000.

Grants can be spread over a number of
years. National charities tend to receive
almost one third of total grant-aid, with
the majority of the remaining funds
going to causes in London, the East
Midlands and South East of England.

In 2000/2001 the foundation gave a total of £2,771,000 in 361 grants ranging from under £1,000 to £150,000. Although the majority of grants were for £5,000 or less, 155 donations were for more than this. A total of £350,680 (13%) was given in 18 grants relevant to this guide, all but one of which were made under the heading of culture. These included:

Under 'culture' –

Dulwich Picture Gallery (£150,000);
National Gallery (£60,000);
National Maritime Museum Cornwall (£50,000);
Horniman Museum, London (£25,000);
British Empire & Commonwealth Museum, Bristol; Byam Shaw School of Art; Sixteen Choir and Orchestra, London (£10,000 each);
*Canterbury Theatre and Festival Trust; Spitalfields Festival (£5,000 each);
*Glyndebourne Arts Trust (£3,680);
Royal Opera House Trust (£3,000);
Deal Summer Music Festival; *Living Paintings Trust (£2,500 each);
City of London Sinfonia Ltd (£2,000).

Under 'education' –

Textile Conservation Centre, Winchester (£2,500).

Exclusions: Individuals, including people taking part in projects sponsored by a charity.

Applications: Appeals are considered on a regular basis. There is no application form but the covering letter to the director should be accompanied by the latest report and accounts and provide details as to the following points.

- What the charity does and what its objectives are.
- Explain the need and purpose of the project for which the grant is required. Who will it benefit and how?
- How much will the project cost? The costings should be itemised and supported with quotations and so on as necessary.
- What size grant is requested.

- How much has already been raised and from whom. How is it planned to raise the shortfall?
- If applicable, how the running costs of the project will be met once the project is established.
- Any other documentation that the applicant feels will help to support or explain the appeal.

Theatre Investment Fund Ltd

CC No: 271349

Palace Theatre, Shaftesbury Avenue, London W1V 8AY

Tel: 020 7287 2144; Fax: 020 7287 0565
Contact: Liz Clift, Administrator
Trustees: Directors: John Whitney, Chairman; Bob Swash, Vice-Chairman; Ken Bennett-Hunter; George Biggs; Rod Coton; John Gale; Thelma Holt; Richard Johnston; Sir Eddie Kulukundis; Sir Cameron Mackintosh; John Newman; Andre Ptaszynski; Rupert Rhymes; Sir Stephen Waley-Cohen; Max Weitzenhofferl Peter Wilson.
Beneficial area: UK.
Grant total: £8,000
Arts grants: £8,000

The Theatre Investment Fund (TIF) Ltd was established for the 'furtherance of education by promoting, improving and extending the knowledge and appreciation of the public for the performing arts, including in particular dramatic, dramatico musical and other theatrical works'. It runs seminars and workshops on all aspects of presenting commercial productions, as well as publishing a starter pack for new producers and giving them individual advice. 'Occasionally the fund invests modestly in productions, provided they meet its rigorous commercial guidelines.'

The TIF's Acorn Scheme offers investment awards for new producers to support the development of new work through workshops and try-out production in London and the regions. In

1998/99 the fund gave £8,000 in such investments.

Applications: Send an A5 envelope to obtain an application form.

Society for Theatre Research

CC No: 266186

c/o The Theatre Museum, 1E Tavistock Street, London WC2 7PA

E-mail: e.cottis@btinternet.com
Website: www.str.org.uk
Contact: Dr Christopher Baugh, Chairman, Research Awards Sub-Committee
Trustees: Committee: Michael Ostler, Chair; Eileen Cottis and Frances Dann, Joint Honorary Secretaries; Barry Sheppard, Honorary Treasurer; G Laurence Harbottle, Honorary Legal Adviser; Cristopher Baugh; Jacky Bratton; Richard Allen Cave; Margaret Collins; Peter Cottis; Graeme Cruickshank; Geoff Davidson; Richard Foulkes; Ian Herbert; Steve Nicholson; Dominic Shellard; Howard Loxton; Sidney Jowers; Pieter van der Merwe.
Beneficial area: UK.
Grant total: around £4,500 annually
Arts grants: £4,500
Awards are made for research into the history and practice of British theatre including music, opera, dance and other associated performing arts. Annually the society makes around £4,500 available consisting of one or two major grants of around £1,000 each with a number of lesser awards of between £200 and £500.

Awards for 2001 included:
The Anthony Denning Award, for research in the history of stage acting;
The Kathleen Baker Award, for work on the history of Salisbury Playhouse;
The Stephen Joseph Award, for video work about architecture in British theatre.

Exclusions: Exclusively literary projects.
Applications: Enquiries concerning application procedure should be made in writing to the chairman of the research awards subcommittee as soon as possible. Completed applications for awards must be submitted by 1 February 2002.

The Theatres Trust Charitable Fund

CC No: 274697

22 Charing Cross Road, London WC2H 0QL

Tel: 020 7836 8591; Fax: 020 7836 3302
E-mail: info@theatrestrust.org.uk
Website: www.theatrestrust.org.uk
Contact: Peter Longman, Director
Trustees: Sir John Drummond, Chairman; Peter Boyden; David Brierley; Axel Burrough; Martyn Heighton; Paul Iles; Jonathan Lane; John Muir; Anne Riches; Fiona Shaw; Phyllis Starkey; Pat Thomas; Sir Stephen Waley-Cohen.
Beneficial area: UK.
Grant total: See below
The Theatres Trust was established by parliament in 1976 and its 15 expert trustees are appointed by the Secretary of State for Culture, Media and Sport.

Its main function is to advise on all planning applications affecting land on which there is a theatre. It also gives information and advice to central and local government, theatre managements and theatre preservation groups. It advises on Lottery applications and maintains a database on theatre buildings throughout the UK.

Occasional very small grants have been given to theatres and charities working to preserve theatres. These grants have not exceeded £10,000 in total for the past several years. The trust now has a proactive policy and is not driven by the applications it receives. The trust states that 'it will now only contribute to feasibility studies'.

Exclusions: Building costs; routine repairs; running costs; the elimination of deficits.

Applications: 'The trust no longer considers grant applications.' See above.

The Tillett Trust

CC No: 257329

27 Corringway, London W5 3AB

Contact: David C Stiff, Honorary Secretary
Trustees: Paul Strang, Chair; David L Booth; Fiona M Grant; Yvonne Minton; Clara Taylor; David Stiff.
Beneficial area: UK.
Grant total: £46,000 (1998/1999)
Arts grants: £46,000
This trust's objectives are the 'promotion, maintenance and advancement of education and, in particular, musical education and the encouragement of the arts including music, drama, mime, dancing and singing'. Support is mainly given to young classical musicians whose main base is in the UK. The trust offers limited financial assistance to young professional musicians of outstanding talent who need help in undertaking special projects at the start of their active solo performing careers. Funds are not normally available for academic courses, either at graduate or postgraduate level. However, the trust sometimes supports shorter performance biased courses as well as other performance related schemes. The majority of grants are given to individuals and range from £200 to £2,000.

Young Artists Platform
The trust runs this annual scheme for British musicians living or studying full time in the UK who are chosen by private audition for a series of concert platforms plus funding towards publicity material. Open to soloists or ensembles of up to 6 players, the scheme has an age limit of 20–25 for instrumentalists and 23–28 for singers. Entry forms are available from the trust administrator in October; the deadline for entry is in late November, with auditions held in January.

The trust's report for 1998/99, the latest on file at the Charity Commission, indicates that a total of £46,000 was given to causes fitting the above criteria. No breakdown of the allocation of funds was available because donations were directed at individuals.

Exclusions: Full-time education courses; instrument purchase; commission of new works; production of commercial recordings.
Applications: In writing to the administrator, giving full details of the proposed project, with an outline budget, a detailed CV, two written references, and, where available, press cuttings, a demo tape/CD and any other relevant material.

The Michael Tippett Musical Foundation

CC No: 278469

50 Broadway, London SW1H OBL

Contact: Miss G Rhydderch
Trustees: Anthony Whitworth-Jones, Chairman; Prof Ian Kemp, Teasurer; Prof John Casken; Paul Crossley; Jonathon Dove; Jeremy Hayes; Joanna MacGregor; Peter Norris; Robert Ponsonby; Veronica Slater; Katie Tearle.
Beneficial area: UK.
Grant total: £14,855 (1998/99) but see below
Arts grants: £14,855
The foundation gives priority to:
- projects designed to encourage an understanding of contemporary music;
- projects in areas of social or economic deprivation;
- projects designed to support the careers of young musicians;
- projects in areas where live musical opportunities are rare.

Although the foundation mainly supports projects, it has stated that it 'will always be sympathetic to the needs of individuals in the music profession'.

Commission fees, music copying costs, recording projects, research or study fees and expenses are **not** among the trustees' priorities, though from time to time they are prepared to see whether there is an exceptional case.

In 1998/99, the latest year for which an annual report was on file at the Charity Commission, the trust gave a total of £14,855 in 33 awards and grants ranging from £100 to £1,500; most were £500 or less. All donations were relevant to this guide and included:

★Leicestershire Michael Tippett Bursary (£1,500);
Pro Corda; Vaganza (£1,000 each);
Oxford Festival of Contemporary Music (£750);
★Northern Junior Philharmonic Orchestra (£600);
Psappha; ★Huddersfield Contemporary Music Festival; Contemporary Music Ensemble of Wales; Tete a Tete Productions (£500 each);
Avon Sinfonia; Music Past & Present (£300 each);
★Spitalfields Festival (£250);
★Koestler Award (£100).

The trust's policy has been to make awards of £16,000 per annum in addition to on-going annual grants which total £2,100. However, the 1998/99 annual report states: 'Sir Michael Tippet died on 8th January 1998 and the charity is expected to benefit under his will. Until such time as the charity does so, the trustees do not consider it appropriate to make any further grants with effect from 1st September 1999, except where there is an on-going commitment.'

In March 2002 the secretary wrote to say that the grantmaking may not be restored for some years.

Applications: In writing to the correspondent, having first obtained a guidance leaflet which is available from the foundation. The trustees meet three times a year.

The Trust for London

CC No: 294708

6 Middle Street, London EC1A 7PH

Tel: 020 7606 6145; **Fax:** 020 7600 1866
Website: www.cityparochial.org.uk
Contact: Bharat Mehta, Secretary
Trustees: City Parochial Foundation (see separate entry).
Beneficial area: Greater London boroughs.
Grant total: £641,000 (2000)
Arts grants: £20,800

The trust has been administered by the City Parochial Foundation (see separate entry in this guide) since 1986. Although its funding policies and methods are distinct from those of the CPF, the Trust for London's target areas are also broadly that of social welfare. The trust focuses on 'small, new and emerging voluntary organisations' that it feels can 'significantly improve the lives of people and communities in London'. The trust's definition of a small group is based on an organisation being made up of volunteers or members, with no more than the equivalent of two full-time paid staff.

Support is particularly targeted towards:

- black, Asian and minority ethnic community organisations;
- organisations providing creative educational activities for children and young people, including supplementary and mother-tongue schools;
- organisations run by disabled people, including those with learning difficulties, mental health problems and people living with AIDS or HIV;
- refugee and migrant groups;
- self-help groups (such as children and family groups, estate-based organisations, lesbian and gay groups, older people's groups, women's groups or youth groups).

Very clear grant guidelines and procedures for the five-year period 2002–2006 can be obtained from the trust or accessed via its website.

In 2000 the trust gave a total of £641,000 in 128 grants ranging from £725 to £21,000; the maximum grant is usually £10,000. Out of this, four arts-related grants were made totalling £20,800 (three per cent of total grant-aid). These were:

Women's Music and Performance Workshops, sessional salary costs (£9,800);

Magpie Dance, ongoing costs (£7,000);

Maya Productions Limited, costs of video project; St Matthew's Creative Dance Group, operational costs (£2,000 each).

These grants were made under the guidelines for the previous quinquennium, which are no longer applicable. This list does, however, provide an indication of the possible level of funding relevant to this guide, and of the type of arts project likely to attract funding. **Applicants should note that arts organisations are not a priority and applications will only be considered where the arts are employed as a medium for work with those who clearly fall within the trust's current priorities.**

Exclusions: Distribution by umbrella bodies; general appeals; holiday playschemes; individuals; purchase or building of premises; part of a full-time salary; replacing spending cuts by local or central government; research; trips abroad.

Applications: Applicants should either telephone a field officer at the trust to discuss proposals; or send written details of the work planned (no more than two sides of A4 paper), along with the organisation's constitution, most recent accounts and, if available, latest annual report. This should be done at least three months before the deadline. If the project fits the grant-making priorities, a field officer will meet the applicant to discuss it further. Once an agreement is reached as to what should be applied for, the field officer will issue an application form. This must be completed and submitted before the relevant deadline:

- 31 January for March meeting;
- 15 April for June meeting;
- 31 July for September meeting;
- 15 October for December meeting.

The field officer presents the application to the grants committee. Applicants will be notified of the trustees' decision in writing following the trustee board meeting.

Trust Fund for the Training of Handicapped Children in Arts and Crafts

CC No: 210052

c/o Paisner & Co., Bouverie House, 154 Fleet Street, London EC4A 2DO

Contact: Mrs E Freeman, Trustee
Trustees: Martin David Paisner; Mrs Eva Tana Freeman; Alan Herbert Freeman.
Beneficial area: UK.
Grant total: £29,000 (1999/2000)
Arts grants: £29,000
This trust was established 'for the relief, education and training of disabled children in arts and crafts'.

In 1999/2000 the trust gave a total of over £29,000 in four donations, the specific purposes of which were not disclosed. The beneficiaries of these grants were:

Jerusalem Foundation, for the Bertha Goodman School (£15,625);

Jerusalem Foundation, for the Misholim Project (£6,932);

Kisharon Day School (£5,035);

Carousel (£2,000).

The Jerusalem Foundation has received support from the trust in most years.

The level of funding detailed above is higher than in previous years as a result of

the receipt of a donation for almost £20,000.

Applications: In writing to the correspondent.

The Tudor Trust

CC No: 206260

7 Ladbroke Grove, London W11 3BD

Tel: 020 7727 8522; Fax: 020 7221 8522
Website: www.tudortrust.org.uk
Contact: The Trustees
Trustees: Grove Charity Management Ltd – Directors: Mary Graves; Helen Dunwell; Desmond Graves; Penelope Buckler; Christopher Graves; Ray Anstice; Catherine Antcliff; Louise Collins; Elizabeth Crawshaw; Matt Dunwell; James Long; Ben Dunwell; Francis Runacres.
Beneficial area: Mainly UK; some overseas.
Grant total: £22,700,000 (2000/01)
Arts grants: £157,800
The trust only funds arts activities serving particular disadvantaged groups (see below). It does not support arts organisations as such or 'arts for arts' sake.'

The trust's fundamental criterion for funding is that organisations and groups 'help people to fulfil their potential and make a positive contribution to the communities in which they live' in both rural and urban areas. Particular attention is given to problems related to isolation and vulnerability amongst young people (aged between 9 and 18), families and the elderly living in disadvantaged or marginalised communities.

In 2000/01 the trust gave a total of £22,700,000 in 1,946 grants ranging from £500 to £668,000. The average new commitment was almost £24,000. Only the 50 largest payments were listed in the annual report, all of which were over £45,000. Support was distributed as follows:

- accommodation – (£3,770,000);
- arts – (£98,000);
- crime prevention – (£1,036,000);
- education – (£1,045,000);
- employment and training – (£481,000);
- environment – (£214,000);
- health – (£3,838,000);
- overseas – (£767,000);
- welfare – (£11,451,000).

In all, £157,800 was given in nine grants relevant to this guide. These were:
Clean Break Theatre Company (£60,000);
Turning Point Theatre Company (£47,000);
National Youth Theatre of Great Britain (£15,000);
Age Exchange Theatre Trust Ltd; Northern Shape (£10,000 each);
Bloomin Arts Ltd (£5,000);
Physical Performing Arts in Lancashire (£4,000);
Royal National Theatre (£3,800);
Theatre Company Blah, Blah, Blah (£3,000).

The trust makes a policy review every three years, the next of which is scheduled for 2003/04. Arts projects are now generally outside the current guidelines and will only receive funding if the organisation's main purpose is specifically relevant to one of the following categories: people with mental health problems or head injuries; homeless people; offenders/ex-offenders.
Exclusions: Individuals; general arts projects; bursaries/scholarships; colleges; large national charities; physical illness; cultural activities; religion; schools.
Applications: In writing only but all potential applicants are strongly advised to obtain the guidelines for applicants before proceeding further.
The information supplied should include:
- a summary of the current work of the organisation, with the latest annual report;

- a description of the project/proposals/ area of work for which funding is required;
- an indication of the number of people involved in the project and how they will benefit;
- a breakdown of costs (for capital works, these might be building costs, VAT, fees, furniture and equipment; for revenue they might be salaries, premises, training, publicity, expenses);
- details of funding raised or committed to date and steps being taken to raise the balance other than the approach to the Tudor Trust;
- any other relevant information such as the catchment area served, numbers attending existing activities per month or per annum, how revenue implications of capital proposals will be met – for new buildings or major refurbishment schemes, drawings/ plans/a photo are usually helpful;
- latest annual accounts (or a copy of a recent financial/bank statement if the organisation is too new to have annual accounts).

Some applicants will be told almost immediately that the trust cannot help. The remainder will usually be told of the outcome eight weeks after receipt of all information by the trust.

A letter will be sent giving the trustees' decision; a letter to a successful applicant will also explain any conditions attached to the grant. Do not telephone for news of progress. Organisations are asked not to publicise funding they receive from the trust in the media or apply for further funding for at least twelve months.

The John Tunnell Trust

CC No: SC018408

4 Royal Terrace, Edinburgh EH7 5AB

Tel: 0131 556 4043
Contact: The Secretary
Trustees: Jonathan C Tunnell, Chair; Wendy Tunnell; David Todd; Christopher J Packard; J C Hogel; Carol Hogel; T J Green; O W Tunell; S Brown.
Beneficial area: Scotland.
Grant total: see below (1998/99)
This trust gives awards rather than grants. It offers support to young chamber musicians at the outset of their professional careers by providing a platform for properly paid engagements with Scottish music societies. The trust wishes to offer music clubs the opportunity to hear young chamber musicians of the highest calibre. Preference is given to British-based groups who have played together as an ensemble for a reasonable length of time and a postgraduate standard of excellence is expected. Ensembles of two to nine instrumental players are considered. The upper age limit is normally around 27.

In 1998/99 there were five award winners. These included:
Belcea String Quartet (10 concerts);
Owen/Gowers Violin & Piano Duo (5 concerts each);
Chinook Clarinet Quartet (3 concerts each).

Applications: On an application form available from the correspondent, to whom completed forms should be returned with 'two tapes and two written references from musicians of standing'. The deadline for receipt of applications in 1999 was 19 June.

Submission tapes should contain two or three contrasting pieces of movements to enable the trustees and their artistic advisers to assess the range of ability of the ensemble. A selected number of groups will be invited to attend for audition in London.

The Douglas Turner Trust

CC No: 227892

1 The Yew Trees, High Street, Henley in Arden, Solihull, West Midlands B95 5BN

Tel: 01564 793 085
Contact: J E Dyke, Trust Administrator
Trustees: W S Ellis; D P Pearson; T J Lunt; Sir Christopher Stuart-White.
Beneficial area: West Midlands, particularly Birmingham.
Grant total: £414,000 (1999/2000)
Arts grants: £41,300
The trust makes grants to a wide range of charities, with a strong preference for social welfare organisations in Birmingham and the West Midlands.

In 1999/2000 the trust gave £414,000 in 87 grants ranging from £300 to £26,000, the majority of which were for between £1,000 and £5,000. Just over £41,000 (10% of total grant-aid) was given in five grants relevant to this guide, some of which were to previous beneficiaries. These were:
★Symphony Hall Birmingham, organ appeal (£25,000);
★Royal Academy of Arts (£10,000);
Royal Birmingham Society of Artists (£5,000);
Royal Academy of Music (£1,000);
★Birmingham Music Festival (£300).

Exclusions: Individuals; non-registered charities.
Applications: In writing to the correspondent, enclosing the latest annual report and accounts. Telephone enquiries before formal applications are welcomed. Trustees meet in April, July, October and December. **However, the trust is understood to be 'heavily committed' and will only consider applications from the Birmingham area.**

Sybil Tutton Charitable Trust

(also known as Miss S M Tutton Charitable Trust)

CC No: 298774

c/o BDO Stoy Hayward, 8 Baker Street, London W1M 1DA

Tel: 020 7486 5888
Contact: The Secretary
Trustees: Sybil Mary Tutton; Richard Van Allan; Jeffery Lockert; Rosemary Pickering.
Beneficial area: UK.
Grant total: £33,000 (1999/2000)
Arts grants: £32,500
This trust's general aims are to advance education, relieve poverty and promote religion but its particular intention is to advance the education of the public in music. To this end it makes Sybil Tutton Awards for individual singers, provides scholarships or bursaries at music schools for postgraduate opera studies, as well as giving grants to music colleges and charities, and to opera companies. **There is minimal scope for new applicants, as very few grants are given to causes unknown to the trustees.**

Grants are made to a limited number of institutions, known to the trustees, who undertake work furthering the aims and objects of the trust. The trust has made grants outside this area only very occasionally.

In 1999/2000 the trust gave a total of £33,000 in grants and awards, £32,500 (98%) of which was to specified arts beneficiaries. Sybil Tutton Awards of between £1,000 and £3,000 were given to eight individuals, to a total of £16,000. A total of £5,000 was given in four grants to individuals at the National Opera Studio. Charitable and other institutions received nearly £11,500 in five grants, all of which were relevant to this guide. These were:
★British Youth Opera (£5,000);
★Clonter Farm Music Trust (£3,000);

*Aldeburgh Foundation for the Bursary Fund of the Britten-Pears School for Advanced Musical Studies (£1,500);
*Young Concert Artists Trust; Singers Academy 2000 (£1,000 each).

Applications: The trust's administrators have stated that **'there is no real purpose in the trust being included in grant giving directories, as this can only waste time and money for both the applicants and the trust'**.

Lisa Ullmann Travelling Scholarship Fund

CC No: 297684

24 Cuppin Street, Chester CH1 2BN

Tel/Fax: 01244 401934
Website: www.ullmann-trav.fsnet.co.uk
Contact: The Secretary
Grant total: £11,560 (2001/02)
Arts grants: £11,560
This fund's objective is to provide assistance to individual professionals and students of movement and dance for travel expenses within the UK and abroad, enabling them to attend conferences, courses of study or to pursue a relevant research project. Applicants from across the country are selected according to merit.

Most scholarships are between £330–£400, although rare exceptions of up to £1,000 have been made.

In 2001/2002 the fund gave 25 scholarships totalling £11,560, all of which were relevant to this guide.
Exclusions: Persons outside the fund's objectives.
Applications: After 1 September application forms and guidelines are on the website and are also obtainable from the secretary by forwarding an A5 SAE. The annual deadline for applications is 25 January. Scholarships are awarded on an annual basis for projects taking place between April of that year and April of the following year. Application forms are

assessed by management committee members, and potential recipients are then scrutinised by the president and trustees.

The ULTACH Trust/Iontaobhas ULTACH

Room 202, Fountain House, 19 Donegall Place, Belfast BT1 5AB

Tel: 028 9023 0749; Fax: 028 9032 1245
E-mail: ultach@cinni.org
Trustees: Ruairí Ó Bleine; Sean Ó Coinn; Barry Kinghan; Ferdia Mac an Fhailigh; Risteard Mac Gabhann; Sue MacGeown; Seamus de Napier; Seán Mac Giolla Ceara; Orla Nig Ruairí; Robin Glendinning.
Beneficial area: Northern Ireland.
Grant total: £90,00–£100,000 annually
The trust aims to widen appreciation and knowledge of the Irish language throughout the entire community in Northern Ireland. The trust normally funds groups based in Northern Ireland involved in cultural activities that promote the Irish language. It has a particular interest in cross-community activity.

Grants do not usually exceed £5,000 and are for specific projects rather than ongoing costs.

In 2001/02 the trust gave a total of £97,000 in furtherance of the objectives outlined above. We do not have a list detailing the beneficiaries or purposes of grants.
Exclusions: Only Irish language activities are funded. Grants are not normally made to individuals; support running costs; fund major capital programmes; support travel expenses; publications or videos.
Applications: Application forms and guidelines are available from the trust.

The Underwood Trust

CC No: 266164

32 Haymarket, London SW1Y 4TP

Website:
www.theunderwoodtrust.org.uk
Contact: Antony P Cox, Manager
Trustees: R Clark; Mrs P A H Clark.
Beneficial area: UK.
Grant total: £600,000 (1999/2000)
Arts grants: £87,000
The trust gives to a wide spectrum of registered charities and other causes recommended by the trustees in the following categories: education, sciences, humanities and religion; medicine and health; welfare; environmental resources.

In 1999/2000 funding was apportioned as follows:
- education, sciences, humanities and religion – £82,250 (10 grants);
- medicine and health – £339,060 (36 grants);
- eelfare – £125,400 (21 grants);
- environmental resources – £52,900 (12 grants).

In 1999/2000 the trust gave £600,000 in 79 grants, of which £87,000 (14%), was directed at 10 arts-related causes, some of which have received repeated support. These included the following:
Under 'education, sciences, humanities and religion' –
Royal Philharmonic Society (£24,000); International Musicians Seminar; London Philharmonic Orchestra; Music For Youth; Scottish Opera (£5,650 each); English Heritage (£5,000).
Under 'medicine and health' –
Living Paintings Trust (£25,000); Listening Books (£5,650).

The trust stated that it would not consider the beneficiaries listed under 'medicine and health' to be arts-related causes. However, the activities of these organisations do fall within the broad scope of this guide, meriting their inclusion in this entry.

Exclusions: Individuals, under any circumstances.
Applications: Applicants must access application forms and further relevant details from the website. New applications are very unlikely to be considered and cannot expect an acknowledgement.

The Trevor Walden Trust – see The Museums Association

The Charles Wallace India Trust

CC No: 283338

9 Shaftesbury Road, Richmond, Surrey TW9 2TD

Tel: 020 8940 9295; Fax: 020 8940 9295
Contact: Dr F H Taylor
Trustees: Professor Judith Brown; Mr C W Perchard; Ms C Lampert.
Beneficial area: UK and India.
Grant total: £293,000 (2000/2001)
The trust's overall policy is to support training in Britain of Indian postgraduate students, scholars and professionals in the arts and humanities. Awards are made for either 'men and women of Indian nationality who are domiciled and normally resident in India to enable them to travel to the UK to follow a course of study or research' or charitable institutions serving this purpose.

Awards are made under the following broad headings: arts awards; conservation awards; curatorial awards; postgraduate awards; research grants and professional visits; visiting fellowships; English studies.

In 2000/2001 the trust gave a total of £293,000 in 122 awards, the individual values of which were not specified in the trust's annual report.
Exclusions: Capital costs.
Applications: In writing to the correspondent.

William Walton Trust

CC No: 289605

c/o Berley, Chartered Accountants,
76 New Cavendish Street, London
W1M 7LB

Contact: The Secretary
Trustees: Lady Walton; H Burton Esq.; J
F da Luz Camacho Esq.; C Graham Esq.;
R Hickox Esq.; Sir John Tooley; Hon. P S
Zuckerman; Lord Palumbo; Marina
Harss.
Beneficial area: UK.
Grant total: £98,000 (1999)
Arts grants: £98,000
This trust 'aims, through the music of
William Walton, both to encourage
education projects in schools and to
develop the potential in young
professional musicians at the start of their
careers'. There are four specific objectives:

- to promote and establish excellence in
 the performing arts (music, theatre,
 dance) within the United Kingdom,
 with special reference to the music of
 William Walton;
- to introduce the arts to the widest
 possible audience;
- to aid educational projects
 encompassing British music,
 particularly for special needs and inner
 city schools;
- to develop a wide range of
 masterclasses covering all aspects of the
 arts under the guidance of leading
 professional artists.

The trust's 1999 annual report provides
the following breakdown of beneficiaries:

- artists, concerts and consultancy –
 £18,977;
- contributions to expenses of
 masterclasses – £13,704;
- William Walton Archive – £1,507;
- donations and sponsorships – £50,020;
- other projects – £13,808.

In 1999 the trust gave a total of £98,000
in grants and sponsorship for arts-
related causes. Beneficiaries included:

Belgrade Theatre, Coventry; Royal
Philharmonic Orchestra; City of London
Sinfonia.

There was no further breakdown of
funding in the annual report but it was
indicated that financial assistance was also
provided for students and coaches
attending masterclasses in Italy.
Applications: These must be for
appropriate musical projects and made in
writing to the correspondent but there is
very little scope for unsolicited applications.

The Warbeck Fund Limited

CC No: 252953

2nd Floor, Pump House, 10 Chapel
Place, Rivington Street, London
EC2A 3DQ

Tel: 020 7739 2224; Fax: 020 7739 5544
Contact: The Secretary
Trustees: Michael Brian David; Neil
Sinclair; Jonathan Gestetner.
Beneficial area: UK and overseas.
Grant total: £178,000 (2000/01)
Arts grants: £51,520
This fund supports Jewish and arts causes,
as well as some in the fields of medical
and social welfare. In 2000/2001 the fund
gave a total of £178,000 in 128 grants,
ranging from £15 to £26,100; most were
for under £1,500. A total of £51,520
(29% of total grant-aid) was given to the
arts in 27 grants. These included:
★Royal National Theatre (£21,250);
★Hampstead Theatre Trust (£10,250);
★Chicken Shed Theatre Company
 (£4,240);
★London Symphony Orchestra (£2,500);
Nordoff Robbins Music Therapy
 (£1,200);
★British Friends of The Arts Museums of
 Israel; ★Heritage of London Trust
 (£1,000 each);
★Friends of Covent Garden (£750);
Friends of the Royal Opera House
 (£650);
★Jewish Museum (£570);
★Almeida Theatre Company (£500);

*English National Opera; English Stage
 Company Limited (£350 each);
*Chamber Orchestra of Europe;
 *National Art Collections Fund
 (£100);
*Chichester Festival Theatre Society
 (£55).

Exclusions: Individuals; organisations
not registered as charities.
**Applications: It is understood that
the trust's funds are fully committed
and that both its income and assets
are expected to be spent in the next
few years.**

The Ward Blenkinsop Trust

CC No: 265449

The Bungalow, Windmill Lane,
Appleton, Warrington, Cheshire
WA4 5JN

Contact: A M Blenkinsop, Trustee
Trustees: A M Blenkinsop; J H Awdry;
Mrs F A Stormer; Miss S Blenkinsop;
Miss H Blenkinsop; Miss C Blenkinsop.
Beneficial area: UK, with a special
interest in the Merseyside area.
Grant total: £220,000 (1999/2000)
Arts grants: £68,000
This trust makes grants for a wide range
of causes, but favours support for medical
charities and education. Preference is
given for causes in Merseyside and the
North West of England, although projects
in other areas are considered.

In 1999/2000 the trust gave a total of
£220,000 in 50 grants ranging from
£1,000 to an exceptional donation of
£100,000 for Clatterbridge Cancer
Research Trust; most were under £5,000.
Arts funding amounting to £68,000
(31% of total grant-aid) was given to the
following four beneficiaries:
*Cheshire County Council, Youth Arts
 Initiative (£25,000);
*Clod Ensemble (£20,000);
*Royal Academy of Dancing (£17,000);
*Manchester Youth Theatre (£6,000).

Exclusions: Individuals; organisations
not registered as charities.
Applications: In writing to the
correspondent.

The Warwick Arts Trust

CC No: 276210

c/o Milton Grundy, 33 Warwick Square,
London SW1V 2AQ

Tel: 020 7834 6120
Trustees: Milton Grundy Foundation
Trustees Ltd, whose directors are Mr M
Grundy and Mr N Patel.
Grant total: £113,000 (1999/2000)
Arts grants: £8,233
This trust is administered through the
Milton Grundy Foundation Trustees
Limited. Its principal function is 'to
promote the arts by using its premises as a
venue to display various artwork and to
facilitate musical competitions and
performances'.

Although the trust's charitable
expenditure for 1999/2000 totalled
£113,000, only £8,233 of this was
accounted for by grants, which were
unspecified, with the remainder
expended upon running costs for its
venue.

The Wates Foundation

CC No: 247941

1260 London Road, Norbury, London
SW16 4EG

Tel: 020 8764 5000; Fax: 020 8679 1541
Contact: Mr Brian Wheelwright,
Director
Trustees: Jane Wates, Chair; Ann Ritchie;
Michael Wates; David Wates; Susan Wates.
(The grants committee of the foundation
also includes other members of the Wates
family.)
Beneficial area: Main emphasis on
Greater London, especially south
London.
Grant total: £1,581,000 (2000/2001)
Arts grants: £138,500

The foundation's primary objective is to 'improve the quality of life of the deprived, disadvantaged and excluded'. Support is focused on a range of issues including domestic violence; homelessness; the care of children; women's rights; vocational training; and refugee communities. The arts are also funded as 'a means of supporting socially excluded persons as well as enhancing the quality of life through general cultural activities'. Funding is particularly directed at pioneering or unpopular causes and largely concentrated on projects in London and the South-East, with a particular preference for the Croydon area. Existing commitments aside, it is unlikely that support will be given to overseas causes or to Northern Ireland and the Midlands.

In 2000/01 the foundation gave a total of £1,581,000 in 252 grants ranging from £100 to £35,000. The average grant size was around £8,000, although the foundation's annual report outlined a policy whereby more support will be given to fewer projects in future.

A total of £138,500 was given in 26 grants relevant to this guide. Of these, 15 donations, totalling £85,000, were made within the 'arts' category while a further 11 grants, amounting to £53,000, were awarded under other headings. Arts-related grants included:

Under 'arts' –

Lambeth Children's Theatre Company Ltd, to extend the theatre's work into primary schools (£15,000);

Community Zone (Lambeth), to help set up organisation offering workshops for young people (£10,500);

Unit for the Arts and Offenders, to help enhance literary skills (£10,000);

Holloway Prison Art Therapy Project (£7,500);

Camberwell Choir School; Grendon Friends Trust, towards setting up a transient trail in a main prison corridor; Live Music Now!; *London Mozart Players, to assist with community programme (£5,000 each);

Lyric Theatre (Hammersmith), to support arts education programmes for the disadvantaged (£1,000).

Under 'education and science' –

Tate Xtra Schools Project, to support the Tate's summer programme for children from Lambeth schools (£6,000);

Age Exchange Theatre Trust, for inter-generational workshops in Southwark and Greenwich (£5,000).

Under 'health' –

Healing Sounds (Sound Foundation), to support a symposium (£2,000).

Under 'community projects and the disadvantaged' –

Chance for Children Trust (South Norwood), to assist with creative arts activities for emotionally disturbed and abused children (£10,000);

Blessed Trinity Housing Association Limited (Wandsworth), towards arts classes for the disabled (£5,000);

Keostler Award Trust, support for award scheme for prisons and Young Offenders Institutions (£1,500).

Under 'heritage, conservation and the environment' –

Architecture Foundation, towards core funding (£15,000).

Exclusions: Individuals; general appeals from well-established organisations; large building projects; schools (other than special schools); projects for children under the age of eight not suffering from special handicaps. No grants in the Republic of Ireland.

Applications: Recipients must have charitable status. Initial letters of application should be kept simple, answering the following questions: What do you do? What do you want to do? How much will it cost? How much do you want from the foundation? Concise, professionally presented applications are most likely to be considered and should not be accompanied by colourful booklets and so on.

Applicants are strongly advised to read the robust guidelines which are available on the website or from the foundation before making any appeal.

The Weinberg Foundation

(formerly The M A Weinberg Charitable Trust)

CC No: 273308

c/o Munslow Messias, Chartered Certified Accountants, First Floor, 143–149 Great Portland Street, London W1N 5FB

Tel: 020 7493 8111
Contact: Maria Torok
Trustees: Neville H Ablitt; Cecil Lyddon Simon.
Beneficial area: UK.
Grant total: £290,000 (1998/99)
Arts grants: £60,000
This foundation mainly supports Jewish, medical and welfare charities, as well as giving a number of arts grants each year.

In 1998/99 the foundation gave a total of more than £290,000 in an unspecified number of grants. This level of funding is much higher than in previous years (1997/98 – £52,000; 1996/97 – £65,000). Grants have not been listed by the trust since 1995/96, when the foundation gave a total of £42,000, out of which £10,000 (24% of total grant-aid) was given in six arts grants. These included:
Royal National Theatre Endowment Fund (£5,000);
Serpentine Gallery (£2,000);
Serpentine Trust (£1,500).

Based on the proportion of arts-related funding in previous years, it is likely that grants relevant to this guide amounted to about £60,000.
Applications: In writing to the correspondent but applicants should note that there is little leeway for new appeals.

The Weinstock Fund

CC No: 222376

PO Box 17734, London SW18 3ZQ

Contact: Miss Jacqueline Elstone
Trustees: Susan Lacroix; Laura Weinstock; Michael Lester.
Beneficial area: UK.
Grant total: £682,000 (1999/2000)
Arts grants: £222,000
The fund gives grants to a wide range of charitable causes supporting disability, social welfare, medicine, children as well as the arts.

In 1999/2000 the fund gave a total of over £682,000 in 207 grants ranging from £300 to an exceptionally large grant of £150,000 made to the British Museum Development Trust. The majority of donations were, however, for £3,000 or less. The fund gave a total of £222,000 (33% of total grant-aid) in 27 grants relevant to this guide. Both the overall level of funding and the proportion of support given to the arts was significantly greater than in previous years. Arts-related donations included:
British Museum Development Trust (£150,000);
Academy of London Trust (£20,000);
★Monteverdi Choir & Orchestra; Royal Opera House Trust (£10,000 each);
Newmarket Millennium Bronze Statue (£5,000);
★Newbury Spring Festival (£4,000);
★Chicken Shed Theatre Company; ★English Concert; ★London Bach Society (£2,000 each);
★National Gallery Trust (£1,500);
Chantry Singers; ★Council for Music in Hospitals; ★English National Ballet; ★Garsington Opera; ★Listening Books; ★Music at Boxgrove (£1,000 each);

Exclusions: Individuals; organisations not registered as charities.
Applications: In writing to the correspondent including the charity registration number; donations are only made to registered charities. 'Where

nationwide charities are concerned, the trustees prefer to make donations centrally.'

The Weldon UK Charitable Trust

CC No: 327497

4 Grosvenor Place, London SW1X 7HJ

Tel: 020 7235 6146; Fax: 020 7235 3081
Contact: J M St J Harris, Trustee
Trustees: J M St J Harris; H J Fritze.
Grant total: £69,000 (1999/2000)
Arts grants: £55,841
The trust makes a small number of donations with a bias towards established national arts-related organisations, many of which are recurrent and tend to be committed some years ahead. In recent years the Royal Opera House has received the majority of the trust's annual funding, in grants of between £50,000 and £75,000.

In 1999/2000 the trust made eight donations totalling £69,000. Out of this, £55,841 (81% of total grant-aid) was given to three beneficiaries. These were:
*Royal Opera House (£50,000);
*Yehudi Menuhin School (£3,341);
*Royal Academy Trust (£2,500).

Exclusions: Individuals.
Applications: In writing.

The Wellcome Trust – Public Engagement with Science

CC No: 210183

183 Euston Road, London NW1 2BE

Tel: 020 7611 7367
E-mail: soss@wellcome.ac.uk
Website: www.wellcome.ac.uk/soss
Beneficial area: UK.
Grant total: see below
This trust, one of the largest in the world, is the main funder of scientific biomedical research in Britain, with spending on a par with the government's Medical Research Council.

Public Engagement with Science
This grants programme introduced a range of new schemes from October 2002. Projects funded under these schemes should aim to do one or more of the following.

- Inform young people or adults about biomedical science, and enable them to evaluate and consider the impact of this science on their lives and on society.
- Explore new ways to engage adults and families in biomedical science and/or its social, cultural and historical context.
- Encourage cross-disciplinary ways of working that enable audiences to connect contemporary biomedical science with its historical roots as well as its ethical, social and cultural contexts.
- Support teachers and others working with young people to become more skilled and confident in handling science and the issues science raises.
- Support the teaching of more contemporary science in school so that young people are excited by science and better prepared to become future scientists.
- Support researchers, science communicators, museum and science centre staff, the media, health professionals or other mediators to become more skilled and confident in handling biomedical science in a way that is relevant to a range of public audiences.
- Encourage artists and other creative professionals to explore biomedical subjects and themes in their work within the public arena.
- Improve understanding of people's attitudes, values and needs in relation to biomedical science.
- Improve understanding of the processes of engaging public audiences in biomedical science.
- Explore new approaches to consulting with a variety of publics on issues raised by biomedical science.

- Evaluate the success of public engagement with biomedical science projects and programmes.

The schemes include:

People Awards – a fast, responsive mechanism for funding initiatives up to £30,000 that encourage and support public engagement with biosciences, especially novel and imaginative activities. The scheme will span historical, social, ethical, cultural and contemporary issues within the biosciences. Mixed, interdisciplinary approaches will be particularly welcomed.

The scheme is open to:

- academics (e.g. biomedical scientists, historians, social scientists or ethicists);
- mediators and practitioners (e.g. science centre staff, science communicators, artists, educators, health professionals etc.).

Projects will be of a maximum duration of three years and might include:

- partnership projects (e.g. between scientists and artists or ethicists and educators);
- local or developmental projects which have the potential for wider application;
- projects taking place in schools, galleries, science centres, health centres and so on;
- conferences or seminars which disseminate academic research findings to a broader audience in a way that is of relevance to the audience;
- projects that are funded in partnership from other recognised bodies.

Applications: Can be made at any time during the year and will be subject to review by referees.

Society Awards – targeted calls for project proposals in specified areas which aim to make a significant impact on public engagement with science research and practice. Funding will mainly be for projects over £50,000 and will include

both research and direct public activities. The first targeted areas:

- arts;
- young people's education;
- 'difficult to reach' audiences.

Applications: Invited by specified deadlines twice a year and will be subject to peer review. Funding decisions will be made by a panel of academics and practitioners with expertise in the particular area.

Enquiries: Dr Veronica McCabe, Programme Officer, Medicine in Society, Tel: 020 7611 8415; 020 7611 8254; E-mail: mis@wellcome.ac.uk

Welsh Broadcasting Trust

CC No: 700780

7 Ffordd Segontiwm, Caernarfon, Gwynedd LL55 2LL

Tel: 01286 673436; **Fax:** 01286 677616
E-mail: info@wbt.org.uk
Website: www.wbt.org.uk
Contact: Siân Teifi, Secretary
Trustees: Mari Beynon Owen, Chair; Wil Aaron; Peter Edwards; Kathryn Morris; Elin Rhys; Euryn Ogwen Williams.
Grant total: about £11,000
Arts grants: £11,000
The Welsh Broadcasting Trust is a registered charity established to promote and support educational activities in relation to television, film, radio and new media. Its aim is to expand and enrich the range of skills and experience for the media of the future. It supports:

- training or career development courses, full- or part-time, for example writing workshops/specialist technical skills/ business development;
- attendance of educational courses at higher degree level (NB: the trust does not fund undergraduate entry to courses);
- travel grants to accredited festivals/ markets;

- training bodies or companies which offer specific training/educational programmes;
- projects which enrich the cultural experience through the medium of television, film, radio and new media.

Applicants must be fully resident in Wales for at least two years prior to making the application, *or* born in Wales, *or* a Welsh speaker. They will be asked to confirm their eligibility.

Applications: Either fill in the application form available via the website or request a printed form from the secretary.

Trustees meet in March and August so applications must be forwarded by 1 March or 1 August. Late applications cannot be considered.

The Welton Foundation

CC No: 245319

33 St Mary Axe, London EC3A 8LL

Tel: 020 7280 2800
Contact: Robin R Jessel, Secretary
Trustees: D B Vaughan; H A Stevenson; Prof. J Newsom-Davis.
Beneficial area: UK, including Jersey.
Grant total: £949,000 (1999/2000)
Arts grants: £181,000
The foundation is primarily concerned with hospitals and medical research but also gives to more general charitable causes, including the arts. The annual report for 1999/2000 shows that the foundation gave a total of £949,000 in 20 grants ranging from £1,000 to £323,000, and an unspecified number of grants for less than £1,000 totalling £7,500. Three donations for over £50,000 were made but most grants were under £20,000. A total of £181,000 (19% of total grant-aid) was given in nine arts-related grants. This level of arts funding is significantly higher than in previous years but this is chiefly attributable to a particularly large

donation to Handel House Trust. Arts-related grants were as follows:
Handel House Trust (£100,000);
★Young Concert Artists Trust (£22,000);
★Drake Music Project (£20,000);
Royal Academy Trust; Sadler's Wells Theatre Trust (£15,000 each);
★British Youth Opera; Chelmsford Cathedral Choral Foundation (£2,500 each);
Chamber Orchestra of Europe; Lambeth Orchestra (£2,000 each).

Exclusions: Organisations not registered as charities; general appeals.
Applications: In writing to the secretary providing brief details of the charity and the specific project, outlining aims and funding required, and enclosing financial statements. Due to the large number of approaches it receives, the foundation only replies to successful applicants.

The Westminster Foundation

CC No: 267618

70 Grosvenor Street, London W1K 3JP

Tel: 01252 722557
Contact: J E Hok, Secretary
Trustees: The Duke of Westminster, Chair; J H M Newsum; R M Moyse.
Beneficial area: The North West of England and London W1/SW1.
Grant total: £3,820,000 (2000)
Arts grants: £24,350
The foundation, established in 1974 by the Duke of Westminster, mainly supports causes in the North West of England and the W1 and SW1 areas of London. In 2000 the foundation gave a total of £3,820,000 in grants ranging from £500 to £1,300,000, under the following headings: arts (1% of total grant-aid); medical (1%); youth (3%); church (2%); education' (42%); conservation' (10%); and 'Social & Welfare' (41%).

A total of £24,350 (one per cent of total grant-aid) was given in seven arts-related grants including:

★Northern Ballet Theatre Ltd (£10,000);
Live Music Now! (£5,350);
★Young Concert Artists Trust (£5,000);
★Chester Summer Music Festival
 (£1,500);
Northlands Festival; Royal Academy Trust
 (£1,000 each).

Exclusions: Individuals; organisations not registered as charities.
Applications: In writing, enclosing an up-to-date set of accounts, brief history of the project and current requirements. Trustees meet in February, May, September and November.
Note: The foundation's arts and arts/education budget is fully committed until at least 2004.

The Garfield Weston Foundation

CC No: 230260

Weston Centre, Bowater House, 68 Knightsbridge, London SW1X 7LQ

Tel: 020 7589 6363; Fax: 020 7584 5921
Contact: Fiona M Foster, Administrator
Trustees: Guy Weston, Chairman; Miriam Burnett; R Nancy Baron; Camilla Dalglish; W G Galen Weston; Jana R Khayat; Anna C Hobhouse; George G Weston; Sophia Mason; Eliza Mitchell.
Beneficial area: UK.
Grant total: £38,900,000 (2000/01)
Arts grants: £5,645,900
This foundation gives support to causes within the following categories: arts; community; education; environment; health; mental health/handicap; religion; welfare; youth; other. Its major grants are generally directed at large established charities but many smaller grants are given to an extremely diverse range of projects. All grants are listed in the foundation's meticulously compiled annual report and accounts.

The grant-making capacity of the foundation has grown enormously in recent years, from £7.9 million in 1993/94, and £26 million in 1997/98, to £38.9 million in 2000/01, disbursed in 1,682 grants. In 2000/01 support was distributed as follows:

- arts – £3,800,500 in 90 grants;
- community – £624,300 in 167 grants;
- education – £13,503,200 in 171 grants;
- environment – £2,277,000 in 48 grants;
- health – £7,783,000 in 134 grants;
- mental health/handicap – £586,250 in 57 grants;
- religion – £3,785,700 in 431 grants;
- welfare – £4,959,450 in 340 grants;
- youth – £2,045,620 in 215 grants;
- other – £532,500 in 29 grants.

Over half of the funding within the arts category was given in two grants of £1 million pounds each to English National Opera and the Royal Albert Hall. Although the vast majority of arts support was disbursed in donations of over £20,000, the foundation also gives a large number of more modest grants to projects where such sums would make a considerable impact. Grants relevant to this guide were not restricted to the specific arts category but were also given under a number of other headings. A total of £5,645,900 (15% of total grant-aid) was given in 113 grants to arts-related causes. These included:
Under 'arts' –
English National Opera; Royal Albert Hall (£1,000,000 each);
Royal National Theatre; Hampstead Theatre (£250,000 each);
Buxton Opera House; Hackney Empire Appeal; Place Contemporary Dance, London (£100,000 each);
Aldeburgh Productions; National Art Collections Fund; Scottish Opera (£50,000 each);
Blackpool Grand Theatre; City Ballet of London (£25,000 each);
Norwich Playhouse (£15,000);
Centre for the Magic Arts, London; Eden Court Theatre & Cinema, Inverness (£10,000 each);

Bigfoot Theatre Company, London; St
 Teilo's Arts Project, Cardiff (£5,000
 each);
Chiltern Sculpture Trust (£3,000).
Under 'education' –
Foundling Museum (£300,000);
Museum of London; National Museums
 & Galleries of Wales (£250,000 each);
Natural History Museum (£75,000);
Royal Society of Arts (£33,000);
Living Paintings Trust; RADA (£10,000
 each);
Camberwell Choir School; Pavilion
 Opera Educational Trust (£5,000
 each).
Under 'environment' –
National History Museum (£1,000,000).
Under 'youth' –
Foundation for Young Musicians
 (£55,000 in two grants).
Under 'community' –
Northern Rock Festival Group, Glasgow
 (£2,500).
Under 'other' –
Koestler Award Trust (£5,000).

Exclusions: Individuals; non-registered
and non-UK charities; animal welfare.
Applications: To the administrator,
Fiona M Foster, from UK registered
charities only. A brief sheet outlining the
foundation's grant-making practice is
available. All applications must include the
following: the charity's registration
number; a copy of the most recent report
and audited accounts; an outline
description of the charity's activities; a
synopsis of the project requiring funding,
with details of who will benefit; a
financial plan; details of current and
proposed fundraising.

The foundation makes one-off cash
donations which are paid during the
financial year they are approved. Trustees
meet on a regular basis to review and
approve grant applications which are
normally processed within three months
of receipt. 'From time to time, more
information about a charity or a visit to
the project might be requested.'

The Peter Whittingham Fund
– *see Musicians' Benevolent Fund*

CC No: 228089/0003

The Harold Hyam Wingate Foundation

CC No: 264114

2nd Floor, 20–22 Stukeley Street,
London WC2B 5LR

Tel: 020 7438 9512
E-mail: karen.marshall@act-arts.co.uk
Website: www.wingate.org.uk
Contact: Karen Marshall
Trustees: R C Wingate; A J Wingate;
Prof. R H Cassen; D L Wingate; W J
Wingate.
Grant total: £520,000 to organisations
(1999/2000)
Arts grants: £153,320
This foundation makes grants towards the
expenses of established charities,
including Jewish causes and the arts.
Many grants are recurrent and a
significant proportion of funding is given
in an annual donation to a connected
charity, the Whitechapel Society for the
Advancement of Knowledge of
Gastroenterology.

In 1999/2000 the foundation gave a
total of £520,000, of which £135,000
was given from the Whitechapel
designated fund. The remainder of the
grants ranged between £50 and £35,000;
most were for £5,000 or less. A total of
£153,320 (29% of total grant-aid) was
given in 26 grants relevant to this guide.
These included:
★National Film & Television School
 Foundation (£35,000);
New Shakespeare Company Limited
 (£30,000);
★English Touring Opera (£15,000);
★London String Quartet; Old Vic Theatre
 Trust (£10,000 each);
★Guildhall School of Music and Drama
 (£8,000);

Springboard Concerts Trust; Royal
Shakespeare Theatre; Jewish Museum
(£5,000 each);
Toynbee Hall (£2,000);
★Israel Museum Jerusalem (£1,935);
East of England Orchestra (£1,500);
English Sinfonia; ★London Choral
Society; ★Young Vic Company;
★Hampstead Theatre Trust (£1,000
each);
Kirckman Concert Society (£400).

In addition to the above, Wingate
Scholarships totalling some £375,000 a
year are also available. However, these
are administered separately, from the
same address but through a different
correspondent (see 'applications'
below).
Exclusions: Individuals; loans; general
funds of large charitable organisations.
Applications: General funding – in
writing, with financial statements where
possible. Applications will only be
acknowledged if an SAE is enclosed or if
the applicant is successful.
Wingate Fellowships – applicants
should access details from the website or
contact Faith Clark at the above address
prior to any appeal.

The Wolfson Foundation

CC No: 206495

8 Queen Anne Street, London W1G 9LD

Tel: 020 7323 5730; Fax: 020 7323 3241
Contact: Dr Victoria Harrison, Executive
Secretary
Trustees: Lord Wolfson of Marylebone,
Chair; Lady Wolfson; Lord Quirk; Lord
Quinton; Professor Sir Eric Ash; Sir
Derek Roberts; Lord McColl; Lord
Turnberg; Mrs Janet Wolfson de Botton;
Mrs Laura Wolfson Townsley; Professor
Sir David Weatherall.
Beneficial area: Mainly UK and Israel.
Grant total: £34,800,000 (2000/01)
Arts grants: £1,350,000
The foundation's major supported areas
are medical research and health care;

science, technology and education; and
arts and humanities. Funding is given to
encourage excellence within these fields
and to projects which may act as a
catalyst, so that the foundation's grants
can attract further support.

The foundation's guidelines state that
the areas assisted under the heading 'arts
and humanities' include libraries,
museums, galleries, the visual arts and
historic buildings.

Two types of grants are made:
- capital projects – grants towards the
 cost of a new building or extension, or
 of renovating existing ones;
- equipment grants – for specific
 purposes, and/or furnishings and
 fittings.

In 2000/01 the foundation allocated
£34.8 million to over 200 projects,
ranging from small grants (£4,000) to
historic buildings, to £10 million over
four years for a merit award scheme for
academic salaries in partnership with the
Royal Society and the Department for
Trade and Industry. Of the awards made
during the year, a total of £1.35 million
(3.9%) was given to arts-related projects.
These included:
London School of Economics, Lionel
Robbins Library (£500,000);
National Galleries of Scotland, Playfair
project (£300,000);
Grants to historic Anglican churches
through programme administered by
the Council for the Care of Churches
(£154,000).

Exclusions: Individuals; overheads,
maintenance costs, VAT of professional
fees; non-specific appeals (including
circulars), endowment funds or conduit
organisations; meetings, exhibitions,
concerts, expeditions; purchase of land;
research involving live animals; film or
video production.
Applications: 'Before submitting an
application please write to enquire
whether your project is eligible, enclosing
a copy of the organisation's audited

accounts for the previous two years...
When an enquiry is received, if the
project is eligible for consideration and
after the accounts have been scrutinised,
current Guidelines for Applicants will be
sent and application invited.'

The trustees meet in June and
December and are advised by specialist
panels who meet before the main board
meetings. Applications must be made by
15 March and 15 September.

The Wolfson Townsley Charitable Trust

CC No: 277928

Berwin Leighton Paisner & Co, Bouverie
House, 154–160 Fleet Street, London
EC4A 2JD

Tel: 020 7353 0299; Fax: 020 7583 8621
Grant total: £113,550 (1999/2000)
Arts grants: £22,750
The trust has general charitable purposes
and makes grants for a range of causes,
including medical research, education,
disability, Jewish charities and the arts. Its
income is largely derived from charitable
donations and, as a result, the resources
available for funding vary from year to
year.

In 1999/2000, the trust gave a total of
£113,550 (£40,000 in 1998/99) in 17
grants ranging from £500 to £21,500;
most were for £15,000 or less. Out of
this, £22,750 (20% of total grant-aid) was
given in the following five arts-related
grants:
Royal Opera House Trust (£15,000);
Hampstead Theatre (£5,000);
British Friends of the Arts Museums of
 Israel (£1,250);
Chicken Shed Theatre Company
 (£1,000);
English National Ballet School (£500).

The trust is also believed to have been a
sponsor of the Kitaj Exhibition at the
National Gallery in November –
December 2001.

The Woo Charitable Foundation

*(formerly the Po-Shing Woo
Charitable Foundation)*

CC No: 1050790

277 Green Lanes, London N13 4XS

Tel: 07974 570475; Fax: 020 8886 3814
Contact: John Dowling, Administrator/
Secretary
Trustees: Sir Po-Shing Woo, Patron;
Nelson K Woo, Chair of Trustees;
Countess Benckendorff; Nigel Kingsley;
Michael A Trask.
Beneficial area: UK.
Grant total: £286,000 (2000/01)
Arts grants: £286,000
'The Woo Charitable Foundation was
established for the advancement of
education through supporting, organising,
promoting or assisting the development
of the arts in England, together with the
specific aim of helping those less able to
help themselves.' Funding is usually
spread over a number of years.

In 2000/01 the foundation gave a total
of almost £286,000 in an unspecified
number of 'artistic grants'. Beneficiaries
included:
★Serpentine Gallery, for educational arts
 activities for under-twelve age group
 (£12,000);
★Opera North, for opera workshops in
 schools (£10,000);
★Centre for Arts and Disability,
 workshops for young disabled people
 (£7,500);
New Addington Musical Project, for
 South London schools musical
 collaboration project (£5,000);
★Slade School of Fine Art, to enhance
 teaching (£3,400);
Stagecoach Youth Theatre, providing live
 theatre experience for disadvantaged
 young people in Yorkshire (£1,000);
North of England Chamber Orchestra,
 for schools in Bradford to participate in
 a music project (£900).

The Woodward Trust

(see also the Sainsbury Family Charitable Trusts)

CC No: 299963

Tel: 020 7410 0330; Fax: 020 7410 0332
Website:
www.woodwardcharitabletrust.org.uk
Contact: Michael Pattison, Director
Trustees: Mrs Camilla D Woodward;
Shaun A Woodward MP; Miss J S Portrait
Beneficial area: UK and overseas.
Grant total: £746,000 (1999/2000)
Arts grants: £406,000
This is the trust of Camilla Woodward,
née Sainsbury, and of her husband, Shaun
Woodward. It is one of the Sainsbury
Family Charitable Trusts which share a
joint administration.

The trust makes the following
statement about its priorities: 'The
trustees give priority to a few charitable
causes of which they have personal
knowledge.'

'In addition they make a limited
number of small grants in response to
selected appeals in their fields of interest.
These grants are usually of £1,000 or less
in each case and rarely more than
£5,000. The trustees prefer to make one-
off grants for specified purposes and they
are generally unable to provide any form
of recurrent core funding. They will,
however, consider subsequent appeals
from previous beneficiaries for further
specific purposes.'

'Unsolicited applications within the
trustees' selected categories and not
covered by the exclusions below will be
considered with care, but there are
limited funds for such appeals. The
trustees expect to make around 100
grants each year but receive many times
this number in applications.'

The current categories of grant
making are:
- arts;
- community and social welfare
 (including children's summer holiday
 schemes, usually considered in May);
- disability and health;
- education;
- environment.

'In all these categories the trustees
strongly favour smaller-scale, locally based
initiatives.'

In 1999/2000 grants totalling
£746,000 were approved for 90
charitable causes, including £406,000
(54%) in arts-related grants. Grants are
always directed at a very small number of
causes and the trust's annual report shows
that the vast majority of funding was
given to the following opera-related
causes:

English National Opera; Royal Opera
House Trust (£200,000 each).

The remainder of the funding relevant to
this guide was given in five grants of
£2,000 or under including:
Futures Theatre Company (£2,000);
BOC Covent Garden Festival (£1,000).

Exclusions: Standard appeals; general
appeals from large national charities;
requests for small contributions to large
appeals; medical research; individuals;
student support; course fees or expedition
costs; hospices; parish facilities; homework
clubs; overseas projects.

Applications: 'Trustees will only
consider applications made on the trust's
own form and returned with the latest
annual report and audited accounts. This
form is downloadable from the website,
together with other information about
the trust's activities. Potential applicants
are encouraged to telephone to discuss
their work if they think it might meet the
trustees' criteria. Application forms will
be sent where the trust's staff believe the
trustees will be able to consider a
proposal, but the trustees are keen to
spare charities the wasted time involved
in applying when there is no prospect of

success. Trustees review applications twice a year, usually in January and July.'

See the entry for the Sainsbury Family Charitable Trusts for further information.

The Zochonis Charitable Trust

CC No: 274769

Cussons House, Bird Hall Lane, Stockport SK3 0XN

Contact: The Secretary
Trustees: John Zochonis; Richard B James; Alan Whittaker.
Beneficial area: UK, particularly Greater Manchester.
Grant total: £1,044,000 (1999/2000)
Arts grants: £167,500
The trust supports a wide range of charitable organisations, with a preference for activities in the Greater Manchester area. In 1999/2000 the trust gave £1,044,000 in 77 grants ranging from £400 to £100,000, most of which were under £10,000. A total of £167,500 (16% of total grant-aid) was given in five grants relevant to this guide. This represented a significant increase on the level of arts funding in previous years. This increase was, however, largely attributable to one grant of £100,000 to Royal Northern College of Music. The remaining arts-related grants were: Octagon Theatre, Bolton (£30,000); Chethams School of Music (£25,000); Portico Library and Gallery (£7,500); JC2000 Millennium Arts Festival for Schools (£5,000).

Exclusions: No grants to individuals, or organisations not registered as charities.
Applications: Unsolicited applications are not welcomed.

COMMUNITY FOUNDATIONS

COMMUNITY FOUNDATION NETWORK

Swallow House, 11 Northdown Street, London N1 9BN
Tel: 020 7713 9326; Fax: 020 7713 9327
E-mail: network@communityfoundations.org.uk
Website: www.communityfoundations.org.uk

Reasons for noting the entire network of community foundations

It is possible that community foundations local to local arts organisations may be interested by proposals from them, particularly if they are engaged in addressing aspects of social need.

In addition, all arts organisations working with young people need to be aware that in 2001 these foundations, through the Community Foundation Network, started playing a major role as administrator of the governmental Local Children's Network funding (see separate entry under Official sources). These funds were scheduled to 'roll out' throughout the country over a three-year period (and may continue for longer). For arts organisations working with young people these funds may also provide a valuable funding opportunity.

Background

Community foundations are both grant-raising and grant-making trusts. They build and manage endowments for the long-term benefit of voluntary and community groups within specific geographic areas. Donations from individuals and companies are invested in a constantly growing pool, with the income providing a sustainable flow of funds for local good causes – often matched to donor's interests and given in their name. Community foundations also channel funds for immediate use on behalf of companies and other agencies which recognise that they have detailed knowledge of local needs. The Community Foundation Network provides support for these local organisations.

The 29 most established community foundations held £92 million in assets and made grants of £22 million in 2001.

New community foundations are being established all the time. As of autumn 2001 around 70% of the English regions were covered, along with all of Scotland, Wales and Northern Ireland. By 2003 the Community Foundation Network anticipates that over 90% of the UK population will have access to a community foundation.

Contact details for the network's members and associates are listed below. The members are all established grant-making foundations. Many of the associates are at an early stage of their development. Some may have grant-making programmes, others may still be at the feasibility stage.

Please remember that each foundation only makes grants within its own geographical area.

LISTING OF MEMBERS

Berkshire Community Foundation:
Arlington Business Park, Theale, Reading RG7 4SA
Tel: 01189 303021; Fax: 01189 304933; E-mail: bct@patrol.i-way.co.uk
Website: www.berksfoundation.org.uk
Contact: Robin Draper, Director

The Birmingham Foundation:
St Peter's Urban Village Trust, Bridge Road, Saltley, Birmingham B8 3TE
Tel: 0121 326 6886; Fax: 0121 328 8575; E-mail: team@bhamfoundation.co.uk
Website: www.bhamfoundation.co.uk
Contact: Harvey Mansfield, Director

Cleveland Community Foundation
Southlands Business Centre, Ormesby Road, Middlesbrough TS3 0HB
Tel: 01642 314200; Fax: 01642 313700; E-mail: office@clevelandfoundation.org.uk
Contact: Kevin Ryan, Director

Community Foundation for Calderdale
Dean Clough Industrial Park, Halifax HX3 5AX
Tel: 01422 349700; Fax: 01422 350017; E-mail: enquiries@ccfound.co.uk
Website: www.ccfound.co.uk
Contact: Chris Harris, Director

Community Foundation for Greater Manchester
Beswick House, Beswick Row, Manchester M4 4LE
Tel: 0161 2140940; Fax: 0161 214094;
E-mail: enquiries@commmunityfoundation.co.uk
Website: www.communityfoundation.co.uk
Contact: Nick Massey, Director

Community Foundation serving Tyne & Wear and Northumberland
Percy House, Percy Street, Newcastle Upon Tyne NE1 4QL
E-mail: general@communityfoundation.org.uk
Website: www.northeast-online.co.uk/TWF
Contact: George Hepburn, Director

The Community Foundation in Wales
14-16 Merthyr Road, Whitchurch, Cardiff CF4 1DG
Tel: 029 2052 0250; Fax: 029 2052 1250;
E-mail: barbara@communityfoundationwales.freeserve.co.uk
Website: www.communityfoundationwales.freeserve.co.uk
Contact: Barbara Williams, Development Director

County Durham Foundation
(includes Darlington)
Aykley Vale Chambers, Durham Road, Aykley Heads, Durham, DH1 5NE
Tel: 0191 383 0055; Fax: 0191 383 2969; E-mail: cdf@freenet.co.uk
Website: www.countydurhamfoundation.org.uk
Contact: Judith Lund, Director

County of Gloucestershire Community Foundation

3 College Green, Gloucester, GL1 2LR
Tel/Fax: 01452 522006; E-mail: darien.parkes@virgin.net
Contact: Darien Parkes, Director

Craven Trust

(covers Keighley, Sedbergh, Grassington, Barnoldswick and the Trough of Bowland)
c/o Charlesworth, Wood & Brown, 23 Otley Street, Skipton BD23 1DY
Tel: 01756 793333; Fax: 01756 794434; E-mail: cwb@dial.pipex.com
Contact: John Sheard, Chairman

Cumbria Community Foundation

Unit 6B, Lakeland Business Park, Cockermouth, CA13 0QT
Tel: 01900 825760; Fax: 01900 826527; E-mail: enquiries@cumbriafoundation.org
Website: www.cumbriafoundation.org

Dacorum Community Trust

48 High Street, Hemel Hempstead, HP1 3AF
Tel: 01442 231396; E-mail: mk@dctrust.org.uk
Website: www.dctrust.org.uk
Contact: Margaret Kingston, Administrator

Derbyshire Community Foundation

The Old Nursery, University of Derby, Chevin Avenue, Micleover, Derby DE22 1GB
Tel/Fax: 01332 621348; E-mail: derbyshirecf@care4free.net
Contact: Hilary Gilbert, Director

Devon Community Foundation:

The Island, Lowman Green, Tiverton, Devon, EX16 4LA
Tel: 01884 235887; E-mail: devon.cf@virgin.net

Essex Community Foundation

52A Moulsham Street, Chelmsford, Essex, CM2 0JA
Tel: 01245 355947; Fax: 01245 251151; E-mail: general@essexcf.freeserve.co.uk
Contact: Laura Warren, Chief Executive

Fermanagh Trust

County Fermanagh's Community Foundation, 48 Forthill Street, Enniskillen,
Co. Fermanagh, BT74 6AJ
Tel: 028 66 320 210; E-mail: fermanaghtrust@talk21.com

Greater Bristol Foundation

Royal Oak House, Royal Oak Avenue, Bristol BS1 4GB
Tel: 0117 989 7700; Fax: 0117 989 7701; E-mail: info@gbf.org.uk
Website: www.gbf.org.uk
Contact: Helen Moss, Director

Heart of England Community Foundation

(covers Coventry and Warwickshire)
Aldermoor House, Aldermoor Lane, Coventry CV3 1LT
Tel: 024 7688 4386; Fax: 024 7688 4726; E-mail: info.hoe@virgin.net
Website: www.heartofenglandcf.co.uk
Contact: Polly Dickinson, Director

Hertfordshire Community Foundation

(includes area of Barnet)

Sylvia Adams House, 24 The Common, Hatfield, Hertfordshire AL10 0NB

Tel: 01707 251351; Fax: (01707) 251133; E-mail: hcf@care4free.net

Contact: Tony Gilbert, Director

Isle of Dogs Community Foundation

PO Box 10449, London E14 9FN

Tel: 020 7345 4444; Fax: 020 75384671; E-mail: idcfjanet@aol.com

Website: www.idcf.org

Contact: Janet Kennedy, Director

Milton Keynes Community Foundation

Acorn House, 381 Midsummer Boulevard, Central Milton Keynes MK9 3HP

Tel: 01908 690276; Fax: 01908 233635;

E-mail: information@mkcommunityfoundation.co.uk

Website: www.mkcommunityfoundation.co.uk

Contact: Julia Seal, Chief Executive

Northern Ireland Voluntary Trust

22 Mount Charles, Belfast BT7 1NZ

Tel: 028 9024 5927; Fax: 028 9032 9839; E-mail: info@communityfoundationni.org

Website: www.nivt.org

Contact: Avila Kilmurray, Director

Oxford Community Foundation

Vanbrugh House, 20 St Michael's Street, Oxford OX1 2EB

Tel: 01865 798666; Fax: 01865 245385; E-mail: ocf@oxfordshire.org

Website: www.oxfordshire.org

Oxfordshire Community Foundation

1 Tower Crescent, New Road, Oxford OX1 1LX

Tel: 01865 798666; Fax: 01865 245385; E-mail: ocf@oxfordshire.org

Website: www.oxfordshire.org

Contact: Emma Tracy, Director

Royal Docks Trust (London)

Church Cottage, Darenth Hill, Dartford DA2 7QY

Tel: 01322 226336; E-mail: john.parker@royaldockstrust.org

Website: www.royaldockstrust.org

Contact: John Parker, Secretary

St Katharine & Shadwell Trust

1 Pennington Street, PO Box 1779, London E1W 2BY

Tel: 020 7782 6962; Fax: 020 7782 6963; E-mail: enquiries@skst.org

Website: www.skst.org

Contact: Jenny Dawes, Director

The Scottish Community Foundation
27 Palmerston Place, Edinburgh EH12 5AP
Tel: 0131 225 9804; Fax: 0131 225 9818; E-mail: mail@scottishcomfound.org.uk
Website: www.scottishcomfound.org.uk
Contact: Alan Hobbett, Chief Executive

South Yorkshire Community Foundation
Heritage House, Heritage Park, 55 Albert Terrace Road, Sheffield S6 3BR
Tel: 0114 273 1765; Fax: 0114 278 0730; E-mail: ab.sycf@btclick.com
Contact: Erica Dunmow, Director

Stevenage Community Trust
c/o Astrium, Gunnels Wood Road, Stevenage SG1 2AS
Tel: 01438 773368; Fax: 01438 773341
Contact: Tom Johnson, Director

Telford and Wrekin Community Trust
Meeting Point House, Southwater Square, Telford, Shropshire TF3 4H5
Tel: 01952 201858; Fax: 01952 210500; E-mail: t-wct@rapidial.co.uk

Wiltshire & Swindon Community Foundation
48 New Park Street, Devizes, Wiltshire SN10 1DS
Tel: 01380 729284; Fax: 01380 729772; E-mail: wcf@dialin.net
Contact: Anna Marsden, Director

Associates

Bath and North East Somerset Community Foundation
c/o NES CVS, Leigh House, 1 Wells Road, Radstock, Bath BA3 3RN
Tel/Fax: 01761 439225; E-mail: nescvs@aol.com
Contact: Basil Wilde

Bedfordshire and Luton Community Foundation
Fairway, 18 Bromham Road, Biddenham, Bedford MK40 4AF
Tel: 01234 359651
Contact: Jim McGivern

The Birmingham Airport Community Trust Fund
Birmingham International Airport plc, Birmingham B26 3QJ
Tel: 0121 767 7311; Fax: 0121 767 7490; E-mail: marieb@bhx.co.uk
Website: www.bhx.co.uk/index_corp.html
Contact: Marie Barnes, Director

The Buckinghamshire Foundation
Unit 4 Farmbrough Close, Aylesbury Vale Industrial Park, Aylesbury HP20 1DQ
Tel: 01296 330134; Fax: 01296 330158; E-mail: patricia@bucksfoundation.f9.co.uk
Website: www.thebucksfoundation.org.uk
Contact: Les Sheldon, Director

Colchester and Tendring Community Trust
Colchester Carers Centre, Rear of Oaks Nursing Home, 25 Oaks Drive, Colchester, Essex CO3 3PR
Tel: 01206 500443; Fax: 01206 500446; E-mail: colcen@netscapeonline.co.uk
Contact: George Posner, Director

Community Foundation for Bournemouth, Dorset and Poole
55 Beaufort Road, Southbourne, Bournemouth BH6 5AT
Tel: 01202 423140; E-mail: greg.singleton@tesco.net
Contact: Greg Singleton

Community Foundation for Ireland
Foundation for Investing in Communities, 1 Fitzwilliam Place, Dublin 2, Ireland
Tel: 00 353 1 661 9800; Fax: 00 353 1 661 9255; E-mail: troche@foundation.ie
Contact: Tina Roche, Chief Executive

Community Foundation in Powys
Sefton House, Middleton Street, Llandrindod Wells, Powys LD1 5DG
Tel: 01597 822110; Fax: 01597 829147; E-mail: Harvey@pavo.org.uk
Contact: Harvey Rose

Corby Community Trust
Corby Volunteer Bureau, 33 Queens Square, Corby, Northants NN17 1PD
Tel: 01536 267873; Fax: 01536 267884
Contact: Mark Howsan, Manager

Cornwall Independent Trust Fund
1 Oaklands, The Square, Week St Mary, Holsworthy, Cornwall EX22 6XH
Tel/Fax: 01288 341298
Contact: Allan Chesney, Secretary

European Foundation Centre
Community Philanthropy Initiative, 51 Rue de la Concorde, B-1050, Brussels, Belgium
Tel: 0032 2 512 8938; Fax: 0032 2 512 3265; E-mail: luis@efc.be
Website: www.efc.be
Contact: Luis Amorim

Freudenberg Stiftung
Freudenbergstrasse 2, D 69469, Weinheim, Germany
Tel: 06201 17498; Fax: 06201 13262
Contact: Pia Gerber

Bishop of Guildford's Foundation
(Covers Surrey and N E Hampshire)
Diocesan House, Quarry Street, Guildford GU1 3XG
Tel: 01483 304000; Fax: 01483 567896; E-mail: trevor.cooper@cofeguildford.org.uk
Contact: Trevor Cooper, Campaign Director

Halton Community Foundation

The Vicarage, Daresbury, Warrington WA4 4AE
Tel: 01925 740348
Contact: Reverend David Felix

Hampshire Community Foundation Steering Committee

Community Action Hampshire, Beaconsfield House, Andover Road, Winchester, SO22 6DT
Tel: 01962 854971; Fax: 01962 841160; E-mail: info@action.hants.org.uk
Contact: Carole Ellwood

Harrow Community Trust

(covers Harrow and Ealing and is currently looking at expanding to the London boroughs of Hillingdon and Brent)
Central Depot, Unit 4, Forward Drive, Wealdstone, Middlesex HA3 8NT
Tel: 020 8424 1167; Fax: 020 8909 1407
Contact: Malcolm Churchill, Director

Herefordshire Community Foundation

Old Court, Brobury, Hereford HR3 6DV
Tel/Fax: 01981 500490; E-mail: RBBulmer@aol.com
Contact: Richard Bulmer

Highland Community Foundation

3 Caulfield Avenue, Inverness IV1 2GA
Tel/Fax: 01463 793772; E-mail: 101376.1270@compuserve.com
Contact: Donald Macleod, Director

Hull & East Yorkshire Community Foundation

11 Larchmont Close, Ellerton, Brough HU15 1AW
Tel: 01482 665456; E-mail: director@foundation.karoo.co.uk
Contact: Richard Howcroft, Director

Kensington and Chelsea Community Foundation

Chelsea Social Council, St Luke's Church Crypt, Sydney Street, London SW3 6NH
Tel: 020 7351 3210; Fax: 020 7352 3405
Contact: Lucy Bingham

Kent Community Foundation

(including Medway)
Action Business Centre, Somerset Road, Ashford, TN24 8EW
Tel: 01233 653200; E-mail: kcf@nascr.net
Website: www.kentcf.org

Lincolnshire Community Foundation Steering Committee

Community Council of Lincolnshire, The Old Mart, Church Lane, Sleaford NG34 7DF
Tel: 01529 302466; Fax: 01529 414267; E-mail: karen.watts@cclincs.com
Contact: Karen Watts

London Community Foundation
2 Plough Yard Shoreditch High Street, London EC2A 4LP
Tel: 020 7422 8614; Fax: 020 7422 8616; E-mail: info@londoncf.org
Website: www.londoncf.org
Contact: Gil Kirby, Research and Information Officer

London North East Community Foundation
PO Box 77, Ilford, Essex IG1 1EB
Tel: 020 8553 9469; Fax: 020 8554 4241; E-mail: LNECF@socialprojects.co.uk
Contact: Christopher Legge, Director

Northamptonshire Community Foundation Steering Committee
Council for Voluntary Service, Northampton and County, 13 Hazelwood Road,
Northampton, NN1 1LG
Tel: 01604 624121; Fax: 01604 601217; E-mail: maryh@cvsnorthamptonshire.org.uk
Contact: Mary Hopkins

North West Leicestershire Community Trust
c/o The Marlene Reid Centre, 85 Belvoir Road, Coalville, Leicestershire
LE67 3PH
Tel: 01530 510515; Fax: 01530 814632; E-mail: Jackie.clay2@care4free.net
Contact: Martin Gage

Nottinghamshire Community Foundation
Durham House, Westgate, Southwell, Nottinghamshire NG25 0JL
Tel: 01626 819219; Fax: 01623 648579; E-mail: rowenamorrell@tiscali.co.uk
Contact: Terry Nash, Company Secretary

O-Regen
Kirkdale House, Kirkdale Road, Leytonstone, London E11 1HP
Tel: 020 8539 5533; Fax: 020 8539 8074; E-mail: bladeshina@o-regen.co.uk
Website: www.o-regen.co.uk
Contact: Bola Adeshina, Company Secretary

The Pukaar Foundation
(covers West Yorkshire)
West Bowling Centre, Clipstone Street, Bradford BD5 8EA
Tel: 01274 735551; Fax: 01274 305689; E-mail: info@qed-uk.org
Website: www.qed-uk.org
Contact: Zulfiqar Ahmed, Projects Development Co-ordinator

Sefton Community Foundation
7–11 Yellow House Lane, Southport PR8 1ER
Tel: 01704 512900; Fax: 01704 531192; E-mail: dave@seftoncf.org.uk
Website: www.seftoncf.org.uk
Contact: Dave Roberts, Director

Solihull Community Foundation

Block 33, Land Rover, Lode Lane, Solihull B92 8NW
Tel: 0121 7003934; Fax: 0121 7009158; E-mail: director@solihullcf.org
Website: www.solihullcf.org
Contact: Robin Evans, Director

South East London Community Foundation

Room 6, Winchester House, 11 Cranmer Road, London SW9 6EJ
Tel: 020 7582 5117; Fax: 020 7582 4020; E-mail: enquiries@selcf.globalnet.co.uk
Contact: John Hunt, Director

South London Community Foundation

Croydon Dialogue, 49 St. Augustine's Avenue, South Croydon CR2 6JP.
Tel/Fax: 020 8686 2978
Contact: John Cheetham, Secretary

Staffordshire Community Foundation

14 Church Road, Swindon, Nr Dudley, West Midlands DY3 4PG
Fax: 0138 291971; E-mail: alan@ajierston.fsnet.co.uk
Contact: Alan Lerston

Thames Community Foundation

LGC-Victoria House, Queens Road, Teddington, Middlesex TW11 0LY
Tel: 020 8943 5525; Fax: 020 8943 2319;
E-mail: ThamesComFoundation@compuserve.com
Website: ourworld.compuserve.com/homepages/thamescomfoundation
Contact: The Director

Worcestershire Community Foundation

c/o Community First (Hertfordshire & Worcestershire),
41a Bridge Street, Hereford HR4 9DG
Tel: 01432 267820; Fax: 01432 269066;
E-mail: rachel@hereford.communityhw.org.uk
Contact: Rachel Billings

York and North Yorkshire Community Foundation

25 Main Street, Wilberfoss, York YO41 5NN
Tel: 01904 761798; Fax: 01759 388890; E-mail: stevebeyer1006@aol.com
Contact: Stephen Beyer, Director

York Challenge Partnership

Guildhall, Citizen's Support Group, York YO1 9QN
Tel: 01904 551028; Fax: 01904 551059; E-mail: rosemary.phizackerley@york.gov.uk
Contact: Ralph Kaner, Chairman

APPENDIX 1
AWARDS FOR INDIVIDUAL ARTISTS

The entries in this guide are mainly directed at organisations. However many funding sources, such as the main arts funding organisations (the National Arts Councils, the Crafts Council, etc.), plus some trusts, particularly those encouraging musical talent, and companies, also support individual artists. A list of these organisations (apart from the National Arts Councils) can be found in the index.

Awards specifically directed at individual artists are legion, far too many to be tackled fully in this guide which gives an overview of the key funding sources for groups and organisations. Many are one-off or short-term PR ventures by companies; others commemorate individuals and so on.

Certain key organisations which administer a range of permanent schemes for individual artists are given an entry. These organisations should be a useful advice point about further sources of funding. They are noted below along with a few magazines/journals – these are helpful sources of information and should be regularly scanned by those seeking funding.

Literature

Arvon Foundation;
Book Trust;
Book Trust Scotland;
Poetry Society;
Society of Authors

Details of awards for novels, short stories and works of non-fiction are found in publications such as:
The Author, the Society of Authors, London, quarterly;
Writers and Artists' Yearbook, which contains a very useful section on Prizes and Awards; A & C Black, London, Tel: 020 7758 0200;
Guide to Literary Prizes, a free fact sheet on grants and awards. This is now available on the internet plus a lot of other useful information, Tel: 020 8516 2977; Fax: 020 8516 2978; Website: www.booktrust.org.uk

Music

Musicians' Benevolent Fund – their *Handbook of Music Awards and Scholarships* is a valuable source of information about a wide of support.
Classical Music, Rhinegold Publishing, London, Tel: 020 7333 1700

Dance

Dance Now, Dance Books, Alton Hants, quarterly, Tel: 01420 86138;
Dancing Times, Dancing Times Ltd, London, monthly, Tel: 020 7250 3006

Visual Arts/Crafts

Federation of British Artists
Museums' Association

a-n Newsletter, AN Publications, Sunderland, monthly, Tel: 0191 241 8000 – invaluable information for visual artists with extensive notices on commissions and other opportunities for artists.

Also publishes an invaluable booklet – *AN Essentials* listing: Arts councils; Travel awards and study abroad scholarships; International information sources; Membership organisations; Arts and disability; Copyright; Business support; Health and safety; Artists' registers; Press and media.

Artists Newsletter website: www.anweb.co.uk – over 700 pages including 200 artists' stories, 50 pages of artists careers, 160 ages of business matters, 1,000 visual arts contacts and an interactive professional forum.

Related websites – www.workingwithartists.co.uk – the interface between artists and the world; www.artistscareers.co.uk – Can I make a living? This and other frequently asked questions on this site.

Crafts, Crafts Council, London, bi-monthly;

British Journal of Photography, Henry Greenwood & Co Ltd, London, weekly.

Direct purchase schemes

This is a growth area. One example follows:

The Internet Gallery promotes the work of new British artists and offers recent arts school graduates the opportunity to sell original works through a virtual gallery where customers can browse at their leisure, learn about the artist and make purchases from home – www.newbritishartists.co.uk

APPENDIX 2
TRAINING COURSES

A number of organisations provide training in fundraising and management for voluntary organisations, some of which are particularly geared to the needs of arts organisations. The following list gives a selection, and some related training support.

The first port of call is your nearest regional arts office or National Arts Council, whichever is the most appropriate for you (see entries for contact details).

The Arts Councils offer a range of training grant opportunities such as individual bursaries, short-term training project grants and Group Training Scheme grants. These are open to administrators as well as professional artists.

Arts & Business run advice sessions and courses throughout the country, often working in conjunction with the relevant regional arts office (for contact details see entry).

Arts Marketing Association (AMA) offers an accredited qualification in arts marketing in partnership with the Chartered Institute of Marketing
7a Clifton Road, Cambridge CB1 7BN
Tel: 01223 578078; Fax: 01223 578079; E-mail: info@a-m-a.co.uk
Website: www.a-m-a.co.uk

Association of Arts Fundraisers
4 St Stephen's Road, Cheltenham GL51 3AA
Tel: 01242 539579; E-mail: artsfundraisers@hotmail.com
Contact: Hilary Jennings, administrator

Directory of Social Change (DSC)
24 Stephenson Way, London NW1 2DP
Tel: 020 7209 4949; Fax: 020 7391 4808; E-mail: training@dsc.org.uk
Website: www.dsc.org.uk
DSC, Northern Office, Federation House, Hope Street, Liverpool L1 9BW,
Tel: 0151 708 0117; Fax: 0151 708 0139; E-mail: north@dsc.org.uk

Independent Theatre Council
12 The Leathermarket, Weston Street, London SE1 3ER
Tel: 020 7403 6698; Fax: 020 7403 1745; E-mail: admin@itc-arts.org
Website: www.itc-arts.org

Interchange Training
Interchange, Hampstead Hall Centre, London NW3 4QP
Tel: 020 7692 5800; Fax: 020 7692 5801; E-mail: bookings @interchange.org.uk
Website: www.interchange.org.uk/training

The Management Centre support also includes the six-day National Arts Fundraising School
Blue Jay Works, 117 Gauden Road, London SW4 6LE
Tel: 020 79778 1516; Fax: 020 7978 2125; E-mail: tmc@managementcentre.co.uk
Website: www.managementcentre.co.uk

The Media Trust provide courses by professionals, not trainers, that offer insight about working with the media (public relations, marketing and communications, etc.)
3-7 Euston Centre, Regent's Place, London NW1 3JG
Tel: 020 7874 7610; Fax: 020 7874 7644; E-mail: info@mediatrust.org
Website: www.mediatrust.org

Voluntary Arts Network
PO Box 200, Cardiff CF5 1YH
Tel: 01222 395395; Fax: 01222 397397; E-mail: info@voluntaryarts.org

APPENDIX 3
BIBLIOGRAPHY OF FUNDING/ SPONSORSHIP GUIDES

All the following titles are published by the Directory of Social Change, unless otherwise stated, and are available from:

Publications Department, Directory of Social Change, 24 Stephenson Way, London NW1 2DP

Call 020 7209 5151 or e-mail books@dsc.org.uk for more details and for a free publications list, which can also be viewed at the DSC website (www.dsc.org.uk).

Details were correct at the time of going to press but may be subject to change.

General
The Complete Fundraising Handbook by Nina Botting & Michael Norton, published in association with the Institute of Fundraising, 4th edition, 2001

Trusts
The *Guide to the Major Trusts* series covers the top 1,500 UK trusts, giving details of the grant-making practice and examples of grant-aid. Volume 1 contains the top 300 trusts, disbursing 80% of charitable trust funding; Volume 2 contains the next 700 trusts; and Volume 3 contains a further 500 trusts.

The Guide to Local Trusts series covers local trust giving in England and is published in four volumes: *Greater London*, *Midlands*, *North* and *South*.

A Guide to Scottish Trusts covers more than 350 trusts that concentrate their grantmaking in Scotland.

The Directory of Grant Making Trusts, published in association with CAF, contains basic information on over 2,500 trusts.

The Grant-making Trusts CD-ROM, published in association with CAF, combines the trusts databases of DSC and CAF to provide comprehensive information on over 3,800 trusts.

An annual subscription to the website *trustfunding.org.uk* will allow you to access the same range of information as on the CD-ROM, but updated regularly through the year.

Also
FunderFinder is a computer programme that helps voluntary groups to identify appropriate charitable trusts. For further information, contact: FunderFinder, 65 Raglan Road, Leeds LS2 9DZ, Tel: 0113 243 3008; Fax: 0113 243 2966; E-mail: info@funderfinder.org.uk

Companies

The Guide to UK Company Giving profiles over 500 companies. The information is also available on *The CD-ROM Company Giving Guide.*

Finding Company Sponsors for Good Causes, starter-level guide by Chris Wells, 2000.

The following nine publications are published by Arts & Business (see entry for contact points):

Did It Make a Difference?, a guide to evaluating community-based business/ arts partnerships.

Did It Deliver?, a guide to evaluating arts-based training inside business.

Did It Work for You?, a guide to evaluating business sponsorship of the arts.

Creative Connections, a guide to business and the arts working together to create a more inclusive society. Includes 10 case studies.

The Sponsorship Manual, including a five-step plan of how to obtain sponsorship.

The Tax Essentials, an Arthur Andersen guide to the tax implications of business partnership with the arts, which could maximise tax efficiency and ensure compliance with the law.

A Creative Education, examining how creativity and the arts enhance MBA and executive development programmes.

Business Investment in the Arts 2000/2001, a report detailing sponsorship spend across the UK, with breakdowns (by region and by art form) of cash sponsorship, corporate membership, sponsorship in kind, and corporate donations.

Examples of Sponsorship Pricing, 2002/03.

European

European Funding and the UK – a guide to the funding process, published by the European Commission, ISBN 92 894 1180 5. A free booklet outlining the programmes, with a useful colour map of the UK Structural Funds Areas eligible under Objectives 1 and 2 during 2000–2006.

A Guide to European Union Funding, by Peter Sluiter and Laurence Wattier, 1999

Your Way Through the Labyrinth: A guide to European Union funding for NGOs, published by ECAS, 8th edition, 2002 (available from DSC).

Cultural Funding in Europe, available from the European Foundation (EFC), 51 rue de la Concorde, B-1050, Brussels, Belgium, Tel: + 32 2 512 89 38; Fax: + 32 2 512 32 65; E-mail: efc@efc.be; Website: www.efc.be Published by the EFC in 1995, the guide contains profiles of foundations and corporate citizenship programmes that support the arts, culture and humanities in Europe.

Other

The Directory of Social Change also publishes a wide range of general fundraising books, such as *Fundraising from Grant-making Trusts and Foundations*, *Organising Special Events* and *Writing Better Fundraising Applications*. It publishes other books for the voluntary sector on communication (for example, *Promoting Your Cause* and *The DIY Guide to Public Relations*), management, finance and law.

GEOGRAPHICAL INDEX OF CHARITABLE TRUSTS

PROVISOS: The following lists indicate those grant-making trusts that have shown a particular interest in supporting activities within these geographical areas. This does not necessarily mean these are the *only* areas within which the trust will give support (though that may be the case with a few). Neither does it mean these are the only trusts to give support in these areas. Most trusts are able to donate widely in the UK.

SUBJECT INDEXES

PROVISOS: Do not confine your use of the guide to these indexes alone. To do so would severely reduce its usefulness.

The following indexes *exclude* individual references to the National Arts Councils, the Film Council and the centrally supported regional agencies/offices. These entries should be consulted for their support to all art forms, and specific types of activity whether touring, international initiatives, or enterprise and management/training support.

Users will be helped by the grouping into sections of sources of official support (listed in the Contents Page). These sources (with a few exceptions that need highlighting) are not listed again in the following lists.

The following indexes mainly direct users to those charitable trusts that display a clear interest in the specific heading. This does not mean that other trusts may not have the potential to assist this area. Most trusts tend to support a range of work in different artforms. Particular artforms and interest areas are only listed where a very definite interest is shown. Some artforms are not listed separately at all. Do not take this to mean that support may not be forthcoming from a number of official sources and certain charitable trusts. It is just that they do not consistently focus on that area of arts activity.

BY ARTFORM

ARCHITECTURE/BUILT HERITAGE

COMBINED ARTS FESTIVALS

COMMUNITY ARTS

CONSERVATION AND CRAFTS

Charitable Trusts

DANCE

Charitable Trusts

MEDIA/MOVING IMAGE

*(See also under Official Sources: Media/Moving
Image and European Funding)*

Official Source

Charitable Trusts

LITERATURE AND POETRY

Charitable Trusts

MUSEUMS AND GALLERIES

Charitable Trusts

MUSIC

Official source

Charitable Trusts

PHOTOGRAPHY

Charitable Trust

THEATRE

Charitable Trusts

OPERA

Charitable Trusts

DISADVANTAGED PEOPLE

Charitable Trusts

MINORITY ETHNIC GROUPS

Charitable Trusts

EDUCATION

(See also Official Sources: Education and Youth)

INTERNATIONAL – Travel/ Exchange, etc

(see also Official Sources: International)

Charitable Trusts

BUSINESS/MANAGEMENT SUPPORT/TRAINING

(See also Official Sources: Enterprise/Business Development)

Charitable Trusts

RURAL

Charitable Trusts